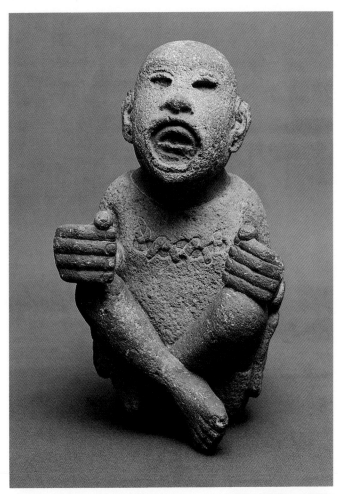

AZTEC ART

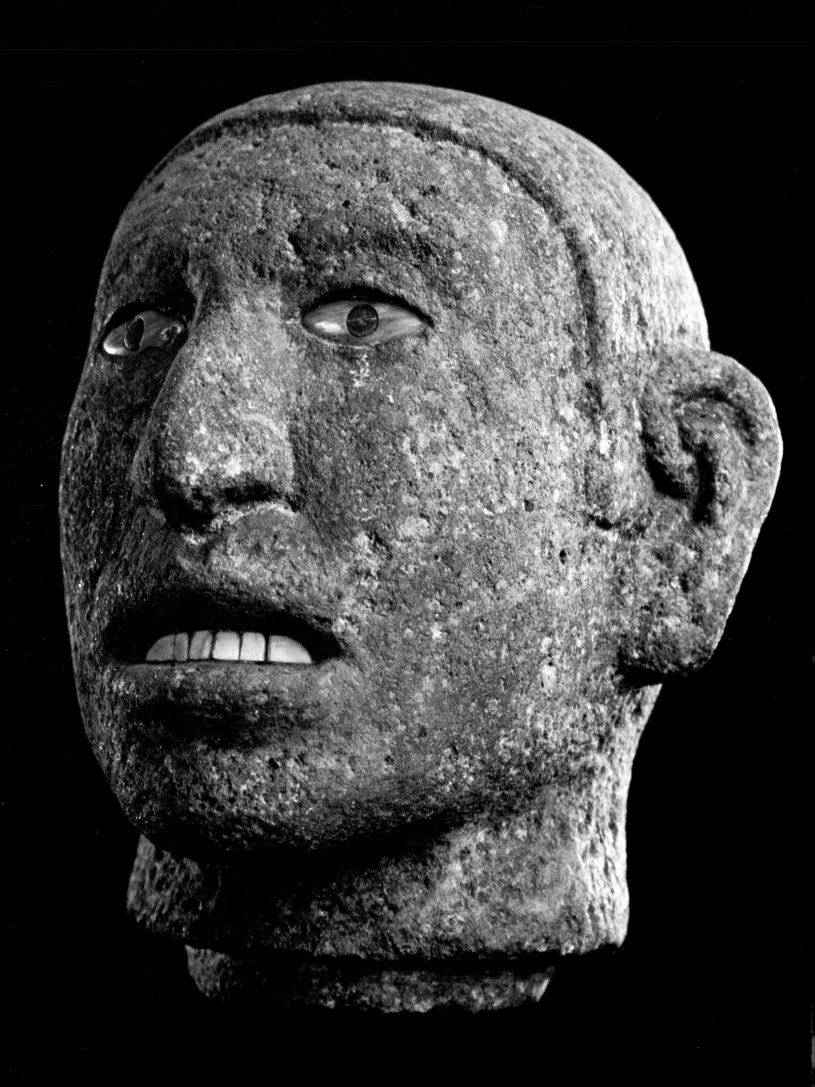

AZTEC ART

ESTHER PASZTORY

HARRY N. ABRAMS, INC., PUBLISHERS

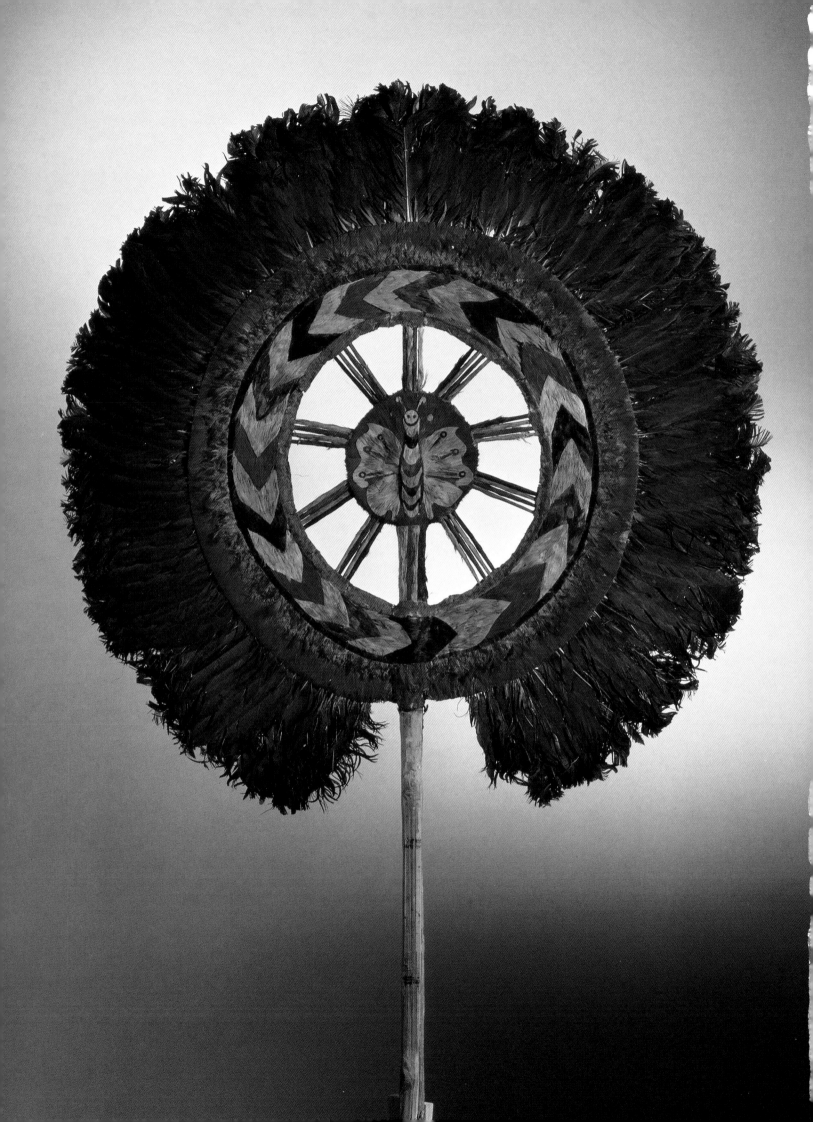

CONTENTS

TO THE MEMORY OF DOUGLAS F. FRASER

EDITOR: *Patricia Egan*
DESIGNER: *Judith Michael*

*Colorplate, Half-title Page. Seated God in
Flayed Skin. Stone with red paint, height
50 cm. Texcoco. 1200–1521. Museum für
Völkerkunde, Basel (Collection Lukas Vischer)*

*Frontispiece. Head with Inlaid Eyes. Andesite
with inlaid eyes and teeth, 19 × 15 cm. Mexico
City. 1200–1521. Museo Nacional de
Antropología, Mexico City*

*Colorplate, Page 4. Fan with Butterfly in
center (Flower on reverse). Feathers and
bamboo, 119 × 68 cm. 1350–1521. Museum
für Völkerkunde, Vienna*

LIBRARY OF CONGRESS CATALOGING IN PUBLICATION DATA

Pasztory, Esther.
 Aztec art.

 Bibliography: p.
 Includes index.
 1. Aztecs—Art. 2. Aztecs—History. 3. Indians of
Mexico—Art. I. Title.
F1219.76.A78P37 1983 709'.72 82–11527
ISBN 0–8109–0687–2

*Published in 1983 by Harry N. Abrams, Incorporated, New York
A Times Mirror Company*

Printed and bound in Japan

PREFACE

It comes as a surprise to realize that this is the first comprehensive book to be published on Aztec art, because the name "Aztec" is for most people synonymous with Pre-Columbian Mexico, and there is no lack of books published on Pre-Columbian art. The Aztecs are so well known because they were in power when Mexico was conquered by the Spaniards in the sixteenth century, but Aztec culture had been in existence only a few hundred years prior to the conquest. Within this span the Aztecs had developed a culture and an art that is one of the most notorious and spectacular in world history.

In the popular view, Aztec culture represents the ultimate in human cruelty and bloodthirstiness, and its art is the macabre expression and illustration of this culture. Others have explored the sources to learn more about the Aztecs, and have been moved by the Aztec sense of philosophical inquiry, poetry, and cosmic vision; they tend to picture the Aztecs as austere priests who humbly carried out their hard pact with the supernatural. The Westerner's dilemma has always been how to reconcile the high civilization of the Aztecs with their seemingly primitive practices. The Spanish conquerors and missionaries of the sixteenth century, for example, were as impressed by the greatness of the Aztec empire and the dignity of its people as they were horrified by its heathen religion. Already they described the Aztecs either as demons of destruction or noble savages; then as now there was difficulty in viewing the Aztecs as a people having constructive as well as destructive aspects. For the same reasons, Aztec art is customarily dismissed as grotesque and primitive, or exalted as a religious vision. It is rarely studied with the combination of objectivity and sympathy that is accorded to the art of most civilizations.

Modern archaeology has revealed civilizations in Mexico before the Aztecs, such as the Olmec, Teotihuacán, and Maya, going back to the first millennium B.C. Because there is a fascination today with the mysteries of early civilizations, interest in the earlier Mexican cultures has grown, to the neglect of the later periods, especially the Aztecs. No volume has illustrated and described all the major works of Aztec art. This book offers to fill this gap and to make these works available to the general reader.

An accidental discovery in Mexico City in 1978 led to the excavation of a major new Aztec sculpture and the exploration of the Main Temple of the Aztec empire. This excavation, ordered by President José López-Portillo, has focused popular and scholarly attention on the Aztecs once more, making this book especially timely.

Until recently the interest in Aztec art has been secondary to the study of Aztec history and religion; works of art have been used mainly to illustrate these subjects. In so far as these works of art were made by the Aztecs for their own use they are a more genuine expression of Aztec culture and outlook than the early colonial

texts, for these were compiled by and for the Spaniards, and are influenced by the conquest events or by European ideas. This analysis of Aztec art will provide another source of information for the reconstruction of Aztec life and mentality. Art is not a mirror of its society, but it reflects ideas and aspirations that embody the nature and structure of ancient thought more expressively than do other material remains.

This study of Aztec art is both a first step and a synthesis. The intention has been to present a framework for the material and a general method of approach. It is understood that individual interpretations for monuments may vary, and that those presented here are reasonable possibilities to be confirmed or rejected by future research.

The writing of a general book on an artistic tradition that has not yet been analyzed in detail is a challenge that has led to adopting a specific method of approach, for it was soon evident that the reader could not grasp the significance of a monument without knowing something of its relationship to the rest of Aztec art in all its forms. In Chapter II the different artistic materials are presented separately, to establish canons of forms and iconography and thereby to bring out significant deviations and special configurations. This approach has yielded an important discovery, that certain deities belong to particular forms of art—monumental sculpture, small-scale stone sculpture, codices, and terracotta figurines. This insight suggests the existence of separate religious cults and the different concerns of the ruling class, the priesthood, and the commoners. Aztec art is not to be seen as a unified phenomenon but as a series of linked phenomena that functioned together in one system. Accordingly, the "minor arts" are equally as significant as the "major arts": the major monuments of Tenochtitlán cannot be understood apart from the terracotta figurines of the commoners.

The Aztec people and their art can only be understood when their historical position is examined. Latecomers to Mexico, the Aztecs became overlords of a land rich in abandoned cities and ruins. Much of their art was an attempt to emulate and surpass the greatness of these earlier traditions. They differed from earlier cultures in having a greater historical awareness, and in consciously incorporating archaistic elements in their arts. Any analysis of Aztec art has to take into consideration the ambivalent response of the Aztecs to this past.

In addition to its introduction to Aztec art, this book offers a set of hypotheses that will serve until complete archives of Aztec materials have been assembled. These methods and ideas were developed in a number of graduate seminars I held at Columbia University. The book originated in a project begun in 1974 with a study of Aztec sculpture in New York museums; this material formed the basis for an exhibition of stone sculpture in 1976 at the Center for Inter-American Relations in New York. An exhibition catalogue, written partially by graduate students, was published. It was evident to everyone concerned that a general book was needed on Aztec art. I undertook this project, which then seemed simple enough: my aim was to bring together for the first time illustrations of the major monuments, and a representative selection of the rest of Aztec art. In selecting the illustrations, the choice has been made from works of art accessible to the public in major museums in Mexico, Europe, and the United States, but this material proved to be so extensive that many interesting pieces had to be excluded, as well as most works in private collections.

It is no exaggeration to say that this book could not have been written without the enthusiastic participation of many graduate students in seminars offered since 1974 on a variety of Aztec subjects. I am especially indebted to Emily Umberger,

who just completed her dissertation on Aztec monuments bearing glyphs. Her analysis of the historical content of these glyphs led to a reevaluation of the chronology and meaning of many of the major monuments of Aztec art, and much of Chapter IV is based on her work. Her photographs of Aztec sculpture in Mexico and in European museums, as well as Wendy Schonfeld's work in establishing a photographic archive at Columbia University, have provided me with much material. Other students, including Susan Bergh, María Fernandez, Eloise Keber, Heidi King, and Debra Nagao, were helpful with various factual and pictorial details, often requested at the last minute.

My research trips to Mexico were made especially fruitful by the generous help of many individuals. Felipe Solís Olguín, curator of the Mexica Hall at the National Museum of Anthropology, took me to see several archaeological sites and showed me through museum collections and storerooms. Eduardo Matos Moctezuma explained new excavations of the Main Temple on more than one occasion. Costanza Vega Sosa and Carmen Aguilera have been helpful in ordering photographs and discussing problems of Aztec art. Doris Heyden provided me with stimulating ideas in addition to a place to stay, and solved endless intellectual and practical problems over the course of many years, for which I am deeply grateful.

The list of Aztec specialists who have been of help and stimulus is long. Foremost, perhaps, is Jacques Soustelle, whose book *The Daily Life of the Aztecs* was a revelation to me when I was still a student. I am indebted to all the scholars who presented papers at the Symposium on Postclassic Iconography that I organized at the International Congress of Americanists in Vancouver in 1979. The conference on the Templo Mayor excavations, organized in 1979 by David Carrasco in Boulder, Colorado, afforded me an excellent opportunity to discuss the nature of Aztec civilization with professionals from many fields. I also wish to thank Edward Calnek, Richard Townsend, Nigel Davies, and Johanna Broda for their many stimulating ideas and conversations over the years. I am deeply sad not to be able to thank the late Thelma Sullivan for her many years of friendship. I have learned much from her translations of Nahuatl texts and hope that she would have approved of the uses I made of them here. H. B. Nicholson has worked on Aztec culture for many more years than I have and has always been helpful. His project for a comprehensive archive of Aztec sculpture is of major importance and will probably modify much that is here simply begun. I know that he will find many details to correct in these pages and I look forward to his learned criticisms. I owe an intellectual debt to George Kubler, whose perceptive writings on Pre-Columbian art have influenced my own thinking in more ways than I have ever acknowledged.

Research in New York has been greatly facilitated by several people. Alan Chapman, the librarian of the Goldwater Library at the Metropolitan Museum of Art, gave access to hard-to-find publications and was always ready with his knowledge of the Aztecs. Anna Roosevelt at the Museum of the American Indian, Heye Foundation; Gordon Ekholm at the American Museum of Natural History; Julie Jones at the Metropolitan Museum of Art; and Diana Fane at the Brooklyn Museum—all have been helpful in allowing me and my students to study the collections and to photograph works whenever necessary.

A first draft of the manuscript was read by Doris Heyden, Cecelia Klein, and Emily Umberger. I am indebted to all of them for their insightful criticisms and corrections. Alva Millian took on the time-consuming task of acquiring the illustrations and writing the captions. She has been a source of moral support throughout

the writing of this book. Janice Robertson made the beautiful drawings and maps that clarify the text and the photographs. And finally, I would like to thank Christopher Couch for typing and editorial assistance and for compiling the glossary. Patricia Egan's editorial pen at Abrams has often simplified the wordings in this text, much to its benefit.

I am deeply grateful to my friends and family for maintaining their interest in the Aztecs over the years and for all the encouragement they gave me while I was writing.

As this book was about to go to press, my professor and colleague at Columbia University, Douglas Fraser, died unexpectedly. In recognition of his encouragement and support of my studies in Pre-Columbian art, I dedicate this book to his memory.

E. P.

Plate 1. Map of the Valley of Mexico in 1519

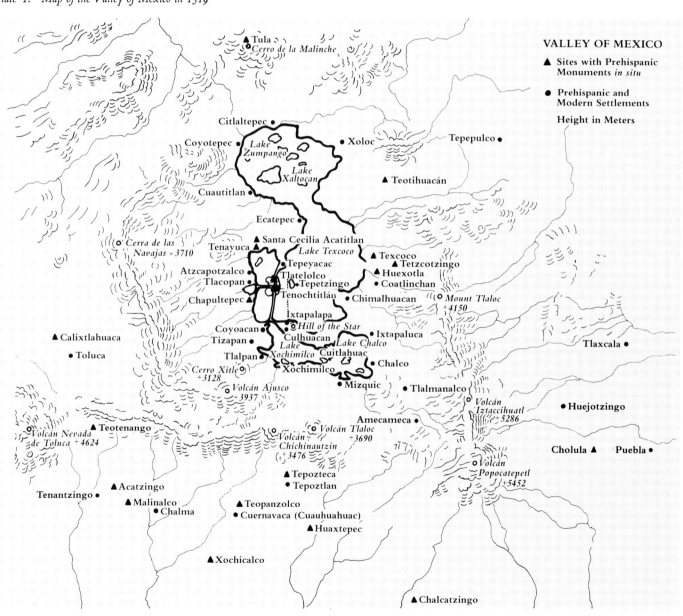

VALLEY OF MEXICO

▲ Sites with Prehispanic Monuments *in situ*

● Prehispanic and Modern Settlements

Height in Meters

I

HISTORICAL AND CULTURAL BACKGROUND

Discovery, Conquest, and Colonization of Mexico

COLUMBUS'S DISCOVERY OF THE AMERICAS. Although Columbus did not reach Asia, as he thought he had, he did find a new land having magnificent natural resources and a pleasant climate which reminded him of spring in Andalusia, barbarian natives who needed to be converted to Christianity, and a few items of gold jewelry. For us, Columbus's discovery set a milestone in the evolution of the scientific outlook, but for Columbus and others in the late fifteenth century it was also a religious event. The fifteenth- and sixteenth-century Europeans who came in contact with the people of the New World shared with them an outlook on life that was in large part governed by supernatural beliefs. Columbus believed that he was led to the discovery by the Holy Ghost, and that this was one in the series of events prophesied to occur just before the end of the world and the second coming of Christ. The riches he found he thought came from the land of Ophir, part of the gifts given to Solomon by the Queen of Sheba. In his view, the New World was, at one and the same time, the Garden of Eden as well as a new and better world to be established after the coming of the millennium (Columbus, 1968).

Columbus sailed among the Caribbean islands and he met Indians who were wearing some gold jewelry that they had traded from Central America but otherwise had very simple material possessions. His trip spurred the colonization of the islands and stimulated competition in exploring further into the Americas with fanatic greed and religious zeal. Two of these expeditions, Cortés's conquest of the Aztecs in 1521 and Pizarro's conquest of the Incas in 1536, far surpassed Columbus's in the quantity of gold treasure they took and the complexity of Indian civilizations they discovered. Rumors of other fantastic cities and treasures—El Dorado and the Seven Cities of Cibola—aroused eager adventurers to undertake any hazard in the hope of surpassing the early conquests, but no civilization greater than those of the Aztecs and Incas was to be found in the Americas (Plate 1).

THE SPANISH CONQUEST OF THE AZTEC EMPIRE

> Broken spears lie in the roads;
> we have torn our hair in our grief.
> The houses are roofless now, and their walls
> are red with blood . . .
>
> We have pounded our hands in despair
> against the adobe walls,
> for our inheritance, our city, is lost and dead.
> The shields of our warriors were its defense,
> but they could not save it.
>
> (LEÓN-PORTILLA, 1962, PP. 137–38)

Science-fiction stories fascinate us today with the possibility of aliens coming from outer space to conquer the earth. We have ambivalent feelings toward these mythical outsiders, imagining them to be either terrible and inhuman or wise and benevolent. But nothing in our own history comes close to the experience of the New World peoples, overpowered by beings completely alien. For the inhabitants of Mexico, who had no knowledge whatever of the Old World, the sudden appearance of strange-looking people possessed of a miraculous technology that included sailing ships, iron, and guns, and of weird animals such as horses, must have been as awesome as a genuine UFO would be for us. It is hardly surprising that many in Mexico, including the ruler Motecuhzoma, took the Spaniards to be gods and held ambivalent attitudes toward them. Once the humanity of the invaders and their conquering mission was evident, the two peoples were locked in a bitter struggle. The devastation and bloodshed during the conquest of Mexico had few equals in the preindustrial world. The Spanish overlords forced the population to change their Indian culture overnight to European ways, foreshadowing the mass suffering wrought by European imperialism and communist revolutions in the nineteenth and twentieth centuries.

In telling the story of the conquest, it is hard to remain impartial. In one view, the Aztecs appear as bloodthirsty, cannibalistic savages who ultimately deserved the punishment of the Spanish conquest, and whose descendants may have been better off under colonial rule. Another view sees the Aztecs as a primitive people having sacrificial cults that were not altogether uncommon, who, in the name of Christianity, were outdone in cruelty by their Spanish destroyers. There is little question that the Aztecs and Spaniards were equal in their cruelty, though their ideas were different of what constituted war and which acts were excessive and inhuman. The tragedy lay in the almost complete absence of understanding in each culture for the other's way of life.

The Spanish conquest of Mexico has often been called the "Last Crusade." Granada, the stronghold of the Moors in Spain, was reconquered by the Spaniards in 1492, the year of Columbus's discovery. Jews and Muslims were expelled from Spain, and any who remained were forcibly converted to Christianity. The conquest of Mexico, this rich new land of infidels, seemed a continuation of Spain's long war against the Muslims—indeed, Cortés compared Aztec costume and architecture to "Moorish" fashion (Cortés, 1971, p. 30).

Few historic events equal the drama of Cortés's conquest of the Aztec empire with an army of five hundred men, sixteen horses, and one cannon.[1] The first governor of Cuba, Diego Velázquez, chose Hernando Cortés to lead an expedition to Mexico. Though Velázquez later changed his mind, Cortés sailed from Cuba in February, 1519, and on the coast of Yucatan he picked up a Spaniard stranded from a previous expedition who spoke Maya and could be his interpreter. Later, in a battle with Indians on the Gulf Coast, he acquired the slave woman Malinche (called after baptism Doña Marina), who could speak both Maya and Nahuatl, the Aztec language. She remained his mistress and interpreter throughout the conquest (Plate 2).

The Aztec ruler, Motecuhzoma II, had been told by his messengers about the strange ships that were sailing in the Caribbean area and eventually up the coast of Mexico. He may have known of the strangers as early as 1507–10; in any case, his information came after reports of a series of evil omens: lightning striking a temple, the boiling of the water of the lake, the sound of a weeping woman at night, and monstrous beings seen walking the streets. The most frightening omen was a comet. These omens were interpreted by Motecuhzoma and his seers as portents of doom

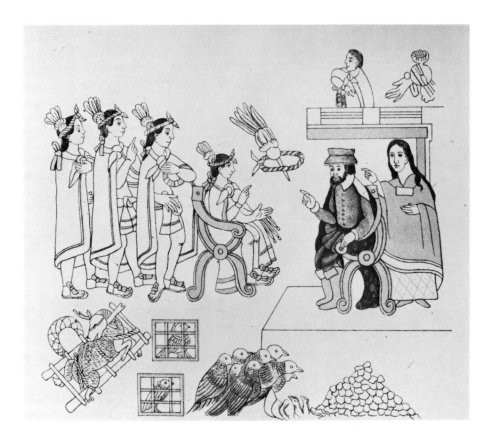

for his empire, and in his fury and frustration he put to death all those who gave him unfavorable prophecies.

Motecuhzoma believed at first that the Spaniards were gods, possibly including the legendary Toltec ruler Quetzalcoatl who had been exiled from Tula and had promised to return—some traditions specified his return in the year 1 Reed. The year 1519 was the year 1 Reed in the Mexican calendar. Motecuhzoma summoned a group of artists and had them make magnificent costumes of feathers and gold to be taken as gifts to the strangers sailing in the "wooden temples," as the Spanish ships looked to them. The messengers took costumes of the gods to Cortés on the ship and robed him as a deity. Two of the costumes were of Quetzalcoatl, the others were of Tezcatlipoca, the patron of royalty, and of Tlaloc, the rain god. Motecuhzoma hoped that the strange gods, or whoever they were, would be satisfied by the gifts, reveal their identity, and go away. But Cortés chained the messengers and then fired the cannon, which made them faint; he revived them with wine, which made them drunk. Evidently he realized he was being taken for a deity, and he made every use of it.

Cortés built a settlement on the coast called Villa Rica de Vera Cruz. He had himself chosen captain general by the municipal government of the new city, thereby refusing allegiance to Velázquez, and he acknowledged responsibility only to Charles V, king of Spain and Holy Roman Emperor. He burned his ships, to ensure that his men could not return to Cuba, and began to march inland toward the Aztec capital, Tenochtitlán. On the way he conquered several towns, not only because he had unheard-of advantages through his horses, crossbows, muskets, and swords, but also

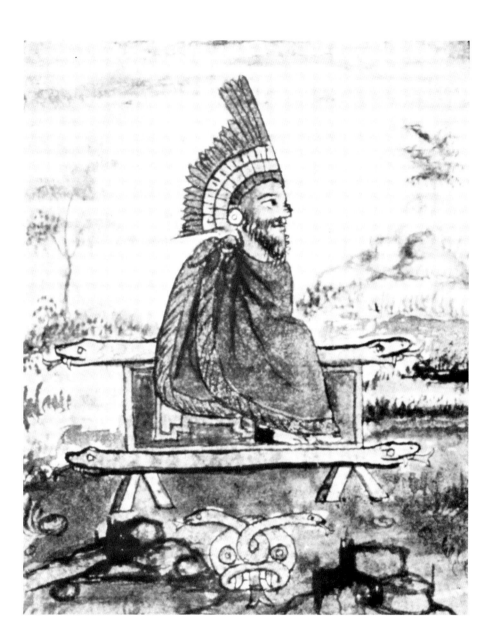

Plate 3. Fair-bearded Ruler Quetzalcoatl Seated on a Litter or Throne with Serpent Ornaments. Durán's Historia de las Indias de Nueva España y Islas de la Tierra Firme, Bk. I, ch. 1, fol. 228r. Manuscript. Valley of Mexico. Early Colonial, c. 1570. Biblioteca Nacional, Madrid

because he faced Pre-Columbian ceremonial warfare. The Mexicans fought with obsidian-bladed weapons, and were dressed in their finery of feathered costumes and standards; they announced the beginning of hostilities with many formalities; instead of killing the enemy in battle, they tried to capture prisoners and take them back to be sacrificed later; if their leader died or their temple was taken, they gave up the fight, and when the battle was over, the leaders of both sides sat down together to discuss the amount of tribute that would henceforth be collected by the winners from the losers.

The Spaniards, by contrast, fought a total war of conquest. They killed on the battlefield and expected to make permanent vassals of the conquered people. Cortés learned that the people living to the east of Tenochtitlán had been conquered only recently by Motecuhzoma and were anxious to regain their independence. He convinced Motecuhzoma's enemies, especially the people of Tlaxcala, to join his ranks and help defeat Tenochtitlán.

As the Spaniards marched ever closer to Tenochtitlán, Motecuhzoma was informed of their actions by his spies, who painted pictures of the invaders. Motecuhzoma remained undecided whether to welcome or attack them, and his advisors were also divided into factions, some peaceable, some warlike. Motecuhzoma plied Cortés with gifts in a futile effort to send him back, yet he also had his magicians cast spells to destroy the approaching Spaniards; for a while he considered escaping to a sacred cave. When Cortés reached the city of Cholula, Motecuhzoma tried to capture him by ambush; Cortés discovered the plot and, in a clever strategic move, caught the Cholulans before their plan was ripe, massacred the population, threw down their idols, and destroyed their temples. An image of the Virgin Mary was set up in the Temple of Huitzilopochtli, the Aztec war god. This victory had decisive psychological results for the Spaniards.

After Cholula, city after city surrendered to Cortés without bloodshed as he approached Tenochtitlán. Motecuhzoma and his nobles met Cortés with an elaborate welcoming ceremony at the southern causeway leading to the island capital (Plate 2), and he is said to have addressed Cortés as the returning descendant of Quetzalcoatl in the following words: "O our lord, thou hast suffered fatigue; thou has spent thyself. Thou hast arrived on earth; thou hast come to thy noble city of Mexico. Thou hast come to occupy thy noble mat and seat, which for a little time I have guarded and watched for thee" (Sahagún, 1950–69, bk. 12, p. 42). Whether or not Motecuhzoma still believed in the legend of Quetzalcoatl, he took refuge in the story to account for his actions. He lodged Cortés in the palace of his father, Axayacatl. There the Spaniards discovered a vast treasure of gold, which they melted down into bars to be sent as tribute to Charles V; the colorful stones and feathers they threw away. On the pretext of treason to the Spanish crown, Cortés took Motecuhzoma prisoner. Since Motecuhzoma was not willing to accept Christianity, Cortés himself smashed the idol of Huitzilopochtli and put up an image of the Virgin in its place. Motecuhzoma was asked to swear fealty to Charles V, and although the captive remained nominally the ruler, Cortés assumed his royal powers and the right to collect tribute from subject peoples. During the six months that Cortés spent in Tenochtitlán he learned a great deal about the Aztec empire.

In the meantime, Velázquez had sent Panfilo de Narváez to bring Cortés back to Cuba and punish him for insubordination. On hearing the news that a group of Spaniards had landed on the coast, Cortés left Tenochtitlán in the charge of Pedro de Alvarado and eighty men and went back to Vera Cruz, defeating Narváez in battle. The latter's soldiers, numbering over 1,000, joined Cortés. During this time, the Aztecs in Tenochtitlán had begun to celebrate the festival of Huitzilopochtli, the war god, and rumors of an ambush spread among the Spaniards. Alvarado's men, vastly outnumbered and fearful of ambush, attacked and massacred the Aztec priests and worshipers, thus starting open warfare. Cortés returned to find Tenochtitlán suffering from lack of food and supplies, and the whole city ready to take up arms. Motecuhzoma tried to talk to his subjects on behalf of the Spaniards but he no longer had their support and they were beginning to rally to Motecuhzoma's brother Cuitlahuac. Some accounts say that Motecuhzoma was stoned to death by his own people, others that he was secretly killed by the Spaniards. The Aztecs began a general insurrection. On June 30, 1520, the Spaniards, laden with gold and treasures, were decimated by the Aztecs as they tried to leave the city. Cortés escaped with fewer than 500 men. The Aztecs, instead of following up on their victory, stopped the pursuit to collect booty and sacrificial offerings.

Cortés returned to Tlaxcala and began to plan a siege, building brigantines and continuing to attract native allies. Motecuhzoma's brother Cuitlahuac died of smallpox, a disease introduced by a soldier with Narváez which became epidemic within two weeks, and the Aztecs then elected Motecuhzoma's young cousin, Cuauhtemoc, to be their ruler and war leader. Nine months later Cortés began to lay siege to Tenochtitlán by blocking the causeways and intercepting the food supplies (Colorplate 1). His forces were much larger this time, and he demolished the city building by building as he went, so that not one house remained in his path. Cuauhtemoc made his last stand at Tlatelolco; even at this late date, the Aztecs used the respite of a day of victory to sacrifice victims and dance before the Temple of Huitzilopochtli rather than to pursue any temporary advantage they might have gained.

When it became evident that Tenochtitlán would fall to Cortés, most of the Aztec soldiers and priests elected to die rather than be taken captive. On August 13, 1521, the city fell after a siege of eighty days. Cuauhtemoc and other captives were tortured to reveal new sources of gold. When they could not, some were torn apart by hungry dogs. Tenochtitlán was abandoned, its shallow canals filled in with the ruins of its buildings. It is estimated that over 200,000 Aztecs died in the conquest, primarily members of the warrior aristocracy and the priesthood of Tenochtitlán. The wreckage was displayed to visiting Aztec chiefs. Ships bringing Spanish wine and pigs provided for the victory orgy.

The trauma of the conquest did not end with the taking of Tenochtitlán. Cortés continued to campaign throughout Mexico and as far south as Honduras, taking Cuauhtemoc with him as prisoner and finally killing him. On returning, Cortés was made Marqués del Valle de Oaxaca, but Charles V would not name him governor of Mexico. Governmental chaos and intrigue among the conquerors and settlers reigned until Viceroy Antonio de Mendoza arrived in 1535. He tried to keep the rule of New Spain in line with the less exploitative edicts of the Spanish royal house; the Spanish crown propounded certain humanitarian laws for governing New Spain, but it was difficult to apply them to the adventurers flocking to Mexico to profit from the conquered population through exorbitant demands for tribute. These demands far exceeded those of Motecuhzoma. Some of the native aristocracy was supported for a generation, but heavy tribute was imposed by the Spaniards. The Spaniards often treated the Indians as slaves and used their forced labor to build residences and churches in the European style from the stones of Aztec temples. Many Indians were worked to death in the silver and gold mines. The population in the countryside was moved into concentrated settlements for easier control and to free their land for the Spaniards (Gibson, 1964).

Smallpox and other epidemics in 1545–48 and 1576–81 cut down the native population by one third. In their now devastated condition, the Indians turned to drink. Drunkenness had been limited in prehispanic times to ceremonial occasions, but it now provided a general form of escape from a disordered and incomprehensible reality. Even greater than the Indians' physical suffering was their spiritual anguish at the destruction of their religious system, values, and world view, which left them emotionally bankrupt. Christianity, immediately and cruelly forced upon them, was eventually accepted as a new form of order and solace.

THE CONVERSION OF THE INDIANS. Cortés had asked Charles V to send missionaries to undertake the conversion of the Indians. Among the first to arrive were twelve Franciscan friars in 1524, followed by Augustinians and Dominicans in the 1530s.

These friars were the first Europeans the Indians had seen who dressed in coarse robes like their own priests and did not hunger after gold. Like Columbus, the friars believed that the discovery of the New World and the conversion of its heathens signified the coming of the millennium (Phelan, 1956).

The Franciscans, following one of the teachings of the twelfth-century mystic Joachim of Floris, thought that three ages would precede the apocalypse: the first was that of the early church; the second, that of the worldly papal church in which they were presently living; the third would be of the spiritual church of the future. The Franciscans thought that the discovery of the New World initiated Joachim of Floris's third age of the new spiritual church. It was no accident that twelve Franciscans, like the twelve apostles of Christ, set sail for the Indies. They believed that the Indians were innocent at heart but misguided by the devil in the guise of the native priests. The friars took sides with the Indians and protected them against rapacious settlers, who thought the Indians subhuman and only fit for slavery.

Not satisfied with mass baptisms and the natives' superficial acceptance of Christianity, the Franciscans early recognized that the Indians were continuing to worship their own gods under the guise of Christian ritual. The secular clergy accepted this form of syncretism, but the Franciscans aimed at destroying the old beliefs completely. To accomplish this they established schools, the most famous being the College of Santa Cruz de Tlatelolco, founded in 1531.

The friars learned the Nahuatl language and transcribed it into the Spanish alphabet to teach the scriptures to the aristocratic Aztec sons. At the same time, the friars undertook vast projects in learning and recording the beliefs and practices of the Aztecs prior to the coming of the Spaniards. Their aim was to recognize pagan elements hidden under a Christian veneer. Since the friars believed that all information about the world was contained in the Christian scriptures, they were interested in ascertaining which biblical traditions related to the origin and history of the Indians. (This kind of scrutiny later led to the identification of the Indians with one of the ten lost tribes of Israel.) They contrasted the pious and spartan Aztecs with the corrupt and soft Spaniards as the Greeks were contrasted with the Romans in antiquity. By preserving the Nahuatl language, the Indians' "good" traditions could be taught again once the spiritual "Republic of Christ" was firmly established.

Franciscan influence had faded by the end of the sixteenth century, their millennarian hopes had disappeared, and their partisanship of the Indians was of little help as they themselves were being questioned by the Inquisition for excessive pro-Indianism. Sahagún's manuscript was confiscated. The secular clergy and the Jesuits by then controlled religious life in Mexico.

The first bishop of Mexico, Juan de Zumárraga, arrived in 1528, and in 1531 he boasted that he had destroyed 500 temples, 20,000 idols, and all the sacred books he could find. By that time most Indians had been forcibly baptized and were expected to carry out Christian ritual; already idolators were ferreted out and executed. Christianized sons were expected to spy on their fathers and report them to the church for "idolatry." The Inquisition functioned in New Spain from 1536 to 1570, and it is hardly surprising that though ancient customs were outwardly given up, the Aztec statues were either buried or hidden in caves. The more idols Zumárraga uncovered, the more rumors were spread of other idols. The statue of Huitzilopochtli was supposed to have been saved and hidden in one of the caves near Tula, but no amount of investigation has ever turned it up.

In 1531, an Indian named Juan Diego saw an apparition of the Virgin Mary at the

former location of a major temple to the Aztec mother goddess, Tonantzin. The vision came to be known as the Dark Virgin of Guadalupe. When the worship of the Virgin of Guadalupe became official—a vision of her reputedly appeared also to Bishop Zumárraga—the remnants of Aztec religion were hidden in the guise of Christian belief. Not even the disapproval of the Franciscans could stop this syncretism that remains characteristic of popular Mexican religion today.

Sources of Information on Aztec Life and Art

THE EARLY COLONIAL WRITTEN TEXTS. Almost everything that we know about the Aztecs comes from eyewitness accounts by the conquerors, chronicles compiled by the missionaries, and legal documents. This is a rich storehouse of information on Aztec life, but none of it is entirely accurate or without bias.

At present, we have six eyewitness accounts of the conquest, all written by Cortés or the men who were with him (Fuentes, 1963). The two most important are the letters Cortés wrote to Charles V in Spain and the *Conquest of New Spain*, a book written by Bernal Díaz del Castillo, one of Cortés's soldiers. Cortés hoped that his letters would convince the king that the significance of the conquest justified his more dubious actions, as well as his request for recognition through titles and estates. He tended to exaggerate his successes in battle and the size of the conquered populations; he explained his atrocities as necessary acts in converting the barbarous and cannibalistic Aztecs.

Bernal Díaz was a soldier of fortune who waited for old age before writing down his account of the heroic days of the conquest as he remembered them. His description of the Spanish soldier's glimpse of Tenochtitlán retains his original sense of wonder and expresses a nostalgia for the civilization he helped destroy:

> . . . Next morning we came to a broad causeway and continued our march towards Ixtapalapa. And when we saw all those cities and villages built in the water, and other great towns on dry land, and that straight and level causeway leading to Mexico, we were astounded. These great towns and *cues* (temples) and buildings rising from the water, all made of stone, seemed like an enchanted vision from the tale of Amadis. Indeed, some of our soldiers asked whether it was not all a dream. It is not surprising therefore that I should write in this vein. It was all so wonderful that I do not know how to describe this first glimpse of things never heard of, seen or dreamed before. . . . Everything was shining with lime and decorated with different kinds of stonework and paintings which were a marvel to gaze on. . . . I say again that I stood looking at it, and thought that no land like it would ever be discovered in the whole world because at that time Peru was neither known nor thought of. But today all that I then saw is overthrown and destroyed; nothing is left standing.
>
> (DÍAZ DEL CASTILLO, 1963, P. 214)

Both Cortés and Bernal Díaz were impressed by the noble behavior of Motecuhzoma and the Aztec aristocracy whom they got to know, but neither understood the Aztecs' view of life. Their interest in Aztec behavior and motivation came from their desire to outmaneuver the Aztecs in battle and in negotiations. Their descriptions are important because they alone saw the Aztec culture relatively intact, though in a situation of extreme stress.

By the time the missionaries arrived in Mexico, after the first decade, they met a

conquered and demoralized people whose way of life was rapidly changing. The friars' interest in the native population went much deeper than that of the conquistadors or colonists because they hoped through understanding to facilitate the saving of their souls. As they began to comprehend the Aztecs they sympathized with their condition, and sought to preserve in writing as much of the disappearing native tradition as possible. Their writings were, however, based on descriptions of Christianized natives rather than on personal observation of what had been.

The most elaborate project was undertaken at Tlatelolco by the Franciscan friar Bernardino de Sahagún (Edmonson, 1974). Sahagún arrived in Mexico in 1529 and spent the next eighteen years learning and transcribing Nahuatl, and translating the Bible into that language. He then undertook the compiling of several manuscripts on Aztec customs, which occupied him from 1547 to 1575; he worked with illustrations drawn by natives and information collected from elders and written down in Nahuatl (Plates 28, 29). Sahagún talked to old men, diviners, women herbalists, and merchants. He recorded oral speeches and prayers and prepared questionnaires to which the Indians responded, sometimes spontaneously elaborating on certain points. His pro-Indian reputation caused his work to be scrutinized by the Inquisition in 1575, and his writings were confiscated, lost to him, and never published during his lifetime; they were not found again until the eighteenth century. Three works are now available by Sahagún: the Primeros Memoriales, the information for which was collected in Tepepulco, and the Manuscrito de Tlatelolco, the first draft of his work at Tlatelolco (both of these are in Madrid and were published as the Codices Matritenses del Real Palacio); and the Florentine Codex, his final compilation, consisting of parallel texts in Nahuatl and Spanish, the Spanish text written partly in his own defense against the Inquisition.

Sahagún's manuscripts offer the largest and most reliable source of information on the life of the Aztecs. Other works are also available, such as the "History of the Indians of New Spain" by Motolinía (Friar Toribio de Benavente, called by the Indians Motolinía, "poor man," because of his poor clothes), who worked for years in Texcoco, Tlaxcala, and Cholula. Motolinía was one of the original twelve Franciscans to come to Mexico; he and Andrés de Olmos wrote their accounts even before Sahagún's. Andrés de Olmos used the same painstaking methods as Sahagún, but his text has disappeared (Wilkerson, 1974). It has been suggested that certain anonymous manuscripts such as the *Histoyre du Mechique*, the Codex Museo de América, and the *Historia de los Mexicanos pur sus Pinturas* are his work, but it is difficult to associate specific authors with any of these (Boone, 1977). Olmos taught at the College of Santa Cruz de Tlatelolco, as well as spending some time in Veracruz.

Following the Franciscans, Dominican friars and Jesuit priests were also recording native traditions during the second half of the sixteenth century. Less imbued with a mystical and millennarian spirit than were the Franciscans, they were more ready to see parallels between the Bible and the gods and stories of the Mexicans. The most important of their works are the writings of a Dominican, Diego Durán, the *Historia de las Indias de Nueva España*, written in 1581 (Durán, 1964; Durán, 1971). Durán was born in Spain but spent his childhood in Texcoco; he was ordained in Mexico. Several manuscripts, such as the *Historia de la Benida de los Yndios* of the Jesuit Juan de Tovar, the *Historia Natural y Moral* of José de Acosta, also a Jesuit, and the *Crónica Mexicana* of Hernando Alvarado Tezozomoc, are so close to Durán's historical account that all these manuscripts have been thought to derive from a lost original called the *Crónica X* (Barlow, 1945). The information in this group of chronicles comes from the ruling families of Tenochtitlán.

All the chronicles have certain distortions stemming from the Aztec informants as well as the point of view of the Spanish writers. The nature of the information varies with the town where the account was written, whether Tlatelolco, Tenochtitlán, or Texcoco, and in each case the hometown is glorified at the expense of others. There can also be a family bias; it is evident that a large portion of the chronicles related to Durán is derived from the descendants of one royal advisor or *cihuacoatl* named Tlacaelel. In these accounts Tlacaelel is the power behind the thrones of five successive rulers. The information also depends on whether the chronicler consulted nobles, as Durán did, or merchants, as in the case of Sahagún. There is almost no material on the outlook or beliefs of ordinary people or the lower classes. Since many important Aztec priests died during the conquest or were unwilling afterward to deal with the Spaniards, the information on religion comes from accounts by upper-class persons. Many ritual actions are described, but there is little theological explanation. It is as if we reconstructed Catholicism on the basis of information from pious Catholics, without consulting priests or the theological literature. Since the Indians' way of life was disintegrating at the time they were being consulted, they were unconsciously reworking their history to explain the conquest by earlier events and prophecies, and attempting to rationalize their own experiences. And in describing their beliefs and their past way of life they tended to idealize their behavior rather than give a picture of reality. In the same way an American might describe the democratic ideal of "one man, one vote" government rather than the actual practice of special-interest pressure groups and lobbies.

Faced with a culture as strange as the Aztecs', the Spaniards sought to understand it by comparing the Aztecs and their many gods with other non-Christians having a pantheon, such as the Greeks and Romans. In trying to fit the Indians into the world history contained in the Bible, they were especially struck by certain apparent similarities between Aztecs and Christians, such as the practice of confession and the use of the cross as a symbol. These subjects they probed in great detail; others they left unexplored.

The legend of Quetzalcoatl is a good example of the interplay of the Aztecs and the Spaniards as they reworked Aztec myths in the sixteenth century (Lafaye, 1976). The Aztecs had a tradition about a god and ruler called Quetzalcoatl, "quetzalbird-serpent" or "precious twin." Quetzalcoatl had both human and divine aspects. As a god, he had helped bring mankind to life in the last creation of the world. As a man, Quetzalcoatl was the king of the Toltecs, the preccessors of the Aztecs in the Valley of Mexico (Plate 3). He was a priest-ruler who did not believe in human sacrifices and sacrificed only birds and butterflies. The warlike deity Tezcatlipoca, "smoking mirror," came to Tula and with his sorcery tricked Quetzalcoatl into getting drunk and having intercourse with his sister. For this reason, Quetzalcoatl was exiled from Tula, and went on a journey to the coast, stopping in various places to teach arts and crafts to his followers, and knowledge of the calendar. He arrived on the Gulf Coast; there, by some traditions, he built a funeral pyre and immolated himself, and his heart became the planet Venus; by others, he sailed away on a raft of serpents and promised to return some day (Bierhorst, 1974, pp. 3–105).

The Quetzalcoatl tale about the Toltec ruler was a heroic epic that explained to the Aztecs the decline of Toltec civilization and the rise of their own military civilization. Motecuhzoma resorted to this legend to account for the otherwise inexplicable arrival of the Spaniards and to explain his own vacillation in dealing with them. He saw himself deceived by Cortés as Quetzalcoatl was tricked by Tezcatlipoca. Cortés exploited the same legend in his own dealings with Motecuhzoma;

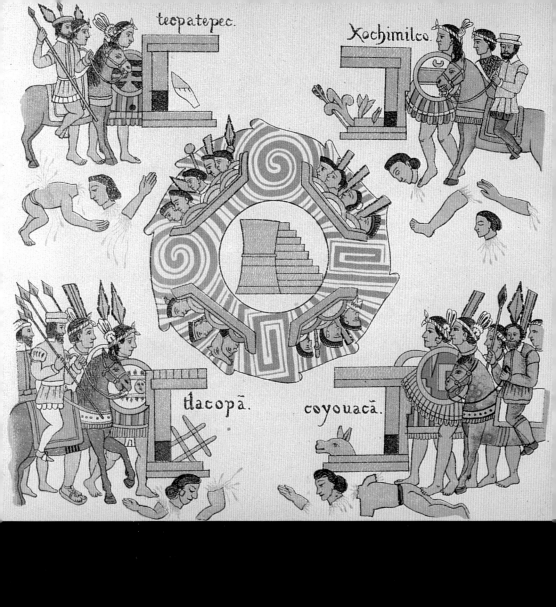

teopatepec. Xochimilco.

tlacopã. coyouacã.

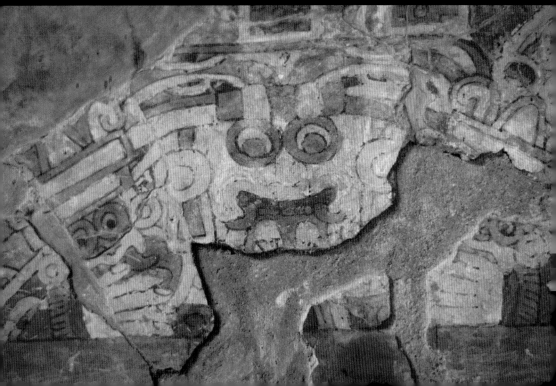

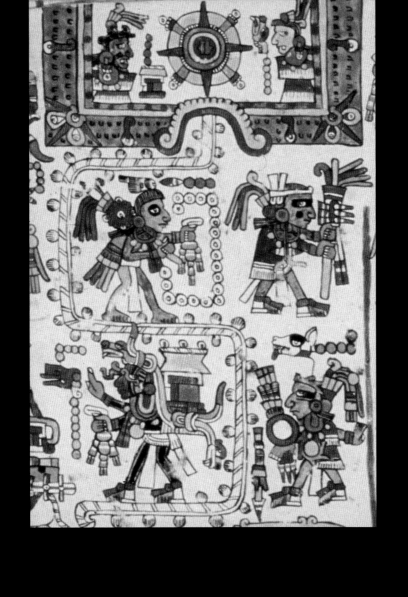

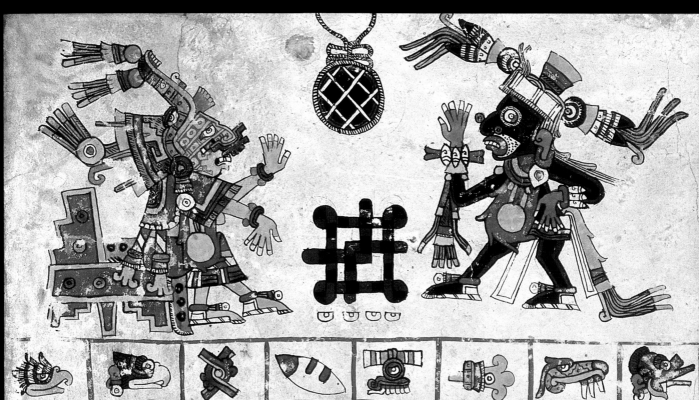

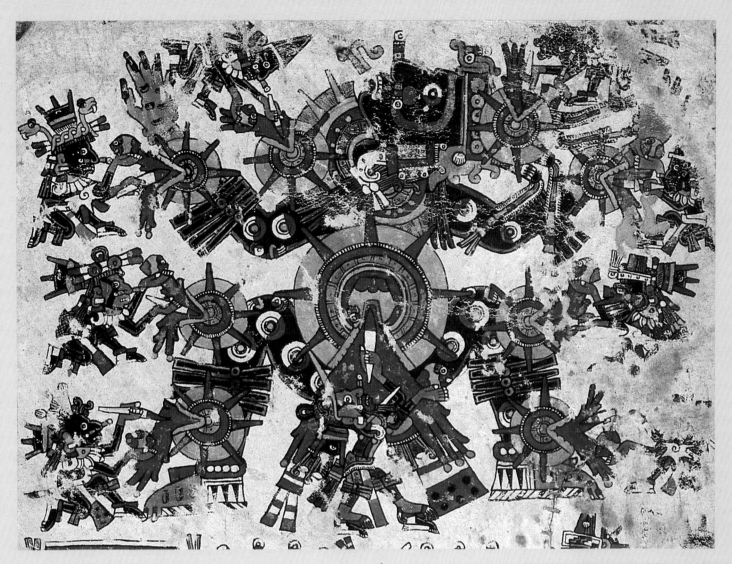

Colorplate 5. Gods of the Underworld. Codex Borgia, p. 40 (portion). Screenfold manuscript, panel c.27 cm. square. Probably Mixteca-Puebla region. Preconquest, before 1519. Biblioteca Apostolica Vaticana, Rome

OPPOSITE, ABOVE
Colorplate 3. Two Old Gods Facing the Sun in the Sky at the Beginning of the World; Heroic Ancestors of Mixtec Kings Descend by a Rope from the Sky, Bringing Artifacts of Civilization. Codex Nuttall, p. 18 (portion). Screenfold manuscript, panel 19 × 23 cm. Mixtec, Western Oaxaca. Preconquest, before 1519. British Museum, London

BELOW
Colorplate 4. Xochiquetzal (left) as Patron of 13-day Period. Codex Borgia, tonalamatl (book of the days), p. 62 (portion). Screenfold manuscript, panel c.27 cm. square. Probably Mixteca-Puebla region. Preconquest, before 1519. Biblioteca Apostolica Vaticana, Rome

OVERLEAF, LEFT
Colorplate 6. Xolotl and Son Nopiltzin Exploring the Shores of Lake Texcoco and Settling in the Area. Codex Xolotl, p. 1. Manuscript, 42 × 48.5 cm. Texcoco. Early Colonial, 16th century. Bibliothèque Nationale, Paris (top of map is east; Teotihuacán, left of lake, is symbolized by two step pyramids and a monster face for a cave)

OVERLEAF, RIGHT
Colorplate 7. Founding of Tenochtitlán. Codex Mendoza, frontispiece. Manuscript, 32.7 × 22.9 cm. Mexico City. Early Colonial, c. 1541–42. Bodleian Library, Oxford

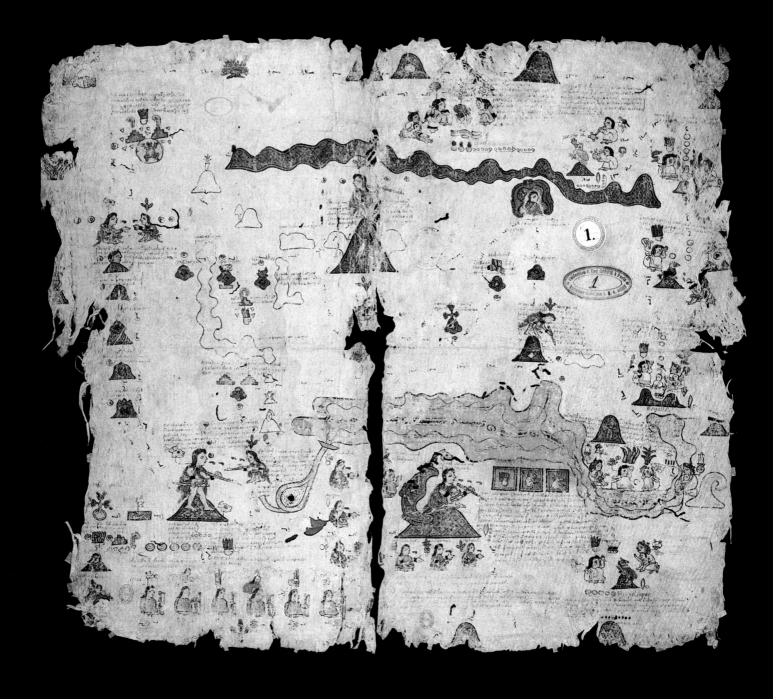

Aaciti · acacin · quauhcouatl · ocelopan · tenuch · xomimitl · xocoyol · xiuhcaqui · atototl

tenochtitlan

colhuacan. pueblo. · tenayucan. pueblo.

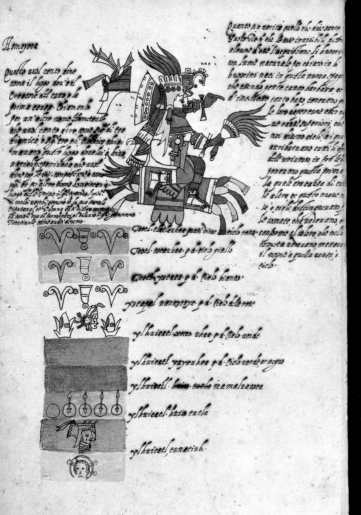

Homeyoca

quello vol dire sopra
come il sopra detto il
cenacatl el cielo p la
prima verso. Chiamono
per un altro nome tlamatecutli
che vuol dire sopra di p la
dignita e p esse el e stato eterna
da un altra p sto lugo dove lui e sia
p crebbe. p credono che vuol
dire p se p esso non sapeva sino che
luego del p trippo el Nacotl sopra...

[marginal text continues]

teotl. tlatlauhca p'd dire il cielo roso
teotl. cozauhca p d cielo giallo
teotl. p xerca p d cielo bianco
yscapel namoxeya p d cielo della terra
ylhuicatl. xoxouhca p d cielo verde
ylhuicatl. yayauhca p d cielo verde et negro
ylhuicatl. luion. uelta mamalauaca
ylhuicatl. hxia euela
ylhuicatl. eunatiuh


quanto p' varia quella che divideno
questo p e sta tra invisibile el di
clouo d'uno Imperatore si huomini...
ton sumo naturale p chiara la
huomini nati in questa vita. p per
che stando varie case del vedere e...
il cui cose tanto basso, come uno p...
lo loro appenano che no...
no come superiori, che...
non vedeno cielo ne i qua...
arrivano uno verso...
dell uniuerso se p fa che...
p per uno questa prima...
la quale in certo di cui...
Et allora se passa nuovo...
se e cielo, del cinquanta p...
lo comete, che vedeueno...
temporea il calore che nella...
tempea vedueuno metteuo...
il negro a quelle cause, d...
cielo

ylhuicatl. tetlaliuc
ylhuicatl. elabeyopanmesteh
esaltre p ee Sa cena

Apano hueye Il passaggio dell'acqua
Tepeh Monampayeia Monte che si tornarono
ystepecel Montagne de Pietra
yee. hecaya
Paxeove tlacoye
Temimina soye Luogo donde se speccia
Tencoyl qualxya
ysmicelan. Apochealoca

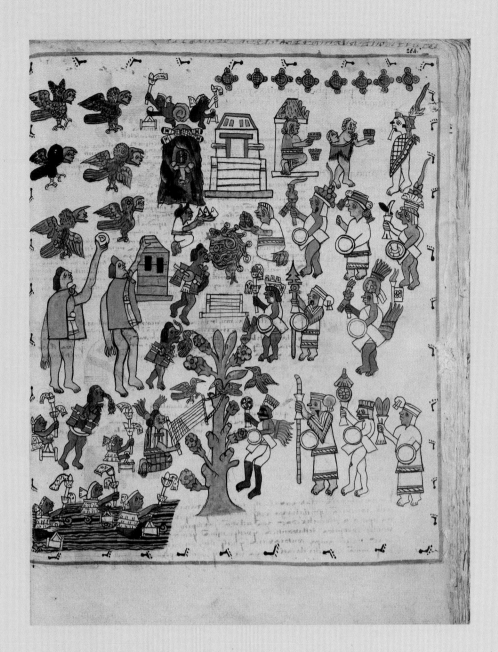

OPPOSITE

Colorplates 8, 9. The Deity Ometeotl and Layers of the Heavens (left); Two Lowest Layers of the Heavens, above Layers of the Earth and the Underworld (right). Codex Vaticanus A, fols. 1v, 2r. Manuscript, each 46 × 29 cm. Valley of Mexico. Early Colonial, c. 1566–89. Biblioteca Apostolica Vaticana, Rome

RIGHT

Colorplate 10. Festival of Atamalqualiztli. Primeros Memoriales of Sahagún's Codices Matritenses, Pl. VI. Manuscript. Tepepulco, Hidalgo. Early Colonial, c. 1559–61. Real Casa, Patrimonio Nacional, Palacio Real, Madrid

Colorplate 11. The Harlot (identified by gaudy clothing and disheveled hair). Sahagún's Florentine Codex. Manuscript. Tlatelolco. Early Colonial, c. 1575–80. Biblioteca Medicea Laurenziana, Florence (after Paso y Troncoso, 1905–7)

OVERLEAF, LEFT

Colorplate 12. Nezahualpilli (1460–1515), Ruler of Texcoco. Codex Ixtlilxochitl, pt. 2. Manuscript, 31 × 21 cm. Texcoco. Early Colonial, 1582(?). Bibliothèque Nationale, Paris

OVERLEAF, RIGHT

Colorplate 13. Nezahualcoyotl (1402–1472), Ruler of Texcoco, in Feathered Battle Costume. Codex Ixtlilxochitl, pt. 2. Manuscript, 31 × 21 cm. Texcoco. Early Colonial, 1582(?). Bibliothèque Nationale, Paris

necasualcoso(3m Rey de Tescuca

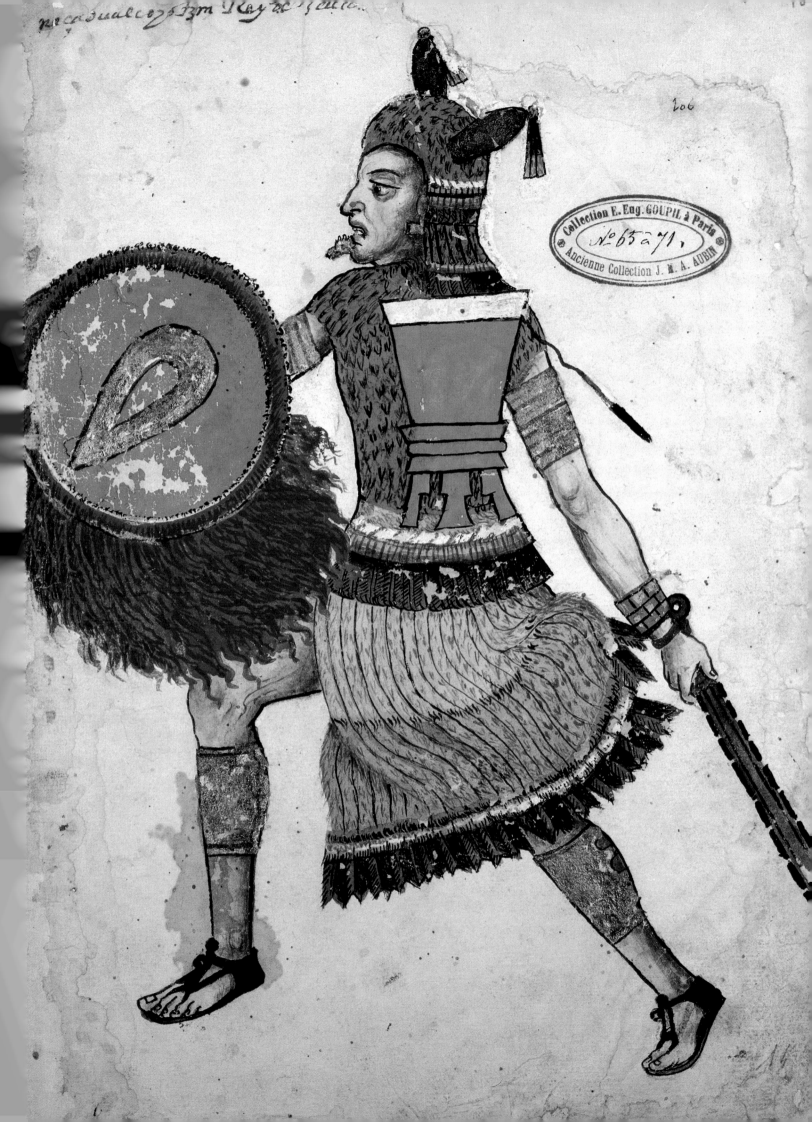

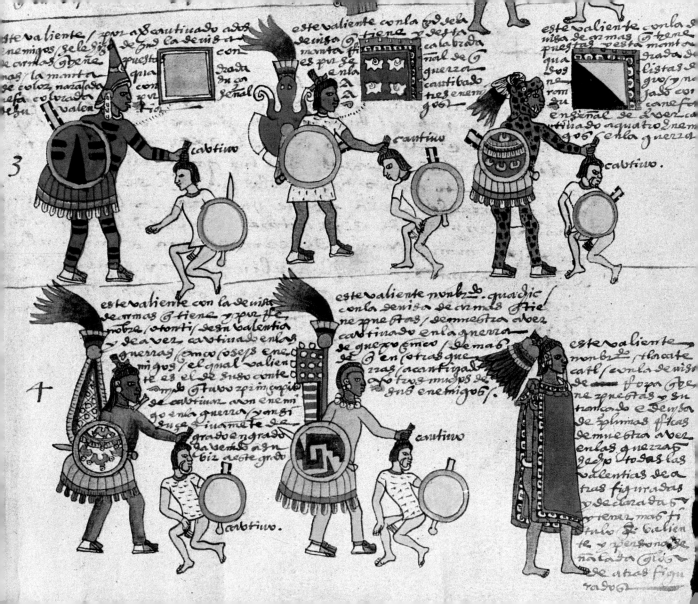

este valiente / ypor a[ver] catiuado ados
enemigos / se le dio
de armas q[ue] tiene
nas / la manta
de color nacarado co[n]
esa colorado
tehu valen[te]

[con]
rada q[ue]
co[n] puesta
co[n]
tio

cabtiuo

este valiente con la [armas] de la
de visa q[ue] tiene y esta
monta fi[gurada]
es pu[esta] en la
nda

cal[a]brada
nal de q[ue]
guerra
catibado
tres ene
migos

cautiuo

este valiente con la
visa de armas q[ue] tiene
puestas y esta monta
qua
bos
listas e
gu[er]o y ne
fa[da] co[n]
co[n] fe
en senal de a[ver] ca
tiuado aquatro ene
migos en la guerra

cabtiuo.

3

este valiente con la devisa
de armas q[ue] tiene y por su
noble otortis desu valentia
y de aver catiuado en los
guerras [cin]co sos sus ene
migos / el qual valien
te es el de suso conte
m[os] q[ue] tuvo p[rin]cipio
se catiuar a un ene
mi[g]o en la guerra y ansi
suce siuamente
grado en grado
la vem a su
biz a este grado

cabtiuo.

este valiente nonb[ra]do quadie
con la devisa de armas q[ue] tie
ne puestas / dem[ue]stra a ver
catiuado en la guerra
se guerre [m]es / de mas
q[ue] en otras que
rras acatiya[n]
[n]os tus mui[s] de
sus enemigos /

cautiuo

este valiente
nonb[ra]do tlacate
catl / con la devisa
de ropa q[ue] tiene
puestas y su
tancado e senbra
de çplumas / q[ue] ef
dem[ue]stra a ver
en las guerras
q[ue] p[o] todas las
valentias de
tras figuradas
y declaradas
y tenar mas ti
tulo de valien
te / y perdona de
natada q[ue]
de atras figu
radas

4

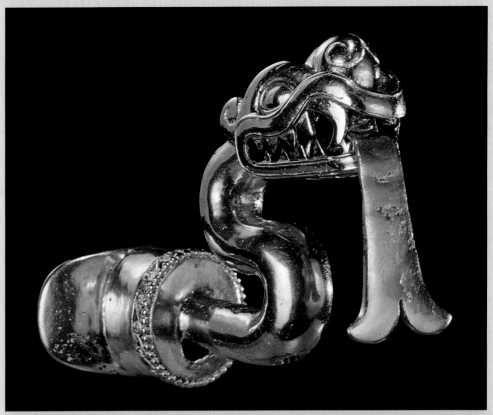

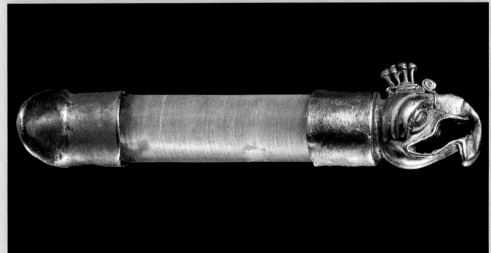

Colorplate 14. Costumes Awarded to Warriors Who Took Captives. Codex Mendoza, p. 64 (lower half). Manuscript, entire page 32.7 × 22.9 cm. Early Colonial, c. 1541–52. Bodleian Library, Oxford. From top left, first warrior receives red-feather costume and orange mantle for taking two prisoners; for three prisoners, next warrior receives butterfly back ornament and mantle with shell designs; for four prisoners, the third warrior receives jaguar costume and diagonally divided mantle. From lower left, first two warriors carry standards received for five and six captives; third figure is high-ranking warrior of aristocratic origin wearing secular mantle, not military dress, but hair decoration of double knot of feathers was reserved for military leaders

Colorplate 15. Lip Plug in the form of a Serpent. Gold, 6.6 × 6.3 cm. Mixtec, 1350–1521. American Museum of Natural History, New York

Colorplate 16. Lip Plug in the form of a Bird, possibly sent to Europe by Cortés. Gold and rock crystal, length 6.2 cm. Aztec-Mixtec, 1350–1521. Museum für Völkerkunde, Vienna (ex-Coll. Becker)

manta de agua de araña.

mata de unsolo señor odecinco
Rosas

manta denariz muerta.

manta del sol negro.

manta de ʃicara tuerta.

manta del beçote del diablo.

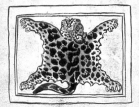
manta de tigre.

manta del aguila.

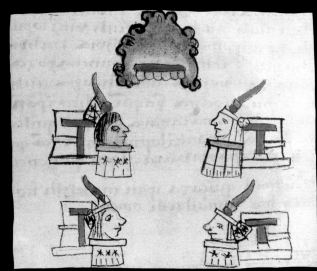

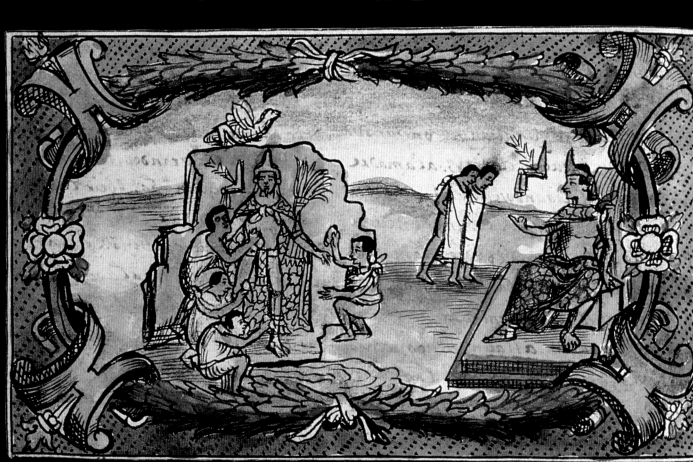

he allowed Motecuhzoma to believe that both the Christian god and the faraway Emperor Charles V might be identical with Quetzalcoatl.

The missionaries wanted to know more about Quetzalcoatl because his personality did not resemble that of the Aztecs, and they speculated that he might have come earlier from the Old World to convert the Indians. In time it was suggested by many that Quetzalcoatl had been the apostle Thomas. Lafaye has shown that the legend of Quetzalcoatl was the only one that both the conquered and the conquerors could use to explain and rationalize the conquest and the conversion. More questions were therefore asked about Quetzalcoatl than about any other figure in Aztec myth and religion.

Among colonial writers on preconquest culture, several were of native Indian ancestry. Their point of view differs from the Spanish writers' in the degree of their nostalgia for the greatness of the Indian past. Hernando Alvarado Tezozomoc, a grandson of Motecuhzoma II on his mother's side, was born after the conquest (c. 1525–30) and lived to become an interpreter of Nahuatl to the Spaniards. His lengthy history of the Mexica, *Crónica Mexicana*, is derived from the same source as Durán's *Historia*, but the style of writing has a stronger Aztec flavor. Two mestizo writers, Juan Bautista Pomar and Fernando de Alva Ixtlilxochitl, were related to the ruling house in Texcoco. In his *Historia Chichimeca* (1600–1640), Ixtlilxochitl tells the history from a Texcoco point of view, depicting Texcoco as politically and culturally superior to the Mexica of Tenochtitlán. Accurate information taken both from Ixtlilxochitl's extensive library of preconquest and early colonial documents and from living Texcocan elders is blended with a romantic view of the past. Writing four generations after the conquest, Ixtlilxochitl was both a learned renaissance humanist and an Indian aristocrat, and his view of the Aztec past was partly modeled on the Greek and Roman histories. He idealized the personality of the ruler Nezahualcoyotl, describing him as a philosopher-poet-king similar to the Toltec Quetzalcoatl, who wished to introduce the worship of a single, unseen god and thereby anticipated Christian belief. As a lawgiver, Nezahualcoyotl is compared to Solomon; as a poet to David; as a philosopher to Plato; and as a ruler, going about *incognito* to observe the condition of commoners, to Harun ar-Rashid. It is Pomar and especially Ixtlilxochitl who give us a picture of Texcoco as the cultural center, the Athens of preconquest Mexico (Hoyo, 1957).

Besides the narrative accounts written by the conquerors, missionaries, and mestizo aristocrats, some important factual texts have also been recently used to reconstruct life in both preconquest and early colonial times. These nonliterary sources include legal documents such as land titles and wills, census reports, geographic and area surveys, and Inquisition records, and they often show the actual structure of Aztec society and behavior in the early days of Spanish rule more clearly than do the ideal descriptions in the chronicles. These sources have been especially useful in reconstructing the life of the commoners. For example, the plan of the non-aristocratic residential sections of Tenochtitlán can now be reconstructed on the basis of land titles used in legal cases (Calnek, 1972).

Out of these descriptions, chronicles, and documents it is now possible to reconstruct something of Aztec life and thought, at least in its broad outlines. The nature of the written sources leads us to know more about the life and ideology of the aristocracy than about the common people, and more about religion than about any other aspect of life. And until recently, these written sources were almost all we had for reconstructing Aztec life.

TOP TO BOTTOM

Colorplate 17. Mantle Designs. Codex Magliabecchiano, fols. 5v, 6v. Manuscript, 15.5 × 21.5 cm. Valley of Mexico. Early Colonial, before c.1566(?). Biblioteca Nazionale Centrale, Florence

Colorplate 18. Dough Figures made for the Tepeilhuitl Festival. Primeros Memoriales of Sahagún's Codices Matritenses. Manuscript (portion of page). Tepepulco, Hidalgo. Early Colonial, c. 1559–61. Real Casa, Patrimonio Nacional, Palacio Real, Madrid

Colorplate 19. Motecuhzoma I Sitting for His Portrait Carved in the Rock at Chapultepec. Durán's Historia de las Indias de la Nueva España y Islas de Tierra Firme, Bk. III, ch. 31. fol. 91v. Manuscript. Valley of Mexico. Early Colonial, c. 1570. Biblioteca Nacional, Madrid

ARCHAEOLOGY AND ANTHROPOLOGY. The Aztecs are a people known to us through history. Remains of Aztec material found on the surface, or just below colonial materials, are in large quantity, but few Aztec sites have been excavated. Many Aztec towns were rebuilt in colonial times and still exist today, often retaining their native names. The modern traveler passes through Texcoco, Tlaxcala, Huejotzingo, Cholula, Tepoztlan—towns famous in Aztec history and the conquest period. The people living in these towns are mestizos, but the Aztec language, Nahuatl, was still spoken even in the 1930s in towns a few hours away from Mexico City.

Although much of the Aztec aristocracy perished in the conquest or became hispanicized, the rural people continued their prehispanic ways of life. Information on popular cults, agricultural rites, sorcery, and cures, for example, about which the sixteenth-century sources are so meager, are richly recorded in modern anthropological studies (Madsen, 1969). All rural cult practices are mixed with Christian elements, but the Pre-Columbian components often remain recognizable (Horcasitas, 1979). For modern Nahuatl communities the major deity is the Virgin of Guadalupe, sometimes called "Tonantzin" in Nahuatl (Madsen, 1960). Her modern worship indicates the importance of female deities in Aztec folk religion.

Archaeologists have been active in Mexico since the late nineteenth century, but they have focused on civilizations prior to the Aztecs. The monuments of these earlier civilizations are found in abandoned areas, from tropical lowlands to highland plateaus, and excavating these sites did not require moving present-day inhabitants. Moreover, these early remains proved to be spectacular, and because little was known about them they seemed that much more fascinating. Twentieth-century archaeologists first tried to establish the true antiquity of civilization in Mexico. They sought to prove that this culture emerged in isolation, independent of Old World centers such as Egypt and Mesopotamia. It has been demonstrated by now that civilization began in Mexico about 1500 B.C., several thousand years before the coming of the Aztecs. In the time between the first millennium B.C. and the conquest of Mexico in 1522 A.D. many different ethnic and cultural centers rose and fell.

Archaeology dealing specifically with the Aztecs has been largely accidental and, until recently, small in extent. In laying foundations for buildings and in excavating for the "Metro" subway in Mexico City, sculptures and other remains have come to light; most of the spectacular Aztec works of art have been fortuitous discoveries. A few temple pyramids not covered by later construction were cleared and consolidated, but they are often crowded in with modern settlements. The excavations at Tenayuca (Tenayuca, 1935) and Tlatelolco (Tlatelolco . . ., 1945–48) provided information on the superposition of buildings and on the ceramics of the Aztec empire. They yielded a date for the occurrence of Aztec-style artifacts in the Valley of Mexico about 1200 A.D. By 1944, Vaillant was able to write a book on the Aztecs in which this archaeological information was related to textual sources.

Only recently have archaeological excavations had the requisite scope and design to test the accuracy of the written records and to provide information beyond what is found in these. A major archaeological survey of the Valley of Mexico has just been completed (Sanders, Parsons, and Santley, 1979). On the basis of the surface distributions of potsherds and habitations in the Aztec period, a team of archaeologists mapped the major towns and even rural hamlets of the valley. Their study has brought out much new information that was absent from the texts concerning the nature of agricultural labor, resources of food and raw materials, population estimates, and a reconstruction of the everyday life of the Aztec peasant. We now have some of the answers to questions about the subsistence and economic basis of the Aztec empire.

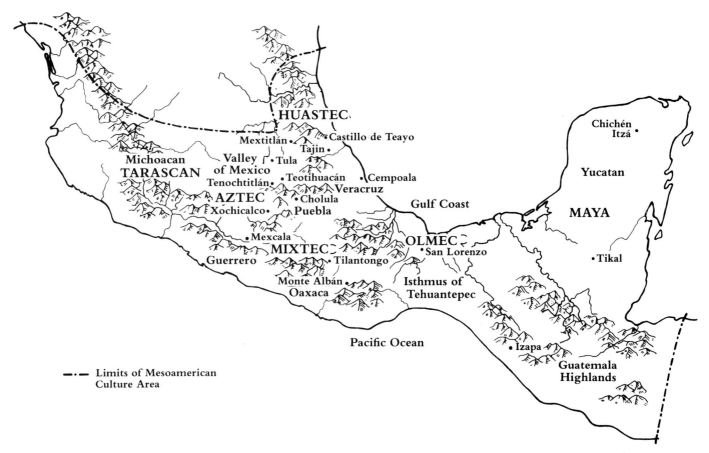

Test pits excavated in the Cathedral area of Mexico City (Vega Sosa, 1978) and the new excavation of the Main Temple (Matos Moctezuma, 1978; 1981) are the first modern, scientific excavations in the Aztec capital of Tenochtitlán on a large scale. Both were begun in the 1970s and their conclusions have not yet been fully published. These excavations bear out the accuracy of the chronicles in some respects, but in others they differ significantly. The history of the city of Tenochtitlán was evidently more complex than the recorded legends indicated. For the first time we also have material evidence of some of the Aztec ritual practices. The correlating of these new archaeological finds with the better-known historical texts will soon occupy students of Aztec culture.

Mexico before the Aztecs

THE LAND. Like the Caribbean Islands, Mexico is a land of varied and beautiful scenery (Plate 4). Most of Mexico is mountainous, and two great mountain chains enclose a central desert in the north. In prehispanic times, the northern desert was thinly inhabited by nomadic Indians. The major seat of civilization was located to the south, in the Central Highlands area, a large plateau of 5,000 square miles, 7,000 feet above sea level. Eruptions from the great snow-capped volcanoes, Iztacci-huatl and Popocatepetl, dammed up the rivers of the plateau and created the large lake, Lake Texcoco, in the center of the Valley of Mexico.

The climate of the Valley of Mexico is cool and dry. The lake and its shores

provided fertile land for agriculture and plenty of water for irrigation. Major civilizations and the largest empires of Mexico developed in the valley, beginning about 200 B.C. Teotihuacán (200 B.C.–750 A.D.) was located in a valley east of Lake Texcoco; Tula (800–1200) was built in a valley north of Teotihuacán at the edge of the Central Highlands and the northern desert; the Aztec capital city, Tenochtitlán, was founded on natural and artificial islands in Lake Texcoco itself.

Much of the lake was filled in at the time of the conquest and what was left was drained in the seventeenth century. Modern Mexico City is built over insecure foundations, the dry lake bed. At Xochimilco, in a small portion of the lake, the prehispanic artificial islands called *chinampas* are still maintained (see Colorplate 22). *Chinampas* are made by draining swampy lands by means of canals, and then heaping mud from the bottom of the lake upon the surface. These partly artificial islands were extremely fertile and were planted with flowers and vegetables. Aztec *chinampa* agriculture was an important supplement to the irrigated fields on the lake shores and in river valleys. In the Valley of Mexico the altitudes and rainfall vary, causing agricultural potential and raw materials to differ between one community and another and stimulating specialization and trade among the communities.

The mountains in the south of Mexico and Guatemala form highland areas also, but neither is as expansive or as favorable for large-scale agriculture as that of the Valley of Mexico. In the western mountains of Oaxaca developed the Zapotec and Mixtec civilizations; other cultures, in which Maya was spoken, such as the Quiché and Cakchiquel, occupied the Guatemala highlands.

The coasts of the Gulf and the Caribbean and the Isthmus of Tehuantepec, all low-lying, hot, and humid regions, were important for the growing of the cacao beans used in preparing a chocolate drink and as a form of currency. In this area also grew the latex-bearing trees from which rubber was made for the ball game and other ceremonial purposes. The Aztecs regarded the people of the south and particularly those of the Veracruz area as rich, artistic, sensuous, and luxury-loving.

Rainfall increases in the low-lying limestone areas of lowland Guatemala and Yucatan, which are covered with dense tropical forest, swamps, and grasslands. By the Aztec period much of Guatemala's tropical forest had lain abandoned for more than four centuries, and only ruins overgrown by vegetation testified to the past greatness of the Maya civilization there. A late variant of Maya culture continued in Yucatan until the conquest (Wolf, 1959).

THE EARLY CIVILIZATIONS OF MESOAMERICA. In prehispanic times, southern Mexico and Guatemala shared a basically similar way of life. The culture of this area does not correspond to modern national boundaries, and the term "Mesoamerica" is used for the whole region. Mesoamerican Indians are often mistakenly called "Aztecs," though Aztec culture developed only in the thirteenth century and its empire had lasted for hardly one hundred years before the Spaniards arrived.

Man was already present in Mesoamerica prior to 20,000 B.C., and a number of civilizations rose and fell prior to the Aztecs. The history of Mesoamerica is traditionally divided into three major periods (Plate 5): Preclassic (1500 B.C.–200 A.D.), Classic (200–900), and Postclassic (900–1521). Almost all our knowledge of cultures during the first two periods is based on archaeological excavation, because we have few textual records for these times. The arts and traditions of these early cultures are sometimes interpreted through use of sixteenth-century texts, although these refer specifically to the Aztecs; many scholars consider it wrong to use Aztec texts in this way, but we often have no other approach to works of the past (Kubler, 1973).

Greater knowledge of Aztec art and its traditions may put such projections into the past on a more solid footing.

By 3000 B.C. the population of Mesoamerica was living in permanent villages and farming the corn, beans, and squash that became basic staple foods for later cultures. Hunting, fishing, gathering wild foods, and the domestication of a few animals such as the dog and turkey added a little to the diet, but Mesoamerica was primarily an agrarian culture in its subsistence and ideology. This largely vegetarian diet, spiced with tomatoes and hot chili peppers, was at least as nourishing as that of other

PERIODS AND DATES		CENTRAL MEXICO	GULF COAST	OAXACA	MAYA AREA
POSTCLASSIC 1521 ... 900	Late	Aztec Tenochtitlán	Spanish Conquest 1519–1542		
			Totonac Huastec	Mixtec	Mayapán
	Early	Toltec Tula			Chichén Itzá
CLASSIC 900 ... 200	Late	Xochicalco Teotihuacán	Classic Veracruz	Zapotec	Classic Maya
	Early		El Tajin	Monte Albán	Tikal
PRECLASSIC 200 ... 1500	Late B.C.\|A.D.	Cuicuilco			Izapa
	Early	Tlatilco	Olmec San Lorenzo		

Plate 5. Chronology of Mesoamerica

preindustrial civilizations. Because Mesoamerican life was based on farming, there was interest in understanding the weather, the alternation of dry and rainy seasons, and the cycles of the sun, moon, and stars to help predict the proper times for agricultural activities. A religion of nature gods and a practical knowledge of the calendar and astronomy probably developed at an early time.

The most advanced Preclassic civilization developed in the Gulf Coast area of Mexico where floodwater river farming was particularly favorable. The Olmec (1200 B.C.–500 B.C.) were the first to use a production surplus to erect monumental architecture and stone sculpture. Their carvings are impressive for their size and for their striking naturalism (Plate 6). It has been a surprise to most Western archaeologists and art historians that the earliest monumental art of Mesoamerica should also be its most realistic. Much of Olmec art was erected to glorify their ruling lords, colossal heads that perhaps were portraits of them. The Olmec empire appears to have been created by military conquest, and warrior imagery is found in Olmec, as it is in most of the subsequent cultures. We do not know whether the Aztecs were aware of Olmec art. They did not make major conquests in the Gulf Coast area, and many of the Olmec monuments had become deeply buried before the spade of the modern archaeologist dug them up. Olmec-style jades were kept as heirlooms, however, by

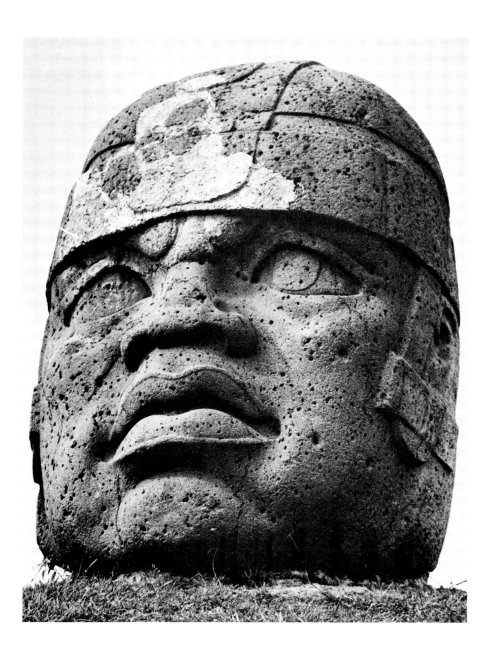

Plate 6. Colossal Olmec Head (Monument 1).
Basalt. San Lorenzo, Veracruz. Preclassic,
c. 1200 B.C. Museo Etnográfico y Arqueológico,
Jalapa, Veracruz

the Maya and other later cultures. A beautiful Olmec-style jade mask has recently
been found among the offerings of the Main Temple of Tenochtitlán (*Bellas Artes,*
1980).

No other Preclassic culture could compete with the Olmecs in the erecting of
beautifully carved sculptures. Most other areas in Mesoamerica are known mainly
for their ceramics and clay figurines, which have been found in great quantities.
When the Olmec were flourishing on the Gulf Coast, the Valley of Mexico was
inhabited by farmers living in simple villages. Their art was oriented toward family
and ritual, and small works were mainly made in clay. Best known of these are the
beautiful clay figurines of Tlatilco (Plate 7); they cannot be identified either as gods
or rulers, and many represent attractive women, sometimes holding a baby. The
complex symbolic imagery of the later periods is not yet present.

During the Classic period there were four major cultures in Mesoamerica: Teo-

tihuacán, Maya, Monte Albán, and Classic Veracruz. Teotihuacán had the strongest political and economic power in Classic Mesoamerica and its influence extended as far south as Guatemala. The first urban center located in the Valley of Mexico, its civilization was based on extensive irrigation systems and the control of trade in necessary substances, such as the mineral obsidian. A city over thirteen miles square was built on a grid plan with two enormous pyramids as its focal points (Plate 8); it had a population estimated at more than 100,000 persons, and for over 700 years Teotihuacán was a great market and pilgrimage center (200 B.C.–750 A.D.).

In comparison with other Mesoamerican cultures, Teotihuacán had little sculpture, and much of that was attached to architecture, as on the Temple of Quetzalcoatl. Among freestanding sculptures, braziers representing seated, bent-over old men holding a vessel on their heads were most common (Plate 9), carved in the flat and angular style of architectural sculpture at Teotihuacán. Such braziers have been found in the patios of house compounds and may represent the old god of fire and the hearth.

The major art form at Teotihuacán was mural painting, representations of war gods and fertility deities flanked by warriors and priests. One of the two major deities was a vegetation-fertility goddess (Plate 10), the other a god of rain and water (Colorplate 2; Plate 11). Rain gods were believed to create rain by pouring water from a vessel, and are so represented here. It appears that Teotihuacán art was primarily concerned with religion, not with historical personages.

The art of Teotihuacán was conventionalized and symbolic. Many of the symbols are similar to glyphs, but writing or dates were not used except in rare instances. We do not know the language of the people of Teotihuacán or the ethnic group they belonged to. Because their symbols and deities have many parallels in Aztec art, some believe that they may have spoken Nahuatl, but there is no proof of this.

Teotihuacán's fall in the eighth century is related to the subsequent decline and abandonment of other Classic period sites. Its colossal monuments and the memory of its greatness survived until the Spanish conquest. For the Aztecs, it was a place of great mythic importance, as its name implies: Teotihuacán in Nahuatl means the "Place of the Gods," and it refers to the Aztec belief that the last creation of the world took place at Teotihuacán. The Aztecs copied many of the arts and some elements of the architecture of Teotihuacán, believing them to be "Toltec."

The Maya of the Classic period (300–900) lived in a number of independent city-states governed by an aristocratic elite. Their cities were located mainly in the tropical forests of Yucatan and Guatemala. Most Maya art and architecture commemorated the life and death of persons in the ruling dynasty. Recent excavations have shown that most of the Maya pyramids were burial places for rulers. In a style of refined realism and intricate detail on low-relief stelae, the Maya lords were represented enthroned, performing rituals, and conquering prisoners. The lives of these rulers were explained in long hieroglyphic inscriptions. Although some forms of dating and hieroglyphic writing systems were developing in southern Mesoamerica late in the Preclassic period, the Classic Maya advanced these systems to their greatest extent. Maya culture collapsed in the tropical forest area between 900 and 1000; their astronomical, mathematical, and writing systems largely perished with them. The Aztecs appear to have been ignorant of the former existence of the Maya.

Oaxaca was a culturally innovative area even before the rise of the Maya and Teotihuacán. Glyphic writing and stone-faced architecture was first developed there. In the Classic period the culture of Monte Albán, in Oaxaca, was intermediate between the Maya and Teotihuacán, both spatially and culturally. The regularity of

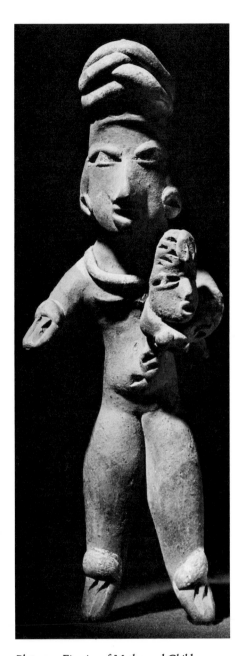

Plate 7. Figurine of Mother and Child. Terracotta. Tlatilco. Preclassic, c. 900 B.C. Museo Nacional de Antropología, Mexico City

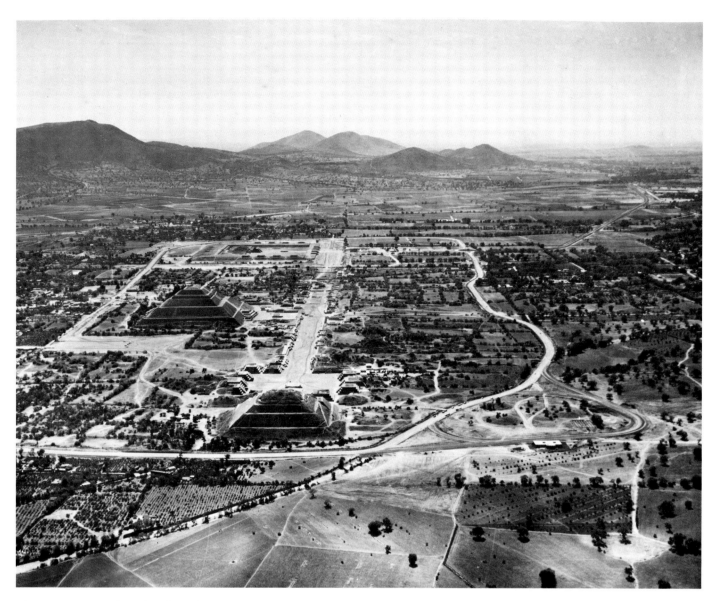

Plate 8. Air View of Teotihuacán, with
Avenue of the Dead and Pyramids of the Sun
and Moon. Courtesy of René Millon (from
Urbanization at Teotihuacán, Mexico,
I, 1, Austin, Texas, 1973)

Plate 9. Old God Holding Incense Burner on
Head. Stone, 58 × 48 cm. Classic, 200–
750 A.D. Museo Arqueológico, Teotihuacán

the architecture at Monte Albán and the deities represented on its terracotta funerary urns (Plate 12) share certain features with the art of Teotihuacán; the erecting of relief-decorated monuments depicting conquering rulers and prisoners, however, is similar in concept to Maya dynastic art. Classic Monte Albán culture declined after the fall of Teotihuacán. The Aztecs were aware of this culture because they made conquests in the region under their rulers Axayacatl and Ahuitzotl, but no direct influence of Monte Albán art can be found in Aztec art.

The principal form of Classic Veracruz art was terracotta sculpture of human and deity figures, made both for burials and for shrines (Plate 13). Veracruz also had stone sculpture, some attached to architecture as at El Tajín, and some on portable pieces connected with the ball game. This game was both a sport and a sacrificial ritual. It was played throughout Mesoamerica, using a large rubber ball that could be hit by the elbows, knees, or hips, but could not be touched by the hands or feet. The game required the players to wear heavy protective equipment, and much paraphernalia was developed during the Classic period. It was often played in masonry courts, and rings or other markers were used for scoring. Stone effigies of ball game equipment, such as yokes (Plate 14) and flat heads, *hachas* (Plate 15), were made in hard-grained, colorful stones.

The sculpture of Veracruz, both in molded terracotta and carved stone, appears to have had influence on the emerging Aztec style. The Aztecs' first conquering missions outside the Valley of Mexico were directed toward the rich and artistic province of Veracruz, and the Aztecs derived from Veracruz the idea of making copies in stone of ceremonial or other objects, whatever the original material. The Veracruz carving style combined three-dimensional sculpture with finely carved detailed ornament, similar in concept to Aztec carving style.

Most of the major centers of the Classic period—Teotihuacán, Monte Albán, El

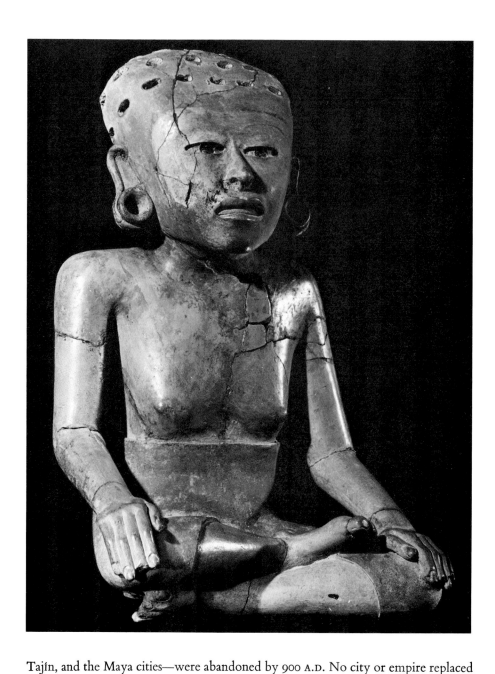

Plate 13. Seated Female Figure. Terracotta, hollow, height 45 cm. Veracruz. Classic, 200–900 A.D. Museo Nacional de Antropología, Mexico City

OPPOSITE, ABOVE LEFT
Plate 14. Carved Yoke. Stone, length 45.5 cm. Veracruz. Classic, 200–900 A.D. American Museum of Natural History, New York

Tajín, and the Maya cities—were abandoned by 900 A.D. No city or empire replaced Teotihuacán in the Valley of Mexico. In the late Classic period (600–900) Xochicalco, a small but important site in Morelos, combined in its arts elements of Teotihuacán, Maya, Classic Veracruz, and Monte Albán. Although Xochicalco was active for only a few hundred years, a beautiful synthesis of the different Classic traditions appears in its works of art. The main pyramid of Xochicalco was ornamented with a feathered serpent as well as with glyphs and figures (Plate 16). The Aztecs considered Xochicalco to be a mythic place, and its name is derived from their word for flower. Located in the warm region south of the Valley of Mexico, the Aztecs associated it with a southern paradise called Tamoanchan. The place is also significant in the legend of Quetzalcoatl of Tula, for he is supposed to have lived there for a time before becoming the ruler of Tula. The style of Xochicalco was influential on those of southern Aztec cities such as Chalco and Tlalmanalco, and it was also directly imitated by the Aztecs (Umberger, 1981).

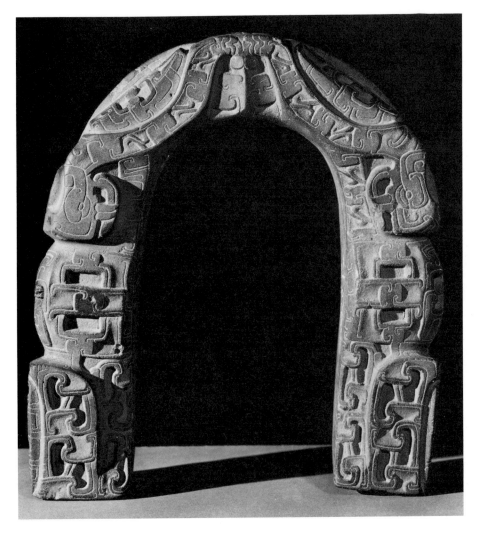

Plate 15. Flat Stone Head (hacha). Stone, height 29 cm. Veracruz. Late Classic, 600–900 A.D. Museum of the American Indian, Heye Foundation, New York

Plate 16. Glyph, relief on side wall of Main Pyramid, Xochicalco, Morelos. Late Classic, 600–900 A.D.

One major difference between the Classic and Postclassic periods comes from the several waves of nomadic invasions from the northern regions who entered the valley during the Postclassic period. The dry desert area of northern Mexico had always been inhabited by hunters and gatherers living a precarious wandering existence, and they must have looked with envy on their rich, city-dwelling southern neighbors. After the great Classic empires fell, it was believed that groups of these northerners migrated south and settled among the descendants of the local cultures. Sixteenth-century written sources record that both the Toltecs and the Aztecs had such a nomadic northern ancestry. We do not know how reliable these traditions are, whether large migrations of tribes entered Mesoamerica, or only small conquering bands who became the rulers. Since the newcomers admired the local civilizations and adopted many of their cultural habits, we do not know how "primitive" they were to begin with. The historical traditions indicate that the polarity between nomadic ancestry and local civilization was extremely important for the people themselves. They seemed to see a great distance between themselves and the earlier cultures, but the works of art and the material objects of the Postclassic period suggest much continuity in themes and ideas.

Early in the Postclassic period (900–1200) two cities assumed the position of Teotihuacán in central Mexico: Tula in the north and Cholula in the south. Tula is

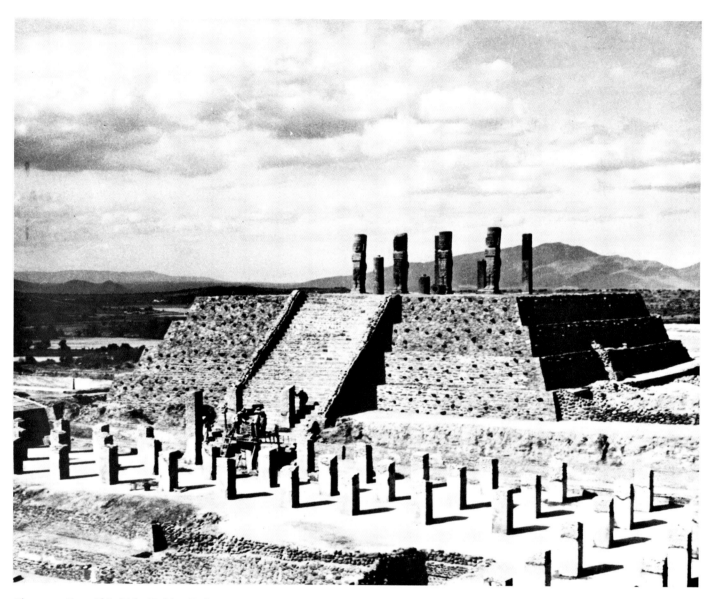

Plate 17. Pyramid B, Tula, Hidalgo. Early
Postclassic, 900–1200

OPPOSITE, RIGHT

Plate 18. Colossal Columnar Warrior
(Atlantid) from top of Pyramid B, Tula,
Hidalgo. Stone, height 4.60 m. Early Postclassic,
900–1200. Museo Nacional de Antropología,
Mexico City

OPPOSITE, ABOVE

Plate 19. Warriors, Bench Relief in Room
with Columns, Tula, Hidalgo.
Stone. Early Postclassic, 900–1200

OPPOSITE, BELOW

Plate 20. Reclining Figure (chac mool).
Stone. Tula, Hidalgo. Early Postclassic,
900–1200

believed to have been founded by nomadic northerners. In contrast to the arts of the
Classic period, the art and architecture of Tula, known as Toltec, is crude and shoddily
constructed (Plate 17). The finest Toltec sculptures were the columnar warrior statues
that probably once supported a temple roof (Plate 18), but more typical are bench
reliefs of warriors (Plate 19) and the reclining figures of *chac mools* that were possibly
sacrificial altars. The art of Tula appears to represent primarily warriors and sacrificial
subjects. The style and iconography are derived in part from Teotihuacán. Other as-
pects relate it to Maya art, especially to the art of Chichén Itzá in Yucatan. We do not
know if the new elements in art, such as the reclining *chac mool* figures, were
invented at Tula or at Chichén Itzá (Plate 20).

Sixteenth-century sources tell us that Tula was the city of the famous king Quetzal-
coatl, who is supposed not to have believed in offering human sacrifices. Many schol-
ars think that there is some historical truth to the legend that Quetzalcoatl, when
expelled from Tula, went to Chichén Itzá and there built a copy of Tula. Similarities
in the sculptures and buildings at these two sites appear to bear out this story. Never-
theless, it raises many questions and problems: if Quetzalcoatl was so peace-loving,
for example, why is so much warfare and sacrifice to be seen in the art of Tula and
Chichén?

For the Aztecs, Tula and the "Toltecs" were synonymous with the great civiliza-

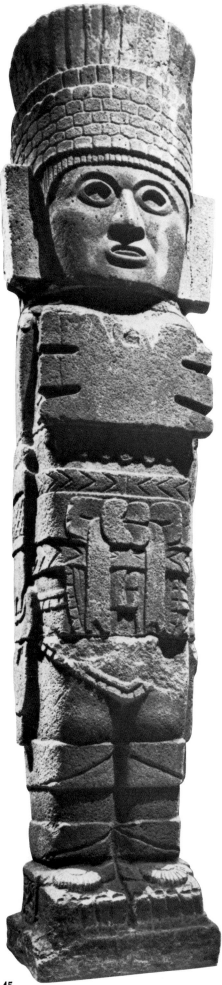

tions of the past. Their own migration legends show that they stopped near Tula, where their patron war god was born. They dug in the ruins of Tula, they took Toltec sculptures back to Tenochtitlán, and they imitated Toltec art in their own works. The most prestigious dynastic families in the Valley of Mexico derived their rulers from the Toltec ruling dynasty (see page 50). Aztec monumental sculpture is in many ways a conscious imitation and continuation of Toltec art.

The extent of the Toltec empire is still undetermined, although ceramic remains indicate trade contacts as far south as Costa Rica; neither do we know why it collapsed in the twelfth century. As an empire and a city, it was not as well organized as Teotihuacán nor did it last as long.

A new style called Mixteca-Puebla spread during the middle and late Postclassic period in Mesoamerica (1000–1521). This style was not associated with a powerful empire, but with many small city-states having diverse ethnic groups. Most of these

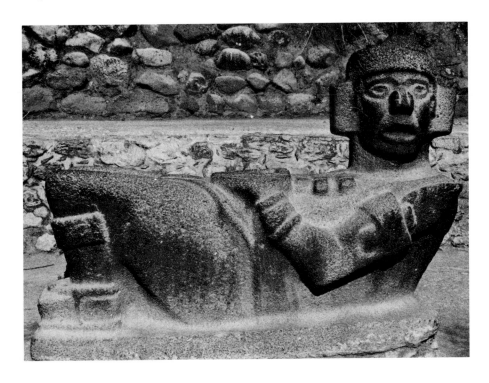

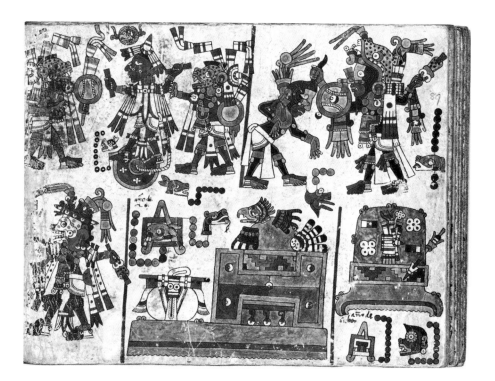

Plate 21. Conquests of 8 Deer: upper right, *8 Deer Holds Prisoner by the Hair;* upper left, *Prisoner Is Sacrificed in Gladiatorial Combat, 8 Deer in Jaguar Costume. Codex Nuttall, p. 83. Screenfold manuscript, panel 19 × 23 cm. Mixtec, Western Oaxaca. Preconquest, before 1519. British Museum, London*

groups had traditions going back to the great civilizations of the Classic period. The Mixteca-Puebla style originated in the city-states of the Oaxaca and Puebla areas. A major center was the city of Cholula, in the modern state of Puebla. Cholula was already an important city in Teotihuacán times, and the equal of Tula in the early Postclassic period. After the fall of Monte Albán many small city-states in the Oaxaca area were inhabited by Mixtec-speaking peoples.

Mixteca-Puebla art is not generally on a monumental scale. It is known primarily from wall paintings and codex painting, and from precious arts such as turquoise mosaic, featherwork, and gold. Elements of Classic Teotihuacán, Monte Albán, and Veracruz styles can be recognized in this new tradition, which emphasized small-scale drawing and decoration. The Mixteca-Puebla style is famous for its fine craftsmanship and miniature preciousness, and is in great contrast to the larger and sometimes crude works of the Toltecs.

The Mixtecs' principal art appears to have been codex painting, and from it is derived both wall painting and ceramic decoration. Unlike the Maya, the Mixtecs had no elaborate hieroglyphic writing system, but used glyphs for place, name, and date, and a form of picture writing that is quite complex and conveys a great deal of information. Religious and historical codices survive from the Mixteca-Puebla region.

Using sixteenth-century maps and chronicles from the Mixtec areas, it has been possible to decipher the historical content of the Mixtec codices. They deal mainly with the history of the ruling families living in the Oaxaca region. The Codex Nuttall represents the story of the dynasty of Tilantongo, beginning with the creation of the world by the gods (Colorplate 3) and chronicling in great detail the conquests of the famous ruler called 8 Deer (Plate 21). The best-known religious codex, the Codex Borgia, represents the gods in charge of the time periods in the ritual calendar (Colorplate 4), and esoteric lore associated with the gods of the sun, the underworld, and sacrifice (Colorplate 5).

The Mixteca-Puebla style appears in sites from northwest Mexico to the east coast of Yucatan. This wide distribution during the late Postclassic period indicates far-flung commercial ties from the center to the peripheries of Mesoamerica. The iconographic system provided the basis of much Aztec art, and the Aztecs used Mixteca-Puebla craftsmen to make their gold, turquoise mosaic, and feather objects. For the Aztecs, Mixteca-Puebla art symbolized the great traditions of the settled civilizations. Many Mixtec cities paid tribute to the Aztec empire, and the city of Cholula had become part of that empire by the late Postclassic period.[2]

Aztec culture developed in the Valley of Mexico in the thirteenth century, and its artistic styles have many formal and iconographic roots in art of the past. Much is derived from the widespread Mixteca-Puebla tradition, especially in painting and the minor arts, so much so that Aztec art has been considered to be a variant of the Mixteca-Puebla (Nicholson, 1966). Unlike the Mixtecs, however, the Aztecs developed a sculptural style that is as powerful in its way as Olmec had been, as well carved as Classic Veracruz and Xochicalco, and as iconographically complex as Teotihuacán art. In its sheer size, three-dimensional monumental Aztec sculpture is rivaled only by that of the Olmecs.

Even Aztec arts that copy earlier works or were derived from earlier styles are characterized as Aztec by their emphasis on realism and their sense of life, powerful expression, and ample space. The synthesis in style and iconography which coalesced in the Valley of Mexico within less than two hundred years was unique, the last great art style in Mesoamerica before the European conquest.

Aztec History and Culture

THE PEOPLE OF CENTRAL MEXICO. During the late Postclassic period, after 1200, the people of central Mexico were living in city-states whose alliances and enmities were shifting. All the people of central Mexico are usually called "Aztecs," although they belonged to a number of separate groups. The word "Aztec" will be used here to refer collectively to the Postclassic population of the Valley of Mexico. In each city-state lived different ethnic groups speaking a variety of languages and specializing in certain crafts and professions. The cities and their different wards had carefully preserved histories as well as a special patron deity. Five types of peoples lived together in central Mexico: people with a nomadic or Chichimec ancestry; people who were descendants of the Toltecs; settled populations that were neither Toltec nor Chichimec; barbarian outsiders; and high-culture outsiders (Carrasco, 1971). Some towns had a highly homogeneous population, others consisted of cosmopolitan wards of the above groups (Plate 1).

The name "Chichimec" (dog people) was used by the Aztecs to describe nomads living by simple hunting and gathering in the arid lands of northern Mexico. Many of these groups spoke Nahuatl. The status of Chichimec groups depended on when they had moved into and settled in the area of Lake Texcoco; the earlier groups to arrive had the higher status. These nomadic groups were warlike; they conquered lands and established cities, or founded the ruling families in older cities having non-Chichimec populations. Three important groups of nomadic origin were the Acolhua (sometimes called the "Chichimec of Xolotl"), the Tepanec, and the Mexica.

The Acolhua were traditionally the first Chichimec group to arrive in the Valley of Mexico. The Codex Xolotl (Colorplate 6) shows the Acolhua leader Xolotl and his son Nopiltzin exploring the mountains, caves, cities, and ruins around Lake

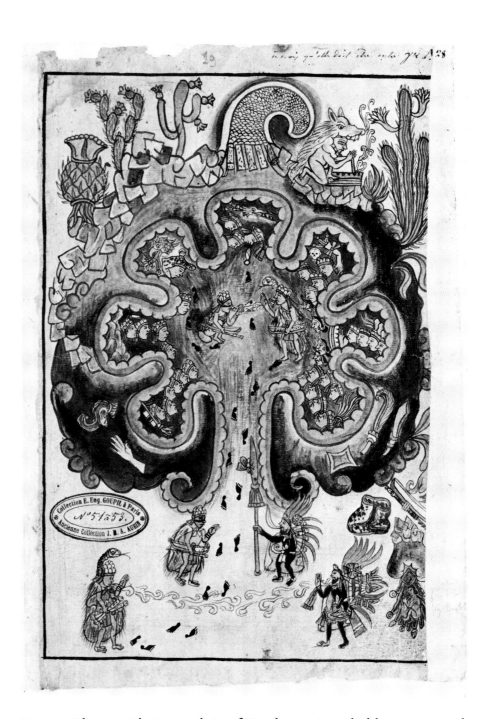

Plate 22. Chicomoztoc (seven caves of origin) of the Aztec Tribes. Historia Tolteca-Chichimeca, p. 28. Manuscript, 30 × 33 cm. Cuauhtinchan, Puebla. Early Colonial, after 1544. Bibliothèque Nationale, Paris

Texcoco. The great Classic period site of Teotihuacán is marked by two pyramids and a cave, its grandeur not lost on these hunters dressed in animal skins. The Acolhua eventually founded the cities of Tenayuca, Texcoco, and Coatlinchan to the north and east of Lake Texcoco. The city of Texcoco became known as the greatest cultural center in the valley.

The Tepanec followed the Acolhua and lived on the west side of Lake Texcoco at Atzcapotzalco and Tlacopan. The last group to arrive were the Mexica, who lived on islands in the lake at Tenochtitlán and Tlatelolco; eventually they became the political overlords of the entire region.

Only one city in the Valley of Mexico, Culhuacan, could boast that its rulers were descended from the dynasty of the Toltecs, whose capital city, Tula, was de-

stroyed around 1200 A.D. The people of Culhuacan spoke Nahuatl and had migrated to their city on the shore of the lake after the downfall of Tula. Other groups were eager to intermarry with the Culhua in order to acquire some Toltec blood.

Besides people having Toltec and Chichimec ancestry, other populations predated the nomadic invasions and perhaps even the Toltec empire. These were people called the Olmeca-Xicalanca and the Nonoalca, who did not speak Nahuatl; they formed a part of the population of the cities of Cholula, Chalco, and Tlaxcala. The rest of the population spoke Nahuatl.

Other groups who lived in the Valley of Mexico included the Otomí around the northern part of the lake at Xaltocan; these were peasant farmers, despised as barbarians by the other populations. Groups of specialized craftsmen were outsiders, such as the Tlailotlaque ("those who have returned"), manuscript painters from the Mixtec area of Oaxaca who settled in Texcoco.

To an outsider, the city-states would have seemed much alike: people lived in the same types of buildings, they ate the same kind of food, they believed in similar gods, and they performed similar rituals. Special patron deities and the histories of their ruling families helped to keep separate their traditions from those of their neighbors, whom otherwise they resembled.

THE HISTORY OF THE MEXICA. At the time of the ruler Itzcoatl, the Mexica burned their books on history and rewrote their past (Sahagún, 1950–78, bk. 10, p. 191). They described their rise to power as foreordained by their god, who selected them as a chosen people to uphold the cosmic order through warfare and sacrifice. The Mexica believed that they came from Aztlan (place of whiteness), an island in a lake, or they came from Chicomoztoc (seven caves) according to other traditions (Plate 22). The word "Aztec" derives from the name "people of Aztlan." While Aztlan was a place associated only with the Mexica, Chicomoztoc was the legendary place of origin for many other Nahuatl-speaking groups who left the caves at different times. The Mexica were the last to leave. Attempts have been made to locate Aztlan or Chicomoztoc in northwestern Mexico, but without success, and perhaps both are purely mythical. The Mexica were led by their god Huitzilopochtli, who told the four priest-rulers, called *teomama* (god bearers), where to go on their migrations.[3]

Huitzilopochtli (hummingbird of the left, or of the south) was said to have been born at Coatepec (serpent hill) near Tula, another stop on the Mexica migration. Sahagún tells the story of Huitzilopochtli's birth (1950–78, bk. 3, pp. 1–5): an older priestess named Coatlicue (serpent skirt) was sweeping the temple one day when she found a ball of down. She put it in the bosom of her dress, but when she had finished sweeping the down ball had disappeared and she discovered that miraculously she was pregnant. Her 400 sons conspired with their sister Coyolxauhqui (she of the golden bells) to kill Coatlicue because she had brought shame upon them; at the moment of her death her unborn son spoke out, saying that he would avenge her death, and he, Huitzilopochtli, then emerged fully armed. He chased away the 400 sons and decapitated Coyolxauhqui. This myth has both religious and political meaning, for Huitzilopochtli was a god of the daytime sky and his mother, Coatlicue, was an earth-mother goddess; thus Huitzilopochtli's birth refers to the victory of day over night. The 400 sons are the "400 Stars" and Coyolxauhqui is the moon, their light daily extinguished by the sun.

The Aztecs believed that the sun died every night in the west and was reborn every morning in the east, after a nightly battle with forces of darkness and the underworld. But Huitzilopochtli was not only the sun god; his major role was that of

special patron of the Mexica. His "birth" at Coatepec is generally interpreted as the triumph of Huitzilopochtli's cult over that of other deities to lead the Mexica. The victory of Huitzilopochtli also signified the future victory of the Mexica over the other peoples in the Valley of Mexico.

During their wanderings the Mexica tribe split up several times in what were both political and religious schisms; once Huitzilopochtli's other sister, Malinalxochitl (maguey flower), a sorceress, sent snakes and scorpions to bite the people. She and her followers were abandoned by Huitzilopochtli's group in the middle of the night. Malinalco was then founded by Malinalxochitl and her followers. Another schism occurred at Coatepec, where the Mexica had settled for a while, built a dam, and created a lake and irrigation system for the fields. They did not want to leave this paradisical land, but Huitzilopochtli insisted that they go on. To force them to continue their journey he destroyed the dam and decapitated his rebellious sister on the ball court. (The fifteenth-century Mexica ruler Motecuhzoma I sent sixty sorcerers to locate Coatepec and to tell Huitzilopochtli's mother about the greatness and power of the Mexica. The sorcerers found an old man who scolded them for their soft civilized ways, and an old woman, presumably Coatlicue, who foretold that the Mexica would one day be overthrown.)

The Mexica went next to Tula and beheld there the ruins of that once-great city; then to Xaltocan, the Otomí city on the northern shores of Lake Texcoco. They stopped on the way to farm and settle, only to pick up again and continue their migration. At this time the lake region was densely settled with farms and cities, and the Mexica had to find what leftover lands they could. The major powers were the Acolhua, east of the lake, and the Tepanec, on the west. The Mexica tried to settle at Chapultepec (grasshopper hill) on the western shore of the lake, but their neighbors, particularly the Tepanecs, disliked them and drove them away several times.

The Mexica asked Culhuacan for protection and they were given poor lands at Tizapan that were infested with snakes. The Mexica ate the snakes and reclaimed the lands. Eventually they became warriors for Culhuacan, intermarried with Culhuacan families, and called themselves the Culhua-Mexica. The Culhua needed the Mexica as warriors, but were appalled by their cruelty. When told not to take prisoners in battle, the Mexica warriors cut off the ears of their victims and brought them back to Culhuacan as proof of their bravery. Huitzilopochtli told the Mexica to ask the Culhua for a royal bride for him; when the girl arrived they sacrificed and flayed her, and invited her father to the festival; he fled in horror when a priest appeared, dancing in the daughter's skin. The Culhua, who despised and feared the Mexica for their barbarous ways, then drove the Mexica out of Tizapan.

This time the Mexica took shelter in the swamps of the lake on an island. Huitzilopochtli told them to look for an eagle perched on a cactus and eating a snake, and to build their city in that place. Tenochtitlán means "place of the fruit of the cactus" (Colorplate 7). Like the mythical homeland Aztlan, Tenochtitlán was to be an island city.

The traditional date for the founding of Tenochtitlán ranges from 1325 to 1369 (Kirchhoff, 1949–50). At this time the Mexica were still ruled by four *teomama*, one of whom, Tenoch, was their main leader. After Tenoch's death, the Mexica asked Culhuacan to send them a ruler of Culhua-Mexica parentage. Acamapichtli was sent, and through him the Mexica dynasty became related to Culhuacan royalty and the Toltecs (Plate 23).

The island north of Tenochtitlán, called Tlatelolco, was settled by a dissident group of the Mexica. According to Tlatelolco accounts, they were there before Tenochti-

tlán was founded. The Tlatelolcans were primarily merchants, while the Tenochca were warriors.

Tezozomoc, the ruler of Atzcapotzalco, was the most powerful in the valley in the fourteenth century. During the reign of the next two Mexica rulers, the Mexica paid tribute to Tezozomoc and fought as mercenaries for him as well. In return they received conquered lands. In a major victory, Tezozomoc conquered Texcoco. The defeated king died and his son, Nezahualcoyotl, went into exile. But before Tezozomoc could consolidate his empire, he died in 1426. His death was followed by dynastic upheaval among the Mexica. Their ruler died also, either by murder or suicide, and Itzcoatl (obsidian serpent) became the new Mexica ruler.

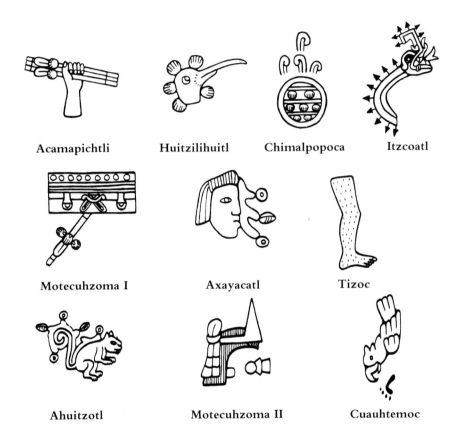

Acamapichtli Huitzilihuitl Chimalpopoca Itzcoatl

Motecuhzoma I Axayacatl Tizoc

Ahuitzotl Motecuhzoma II Cuauhtemoc

Plate 23. Drawing of Name Glyphs of Aztec Rulers, from Codex Mendoza and Tira de Tepechpan (Cuauhtemoc)

Mexica power in the valley began with the death of Tezozomoc and the accession of Itzcoatl. Itzcoatl was advised by his nephews Motecuhzoma and Tlacaelel. Tlacaelel took the title *cihuacoatl* (woman serpent), that of a priestly office second to the title of *tlatoani* (he who speaks) held by the ruler. The ruler was advised by a council of four, including generals and the *cihuacoatl*, and henceforth any new ruler would be selected from this council. Itzcoatl, Motecuhzoma, and Tlacaelel reversed the previous policy: they rejected the overlordship of Atzcapotzalco, and decided to reconquer Texcoco for the exiled Nezahualcoyotl. According to one story, Tlacaelel went to Atzcapotzalco and declared war by dressing Maxtla (Tezozomoc's successor) with the black-paint and white-feather headdress of death and putting weapons of war into his hands. Tenochtitlán, Texcoco, and Huejotzingo formed an alliance and reconquered Texcoco and, after a long siege, even Atzcapotzalco. The Mexica thus controlled the lands on both shores of Lake Texcoco.

Under Itzcoatl the Mexica burned the old books and rewrote their history. They

began to rebuild Tenochtitlán, then still a modest village, on a larger scale and in stone. After conquering Xochimilco, a town famous for its architects, they ordered these architects to build a causeway between Tenochtitlán and the mainland.

Itzcoatl died in 1440; Motecuhzoma, a member of the council of four, was selected as the new ruler, and named Motecuhzoma I Ilhuicamina (the angry lord who shoots into the sky). He is the only ruler who was said to have had a supernatural birth: his mother, a woman from Cuernavaca, was made pregnant while in her courtyard by one of Huitzilhuitl's arrowheads.

A Mexica ruler had to prove himself before his coronation by a victory in battle. Motecuhzoma I fought the city of Chalco. So many men of Chalco died in this battle that, to fulfill the tribute agreement, the Chalco women had to go to Tenochtitlán to build the temples. At his coronation, Motecuhzoma was dressed as Huitzilopochtli, and he became the first ruler to be treated as a near divinity. Henceforth he appeared in public only on rare occasions.

At this time the Valley of Mexico was controlled by a new league of three cities, Tenochtitlán, Texcoco, and Tlacopan; of these, Tenochtitlán was the dominant power. It is this Triple Alliance, lasting until the time of the Spanish conquest, that is usually called the "Aztec empire." Since all the cities around the lake were now under the control of the league, wars were fought farther away. Motecuhzoma led campaigns to the east, toward Tlaxcala and the Gulf Coast, as well as to the west, to the Mixteca and Oaxaca. Some of these conquests were not made only to acquire more tribute in luxury goods, but tribute in productive lands as well.

Motecuhzoma's reign was beset by major disasters. There were floods in 1450, and a nine-mile-long dike in the lake, suggested by Nezahualcoyotl for future protection, took thirteen years to build. The winters of 1452 and 1454 were unusually cold and snowy, and were followed by droughts. The Mexica increased their sacrifices to the gods. Since wars were now fought at greater distances and it was difficult to bring back prisoners to Tenochtitlán, a ceremonial form of warfare called "flowery war" was established with their neighboring enemy Tlaxcala, enabling either side to take prisoners locally. The invention of "flowery war" was attributed to the counsellor Tlacaelel.

Motecuhzoma codified the laws and established the insignia of rank. He also continued the construction of the Temple of Huitzilopochtli begun by Itzcoatl, and set up a number of carved monuments. According to Durán, his portrait was carved in the rock at Chapultepec (see Colorplate 19).

After Motecuhzoma died in 1468, his grandson Axayacatl was selected as ruler. During his reign the rivalry between Tenochtitlán and Tlatelolco came to a head. Tlatelolco had just dedicated new shrines when Axayacatl attacked them, destroyed the ruling dynasty, defaced the temples, and brought the great Tlatelolco market under the control of Tenochtitlán. Axayacatl fought a war against the Tarascans in the west, the only people in Mesoamerica who had bronze weapons, and was badly defeated. Wounded in a campaign, he died young, and like all the Mexica rulers, he had elaborate funeral rites. Before cremation, his mummy was dressed in the costumes of the gods Huitzilopochtli, Tlaloc, Xipe, and Quetzalcoatl.

Axayacatl was succeeded by his older brother Tizoc, who governed for only five years, from 1481 to 1486. He seems to have been more interested in religion and building projects than in warfare, and his first campaign was a disaster. Little is known about his reign, except that he enlarged the Temple of Huitzilopochtli and commissioned the Stone of Tizoc (see Plate 90). He met an early death, perhaps murdered by his brother Ahuitzotl.

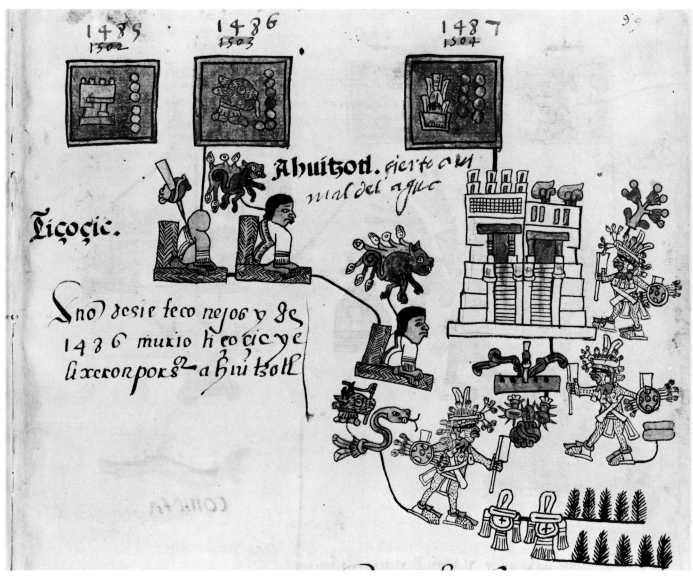

1485 1502 · 1486 1503 1487 1504 9 ç

Țiçoçic.

Aħuitzotl. fierte oțu mal del agu̓e

Sno̓ ƌcsie feco ne̓joɓ y ƺç
143 6 muxıo ħeoçıc̓ye
li xcro̓npoxŝ̄ aħıu̓ɓoĦ

Plate 24. Death of Tizoc, Ascendancy of Ahuitzotl, and Dedication Ceremonies of the Main Temple of Tenochtitlán. Codex Telleriano-Remensis, fol. 39 (portion). Manuscript, 32 × 22 cm. Valley of Mexico. Early Colonial, c. 1562–63. Bibliothèque Nationale, Paris

Ahuitzotl was the last great conqueror among the Mexica rulers. He was in power from 1486 to 1502. His reign began in 1487 with the dedication of Tenochtitlán's Great Temple of Huitzilopochtli and Tlaloc, celebrated by four days of sacrifices. The Codex Telleriano-Remensis shows the death of Tizoc and the inauguration of Ahuitzotl (Plate 24): Ahuitzotl's name symbol is the doglike water monster, and the dedication of the great temple is indicated by the twin pyramids; the cactus on a stone is a glyph for the city of Tenochtitlán; the incense bags and leaves refer to the number of victims sacrificed. The Spanish text says that in 1487 20,000 victims were sacrificed. To the festivities both friendly and enemy rulers were invited and all feasted lavishly, the hostile rulers in secret so that the population would not recognize them and try to kill them. The thousands of prisoners were sacrificed, and Ahuitzotl and the other league rulers took part in the theatrical display and even the killing. In these dedication ceremonies the Mexica sought to impress their allies as well as their enemies with their wealth and wanton cruelty, and thus to keep them all in line. Human sacrifice in such numbers is usually attributed to the Mexica,

because we have textual evidence for it. We do not know if it existed to this extent in earlier cultures.

Ahuitzotl extended Mexica military forays as far as the Guatemala highlands and the Gulf Coast (Plate 25). After another major drought he had a huge aqueduct built in the lake to bring water to Tenochtitlán. At its dedication the priest was dressed in the garment of the water goddess, and all the ceremonial paraphernalia were blue. The next year great rains and floods damaged the city and the aqueduct had to be broken up. Ahuitzotl died young, either from an accident or from illness. During his reign a number of evil omens occurred, such as a solar eclipse, an earthquake, and visions of phantoms.

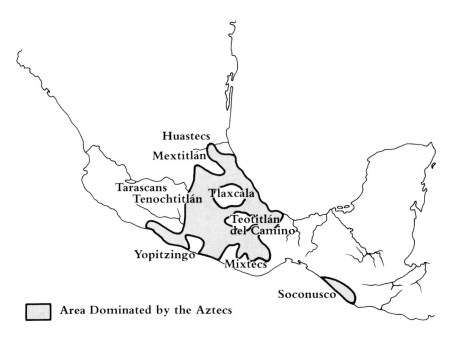

Plate 25. Map of the Aztec Empire in 1519

☐ Area Dominated by the Aztecs

Motecuhzoma II Xocoyotzin (the younger) was for the Mexica the most absolute and tyrannical of rulers (Plate 26). It is difficult to evaluate his rule and personality apart from his tragic role in the Spanish conquest. Many of the historical sources tried to explain the conquest by making Motecuhzoma "predestined" for such a fate. He had a reputation for being fanatically religious, preoccupied by sorcery and the divination of the future. Unlike Ahuitzotl, who was a convivial soldier, Motecuhzoma emphasized the superiority of the aristocracy over the commoners and had rigid notions of protocol and precise ritual. Throughout most of his reign he was at war with Tlaxcala, and his relations with Texcoco deteriorated steadily. Many of his campaigns came from the necessity to put down rebellions on the Gulf Coast.

As a ruler seriously interested in religion, Motecuhzoma rebuilt a number of temples and erected sculptures, all dedicated through lavish sacrifices. After a series of bad omens Motecuhzoma consulted the ruler of Texcoco, Nezahualpilli, asking him to foretell the future. At this time, his political relations with Texcoco were strained; Nezahualpilli foretold an invasion that was to come from the east, and he may have mentioned the "return of Quetzalcoatl" as a vague threat to arouse fear in Motecuhzoma. By 1515 Nezahualpilli had died and Texcoco was torn apart by rival factions, in which Motecuhzoma intervened to put his man, Cacama, on that throne. Worried about the future, Motecuhzoma had his portrait carved at the

cliffs of Chapultepec in 1519, the same year of the definite news of the arrival of Cortés. Motecuhzoma's superstitiously fearful yet imperious personality as well as his political and military actions raised much resentment in his empire. This self-destructive ability to create discord paved the way for Cortés's easy victory.

The Mexica attitude toward their nomadic origin and military success was ambivalent. On the one hand they despised their ancestors for being cave-dwellers; on the other, they glorified them as "noble savages" having stoic virtues. Proud of their conquest of the more settled and civilized populations, they nevertheless had doubts that their rule was entirely legitimate. Their history contains the interplay of two myths: the myth of Huitzilopochtli, and the myth of Quetzalcoatl of Tula.

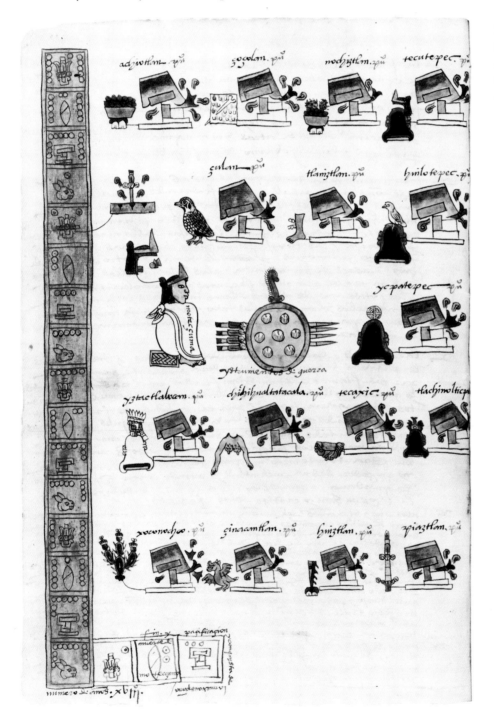

Plate 26. Motecuhzoma II Facing Place Glyphs of His Conquered Towns. Codex Mendoza, p. 15. Manuscript, 32.7 × 22.9 cm. Mexico City. Early Colonial, c. 1541–42. Bodleian Library, Oxford

The cult of Huitzilopochtli, a combined sun god and deity who drove his chosen people to conquer, may have been consolidated late in Mexica history, perhaps as late as during the successful reign of Itzcoatl, and been projected back into their nomadic time. Those who opposed Huitzilopochtli were said to be led by his sisters, thus implying they were effeminate weaklings. Huitzilopochtli justified the Mexica military aggressiveness and cruelty that even their contemporaries considered excessive. Since the Mexica did not come from an illustrious or ancient dynasty, they venerated their patron god above all else. It is quite possible that much of this was propaganda, that the Mexica were not as primitive and nomadic and did not come from as far away as the official histories imply. The poverty of their background may have been exaggerated to dramatize their successes and urge them on in their conquering mission.

The myth of Quetzalcoatl of Tula accounted for the disappearance of the superior ancient civilizations and the illegitimacy of the subsequent contenders for power. To acquire legitimacy, the Mexica married into the Toltec-related dynasty of Culhuacan. Despite this link through marriage and their own accomplishments, the Mexica still felt inferior, viewing their legitimacy to be based on conquest, not on legal right. When Cortés arrived, claiming the New World in the name of his king and god, Motecuhzoma in effect handed over Tenochtitlán to the man he thought might have been Quetzalcoatl's heir.

Evidence of the importance of the Quetzalcoatl myth for the Mexica is the relief on a rock near Tula (see Plates 67, 68) representing a man dressed as a ruler with a feathered serpent behind him and the date 1 Reed (Ce Acatl), the glyph for the birth date and name of Quetzalcoatl the Ruler. The style of this relief is not Toltec, but Aztec. Whether Tula ever had a ruler named Quetzalcoatl we do not know, but the Mexica thought so, and they put his portrait on the rock where, in their opinion, it belonged. Huitzilopochtli represented the Mexica drive to success; Quetzalcoatl, the Mexica fear of disaster.

THE WORLD OF THE SUPERNATURAL. From birth to death the life of an Aztec unfolded within a religious pageant that gave it form and meaning. This religion is particularly bewildering to Westerners for the multiplicity and contradictory nature of the gods, and the importance of blood sacrifice. Aztec religion did not emphasize individual deities or a single sacred text. New gods and rituals were easily added or old ones discarded without effecting any basic change. The Aztecs would have been quite willing to accept the god of the Christians next to their own gods; what they could not understand was the exclusivity of Christianity. Just as the Aztecs were a heterogeneous people with different languages and histories, their multifaceted religious system was not practiced by everyone in the same way. There were various contradictory myths about the creation of the world, there were hundreds of gods and spirits; sometimes the same god was worshiped under several names, sometimes many gods as different aspects of one.[4]

Aztec religion was unified by a few common concepts, the inherent sacredness of all aspects of existence, and a cyclic pattern of transformation. Since all of nature was viewed as being pervaded by the supernatural, the number of spirits was potentially endless. If there was a drought, one called on the gods of rain, wind, and storm. One could summon a single god, or as many as one could name. In a prayer, the deity would be evoked by as many names, titles, and metaphors as possible. Here is the beginning of a prayer to Tlaloc, the god of rain:

O Lord, Our Lord, O Provider, O Lord of Verdure,
Lord of Tlalocan, Lord of the Sweet-Scented Marigold, Lord of Copal!
The gods, Our Lords, the Providers,
the Lords of Rubber, the Lords of the Sweet-Scented Marigold, the Lords of Copal,
have sealed themselves in a coffer, they have locked themselves in a box.
They have hidden the jade and turquoise and precious jewels of life,
they have carried off their sister, Chicomecoatl, the fruits of the earth,
and the Crimson Goddess, the chile.

Oh, the fruits of the earth lie panting:
the sister of the gods, the sustenances of life,
feebly drags herself along,
she is covered with dust, she is covered with cobwebs,
she is utterly worn and weary.

<div style="text-align: right;">

(SAHAGÚN, FLORENTINE CODEX, BK. 6, CH. 8;

TRANS. THELMA SULLIVAN, 1965, P. 43)

</div>

As this passage indicates, the gods were not anthropomorphic beings who controlled natural phenomena, they were themselves the phenomena. Tlaloc was lightning, thunder, and rain, Chicomecoatl was food, especially maize. In the prayer, the Tlalocs are accused of having hidden the food, referred to as "the precious jewels of life . . . covered with cobwebs." For the god was not necessarily a person, he was the name or metaphor given to an aspect of nature. Relationships between gods were also metaphoric rather than personal: when Chalchiutlicue, goddess of rivers and lakes, is described as the sister and the wife of Tlaloc, these are both acceptable metaphors expressing the close relationship between rain and water—not evidence of the Aztecs' confusion or inconsistency. In their view nature was not embodied in a group of static beings, but seen as a succession of stages in a continuous development.

The two basic metaphors for transformation in ancient Mesoamerica were sexuality and death, because both were seen to result in the creation of life. The sexual metaphor was used to explain the seasonal renewal of nature. It has to be reconstructed from hymns and rituals for it is not described in any one myth. The use of this metaphor was especially widespread in the Classic period and continues in the rituals of modern Indians today (Girard, 1966). The sun god was believed to descend into the earth at the end of the dry season and to mate with the earth goddess, who then gave birth to the maize and the other plants that grow in the rainy season. The sun god died in the sexual encounter, to be reborn in the form of maize. The earth goddess died subsequently in the process of giving birth (Cohodas, 1974; Thompson, 1939). The sun god and the earth goddess are in their basic aspects the same as the deities called the Lord and Lady of Duality (Ometeotl and Omecihuatl), who were considered to be the creators of the universe. They stand for the union of male and female principles who were responsible for the eternal renewal of nature. Since nature was believed to be in a state of balance, no new life could be created without the death of the old.

The second metaphor used to explain change was death as a result of armed combat. This metaphor is attributed to the military aristocracies that came to power in Mesoamerica in the Classic period. It is associated with the development of stratified state societies and the military upper class. The disappearance of the sun at night was metaphorically described as a battle between the forces of light and those of the darkness of the earth in which the sun died. The reappearance of the sun in the morning signified its rebirth, after successfully fighting the night. In the old Meso-

american view, life and death were locked in an endless struggle of alternating victory and defeat. The birth of a child was a life gained through sexuality, and thereby tainted with sin that had to be ritually removed; the afterlife gained by dying in battle or as a sacrificial victim was pure and brought the reward of paradise. For this reason a woman who died in childbirth with the child still in her womb was compared to a warrior who took a prisoner, and she too went to the paradise of the sun with the warriors.

The gods themselves were not immortal, and remained within this cycle of death and rebirth. The processes of living and dying were frequently reduced to the metaphor of eating. When humans were eating maize they were actually eating the flesh of the maize god Centeotl; this had to be restored to the god in the form of human sacrifices—the blood into which the maize had been transformed. The dead, whether people or gods, were eaten by the earth, imagined as a great monster. One of the most powerful images of Aztec art is the open jaw of the earth monster ready to devour its victims.

The gods' self-sacrifice for the sake of humanity is illustrated by a creation myth recounted by Sahagún (1950–78, bk. 7, pp. 3–8). After the end of the fourth destruction of the world, the gods got together at the ruins of Teotihuacán and built a great bonfire. The god who would throw himself into the fire would become the sun. A wealthy god, Tecuciztecatl, sacrificed precious stones and feathers, but could not bear to throw himself in; a poor syphilitic god, Nanahuatzin, who had nothing to offer but himself, jumped fearlessly into the fire and became the sun. Ashamed of himself, Tecuciztecatl followed, and became the moon. However, the sun remained stationary until all the other gods jumped into the fire. In the Aztec view, gods and humans had a contract: they agreed to keep each other alive by providing one another with the appropriate nourishment (Caso, 1958).

The gods were propitiated and repaid in festivals held in their honor in which the climax was usually the sacrifice of human victims. The blood of the victims was smeared on the mouths of the idols. These victims were often dressed as the gods and impersonated them. In their sacrifice was a re-enactment both of the deity's original and cyclical self-sacrifice and of man's continuing gratitude, which was needed to keep the deity alive. Since the victim impersonated the deity, he was well treated and might be given a narcotic to drink so he could play his role in the ceremony without fear. Certain portions of the victim's body were cooked and eaten, thus symbolically allowing the partaking of the deity's flesh through that of his impersonator. Human sacrifice and ritual cannibalism were essential and integral outgrowths of the Aztec view of the dynamics of the universe. Both had been practiced throughout the history of Mesoamerica, and it is generally assumed that the Aztecs, for political reasons, only increased greatly the number of victims.

The Aztec concept of the sacrificial victim was, in reality, not without some ambivalence. The victim represented the god, he was destined to go to a special paradise after dying, and his captor called him reverently "my son," all indications of high esteem. Nevertheless, people tried to avoid becoming victims, although they hoped to display courage in dying if that was their fate. Since one became a victim by being captured or sold, it was a position of low status; to compare a person to a victim could be an insult.

Constant transformations in the universe were made intelligible by plotting them in space and in time. Since the Aztecs' world view was a dynamic one, temporal concepts were more important than spatial ones. Most preconquest religious manuscripts illustrate sacred time, while only one sixteenth-century manuscript, made for

the Spaniards, represents the structure of sacred space (Colorplates 8, 9). The Aztecs believed that the cosmos was divided into a number of horizontal layers, vertically aligned. They visualized the earth as a flat disk surrounded by water, or as a giant crocodilian monster swimming in a sea covered by water lilies. The earth was divided into four cardinal directions: the east of the rising sun signified birth, life, and masculinity, and the west of the setting sun signified death, destruction, and femininity. Above the earth rose the thirteen layers of the heavens, the place of the clouds, the sun, moon, and planets, and the stars. The topmost heaven was the home of the Lord and Lady of Duality. The upper world of the sun was also the paradise of warriors killed in battle, sacrificial victims, and women who died in childbirth. Those who died by drowning, by being struck by lightning, or by diseases sent by the rain gods went to Tlalocan, the paradise of Tlaloc, thought to be located on mountaintops halfway between earth and sky.

The underworld, Mictlan, was divided into nine layers and was governed by the nine Lords of the Night. The entrance to the earth was through the gaping jaws of a saurian earth monster. The underworld was the destination of those who died an ordinary death. Their souls had to travel through many dangers and could be accompanied by a small dog. Like the Hades of Greek mythology, Mictlan was unpleasant but morally indifferent; it was not a place of punishment. Space and time had their mythical equivalents: the underworld was associated with night and especially with the starry sky, the upperworld with daytime and the sunny sky.

The Aztecs saw time in both cyclical and linear ways (Broda, 1969). Cyclical time governed the year, and formed the basis of a divinatory almanac. Linear time was significant for the history of the ruling elite. It is possible that like the Maya, the Aztecs developed a calendar that began with a fixed point in the past. Generally, linear time was measured in periods of fifty-two years, and was strongly influenced by a belief in cyclically recurring events. The Aztec universe was regulated by a complex calendrical scheme which consisted of two interlocking cycles: the solar year and the divinatory almanac. The 365-day solar year was divided into 18 months of 20 days each, with an extra 5 days at the end. Each month had its own presiding deity and ritual related primarily to the agricultural seasons, and to crafts and professions. The last five days were unlucky and inactive.

More important than the solar year was the 260-day divinatory almanac or ritual calendar which disclosed man's fate day by day. This 260-day cycle consisted of 13 numbers and 20 day names such as "crocodile" or "wind" (Plate 27). The 13 numbers were added to the day signs to form "1 Crocodile," "2 Wind," and so on. The combination of 1 Crocodile would repeat only after 260 days had passed (Plate 28). Each day name and each number was under the rule of a deity—or, more correctly in the Aztec view, the days were burdens carried by the gods. Each day sign and number signified a good, bad, or indifferent fortune. Gods and men took their names and destinies from the day of their birth. A woman born on the day 1 Flower would become an embroiderer; a person born on 1 Rabbit would become a drunkard; anyone born on 1 House would come to a bad end as a thief or prostitute. Priests had codices with pictures of the almanac which they consulted for their prognostications. Fate could be ameliorated in certain ways; if a child's naming day happened to be unlucky, it could be postponed for a better one. Some years, such as 1 Rabbit, were entirely unlucky. In Aztec history, droughts were said to occur in years named 1 Rabbit, and good weather in those named 2 Reed; it is an interesting question whether historical facts were distorted to fit the pattern of prognostication. The Aztecs believed that there had been four previous worlds which had been destroyed respec-

Crocodile

Wind

House

Lizard

Serpent

Death

Deer

Rabbit

Water

Dog

Monkey

Grass

Reed

Jaguar

Eagle

Vulture

Movement

Flintknife

Rain

Flower

tively on the days 4 Wind, 4 Water, 4 Jaguar, and 4 Rain of Fire. These worlds ended in catastrophes appropriate to their signs, and each time all humanity perished. The Aztecs were living in the fifth world, which would be destroyed by earthquake on the day 4 Movement.

| Day sign | | | | | | | | | | | | | |
|---|---|---|---|---|---|---|---|---|---|---|---|---|
| Cipactli | 1 | 8 | 2 | 9 | 3 | 10 | 4 | 11 | 5 | 12 | 6 | 13 | 7 |
| Hecatl | 2 | 9 | 3 | 10 | 4 | 11 | 5 | 12 | 6 | 13 | 7 | 1 | 8 |
| Calli | 3 | 10 | 4 | 11 | 5 | 12 | 6 | 13 | 7 | 1 | 8 | 2 | 9 |
| Cuetspali | 4 | 11 | 5 | 12 | 6 | 13 | 7 | 1 | 8 | 2 | 9 | 3 | 10 |
| Coatl | 5 | 12 | 6 | 13 | 7 | 1 | 8 | 2 | 9 | 3 | 10 | 4 | 11 |
| miquistli | 6 | 13 | 7 | 1 | 8 | 2 | 9 | 3 | 10 | 4 | 11 | 5 | 12 |
| maçatl | 7 | 1 | 8 | 2 | 9 | 3 | 10 | 4 | 11 | 5 | 12 | 6 | 13 |
| tochtli | 8 | 2 | 9 | 3 | 10 | 4 | 11 | 5 | 12 | 6 | 13 | 7 | 1 |
| Atl | 9 | 3 | 10 | 4 | 11 | 5 | 12 | 6 | 13 | 7 | 1 | 8 | 2 |
| ytscuintli | 10 | 4 | 11 | 5 | 12 | 6 | 13 | 7 | 1 | 8 | 2 | 9 | 3 |
| oçomatli | 11 | 5 | 12 | 6 | 13 | 7 | 1 | 8 | 2 | 9 | 3 | 10 | 4 |
| malinalli | 12 | 6 | 13 | 7 | 1 | 8 | 2 | 9 | 3 | 10 | 4 | 11 | 5 |
| Acatl | 13 | 7 | 1 | 8 | 2 | 9 | 3 | 10 | 4 | 11 | 5 | 12 | 6 |
| Ocelotl | 1 | 8 | 2 | 9 | 3 | 10 | 4 | 11 | 5 | 12 | 6 | 13 | 7 |
| quauhtli | 2 | 9 | 3 | 10 | 4 | 11 | 5 | 12 | 6 | 13 | 7 | 1 | 8 |
| Cozcaquauhtli | 3 | 10 | 4 | 11 | 5 | 12 | 6 | 13 | 7 | 1 | 8 | 2 | 9 |
| olin | 4 | 11 | 5 | 12 | 6 | 13 | 7 | 1 | 8 | 2 | 9 | 3 | 10 |
| tecpatl | 5 | 12 | 6 | 13 | 7 | 1 | 8 | 2 | 9 | 3 | 10 | 4 | 11 |
| quiavitl | 6 | 13 | 7 | 1 | 8 | 2 | 9 | 3 | 10 | 4 | 11 | 5 | 12 |
| Xochitl | 7 | 1 | 8 | 2 | 9 | 3 | 10 | 4 | 11 | 5 | 12 | 6 | 13 |

The two calendrical cycles of 365 days and 260 days coincided every 52 years to make the cycle that was the Aztec equivalent of our century. Each year within a 52-year cycle could begin only with the name Reed, Flintknife, Rabbit, or House (Plate 29). These signs were called "year bearers," and events in the historical manuscripts were dated by them. Since the patterns of the year bearers repeated every 52 years, it is now difficult to know in which cycle a date belongs, in the absence of other information; it is as if we knew that an event was dated in the year 42, but not whether this meant 1542 or 1942. Moreover, the year bearers were not identical from city to city or time to time, which makes the interpretation of dates in Aztec history hard to synchronize with the Christian calendar.

The Aztecs did not invent the calendrical system described here, but inherited it from the settled populations in the Valley of Mexico whom they had conquered. All peoples of Mesoamerica had this calendrical system and its origins go back at least as far as the Preclassic period. The people of Mesoamerica took an intellectual delight

in the numerical permutations of their system. For example, the natural cycle of the planet Venus as morning and evening star is 584 days. Five synodical revolutions of

OPPOSITE, FAR LEFT
Plate 27. Drawing of Day Signs of the Ritual Almanac, from the Calendar Stone

OPPOSITE, LEFT
Plate 28. Chart of Combinations for Day Signs and Numbers in 260-day Ritual Almanac (text in Nahuatl). Sahagún's Codices Matritenses. Manuscript. Tlatelolco. Early Colonial, c. 1564. Real Casa, Patrimonio Nacional, Palacio Real, Madrid

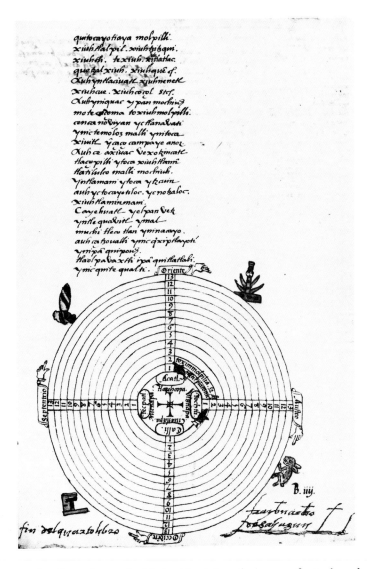

Plate 29. Calendar Wheel Showing Division of the 52-year Cycle (text in Nahuatl). Sahagún's Codices Matritenses. Manuscript. Tlatelolco. Early Colonial, c. 1564. Real Casa, Patrimonio Nacional, Palacio Real, Madrid (4 sections of 13 years each; alternation of the 4 year bearers, Reed, Rabbit, House, and Flintknife. The 4 sets of 13 years are associated with the 4 cardinal directions, thereby relating space and time)

the Venus cycle of 584 days coincided with eight solar years of 365 days, both consisting of 2920 days; this eight-year confluence was usually celebrated by rituals.

At the end of fifty-two years, the Aztecs performed a New Fire Ceremony. Periods over fifty-two years were counted by the number of New Fire Ceremonies that had taken place since a legendary point in the past. At the end of the old fifty-two-year cycle, fires were allowed to go out and the priests burned the bundle of sticks which symbolized the previous era; there was always fear that at the end of a cycle the earth would be destroyed. A procession went to Hill of the Star, a mountaintop near Culhuacan, and the new fire was kindled on the breast of a sacrificial victim. The last New Fire Ceremony in Mexico was celebrated in 1507 under Motecuhzoma II. The Atzec calendar has been synchronized with the Christian calendar on the basis of the date of the fall of Tenochtitlán to Cortés—August 13, 1521, which was, according to one source, the year 3 House and the day 1 Snake (Caso, 1967).

The hundreds of gods and spirits in the Aztec pantheon were not equally venerated by all Aztecs. Different social groups had different deities whose festivals they orga-

nized and attended. Many commoners and peasants venerated the spirits of sun, moon, caves, mountains, wind, and rain, and the spirits of seeds in all their transformations from sowing to harvest. Some spirits were known in collective groups, such as the Mimixcoa, the clouds, or the Eecatontin, the winds, or the Centzon Totochtin, the four hundred rabbits of drunkenness. Others were worshiped individually: Tonatiuh, god of the sun; Chalchiutlicue, goddess of water; Tlaloc, god of rain; Xochipilli, solar god of music; Macuilxochitl, god of games and feasting; Centeotl, the young god of maize; Teteoinnan and Toci, the mother and grandmother goddesses. These nature deities were venerated during the months of the solar year by feasts and sacrifices. In special aspects they were the patron gods of crafts—such as salt-making, basketry, pottery, mat-making, and weaving—and had special days of veneration in the calendar. Unlike the Greek and Roman gods, these deities had few myths associated with them. They were called upon in poetic hymns and prayers that were sometimes obscure in meaning and archaic in language.

The following is a portion of a hymn sung at the Atamalqualiztli festival, held every eight years at the conclusion of solar and Venus cycles. It is a hymn of joy to the birth of maize:

> The flower of my heart lieth burst open, the lord of the night.
> She hath come, she hath come, our mother, the goddess Tlazolteotl.
> Cinteotl is born at Tamoanchan, the flowery place, on day ce xochitl [1 Flower].
> Cinteotl is born in the place of rain and mist, where the children of men are made, where the jeweled fish are sought.
> Day is here, it hath dawned. The varied spoonbills taste [flowers] where the flowers grow.
> Here on earth, in the market place, thou appearest. I, the prince, I [am] Quetzalcoatl.
> (SAHAGÚN, 1950–78, BK. 2, P. 212)

The Atamalqualiztli festival as recorded by Sahagún illustrates some of these ritual activities (Colorplate 10). People fasted for seven days before the feast day. On the day of the feast, all the gods came to dance dressed as birds, butterflies, and bees, and as impersonators of people such as vegetable sellers. A vessel of water, full of frogs and serpents, was placed in front of an image of Tlaloc. Some people caught and swallowed these live water creatures, dancing as they ate them. Others brought them gifts. The following day ended with processions around the temple. This ritual of fasting and of pretending to go back to primitive and animalistic practices of eating live creatures was designed to give the maize a rest every eight years. "For it was said that we brought much torment to it—that we ate [it], we put *chili* on it, we mixed salt with it, we mixed saltpeter with it; it was mixed with lime. As we troubled [our food] to death, thus we revived it" (Sahagún, 1950–69, bk. 2, p. 164).

The veneration of the nature gods was in the elaborate form of ritual, which included eating special foods, dramatic performances, dances, processions, offerings, and sacrifices. Since each month of the year as well as special dates all had festivals lasting several days, much leisure activity was devoted to the preparation of festive foods, the making of costumes, and the rehearsing of songs and dances. Except for the five unlucky days at the end of the year, when activity was kept to a minimum, not a day passed in the life of an Aztec without a ceremony or the preparation for one.

Although the Aztec elite—the rulers, hereditary and military aristocracy, and the priests—were also concerned with agricultural ritual, they had their own special cults and deities. The priests were mainly in charge of coordinating the festivals of all segments of society with the calendar, with divination, and with the observed

positions of stars and planets. The priests particularly venerated the gods Quetzalcoatl and Tezcatlipoca, who were patrons of the divinatory calendar and of austere priestly conduct; both frequently appear in the codices, that are such good sources on the special interests of the priesthood. The secular ruling class in each city was particularly devoted to the cult of their patron god—Huitzilopochtli of the Mexica, Mixcoatl of the Acolhua, Quetzalcoatl of Cholula. These deities were considered to be creator gods, and they were also culture heroes who had once had a human aspect. They stood for the principles of action, individualism, and history unfolding in linear time. The lives of these gods were told in long epic narratives that intertwined cosmic myth with dynastic history.

While the commoners' main concerns were with the recurrent cycles of the solar year and the gods of nature, the aristocracy was interested in questions of origins and purpose—the creation of the world, and the ultimate destiny of all life—because they believed themselves to be charged with maintaining cosmic order. The ruler and the military aristocracy had the mission of supporting the universe, accomplished through the ceremony of warfare and the acquisition of victims for blood sacrifice. The world view of the aristocracy was essentially pessimistic; believing life and death to be opposing and alternating forces, they had no choice but to accept that the Aztec empire and this universe would one day end, to be replaced by another world. The commoners, who placed the continuity of the group above the destiny of the individual, may have accepted this idea with equanimity. The cycles of nature on which they relied had survived many political upheavals. But for the elite, who saw themselves as individuals having fame and fortune earned through birth and merit, the collapse of their empire would be equivalent to the collapse of the universe, and their own tragedy besides. Their concern for the universe was therefore political and personal. In a rebellious and rational spirit they questioned the immutable laws of nature.

The Aztec ruling class expressed their world view in poetry. Poetry was composed mainly by the nobility and sung or recited by professional singers at feasts and public occasions. The most famous poet-ruler was Nezahualcoyotl, the ruler of Texcoco. Many Nahuatl poems concern the glory of battle and the brief and transitory nature of life on earth:

> Will I have to go like the flowers that perish?
> Will nothing remain of my name?
> Nothing of my fame here on earth?
> At least my flowers, at least my songs!
> Earth is the region of the fleeting moment.
> Is it also thus in the place
> where in some way one lives?
> Is there joy there, is there friendship?
> Or is it only here on earth
> we come to know our faces?
>
> (LEÓN-PORTILLA, 1969, PP. 81–82)

The pessimism of Aztec poetry illustrates that religion, despite its richness and complexity, did not provide a sense of certainty and transcendent meaning for the Aztec ruling class.

Nezahualcoyotl and other aristocratic thinkers are often said to have come to believe in one god and to have begun an incipient monotheism. The entire distinction between polytheism and monotheism in Aztec religion is a false problem created by

the Spanish missionaries, who could not understand a system so different from their own. Nezahualcoyotl erected a nine-story temple to Tloque Nahuaque (Lord of the Far and Near), the unseen and unknown god of the universe who was not represented by a statue, and he frequently called upon this deity in poetry. This might seem in opposition to polytheistic belief, but such is not the case. Implicit in the view that all nature is animated spiritual power is the idea of unity within multiplicity. Any and all gods could be referred to as the "Fathers and Mothers" of humanity, and thus be equated with the original creator couple, Ometeotl and Omecihuatl. The first day of the ritual calendar and first thirteen-day period were under the patronage of this Lord and Lady of duality, sustenance, and origins in the codices, which in itself indicates their importance. What is perhaps significant is that the rulers, who had the title "Fathers and Mothers" of people on earth, tended to identify themselves with the concept of unity within the supernatural, as embodied in one being, rather than with the multiple and fragmented manifestations embodied in many beings.

The temple to Tloque Nahuaque may have had its political aspect as well. Texcoco did not like to have to worship the Mexica god Huitzilopochtli, and its citizens could have suggested a superior being on "philosophical" grounds, to maintain the city's sense of ethnic individuality.

Unless one were divinely selected in the manner of death, Aztec religion promised no afterlife or reward for virtue and suffering on earth. Life was a vale of tears, to be endured with fortitude. At the celebration of the birth of a first child to a noble family the elders addressed the baby in a long speech that included the following words: "Thou wert sent here on earth, a place of weariness, a place of pain, a place of affliction, a place of torment; a place where misery, where torment emerge; where they arise; here where pain, where afflictions are endured, suffered, glorified" (Sahagún, 1950–78, bk. 6, p. 183). Fate was predetermined at birth, and it explained but did not fully excuse sinful living. On ritual occasions and at festivals the nobility, priests, and elders gave long moral exhortations extolling the virtues of chastity, humility, and sobriety, while castigating vanity, adultery, drunkenness, and coward-ice. By humble and austere living one could ameliorate one's fate and lead a happy and prosperous life, which was its own reward. In one poem the singer calls on his friends to enjoy life to the fullest:

> Remove trouble from your hearts, oh my friends.
> As I know, so do others:
> only once do we live.
> Let us in peace and pleasure spend our lives;
> come, let us enjoy ourselves!
> Let not those who live in anger join us,
> the earth is so vast.
> Oh! that one could live forever!
> Oh! that one never had to die!
>
> (LEÓN-PORTILLA, 1963, P. 131)

We know little about mysticism and philosophy in Aztec religion (León-Portilla, 1963). To the missionaries who recorded the information we have about religion, it was the work of the devil; they were not likely to search for its profound tenets, even if they could have understood them. We do not know if Aztec priests and other religious men sought any mystical union with the supernatural, an aspiration not inconsistent with what we know about Aztec religion. Hallucinogens such as mush-

rooms and peyote were used, but Spanish disapproval has left us little information on the role they played in religion. In the texts, elders frequently warn against the abuse of hallucinogens by prostitutes and sorcerers.

The existing texts indicate that knowledge was handed down in traditional orations and hymns, and that philosophical and ethical concepts took the form of poetic metaphors rather than abstractions. Expressions of doubt and the questioning of life and its meaning seem to have been reserved for the secular aristocratic elite. The Aztecs clung to their religion after the conquest and abandoned it only when they had to. Rural practice in Indian villages retains many aspects of Pre-Columbian religion even today, under the guise of a Christianity often misunderstood. A group of Aztec wise men, confronting in 1524 the twelve Franciscan friars first sent by Spain, defended their religion in the name of their ancestors and long history:

> You said
> that our gods are not true gods.
> New words are these
> that you speak;
> because of them we are disturbed,
> because of them we are troubled.
> For our ancestors
> before us, who lived upon the earth,
> were unaccustomed to speak thus.
> From them we have inherited
> our pattern of life
> which in truth did they hold;
> in reverence they held,
> the honored, our gods.
> They taught us
> all their rules of worship,
> all their ways of honoring the gods.
> Thus before them, do we prostrate ourselves;
> in their names we bleed ourselves;
> our oaths we keep,
> incense we burn,
> and sacrifices we offer.
>
> It was the doctrine of the elders
> that there is life because of the gods;
> with their sacrifice, they gave us life.

(LEÓN-PORTILLA, 1969, P. 64)

THE SOCIAL WORLD. Aztec society was a highly stratified one, and social mobility was made possible primarily through warfare. Class divisions were most highly developed by the time of Motecuhzoma II; the Aztecs viewed their nomadic past as a socially egalitarian time. By the sixteenth century society was divided into three broad classes: the ruling dynasty, hereditary and military aristocracy, and the priesthood formed the upper class; merchants and artisans, the middle class; and commoners, serfs, and slaves, the lower class (Carrasco, 1971; Carrasco, 1976).

The *tlatoani* or ruler was usually elected, or less frequently designated by the reigning ruler, from the eligible sons in the dynasty. Some city-states in the Valley of Mexico had dual rulership, and the office of *cihuacoatl* (woman-serpent) among the Mexica was possibly equal to that of *tlatoani*. It has been suggested that while the

tlatoani was concerned primarily with war and foreign relations, the *cihuacoatl* was in charge of domestic affairs. That the *cihuacoatl* had the name of a woman suggests a division into male and female roles that may mirror the divine concept of duality illustrated by the creator gods Ometeotl and Omecihuatl (Van Zantwijk, 1963). The Mexica had obtained their ruling dynasty from Culhuacan, a city whose patron deity was Cihuacoatl. Prior to that time they were ruled by elders, who at least in the beginning of their migration had included a woman (see Plate 148).

By the time of the conquest, the Mexican *tlatoani* achieved almost divine status. He rarely appeared in public, and even great lords had to remove their sandals in his presence. He ruled with the aid of a council of four, which included the *cihuacoatl* and his war generals. These men were chosen from among his sons and brothers, and one of them would be selected as his successor.

The aristocracy was divided into the great lords (*tecuhtli*) of feudal families and their lesser noble descendants. The great lords were also chosen by election, their title to be confirmed by the *tlatoani*. The lords' lands were often worked by serfs who could be called to military service if the lord so needed. Many members of the lesser nobility who did not distinguish themselves in war joined the priesthood or became artists and craftsmen. Warriors from any class who distinguished themselves in battle by capturing four or more prisoners, or other daring deeds, could be given the title "lord," and awarded lands for their use while they lived—lands distributed from conquered territories. Warriors known for special bravery acquired the titles of eagle and jaguar warriors, and they could wear special costumes into battle (see Colorplate 14). A hereditary lord had to justify his right to his family domain through warfare and demonstrable wealth. He was expected to validate his privileges by giving banquets and lavish gifts, and by sacrificing slaves or captives at the appropriate ceremonies. The bureaucratic functionaries of the Aztec state, such as judges and collectors of tax and tribute, were selected from the aristocracy.

Despite the importance of religion in Aztec life, the priesthood had little secular or political influence. Most members of the priesthood were younger sons of the lords or came from the lesser nobility, and they rose through the religious hierarchy by stages under the leadership of two chief priests called "Quetzalcoatl." Priests had charge of the rituals and esoteric lore associated with their temples. They were expected to live in poverty, to fast, and to draw blood from their bodies. Some priests accompanied the warriors on military expeditions, others were scholars and astronomers. In the Codex Mendoza (Plate 30) priests are seen burning incense, playing the drums, and observing the stars. Diviners were a special class of priests who were not necessarily attached to temples but worked as individuals, since their services were frequently needed. They appear to have been ranked lower than the temple priests. The ruler had power over the priesthood, and could order the beginning of ceremonies and punish the priests. Rulers such as Motecuhzoma I and his *cihuacoatl* Tlacaelel modified religious cults as they saw fit. Temples and the monumental sculptures that adorned them were erected at the behest of rulers and to their specifications.

Merchants and artisans formed a significant social group between the aristocracy and commoners (Carrasco and Broda, 1978). Long-distance trade, especially in luxury goods, was in the hands of professional merchants called *pochteca,* who lived in their own districts, worshiped their own patron gods, and married among themselves. They appear to have been resented by the warrior aristocracy, and for that reason they kept a low profile. While the nobility made a great show of wealth, the merchants hid theirs and abased themselves before the nobility. The merchants were, however, an acknowledged element in the Mexica empire because they were acquainted with

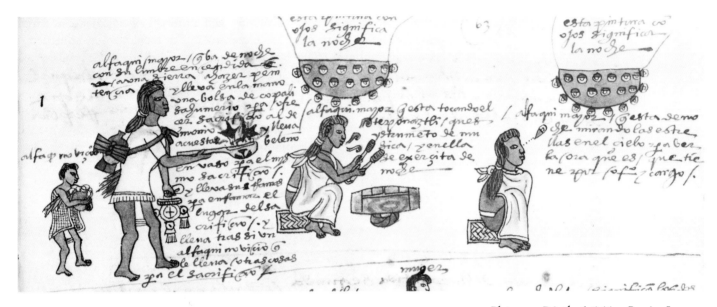

foreign lands and often functioned as spies and agents provocateurs. Merchants had to prepare for trips as warriors for battle, their travels frequently taking them through hostile territory in which they might have to defend themselves. In recognition of their services they were allowed to buy the sacrificial victims required for ceremonies, while warriors had to capture theirs.

A major distinction separated the artisans who worked for the elite from the ordinary craftsmen. Crafts such as goldwork, featherwork, and the lapidary arts were open to the sons of the lesser nobility; so too was the work of scribes and manuscript painters, who were trained by priests. These artists were highly regarded, and often compared to the ancient Toltecs in skill. The large majority of craftsmen, however, were in nonaristocratic groups whose skills passed from father to son and who lived, like the merchants, in separate districts.

The commoners consisted of freemen, serfs, and slaves. Serfs worked the lands of their lords, which they were not allowed to leave, and paid taxes to their lords, who, in return, assured their livelihood. Freemen were commoners who belonged to *calpulli* groups and held their land in common. It is difficult to determine the nature of the *calpulli*, because the Spaniards do not seem to have understood it clearly; the *calpulli* may have been a kin group such as a lineage, or a residential group such as a barrio or district. To confuse matters further, the Mexica described themselves in their migration legends as the members of *calpulli* traveling together. According to tradition, the city of Tenochtitlán at its foundation was divided into separate residential districts for the original groups of *calpulli* which had traveled together. On the foundation page of the Codex Mendoza the ten figures seated around the eagle may illustrate the original ten *calpulli* leaders (Colorplate 7). By the sixteenth century, however, most *calpulli* were peasant groups. Land was owned communally and distributed by the elders for use according to need; taxes were paid directly to the ruler. Besides farming, *calpulli* also specialized in salt-making, mat-making, *pulque*-making, pottery, and other activities of non-elite status.

A great deal of confusion surrounds the status of slaves among the Aztecs. Slaves were either captured in war, or were sold by their families or even by themselves. Most slaves captured were destined to be sacrificed. Others became porters, the most arduous and lowest-class occupation, or fared better as household servants.

Plate 30. Priestly Activities: Burning Incense, Playing Drums, Studying the Stars. Codex Mendoza, p. 63 (upper row). Manuscript, entire page 32.7 × 22.9 cm. Mexico City. Early Colonial, c. 1541–42. Bodleian Library, Oxford

People sold themselves into slavery if they had no means of livelihood, as during the great famines in the reign of Motecuhzoma I. They could also be sentenced to slavery for committing a crime. Slaves were not particularly mistreated and were in fact hard to distinguish from serfs. They could marry and their children were born free. The Aztec ruler Itzcoatl was the son of Acamapichtli by a slave woman.

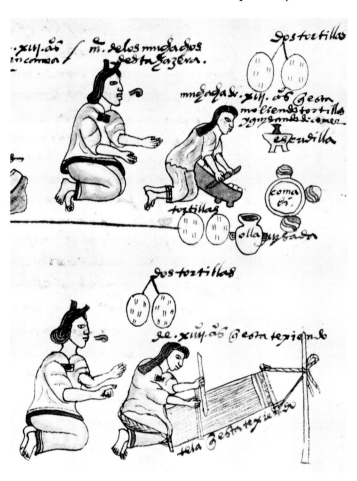

Plate 31. Women Grinding Corn and Weaving. Codex Mendoza, p. 60 (portion). Manuscript, entire page 32.7 × 22.9 cm. Mexico City. Early Colonial, c. 1541–42. Bodleian Library, Oxford

All Aztec youths were expected to go to the school for the warriors (telpochcalli) or to a school for priests (calmecac). Social mobility was possible by rising through the ranks of these schools. Education in the priestly school was harsh and severe; the boys in the warriors' school were more carefree, and enjoyed the services of the prostitutes who were assigned to live with them. Girls were taught at home or went to priestly schools where they were strictly supervised by older women. Their major occupations were to prepare food, weave, and embroider textiles (Plate 31). Some women became priestesses and midwives, but generally women acquired titles or status only through their husbands.

It is evident in the sources that the population of a large urban community like Tenochtitlán had its share of poor people and criminals outside the class divisions, including gamblers, sorcerers, thieves, and prostitutes. Some sorcerers were said to mesmerize their victims, and rob them in their sleep. Girls were admonished against becoming gaudily dressed prostitutes prowling the markets (Colorplate 11); boys were told to stay away from the prostitutes' enticing ways. (The women who were companions of the unmarried boys in the warriors' houses were socially sanctioned,

different from the prostitutes.) The frequency of the warnings in the texts against excessive gambling, drinking, and sexuality indicates that ideal morality was hard to enforce in the crowded and heterogeneous populations of the city-states.

The social status of an individual was demonstrated by his dress. The lower classes went barefoot and wore maguey fiber textiles. Only the nobility could wear sandals and embroidered cotton cloth. The wearing of other precious materials such as feathers for clothing and ornaments was also limited to the upper classes. The Texcoco ruler Nezahualcoyotl is illustrated in a late sixteenth-century codex in his war costume: he wears a feather tunic with its feather skirt, a drum-shaped device on his back, and carries a feather-decorated shield and an obsidian-bladed war club (Color-plate 13). His son Nezahualpilli is dressed, in the same manuscript, in a richly embroidered loincloth and mantle, gold and jade jewelry, and feathered plumes. He holds flowers in his hands, a gesture which indicated aristocratic refinement (Color-plate 12). The title of *tlatoani* is signified by a turquoise diadem worn on the forehead (Plate 26). Costume also indicated age and special status; certain headdresses and mantles distinguished judges from generals. Warriors who had taken captives were awarded military insignia, including costumes, shields, and standards: the Codex Mendoza illustrates costumes that signify one, two, or more captives (Color-plate 14). These items of dress were a major part of the tribute collected by the Aztecs and distributed during festivals. The various classes, titles, and positions of the people of the Aztec empire were displayed by their colorful dress and ornament, which were among their most prized possessions.

Notes

Since this chapter summarizes briefly a great deal of material, only a few references are made in the text. The notes below refer to the major sources, grouped by subject. Emphasis is on secondary sources in English that might profitably be consulted by the general reader. For fuller references, see Bibliography.

[1] The story of the conquest of Mexico is retold in several books, and a number of primary sources have been translated into English: Brundage, 1972; Cortés, 1971; Davies, 1973; De Fuentes, 1963; Diaz del Castillo, 1963; León-Portilla, 1962; Padden, 1967; Prescott, 1931; Sahagún, 1978.

[2] For a more complete survey of the art and archaeology of the earlier civilizations in Meso-america, the reader may turn to: Bernal, 1968; Coe, 1966, 1977; Kubler, 1975; VonWinning, 1968; Wauchope, 1965, 1978; Weaver, 1981.

[3] The history of the Mexica is based on many sixteenth-century texts, of which the most important are: Durán, 1964; Motolinía, 1950; Sahagún, 1950–78, 1978; Tezozomoc, 1878, 1881. Scholarly as well as popular accounts include: Bernal, 1975; Brundage, 1972; Davies, 1973; Padden, 1967; Soustelle, 1961; Vaillant, 1965.

[4] There is more literature on religion than on any other aspect of Aztec life. The sources listed here include the most frequently used sixteenth-century chronicles and the most influential modern interpretations and syntheses: Caso, 1958; Durán, 1971; Hunt, 1977; Hvidtfeldt, 1958; León-Portilla, 1963; López Austin, 1973; Nicholson, 1975; Sahagún, 1950–69; Soustelle, 1979.

II

A DEFINITION OF AZTEC ART

The Language of Aztec Art

Precisely like jade, precisely like turquoise, long as a reed, and very round.

These words were said of a royal orator who counselled the people very well. They said: "He spoke magnificently—*like jades, like turquoises*—and his words sounded like precious stones, *long as reeds and very round.*"

(SAHAGÚN, FLORENTINE CODEX, BK. 6, CH. 43; TRANS. THELMA SULLIVAN, 1963, P. 155)

Artistic activity was not only highly respected and important in Aztec life, but it was also essential to the functioning of society. For this society did not have a written language, and the visual arts had a major role in communicating and preserving cultural traditions. Many aspects of religious ritual, and of social and ethnic distinctions, were meaningless unless expressed visually in works of art. In the absence of a money economy, too, works of art comprised wealth as well as status. The beauty and high craftsmanship of objects provided the metaphor for any thing or activity well done, such as speech or poetry. Works of art were so essential on a practical and ideological level in integrating Aztec society that the Spaniards were anxious to obliterate or transform them as soon as possible, aware that in destroying the visual expression of Indian traditions, they were destroying the traditions themselves.

We can only guess at the vast quantity of works that must have existed. Great numbers survive today, even though the works in perishable media have largely disappeared and many works were destroyed or hidden in the sixteenth century. Motolinía stated that: " . . . if a hundred years from now they were to dig in the courtyards of the temples of the ancient idols, they would always find idols, because the Indians made so many of them. For it would happen that when a child was born they would make an idol, and a year later, another bigger one, and on the fourth year they would make another, and as the child grew, they would keep on making idols and of these the foundations and the walls are full and there are many of them in the courtyards" (1950, p. 277).

The surviving works of Aztec art are among the most important sources of information that we have about them. The Aztecs made these works for themselves, and therefore they are primary sources, their information more reliable than the sixteenth-century chronicles collected by the Spaniards. As tangible expressions of thought and sensibility, their study is necessary to our understanding of Aztec culture. If we can but read them correctly, works of art may explain certain aspects of Aztec life that neither the texts nor archaeological evidence can do by themselves.

In studying a culture that is known in large part through archaeology, it is tempting to describe actual life in terms of artistic representations. This can often be misleading, because art does not represent life directly. A historian from another planet, upon seeing the many paintings of nudes in nineteenth-century Western art, might conclude in the absence of texts that most women in those days lounged about in the nude.

Misleading statements have often been made on the relative peaceability or bellicosity of a culture, based on representations in their art. One must be extremely cautious in making inferences about life on the basis of works of art: these may be articulate about some aspects of life and have nothing to say about others. Certain Aztec deities, for example, play important roles in the illustrated chronicles, but are rarely found elsewhere; many extant images, on the other hand, do not appear in the codices.

For our analysis, works of art are defined as figurative or decorative objects of all sorts, ranging from buildings to painted pottery. Excluded are tools and utilitarian household objects; our concern in this book is with objects that have been transformed in some way to express ideas. It is the opinion of the author that no one work is fully intelligible without knowing something of the other arts of the society in question. This is especially true of the elite or fine arts; we cannot understand their special qualities unless we know about the popular or folk arts against which the elite arts often stand in intentional contrast. The works will be analyzed for their functions, materials, frequency, style, and iconography.

Although we like to think that in Western art there can be "art for art's sake," art that has no overt function, actually all art has specific and general social functions that determine the practical reasons for which it was made. Even abstract painting can be said to have the specific function of decorating a wall, and the general function of expressing the wealth, status, education, and taste of the collector. In preindustrial cultures in which writing was limited to a few types of glyphs, works of art were so numerous because they filled functions that nothing else could.

The primary function of Aztec art was the communication of ideas about man's place in the cosmos and in human society. Works of art preserved and handed down information about the appearance and relationships of gods and men. They could take the form of propaganda, expressing current values or justifying political realities. The works often served to identify one or more individuals as belonging to a certain group or class, or performing certain tasks.

Second, works of art were often the major objects of wealth in a society that had no fully developed monetary economy. Ornamented textiles were one form of currency. Gold was not minted in coins but used in the form of jewelry. The state invested its wealth in buildings and monuments. All objects, even those associated with high religious and military status such as sacrificial knives, warriors' costumes, and divine images, were made in fulfillment of specific uses. We know the time and place for which certain objects were commissioned, and this information is essential for our understanding of their meaning.

The material of which an object was made may be as important as its function, for both practical and symbolic reasons. Among different materials there are major differences in style and iconography; this is partly the result of guild and workshop specialization, for different guilds evidently carved the major stone monuments in Tenochtitlán and the smaller stone sculptures throughout the rest of the Valley of Mexico. Yet works in each material retain a degree of stylistic and iconographic coherence, and in this book each has a separate chapter.

Materials, moreover, had symbolic value and were not selected at random. One of the most expensive and prestigious crafts, for example, was featherwork. Feather insignia and costumes were used by the rulers and military aristocracy in their most ostentatious display. Since many of the feathers were imported from regions further south, they were exotic and rare in the Valley of Mexico. By contrast, animal pelts occur less often, except for the equally exotic pelt of the jaguar which was used by the ruler; other animal skins and pelts symbolized nomadic and barbarian peoples

to the Aztecs and were not incorporated into their status costumes. Part of the significance of an art object resides in the material of which it was made.

Another factor in considering a work of art is the frequency of the image or type of object. Unique or rare objects must be distinguished from those produced in large quantities. Of the works that once existed we may have only a small sample, but these can be enough to be representative. It is now apparent that the major monuments of Tenochtitlán were often unique in form and iconography. Recent excavations support this observation, in that the newly found large monuments differ from those known already. Yet this does not accord with the information in the chronicles, which state that successive rulers commissioned similar monuments. Either these "similar" monuments have not yet come to light, or the Aztecs attached the same names to objects of different appearance.

The frequent representation of deity figures may also be a reflection of cult practice. Carvings of maize goddesses outnumber all other forms of stone sculpture, probably an indication of the importance of this goddess in popular religion. Since there was not yet a comprehensive archive of Aztec materials when this book was written, the relative frequency of a given type of figure is a rough estimate based on publications and museum collections.

Because the major function of art was to communicate and preserve information, the Aztecs placed much emphasis on symbolic representation. For them, art fulfilled the function that writing has in many other cultures. To provide a comprehensible system of communication, the units of meaning had to be limited in number and easily recognizable in varied contexts. In Aztec art the units of meaning are actual glyphs, individual symbols, composite emblems, deities, and figures in action. These units can be compared with dates, personal names and place names (glyphs), nouns and adjectives (symbols), complex concepts (emblems and deities), and verbs (figures in action). Little in Aztec art is purely decorative, not part of this symbolic system.

Meaning is expressed by the figures' actions, which are limited to a few basic types, or more commonly by placement. The motifs are arranged in complex patterns that reflect principles of hierarchy, topography, and substitution. As the Nahuatl language is richer in nouns than in verb inflections, Aztec art is richer in emblems than in actions. Meaning lies in the internal composition of the images, particularly the complex emblems, and in the placing of the motifs in relation to each other. This may be compared to the complex inflection of noun forms in the Nahuatl language, yet a linguistic description of the motifs and organization of Aztec iconography, however useful in conveying its structure as a form of communication, is misleading if taken too literally.

The structure of Aztec iconography is related to writing as the structure of poetry is to prose. Unlike prose, Aztec iconography did not express meaning in precise and limited forms. The meaning of the individual motifs in art could have multiple associations and, as in poetry, the meaning of the whole included several messages simultaneously transmitted on different levels. Such multiple meanings and associations were admired by the Aztecs, whose rhetorical speeches and poems abound in metaphors ("Precisely like jade, precisely like turquoise, long as a reed, and very round"). Even glyphs may have several meanings—a major source of confusion for us, but multiple and metaphoric meanings were a sign of profundity and truth for the Aztecs.

In Aztec art we find an iconographic tradition that is very rich but presents difficulties. The first step in understanding it is to analyze the vocabulary of the individual motifs, and to reconstruct the rules followed in composing complex images and

scenes. The simple meanings of individual symbols are recognizable from their contexts or may be named in sixteenth-century texts, which also provide information that helps to identify the motifs and figures. Other more extensive texts include myths, historical legends, and rituals. Occasional mentions of a figure or symbol may occur in a variety of sources, providing associations in often bewildering array.

Works of art, however, were functional objects, not made to illustrate myths, legends, or rituals. When we analyze their meaning we must consider the relationship of the chosen designs to the specific and general purposes of the object. The aim of the art historian will be to identify the motifs as exactly as possible and to explain why a certain combination was selected for a given object.

Iconographic analysis can provide at least three types of meanings: intended meanings, underlying meanings, and connotations. The first level of interpretation is the recovery of the meanings primarily intended by the artist and by the patron who commissioned the object. Works of art, however, usually express more than just the conscious meanings of their makers. An underlying meaning can be of various sorts: in the many major monuments of Tenochtitlán there is an apparent religious content that was the primary intended meaning, but in some works there also seems to be an underlying political meaning. A political meaning is considered to be secondary or "underlying" if it is expressed indirectly, through metaphoric analogy or by inference. We cannot always ascertain which underlying meanings were consciously or unconsciously incorporated into the objects, nor to what extent, nor how fully they were understood by others.

A third type of meaning makes use of connotation. Within the metaphoric thought system of the Aztecs a figure or an image could refer to many ideas and concepts, and these need not be mutually exclusive. The image of a dog, for example, could have several connotations. The dog was a domestic animal kept for food, but it had ritual and symbolic functions as well; a dog was usually buried with the dead because it was believed that the deceased needed the spirit of a dog to lead him on the hazardous journey through the underworld. Deities could take on the form of a dog if they too were traveling in the underworld. The dog was one of the calendar signs used in divination. To be called a dog or dog-headed could be insulting, a reference to primitive and nomadic tribes. Thus the dog symbolized a variety of concepts, interrelated perhaps but also different. When encountering the image of a dog having no specific symbolic context, any or all of these connotations may apply. Elements that can carry such a multiplicity of meanings are described as being "multivalent," and multivalent imagery is frequent in Aztec art. An image that appears simple to us may have had a rich and varied set of connotations to an Aztec mind.

It is evident from this description of the nature of Aztec imagery that a precise identification of motifs is not always easy, and that there is room for further interpretation of intended and underlying meanings as well as connotations. The interpretations presented in this book demonstrate the usefulness of this method and suggest the kinds of meanings that are likely. No interpretations are final or absolute, since, given the nature of the material and the small amount of scholarship so far devoted to it, this would be hardly possible.

The Function and Meaning of Materials

Aztec art is here discussed by materials to emphasize the functional and symbolic aspects of different types of works of art and of the materials of which they were

made. Each material or type of object had its own significance, but the conventions of one were sometimes copied in another. As in Aztec rhetoric, where a set of synonyms would be used for emphasis, the same concept or image could appear in different mediums but in similar contexts. A ritual, for example, might include a deity manifested in its usual stone or wooden image, also in a dough image, in a human image or images (the priest and the sacrificial victim dressed as the deity), and in a codex picture. These representations of the deity shared much the same imagery in their different materials, and the Aztecs used both permanent and perishable materials to express their visual ideas. If this book could have been written in 1519, as much space would have been needed for the ephemeral materials as is here devoted to the permanent ones. In this section I will describe briefly the functions and meanings of some of the artistic mediums, existing as well as lost.

ARCHITECTURE. Architecture is an art that is at the same time utilitarian and expressive. Aztec architecture and settlement planning (see Chapter III) were intimately related to land use (irrigation agriculture, drainage, terracing), to political organization (the hierarchy of towns and villages), and to economic patterns (markets, transportation, and distribution of goods). The Aztecs, especially after 1427 and under the Triple Alliance, lived in an urban environment having an efficient agricultural and commercial system. Planning made use of uniform measurements and grid plans. The transformation of nature in the Valley of Mexico toward utilitarian purposes was greater under the Aztecs than at any previous time.

In Aztec towns the most ambitious buildings were the temple centers and administrative palaces, their size correlated with the wealth and political importance of the towns. The main temple of the city was its symbolic center. It was usually a rectangular stepped pyramid with a one-room building on top, and a high ornamental roof that was visible from a great distance. These general features were inherited from earlier civilizations; judging from what little Aztec architecture survives, the buildings were relatively simple in form, partly because they served as a background for free-standing sculptures.

The Aztecs were unique among Mesoamerican peoples for building mountain shrines in beautiful and historically significant locations. These shrines combined palaces, temples, and cliff sculptures, and they were located near natural features such as caves, springs, and rock outcrops. The mountain shrines, in which the man-made elements are in balance with natural elements, are in strong contrast to the cities and agricultural lands so thoroughly remade by man. The Aztecs' concept of monumental architecture was strongly shaped by their explorations in ancient ruined cities such as Teotihuacán and Tula. The romantic setting of the Aztec mountain shrines may be an intentional evocation of the partly overgrown ruins of these earlier civilizations.

MONUMENTAL SCULPTURE. Monumental, often colossal, sculptures had been erected in Mesoamerica over a thousand years before the Aztecs, usually by empires wishing to proclaim visually their great political and supernatural powers. Not every town or center had the ambition or the resources to erect a large monument; in the Postclassic period, large monuments were made in the Valley of Mexico mainly by the Mexica of Tenochtitlán. These Mexica monuments were ordered by the rulers, and thus reflect the desired image of the empire. For inspiration, the artists turned first to the arts of Tula, Teotihuacán, and Xochicalco, but they soon evolved a unique new style of their own.

Mexica monumental sculpture (Chapter IV) combines religious and historical meanings. Historical events are placed in a cosmic context to increase the impression of their divine inevitability. The deities and emblems refer to the legendary origins and history of the Mexica, and only infrequently do they represent the actual rulers. The major concern in these sculptures is with warfare and sacrifice as justifications for the empire. The imagery emphasizes themes of destruction and death to a degree that has rarely been equaled in the arts elsewhere in the world. The Mexica was a conquering empire; Mexica art was meant, in part, to terrify subject peoples into submission. In other respects the works sought to confirm the right of the Mexica to rule through legitimate succession by references to earlier monuments. In time archaistic references to earlier monuments change, but this remains an essential aspect in all phases of this art. Finally, the Mexica monuments justified on religious grounds the necessity of the empire. The empire was equated with the last creation of the world, and the monuments proclaimed that both empire and world would last only as long as the sacrificial contract was maintained between gods and men.

CODICES. Codex illustrations (Chapter V) were also made for the political and religious elite, but they differed in several respects from the other arts. The work was done by a small group of specialists, and special training was required to understand it. The codices had a mnemonic function, conveying basic information in forms similar to those in charts, maps, and annals. Oral explanations were needed to make them fully understood. Since the emphasis in the codices was on the organization of large amounts of factual information, the approach was intellectual rather than affective. Monumental sculpture was made not only to convey information about the gods and cults but to inspire awe and terror; the purpose of the codex illustrations was more emotionally neutral.

The historical manuscripts focus on dates and places important in native history; the human figures are reduced to small conventionalized forms having no personal characterization. Name, place, and time information is conveyed by pictographic-phonetic glyphs. Aztec historical manuscripts exhibit a sense of space and time to an unusual degree; Mexica manuscripts emphasize narrative through time, whereas Texcocan manuscripts, by contrast, emphasize geographic space.

The religious codices represent the gods in temporal arrangements that have significance for prognostications. The deities are shown with their insignia and sometimes with characteristics associated with their place in the divinatory system, but not in actions or in narratives. In this, the Aztec manuscripts are derived from Mixteca-Puebla traditions. Many of the gods in the codices appear only there, and may not have had active cults. They were survivors from old traditions and priestly speculation. The images in the religious codices concerned with divination were totally outside Mexica political imagery.

STONE SCULPTURE. Small-scale stone sculpture, as seen in Chapter VI, was made throughout the Aztec empire and seems to have been used for the temples and for offerings on all levels of society. Some works are as fine as the monumental works of the Mexica, some are crude blocks of volcanic rock barely carved. The sheer quantity of Aztec stone sculptures is unusual for the cultures in the Valley of Mexico; preferring the durability of stone, the Aztecs imitated many objects that previously were made in other materials.

Most of the sculptures represent deities, but there are plants, animals, and ritual objects as well. The deities include about a dozen male and female figures. These

coincide hardly at all with the deities seen in the major monuments of the Mexica, and only partly with those in the religious codices. Most prominent among the stone sculptures are the fertility deities, remarkable for the absence of grotesque or death imagery; if these sculptures provide an indication, it is that a large segment of the Aztec population worshiped gods having a calm and benevolent appearance. Iconography related to the major monuments of the Mexica appears on ritual objects associated with sacrifice, such as vessels and boxes.

LAPIDARY ARTS. Lapidary sculptures (Chapter VII) carved from rare and precious stones such as greenstone and alabaster were owned by the elite. Vessels and jewelry made for the aristocracy, especially expensive ritual objects, were commissioned by the rulers. In their style and iconography the finest pieces of carved greenstone are related to the major monuments of Tenochtitlán, and may have been made in the same workshops. Traditionally, greenstone was the most precious material in Mesoamerica, and its green color also symbolized life and fertility. The colossal size of some greenstone sculptures made by the Mexica was in itself conspicuous consumption; our equivalent would be large sculptures made of gold. Since ancient times, greenstone had been an important material for making offerings, and the Aztecs buried large quantities of it in their temple offerings.

WOOD SCULPTURE. A major medium for Aztec art was wood, but because it is so perishable, little has survived (see Chapter VIII). Wood was used for furniture, house posts, canoes, weapons, and tools, as well as for idols. Surviving idols indicate that these were close to, and perhaps interchangeable with, small-scale stone sculptures. Wooden objects made for the elite were richly ornamented with turquoise mosaic inlay, gilding, and feather attachments. Much of the paraphernalia used in the main temples was so ornamented, probably imported, from the Mixtec craftsmen who were famous for their mastery of this art. Turquoise mosaic had the highest status, and was used to ornament the golden diadem of Aztec lords and rulers. Many of the sumptuous gifts given to Cortés by Motecuhzoma were covered by turquoise mosaic.

FEATHERWORK. We are fortunate that any examples of this, one of the most costly and perishable of Aztec materials, have survived, as we will see in Chapter IX, for Europeans neither admired nor preserved the feather arts. The costumes, shields, and standards made in featherwork were the insignia of the Aztec military aristocracy, precise indications of their status. Featherwork was a form of wealth kept in the treasuries and storerooms of the aristocracy. The most expensive works were ornamented in gold; feathers most highly prized were the deep green quetzal feathers from birds in the mountains of Guatemala.

Like turquoise mosaic, featherwork was an ancient art in Mesoamerica and for the Aztecs it symbolized the craftsmanship of settled civilizations. The featherwork they lavished on military costume and insignia indicates the high status of warfare in their society.

CLAY. Like wood, clay was essential for household utensils as well as for the ritual and ceremonial objects discussed in Chapters X and XI. The Aztecs, unlike other Mesoamerican cultures, did not make quantities of large hollow clay figures. They did, however, make countless clay figurines, continuing a primarily folk tradition begun more than a thousand years earlier. These figurines are a small group

of deities in which a female figure is predominant. If the figurines are an indication of cult practice, the major household deity of the Aztec commoner was a goddess of fertility and motherhood who is not represented in any other material, but is related to some of the codex figures of the ritual calendar.

Aztec ceramic vessels were made for all levels of society and the forms range from utilitarian to elaborate. The decoration is nonfigurative in the early periods, but natural forms and symbols are added later. The Aztecs did not consider ceramic to be an important artistic medium, and the prestige vessels of the elite and for ritual use were usually imported. The generally cursive style of design is in contrast to the more controlled forms of Aztec style as seen in other mediums.

GOLD. There were other artistic mediums in Aztec art, equally important but now either rare or completely unknown. The best known of these is gold, which was used exclusively for status and ritual purposes. Gold technology became widespread in Mesoamerica only during the Postclassic period, when the tradition diffused north from Central America. Because it was relatively new, it was not deemed as precious as the older treasured materials such as greenstone and quetzal feathers. The acquisition of gold was one of the major aims of the Spanish conquest. Motecuhzoma made gifts of great quantities to Cortés, and Cortés and his men found and emptied a treasure room of the palace where they were guests; later, remarkable amounts of gold were extracted from the Aztecs by tribute. Much of this gold was melted down and cast in bars, these divided among the conquerors after the royal fifth was shipped to Spain. Cortés, for example, immediately had a dining service made in the European fashion (Saville, 1920, p. 49). The destruction of gold treasures was so complete that now there remain only a few items that might be identified as Aztec. It is possible that goldworking, like turquoise mosaic, was by Mixtec craftsmen, and similar in style to Mixtec works.

The lip plug in the form of a serpent is an example of the fine Mixtec craftsmanship that probably characterized the jewelry of the Aztec elite (Colorplate 15). One lip plug of gold and rock crystal in the Vienna Museum may have been among the treasures Cortés sent back to Europe in the sixteenth century; it represents an eagle or similar raptorial bird (Colorplate 16).

Gold objects sent to Europe were itemized on shipping lists and some were described on arrival, but ultimately few escaped the melting pot. Besides gold jewelry, there were gold plaques with relief designs apparently similar to designs in the codices or on relief sculpture. The most famous of these were two great wheels of gold and silver, allegedly representing the sun and the moon, which several eyewitnesses have described. Peter Martyr's comments follow:

> Let us now therefore come to the other presents which were brought to the kings. Among these were two broad and round plates (which some have named the images of the sun and moon), the one of silver and the other of gold, in largeness and roundness much like the stone of hand mills: yet but thin, and in manner both of one of circumference, that is XVIII spans in circuit. . . . In the center of this, was the image of a king of half a cubit long, sitting in a throne and appareled to the knee . . . with such countenance as our painters are wont to paint fairies or sprites. About the image, were the shapes of trees and flowers, so that it seemed to sit as though it had been in a field. The other, of silver, was made to the similitude, being also in manner of the same weight, and both of pure metal.
> (SAVILLE, 1920, PP. 195–96)

Among the Aztecs, gold was not made into coins and did not have monetary value.

A few hammered gold ornaments and gold bells were found as offerings in the Temple of Huitzilopochtli excavations (Batres, 1900; Arana A., 1979). These modest pieces hardly compare to the magnificent objects described in Peter Martyr's text.

Although its yellow color might have made gold a suitable symbol for maize, this metaphor was rarely used. The symbolic associations of gold were with fire, because heat was needed to melt the metal. Blue and green were the Aztecs' preferred colors, and gold was often merely a setting for them: even the fire god's color was turquoise.

TEXTILES. Objects having the function of currency were copper axes, cacao beans, and textile mantles, and of these, perhaps the textile mantles were in most frequent use. Although great numbers of these were sent to Europe, no complete textiles survive. The commoners' clothing was made of plain maguey fiber; the dress of the elite was of cotton, ornamented with embroidery and sometimes featherwork. Men usually wore a loincloth and, in cool weather, a mantle as large as a blanket, fastened on one shoulder (see Colorplate 12). For ritual activities men also wore a wide sleeveless jacket with fringed hem (see Plate 30). Women (see Plate 31) usually wore a long skirt, and over it a loose three-quarter-length blouse (Anawalt, 1976).

Costume identified its wearers by class, occupation, age, and sex. The Codex Mendoza illustrates the mantles bearing different designs that were given to warriors who had captured one, two, or more prisoners (see Colorplate 14); illustrations of different mantle designs are also found in the Codex Magliabecchiano (Colorplate 17). The designs include elements of common symbolic meanings, such as shells, jaguar spots, feathers, frets, and abbreviated emblems of deities. The designs are ornamental and heraldic rather than narrative. Like the featherwork costumes and shields, each mantle had a name related to the design and signified primarily status and wealth.

DOUGH. Three other materials, dough, resin, and paper, had primarily ritual importance. Dough idols made of a paste of various seeds, including the ritually important amaranth, represented many fertility deities and were cut apart and eaten at the end of the ritual. For one festival, dough images were made of all the mountains around the Valley of Mexico in a ritual of ancestor veneration; this was appropriate to Aztec thought because, according to one creation myth, man was made out of corn meal. In the festival of Xocotlhuetzi, a dough image was placed on top of a pole and youths competed in climbing up and throwing down pieces of it to the crowds below. The significance of dough images is related to eating, an important concept in Mesoamerican thought. The gods, in the form of grain and animals, are the food of men; and men, in the form of blood and hearts, are the food of the gods. Many important deities had at least three distinct types of image: a permanent representation as an effigy made of stone, wood, or terracotta, which was fed, dressed, and scented; a temporary representation in a dough image, which was sacrificed and eaten by the people, representing the gods' original sacrifice; and another temporary representation in the form of a living victim who was sacrificed and then eaten by the people, standing for the original sacrifice of the deities as well as man's return of their gift of life. In Aztec thought these perishable and communally ingested deity representations were as important as the permanent statues. The making of dough images may have predated the images made of wood and clay, and perhaps originated in agricultural ritual when plants were domesticated in Mesoamerica in early times.

We do not know the forms of the dough images, but they may have resembled the stone, wood, or clay figures of nature deities. In the Codices Matritenses the il-

lustrations of the dough images that represent mountains show them as deity busts against a temple doorway (Colorplate 18).

RESIN. Resin, like dough, was also used for images of nature deities, but more rarely. Several figures have been found, one with the goggles and mustache of the rain god Tlaloc (Plate 32), a popular deity. The seated pose of male figures with arms across the knees is the same in stone and wood sculptures.

PAPER. The Aztecs made paper from the bark of a wild fig tree. Paper was used for codices, and also for ritual costume elements (Von Hagen, 1944). Fans, rosettes, and streamers worn by the fertility deities, the stone idols as well as those in the codices, stand for actual paper ornaments worn by priests, sacrificial victims, and god-impersonators (see Colorplate 34). Paper ornaments also covered the funerary bundles of the dead which were to be cremated. Paper, an inexpensive material, seems to have been much in use for the popular fertility cults. It has been suggested that many ceramic stamps found at archaeological sites (see Plates 315, 316) were used to print designs on paper strips to make modest popular offerings. In contrast to textiles, which were the product of intense human labor and skill and stood for wealth, status, and cultural achievement, bark paper referred to the realm of natural materials and to the supernatural powers that controlled agriculture and other subsistence activities. The ritual function of paper is still seen in the modern Otomí village of San Pablito of Puebla, where bark-paper cutouts of spirits are made for fertility rituals as well as for sorcery.

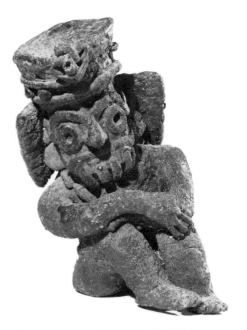

Plate 32. Figure of the Rain God Tlaloc. Resin, height 30 cm. San Rafael, State of Mexico. Aztec, 1200–1521. Museo Nacional de Antropología, Mexico City

Iconographic Conventions

Since the primary function of Aztec art was to convey meaning, the imagery was conventionalized, in some ways structured like language. The Aztec iconographic system can be divided into ornamental designs, symbols, emblems, deities, and glyphs. Sometimes actions, but more often compositional patterns, indicate the relationships among different elements. The meanings thus expressed could be highly specific, richly multivalent, and subtle in associations.

DESIGNS. Very little art in the Aztec tradition is purely ornamental (Plates 33, 34). Ornamental designs are rarely found alone on stone sculptures (see Plate 245), and occur mostly on ceramics, clay stamps, and presumably on woven textiles. Aztec ornamental designs consist of parallel lines arranged in frets, concentric circles, and diagonal and diamond patterns. We do not know whether these abstract designs, which seem to be mainly ornamental, may have been partly symbolic as well. The concentric circles could be related to sun or flower forms, and thus became abbreviated symbols. There is a similar problem with an ancient and ubiquitous Mesoamerican design, the stepped fret. This design occurs in a wide variety of mediums (see Colorplates 65, 66) and even in architecture. It is among the major designs of Mixteca-Puebla culture, but it can be found as early as the art of Teotihuacán. Its meaning is unknown, although it has been thought to derive from a serpent or a wave image (Beyer, 1925; Westheim, 1965). The stepped fret was called *xicalcoliuhqui*; other designs appear to have had descriptive names as well. A diamond design with dots in the center was the "snakeskin pattern." Even if designs had representational

Plate 33. Drawing of Geometric Design of
Stepped Frets and Concentric Circles, from mold
of a Postclassic rectangular clay stamp, Museo
Nacional de Antropología, Mexico City

Plate 34. Drawing of Geometric Diamond
Design, from Postclassic cylindrical clay stamp
(after Field, 1974, p. 206, fig. 29)

origins or descriptive names, we still do not know whether they were thought to be primarily symbolic or ornamental.

SYMBOLS. Most Aztec art consists of individual units, each having specific symbolic meaning (Plate 35). A symbol is here defined as a frequently recurring simple motif or figure that may appear alone, but is often part of a more complex design or emblem. Such symbols in Aztec art include the human heart, sacrificial knife, feather, flame, skull or skull-and-crossbones, shell, flower, star, planet Venus, sun, moon, spear, stone, maguey thorn, liquid (water), smoke, and corn. The stylization of these symbols remains consistent in the various arts. Their forms appear to derive from Mixteca-Puebla designs in manuscripts and polychrome pottery, and to predate the development of Aztec art. They are so standardized that they almost function as glyphs in picture-writing.

Each symbol was highly charged with meaning and could have multiple associations. The flower is an example of the difficulty of interpretation. "Flower" is the final day sign in the cycle of twenty, and as such, a major standard symbol (Heyden, 1979); it can stand for fertility in general, or specifically for sexuality. The smelling of certain flowers was restricted to the elite, and thus a flower could symbolize social status; metaphorically, flowers signified song and beauty, and could represent the brevity and preciousness of human life. In Aztec aristocratic

poetry, flower is often a metaphor for blood spilled on the battlefield. In the absence of further information, it is difficult to know if a particular flower refers to only one of these ideas or suggests all of them in general.

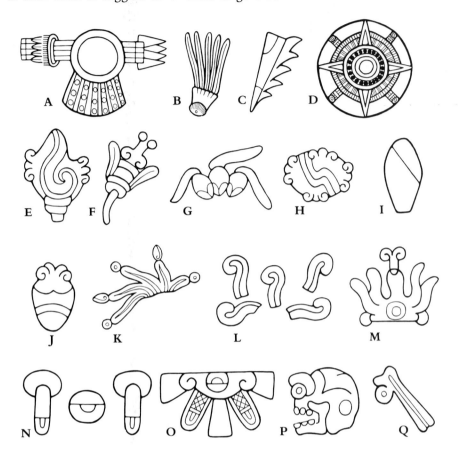

Plate 35. Drawing of Symbols in Aztec Art, from the Codex Borbonicus:
A) Shield
B) Feather
C) Cactus Thorn
D) Solar Disk
E) Shell
F) Flower
G) Maize
H) Stone
I) Knife
J) Heart
K) Water
L) Smoke
M) Flame
N) Stars
O) Planet Venus
P) Skull
Q) Bone

EMBLEMS. More specific and essential to understanding Aztec art are a group of nine emblems selected for discussion because of their ubiquity (Plates 36–44). An emblem is here defined as a complex image consisting of several symbolic units that generally occur together. The nine major emblems in Aztec art include the solar disk, the earth monster, the grass ball of sacrifice, the sky band, the jaguar-eagle pair, the feathered serpent, the fire serpent, the water–fire stream, and the smoking mirror. Although their origin is in Mixteca-Puebla art, they have a new function in Aztec art. These Aztec emblems become more standardized, and take their place among the major themes on stone sculpture. While these emblems had a subsidiary role in Mixtec art, here their position is of primary importance, the equivalent of human figures or deity images in compositions.

These emblems are concepts, not deities. The anthropomorphic sun deity is represented in different aspects by several gods—Tonatiuh, Huitzilopochtli, or Piltzintecuhtli; the solar disk image stands for the more abstract concept of the sun as the equivalent of the Aztecs' cosmic era. Similarly, the emblem of the earth monster is not a deity, though it may be called Tlaltecuhtli, Lord of the Earth; it is the concept of the dark, devouring, or nurturing earth. The sun disk usually has concentric rings with rays or arrow points marking the four directions. In its center may be the glyph for movement, or for 4 Movement, the date of the future destruction of the present era, or a youthful sun deity dressed as a warrior (Plate 36).

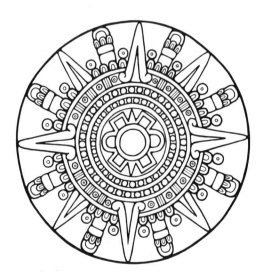

Plate 36. Drawing of Solar Disk Emblem, from stone block, Peabody Museum of Natural History, Yale University, New Haven

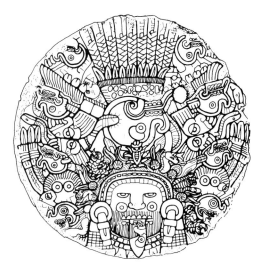

Plate 37. *Drawing of Earth Monster Emblem, from base relief of cylindrical stone, Museo Nacional de Antropología, Mexico City*

Plate 38. *Drawing of Grass Ball of Sacrifice Emblem, from side of stone box, Museo Nacional de Antropología, Mexico City*

Plate 39. *Drawing of Sky Band Emblem, from top border of the Stone of Tizoc, Museo Nacional de Antropología, Mexico City*

The earth monster is a toad-saurian creature (Plate 37). The posture has been compared to that of a woman in sexual intercourse or giving birth. The sex of the figure is ambiguous and it may be male or female; its primary significance is that it is bestial. Its head is usually thrown back, the tousled hair full of noxious insects, the teeth in the form of sacrificial knives. The joints of the creature are ornamented with skulls. Nicholson (1967) distinguished three different types of earth monsters: the first has a human face, as here; the second a wide crocodilian jaw (see Plate 97); and the third has the face of the rain god (see Plate 113). The earth monster may also be abbreviated into a design band consisting only of the crocodilian face of the creature with an emphasis on its mouth (see Plate 90); this earth band is always below a sky emblem.

These two emblems are the most important in Aztec art, and in their placement they express a conceptual opposition. The sun disk is the rational order of calendar time, as indicated by the glyph for the light of day; the earth monster is the chaos of darkness, unmeasured time, and unformed matter. In art the sun disk is usually on the top, side, or interior of objects, while the earth monster is almost always on the bottom. (In the few instances where the earth monster is on the top, it is because these objects represent the surface of the earth.) The opposition of these two emblems signifies both the orderly cycles of day and night and of dry and rainy seasons, and the concept of the present cosmic era ending in eventual destruction.

The third major emblem, the grass ball of sacrifice, is found in the same locations as the sun disk (Plate 38). It is a semicircular representation of grass into which are placed the sharp bones or maguey thorns used to draw blood, man's personal contribution to the forces of light; its design is interchangeable with the emblem of light. No emblem can alternate with the earth monster, which is chaos par excellence. These three emblems, the solar disk, earth monster, and grass ball, express most clearly the elite view of the cosmos held by the Aztec and Mexica.

In Aztec art there is a sky band, a band with eyes representing stars and the symbol of the planet Venus (Plate 39), often used as a border design. When it occurs as a major emblem, a sun disk is usually at its center. The sky band represents the starry night sky and it, too, is in opposition to the earth monster.

The pattern of opposition and duality evident in the juxtapositions of the sun disk with the earth monster, of sky band with earth band, is to be found in several other emblems. Figures frequently paired are the jaguar and the eagle (Plate 40), referring to elite warriors who were metaphorically called "eagles and jaguars." This phrase is usually derived from the eagle and jaguar animal costumes that the Aztecs wore into battle, but few indications suggest that eagle costumes were actually worn, though we know that there were jaguar costumes. The visual representation of eagles and jaguars comes from the verbal metaphor, not from observation, another example of the close relationship between the visual arts and verbal expression.

In the jaguar-eagle dualism, the images are both alike and opposite. Both refer to valiant warriors: the eagle is a creature of the sky, however, and the jaguar a creature of the land. In Aztec thought the jaguar was an animal of the underworld, and the two animals were in some way opposites like the sun disk and earth monster. Both can also be images of the sun while descending (eagle), and while dead in the underworld (jaguar). This solar association refers to the Aztec warrior cult and its primary function, the acquiring of victims to nourish the sun. The Aztec eagle-jaguar emblem is usually a secondary image, not the focal point of a design.

Two other related but opposite emblems are the feathered serpent and the fire serpent. The feathered serpent is simple in form, a rattlesnake covered with quetzal feathers instead of scales, but it is complex in meaning. On one level it refers to the

green and fruitful surface of the earth, the rainy season, and agricultural fertility; on another it recalls the Toltec ruler named Quetzalcoatl, and therefore the past. Like the sky band, it is usually a secondary emblem, and it may be used as a border design (Plate 41).

The fire serpent refers to the burning rays of the sun and it is sometimes believed to carry the sun across the daytime sky. The creature is also the emblem of the old fire god Xiuhtecuhtli, who is generally located in the earth and whose fire is volcanic, originating underground. To the Mexica, the fire serpent was the weapon of Huitzilopochtli, and it refers to the power of solar rays to illuminate the sky. The fire serpent could also refer to the destructive aspects of solar fire that causes the dry season and droughts (Plate 42). The fire serpent is a reptilian creature; he has a long snout that turns up like the trunk of an elephant, a body segmented into rectilinear sections, a reptilian front leg, and a tail ending in a flame symbol or a solar ray.

The final two emblems are usually added or attached to others. The intertwined water–fire stream is a stream of water as a band with segmented sections, and a flame design derived from the fire serpent. Seler interpreted the emblem as a visualization of the verbal metaphor for war, *atl tlachinolli*, meaning literally "water–fire"; the image may also be related to *teuatl tlachinolli*, "divine liquid–fire." According to Sahagún, "This was said when a great war or pestilence occurred. They said: Divine liquid and fire have overcome us, have swept over us. This means pestilence or war itself" (Sullivan, 1963, p. 147). This image of water is both in contrast to fire and associated with it; water refers to fertility and life, but is also a symbol of transience, of those swept away by the elements or by circumstances. The water–fire emblem was usually placed in front of the mouths of figures as if it were a form of speech, song, or exclamation (Plate 43).

The smoking mirror normally consists of a circular design with a shaft through

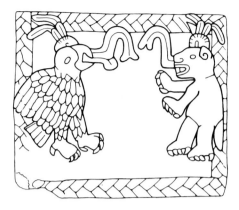

Plate 40. *Drawing of Eagle–Jaguar Pair Emblem, from a stone relief, Museo Nacional de Antropología, Mexico City*

Plate 41. *Drawing of Feathered Serpent Emblem, from top of the Greenstone Box, Hamburgisches Museum für Völkerkunde und Vorgeschichte, Hamburg*

LEFT
Plate 42. *Drawing of Fire Serpent Emblem, from the Calendar Stone, Museo Nacional de Antropología, Mexico City*

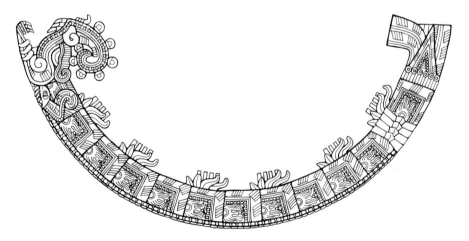

it and two curling forms, representing smoke, emerging on both sides (Plate 44). This emblem referred both to the ruler and to the deity Tezcatlipoca. The speech of the ruler was compared to a mirror: "*I set before you a light, a torch, a model, a measuring rod, a great mirror. This phrase was said of a lord who spoke to the people and placed before them excellent words. . . . He told them . . . You shall take it as a model, you shall take it as an example so that you may live properly or that you may speak well*" (Sullivan, 1963, p. 151). Smoke and mist signified fame and glory: "This was said about a king not long dead whose *smoke and mist*, meaning his *fame and glory*, had not yet vanished" (Sullivan, 1963, p. 145).

Plate 43. *Drawing of Water–Fire Stream Emblem, from the Temple Stone, Museo Nacional de Antropología, Mexico City*

Plate 44. *Drawing of Smoking Mirror Emblem, from the Temple Stone, Museo Nacional de Antropología, Mexico City*

Besides referring to the ruler, the smoking mirror is also the divinatory mirror of the god of fortune and chance, Tezcatlipoca, who may have a smoking mirror in his headdress and sometimes a mirror replacing one of his feet; in one myth the earth monster bit off the missing foot in a struggle during the creation of the world. In Aztec art, the smoking mirror emblem is found attached to skulls, masks, and historical ruler figures. It is a primary symbol of unpredictable divine power exemplified among the gods by Tezcatlipoca, and on earth by the ruler.

DEITIES. Deity images in Aztec art are similar to emblems in their composite construction and verbal referents. While they are generally anthropomorphic or, infrequently, zoomorphic, their sacredness does not reside in their bodies but in their costume and in associated insignia and symbols. The most elaborate deity depictions are in the codices; the images are abbreviated in stone, wood, and clay sculptures. All of them are based on ritual impersonators of the deity, dressed in complex costumes.

The basic identification of the deity depended on its headdress and facial forms. When Motecuhzoma's messengers delivered his first gifts to Cortés on shipboard, they were told to bring back with them one of the Spanish soldier's helmets; Motecuhzoma then asked his priests to see if any of the old books showed deities wearing a similar helmet (Padden, 1967, pp. 126, 145). He was attempting to identify the "new deities" by their headdress.

Frequently the name of the deity is illustrated by the headdress. Xochiquetzal, "flower-quetzalbird," in the Codex Borbonicus is a woman wearing the helmet of a quetzalbird head with flowers emerging from her mouth (see Colorplate 31). Each deity emblem in this codex is surrounded by scattered symbols referring to various associations and activities.

There has been discussion recently as to whether images of Aztec deities represent the gods or human impersonators of the gods (Hvidtfeldt, 1958; Townsend, 1979). Since impersonators of the gods were metaphorically the gods themselves, this distinction usually cannot be made in the visual images. They represent both.

In Aztec art the deities are usually shown seated or standing, except in narrative scenes. Deities either hold ritual objects in their hands or have expressive hand gestures. The Aztecs conceived of their gods as powers and natural phenomena, not as characters in a story.

GLYPHS. In their artistic vocabulary glyphs are related to symbols; in their composition, to emblems and deity images. Some glyphs are indeed practically emblematic in function, such as those for the dates of the four previous eras of creation which appear as secondary elements in sun disk designs (see Plate 132). Conversely many symbols, like "flower" (Plate 35, f), are also glyphs. The types of glyphs include day signs (Plate 27), year signs (Plate 29), personal names (Plate 23), names of places or ethnic groups (see Colorplates 41–44), and qualities (Plate 45). Glyphs with numbers occur mainly in codices and on the monumental art of the elite. They are not found on terracotta figurines or ceramics.

Day signs and numbers refer to the names of people and gods or to dates significant in myth or history. Only by a thorough knowledge of its contents can the glyph be interpreted for which of its meanings was intended. A frequent day sign on the monuments is 1 Rabbit; this is the mythic date of the creation of the earth, but it could also refer to a specific year and its events. In sculpture, important years may

have a cartouche around them to separate them from other signs, but this is not always the case.

New Fire Ceremony dates may be indicated by a cartouche and by a rope as well, symbolizing the tying of the years (see Plate 125). The last New Fire Ceremony took place at the beginning of the year 2 Reed in 1507, which accounts for the importance of this date on monuments such as the Temple Stone and Year Bundle (see Plates 124, 125). However the date 2 Reed is among those most frequently seen on sculpture and its meaning is not always clear. Two Reed was one of the dates associated with the god Tezcatlipoca (see Plate 269).

Qualities are indicated by glyphs having meanings such as "preciousness," as seen in the glyphs for jade, turquoise, and gold (Plate 45). The glyph for jade was also the place glyph of the city of Chalco, a lapidary center, thus permitting the kind of pun that the Aztecs appreciated and that causes endless confusion for us.

WRITING AND COUNTING. There is no easy distinction in Aztec representations between symbols and glyphs, or among writing, counting, and pictorial representations. When a work consists largely of glyphs, we speak of writing; when more of symbols, we speak of art. This distinction is ours and was of no significance for the Aztecs (Galarza, 1979).

Plate 45. *Drawing of Three Glyphs of Preciousness:* left, *Jade;* top right, *Gold;* lower right, *Turquoise (from stone carvings)*

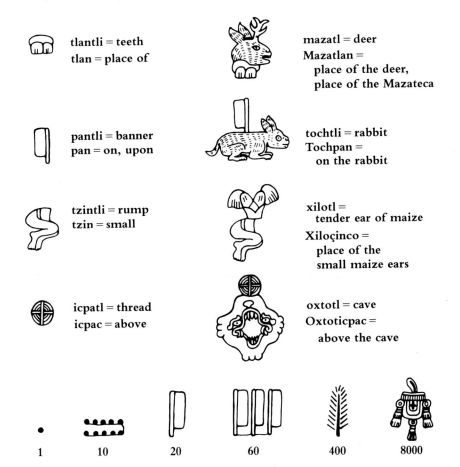

tlantli = teeth
tlan = place of

mazatl = deer
Mazatlan =
 place of the deer,
 place of the Mazateca

pantli = banner
pan = on, upon

tochtli = rabbit
Tochpan =
 on the rabbit

tzintli = rump
tzin = small

xilotl =
 tender ear of maize
Xiloçinco =
 place of the
 small maize ears

icpatl = thread
icpac = above

oxtotl = cave
Oxtoticpac =
 above the cave

1 10 20 60 400 8000

Plate 46. *Drawing of Aztec Writing, after the Codex Mendoza:* left, *phonetic symbols;* right, *place glyphs;* below, *symbols for numbers*

Aztec picture writing presents mainly recognizable objects and some conventionalized symbols for objects and abstract concepts. The jade symbol, for example, can

signify not only the object, "green stone," but the concept "precious." The greatest difficulty in the Aztec picture-writing system was evidently in rendering place names of the empire. To express in Nahuatl some of the complex, unusual, or foreign names of places ruled by the empire, the Aztecs resorted to hieroglyphic writing: in hieroglyphs, several pictures having conventionalized meaning are joined together to express phonetically the name of a place (Nicholson, 1973). In the name Mazatlan, for example, *mazatl* (deer) is illustrated by the head of a deer and *tlan* by two teeth (Plate 46); the image of teeth refers to the Nahuatl word *tlantli*, and conventionally stands for the word *tlan*, meaning "place of" in picture writing. Mazatlan means in Nahuatl "place of the deer," but in fact Mazatlan was a non-Nahuatl-speaking region in the southern part of the Aztec empire, and the place sign is a phonetic approximation in Nahuatl of a foreign name. It really means "place of the Mazatecs."

The use of phonetic indicators such as teeth for *tlan* (place of) is characteristic of rebus writing, which is the essential element of hieroglyphic writing. To understand such hieroglyphs one must know the language that was spoken by the culture. Other Aztec phonetic indicators in the manuscripts include a banner, *pantli*, to express *pan*, meaning on or upon; a ball of thread, *icpatl*, to express *icpac*, meaning on top of; human buttocks, *tzintli*, to express the diminutive *tzin*.

Phonetic indicators are infrequent in monumental art, and even in manuscript painting they became more frequent in the works from the colonial period. There is no doubt that the most complex forms of Aztec writing were influenced by European writing (Dibble, 1971). The Aztec writing system was a composite picture-writing and hieroglyphic system, but internally it was not totally consistent. Glyphs vary from one manuscript to another and do not always use phonetic indicators. The reader has to know if the name of a town ends in *-tlan* or *-pan*. Without the Nahuatl glosses identifying the glyphs in some of the manuscripts, the names and locations would not be easy to determine. Confusion is also created by the use of the same symbol to mean different things: the banner in place names stands for *pan*, meaning "on" or "upon"; the banner used as a number signifies twenty.

Some believe that Aztec writing was becoming progressively more phonetic and might in time have turned into a complex hieroglyphic system like that of the Maya. The phonetic elements are a minor part of the system, however, and the glyphs are too varied and can be expressed in too many different ways for this to be likely. The writing system of the Aztecs, like their symbol system in general, emphasized flexibility and resisted precise categorization (Robertson, 1982).

The Aztec symbols for numbers were not developed to make arithmetical calculations, but to indicate different quantities. The Aztecs, like all Mesoamerican peoples, counted vigesimally, by twenties. In the tribute manuscripts a standard set of symbols is used: a dot stands for one, and numbers up to twenty are indicated by dots. Twenty is a flag; four hundred is a feather (some authors see this symbol as a hair); eight thousand is a bag (Plate 46).

HUMAN FIGURES AND ACTIONS. Human figures in Aztec art are secondary in importance to symbols, emblems, deities, and glyphs. Even in the historical codices, which present the history of ethnic groups and rulers, most of the information is expressed in glyphs of place and time. Standardized types of human figures represent rulers, warriors, priests, and a kind of everyman for commoner figures. The movement of these figures is limited to a few conventionalized poses. A seated position means being and rest, if the figure is male; if the figure is female, it is a kneeling position.

The male seated position resembles the seated position of the dead body wrapped for cremation, a similarity underscored in historical codices showing the seated mummy of the dead ruler followed by the similarly seated figure of his living successor: Tizoc and Ahuitzotl appear thus in the Codex Telleriano-Remensis (see Plate 24).

Action and movement is expressed by walking. Standing positions, especially in frontal view, imply power and importance. The most dramatic actions in Aztec art are the drawing of human blood (see Plates 94, 252), and the capture of a prisoner by holding his hair (see Colorplate 14). Most figures merely sit or stand, displaying weapons, instruments of sacrifice, or other insignia; the nature of their activity is indicated by their costume—ritual or military dress—and by the objects they hold. Human figures may wear emblems and costumes of deities to indicate the patronage of specific gods, sometimes blurring the distinction between god and human.

NARRATION. In general, Aztec art was not concerned with telling a story. Narrative representation is as rare in Aztec art as scenes of action. It is found mainly in the historical codices; narrative develops from the linear unfolding of events on a long sheet of paper. Footprints or a line of dates indicate the course of action, and figures are repeated in successive scenes as called for.

SPACE AND SETTING. Aztec art is primarily concerned with being, relationships, and transformation, and naturalistic space and settings are quite rare. Cosmic settings are indicated by sky and earth emblems in many monuments and in the codices; historical scenes frequently take place between these two cosmic regions. Because the space is cosmic, there is no interest in natural appearance or the illusion of perspective. Even overlapping is avoided unless for some reason it is necessary.

The Aztec concept of space provides plenty of room for everything; conversely, what space there is, is completely filled up in an orderly manner. In the compositions there is neither excessive crowding of elements nor large empty spaces. To describe these compositions Westerners use such terms as *horror vacui*, or fear of empty spaces, but it could as well be *horror confusionis*, fear of confusion. All figures and emblems are given space sufficient for their clear delineation, distinct from other figures and emblems. To an Aztec, large empty spaces would have suggested nothingness, chaos, and poor design.

Although the Aztecs' approach to depicting space was a conceptual one, they could represent natural features with accuracy in maps and historical manuscripts. The maps we have are already colonial in date, but there is no doubt that they are based on preconquest prototypes. Motecuhzoma II had many maps in his possession; and Cortés, when he went to Honduras, followed a map he had received from a native source. In such early colonial maps as the Codex Xolotl, the Valley of Mexico with Lake Texcoco and the surrounding mountains is clearly and correctly represented; towns are indicated in their proper locations by place glyphs (see Colorplate 6). Aztec maps were oriented with east at the top and west at the bottom, according to the associations of east with sky, sunrise, and the direction up, and west with earth, sunset, and the direction down.

The Aztec concept of space is topographic rather than illusionistic. It is concerned with representing the cosmos, or geographic realities on a vast scale, not with what the human eye can take in. Space in all Aztec representations was charted, as on a map.

RELATIONSHIPS. The relationships among various elements of Aztec iconography are usually expressed not through drama and narrative, but by placement. Placement

is partly governed by the spatial considerations just discussed, such as the sun and sky above and the earth below. Other relationships are between the figures and the emblems: these include hierarchy, equality, opposition, intertwining, and substitution.

Hierarchy is one of the most important compositional principles in Aztec art. The dominant figures are usually larger in size and more ornately conceived. The importance of an image is also furthered by being symmetrically flanked; an emblem such as a sun disk may be flanked on both sides by profile figures, who are shown as subservient even if they are gods and rulers (see Plate 127). Hierarchy is also indicated by elevation: gods sit on the top of temples (see Plates 304, 306); rulers sit higher than the rest of their court (see Colorplate 21).

Equality among figures and emblems is indicated by equal size, similar shape, or posture. This is illustrated by the processions of warriors on several sculptures (see Plates 86, 87, 89), the similar size and poses of deity patrons in the calendar books (see Colorplates 29–33, 36–38), and of place names in the tribute books (see Colorplates 41–44). Figures and emblems of equal rank are arranged in processional series, in rows or in registers one above the other.

Aztecs saw the universe not as static but dynamic, based on the cyclical confrontation of forces having equal but essentially irreconcilable powers. This concept, frequently called dualism, operates both as two forces opposed, and as one force divided into two similar yet different powers. In art these concepts are shown by opposition, pairing, and intertwining. Opposition is expressed by the contrasted placing of sun disk above and earth monster below. Opposition may also be in paired units, the figures back-to-back or facing one another: eagles and jaguars are paired oppositions having similar but different forms. In the Codex Borbonicus the opposite deities Tezcatlipoca and Quetzalcoatl are facing one another (see Colorplate 33). The ultimate and most basic opposition of equal forces is that between life and death, illustrated in the deity whose face is half alive and half a skull (see Plate 195).

Intertwining, a less frequent compositional device, is similar to opposition in bringing together two antithetical elements; the elements mingle, but remain separate and equal. An example is the water–fire stream emblem, two opposites intertwining to express the concept of divine calamity (Plate 43).

Substitution was mentioned above as a mode of Aztec composition, the grass ball of sacrifice taking the same place as the solar disk and therefore having some of the same meanings. The substitution of motifs is based on the importance of verbal synonyms in Aztec rhetorical language. Synonyms here mean concepts that are different, but could fulfill the same meanings: a long list of synonyms was a favorite device in Aztec speeches. In their visual art, synonyms are usually evident not in groups but through the substitution of one motif for another. Turquoise and jade, for example, are synonyms for preciousness and blue-green color, and their glyphs are found interchangeably on the earth monsters and the belly of water creatures.

TRANSFORMATIONS. Much of the meaning in Aztec art lies not in relationships among figures but in the complexities within the figure itself and the symbols associated with it. We have seen how symbols, glyphs, emblems, deities, and humans may be varied through abbreviation or ornamental elaboration. Their meaning too may be transformed or adjusted by the incorporation of symbols or motifs that normally belong to other image clusters and bring with them these associations. Alien motifs may be used for emphasis, to underline an aspect, or for contrast, to point out an opposition or ambivalence. This is the richest and most bewildering aspect of Aztec iconographic structure, but it is also the most essential to understand.

Because the Aztec symbol system expressed dynamic powers and relationships, meaning was conveyed by the variation and manipulation of symbols, not just their static repetition. It is evident that special shades of meaning could be expressed by manipulating symbols having different origins but brought together in one image.

The most dramatic example of transformation occurs on the Calendar Stone (see Plate 132), where the solar disk and the earth monster, two images that are always represented separately, are brought together. The juxtaposition would have been unusual and striking to the Aztec eye. It might mean that the sun had taken on aspects of the earth, being shown during its journey through the interior of the earth; it could also represent the obliteration of the sun by the earth when the present era is destroyed (Klein, 1976b; Navarrete and Heyden, 1974).

Less dramatic juxtapositions transform the images in codex representations. The black-and-white headdress of the goddess of lust, Tlazolteotl, is among the scattered elements associated with the water goddess Chalchiuhtlicue (see Colorplate 29); the headdress occurs twice, at the upper right of the page and in the stream of water below the goddess's throne. (Note that the headdress symbol of the goddess clearly functions as the glyph for her name.) This symbol is meant to express some relationship between these goddesses; perhaps it means, literally, that on some occasion Chalchiuhtlicue "wears" the headdress of Tlazolteotl. Both goddesses have to do with forgiving and purifying the sins of sexuality. Chalchiuhtlicue was invoked at the time of childbirth to wash away the sins of the parents, and in this sense water symbolizes purification. The headdress in the stream of water may have a related, but different, meaning, for the water is bearing it away along with helpless human victims and a shield and spear, symbols of war. This probably refers to the bad luck of those born under the sign of water, who might undergo war, adultery, or drowning.

This method of sharing symbols and insignia from different contexts could also be used in creating new images. The Aztecs gave visual form to the gods of the Mexica legend by borrowing insignia from other deities whose imagery was already established. An example is the goddess Coyolxauhqui (see Plate 99), a Mexica deity whose images were based on the figure of the fire goddess Chantico, with the addition of golden bells on her cheeks and features of death, because she has been decapitated; the golden bells signify her name, "she of the golden bells." Thanks to these compositional patterns, we can recognize unusual or unexpected arrangements, and perhaps interpret the specific meanings they were intended to express.

The Aztec system of symbols brought together a fairly regular group of symbols, emblems, deities, figures, actions, and glyphs, their interrelationships governed by a few basic rules. The elements were simple, and the system was flexible enough to allow for great variety, innovation, subtlety of meaning, and even a degree of drama and surprise. The special beauty of the system was the potential richness of its meaning within a restricted space. In a single image the Aztec artist could express so many levels of meaning that whole volumes of texts would be needed to explain them in writing. From the Aztec point of view, the fact that this system was also multivalent and capable of different reinterpretations added to its universal truth and applicability. Since a specialist was obviously needed to read and interpret the images, the system was effective only for the schooled aristocratic and priestly class.

VISIBILITY AND INVISIBILITY. We are so used to seeing works of art in well-lit museum galleries that we assume the ancients saw them likewise, but all Aztec art was not made for universal viewing or lengthy examination. Visibility was important in sumptuary art, in which status differences were expressed. The designs of mantles,

feather costumes, and other insignia usually consisted of simple motifs that had known significance for all segments of Aztec society. The complex imagery relating to the gods and religion was seen by most people only in the costumes worn by god-impersonators in dramatic performances during religious festivals. People could also see the monumental sculptures set up in the temple precincts on ritual occasions, but the unusual and complex iconography may not have been understood in all its ramifications. The Aztec commoner learned this visual language from the perishable arts of ritual life and from simple works in stone, wood, and clay. Books were the exclusive possession of the aristocratic elite and of priests. While the commoner was probably familiar with the basic symbol system, he was in no position to manipulate it to express new or different ideas.

Some aspects of Aztec art were hardly visible at all. Many sculptures we know today were once covered with paint, clothing, and anointed with blood offerings, but placed inside the dark temples they could not be seen except perhaps for their shining inlaid eyes. Many sculptures were made to be buried as offerings in the temples. Least visible were the designs carved on the bases of boxes, vessels, and large immobile sculptures, designs not meant to be seen and frequently representing the earth monster and symbolizing the underworld. Such esoteric images may have functioned as ritual propitiations of the earth, and they were characteristic of Aztec and especially of Mexica art. For the Aztecs, their artistic images communicated not only with other human beings, but also with the unseen powers of the cosmos.

The Artist, Antiquity, and Aesthetics

The Toltecs were a skillful people;
all of their works were good, all were exact,
all well made and admirable.

The remains of what they made and left behind
are still there and can be seen, among them
the works not finished, among them
the serpent columns, the round columns of serpents,
with their heads resting on the ground,
their tails and rattles in the air.
The mountain of the Toltecs can be seen there
and the Toltec pyramids, the structures
of stone and earth with stucco walls.
The remains of Toltec pottery also are there;
cups and pots of the Toltecs can be dug from the ruins;
Toltec necklaces are often dug from the earth,
and marvelous bracelets, precious green stones . . .

(FROM SAHAGÚN'S CODICES MATRITENSES,
TRANS. LEÓN-PORTILLA, 1963, P. 167)

The Aztecs were very interested in art of the past, and they even made excavations to find precious antiques. They were not looking only for treasures of gold or greenstone, for they were equally interested in architecture, sculpture, and even pottery. The works of the past provided models that stimulated the craftsmanship of the Aztecs. We tend to view such old excavations as "looting," which in part it was, but it was also a search for knowledge.

Archaism was primarily seen in the arts made for the Mexica ruling elite, who were interested in ancient history and in proving the legitimacy of their own rule. Archaism took many forms: older works were directly imitated; the gods and rulers of the past were represented in Mexica style; and symbols of the past were borrowed and put to new uses in the present. This practice of turning to earlier monuments creates a continuity in Aztec artistic traditions that may not have existed in many other aspects of their life or culture. The elite arts of the Mexica can only be understood as a conscious response to the art of earlier civilizations, referred to generically as "Toltec."

The making of artistic objects was considered to be an activity of the settled civilizations prior to the Aztec arrival, and it was associated especially with the Toltecs. The highest praise an artist could receive was that he worked like a Toltec, and the word for artist was *toltecatl.*

The large number of professional craftsmen, together with the merchants who distributed their manufactures, generally constituted the middle class of Aztec society. Organized in guilds, most artists worked on commission or directly for a market. The crafts of the commoners were available primarily in the markets; most elite arts were made on commission, and many sumptuary objects were distributed as gifts. One control the Aztec rulers had over the military aristocracy was to allow them to acquire as gifts the necessary luxury insignia, but only in reward for meritorious services.

Actually, the social status varied for different kinds of artists. The painters of the manuscripts were probably learned priests or educated members of the upper class, and among them, the historians were especially revered—we even know some of their names (Padden, 1967, p. 55). The younger sons of the nobility, having little chance to inherit a title and wealth, were encouraged to become artists, especially in precious materials such as the lapidary arts. These artists lived within the palace compounds.

At the other end of the scale, some craftsmen were low in social standing. Among these were apparently the female textile workers and embroiderers, who were close to and sometimes members of the despised class of prostitutes. We know very little about the organization and working conditions of the craftsmen who were mass-producers of objects for quantity sale.

Any artist was regarded as a craftsman making necessary objects for society; he was not seen as a genius who was different from other people, and his name was not associated with his works. Instead of working alone, Aztec artists often worked together in groups, as we see in Durán's illustration of Motecuhzoma I sitting for his portrait (Colorplate 19). According to Tezozomoc (1878, p. 669), Motecuhzoma II's portrait relief at Chapultepec was carved by fourteen sculptors, and they received in payment rich tribute from a conquered province in Veracruz—food, clothing, dishes, salt, cocoa, and slaves.

Artistic activity was not without the pervasive ritualism of Aztec life. Certain calendric days, such as 7 Flower, were propitious for an artist's birth. Nor were ethical and aesthetic considerations kept separate—a morally bad person could not be a good artist, as this passage from Sahagún indicates:

> And the symbol Seven Flower
> was said to be both good and bad.
> When good, they celebrated it
> with great devotion;
> the painters honored it,

they painted its image,
they made offerings to it.
The embroiderers were also joyful
under this symbol.
First they fasted in its honor,
some for eighty days, or forty,
or they fasted for twenty days.

And this is why they made these supplications
and performed these rites:
to be able to work well,
to be skillful,
to be artists like the Toltecs,
to order their works well,
whether embroidery or painting.

And when this symbol was bad,
when an embroiderer broke her fast,
they said that she deserved to become a woman of the streets,
this was her reputation and her way of life,
to work as a prostitute.

But for the one whose actions were good,
who worked well, who guided herself,
all was good; she was esteemed . . .

(FROM SAHAGÚN'S CODICES MATRITENSES,
TRANS. LEÓN-PORTILLA, 1963, PP. 170–71)

Such textual references to the task of the artist and the concepts of values in art indicate that the Aztecs were developing a degree of verbal analysis of the visual arts, the first step in the development of aesthetics and a philosophy of art. In this respect the visual arts lagged behind poetry, the most individual and self-conscious of the Aztec arts. Poetry had clearly promulgated rules, and the merits of poems were evaluated in contests, extensively discussed, and handed down from one generation to another, with the names of the poets incorporated into the texts of the poems (León-Portilla, 1969, pp. 76–89). Most poets were the rulers and great nobles whose deeds and histories were also preserved by court historians, which partly explains this high development of poetry. The visual arts were usually made for more communal purposes by guild-craftsmen, and the expression of personal ideas was deemed inappropriate.

Since the Aztecs did not believe in the artist's special genius, no Vasari chronicled their lives and ideas. Nevertheless the Aztecs were aware of the arts, had definite aesthetic ideas and opinions on the merits of different works, and a clear idea of what they considered to be good in art: they admired technical skill and virtuosity, order and clarity, and realistic representation. This may come as a surprise to us, because Aztec art is not realistic in our sense of the term. What they valued as real was not a visual illusion, but a sense of vitality in the work of art. The following is a description of the work of the goldsmith:

Whatever the artist makes
is an image of reality;
he seeks its true appearance.

If he makes a turtle,
the carbon is fashioned thus:
its shell as if it were moving,
its head thrust out, seeming to move,
its neck and feet
as if it were stretching them out.

(FROM SAHAGÚN'S CODICES MATRITENSES,
TRANS. LEÓN-PORTILLA, 1963, P. 174)

The definition of realism in Aztec art required recognizable figures, together with an expression of the vitality believed to reside in all things. The above quotation makes it clear that the artist's special effort was to express the potential for movement within organic forms. This effect is most evident in the three-dimensional sculpture of figures and animals that are not encumbered with symbolic details. "Realism" is often confined in other works to details, such as the lines in the fingers and palms of Coyolxauhqui (see Plate 104 a, b).

For the Aztecs, realism had a secondary value in art; it was only one aspect of the skill and virtuosity of great artists. The Aztecs admired technical excellence; although they worked with stone tools—flint and obsidian blades and a simple drill—they created such miracles in carving as the paper-thin obsidian earspools in Plate 261. Colossal works and miniature objects alike display the degree of virtuosity that moved the Renaissance master artist Albrecht Dürer, after seeing the treasures Cortés sent back to Europe, to write in his diary: "All the days of my life I have seen nothing that rejoiced my heart so much as these things, for I saw amongst them wonderful works of art, and I marvelled at the subtle *Ingenia* of men in foreign lands" (Conway, 1889, p. 101). Stoneworking, featherworking, and turquoise mosaic techniques were not only difficult, but required an amount of time and patience that we can hardly imagine devoting to a project.

With materials so resistant and tools so simple, the creation of exact shapes and lines was extremely difficult. The Aztecs admired controlled and precisely outlined forms. Their aesthetic had no room for the irregular, sketchy, or personal hand of the artist; the loose, calligraphic lines decorating Aztec household pottery do not appear in the other arts, and may have been considered poor and sloppy, the work of untutored commoners. The worst quality a work of art could have from the Aztec point of view was disorganization or confusion. Essential to good art was the clarity and recognizability of individual forms and a sense of order in their arrangement. In any choice between realism and clarity, the second was usually chosen. Only in their iconography did they prefer metaphoric complexity.

Individual creativity in art was not overtly glorified in Aztec culture, but it is evident from the surviving works that creativity was in fact highly valued and encouraged, especially among the elite. While the works made for the lower classes were mass-produced, homogeneous, and little varied from a formula, those made for the elite are not only more highly polished, iconographically complex, and realistically detailed, but they were also new in conception. The Aztecs admired and copied some examples of Toltec art, and transformed their imitations after the early stages toward Aztec concepts of clarity and vitality.

A large number of major Mexica works, such as the Calendar Stone, the Stone of Tizoc, Coatlicue, and the Temple Stone (see Chapter IV), have no prototypes in earlier art. They were invented to fulfill Mexica needs and reflect Mexica concepts. These new monuments were not necessarily copied by later artists, and major monu-

ments continued to reflect new and different forms throughout Mexica history. This variety is best seen in the colossal monuments; it may also have been evident in other luxury materials, such as the lapidary arts, turquoise mosaic, and featherwork, but the paucity of surviving examples makes it harder to demonstrate.

One reason that the Mexica rulers commissioned new and different works of art is that they were as concerned with leaving unique monuments behind them as they were with conquering new territories. The historical chronicles frequently refer to sculptures ordered by the rulers to commemorate specific events. Like poems, the major monuments of Tenochtitlán were expressions not only of the greatness of the rulers but also of their individuality. On seeing his portrait at Chapultepec Motecuhzoma II is supposed to have exclaimed: "If our bodies were as durable in this life as this carved effigy is upon this rock, who would be afraid of death? But I know that I must perish and this is the only memorial that will remain of me" (Durán, 1964, p. 254).

The surviving masterpieces of Aztec art testify to the creativity and originality of the royal patrons and the artists. Since the Mexica were not originally artists, they either acquired works from conquered peoples or they encouraged the settling in Tenochtitlán of specialists from other areas. The skills and traditions of other contemporary peoples were brought together in the workshops of the capital. Out of these eclectic sources was created a new style and iconography that expressed the Aztec concept of themselves as the builders of a dynamic new empire.

III

AZTEC ARCHITECTURE
AND CLIFF SCULPTURE

Introduction

Aztec settlements and their architecture reflect Aztec solutions to practical problems and historical events, and the expression of their religious ethos. Few actual buildings survive. Towns were either destroyed or slowly transformed into colonial centers. Christian churches replaced most temples. It is possible sometimes to locate streets, blocks, and buildings; sixteenth-century descriptions and plans and the few remaining structures scattered throughout the Aztec empire make a general description possible.

The Aztecs transformed the land by building artificial islands called *chinampas* in lakes (Colorplate 20), by draining swampy lands, and by terracing fields. Some older centers such as Cholula had continued to flourish after the fall of the Toltec empire, and the Aztecs founded many new cities, each having a religious precinct at its center and roads, aqueducts, and canals. Picturesque natural formations or ancient ruins beyond the cultivated fields and cities became places for religious shrines or the pleasure gardens of the rulers. Sculptures carved into cliffs and boulders identified some of these places as sacred to myth and history. All landscape, whether transformed by man or left wild, had symbolic significance.

Despite the ethnic heterogeneity that the histories suggest, the physical layout of Aztec cities and temples throughout their empire had many elements in common. This may not be the Aztecs' influence so much as shared ideas from preceding times. Our information about provincial cities and the Aztec capital is not of equal value. The written sources record primarily the area of the Valley of Mexico, but many of the better-preserved buildings are outside of Tenochtitlán, and they show that in sacred architecture certain elements were widespread and standardized in the Aztec empire: single and double pyramids, round buildings, platforms, and ball courts. There are twin pyramids to be found from Veracruz to Morelos, and they predate the founding of Tenochtitlán. The general vocabulary of Aztec architecture developed from the twelfth to the fourteenth century, between the fall of Tula and the rise of the Mexica. Certain aspects of buildings became as set as the forms of small-scale sculpture were, and as frequent. The Mexica drew on this vocabulary in building their capital city.

During the height of the Aztec empire (1450–1521) the most dramatic projects were built in the Valley of Mexico and in the Mexica capital of Tenochtitlán. The political centering of the empire in that region became physically manifest in the development of urbanism. If we could go back to 1519 and stand with Cortés and his men at the causeway leading to Tenochtitlán, we would see a great lake with towns and settlements all around the shores and on the islands, stucco-covered pyramids glistening in the sun as they rose above the crowded houses and gardens, and everywhere canoes so filled with people and merchandise that they clogged the canals. Some Aztec cities were destroyed in the conquest; others that were continuously

inhabited became colonial, then modern settlements; and much of the lake was drained in the eighteenth century. Present-day Mexico City was built on the ruins of Tenochtitlán and its suburbs now reach to settlements once located beyond the shores of the lake.

The urbanization of the Valley of Mexico in the late Postclassic period is remarkable: the entire shore of twelve-mile-long Lake Texcoco and its islands were dotted with settlements ranging from villages to cities, a development unprecedented in Mesoamerican history. Tenochtitlán was the largest of these cities, its population estimated at about 200,000 to 300,000 persons (Sanders, Parsons, and Santley, 1979, p. 403). Important towns were located on the east, north, and west sides of Lake Texcoco. Three major Acolhua towns on the east side included Texcoco, the capital of that domain, Huexotla, and Coatlinchan, all founded in the Postclassic period and flourishing after the fall of Atzcapotzalco. A large hilly peninsula divided Lake Texcoco from Lake Chalco to the south, and on the peninsula grew up the cities of Ixtapalapa and Culhuacan. It was from Ixtapalapa that Cortés first viewed Tenochtitlán, and Culhuacan may be one of the oldest Aztec settlements on the lake, its antiquity marked by the holding of the New Fire Ceremony on the Hill of the Star above the city. The southern cities of Chalco, Tlalmanalco, and Xochimilco, also old settlements and long-time enemies of Tenochtitlán, were eventually incorporated into the Aztec empire. Xochimilco was a *chinampa* city—the only one in Mexico where *chinampas* still survive today. The major settlements on the west coast of the lake are Tepanec cities—Coyoacan, Tlacopan, and Atzcapotzalco. With the fall of King Tezozomoc, Atzcapotzalco lost its primacy to Tlacopan, later one member of the Triple Alliance. Further north was the city of Tenayuca, founded by Xolotl, the ancestor of the Acolhua empire; it was one of the first towns built near the lake. In the middle of the lake, built on islands and *chinampas* and connected to the mainland by five causeways, rose the two cities of Tenochtitlán and Tlatelolco. In 1473 Tlatelolco was conquered by the Mexica and became a ward of their city.

Tenochtitlán, therefore, belonged to a network of cities that was urban in its totality. Villages, towns, and cities, however divided by their ethnic affiliations, were united in a hierarchic organization based on feudal obligations and alliances. This situation was different from that of the Teotihuacán empire, which had consisted of one enormous city and a vast rural hinterland.

A recently completed survey of settlements and agricultural works in the Valley of Mexico has yielded new information that helps to explain this circumstance (Sanders, Parsons, and Santley, 1979). Data was collected on all the historical phases in the valley, enabling us to compare the Aztec empire with the earlier Teotihuacán and Toltec empires. The survey shows that at the time of the conquest the population in the area was over one million, four times larger than the largest population of the preceding Teotihuacán period and not exceeded until the early twentieth century. So large a population was supported by an agricultural system more far-reaching than at any time before.

Rivers and springs had been used for irrigation agriculture since the time of Teotihuacán, and these continued to be exploited. However, the Postclassic urban area around Lake Texcoco was unusual in its lacustrine orientation. Classic Teotihuacán had been located in a valley northeast of the lake, and the lake resources were largely neglected until the Aztecs arrived. The lake offered rich natural resources, but these were difficult to exploit without technology or social organization.

Lake Texcoco actually consisted of five shallow, interconnected lakes of varying depths (three to nine feet). The deepest was the eastern lake, also called Texcoco,

Colorplate 20. Chinampas (*"floating gardens"*) at Xochimilco, created by digging canals and raising the land by adding mud from the lake bottom

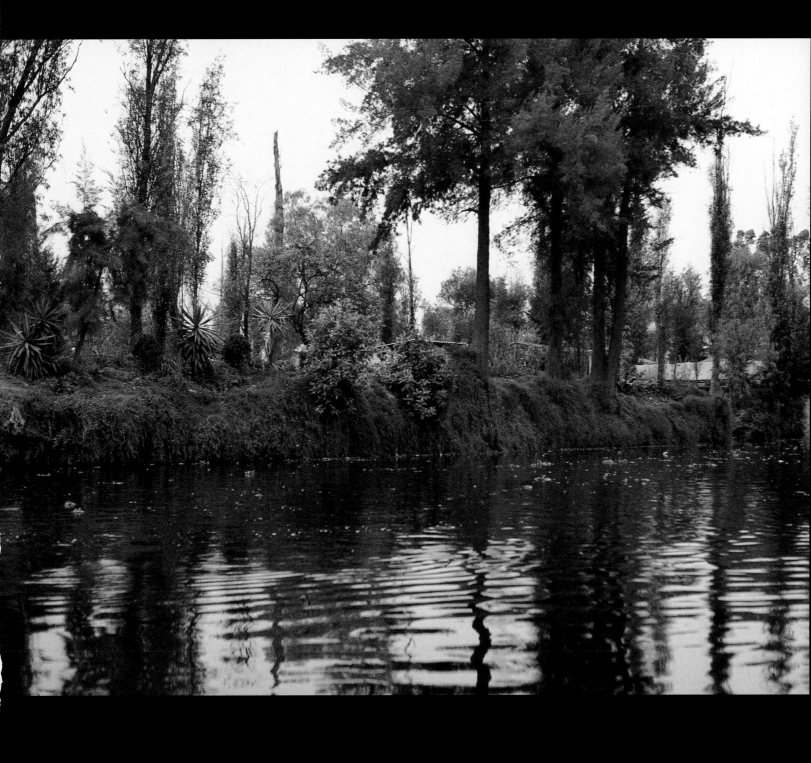

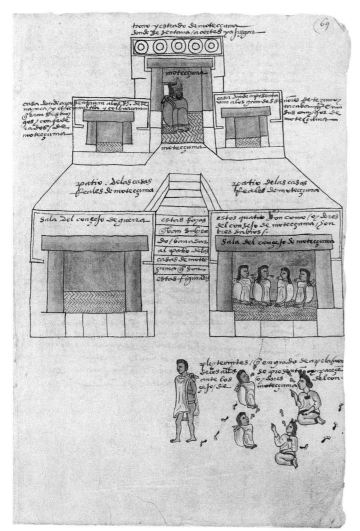

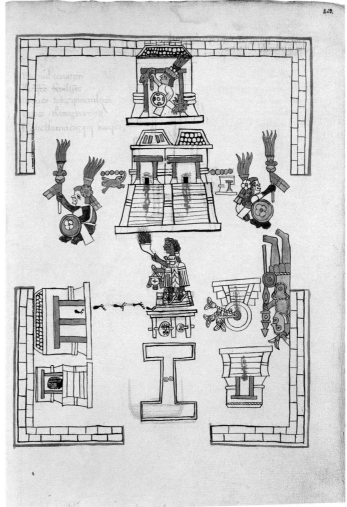

Colorplate 21. Palace of Motecuhzoma II
at Tenochtitlán. Codex Mendoza, p. 69.
Manuscript, 32.7 × 22.9 cm. Mexico City.
Early Colonial, c. 1541–42. Bodleian Library,
Oxford

Colorplate 22. Main Temple Area at
Tenochtitlán. Primeros Memoriales of
Sahagún's Codices Matritenses, Pl. XVI.
Manuscript. Tepepulco, Hidalgo. Early
Colonial, c. 1559–61. Real Casa, Patrimonio
Nacional, Palacio Real, Madrid

OPPOSITE

Colorplate 23. Twin Pyramid, Tlatelolco

Colorplate 24. Portion of Wall Surrounding
Temple Area, Huexotla, Acolhuacan

Colorplate 25. Reconstructed Temple Pyramid,
Santa Cecilia Acatitlan

whose water was salty or brackish; the lakes of Xaltocan and Zumpango in the north, and of Chalco and Xochimilco in the south, were shallower, and the southern lakes had sweet water. Serious problems were the swampy shores and the periodic flooding of the salt water into the sweet-water lakes. We do not know whether the actual lake areas became inhabited because all available shoreland was already settled, or whether the lake was selected for ideological reasons.

The Aztecs initiated major hydraulic projects for drainage and for flood control. Canals were cut in swampy areas, and the resulting islands of land were firmed by heaping mud onto them from the bottom of the lake. These *chinampas*, partly artificial islands, provided many new acres of fertile soil for agriculture all around the lake. Excavations have shown that all the *chinampas* were built during the second half of the Postclassic period. The islands, natural or newly formed, were made habitable by dikes in the lake that controlled the flooding of salt water into fresh-water areas.

Besides reclaiming swampy lands, the Aztecs terraced all marginal hillsides, increasing the land suitable for growing crops. The labor for building the canals, *chinampas*, and terraces required a centralized operation organized by the rulers, evident in the regular patterning of canals and terraces and implied in one ruler's speech to his sons in which he instructs them to take care "of the ridge, of the ditch" (Sahagún, 1950–78, bk. 6, p. 90). The phrase "of the ridge, of the ditch" is the metaphorical description of agricultural activity. Agriculture was locally specialized: corn was grown on the irrigated fields of flat terrain, maguey and nopal cactus was cultivated on the terraced hillsides at higher altitudes.

Less than half the population lived in rural villages and hamlets, or as resident serfs on the lands of the nobility. The larger proportion of the population lived in urban settlements. Of these, six major cities including Tenochititlán had populations from 20,000 to 300,000; at least forty smaller cities had populations from 2,000 to 20,000 (Plate 47).

Once the shores were settled, Lake Texcoco with its canals proved to be an efficient area for transportation and commerce. Busy canal traffic by canoe helped to distribute goods, and to move people among the different centers. Necessary household wares such as pottery, mats, stones for cutting and grinding, and even folk-ritual figurines were mass-produced at centers that specialized in each activity. They were available in the markets which were held in every town at least once a week; large daily markets were limited to capital cities such as Tenochtitlán and Texcoco.

While the historical texts focus on the drama of warfare and the tribute gained from subject peoples, the economic basis of the Aztec empire was its efficiently organized system of agriculture and trade. Local resources were successfully adapted to support one of the most populous areas of the preindustrial world. The system also demonstrates that the Aztecs had a highly practical and experimental approach to the problems of settlement and agricultural labor, apart from their focus on the spiritual aspects of religion or the politics of their empire-building. This is not to say that the agricultural works were always adequate for the large populations. The sources frequently refer to droughts and crop failures causing great famines. In the course of constructing canals, dikes, irrigation ditches, terraces, cities, and villages the Aztecs left almost no area of the Valley of Mexico unchanged by human labor.

Many Aztec towns newly founded in the Postclassic period were neither based on earlier plans nor built around earlier buildings. They shared certain basic aspects of planning that can be summarized as diversity within a hierarchic unity. The central core of a city usually included a major temple precinct, a plaza where the market was held, and a royal and administrative residence. The temple precinct was often walled

Colorplate 26. "Queen's Bath," small pool cut into the rock, Tetzcotzingo, near Texcoco. 15th century

Colorplate 27. "Queen's Bath" with stairway on cliff side, Tetzcotzingo, near Texcoco. 15th century

for practical as well as symbolic reasons, the wall separating the sacred area from the residential city and increasing its visual importance. Temple pyramids also served, however, as forts in case of war, and the walls functioned as defenses. The building to be defended to the end was the temple of the city's patron deity, for its capture signified the conquest of the town. The conquest of Tlatelolco is illustrated in the Codex Mendoza by the ruler falling from the pyramid.

Major streets and canals usually divided the rest of the city into two, four, or more districts, each with its own deity and temple center. The districts were further subdivided into wards (now called barrios) or *calpulli*. These wards could represent residential or social divisions, for they often corresponded to professional groups such as guilds, or to groups which had traditionally traveled together in the migrations. Each ward had its own temple and its own school in which youths were trained. Individual households consisted of extended families—one or more couples and their children living with a few other relatives—in houses arranged around internal courtyards and having small gardens (Calnek, 1976, p. 206). Most of these buildings were single-story constructions. Houses more than one story high were reserved for the ruler and the highest nobility, and were clustered around the center of the city.

The Aztecs lived in a land sanctified by religion and history. It is difficult to know whether historical events were caused by a practical action that was later justified in myth, or by a myth that stimulated practical action. In building cities around the lake, the Aztecs were trying to re-create a paradisical ideal. The Nahuatl name for a city is *altepetl*, meaning "water–mountain," and it signifies that a settlement must have water and a mountain to be habitable in both the practical and mythic senses. The Mexica believed that their original homeland had been an island in a lake from whence they were led by Huitzilopochtli on their migration. The location of their future city was also to be on an island. Tenochtitlán was both a new town and a re-creation of the Mexica homeland. The concept of an island-city surrounded by water is analogous to the Aztec concept of the earth, a large disk surrounded by an ocean-river. Tenochtitlán was therefore a microcosm of the universe. Mountains were significant because the nature gods of the ancestors dwelled there. The clouds of Tlaloc congregated on the tops, and cool streams emerged from their sides. The ancestors of many Aztec tribes were believed to have come from Chicomoztoc, or Seven Caves, and all caves were therefore potentially sacred places of origin and emergence.

Some natural formations had significance for the entire Valley of Mexico, others had historical significance only for certain ethnic groups. On the Hill of the Star rising behind the city of Culhuacan the New Fire Ceremony was celebrated every fifty-two years for the entire lake basin. The top of Mount Tlaloc had a temple to the rain god where annual offerings were made together by all the rulers of the valley. The colonial church of the Virgin of Guadalupe, now north of the center of Mexico City, is on the location of an important shrine of the Aztec mother goddess at Tepeyacac. The hills of Chapultepec, on the west shore of Lake Texcoco, were especially significant for the Mexica, for there they had first settled in the area; the Mexica kings had their portraits carved in its cliffs. The hill of Tetzcotzingo near Texcoco was sacred to the rulers of Texcoco, for whom it was a pleasure garden and temple precinct. Cliff temples and sculptures were carved by the Mexica in the mountains of conquered territory as well, such as at Malinalco near Toluca.

Though springs and mountains were considered to be sacred as natural phenomena and as the dwelling places of spirits, there was no obligation to leave them in their natural state. The Aztecs transformed the natural features of the valley more radically

Plate 47. Map of Tenochtitlán and Surrounding Cities on the Western Side of Lake Texcoco (after Sanders, Parsons, and Santley, 1979, Map 19)

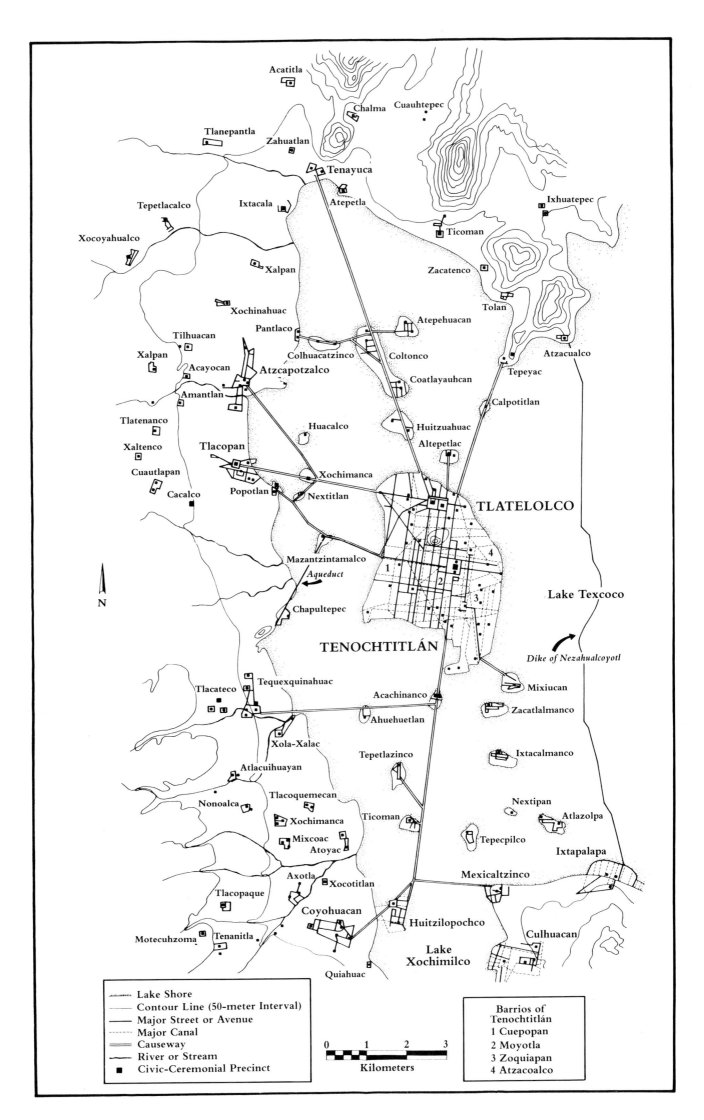

Acatitla

Chalma Cuauhtepec

Tlanepantla

Zahuatlan

Tepetlacalco Ixtacala Tenayuca Ixhuatepec

Xocoyahualco Atepetla Ticoman

Xalpan Zacatenco

Xochinahuac Tolan

Tilhuacan Pantlaco Atepehuacan

Xalpan Colhuacatzinco Coltonco Atzacualco

Acayocan Atzcapotzalco Coatlayauhcan Tepeyac

Amantlan Calpotitlan

Tlatenanco Huacalco Huitzuahuac

Xaltenco Tlacopan Altepetlac

Cuautlapan Xochimanca

Cacalco Popotlan Nextitlan **TLATELOLCO**

4

N

Mazantzintamalco 1 Lake Texcoco

Aqueduct 2 3

Chapultepec **TENOCHTITLÁN** *Dike of Nezahualcoyotl*

Tequexquinahuac Mixiucan

Tlacateco Acachinanco Zacatlalmanco

Ahuehuetlan

Xola-Xalac Ixtacalmanco

Atlacuihuayan Tepetlazinco

Nonoalca Tlacoquemecan Nextipan

Xochimanca Ticoman Atlazolpa

Mixcoac Tepecpilco

Atoyac Ixtapalapa

Axotla Xocotitlan Mexicaltzinco

Tlacopaque Culhuacan

Motecuhzoma Tenanitla Coyohuacan Huitzilopochco

Lake Culhuacan

Quiahuac Xochimilco

Lake Shore

Contour Line (50-meter Interval)

Major Street or Avenue

Major Canal

Causeway

River or Stream

Civic-Ceremonial Precinct

0 1 2 3

Kilometers

Barrios of
Tenochtitlán
1 Cuepopan
2 Moyotla
3 Zoquiapan
4 Atzacoalco

than had any previous culture. By irrigating the fields, draining the swamps, separating the lakes, and terracing the hillsides, they harnessed nature to support human life. Places of ritual importance were sanctified by buildings and reliefs. While some of these places may have been sacred before they arrived, the Aztecs were the first to carve temples and images of themselves into the living rock, thereby claiming a landscape that had become theirs by conquest and by practical utilization, rather than by ancestral inheritance.

Tenochtitlán–Tlatelolco, the Mexica Capital

> But when I saw how rebellious the people of this city were, and how they seemed more determined to perish than any race of man known before, I did not know by what means we might relieve ourselves of all these dangers and hardships, and yet avoid destroying them and their city which was indeed the most beautiful thing in the world. . . . My plan was to raze to the ground all the houses on both sides of the streets along which we advanced, so that we should move not a step without leaving everything behind us in ruins; and all the canals were to be filled in, no matter how long it took us.
>
> (CORTÉS, 1971, PP. 247–48)

An area almost one mile square called La Traza was cleared in the center of the capital, and on these ruins the Spanish colonial city was then built. The area within La Traza remains poorly known; outside this zone, some of the Indian city survived. Traces of the avenues and canals of the prehispanic city were still to be seen in twentieth-century aerial photographs (Calnek, personal communication).

Our knowledge of Tenochtitlán comes from sixteenth-century sources, both visual and textual, and archaeological excavations. Although numerous maps of the city must have existed at the time of the conquest, only one has come down to us, the map published in Nuremberg in 1524 to illustrate an edition of Cortés's second and third letters to Charles V (Plate 48). This may be a woodcut version of a sketch made by Cortés or for him. While inaccurate in many details, it is our major source for reconstructing the city center and the causeways linking it to the mainland. Of the temple precinct in the center of Tenochtitlán there is only one plan, made by Sahagún (Colorplate 22). Schematic illustrations of its great temples appear in several codices, and the Codex Mendoza has an illustration of Motecuhzoma's palace (Colorplate 21). But the visual material on the city is sparse and fragmentary in contrast to the many textual descriptions. The texts are usually not keyed to a map and are often unclear or contradictory in their references, yet several attempts have been made to re-create a plan of the ancient city on the basis of these documents. Most recently Calnek (1972) has been reconstructing the major features of Tenochtitlán by using hundreds of sixteenth-century legal cases that involved land and house claims (Plate 49); he has evidence for the important streets and canals and the pattern of domestic habitations. Since many barrios even in eighteenth- and nineteenth-century Mexico City still followed prehispanic districting, he has been able to reconstruct the layout of the preconquest city in its general terms outside the colonial square.

Archaeological excavation cannot be undertaken in Mexico City without removing postconquest buildings, and it has therefore been quite meager. A sewer pipe break in 1900 at Escalerillas Street, near the Cathedral, permitted excavations that revealed a corner of the Main Temple of Tenochtitlán. This area was excavated a bit more in 1915 and in 1934, and it was discovered that the temple consisted of several superim-

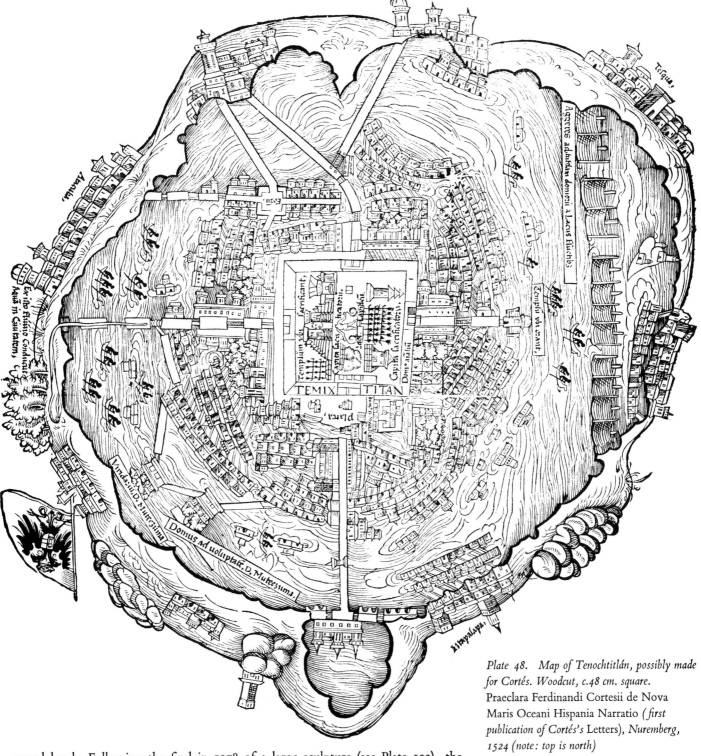

Plate 48. Map of Tenochtitlán, possibly made for Cortés. Woodcut, c.48 cm. square. Praeclara Ferdinandi Cortesii de Nova Maris Oceani Hispania Narratio (first publication of Cortés's Letters), Nuremberg, 1524 (note: top is north)

posed levels. Following the find in 1978 of a large sculpture (see Plate 102), the Instituto Nacional de Antropología e Historia decided to clear the entire stairway of the main pyramid, and removed the colonial Libreria Robredo for this purpose (Matos Moctezuma, 1978, 1981). Excavations have now revealed the earliest building stage of the Mexica temple.

The central precinct of the twin city of Tlatelolco was excavated between 1945 and 1965, before the northern section of Mexico City was fully built up; it is now a part of the Plaza de las Tres Culturas, the largest reconstructed temple precinct of the Aztec period in the Valley of Mexico. The Metro (subway) excavations brought to light an unusual building at the Piño Suarez station in the southern part of Mexico City; other information that concerns the layout and architecture of Tenochtitlán is only beginning to be published (see Plate 51).

Historical traditions tell us that Tenochtitlán was founded in 1325 as a small village of thatched huts. Within less than 200 years it had become an urban city of 200,000 inhabitants. To build and maintain so large a city in the middle of a lake and to organize its heterogeneous population into residential and social units were among the great practical achievements of the Mexica. Problems to be solved, including water-level control, communication with the mainland by causeways, and the acquiring of fresh drinking water, concerned the Tenochtitlán rulers. But at the same time the city was planned to have metaphoric significance, and its location, planning, and measurements indicate reference to three symbolic concepts: to specific events in the Mexica migration legend, to the cities of past civilizations such as Teotihuacán, and to past and present relationships with other centers around the lake. Practically, Tenochtitlán was the control center of the Valley of Mexico and the Aztec empire; symbolically, it was the center of a universe newly created by the Mexica. While its architecture and plan were similar in some respects to that of other Valley cities, Tenochtitlán was in other ways unique—or so the evidence suggests, but this is difficult to prove in detail because comparative information on other cities is too fragmentary.

Legend has it that the first building erected when Tenochtitlán was founded on an island in the lake was an earth-and-thatch temple to the patron god Huitzilopochtli; the texts say that Huitzilopochtli himself ordered the specific plan of the city (Lombardo de Ruiz, 1973, p. 50). The temple was located near a spring and pool of water. The Codex Mendoza (see Colorplate 9) shows the city divided into four quarters and settled by ten kin groups with their own leaders. The houses were modest huts of reeds and rushes.

Recent stratigraphic excavations under the Cathedral have revealed not one but two periods of occupation for Tenochtitlán, separated by a major flood that inundated the earlier level. The buildings of the earlier level have been dated to the eleventh century (Reyes Cortés, 1978; Vega Sosa, 1978). The site was abandoned for a time before the second occupation, believed to be the Mexica one of 1325, traditional in the historical sources. As the ceramics of the earlier occupation are mainly Aztec II and III (see Plate 310), these excavations indicate a more complex history than that told in the migration legends in the chronicles.

According to Mexica histories, Tlatelolco was founded in 1357 on an island to the north by a dissident group of Mexica. Archaeological excavations and the histories of other centers indicate, however, that Tlatelolco is the older perhaps by more than a century, and that its later foundation date was a Mexica fabrication to secure primacy of settlement for Tenochtitlán. Tlatelolco was a center for merchants; a major market was built near its ceremonial precinct and the city was relatively rich and powerful, an ally of the Tepanecs. By contrast the first people of Tenochtitlán were poor fishermen and soldiers having limited resources, who settled on the island as a place of refuge.

From 1367 to 1427 the major power in the valley was the Tepanec kingdom of Atzcapotzalco. The Mexica were linked to the weak city of Culhuacan (from whom they got their first ruler), and had to trade for wood and building stone in their neighbor's markets. As Mexica soldiers served the Tepanecs, the Mexica eventually received land and tribute as their share in victories, and their settlement prospered and grew in size. The first canals were built, forming *chinampas* that extended the limited land of the islands. The growing city did not have enough fresh water, and the Mexica had to ask permission of their Tepanec overlords to build an aqueduct from the Chapultepec springs on the mainland. This modest aqueduct of reeds and clay needed constant repairs to keep it working.

The fortunes of the Mexica suddenly improved under Itzcoatl, with the defeat of the Tepanecs through the alliance of Texcoco, Tenochtitlán, and Huejotzingo. This triple alliance conquered Atzcapotzalco in 1428, which left Tenochtitlán as the power center in the Valley of Mexico. Two years later the Mexica conquered the southern cities Xochimilco and Coyoacan, and as tribute the defeated peoples were forced to build a causeway from Ixtapalapa to Tenochtitlán. Five miles long and 135 to 145 feet wide, the road ran between two canals which were used in water-level control. Sections of this highway were excavated recently and its dimensions confirmed (Gonzalez Rul and Mooser, 1961).

The Ixtapalapa causeway was not the first between Tenochtitlán–Tlatelolco and the mainland. Tlatelolco was linked by causeways to Tenayuca, and to the Tepanec city of Tlacopan by way of Nonoalco. Tenochtitlán had a separate causeway to Tlacopan, also built by order of the Tepanecs, and another causeway to the shrine of the mother goddess at Tepeyacac in the north (Gonzalez Aparicio, 1973). The causeways linking the cities with the mainland were generally built by the weaker political powers on the order of the stronger ones. Their purpose was to facilitate political control, to cement commercial relations, and, as dikes, to control the water level. Durán describes how the tribute labor was organized for aqueduct construction, under Ahuitzotl:

> Tezcoco and Tepanec workmen brought light and heavy stone. Chalco sent poles, stakes and volcanic stone for the foundation. Xochimilco sent instruments to cut blocks of earth and canoes filled with dirt in order to dam the water. People from the hot country brought great loads of lime. (Durán, 1964, p. 210)

Relations between Tlatelolco and Tenochtitlán remained difficult throughout their history. In 1431 the Tlatelolcans built a barrier between their city and the suddenly expanding Tenochtitlán; a few years later the barrier was removed and the cities rejoined. In the 1450s Tlatelolco was separated from Tenochtitlán by a canal. Civil war broke out between the two cities in the 1470s, which ended with the conquest of Tlatelolco and its final annexation. Tlatelolcans were required to come to Tenochtitlán and worship at the Temple of Huitzilopochtli, and the famous market at Tlatelolco came under the control of Tenochtitlán.

Although Itzcoatl first began to renovate the Temple of Huitzilopochtli so that the grandeur of the temples would reflect the increasing political power, it is Motecuhzoma I (1441–1469) who is credited with the major rebuilding of the city and its temples. Motecuhzoma also built a royal palace which was used by his successors and enlarged by Axayacatl. In this palace (Casas Viejas) the Spaniards were lodged, and in one room they found a sealed-up treasure. During Motecuhzoma's reign most buildings in the center of the city were large and built of stone, either by the Mexica nobility or by conquered rulers who resided part of the year in Tenochtitlán. Two-story structures must have been widespread, for by law they had to be restricted to the nobility. Some of these palaces were built by the Chalca, a recently conquered people who were famous as masons. Because the struggle had spared few men, the Chalca women had to do the building (Brundage, 1972, p. 145).

The growth of Tenochtitlán under the rule of Motecuhzoma is also indicated by the increased number of problems and the need for major public works. After a flood heavily damaged the city, a nine-mile-long dike was built to separate Lake Chalco from Lake Texcoco; the ground level of the city was raised and its houses rebuilt. To bring water from the Chapultepec springs a new aqueduct was built, having two channels that were used alternately to allow for cleaning. These hydraulic works were

designed after the advice of King Nezahualcoyotl of Texcoco. Because the Texcoco area had major problems with drainage, their engineers were the most knowledgeable about water control in the Valley of Mexico.

Further reconstructions of the Temple of Huitzilopochtli and the sacred precinct were undertaken by Tizoc and completed in 1487 by Ahuitzotl (see Plate 24). This reconstruction must have been important because the impressive dedication ceremony associated with it included the sacrifice of thousands of victims brought from military victories in the Huastec region (Durán, 1964, pp. 190–96). Ahuitzotl's other major building enterprise, the construction of an aqueduct from Coyoacan to Tenochtitlán, ended in disaster and flooding, perhaps from the absence of Texcoco's advice (Nezahualcoyotl had died in 1472) and Tenochtitlán's inexperience in hydraulic engineering.

Motecuhzoma II's major architectural contribution to Tenochtitlán was a new palace, built opposite to the old royal palace; the ruler was particularly concerned with court life and surrounded himself with hereditary nobility. He had a famous zoo at Tenochtitlán and several palaces and gardens both inside and outside the city, some of these in the lake with private causeways. For the 1507 New Fire Ceremony that fell due in his reign, he rebuilt the temple of the Hill of the Star near Culhuacan.

The Nuremberg plan attributed to Cortés (Plate 48) shows the square temple precinct surrounded by a wall, the city divided into four quarters, and the several causeways leading to the mainland. The plaza south of the central square is the market, with the old palace on the west side and Motecuhzoma II's new palace on the east. A small square represents Tlatelolco in the north. Nezahualcoyotl's dike is shown as a fence east of the city. The emphasis on roads into the city and on a few major buildings suggests the strategic military preoccupations of the conquerors. The movable bridges on the Tlacopan causeway are clearly marked, as is the fort at the entrance to the Ixtapalapa causeway. In many other aspects the map is incorrect. The circular configuration of the lake and of the city appears to be an idealized representation, not the actual shapes. The circular plan was associated in Europe with ideal islands, and the plan of Tenochtitlán was published in many *islarios* such as Benedetto Bordone's Venetian publications of the sixteenth century (Toussaint, Gómez de Orozco, and Fernández, 1938, p. 93). In the Nuremberg map the major temples face in the wrong direction, east rather than west; the zoo is probably in the wrong place; and the houses do not represent street or district patterns but appear to be "filler" motifs of a European type.

THE CAPITAL IN 1519. Tenochtitlán-Tlatelolco covered an urban area estimated at about thirty-five square miles of islands and *chinampas* (Plate 47). The four major districts of the city were marked by avenues, two of which (west and south) ended in major causeways, while the other two were shorter, purely internal divisions. Each district had its own temple, palace, and local marketplace; after the conquest a colonial church was built in each of the four centers. (The temple of Teopan, in the southeastern ward, became the church of San Pablo; that of Moyotlan, in the southwest, became the church of San Juan; that of the northwestern ward of Cuepopan became Santa Maria la Redonda; and Atzacualco's temple became the church of San Sebastian in the northeastern ward.) The southern section of the city was built in the sweet-water lakes and grew more rapidly (Lombardo de Ruiz, 1973, p. 119). In so far as it was possible, the city had a regular grid plan: from east to west, five major canals traversed the city, alternating with avenues; drainage patterns made the north-south canals more irregular and less continuous.

Within the major avenues and canals there was a regular alternation of smaller canals and streets (Plate 49). Houses were located on the street side of the blocks, *chinampa* gardens on the canal sides (Calnek, 1972, p. 109). Every household had a canoe. Domestic habitations were within walled compounds, the houses arranged around a patio and inhabited by two to six nuclear families related to one another. In the *chinampa* gardens fresh vegetables were grown, augmenting by no more than five percent the city's imported foods.

The residential area of Tenochtitlán was divided into about seventy-five to one hundred districts or barrios, each with its own temple and warriors' house. These districts, often called *calpulli*, are said to be derived from the original seven tribal divisions of the migrating Mexica. By 1519, however, the population had become more complex and heterogeneous and the barrios were simply residential sections called *tlaxiccacalli*. Sixteenth-century sources permitted the areas of these barrios outside La Traza to be mapped and named (Caso, 1956). So far as we know, no physical features divided one district from another. Most districts were characterized by occupational specialization; Yopico was known as the district of metalworkers, for example.

The plan of Tlatelolco had major differences from that of Tenochtitlán. Its streets and canals were irregular and not precisely oriented. Evidently the grid plan and orientation of Tenochtitlán were not typical of all Aztec settlements. Tenochtitlán was oriented 7° 35' east of north; as the layout of the four avenues and streets accorded precisely with this axis for a distance of about half a mile from the center, that area must have been the planned core of the city. The streets at the center were at 720-foot intervals, and Calnek believes that the Aztecs used a standard system of measurement (personal communication).

We know something of one major building outside the temple precinct, the palace of Motecuhzoma II (Colorplate 21). As illustrated in the Codex Mendoza, this was a two-story building with a stairway leading to spacious terraces on the second floor. Unfortunately, the illustration is not a plan, but a simplified elevation drawing showing only five rooms. Twenty large doorways are described as opening onto the main plaza; the palace spread out over six acres (Calnek, personal communication; Lombardo de Ruiz, 1973, p. 152). The floors were covered with mats, the doorways hung with cotton and feather textiles or with mats ornamented with small gold bells that tinkled when anyone approached. The palace was both a residence and a center of administration. The Codex Mendoza shows special halls devoted to the war council and to Motecuhzoma's private council; the courtyard of the Texcoco palace illustrated on the Mapa Quinatzin (see Colorplate 40) shows that the palace was used as an assembly for vassal lords. The Tenochtitlán district headmen assembled every day in special rooms to receive their orders from the ruler. The palaces also included quarters for servants and resident artists, and facilities for the storage of tools, foodstuffs, textiles, weapons, and insignia.

THE TEMPLE PRECINCT AT TENOCHTITLÁN. The temple precinct was the actual and the symbolic core of Tenochtitlán where the four roads, symbolic divisions of the empire and universe, came together. Because space was scarce in the island city, the precinct is believed to have been quite small, only about 1,300 feet square, close to the size of the Ciudadela at Teotihuacán. According to the texts, the compound was walled, with either three or four gateways leading to the streets.

The arrangement of buildings within the temple precinct is known from two illustrations and many descriptions. On the Nuremberg map (Plate 48) are eight

Plate 49. *Plan of Tenochtitlán:* wavy lines, canals; narrow rectangles, chinampas; larger rectangles, *house plots (after Calnek, 1972, fig. 4)*

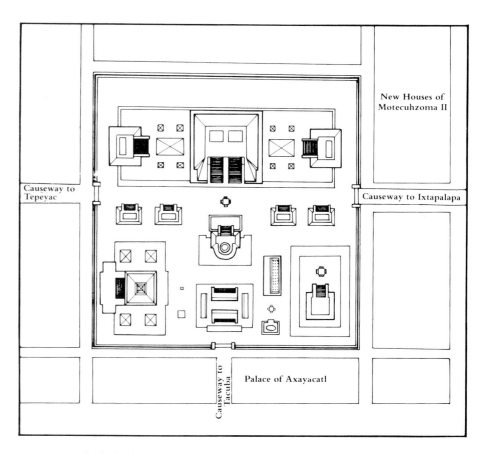

New Houses of
Motecuhzoma II

Causeway to
Tepeyac

Causeway to Ixtapalapa

Causeway to Tacuba

Palace of Axayacatl

Plate 50. Plan of Main Temple Area at Tenochtitlán, Marquina's reconstruction (after Hardoy, 1968, fig. 36)

structures of which the twin pyramid, skull racks, and a room complex are identifiable. Sahagún's drawing from the Codices Matritenses shows nine buildings and five deity figures (Colorplate 22); recognizable are the twin pyramid, skull rack, ball court, and platform for gladiatorial sacrifice. These illustrations are difficult to relate to textual descriptions. In the Florentine Codex are listed seventy-eight temples, possibly once illustrated on a plan now lost; the number includes small shrines as well as city temples outside the temple precinct (Sahagún, 1950–78, bk. 2, pp. 165–80). Certain temples, such as the round building with a low doorway, so impressed the conquerors that they described them in detail, but in both extant plans these buildings are missing.

Archaeological excavations have established the location and dimensions of the twin pyramid dedicated to the patron god Huitzilopochtli and the rain god Tlaloc. The remains of several other platforms have been located under the Cathedral vicinity. The rest of the plan is still conjectural. Marquina (1960) has presented a possible reconstruction of the temple center (Plate 50), of which an attractive model has been made that is now displayed in the National Museum of Anthropology. This plan shows thirty structures arranged on both sides of a central axis that terminates in the towering twin pyramid. The symmetrical arrangement seen in both the Nuremberg and Sahagún plans may not have been exactly the case. The oval relief of Coyolxauhqui recently found in front of the stairway of the Temple of Huitzilopochtli (see Plate 102) may mark the center of the precinct (Calnek, personal communication). Thus the twin pyramid was perhaps askew, with the Temple of Huitzilopochtli half in the center and the Temple of Tlaloc half off center.

Marquina's plan shows the temples evenly distributed within the precinct, yet it is just as possible that some buildings were grouped together to leave open the large

spaces necessary for dances and processions. The number of temples need not have been large, since every god in the pantheon did not need to have its own temple. For the ritual of gods who had no temple, an appropriate related temple was used: on the Temple of Tlaloc, for example, rituals of other fertility deities took place. Finally, the temple center included elements of the natural landscape that had symbolic significance—there was a spring and a pool of water, and areas with trees and shrubs.

Excavations during 1978–79 uncovered the entire twin pyramid, including evidence that it was rebuilt or modified at least eleven times. The earliest structure consists of two temples, well preserved because they were covered over by later constructions (Plate 52).

On the basis of excavations under and near the Cathedral in 1968–76, and of the Main Temple excavations of 1978–81, a new reconstruction sketch has been made

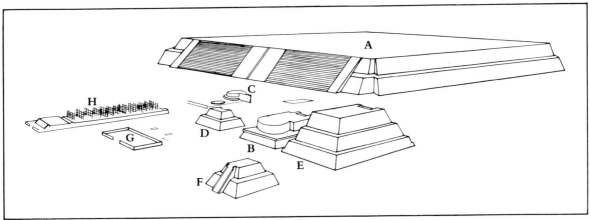

Plate 51. Temple Precinct, Tenochtitlán. Reconstruction sketch (not to scale) based on excavations under Cathedral and Main Temple, 1968–79 (after Vega Sosa, 1979, opp. p. 50, and Bellas Artes, p. 41)

for the temple precinct (Plate 51). The Main Temple (A) dwarfs all other structures. Buildings B and C were round. The identity of the square platforms E, F, and D is unclear, but a solar design on structure E makes a temple to a solar deity such as Tonatiuh a possibility. G is a sunken court, and H was a platform, possibly a skull rack (Vega Sosa, 1979, pl. opp. p. 50). Not shown on this plate are several small platforms recently excavated by Matos Moctezuma north of the Main Temple (Matos Moctezuma, 1981, plan opp. last p.).

The Huitzilopochtli temple has a trapezoidal stone, perhaps for sacrifice, set in front of the doorway, and two dates, 2 Rabbit and 1 House, carved in the stairway below. The Tlaloc temple is better preserved, with a stone-and-stucco reclining figure, a *chac mool*, set in front of the doorway (see Colorplate 28) and walls covered with mural paintings. These are being cleaned and restored (Plate 52), and Matos believes they may be as early as 1390 (Matos Moctezuma, 1981).

The pyramid walls at several later levels were studded with uncarved projecting stones; this may, according to Matos Moctezuma (personal communication), signify the poverty of Mexica artistic and economic resources in the early periods of their history. In the latest structure carved serpent heads replaced unworked stones. One fine serpent head (Plate 53) has on its base the number 8 and the date 2 Reed, carved in a style derived from Xochicalco.

The most elaborate rebuilding of the twin pyramid took place at the level where the Coyolxauhqui oval relief was found. The stairways of this level terminated below in heads of large feathered serpents (Plate 54). On the Tlaloc Temple side, carved frogs ornamented the balustrades (Matos Moctezuma, 1981, foto 12). The dates of the successive building periods cannot be set until the excavation data have been analyzed in detail; the Coyolxauhqui level may correspond to the major dedication of the temple

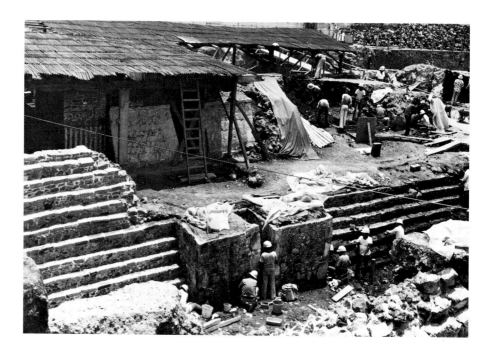

Plate 52. *Excavating Earliest Twin Pyramid in Main Temple Area, Tenochtitlán, 1979*

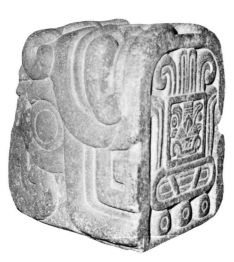

Plate 53. *Tenoned Serpent Head ("2 Reed" glyph and Number 8 on base). Stone, 46 × 40 cm. Tenochtitlán. Museo Nacional de Antropología, Mexico City*

at the time of Ahuitzotl, as noted in the chronicles. Matos has suggested that it may have been erected by Axayacatl in 1469, because the date 3 House is found on the platform (Matos Moctezuma, 1981, p. 37). Of the last rebuilding of the twin pyramid, the one the Spaniards saw, only portions of the wall, ornamented with serpents, remain.

Of the buildings on top of the later levels nothing survives, but several illustrations suggest that they were separate and different. In the drawing in the Codex Ixtlilxochitl (Plate 55), the roof of the Temple of Huitzilopochtli at Tenochtitlán is taller, and ornamented with tenoned skulls; the smaller Temple of Tlaloc had vertical bands. Small colonnaded halls at the base of the twin pyramid in the codex may represent priestly schools and dwellings attached to the temple.

We have little idea what the ball court, skull rack, or platform for gladiatorial sacrifice looked like. No Aztec ball court has yet been excavated. In Marquina's plan the ball court of Tenochtitlán has been reconstructed on the basis of Toltec and Guatemalan courts. Its plan was probably in an I-form, with spectators standing on top of the walls looking down at the game.

A drawing by Durán shows a masonry platform supporting a skull rack, the wooden framework on which the skulls were placed. Several skull racks are to be seen in the Nuremberg map of Tenochtitlán. In 1900 Batres excavated a platform carved on all sides with skulls and reliefs of skulls and crossed bones (Plate 56). Perhaps this is one of those structures originally located in front of the main pyramid. An architectural platform ornamented with skulls has just been excavated on the north side of the Main Temple. This area had other platforms, some ornamented with eagle heads, which do not correspond to descriptions in the texts. The excavations under the Cathedral area also uncovered a platform that may have been a skull rack (Plate 51). The temple precinct may have had several, as the Cortés map indicates (Plate 48).

Another platform described by the chroniclers had attached to it a large disk-shaped stone with a hole in the center (see Plate 84). During the feast of the god Xipe, prisoners of war were tied to this stone and, armed only with feather-decorated blades, had to fight eagle and jaguar knights armed with obsidian-bladed war clubs. The

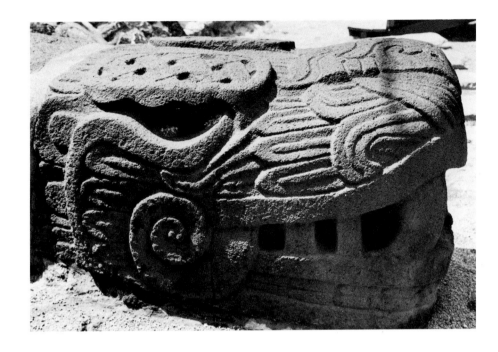

Stone of Tizoc (see Plate 90), having a circular form and central hole, was thought to be such a stone for gladiatorial combat, but this theory is no longer held. In Durán's illustration, this platform was low and had stairways on all four sides. It is said to have been located in the court of the Temple of the Sun, the major temple of the elite knights.

Two other structures have frequent mention in the sources but do not appear on any plan: the temple where the statues taken from enemy temples were kept "cap-

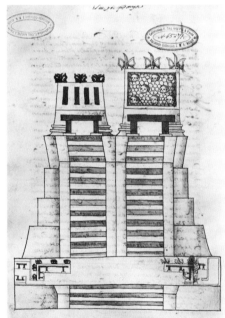

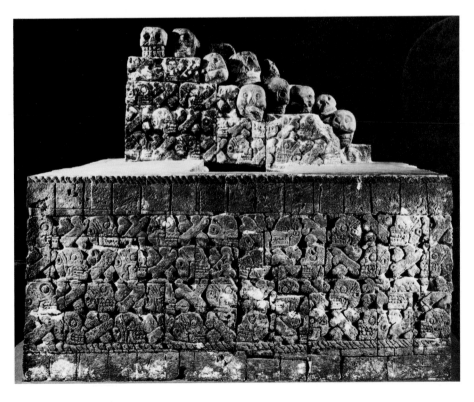

tive," and the temple of the goddess Cihuacoatl. Although no actual "temple of captive statues" has been found, recent excavations of offerings have shown that the Aztecs collected works of art from many parts of their empire. Among the finds there are a fine Olmec mask, a Classic period Monte Albán jade, a Mixtec Tlaloc, and dozens of masks and figures from Mezcala. The Temple of Cihuacoatl (woman serpent), the voracious earth and war goddess, was not built on the top of a platform, and its entrance was so low that whoever wanted to get into the dark and frightening interior had to crawl. This temple apparently represented a cave in the interior of the earth, symbolic of the womb of the goddess.

THE TEMPLE PRECINCT AT TLATELOLCO. In contrast to Tenochtitlán, where many texts refer to the temple precinct but few buildings survive, Tlatelolco has many buildings (Plate 57) but few descriptions (González, 1964). A large part of the excavated section of the temple precinct of Tlatelolco consists of the eight stages of building the main pyramid (Colorplate 23). In stages 1, 2, 6, and 8 this was a twin pyramid; in stages 3, 4, 5, and 7, a single platform (Taylor, n.d.). The platform and a single staircase could have supported two or more structures, of course.

Plate 57. Plan of Excavated Portion of Temple Precinct, Tlatelolco (after Gonzalez, 1964, p. 19)

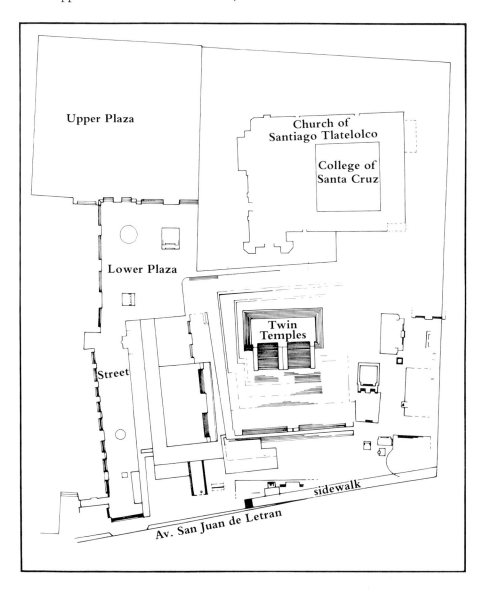

The other temples at Tlatelolco are quite small in relation to the main pyramid. One unusual temple is ornamented on its sides by niches containing reliefs of glyphs and numbers. Both Cortés and Bernal Díaz were impressed by a round building on their first visit to Tlatelolco: "A little apart from the *cue* [temple] stood another small tower which was also an idol-house or true hell, for one of its doors was in the shape of a terrible mouth, such as they paint to depict the jaws of hell. This mouth was open and contained great fangs to devour souls" (Díaz del Castillo, 1963, p. 239). No such building is presently visible at Tlatelolco, although a round platform there could have supported such a temple. Marquina reconstructs such a building in the center of his model of Tenochtitlán. Portions of what may have been a round platform (Plate 51, B) have recently been located underneath the Cathedral (Vega Sosa, 1978; 1980).

The Metro excavations have uncovered temples outside Tenochtitlán's temple precinct. One is an unusual platform now in the Piño Suarez station (Plate 58): two progressively small round stages were erected upon a square form. The statues of two deities were found in offerings associated with the structure (see Plates 175, 193), one representing the Seated Old God with Headdress of Two Horns, the other a monkey-like figure of the God with Buccal Mask holding serpents (Gussinyer, 1970; Matos Moctezuma, 1979, pp. 242–43). A figure of the Old God with Headdress of Two Horns was also found in an offering at the twin pyramid related to the level of the Coyolxauhqui sculpture. Deities found in such offerings do not necessarily represent the gods to whom the temples were dedicated.

TENOCHTITLÁN AS A SACRED CENTER. The iconographic program of Tenochtitlán's sacred precinct is difficult to determine in the absence of texts for the structures and for the area as a whole. In plan it appears to have been eclectic and synthetic. Ball courts, platforms, skull racks, round buildings, and twin pyramids are all structures having a history prior to the Aztec period, but only at Tenochtitlán were they brought together in the same precinct, so far as we know today. The variety of buildings is in strong contrast with earlier sites such as Teotihuacán, where sacred architecture is more homogeneous. Within a precinct there was usually a single most impor-

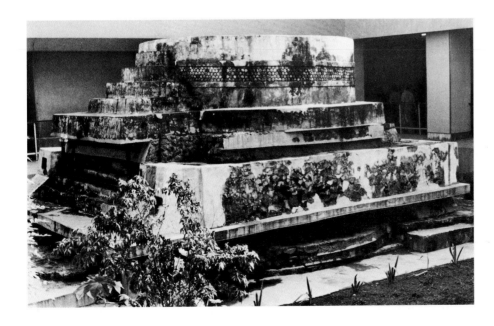

Plate 58. Round Platform Excavated at Piño Suarez Metro Station, Mexico City

tant building, as seen in the sources and in excavated buildings. This one structure, the temple of the patron deity, was frequently enlarged and renovated, and in its latest form dwarfed every nearby temple.

Tenochtitlán had grown from a marshy refuge to become the urban capital of a large empire. In its plan and buildings Tenochtitlán copies some of the practical solutions found in older cities in the Valley of Mexico, but from the time of its official founding a sense of its uniqueness was manifest both on the real and symbolic levels. Tenochtitlán was related to the legendary history of the Mexica and its first acts of city building—founding and dividing the city and building the first temple—were attributed to orders by Huitzilopochtli. The Temple of Huitzilopochtli was built on the spot where the Mexica saw an eagle perched on a cactus, as their god had foretold. In front of the cactus was a spring of white water from which the god Tlaloc emerged, welcoming Huitzilopochtli to the site as his son. The spring and pool of water remained as part of the sacred precinct (the spring was still flowing during the 1900 excavations). Tlaloc, the old nature god who was the nominal owner of the earth and who allowed the Mexica to settle, was venerated in the twin pyramid next to Huitzilopochtli's.

The Temple of Huitzilopochtli was also a place of conquest, as two myths suggest. The legend of the birth of Huitzilopochtli tells that his mother, Coatlicue, lived on the hill of Coatepec (serpent hill) near Tula when she became miraculously pregnant. It was from that hill that Huitzilopochtli sent his weapon, the fire serpent Xiuhcoatl, to vanquish his enemy brothers, the 400 Stars, and to dismember his sister Coyolxauhqui. This myth was re-enacted during the festival of Panquetzaliztli, Huitzilopochtli's major feast. A messenger of the god Huitzilopochtli descended from the temple of the god to fight mock battles, and to sacrifice victims in various parts of the temple precinct and at sites along a circuit around the city—at Tlatelolco, Chapultepec, Coyoacan, and back to Tenochtitlán. This counterclockwise procession commemorated the rout of the 400 Stars and reaffirmed the core area of Tenochtitlán. León-Portilla (1978) has shown that the Temple of Huitzilopochtli was a symbolic form of the hill of Coatepec, the serpent heads set into the walls and balustrades of the pyramid serving to identify it as "serpent hill." Although the temple was apparently always a twin temple also dedicated to Tlaloc, it was generally referred to as the Temple of Huitzilopochtli.

In another legend, the cactus grew out of the heart of Copil, an enemy of the Mexica. During their wanderings, the Mexica had separated themselves from a related group that was led by a woman called Malinalxochitl (whose group settled in Malinalco). Malinalxochitl, in revenge for being left behind, sent her son Copil to destroy the Mexica, who by then were living in Chapultepec. Copil climbed a high rock nearby called Tepetzingo (also called Peñon de los Baños), but he was captured by the priests of Huitzilopochtli; they sacrificed Copil, and threw his heart into the lake. From the heart of Copil grew the nopal cactus. The very center of Tenochtitlán, in front of the stairway of the Temple of Huitzilopochtli, was marked by the oval relief bearing the dismembered image of Coyolxauhqui (Plate 102), Huitzilopochtli's dissident sister who much resembled Malinalxochitl. This sculpture indicates that Tenochtitlán was also founded through conquest and sacrifice. No corresponding sculpture marks the front of the Tlaloc temple.

The rock of Tepetzingo is an unusual volcanic outcrop near hot springs on a small island east of the city (Krickeberg, 1969, pp. 131–34). It was a nature shrine as well as a place important in Mexica myth, and several Aztec reliefs were carved on the rock, including conquest scenes and a tree with a bird in its branches (Plate 59). The

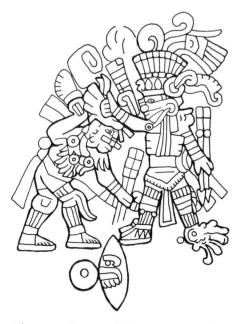

Plate 59. Drawing of Conquest Scene, rock relief at Tepetzingo, Peñon de los Baños (now destroyed; after Krickeberg, 1969, fig. 86)

hill of Tepetzingo now supports a radio tower near the airport and the reliefs are destroyed, but the conquest scene was similar to those on the Stone of Tizoc (see Plate 90): a figure dressed as the god Tezcatlipoca, with a smoking mirror instead of a foot, held a prisoner by the hair, and beneath them was the date 1 Flintknife, the year in which the Mexica began their migration from Aztlan. Placed on a rock associated with conquest, the relief represented the Mexica subduing the people of the Valley of Mexico and fulfilling the destiny begun at Aztlan. Since the myth of Huitzilopochtli and the Mexica destiny are attributed to the time of Itzcoatl and Motecuhzoma I, and since in style and iconography the Tepetzingo reliefs were close to the Stone of Tizoc, the carving probably should be dated between 1450 and 1486, in the early period of Mexica art.

Besides referring to the history of the Mexica in the layout of the city, the plan and orientation also acknowledged the great empires of the past, particularly that of Teotihuacán. Aztec cities are generally oriented 17° east of north; the idea of precise orientation derives, according to Aveni (1975, pp. 168–70), from Teotihuacán, which was oriented 15°25′ east of north. Tenochtitlán was oriented to face the sunrise over Mount Tlaloc, visible behind Tepetzingo, at the time of the summer solstice (Calnek, personal communication).

While the Mexica followed Toltec models in sculpture, in architecture they were inspired by Teotihuacán. Not only did the Aztecs situate the creation of the fourth universe in Teotihuacán, but it was there, according to some traditions, that the Aztecs had stopped on their migrations and learned the "laws" of civilization. The grid plan of the city of Tenochtitlán and its division into four quarters may derive from Teotihuacán; certainly the grid plan was in marked contrast to the irregular plan of Tlatelolco. For a time Teotihuacán was given to the Mexica as conquered land, in return for their help under Itzcoatl in restoring Nezahualcoyotl to his Texcoco throne in 1430. It must have been surveyed by the Mexica and well known to them by the time they were undertaking major rebuilding of their own city. This coincides in time with the mythic justification of imperial domination which they were then formulating. The unit of measure used at Teotihuacán is so close to that at Tenochtitlán that it was either passed down through a local priesthood, such as that of Culhuacan, or arrived at through knowledge of the older city. For Tenochtitlán may have been an imitation of Teotihuacán: as Teotihuacán in the Mexica view was the ruined center of an earlier empire and creation, so Tenochtitlán would be the center of a new world created by Huitzilopochtli.

As a microcosm of the universe, Tenochtitlán improved on its model by being situated on an island in a lake. An island location was considered to be ideal, a projection backward to Aztlan, the paradisical island homeland. It was also a model of the universe, which was imagined to be an island in a great ocean. The Mexica therefore turned their island refuge into a place symbolizing the center of the world. The location of the island in a lake, surrounded on three sides by the habitations of diverse ethnic groups and joined to them by causeways, was a visible image of centrality and superiority. In a broader geographic view Tenochtitlán, in the center of the lake, was flanked by its allies Texcoco on the east and Tlacopan on the west. It is not impossible that the Mexica plans of Tenochtitlán and Lake Texcoco may have been visually conceived, like the universe, as a circle with the city in its center. The Nuremberg plan may express, by design (if it is based on an Aztec map) or coincidence, the Mexica symbolic view of Tenochtitlán as the world center.

The emotional identification that the Mexica felt with Tenochtitlán is evident in their poetry, in which the city is mentioned with love and pride. When Motecuhzo-

ma I was ill, Nezahualcoyotl came to offer his good wishes in the form of a poem. The poem describes the beauty and greatness of Tenochtitlán, the contemplation of which will make the ailing ruler well:

SONG OF NEZAHUALCOYOTL OF ACOLHUACAN
(with which he greeted Motecuhzoma the Great, when ill)

Nezahualcoyotl
See me, I have arrived here.
I am the White Flowery Currassow;
flowers are raining down.
I come from Acolhuacan.

Listen to the song I shall sing
I come to amuse Motecuzomatzin . . .
　　 . . .
Where the turquoise pillars are standing,
Where the turquoise pillars are aligned,
here in Mexico, where in the black waters
grow the white willows,
here your grandfathers deserve you,
that Huitzilihuitl, and that Acamapichtli:
Cry for them, Motecuhzoma,
from whom you have your power and your throne. . . .
　　 . . .

Singer
Weep for them, Motecuhzoma:
you are gazing at the city, and there
presently, O Nezahualcoyotl, you see your ill friend, . . .
　　 . . .
Here is the shrieking Eagle,
Here is the roaring Tiger:
this is Mexico where you ruled, O Itzcoatl,
and for him you hold your power and throne.

Where there are white willows
you are ruling, and where there are white reeds,
where there are white sedges
where spreads the water of jade,
here in Mexico you rule.

Chorus
You, with precious willows
green like jade and quetzal, decorating the city:
the cloud spreads over us:
many new beautiful flowers grow
and may they be woven together by your hands.
It will be your song and your word!

Your quetzal-feather fan
is moving in the air:
The Heron is looking at it, the Quetzal is looking at it! . . .
　　 . . .

Erect flowers of light open their petals
where the water moss spreads out, here in Mexico,
calmly they are extending,
and in the middle of the moss and of the reeds
spreads out the city of Tenochtitlán:
The god makes it expand and flower: . . .

 . . .

God fashions the turquoise pillars,
He fashions the pillars of heaven.
It is the god who supports the city,
and carries in his arms Anáhuac [the world] in the immense lake.

Precious flowers are in your hands,
with precious green willows is the city sprinkled,
and in the entire enclosure, and all day. . . .

(TRANSLATION BASED ON MARTINEZ, 1972, PP. 219–21;
A FEW PASSAGES TRANSLATED FROM THE NAHUATL BY THELMA SULLIVAN,
WHOSE VERSION IS INCLUDED IN THE APPROPRIATE PLACES)

Surviving Aztec Temples

Aztec religious architecture was determined by symbolic meanings and by ritual requirements. Since rituals such as dances and processions involving many people were usually held outside, the precinct had to have open plaza space for assembly. The temple precinct was the symbolic heart of an Aztec city. The first building to be erected was usually that of the patron deity of the city, constituting the act of city foundation.

The temples were small structures, entered only by priests, that housed the images of the gods and paraphernalia used in worship. Although small in interior space, they were placed on tall pyramid platforms that the Spaniards described as "towers." The temples were thus elevated above the crowds who watched the sacrifices that were taking place at the top of the stairways. A number of temples housed the images of various gods, and the rituals often consisted of processions from one building to another. All areas of the sacred precinct had ritual meaning, and the entire space became a microcosm for the re-creation of cosmic dramas, functioning as a large stage set with assorted buildings and open spaces. The audience took the part of observer or participant, as the events demanded. In theaters derived from the Greco-Roman tradition, the spectators usually look down at the stage; in Mesoamerica, the sacred dramas took place on top of the pyramids and platforms and on their stairways, while the spectators were on the plaza below, looking up.

Architectural forms had standard meanings for the Aztecs. A wall or a row of platforms separated the precinct from the residential or mundane world; the degree of elevation signified the importance of a temple, and the highest temple in a city was generally the major one. Most structures were rectangular in plan and form, and the direction of stairways and doorways had symbolic meaning: facing east referred to the rising sun, facing west to its setting. In contrast to their tall, rectangular buildings, many centers had one or more round buildings, sometimes with a low doorway in reference to the earth and the underworld, to be entered only by crouching.

Besides structures that were essentially containers for sacred objects on pedestals, there were low platforms used for theatrical rituals that would be more readily visible from the ground. In placement these platforms were often related to the pyramids.

The sixteenth-century sources also describe temporary structures for the festivals, wooden poles and platforms that were taken down afterward. Surviving from such a ritual is the pole erected today for the eagle dancers of Veracruz: four dancers are tied by ropes to a small platform at the top of a wooden pillar, and to the sound of a flute they twirl downward in thirteen cycles that commemorate the fifty-two-year cycle.

While many of the building types were similar in the Aztec ceremonial centers, their specific significance probably varied a great deal. Each center was dedicated to the worship of some nature gods held in common, and to individual patron gods. The temples referred to the cosmos as well as to individual mythic and historic places. In the surviving remains there are some common elements of structure, but not the meanings or their specific contexts.

Aztec temple architecture, like their small-scale sculpture, was standardized. Cities had walled temple precincts at their centers, and in the residential areas there were district temples. Judging from our records of colonial churches built over ruined Aztec temples, large cities could have had over one hundred temples. The city of Cholula, for example, was said to have had a different temple for every day of the year.

We have a general idea of the plans of these centers because some have been excavated—Tlatelolco, Teopanzolco, Calixtlahuaca, and Cempoala. Strict bilateral symmetry does not appear to have been of primary importance. The plan of the temple precinct of Cempoala (Plate 60) is one of the few available to us. Cempoala, a city in Veracruz province that was conquered by the Mexica, is well known because Cortés visited it with his soldiers on his way to Tenochtitlán and destroyed the idols on the temples. The walled precinct of Cempoala is trapezoidal in plan. (Irregular or nonrectangular plans may have been used in other Aztec cities, since not all were built on a grid like Tenochtitlán's.) Within the wall, buildings are arranged in three groups around courtyards, and in the center a large open area. The organization is not symmetrical: one group consists of a pyramid with a double stairway, and next to it is a round building. The plan of Cempoala indicates that Aztec ceremonial precincts may often have been irregular geometric shapes with the buildings distributed in groups leaving large open spaces in between.

In Huexotla a segment remains of the fortification wall surrounding the central precinct, though a Christian church replaced the main temple and the rest of the precinct has not been excavated. The wall is about ten feet high and made of rubble faced with irregular fieldstones (Colorplate 24). Thick at the base, the walls are battered on both sides and in one section there are window-like openings. The heavy walls at Huexotla indicate that the military function of the precinct was to provide the last place of defense in time of war. (Curiously, such high walls have not so far been found at Tenochtitlán and Tlatelolco.)

Within the sacred precincts the buildings consist of temple platforms, ball courts, and room complexes. Temples are defined as small structures on tall platforms, or "pyramids." These platforms go back to the Preclassic period in Mesoamerican history. In the Valley of Mexico, they usually contained no burials but served primarily to elevate the shrines. Postclassic platforms are normally rectangular and built in steps or stages with a single stairway. The balustrades are low and flat except at the top, where they project as small terraces that support incense burners or standard-bearer figures.

One Aztec pyramid that has been reconstructed with its shrine on top is the small structure at Santa Cecilia Acatitlan (Colorplate 25). The building on top of the tall platform is set back, leaving space for sacrifice rituals in front. This temple has one

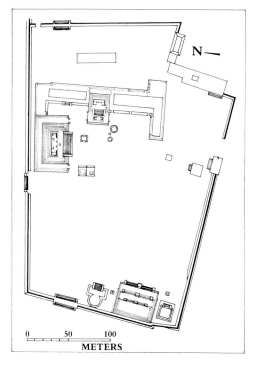

Plate 60. Plan of Temple Precinct, Cempoala, Veracruz (after Marquina, 1964, pl. 134)

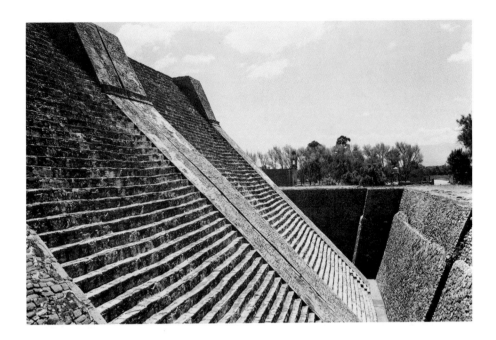

Plate 61. Detail of Stairways, Twin Pyramid, Tenayuca

room, its single, wide doorway topped by a wooden lintel. The flat roof is elevated to form a trapezoidal shape almost as tall as the supporting walls; the walls of this roof are ornamented with projecting tenoned stones. Aztec clay temple models have decoration of this type (see Plate 305), as do temples in the sixteenth-century codices. These Postclassic temples did not usually have complex sculptural or painted designs; importance was given to the freestanding sculptures set up on the inside and outside. The walls of the entire temple were originally covered with plaster, painted and burnished. These walls shone so brightly that Spanish soldiers at the conquest thought they were made of silver or other precious metals (López de Gómara, 1964, p. 71).

One kind of pyramid was built only during the Postclassic period: the twin pyramid. This consists of a single platform base with two stairways which originally supported two structures at the top. Because the main pyramid at Tenochtitlán was a twin pyramid, this type of structure has been associated with the rise of the Mexica, but a major twin pyramid was built at Tenayuca, prior to the rise of Tenochtitlán (Plate 61). Tenayuca, some five miles north of Mexico City, is the center associated with the Chichimec, who were led there by their ruler Xolotl, and it was settled possibly as early as the twelfth century (Brundage, 1972, p. 16). Since the Chichimec were a nomadic people having a migration history similar to that of the Mexica, perhaps they invented the twin pyramid. The Tenayuca pyramid may have been dedicated to the Chichimec tribal leader Mixcoatl, and to Tlaloc.

The Tenayuca twin pyramid was rebuilt six times, each time enlarged by building a new shell over the earlier structure. The pyramid now visible is the next-to-last rebuilding, having characteristic Aztec balustrade profiles projecting at the top. No buildings survive above. The final structure had sculptures of serpents on the outside, and serpent heads were tenoned into the walls (Plate 62). The presence of serpents signifies that the pyramid at Tenayuca represents the surface of the earth-mountain. The serpents were painted blue on the south and half of the west side, black on the north and the other half of the west side; this division probably referred to the two temples above, blue for Tlaloc and black for Mixcoatl (Tenayuca, 1935).

The duality at Tenayuca of the double stairway and the opposition of colors is a visualization of the dual concept in the Valley of Mexico, a new culture united with

Plate 62. Side Wall of Twin Pyramid with Serpent Bodies and Tenoned Heads, Tenayuca

older traditions. This dual concept was evidently pre-Mexica, possibly Chichimec in origin. Where did the Chichimec get the idea to build twin pyramids? Perhaps from the two large pyramids at Teotihuacán, though they are not located together. The place glyph for Teotihuacán in the Codex Xolotl shows two identical pyramids next to one another with a cave symbolized below (see Colorplate 6). The concept of duality may also be a reference to Teotihuacán and its two pyramids, dedicated, according to Aztec traditions, to the sun and moon.

The twin pyramid as a major building type has been associated with the Mexica, and the presence of twin pyramids at Teopanzolco (Plate 63) and Calixtlahuaca is

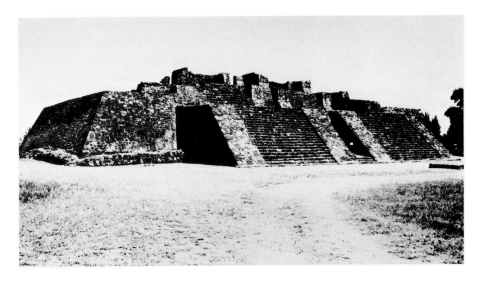

Plate 63. Twin Pyramid, Teopanzolco, Morelos

usually explained by Aztec domination; in each case one side was presumably dedicated to a local deity and the other to the Aztec deity Huitzilopochtli. Besides representing the duality of fertility and war cults, the twin pyramid also offered a political solution to peoples the Aztecs had conquered who were required to erect a temple to Huitzilopochtli. In this way they could do so while continuing to worship their local god on an equal basis. The twin pyramid therefore signified both conquest and peaceful coexistence in the political life of the Valley of Mexico in the Postclassic period.

The most unusual Postclassic structures were round buildings. Round "pyramids" were frequent in Preclassic Mesoamerica, but became rare in the Classic period except in the Huastec (northeastern) region and in western Mexico. Round buildings were frequent in Tarascan architecture, west of the Valley of Mexico and contemporary with the Aztecs. During the Postclassic period round buildings are again found at almost every center of the Aztec empire. Because a Standing Male God with Buccal Mask was found inside the rubble of a round building at Calixtlahuaca (Plate 64; see Plate 160) and round temple figurines of clay show the same god (see Plate 306), all round temples are being attributed to the worship of the wind god Ehecatl

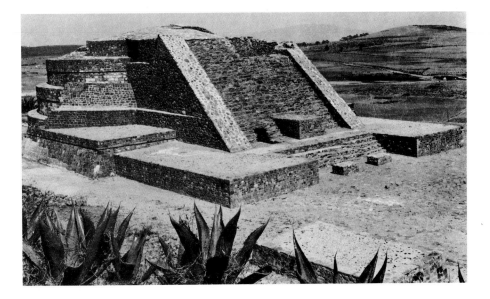

Plate 64. Round Pyramid, Calixtlahuaca, Mexico

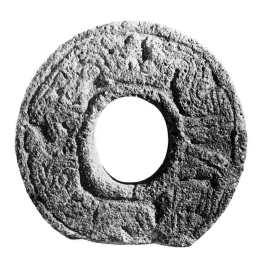

*Plate 65. Ring of a Ball Court. Stone, 91 ×
94 cm. Mexico City. 1200–1521. Museo
Nacional de Antropología, Mexico City*

(Pollock, 1936); the cult of Ehecatl is also believed to have originated in the Huastec area. The presence of round buildings in the Aztec empire may indicate the northern origins and affiliations of the Mexica and Chichimec groups, but some sites, such as Teopanzolco, have more than one circular platform, and the sculptures in the round rock-cut temple at Malinalco bear no relationship to the Ehecatl cult. Round buildings may have been dedicated to more than one deity, not solely to Ehecatl.

Round buildings having the doorway in the form of a serpent's maw may have symbolized the entrance into the underworld through a cave. In the Codex Borgia the fifth or central world direction is represented by a maize plant growing out of a circular pool of water. One of the most important motifs of Aztec sculpture is the circular sun disk which refers to the fifth and last creation of the world. Circular forms signify both central and cyclical completion in terms of space and time.

Sixteenth-century chroniclers note that ball courts were found in many ceremonial precincts or in the market plazas near them. The Mesoamerican ball game was played with a heavy ball of solid rubber that had to be hit with the knees, elbows, or hips and never touched by the hands or feet. The aim of each team was to prevent the ball from bouncing in their side of the court. Rings of stone were set into the high walls of the ball court, and putting a solid rubber ball through one ring with a thrust from the hip was an unusual occurrence that ended the game. Several ball-game rings have been found (Plate 65). The ball game was both an entertainment and a ritual. The path of the ball represented metaphorically the daily and yearly trajectories of the sun; the ball court was the underworld, and also the night sky traversed by the sun between sunset and sunrise.

Mountain Shrines

We usually associate petroglyphs with primitive cultures, but most rock carvings in the Valley of Mexico were made late in the Postclassic period. The Aztecs carved mythical and historical subjects and even entire temples into the rock, and converted hills into complex shrines having temples, palaces, aqueducts, gardens, and reliefs. So far as we know, neither the Toltec nor Teotihuacán cultures combined art with the natural landscape in this manner. Some rock reliefs from the Olmec period were known to the Aztecs, such as those at Chalcatzingo in Morelos; here the Aztecs built a stairway on the side of the cliff and may have found inspiration in these Olmec reliefs.

Although stone outcrops and hills were not necessarily marked by sculpture or architecture, most unusual locations were associated with nature spirits who were venerated at certain times. Such observance probably originated before the Postclassic period. In the fall, during the festival of Tepeilhuitl, the Aztecs venerated the mountains around the Valley of Mexico, as well as their ancestors who were believed to have lived there. On Mount Tlaloc, one of the largest volcanoes in the Valley of Mexico, a shrine was dedicated to the rain god Tlaloc: sixteenth-century chroniclers described its main idol as a statue with a vessel on its head, an image the Aztecs attributed to their Toltec predecessors (Wicke and Horcasitas, 1957). A child sacrifice to Tlaloc was said to have last taken place here in the nineteenth century. Mountains in modern folk belief are still places of nature spirits, including rain dwarfs and enchantresses, and their caves are believed to contain hidden treasures. Mountains with caves, such as Chicomoztoc and Culhuacan, were the mythic homes of origin for

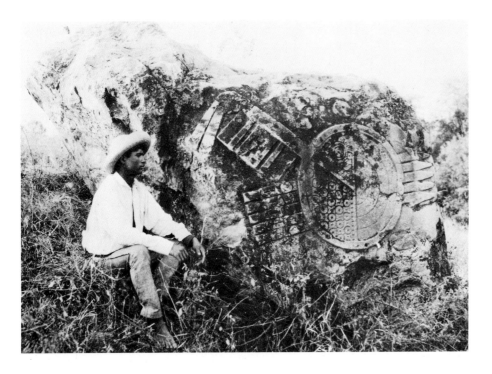

Plate 66. Relief of Shield and Weapons, on boulder at Cuernavaca, Morelos. Aztec, 1350–1519

the Aztec tribes, and provided places of refuge in time of trouble. Nezahualcoyotl hid in the hill of Tetzcotzingo after his defeat by the Tepanecs, and at one time Motecuhzoma II planned to hide at Chapultepec from the advancing Spaniards.

The Aztecs had migrated into a land that was full of places sacred to local nature deities since the Classic and even Preclassic periods, and they inherited the cults of many of these natural spirits. At the same time, they marked their own presence by sculptures and temples cut into the rock. Like foreigners discovering in a new country beautiful landscapes and unusual natural formations, the Aztecs took such places for the focal points of their shrines and pleasure gardens. By carving into the living rock they were visually possessing the land for themselves and their descendants. Although the Mexica carved spears and shields, obvious images of conquest, on the rocks of conquered territories, as at Cuernavaca (Plate 66), they were concerned that their gods should coexist elsewhere with the local gods. As twin pyramids were dedicated both to a local nature god and to an Aztec patron or war god, the mountain and rock shrines often had associations with the nature gods and with dynastic and martial themes. Many reliefs have accompanying glyphs, but the significance of these dates is not always clear. Some perhaps refer to known rulers and peoples; others may have been carved at any time during the Postclassic period.

CERRO DE LA MALINCHE, TULA. The reliefs of Cerro de la Malinche near Tula express best the Aztec desire to represent visually their legitimacy in the Valley of Mexico. The two panels, set high on a cliff overlooking the now-ruined city of Tula, display a frontal goddess and a man in profile with a feathered serpent (Plates 67, 68). Because the glyph 1 Reed, the birth and name date of Quetzalcoatl, is carved above the male figure, this relief apparently shows the legendary Toltec ruler, but Nicholson (1957) has noted that the relief is not Toltec in style but Aztec, and very likely Mexica. The figure is drawing blood from its ear, like the rulers Ahuitzotl and Tizoc on the Dedication Stone of the Main Temple (see Plates 94–96). This act of penance was per-

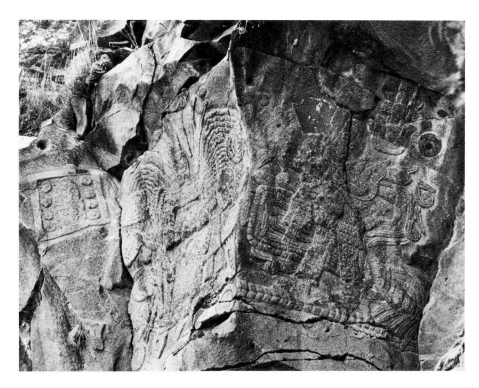

formed during the coronation ceremonies of an Aztec ruler and does not appear in art in central Mexico prior to the Aztecs. The Tula relief with the serpent is similar to the Aqueduct Relief showing Ahuitzotl (see Plates 118, 119) and may have been

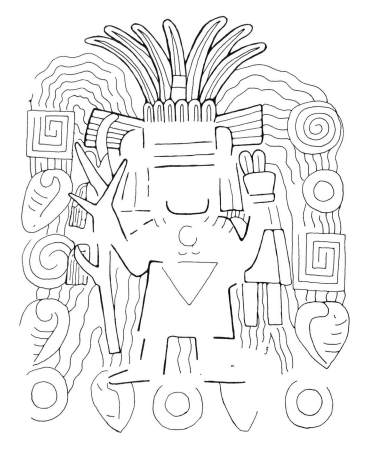

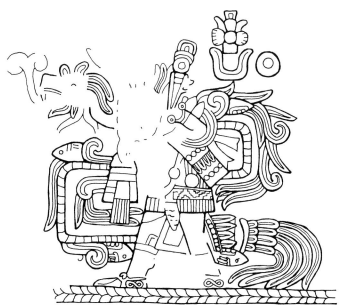

Plate 68. Drawing of Maize–Water Goddess (left) and Quetzalcoatl (below), cliff relief at Cerro de la Malinche, Tula, Hidalgo. Aztec, 1486–1519 (after Krickeberg, 1969, fig. 18)

done during his reign (1486–1502). Tula was conquered by the Mexica under Mote-cuhzoma I (1440–1469) and its art had been imitated in some of the earliest reliefs associated with the Temple of Huitzilopochtli at Tenochtitlán (see Plates 86–88).

Why did the Mexica carve the image of a Toltec ruler on a rock near Tula? The Mexica rulers, beginning either with Motecuhzoma I or Ahuitzotl, had decided to carve images of themselves in the rock at Chapultepec, and to show that they were following the tradition of the Toltecs, with whose dynasty they were linked, they carved the image of this legendary ancestor above his ruined city.

The maize–water goddess next to Quetzalcoatl is probably the local spirit of the mountain worshiped by the Toltec ruler. Her frontal pose with outstretched arms holding a maize plant and a ritual staff is similar to the pose in a number of relief panels. These frontal figures also resemble the maize and water deities depicted in the murals at Teotihuacán (see Plate 10; Colorplate 2), and may have had some archaic connotation for the Mexica.

CHAPULTEPEC. The sacred mountain shrine of the Mexica rulers was Chapultepec, a hill on the west shore of Lake Texcoco. The architectural and sculptural remains on this hill were destroyed by order of Bishop Zumárraga in 1539, by the building of a viceregal palace on the top of the hill at the end of the seventeenth century, and by vandals using explosives in the late eighteenth and early nineteenth centuries. The site is now part of a park with museums, zoos, and playgrounds, a popular Sunday outing place for Mexico City.

Originally Chapultepec had gardens, temples, palaces, and cliff reliefs. Recently excavated from a shrine is a Tlaloc sculpture. This mountain was dedicated in part to nature deities, like so many others, but it is most famous as the place where the Mexica rulers had their portraits carved in the rock. This practice is attributed to Motecuhzoma I by Durán and Tezozomoc. Both authors describe how Motecuhzoma and Tlacaelel discussed the erecting of these portraits, to be more permanent than the wooden statues erected for Toltec rulers. Durán illustrates Motecuhzoma I sitting for his portrait (see Colorplate 19), which appears to be a cliff relief. Besides Motecuhzoma I, Axayacatl, Ahuitzotl, and Motecuhzoma II were said to have been sculptured on the rocks, but the earliest Spanish descriptions of the actual carvings refer to two figures, not four. These may have been Motecuhzoma II and Ahuitzotl or Axayacatl. Only one figure survives; perhaps the fragmentary relief of a shield carved nearby belonged to the portrait of another ruler.

Although battered (Plate 69), Motecuhzoma II's portrait was conclusively identified by Nicholson (1961). Motecuhzoma is said to have ordered his portrait when he was fifty-two years old in 1519, a time close to the first report of the coming of the Spaniards. The relief, carved by fourteen sculptors, was completed in thirty days. Motecuhzoma is shown in high relief, standing frontally, and holding a rattle staff. He is dressed in the costume of the flayed god Xipe Totec, which was the military costume of the Aztec ruler. The figure, which measures four feet five inches to the shoulder, must have been about lifesize—the ruler was said to be about five feet four inches tall—and quite realistic. This is possible given the tendency for realism that developed in the court sculpture under Motecuhzoma II.

Motecuhzoma has his name glyph, the royal headdress and nose plug carved next to him, identified by Umberger (1981, pp. 66–71). The large date glyph 2 Reed represents the year 1507, that of the New Fire Ceremony, so lavishly commemorated on sculptures such as the Temple Stone that Motecuhzoma clearly considered it the major event within his reign. The animal with the spiky outline represents the date

Plate 69. *Portrait of Motecuhzoma II, cliff relief at Chapultepec, Mexico City. Stone, height 2.58 m. 1502–20*

glyph 1 Crocodile, perhaps the coronation date of Motecuhzoma and of other Aztec rulers. The glyph 1 Reed on the other side of the figure may have multiple meanings, perhaps referring to the year of the carving of the relief and the coming of the Spaniards in 1519. Motecuhzoma was therefore portrayed when he was as old as the Aztec "century" of fifty-two years, a coincidence that must have had mystical significance for him.

Chapultepec, meaning "grasshopper hill," had importance for the Mexica as the place of their first settlement in the Valley of Mexico region, as illustrated in the Codex Boturini (see Plate 150), where they elected their first king and performed the first human sacrifice. As a place connoting the royal ancestors, Chapultepec was appropriate for their commemorative portraits; it was also associated with the last Toltec king, Huemac, who was said to have disappeared with his treasures into one of its caves. It was Huemac's advice that Motecuhzoma II sought in dealing with the Spaniards and in planning his own escape. Chapultepec was also a priceless natural treasure for Tenochtitlán, its springs supplying fresh water through aqueducts for the city's use.

The fragmentary condition of Chapultepec as a mountain shrine makes its complete meaning and iconography impossible to reconstruct. Probably Chapultepec was sacred to the Mexica as Tetzcotzingo was to the Acolhua. Not only the appearance of the remains suggests a parallel; they were also designed in the same period. At the time that the aqueduct of Chapultepec was built on Nezahualcoyotl's advice and the first commemorative sculpture of Motecuhzoma I was probably carved in the cliffs,

Nezahualcoyotl was building Tetzcotzingo, which is better preserved than Chapultepec, despite the destruction ordered and supervised by Bishop Zumárraga, and subsequent vandalism and treasure hunting.

TETZCOTZINGO. Tetzcotzingo is a small oval hill over 500 feet high, a few miles southeast of Texcoco. The building project was begun in 1455 on Nezahualcoyotl's fifty-second birthday and completed twelve years later. Its iconographic program is the most complex to survive in Aztec architecture. A description by Fernando

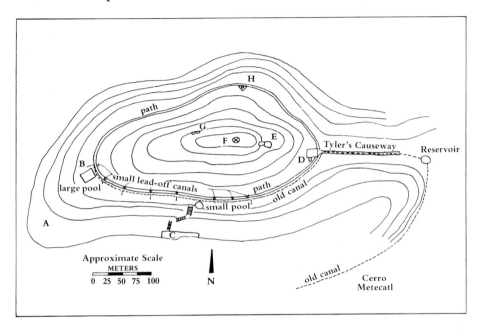

Plate 70. Plan of Tetzcotzingo, near Texcoco. 15th century (after Parsons, 1971, fig. 24)

Alva Ixtlilxochitl, a chronicler descended from the Texcocan rulers but born after the destruction of the site, gives much information on the meaning of the monuments. His emphasis is on the gardens: "all the rest of this forest was planted with a variety of trees and sweet-smelling flowers; and in them a variety of birds, except those from various places which the king kept in cages, made a harmony and a melody so that people could not hear themselves" (Parsons, 1971, p. 123).

To turn Tetzcotzingo into a garden and shrine, water was brought in by aqueduct from the nearby Cerro Metecatl along a 500-foot causeway by way of a stone-lined reservoir (Plate 70). The canal then followed a road cut into the hill on the south side and provided water for two masonry pools and for the gardens below. Many small canals branch off from the main one to scatter water that would "fall like rain," according to Ixtlilxochitl. The first pool, called popularly the "Queen's Bath," is a round depression three feet deep carved into a rocky outcrop (Colorplates 26, 27). It is framed by niches in a stepped design. Stairs lead down to what may have been a palace structure near the gardens below. The canal continues to a large masonry enclosure containing the second or "King's Bath," 10 1/2 feet in diameter, with a sculptured stone frog on one side. Here the canal stops, but another small pool is cut into the rock on the north side (H). A roadway encircles the hill and steps lead to temples at different levels. Three rock-cut temples have the remains of walls and stairways at D, E, and G; these were once ornamented with relief sculptures, but all that survive are the feet and portion of one headdress of two figures at G, popularly known as portraits of King Nezahualcoyotl and his son Nezahualpilli (Plate 71). At

Plate 71. *Relief of Two Figures, almost completely destroyed. Rock, 2.5 × 3.25 m. Tetzcotzingo, near Texcoco. 15th century*

Plate 72. *Headdress fragment (upside down as it now lies) below right-hand figure in Plate 71. Rock, height 1.1 m. Tetzcotzingo, near Texcoco. 15th century*

Plate 73. *Drawing of Two Frontal Goddess Figures Carved in a Cliff. Codex de Teotenantzin. Manuscript, 44 × 117 cm. Valley of Mexico. 18th century. Museo Nacional de Antropología, Mexico City*

the top of the hill a relief of the rain god Tlaloc is carved in the rock. A cave has recently been found near terraces at A that is said to lead 200 feet into the hill.

Tetzcotzingo was principally a place of recreation where the ruler could enjoy his gardens. His palace is described as large enough to entertain other rulers in the valley, and Nezahualcoyotl slept in a highly unusual round bedroom. The gardens were ornamental, practical, and symbolic. The gardeners tried to acclimatize plants from different parts of Mesoamerica and to introduce them in the Texcoco region. The Mapa Quinatzin shows the Texcocans experimenting in growing different types of maize and food plants (see Colorplate 39). They were also greatly interested in plants having medicinal properties: several hundred of these were known. The dam and many canal stones of the aqueduct are still well preserved. Numerous waterspouts were carved in the form of tenoned heads. A monkey-head spout (Plate 74) is said to come from Tetzcotzingo and may have been part of these waterworks.

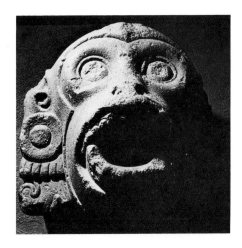

Plate 74. *Monkey-head Spout. Stone, 40 × 47 cm. Tetzcotzingo, near Texcoco. 15th century. Museo Nacional de Antropología, Mexico City*

The gardens of Tetzcotzingo were not unique. The Mexica botanical gardens were in Uaxtepec, near modern Cuernavaca in the State of Morelos. In this location of hot springs and fertile soil, exotic plants were grown. The Uaxtepec gardens still existed in the 1570s when Francisco Hernández, a botanist sent from Spain by King Philip II, came to study its plants. The Aztecs did not distinguish scientific from religious knowledge, and these botanical gardens with adjoining zoos, in which attempts were made to grow or keep examples of all known flora and fauna, were meant to be miniature replicas of their universe.

Although the Tetzcotzingo "baths" suggest to us a place of pleasure, they were more likely ritual fountains. Umberger noted a passage in which Ixtlilxochitl associates the three pools with cities: the Queen's Bath with Tenayuca, whose glyphic symbol was a wall having a stepped design; the King's Bath with Lake Texcoco, with the frogs on its shores, perhaps originally three, representing the allied cities of Texcoco, Tenochtitlán, and Tlacopan; and the third rock-cut pool with the ancient city of Tula. According to Umberger (personal communication), the walkway connecting the pools may represent the earth and the three major cities and ethnic groups that were important for Texcoco.

Texcoco's Toltec ancestry was shared with the Mexica and other Nahuatl groups. Apart from this, the Texcocans derived their dynasty from the Chichimecs led by Xolotl, whose first settlement in the lake area was at Tenayuca; the symbol of Tenayuca was therefore specific to the Texcocans. The second pool represents the Aztec empire of the Triple Alliance, in which Texcoco was the second most important power. It is significant that the Toltec pool is at a distance, not part of the Aztec hydraulic system. The use of pools carved or built into rock to represent cities is a graphic illustration of *altepetl* (water–mountain), the name for city or settlement.

The absence of much of the sculpture makes the dedication of the temples more difficult to identify. Ixtlilxochitl and other early chroniclers referred to a calendar wheel, or perhaps a sun disk, but its location is now unclear. The temples were one-room structures with a thatched roof, and holes for the wooden beams are still to be seen in the rocks. The carvings of the frogs, and of Tlaloc on top of the hill, indicate the association of Tetzcotzingo with water and rain deities, frequently the case in mountain shrines.

The carved figures at G were built into a rock-cut enclosure and platform (Plate 71). While they are thought to represent the great rulers of Texcoco, Krickeberg has shown that the surviving headdress fragment which lies in front of the relief (Plate 72) is like the temple headdress of the maize goddess (1949, p. 107). This headdress is similar to sculptures of the goddess (see Plates 155, 180–82), and to the imper-

sonator of the harvest deity in the Codex Borbonicus (see Colorplate 34). Umberger brought to my attention an eighteenth-century drawing that shows two frontal goddesses carved in a cliff that resembles Tetzcotzingo (Plate 73); it is supposed to represent the main images in the sanctuary of the mother goddess Tonantzin at Tepeyacac, also a cliff relief. At Tepeyacac is now located the church of the Virgin of Guadalupe, one of the most important pilgrimage centers in Latin America, where the cult of the Virgin Mary was clearly introduced to supplant the cult of the Aztec mother goddess. (According to legend, the Virgin appeared in this location to Juan Diego, a converted Indian, in 1531. Bishop Zumárraga then ordered the building of the church and probably the destruction of the old reliefs.)

The relief of the goddess at Tula, the Tetzcotzingo figures, and the drawing of Tepeyacac all make it clear that the Aztec maize-water-earth goddesses were represented as frontal figures on a number of cliff reliefs. They were thus literally formations of the earth. The figures at Tetzcotzingo face west, toward the mythical land of women and, in Aztec thought, the entrance to the underworld (Klein, 1976a).

The carvings at Tetzcotzingo also had specific references to Nezahualcoyotl and his achievements, but we know of these only from textual descriptions. There were supposed to have been reliefs of major events of his reign, as well as portraits of his vassal lords, carved near a calendar wheel. These were all destroyed in the belief that they were heathen idols. Near the top of the hill there was a relief of a coyote with a man's head in its mouth probably representing the name glyph of Nezahualcoyotl, or "fasting coyote," and the glyph for the city of Texcoco, a hill with a stone and a vessel inside it. The most personal reference in the iconography of Tetzcotzingo was a date carved on a stairway. According to Ixtlilxochitl, this commemorated the sad day when Nezahualcoyotl heard the news that a Huejotzingo prince, whom he had loved during his exile, had died.

Complex symbolic meanings can be seen in Tetzcotzingo, even in its mutilated state. It was a microcosm of the universe, and of the history of Texcoco as personified by Nezahualcoyotl (Townsend, n.d.). The temples and reliefs were probably related to the four directions in significance. Umberger (personal communication) suggests that the top of the hill may have been the upperworld, the bottom the underworld, and the middle, with its processional paths and "cities," the surface of the earth. This natural world was represented by the plants and animals in the gardens at the lower levels; in man's world were the fountains signifying cities in Texcocan history, and the reliefs of Nezahualcoyotl, whose personal, sacred place this was. The mountain symbolism included the cave origins of the people, as in the Mapa Quinatzin (see Colorplate 39); the refuge of Nezahualcoyotl during the conquest of Texcoco by Tezozomoc; and Nezahualcoyotl's triumphant reconquest of his kingdom with the aid of the first alliance. Tetzcotzingo thus associated the empire of Texcoco with its ruler's magnificent practical and political achievements. Begun in a year of famine, the gardens celebrated the plenty Nezahualcoyotl's reign would bring.

Although the Aztecs were not the first to worship at sacred places in the landscape, they were the first to combine in their mountain shrines the works of man—canals, gardens, temples, and reliefs—with the manifestations of nature—hills, caves, springs, and rocks. Far more than any previous group, the Aztecs had transformed the Valley of Mexico by intensive agriculture, hydraulic works, *chinampas*, and by harnessing nature to support their cultural pursuits. Their success in these undertakings was sometimes dramatically reversed by floods or droughts causing widespread famine and

suffering. The Aztecs saw these disasters as manifestations of the gods' anger, and they sought to pacify them through sacrifices and rituals. In building the mountain shrines they were creating paradisical environments, places for ritual and contemplation, representing the harmonious integration of nature and the works of man, where nature was allowed to remain prominent. This concept may have been developed by Nezahualcoyotl, a thinker much interested in the relationship of man with nature and with the supernatural. The design of Tetzcotzingo may represent his philosophical tenets about the universe and man's role in it.

THE TOLUCA–CUERNAVACA AREA. While Chapultepec and Tetzcotzingo were mountain shrines where the Mexica and Texcoco dynastic origins were venerated, two mountain shrines in the Toluca–Cuernavaca area, Tepoztlan and Malinalco, were built in enemy territory that had been subsequently colonized by the Mexica; thus their iconographic programs were different. The area around Toluca and Cuernavaca is mountainous in the north, sloping down through spectacular scenery into warm subtropical land in the south. To the Mexica this area was at once foreign and exotic yet near and familiar. They were attracted to the region from early times and conquests began in the reign of Itzcoatl, but the region was not fully controlled until Ahuitzotl's reign. The area had strategic importance for the military, for through it passed routes west to the Tarascan kingdoms, southeast to Oaxaca, and east to the Mixteca. It was colonized in part to support the war against the Tarascans, an unsuccessful project.

In the region lived Matlatzinca and Tlahuica groups, related to the Mexica but having a different cultural outlook. Motecuhzoma I's mother was a princess from Cuernavaca, who, according to legend was made miraculously pregnant by one of Huitzilhuitl's arrows (Davies, 1974, p. 50); the story is parallel to that of Huitzilopochtli's supernatural birth. Motecuhzoma I is credited with building a pleasure garden in Uaxtepec near Cuernavaca, where he escaped among its hot springs and exotic flowers from the cold city of Tenochtitlán. The area is also mentioned in the Mexica migration legends: when the sister Malinalxochitl and her people are left behind by the Mexica, she founds Malinalco and sends her son Copil to avenge her in battle with the Mexica at Chapultepec. With his capture Malinalxochitl involuntarily provided the sacrificial victim whose heart, thrown into the lake, determined the future location of the Temple of Huitzilopochtli. In the histories she is an evil sorceress; the people in this area were famous for their knowledge of the occult.

Some of their most important gods resided in caves where there were also oracles (Giménez, 1978, pp. 70–72). In recognition of this, the Spaniards established the worship of the Christ of Chalma, associated with a prehispanic cave shrine near hot springs still used for ritual baths today. The cult is second in importance in Mexico only to that of the Virgin of Guadalupe. We do not know the name of the cave deity worshiped by the Aztecs, but he may have been related to Tepeyollotl, the jaguar god of the interior of the earth, or to Tlaloc, god of rain and the earth. Some of these cave deities were female, since caves often symbolized the womb of the mother goddesses. A cliff relief at Acatzingo near Malinalco may represent a goddess unusual in Aztec sculpture for being nude (Plate 75), seated cross-legged with her genitals indicated (Krickeberg, 1969, pp. 124–30); or the figure might be male, the marks on the abdomen representing a loincloth. Umberger suggests that the sculpture represents a man wearing an heirloom necklace, and that the date carved near his head, 2 Reed, refers to 1507 (1981, pp. 164–67). Near to the relief is the mouth of a freshwater

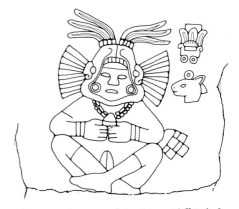

Plate 75. Drawing of Acatzingo Cliff Relief in Toluca area (after Krickeberg, 1969, fig. 80)

spring. The sculptures representing female deities in the Toluca area are unusual in showing luxuriously dressed women, gaudy in comparison to the more puritanical Mexica ideal (see Plate 185).

Besides its female deities symbolizing sexuality, the area was famous for its cult of *pulque* drinking. Tepoztlan's patron deity was 2 Rabbit, called Tepoztecatl, who was a god of alcoholic excess. The sixteenth-century Codex Magliabecchiano, which may refer to the gods of this area, represents a dozen different gods of *pulque*. Xochiquetzal, the major goddess of Cuernavaca, was also a goddess of sexuality and drunkenness (Broda, 1971, p. 308). *Pulque* and drunkenness symbolized fertility and abundance. The local cults of drunkenness, sexuality, and sorcery all looked dangerous to the spartan outlook of the Mexica warrior aristocracy, but they were also enticing.

The Toluca–Cuernavaca area was fully conquered by Ahuitzotl (1490–1501), and populated by so many Mexica colonies that Cortés could not count on local allies to help him and feared being ambushed. Ahuitzotl is credited with erecting a twin temple now in the modern city of Cuernavaca, called Teopanzolco (Plate 63), and the temple at Tepoztlan, and with beginning the temples of Malinalco, which were still being built when the Spaniards arrived.

TEPOZTLAN. The temple of Tepoztlan has a dramatic site on top of a mountain out-crop eroded into fantastic shapes. After an arduous 2,000-foot climb above the village, a magnificent panorama spreads out before the visitor. The temple, on a pyramid platform, is a rectangular structure with a veranda and an inner room (Plates 76–78).

Plate 76. Exterior of Mountaintop Temple at Tepoztlan, Morelos, built by Ahuitzotl. 15th century

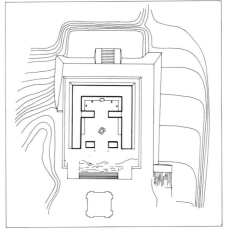

Plate 77. *Interior of Mountaintop Temple at Tepoztlan, Morelos. 15th century*

Plate 78. *Plan of Mountaintop Temple at Tepoztlan, Morelos. 15th century (after Marquina, 1964, pl. 62)*

A low bench follows the wall and there is an irregular hole in the center of the floor of the front room. Pieces of *tezontle*, carved stones, found in the rubble raise the possibility that the structure had some form of vaulted stone roof, which would be unique in central Mexican architecture (Marquina, 1964, pp. 218–20). The relief of a water monster representing the mythical beast *ahuitzotl*, the name of the ruler, was found built into the wall (Plate 79).

Reliefs ornament the walls and the bench. The wall reliefs are mainly decorative rows of feathers, circles, and frets; the bench relief is a frieze of symbols. Seler has suggested that the images represent funerary insignia, such as headdresses and the paper ornaments of valiant warriors (1902–23, III, pp. 487–513). The reliefs are difficult to interpret because they do not resemble other known monuments. The emblems of the frieze are not glyphs with numbers; among them can be recognized the royal diadem and a design of shields and spears, referring to the Aztec ruler and military conquests. Other emblems have elements of water or liquid drops, similar to the stream of liquid on the plaque of Ahuitzotl. There is a headdress of a fertility deity with a paper fan, and the half-moon nosebar of the *pulque* gods. The frieze may therefore consist of emblems of the *pulque* cult combined with references to Ahuitzotl as conqueror of the region.

The function of the temple at Tepoztlan (like that at Malinalco) was to express Mexica power, both military and religious, in a conquered territory. Its purpose was to caution against rebellion, equating rebellion with the destruction of the natural order and cosmic chaos. As the Spaniards would do later, the Mexica built their temples to supersede temples of the local population. This was a two-fold process: they usurped the cult expressions of the local population with their own, while imposing Mexica cults. This process was probably the stimulus behind the building of Tepoztlan also, but it is especially evident in the rock-cut temples of Malinalco.

MALINALCO.　Malinalco is hidden in the mountains thirty miles east of Tenantzingo. Its temples escaped major destruction by Spanish hands and were cleared only in the 1930s, making this one of the best-preserved Aztec shrines (Krickeberg, 1949,

Plate 79. *Ahuitzotl, Relief from Wall of Temple. Tepoztlan, Morelos. 15th century. Museo Nacional de Antropología, Mexico City*

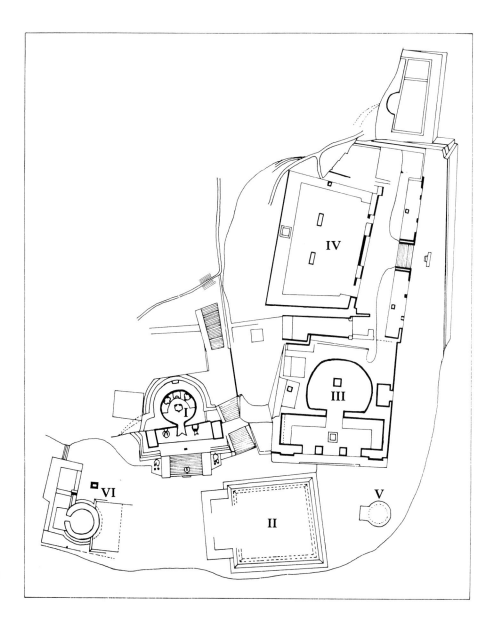

Plate 80. Plan of Temples at Malinalco,
probably built by Motecuhzoma II. 1502–20
(after Marquina, 1964, pl. 59)

pp. 123–97; Marquina, 1964, pp. 204–16). The complex consists of seven structures
on two sides of the corner of a hill, partly carved into the cliff and partly built of
masonry (Plate 80). The buildings are not aligned or symmetrically arranged. Four
of the structures were partly or completely round, an unusual form in Aztec architec-
ture. One platform, structure V, is so small that it must be a pedestal rather than a
building. A fragment of a mural painting was found in structure III, a representation of
a procession of warriors along a path decorated with jaguar spots (Plate 81). This is
the only example of Mexica mural painting that, in its proportions, design, and
quality of outline, equals the best of Mexica sculpture.

The most elaborate building is structure I, carved almost entirely into the cliff
(Plates 82, 83). It has the form of a temple, including its related sculptures and sacred
objects inside and outside. As such it is the largest example in the category of Aztec
works in stone that are copies of works in other mediums (see Plates 124, 256–58),
a tour de force in its concept and execution. This grandiose scheme is parallel to that
in sculptures such as the Calendar Stone, late developments in Mexica art.

The creation of a complete temple with its paraphernalia, all cut from the living

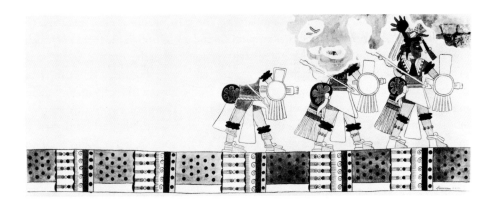

Plate 81. Reconstruction of Mural Painting, Temple III, Malinalco (rendering by Miguel Angel Fernandez)

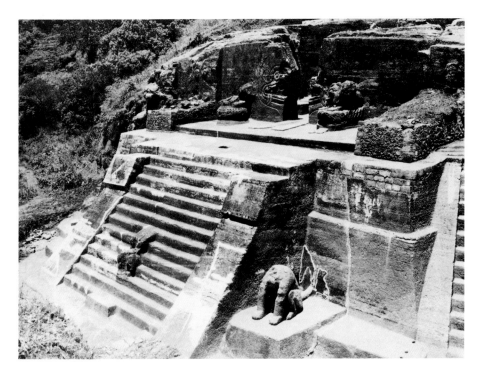

Plate 82. Exterior of Temple I, with Doorway in form of a Serpent Mouth, Malinalco

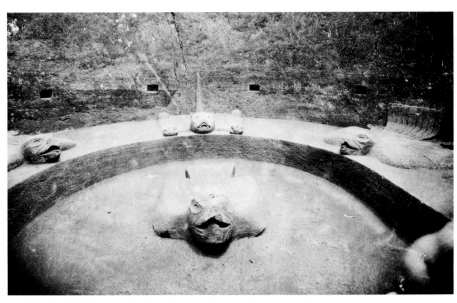

Plate 83. Interior of Temple I, with Jaguar and Eagle Pelts as Seats, Malinalco

rock, must have amazed the local population. The relationship is clear between the three-dimensional sculptures and the temples. Attendant figures in the form of crouching animals, possibly felines, flank the stairway on pedestals; on the stairway are preserved the legs of a figure, possibly a standard bearer. Figures also flanked the doorway of the chamber; on one side is a drum, on the other a fire serpent, and standing upon them are lower parts of the legs of figures. The doorway of the temple is in the form of a monstrous serpent maw in low relief, with fangs at the corners of the mouth—one actually walks on the monster's bifid tongue, carved into the floor of the temple chamber. The interior of the building is round, almost ten feet in diameter, with a low bench along the back wall. Entering, one is met by a dramatic sight: three animals carved on the bench and one on the floor, their three-dimensional heads raised, mouths and beaks open and facing the door. Two eagles flank a central jaguar on the bench; another eagle is on the floor. Their bodies are flattened to form seats, and they represent pelts rather than living animals. In front of the jaguar there is a hole in the floor, and another in the top of the pyramid platform.

Because eagle and jaguar images are so prominent, the building at Malinalco is usually interpreted as a dedication to the cult of the warriors. The elite warriors of the Mexica were entitled to wear such animal costumes, illustrated in the Codex Mendoza (see Colorplate 14), and warriors are seen in the mural painting in structure III. On a wooden drum that probably comes from Malinalco (see Plates 289, 290), eagles and jaguars stand for warriors with sacrificial banners; the figures flank the symbol of 4 Movement, referring to the fifth sun, the era of the Mexica, and war signs emerge from the animals' mouths. Although this imagery is filled with symbols of warfare, Malinalco was not necessarily built as a shrine for the rites of elite warriors. The eagle and jaguar pelts are not idols in themselves, they are seats providing support for people or objects that are no longer there.

Other aspects of the meaning emerge when the façade of the rock-cut building is examined. In Aztec iconography, a monster's open maw represents a cave, as in the sign for Teotihuacán in the Codex Xolotl (see Colorplate 6). Monster-maw entrances into caves or buildings are known in Mesoamerican sculpture and architecture since the Olmec period. The entrance unquestionably signifies a cave in the interior of the earth; it is in fact a man-made cave. The round form probably refers to natural caves, in opposition to rectilinear construction usual in architecture. It may also have a female connotation as the womb of the earth.

We do not know the name of the deity to whom the Malinalco temple was dedicated, but the temple symbolized the Aztec empire victorious beyond the Valley of Mexico. Since the major deities of the Malinalco area lived in caves, the Mexica monument celebrating the conquest represents a cave furnished with the images of Mexica warrior symbolism. To the Mexica, Malinalco was associated with Huitzilopochtli's enemy sister Malinalxochitl, now conquered by the Mexica. The jaguar seat may also be a symbol of the Aztec ruler, who alone had the right to sit on a jaguar mat. Perhaps the Mexica ruler used the temple when he was in the area and sat with his advisors on the jaguar and eagle thrones, literally occupying a cave sacred to the local population.

IV

THE MAJOR MONUMENTS
OF TENOCHTITLÁN

Introduction

When the Spanish conquerors entered Tenochtitlán they saw many sculptures and idols, but the destruction during and after the conquest was so complete that by the end of the eighteenth century there were few major Mexica monuments to be seen. Monuments were known from the conquerors' descriptions and the sixteenth-century chronicles. Sculptures not buried at the time of the conquest were either destroyed by the Christians or hidden by the natives. Even in 1790, when reconstruction work on the foundations of the Cathedral uncovered the first Mexica sculptures in Mexico City, they would have been cut up for cobblestones had an enlightened priest not saved them. The chroniclers who had access to native informants considered the monuments to be works of the devil and did not ask questions about them or have them illustrated. One of the few pictures of an Aztec stone sculpture in a sixteenth-century manuscript is seen in Durán (Plate 84), showing a prisoner tied to a stone that bears a carved sun glyph on it. But it is difficult to match up the works that have been accidentally preserved for us with the texts that we have.

The major monuments of Tenochtitlán constitute one of the great traditions of sculpture in the world. They are remarkable for their colossal size, their technical refinement in detail and polish, their juxtaposition of realism, abstraction, and grotesque imagery, and the complexity of their iconography. They reflect the changing ideas the Mexica rulers had of their history and religion. Unlike the chronicles, in which historical information is filtered through the sixteenth-century vision of Aztecs and Spaniards, these sculptures express directly the beliefs and preoccupations of the Mexica elite at the time the works were commissioned.

Conquerors and chroniclers describe two types of major monuments: the idols placed in and around temples, and ritual stones, such as those used as sacrificial vessels or as platforms for gladiatorial combat. No idols from the main temples have survived—not surprisingly, for the missionaries concentrated their zeal especially against them. These main idols were made of wood, dough, or stone, and covered with precious stones. Of the Mexica patron deity, Huitzilopochtli, we do not have a single example in stone, but Bernal Díaz gives the following description of the sculpture he saw in Huitzilopochtli's temple:

> They said that on the right was Huichilobos, their war-god. He had a very broad face and huge terrible eyes. And there were so many precious stones, so much gold, so many pearls and seed-pearls stuck to him with a paste which the natives made from a sort of root, that his whole body and head were covered with them. He was girdled with huge snakes made of gold and precious stones, and in one hand he held a bow, in the other some arrows. . . . Around Huichilobos' neck hung some Indian faces and other objects in the shape of hearts, the former made of gold and the latter of silver, with many precious blue stones.
> (DÍAZ DEL CASTILLO, 1963, P. 236)

Plate 84. Prisoner of War Standing on a Stone Bearing "4 Movement" Glyph. Durán's Historia de las Indias de Nueva España y Islas de Tierra Firme, Bk. 1, ch. 10, fol. 271r. Manuscript. Valley of Mexico. Early Colonial, c. 1570. Biblioteca Nacional, Madrid

139

Plate 85. Engraving from "A Description of the Unique Exhibition Called Ancient Mexico: Collected on the Spot in 1823 by the Assistance of the Mexican Government and Now Open to Public Inspection at the Egyptian Hall, Piccadilly," by W. Bullock, London, 1824 (showing the Calendar Stone, Coatlicue, and Stone of Tizoc)

Judging from this description, the statue of Huitzilopochtli may have had features in common with that of Coatlicue (Plate 110). It is noteworthy that Bernal Díaz emphasizes all the precious metals and stones on the surface of the monument, but never tells us what material the statue was made of.

Many references are made in the chronicles to the Mexica rulers erecting colossal monuments. Motecuhzoma I was reputed to have erected a giant circular *temalacatl*, or stone for gladiatorial combat, on which his conquests were represented (Durán, 1964, pp. 119–20); and after a successful campaign in Toluca, the emperor Axayacatl ordered a new *cuauhxicalli*, a sacrificial vessel, and a *temalacatl*. The monuments described in the sources were ordered by rulers, and intended for use in rituals; they were ornamented with images of the greatness of the Mexica and their gods. The Calendar Stone and the Stone of Tizoc may belong in a category of commemorative monuments, although the available evidence does not permit us to determine whether they were offering-vessels or gladiatorial combat stones, or served some other function.

The first group of Mexica monuments, as mentioned above, came to light in Mexico City in 1790 when the Cathedral foundations were being repaired (León y Gama, 1792). At that time the Calendar Stone, the Stone of Tizoc, and the statue of Coatlicue were found. The Stone of Tizoc and the Calendar Stone remained above ground, but the priests reburied Coatlicue. In 1823 an enterprising Liverpool jeweler, William Bullock, wanted to have plaster casts of them for exhibition in the Egyptian Hall on Piccadilly (Plate 85). Coatlicue was dug up for the purpose of making the cast, which was shipped to England, but the Mexican peasants put garlands of flowers on the original and it was reburied lest it foster a return to idolatry. It is amazing that as late as the nineteenth century Mexican officials should still have feared the power of an Aztec monument. The engraving of the Piccadilly exhibition is correct in general, but nothing corresponding to its great serpent seen on the left has ever been found; it might have been invented to awe the English public.

A museum was established in Mexico City in 1825 and subsequently the three Mexica monuments, along with a number of others found near the Cathedral and in other parts of Mexico City during the nineteenth century, were assembled there;

by 1900 most of the major Mexica monuments were known. But in that year, during Cathedral repairs at Escalerillas Street, a corner of the Temple of Huitzilopochtli was found, together with many sculptures, incense burners, jades, and other associated offerings (Batres, 1902). In the course of the Metro excavations, begun in 1966, one major monument has thus far been uncovered, the seated Metro Earth Monster. In 1978 a new colossal disk with a relief of Coyolxauhqui was found near the Cathedral. There may still be many sculptures in the foundations of Mexico City, but the dozen or more now excavated give us a fair idea of the course of artistic development.

Major monuments are distinguished from the rest of Aztec sculpture by their stylistic, iconographic, and historical value. Unlike most Aztec sculpture, these figures are often very large, even colossal in size, and some are made of precious materials, such as greenstone. They are not merely bigger or better-carved versions of small carvings; their form and iconography are strikingly different from other works. Most of the major monuments have been individually conceived. Part of the drama of recent excavations in Mexico City has been the discovery that the three most important monuments—the Metro Earth Monster, the Coyolxauhqui Relief, and the Greenstone Goddess—are not only different from one another but also from previously known Aztec art. The artists created these major monuments from representations in traditional small-scale sculpture such as boxes and deity figures, from Aztec and Mixtec religious and historical codices, and from the older art of Tula and Xochicalco. The meanings of these monuments are often multivalent and new concepts were expressed by unusual juxtapositions of old images, changing the meanings of the original prototypes. These sculptures are remarkable works for the creativity and originality of their compositions. As unique monuments of great complexity, they can be considered masterpieces in Pre-Columbian art (Pasztory, 1980).

These major monuments have been found almost exclusively in Tenochtitlán. (Kubler [1943] called the artists of this sculpture the Metropolitan School.) They are also remarkable in their large number and their many historical associations. A few fine carvings have also come from Texcoco, Coxcatlan, Tlalmanalco, and Castillo de Teayo, but most of these are smaller in their scale and scope and they will be discussed with the other stone sculptures in Chapter VI. Most of the Tenochtitlán monuments were made for the Main Temple precinct and date from about 1400 to 1520. Within this period, the sculptures not only show technical progress but they also express Mexica values more articulately. It is evident that Mexica workshops brought in artists from other regions, such as Atzcapotzalco and the Xochimilco area. Out of these divergent sources and artistic schools an imperial style had emerged by the end of the fifteenth century.

The Tepanec empire was nearly as large as that of the Mexica, and the city of Texcoco had the reputation of being the artistic center of the Valley of Mexico. Yet in neither were there important schools of sculpture like that at Tenochtitlán. The major monuments of Tenochtitlán can only be understood as imperial monuments, set up for specific reasons. In the beginning, the purpose was to express the legitimacy of Mexica rule by erecting monuments that were copies of Toltec sculptures. But as the Mexica became better established, their monuments expressed their power to rule through colossal size, precious materials and their intimidating iconography that emphasized military conquest. The monuments, like the mass human sacrifices at the dedication of the temple, were intended to impress visitors with the power and wealth of Tenochtitlán, as well as with the military strength of the empire. The colossal scale of the monuments is an imitation of Toltec and Teotihuacán art.

Subsequent Mexica monuments were carved to validate Aztec power on a more

complex astrological level. In addition to references to military conquest and Toltec legitimacy, greater emphasis was placed on divine selection. The era of Mexica historical power was equated with such cosmic events as the creation of the sun, and with a self-conscious evolution of historical thought which assigned the Toltecs and Aztecs to successive stages. These interrelated cosmic and historical events were first expressed by blending human with divine costumes, and later mainly by the date glyphs from the divinatory calendar. Date glyphs were a metaphoric assertion that the Mexica empire was as fundamental to the life of the Valley of Mexico as the divinatory calendar, which governed the practical and religious lives of the inhabitants whose origins were lost in time.

Umberger's 1981 study of the glyphs on Aztec monuments showed that historical and mythological meanings were purposefully combined in the Mexica date glyphs to certify the cosmic import of historical events. Her study has solved one major problem in the interpretation of Mexica art. Nineteenth-century scholars such as Orozco y Berra and Chavero had assumed that the monuments represented historical rulers and the events in their reigns. When attributions made on this basis proved often to be casual and incorrect, scholars working at the turn of the century, notably Seler, Beyer, and Paso y Troncoso, assumed that all historical interpretations were in error, and they identified most figures and dates as gods and mythic events. Their views remained current until a reappraisal began with the work of Nicholson (n.d.) and Townsend (1979). Recent work has demonstrated that historical dates were significant for the Aztecs only if they could be made to coincide with cosmic dates. The Aztecs not only revised historical dates to coincide better with dates of cosmic significance, they selected dates for their practical actions, such as battles or migrations, on the basis of the appropriate divinatory dates (López Austin, 1973).

The carving of dates and glyphs on Aztec stone monuments did not come from either Teotihuacán or Toltec art, for the state art of both these earlier traditions had almost no glyphic inscriptions. Umberger has suggested that the source for glyphic inscriptions was in the Classic period site of Xochicalco (see Plate 16); the tradition of carving glyphs on architecture and sculpture at Xochicalco similarly combined cosmic and historical events, and the Aztecs imitated the Xochicalco sculptural style in the gyphs of tenoned heads (see Plate 53). Xochicalco was called Tamoanchan in Aztec tradition, and was thought to be a paradisical land in the south. Legend attributed the invention of the calendar to the wise men of Tamoanchan at the beginning of the world, prior to the rise of the Toltec and Aztec (Sahagún, 1950–69, bk. 10, pp. 190–91).

Although many of the glyphs on Mexica monuments have more than one meaning, it is possible to place the works in a historical and stylistic sequence. The historical sequence is based on monuments bearing the names of rulers, such as Tizoc, Ahuitzotl, and Motecuhzoma II, and on a few dates whose meaning is particularly clear. The four most important of these works are: the Dedication Stone of the Main Temple, a plaque carved for the dedication ceremony in 1487 bearing the date 8 Reed; the Aqueduct Relief carved for Ahuitzotl's hydraulic project in 7 Reed, 1499; the Temple Stone carved for Motecuhzoma II for the New Fire Ceremony of 2 Reed, 1507; and the cliff relief of Motecuhzoma II at Chapultepec (see Plate 69), carved probably in 1 Reed, 1519. A second source of historical information comes from archaeology, by finding in their original places the early Chac Mool, the Coyolxauhqui Relief, and the Bench Relief. Umberger has suggested a historical sequence on the basis of style and the popularity of different glyphs at different times. She considers each ruler to have had monuments carved in different styles.

In general, Mexica sculpture undergoes four stages of development. The first stage, from 1427 to 1481, consists of crudely executed monuments that imitate Toltec prototypes directly. No ruler is identified on these sculptures by a name glyph. Examples include the Stone of the Warriors, the Bench Relief, and the recently excavated Chac Mool. These monuments may belong to the time of Itzcoatl, Motecuhzoma I, and Axayacatl.

The second stage, from 1481 to 1487, includes the works of Tizoc's reign and the monuments made for the dedication of the Main Temple in 1487. These sculptures are characterized by the use of fine-grained stone, especially greenstone, by fine craftsmanship and polish, and by more complex iconography. The new imagery is derived in part from Mixteca-Puebla manuscript art, and there are also archaistic references to the art of Teotihuacán. The refinement in surface treatment suggests the lapidary arts, and seems to come from adapting small-scale stoneworking techniques to monumental sculpture. The Mexica probably employed artists from southern communities such as Chalco or Xochimilco to make their monuments. The iconographic program is coherent, a strong glorification of Mexica rule in a cosmic context, and it may have been developed by the persons in Mexica history who are supposed to have been the architects of this vision—Motecuhzoma I and his minister Tlacaelel. Some of the monuments that have no names of rulers may have been made at the time of Tizoc, or earlier.

The third stage is coeval with the latter part of Ahuitzotl's reign, which lasted from 1487 to 1502. During this time a Tenochtitlán sculptural workshop must have been firmly established; the style developed toward higher three-dimensional modeling, overlapping of design elements, and a general complexity that sometimes becomes cluttered and unclear. Some monuments planned at the time of the dedication in 1487 may have been completed only later in Ahuitzotl's reign, such as the massive and complex statues of Coatlicue and Yollotlicue (Plates 110, 114).

The fourth stage corresponds with the reign of Motecuhzoma II, 1502 to 1520. These monuments are complex images in which three-dimensional modeling and naturalistic representation predominate. The glyphic inscriptions, some in imitation of the art of Xochicalco, are more complicated, but they are laid out in formal arrangements that have greater intellectual coherence. Allusions continue to art of the past but on these monuments the Toltec past is represented as dead, long superseded by the Mexica: archaistic sculptures include a Toltec standard bearer, a *chac mool*, and a Tlaloc brazier. Some of Motecuhzoma II's monuments refer to earlier events and dates in Mexica history at the time of Motecuhzoma I. It is unclear whether some early Mexica monuments were copies, because so few early sculptures are known. In this chapter the monuments are ordered in part by chronology and in part by their stylistic or iconographic similarities.

The major monuments of Tenochtitlán express an imperial vision of the Mexica, as this was understood by its rulers from Itzcoatl to Motecuhzoma II. The aim of these works was a visual validation of political power. For subject matter there were references to the gods and rulers of the past, to the gods, rulers, and divine mission of the Mexica, and to the role of Mexica history in the context of cosmic time. Rulers were represented, but not as the focus of the compositions as they had been in Maya art; in Aztec art they are infrequent. When they are represented, it is as priests performing penitential rites, or sometimes only as a name glyph. The historical chronicles focus on the individual achievements and personalities of the Mexica rulers, but the major sculptural monuments glorify Mexica rule as a divine and historical necessity, as a suprahuman abstraction rather than a personality cult. The Aztec

viewer was not asked to identify with his ruler as an individual so much as with the ruler as a symbol of the corporate destiny of his ethnic group.

The Early Chac Mool

Excavations in 1979 of the twin pyramids of Tenochtitlán have uncovered what may be the earliest Aztec temple and the earliest sculpture. Set in the floor in front of the temple dedicated to Tlaloc was found the statue of a reclining figure called a *chac mool* (Colorplate 28). Matos (1981) suggests that this may date from 1375–1427. Although the stone and plaster figure is cracked and somewhat deteriorated, its surface color is quite well preserved. *Chac mool* figures are frequent at Chichén Itzá and Tula in the early Postclassic period (see Plate 20). At the entrance of the Temple of the Warriors at Chichén Itzá a *chac mool* is set into the floor, and this Tenochtitlán Chac Mool was positioned likewise. In the minds of the Mexica, *chac mool* figures were associated with the art of the Toltecs and their predecessors in the Valley of Mexico. Since Tlaloc, the rain god, was also believed to be the god of the Toltecs, a statue of Toltec ancestry was appropriate to his temple (Pasztory, n.d.). In some historical accounts, Tlaloc gave permission to the Mexica to settle at Tenochtitlán.

Beside being appropriate for the Tlaloc temple, this Toltec type of sculpture is the first instance of a Mexica copy from the Toltec monumental arts. The Chac Mool is not yet as realistic as later Mexica carvings and it is angular and crudely finished, like its Toltec prototypes; details were evidently painted rather than carved. The paint on the surface of this sculpture is unusual in its fine preservation. The colors include red, blue, white, black, and yellow. A later *chac mool* in the guise of the deity Tlaloc, carved probably during the reign of Motecuhzoma II, illustrates the changes in style and iconography as Mexica art advanced (Plate 137).

The facial part of the Chac Mool statue from the Temple of Tlaloc is weathered, but the figure does not appear to represent a deity. As in Toltec art, the Chac Mool is a scantily dressed male holding a dish on his stomach. He reclines in an uncomfortable position with raised knees, his head turned away from the temple by ninety degrees and looking over one shoulder. (The English sculptor Henry Moore was inspired by Toltec *chac mool* sculptures to carve a series of reclining figures; in line with European traditions, he changed the figure's sex from male to female.) We do not know what this posture signified in either Toltec or Aztec art. The fan at the back of the neck suggests a fertility deity. The place of the sculpture in front of the temple doorway and the dish that it holds suggest that it may have been a sacrificial stone or a receptacle for offerings.

Bench Relief

The fifty-two panels of the Bench Relief were, until the finding of the Chac Mool, the earliest known sculptures of the Mexica (Plates 86–88). The relief had been disassembled and the stones reused in one of the periodic rebuildings of the Main Temple of Tenochtitlán. Originally, the stones with the procession of warriors formed the sloping base of a bench, while the stones with the serpents belonged to a cornice design (Beyer, 1955). Twenty-one of the serpent stones are now in Mexico City's National Museum of Anthropology, but they do not form a continuous frieze; the location of the remaining thirty-one panels is unknown.

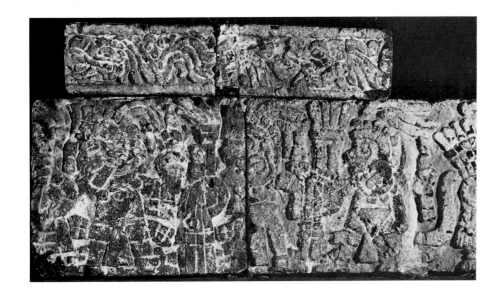

Plate 86. Bench Relief, Warrior Procession. Stone, 56 × 28 cm. Main Temple Area, Tenochtitlán. 1350–1486. Museo Nacional de Antropología, Mexico City

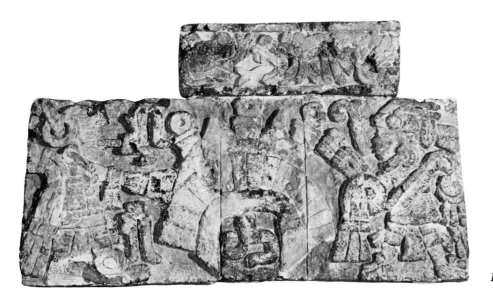

Plate 87. Bench Relief, center stones

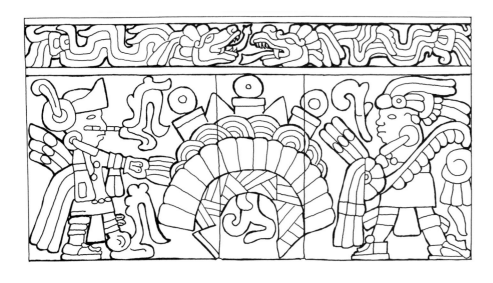

Plate 88. Drawing of center stones of Bench Relief (after Beyer, 1955, Fig. E)

Two sets of warriors are converging on a central emblem, the grass ball into which sacrificial bones and thorns are placed. They hold spears, shields, and spearthrowers, and wear three types of headdresses: the turquoise diadem of a chief, the great feather headdress of a lord, and a headdress with two feathers also indicating high rank. All these figures are clearly human, but the figure that leads the procession combines human and deity features. Leading these Mexica warrior-aristocrats is their ruler in the guise of the god Tezcatlipoca, whose deity features include a leg that ends in a conventionalized representation for smoke rather than a foot, and the smoking mirror in the hair; his human and royal aspects include the turquoise diadem and the nosebar—the ruler received the nosebar as part of the investiture ceremony. The figure on the left of the grass ball may therefore represent the ruler of Tenochtitlán, the florid curl in front of his face signifying an oration or prayer. Otherwise there are no glyphs on the panels, and in their absence there is no way to know which Mexica ruler is represented. The great temple of Tenochtitlán was first ordered rebuilt by Motecuhzoma I (another rebuilding is also attributed to Tizoc), and the ruler in the Bench Relief may be either Itzcoatl or Motecuhzoma I. It may date between 1427 and 1469.

The Bench Relief is more remarkable as a historical than an artistic monument. The carving is crude, with few modulations in relief; the outlines are rough, and the contrast between ornamented and plain surfaces lacks harmony. Of the stucco and paint, which would have made the figures more distinct from the background, only traces remain. The relief is so close to Toltec bench reliefs (see Plate 19) that there is little question that the Mexica were imitating a Toltec prototype. The bench relief at Tula also has a feathered serpent border and a procession of warriors. A major innovation in the Mexica relief is the focus of the penitential emblem in the center and on the figure of the ruler, an emphasis that remains primary in later Mexica art.

Stone of the Warriors

The Stone of the Warriors was found in 1897 near the southwest corner of the present Zócalo, or main square, in Mexico City (Plate 89). The stone is a rectangular block carved on all sides with a procession of warriors holding weapons, who converge on

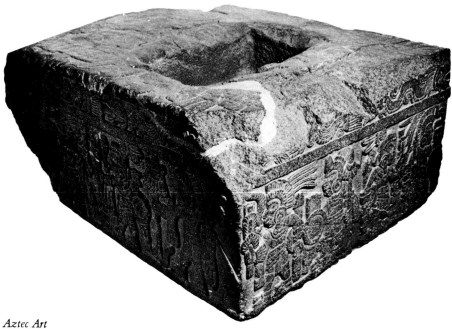

Plate 89. Stone of the Warriors. Stone, 65 × 157 cm. Tenochtitlán. Before 1486. Museo Nacional de Antropología, Mexico City

a sacrificial emblem, the grass ball. Unfortunately, the face of the ruler next to the grass ball is effaced, and there are no glyphs to identify him. As on the Bench Relief, the warriors wear different headdresses. On the top border plain and feathered serpents alternate. The execution of the relief is more refined than on the Bench Relief, but the two are alike in composition and in the uncomplicated style of carving. Its date is probably before the 1480s, when the Stone of Tizoc (Plate 90) was carved. The presence of an earth monster figure carved on top of the monument indicates that it was probably an altar or a throne (the irregular hole in the center was doubtless cut in the colonial period); the earth monster was usually carved on the bottom unless the monument served as a throne or seat and its top represented the earth. In this respect the Stone of the Warriors is similar to the later Temple Stone (Plate 125). The fourteen warriors may represent the ward leaders of the city of Tenochtitlán, and, by extension, the Mexica empire.

Stone of Tizoc

The Stone of Tizoc is the first great Mexica monument that can be dated and attributed by glyph to a known ruler (Plates 90–93), Tizoc, who ruled between 1481 and 1486. This cylindrical stone, eight and one-half feet in diameter and three feet high, must have been carved within those years. The composition of the monument is simple, the elements drawn from Toltec and Mixteca-Puebla models. On the top of the cylinder is an ornate sun disk with eight rays. The side has a sky border of stars at the top and a border representing the maw of the earth monster on the bottom; in the frieze between are fifteen pairs of figures, each pair a Mexica warrior holding a captive by the hair. Each captive is identified by a different glyph.

As a procession of repeating units between framing borders, the composition is similar to the Bench Relief. However, the Stone of Tizoc does not copy a Toltec relief; its inspiration is from Mixteca-Puebla manuscript painting. The sun disk, the sky border, and the earth monster border have their origins in manuscripts such as the Codex Nuttall (see Colorplate 3) and the Codex Borgia (see Colorplate 5). The warrior-and-prisoner pairs and identifying glyphs come from the tradition of

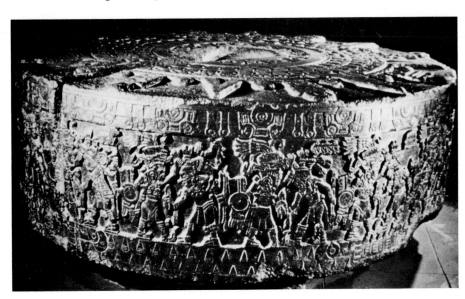

Plate 90. Stone of Tizoc. Stone, 90 × 270 cm. Tenochtitlán. 1481–86. Museo Nacional de Antropología, Mexico City

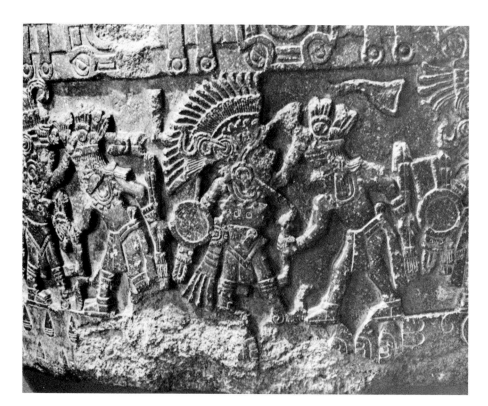

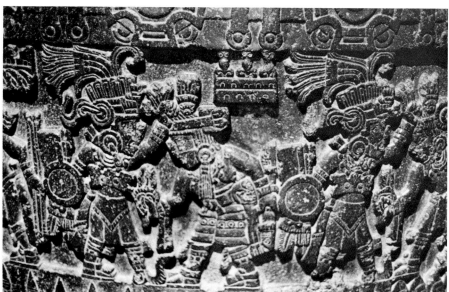

Plate 91. Stone of Tizoc, detail of Tizoc, his name glyph (a leg) next to his head

Plate 92. Stone of Tizoc, detail of Conquest of Xochimilco (Xochimilco represented by female figure)

Mixtec historical manuscript painting (see Plate 21), as the illustration of the conquests by the Mixtec ruler 8 Deer indicates. What is uniquely Mexica is the use of a historical subject in a cosmic setting to decorate an object that may have functioned as a ritual receptacle.

When the monument was found in 1790, a priest saved it from being broken up to make cobblestones, and the channel across the top was probably cut at that time. It is unlikely that the circular depression in the center, a round concavity eighteen inches in diameter and six inches deep, was also a mutilation, and if it is indeed original, the sculpture may have been a large offering stone with a vessel-like center.

Usually the ruler is wearing priestly attire and drawing blood; this is one of the few Mexica monuments that represents him as a conqueror. Tizoc was the least successful military leader of the Mexica, and in several accounts he was said to be a coward.

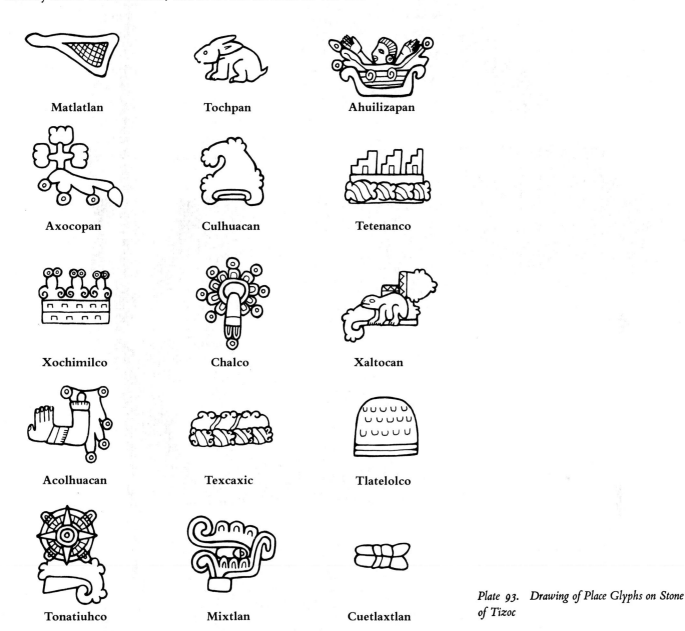

Matlatlan	Tochpan	Ahuilizapan
Axocopan	Culhuacan	Tetenanco
Xochimilco	Chalco	Xaltocan
Acolhuacan	Texcaxic	Tlatelolco
Tonatiuhco	Mixtlan	Cuetlaxtlan

Plate 93. Drawing of Place Glyphs on Stone of Tizoc

Each Mexica ruler, after he was chosen to succeed to the throne but before being installed, had to fight a battle and bring back prisoners. Tizoc's first campaign against Matlatlan was unsuccessful; it is said he lost 300 men and brought back only 40 prisoners. Tizoc reigned briefly and died under mysterious circumstances, possibly from poison. Sixteenth-century sources, such as the Codex Mendoza, attribute only fourteen conquests to his five-year reign.

Orozco y Berra had noted in 1877 that a number of the conquests on the stone were those of Tizoc's predecessors, not his own, but most attempts to match up the place signs with the battles have concentrated on the time of Tizoc's reign. The ques-

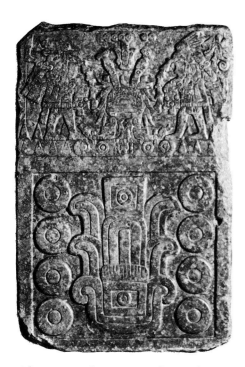

Plate 94. Dedication Stone, showing the Rulers Tizoc and Ahuitzotl. Greenstone, 92 × 62 cm. 1487. Museo Nacional de Antropología, Mexico City

Plate 95. Drawing of Dedication Stone (after Seler, II, 1904, p. 766, fig. 47)

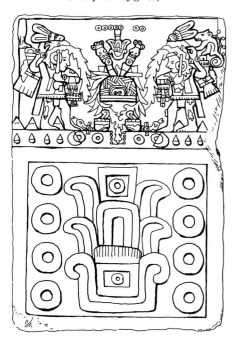

tion now asked is whether the monument commemorates the conquests of a single ruler or the whole course of Mexica expansion. The Mexica conquerors wear identical costumes in which are combined military insignia, Toltec costume, and deity symbolism. The triangular loincloth and stepped breastplate are imitations of Toltec costume as seen on the atlantids of Tula (see Plate 18); the stepped breastplate also refers to the fire god Xiuhtecuhtli, who wears that ornament (see Colorplate 37). The Mexica considered Xiuhtecuhtli to be an old god, and he was one of the rulers' patrons (Noguez Ramírez, 1971).

In this monument the Mexica have ceased to imitate Toltec models and are creating their own imperial art. References to the Toltecs are limited to costume details, while the emphasis is on the patron gods of the Mexica. The left leg of each of the fifteen conquering warriors ends in a smoking design rather than a foot, and each wears a smoking mirror in his headdress, the emblem of Tezcatlipoca, one of the patron gods of rulers. Only one of the fifteen conquerors is identified by the "leg" symbol, the glyph of Tizoc, and only he wears the hummingbird helmet of the god Huitzilopochtli (Plate 91); of the fifteen figures, therefore, only one represents Tizoc. The rest may be the Mexica captains under him (Wicke, 1976). Several sources state that the Mexica had fifteen chiefs in their early history, or fifteen city wards, the *calpulli*—the number fifteen probably represents the Mexica military and political divisions led by the ruler at the time of Tizoc (note that the Stone of the Warriors shows fourteen Mexica warriors).

Like the conquerors, the captives also combine human and divine attributes. Dressed in the guise of their city's patron gods and goddesses, they represent their rulers. The two female figures are associated with Culhuacan and Xochimilco (Plate 92). When the Mexica conquered a city, they took "captive" some of the local idols and brought them back to be held in a special temple in Tenochtitlán. The events on the Stone of Tizoc therefore take place both on human and divine planes—historical rulers are capturing specific towns, but success or failure is attributed to the gods. The glyphs of the conquered towns, when compared with the glyphs in the codices, stand for the major conquests of the Mexica up to the time of Tizoc (Plate 93). Umberger suggests that the glyphs are not place names, but symbols for the names of ethnic groups (1981, p. 137). The carving as a whole, therefore, represents the Mexica empire, created by conquest, and it commemorates the reign of Tizoc by including him among the fifteen captors. The glyph next to Tizoc's prisoner is that of Matlatlan, his first campaign.

Tizoc's major contribution to Mexica history was in building, not in war. He is credited with initiating a large-scale rebuilding of the main temples of Tenochtitlán, which was completed under his successor, Ahuitzotl. The Stone of Tizoc was probably among the impressive monuments intended for the new precinct. On it we see Mexica style and iconography emerging from its Toltec and Mixteca-Puebla sources, in a new and unique synthesis.

Dedication Stone

The Dedication Stone, a beautifully carved greenstone plaque, commemorates the completion of the Temple of Huitzilopochtli at Tenochtitlán in 1487, the year 8 Reed (Plates 94–96). The lower half of the panel contains the glyph 8 Reed carved as an abstract design with heavy double outlines. The relief above it has similarities with the Bench Relief and the Stone of Tizoc: the rulers Tizoc and Ahuitzotl, both

dressed as priests, are holding incense bags and piercing their ears with a bone. The blood flows over their heads and down to an incense burner into the gaping maw of the earth monster border. Between the rulers is the grass ball of sacrifice with bone piercers stuck into it; blood also flows from wounds in one leg of each figure. Tizoc is identified by his "bleeding leg" glyph, Ahuitzotl by the water creature with the curly tail.

Relief panels with dates were usually set into architecture. Recent excavations at the Main Temple have uncovered several dates set into stairways and into the rear walls of pyramid platforms. The original location of this panel is unknown.

In its style and relative complexity the carving is close to the Stone of Tizoc. Furthermore, the glyph panel, so beautifully detailed, is similar to the style of the city of Chalco as carved on a stone box (see Plates 246–49); though the box is not dated, its style comes from late Classic traditions such as that of Xochicalco (see Plate 16).

Greenstone Earth Monster

The slab of greenstone used for this Earth Monster (Plates 97, 98) is close in size to the Dedication Stone; the works are close in style. The crouching beast with upturned head is carved in very low relief with flattened surfaces and beautiful linear definition. Unlike later Mexica examples, this figure is clearly and simply organized and easy to comprehend. The maws of the earth monster were used as a bordering device in the Dedication Stone and the Stone of Tizoc, and in all these examples the earth monster is close in form to representations in the Mixteca-Puebla codices. However, its occurrence in these contexts may have a political meaning as well: earth monster images may signify the earth ruled by the Mexica, and provide a divine motivation for conquest and sacrifice (Townsend, 1979).

The emblem in the center of the Earth Monster plaque is the symbol for jade or preciousness—the same symbol that appears on the Stone of Tizoc and the glyph

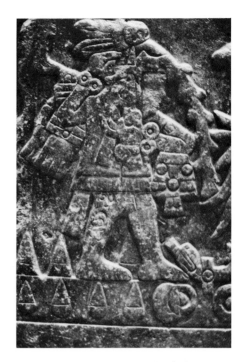

Plate 96. Dedication Stone, detail of Tizoc

Plate 97. Earth Monster. Greenstone, 86 × 57 cm. Tenochtitlán. 15th century. Museo Nacional de Antropología, Mexico City

Plate 98. Drawing of Earth Monster

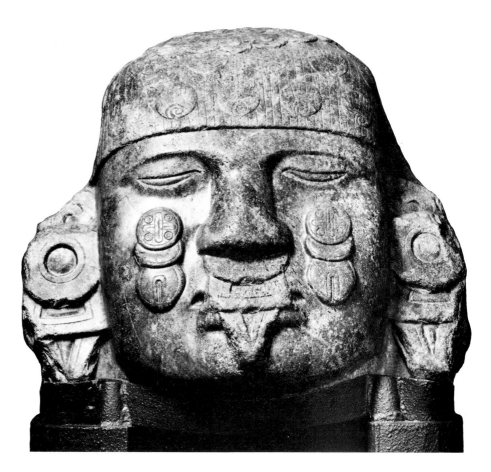

Plate 99. Colossal Head of the Goddess Coyolxauhqui. Greenstone, 80 × 85 cm. Tenochtitlán. 15th century. Museo Nacional de Antropología, Mexico City

for the town of Chalco. Klein (n.d.) suggests that this relief may also have a political significance, referring to the Mexica conquest of that city.

Like the Dedication Stone and the Head of Coyolxauhqui (Plates 94, 99), this greenstone monument may also have been carved for the dedication of the Main Temple in 1487.

Head of Coyolxauhqui

The colossal carving in diorite of the head of the goddess Coyolxauhqui illustrates important innovations in Mexica monumental sculpture (Plates 99–101). The function and meaning of the head are expanded and more specifically related to Mexica history than in any previously discussed monument (Bobry, n.d.). Almost three feet high, it is impressive for the sheer size and bulk of so large an amount of precious stone. Greenstone was the most precious material in Mesoamerica and this is the largest known monument to be carved of it. The head retains the rounded shape of the boulder; features and decorative details are carved and incised with a minimum of three-dimensional form, but an emphasis on precise line and fine surface polish. The exquisite line of the half-closed eyes contrasts with the heavy nose and the smooth striated hair.

The surname Coyolxauhqui, meaning "she of the golden bells," identifies the head. The image of a bell is carved in low relief on each cheek with the gold symbol, a cross with four dots, incised in a circle above. The ornaments at nose and ears have the form of a trapeze-and-ray sign, characteristic of the fire gods. On the hair are shell-like designs that represent balls of down, symbolic of sacrificial victims. The head is a complete work, not a fragment, for on the underside is carved a relief of two serpents intertwining with a stream of water, a stream of fire, and a rope with plumes. The glyph 1 Rabbit is in the front left-hand corner. Coyolxauhqui represents a decapitated head, the serpents symbolizing the flow of blood.

The goddess Coyolxauhqui had particular significance to the Mexica. The sister of Huitzilopochtli, she is mentioned in two legends. We have already encountered the story of the pregnancy of Coatlicue and the birth of Huitzilopochtli as collected by Sahagún (1950–78, bk. 3, pp. 1–5). Once born fully armed, Huitzilopochtli decapitated his sister Coyolxauhqui and killed or drove away all of the 400 sons. This myth in usually interpreted in cosmic terms, following Seler (1902–23, III, pp. 325–31): Coatlicue is the moon; and the 400 sons are the stars. The birth of Huitzilopochtli was the birth of light at dawn, and thus the death of the moon and disappearance of the stars.

As in other instances, the Mexica myth has both cosmic and political meanings, and the political meanings come clear in another story recounting an event in the migration history of the Mexica (Durán, 1964, p. 18). The Mexica had settled at Coatepec and built a magnificent city there, on the advice of Huitzilopochtli. This city was not to be their final destination, however, and Huitzilopochtli urged them to move on, but many, led by his sister Coyolxauhqui, were unwilling to leave. Huitzilopochtli forthwith decapitated Coyolxauhqui on the ball court. The city and the fertile countryside surrounding it vanished, and the Mexica continued their migration.

In this story Coyolxauhqui appears to represent a dissident faction among the Mexica which was overcome by the followers of Huitzilopochtli. But in both stories Coyolxauhqui is an opponent of Huitzilopochtli and eventually his victim, and her head is a sacrifice and a war trophy. As a goddess of the Mexica, she symbolizes all the enemies to be conquered by the people of Huitzilopochtli.

Durán tells us that Ahuitzotl ordered the completion of the Temple of Huitzilopochtli and had an image carved of Coyolxauhqui (1964, p. 191). If his statement is correct, then this head was made for the dedication of the Main Temple in 1487. The style of low relief and the green diorite are so similar to the Dedication Stone that it is highly likely that they are near in date. The statue was found in 1829 on the grounds of the Convent of the Conception, Republica de Guatemala Street, close to the Main Temple of Tenochtitlán. The head may have been a precious trophy presented at the dedication.

Plate 100. Relief under base of Colossal Head of the Goddess Coyolxauhqui

Since Coyolxauhqui was a specifically Mexica goddess, there were no established conventions for representing her in stone or in manuscripts, and a new image had to be created to correspond to her image in the stories. The head with its long hair and balls of down is similar to the heads of death goddess sculptures (see Plates 186–87), and it symbolizes her martial aspect. The remainder of the iconography is related to the goddess of the hearth, Chantico. In the Codex Borbonicus, Chantico's hair is decorated with balls of down, and an intertwined water-and-fire band emerges from her headdress.

The intertwined water–fire design under the base of the head is a well-known Aztec motif that has been interpreted as a symbol of sacred warfare (*atl tlachinolli,* "water, a burned thing," water–fire). If that is its meaning, then it refers to the necessity for war and for acquiring sacrificial victims. The date 1 Rabbit is the mythical creation date of the earth. The death of Coyolxauhqui may thus symbolize the founding of Tenochtitlán by conquest under the guidance of Huitzilopochtli.

The goddess Chantico, who was the iconographical prototype for the head of Coyolxauhqui, was the patron of Xochimilco, a city known for its builders and artisans in precious stone. So large a piece of diorite could have been an item of tribute requested from the conquered city of Xochimilco, and their artists required to make the Head of Coyolxauhqui in the likeness of Chantico as an added humiliation (Bobry, n.d.). The conquest of such rich southern cities as Chalco and Xochimilco, recorded

Plate 101. Drawing of Relief under base of Colossal Head of the Goddess Coyolxauhqui

on the Stone of Tizoc, brought a major source of wealth toward the lavish Mexica building program. By equating Chantico, the goddess of the Xochimilca, with Huitzilopochtli's rebellious sister, the Mexica justified their conquest on mythic grounds. The people of the Valley of Mexico were as aware of the political message as of the cosmic legend.

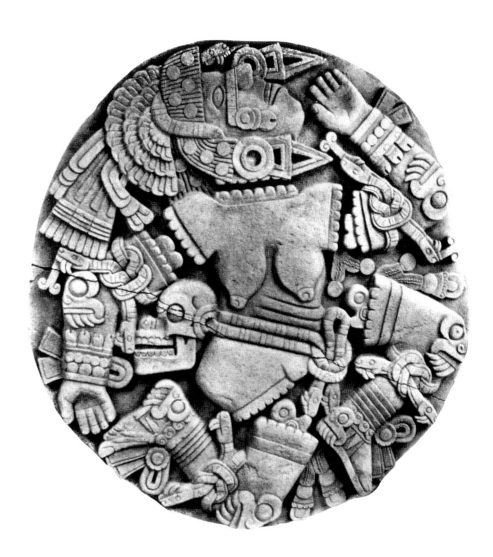

Plate 102. *Coyolxauhqui Relief. Fine-grained volcanic stone, diameter 3.3 m. Main Temple Area, Tenochtitlán. Possibly 1469. In situ, Mexico City*

Plate 103. *Drawing of Coyolxauhqui Relief (after García Cook and Arana A., 1978, fig. 12)*

Coyolxauhqui Relief

One of the largest Aztec monuments ever found was accidentally discovered in 1978 by workmen digging near the Cathedral in Mexico City (Plates 102, 103): an oval stone eleven feet long, its flat upper surface carved with the image of a dismembered goddess. The similarities to the head of Coyolxauhqui—hair adorned with feathers, fire-god earplugs, and golden bells on the cheeks—led to identifying this goddess too as Coyolxauhqui (Aguilera, 1978; Nicholson, in press).

The head and legs of the goddess in the oval relief are in profile, her torso is frontal.

She is naked, with large breasts, folds in her belly, and naked buttocks; the central body stands out because it is free of the symbolic motifs that cover the peripheral elements. Aztec men and women are usually shown properly dressed, for public nudity was a form of humiliation. Traditionally in Mesoamerican art captives are nude to indicate their loss of social personhood, their reduction to a naked, almost animal level. A rope belt threaded through a skull encircles Coyolxauhqui's torso. That she is dead is indicated by the severed limbs arranged in pinwheel fashion around the torso, fitted into the oval outline. The cuts between body parts are shown as scalloped lines, bones protruding from the limbs.

Each limb is itself a complex design. The limbs wear ornate bracelets and anklets, among which bells, referring to the name "she of the golden bells," are prominent. Sandal heels and the joints at knees and elbows bear fanged monstrous masks. Such accessory masks are usually on earth monster images, and their presence relates Coyolxauhqui to those emblems of darkness and chaos—indeed, the entire design of the body appears to be an asymmetrical, profile representation of an earth monster. Each limb is tied around with double snakes; the meaning of this detail is unclear, but it is similar to the double snakes in the fire–water design on the base of the Coyolxauhqui head (Plate 99).

This relief is also unusual for the large forms that project several inches above the background plane, and for the relatively simple detail (Plate 104 a, b). Certain forms stand out for their realism—the modeled creases of the palms, for example—while the planes of face and torso are smoothly rounded. Surprisingly, glyphs are absent. It is possible that the relief was made for the major dedication of the Temple of Huitzilopochtli in 1487 (Nicholson, in press). Matos places it earlier, in 1469, during the reign of Axayacatl, because that date, 3 House, was found in the wall of the pyramid built at the same time as the relief (Matos Moctezuma, 1981, p. 37). Since many major monuments were made around the time of the Stone of Tizoc, this monument quite possibly dates prior to Tizoc's reign; in that case the Coyolxauhqui Relief would be earlier than the Coyolxauhqui Head.

The location of this relief offers another aspect of its meaning. It was set into the floor in front of the Temple of Huitzilopochtli, the head facing toward the stairway; the relief gains in prominence because there is no symmetrical monument on the Temple of Tlaloc side. Calnek has suggested that the monument may mark the conceptual center of Tenochtitlán, the point marked by conquest and sacrifice as in the story of Copil, the enemy of the Mexica, who was sacrificed and from whose heart, thrown into the lake, the cactus grew. Copil's mother, the evil sorceress Malinalxochitl, was a sister of Huitzilopochtli and of a character similar to Coyolxauhqui. This may be the first image that refers to the myths of Huitzilopochtli as the patron of the Mexica; it is also the first major monument filled with destructive imagery. The relief set into the floor was seen from above, perhaps walked on, and the bodies of sacrificial victims when rolled off the temple on top of the pyramid landed on or near it. To any visitor to Tenochtitlán the relief must have been a terrifying reminder of the sacrificial fate reserved for the enemies of Huitzilopochtli and his chosen people.

Greenstone Relief of a Goddess

After finding the Coyolxauhqui Relief in 1978 the area around that stone was excavated further. A number of offerings were revealed, including stone statues and

Plate 104 a, b. Coyolxauhqui Relief, details

a wide variety of objects such as obsidian, animal bones, gold disks and bells, skulls, and flintknives. In one offertory deposit a large greenstone relief of a goddess was found together with more than a dozen imported Mezcala figurines in greenstone (García Cook and Arana A., 1978, pp. 58–64). The relief is carved in magnificent deep green olivine with yellow streaks (Plates 105, 106).

The goddess was first identified as Coyolxauhqui III, then renamed Mayahuel, goddess of *pulque*, by López Austin (n.d.), as we will see below. The relief is continuous across the front and sides of the stone. It represents a death goddess, as suggested by the mouth full of teeth, the long hair decorated with paper banners, and the

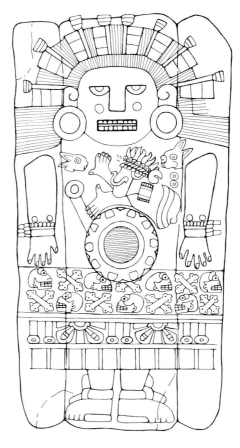

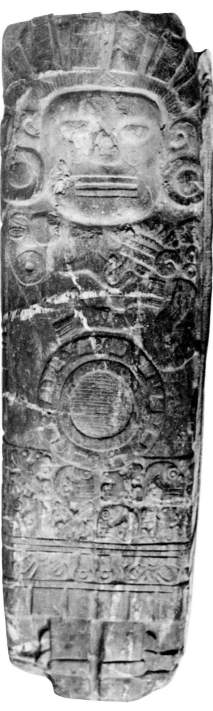

Plate 105. Greenstone Relief of a Goddess, found in Offering No. 5 near the Coyolxauhqui Relief. Greenstone, 135 × 41 × 20 cm. Main Temple Area, Tenochtitlán

Plate 106. Drawing of Greenstone Relief of a Goddess (after López Austin, unpublished manuscript)

skirt having the skull-and-crossbones design and a sky band. But the disk in the center, representing either a mirror, a vessel of water, or a preciousness symbol, occurs in association with fertility deities, as on a wooden sculpture (see Plate 285), and in pre-Mexica art on a statue attributed to Xochicalco from the late Classic or early Postclassic period.

The two glyphs, 1 Rabbit and 2 Rabbit, may help in identifying the figure. One Rabbit refers to the date of the creation of the earth, and appears on the base of the Coyolxauhqui Head as well as on the statue of Coatlicue (Plates 110–12); 2 Rabbit may relate to the little figure who emerges from the heart symbol. The U-shaped nose ornament of this figure usually signifies the god of *pulque*, and 2 Rabbit is the calendrical name of certain *pulque* gods. For this reason López Austin identified the figure as the *pulque* goddess Mayahuel. Clearly this goddess has both death and birth aspects and refers to the destructive and creative functions so characteristic of female deities in Mesoamerican thought.

The identity of the Greenstone Relief of a Goddess is conjectural. In many aspects, such as the *pulque* features, this goddess is unlike the other sculptures at Tenochtitlán, and the carving makes a more complex use of glyphs than does the Coyolxauhqui Relief discussed above. Why was such a beautiful stone relief buried as an offering? We do not know. Perhaps the statue was an idol captured from a conquered temple; Tenochtitlán did not have a special temple for conquered deities until later. Because the relief was found with the offering of Mezcala figures, it too could be of foreign origin. In southern towns having well-developed artistic traditions, such as Chalco and Xochimilco, many of the patron deities were female. The skirt design of a sky band with skulls and crossed bones is reminiscent of Mixtec codex imagery. Reliefs such as this may have influenced the Mexica style seen in the Stone of Tizoc, the Dedication Stone, and the Greenstone Earth Monster.

Skeletal Goddess

A most unusual Mexica sculpture is a death deity carved in greenstone (Plate 107) that represents a skull on a skeletal upper torso with prominent ribs. The figure has long hair and a floral ornament with streamers, similar to the head of Coyolxauhqui, and may represent a goddess. The sculpture is surprising in that the figure has four arms, and the reliefs on both sides of the head represent a death god who also has four arms (Plate 108). In the reliefs the skeleton is seated cross-legged in a position normally associated with male figures.

Figures with multiple limbs, so frequent in the art of Asia, are extremely rare in Pre-Columbian art; supernatural power is usually represented through costume and insignia rather than by variants of the human body. Umberger has suggested that the four arms of these death figures may be the result of a misunderstanding of an earlier prototype; a bust similar to the Mexica carving has been found at Teotihuacán (Umberger, 1981, fig. 48). The Teotihuacán figure also has four arms, but this is understandable for it has two heads as well, and indeed two figures back to back. The Mexica carver who may have found his inspiration in such a sculpture kept the four arms, but did not understand that these belonged to a "janus" figure (Umberger, 1981, pp. 80–81). The bottom of the greenstone Skeletal Goddess is carved with a relief of an earth monster with a Tlaloc face similar to the one beneath Coatlicue (Plate 109; see Plate 113). It has the date 1 Rabbit above the head. The carving of a Tlaloc earth-monster image on the bottom may be another archaistic imitation of Teotihuacán art—Tlaloc is not only frequently represented in Teotihuacán murals (see Colorplate 2; Plate 11), but there is one instance in which it was carved on the base of a late-style Teotihuacán vessel (Pasztory, 1974, fig. 23).

We do not know where this figure originally stood. The use of greenstone, however, and the archaistic elements and death goddess iconography may relate this work to the monuments that were made for the temple rebuilding associated with the Coyolxauhqui Head. It was found by Batres (1902) in his excavations near the corner of the Temple of Huitzilopochtli.

Coatlicue and Yollotlicue

No monument evokes more strongly the Pre-Columbian past and elicits admiration

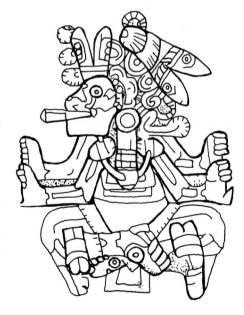

Plate 107. Skeletal Goddess. Greenstone, height c.76 cm. 15th century. Museo Nacional de Antropología, Mexico City

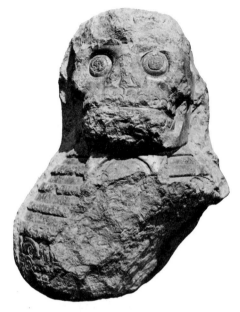

Plate 108. Drawing of Four-armed Figure on side of Skeletal Goddess (after Batres, 1900, fig. 3)

so mingled with terror as the colossal statue of Coatlicue (Plates 110–13). From complete form to smallest detail, the sculpture embodies the duality of Mexica consciousness. The colossal mass of the eight-foot cruciform stone has an overpowering impact; the intricate detail is recognizable in part, but is not immediately comprehensible as a whole. Realistic details may catch the eye, such as hands modeled with lines in the palms, but these bear no easy relation to the grotesque fanged heads around them. At the very center of the figure is a contrast of quintessential opposites: breasts seen behind a skull, the two images of life and death. The figure is at once passive and active, monster and victim. The front view is static and bilaterally symmetrical; the side view is slanting, and appears to be advancing forward. The huge feet have raptorial claws; the arms are raised in a threatening gesture; the figure wears a necklace of heart and hand trophies with skull pendants at front and back. Yet she too is a victim—the two snakes that form her face are the streams of blood that emerged from her decapitated neck. Serpents of blood flow down from between her legs and from her wrists.

Contrasts persist in the carving on the bottom. Instead of the voracious earth monster the image is that of the rain god Tlaloc, but he is in the earth monster's crouching position (Plate 113). The central emblem is the precious turquoise symbol, but skulls adorn the knees and elbows and are held in the hands. Above Tlaloc's headdress the glyph 1 Rabbit is incised. The composition is similar to that under the base of the Skeletal Goddess.

Coatlicue was found in 1790 together with the Calendar Stone and the Stone of Tizoc. In 1940 an almost identical statue was excavated but she wears a skirt of hearts rather than intertwined serpents (Plate 114). This statue is much more battered and eroded. Both statues have the date 12 Reed carved on the back. Fragments of an arm with a grotesque face on the elbow, also found in Mexico City, indicate that there was once a third similar statue. Depite the existence of these three sculptures, most interpretations are based solely on Coatlicue (Fernández, 1954).

The statue with the skirt of plaited serpents is usually called Coatlicue (meaning "serpent skirt"), the name of Huitzilopochtli's mother, who, in the myth of the god's birth, is killed by her daughter Coyolxauhqui; Coatlicue is thus the earth mother from whom the Mexica originated. But Coatlicue is not the only possible identification: a figure with death and serpent attributes may also represent Cihuacoatl, or "woman-serpent," a goddess who personified the voracious earth (Alcocer, 1935). Her temple was called Tlillancalco, "the house of darkness," and she demanded war and sacrificial victims. Besides being an earth goddess, Cihuacoatl had special significance as the patron goddess of Culhuacan, the community with a Toltec-related ruling dynasty through which the rulers of Tenochtitlán claimed Toltec descent. Cihuacoatl therefore symbolized the Toltec earth mother of the Mexica, and the name Coatlicue is merely the Mexica variant of Cihuacoatl. The myth of the birth of Huitzilopochtli may signify the birth of the Mexica god from the Toltec mother goddess, who dies in parturition.

That the goddess Cihuacoatl had a political significance as well is indicated by the use of her name, *cihuacoatl*, for the title of the lord next in power to the ruler, the *tlatoani*. The *tlatoani* was concerned primarily with war and external relations, the *cihuacoatl* with domestic affairs. The division of rulership into two offices, the *tlatoani* in the guise of the Mexica sun god Huitzilopochtli and the *cihuacoatl* in the guise of the Toltec earth mother, suggests the twin-temple concept; it brings together the old and the new, war and fertility, life and death, Mexica and Toltec, conqueror and conquered. Tlaloc, considered to be the special god of the Toltecs, is shown on the statue

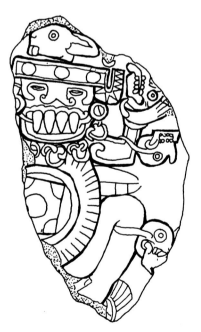

Plate 109. *Drawing of Relief under base of Skeletal Goddess (after Batres, 1900, fig. 6; see Plate 107)*

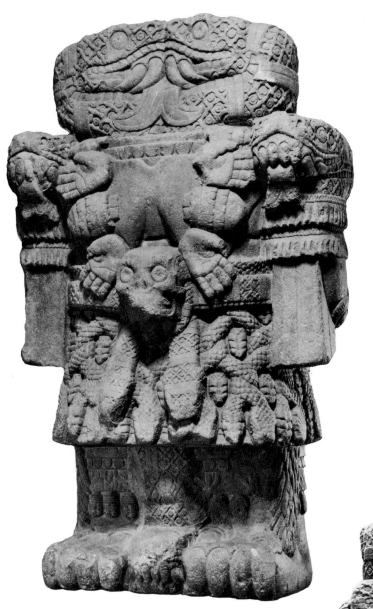

Plate 110. Coatlicue, "Serpent Skirt."
Stone, height 3.5 m. Tenochtitlán. 1487–1520.
Museo Nacional de Antropología, Mexico City

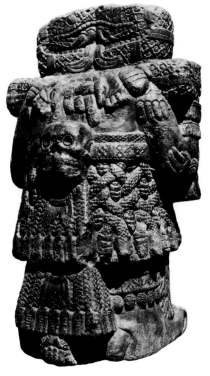

Plate 112. Back of Coatlicue

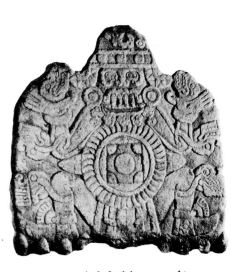

Plate 111. Side of Coatlicue

Plate 113. Relief of Tlaloc in crouching
earth-monster position, under base of Coatlicue

The Major Monuments of Tenochtitlán **159**

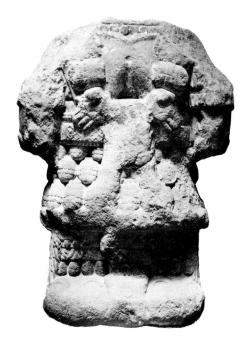

Plate 114. Yollotlicue, "Heart Skirt." Stone, height 2.14 m. Tenochtitlán. 1486–1520. Museo Nacional de Antropología, Mexico City

bases of Coatlicue and Yollotlicue, thereby indicating the roots of these images in the earth and in past civilizations. In these images were combined concepts relating to both Coatlicue and Cihuacoatl.

The earth goddesses represented in the two sculptures are both victims and devourers. As victims, they give their life for the birth of the Mexica state. They are devourers because they demand sacrifices in return, and may punish their offspring. In another story related by Durán the threatening aspect of Coatlicue is seen: Motecuhzoma I sent a group of priests to find Coatlicue at Coatepec and to tell her of the greatness of Mexica achievements. The priests found an old hag who was not impressed by their news, but lectured the Mexica on their softness and love of luxury, and prophesied their eventual destruction (Durán, 1964, pp. 133–38). During the reigns of both Motecuhzoma I and Motecuhzoma II major droughts occurred, both times interpreted as the angry earth's refusal to bear fruit; in propitiation, increased numbers of sacrifices were made to the earth.

Since there were at least three related sculptures of these goddesses, they were probably not idols made for temple sanctuaries (despite their similarity to the idol of Huitzilopochtli, as described by Bernal Díaz). It is more likely that they were set up outside, like other Mexica sculptures. Boone (n.d.) has suggested that these sculptures represented the *tzitzimime*, the female monsters who descend to destroy man at the end of the world. Tezozomoc refers to the carving of *tzitzimime* sculptures during the reigns of Motecuhzoma I, Tizoc, and Ahuitzotl, sculptures said to have been ordered by Tlacaelel. Carrera (n.d.) attributed the cult of these voracious earth goddesses to Tlacaelel, the first *cihuacoatl*.

When were these sculptures carved? Umberger (1981, p. 77) argues that because of the date 12 Reed on both the backs, and the date 1 Rabbit and the Tlaloc earth monster under the bases, the Coatlicue and Yollotlicue statues have been associated with the monuments erected between 1487 and 1499. But the style of the sculptures, so three-dimensional, realistic, and complex, brings them closer to the Temple Stone, Calendar Stone, and Jaguar Vessel and thus to a later date. Motecuhzoma II had a new temple built for Coatlicue in 1506, after a drought and at the end of a fifty-two-year cycle. He may have ordered the statue in conscious imitation of an earlier sculpture.

The great Coatlicue and Yollotlicue statues give some idea of the difficulties encountered in interpreting Mexica monuments. The combination of the elements is appropriate to several supernatural beings, in this case Coatlicue, Cihuacoatl, and the *tzitzimime*. In political terms the images may be specifically Mexica, or may refer to relationships with Culhuacan. In general terms, the options are numerous: the statues may represent the Mexica concept of the earth as both the nurturing and the self-sacrificing mother; the civilized past; the world conquered by the Mexica; and the dynamic principle, which no amount of sacrifice can satisfy. Why should there have been so many frightening female images at the Temple of Huitzilopochtli? Possibly they symbolize the Mexica conquest of the earth on the one hand, and the legitimate birth of the Mexica out of the civilization of the past on the other. The Teotihuacán-derived Tlaloc images on the bases support this interpretation.

Metro Earth Monster

When this sculpture of the earth monster was found during the Metro excavations in 1967 (Plate 115) it was nicknamed "Coatlicue del Metro," so great is its similarity in style and iconography to the colossal Coatlicue statue discussed above. The figure

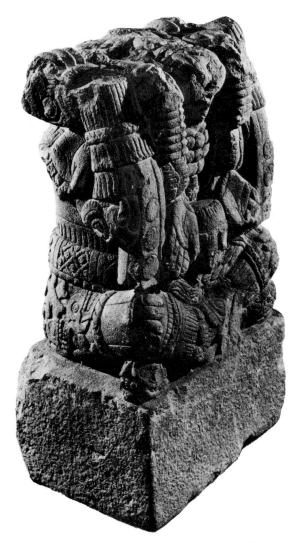

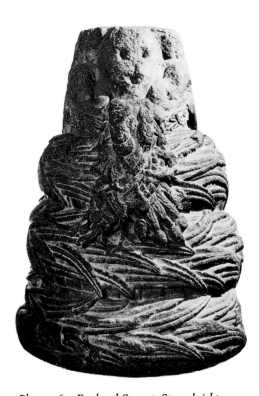

wears a necklace of hearts and hands and on the back a skull ornament, all looking like those of Coatlicue. The absence of breasts and the cross-legged seated position indicate that this figure is probably male rather than female, and represents the earth monster. But in style the two sculptures are so close that they were probably carved in the same workshop at the same time. The sculpture apparently did not belong to the Main Temple since it was found somewhat further south, at the corner of Izazaga and Isabel la Católica streets.

The earth monster is generally represented in relief, as on the Greenstone Earth Monster (Plate 97), making this example, carved in the round, unique in Mexica art. In this sculpture the sense of relief carving is evident in the disposition of the figure within a cubic mass, the arms raised and flanking the upturned head. The face with its long tongue is similar to the central face of the Calendar Stone (Plate 132). This compact and contorted image represents the voracious earth whom the Mexica hoped to satisfy by sacrifices. To a non-Mexica viewer such images represented the ferocity of the Mexica, and of the gods in whose name they went to war. The Metro Earth Monster demonstrates the virtuosity in three-dimensional carving that was achieved by the Mexica artists late in Ahuitzotl's reign and under Motecuhzoma II.

Feathered Serpent

The coiled feathered serpent with a human face emerging from its open jaw has underneath a relief of a Tlaloc earth monster (Plates 116, 117) nearly identical to that under

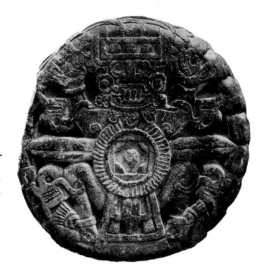

the base of Coatlicue (Plate 113). The monuments may therefore be contemporary.

While serpents, with or without feathers, are frequently found in small-scale stone sculpture, this is the only large monument of this subject. Feathered serpents occur as border designs on the Bench Relief, Stone of the Warriors, and the Aqueduct Relief. The name of the legendary Toltec ruler Quetzalcoatl means "feathered serpent," and the emperors Ahuitzotl and Motecuhzoma II were both much interested in him. Ahuitzotl had a feathered serpent behind his representation on the Aqueduct Relief (Plate 118), and he may have ordered the Tula cliff relief carving of Quetzalcoatl (see Plate 68). Motecuhzoma II had a greenstone box carved, on which he and Quetzalcoatl are represented and identified by glyphs (see Plate 275 a, b).

The human face emerging from the maw of a feathered serpent probably renders an image of rebirth. In Mesoamerican art the disappearance and reappearance of the sun, the stars, and the planets were represented metaphorically as being swallowed and regurgitated by a monster which often demonstrated serpent characteristics. The theme is frequent in Toltec art and may have been known to be "Toltec" by the Aztecs. An elaborate water–fire band, signifying war, emerges from the lower jaw and streams over the feathered coils. The sculpture may symbolize the birth of the Mexica empire out of the Toltec past, based on sacred warfare—an interpretation supported by the Tlaloc earth monster under the base, referring to the original owner of the earth.

Aqueduct Relief

An increasingly complex and three-dimensional carving style developed under the ruler Ahuitzotl, and two sculptures dated 7 Reed, or 1499, may specify the initial year. One is the fragment of a large relief, the other a stone box, both sculptures having water as a theme. The relief was probably made for the dedication of an aqueduct (Plates 118, 119).

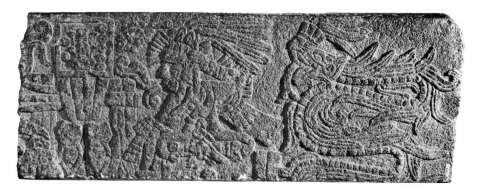

Plate 118. Aqueduct Relief, showing the Ruler Ahuitzotl. Stone, 163 × 76 × 30 cm. Tenochtitlán. c.1499. Museo Nacional de Antropología, Mexico City

The year 1498 had seen a drought in Tenochtitlán and Ahuitzotl, in seeking new sources of water, asked the subject ruler of Coyoacan to divert the waters from five Coyoacan springs into an aqueduct. The ruler refused, arguing that the irregular flow of their springs made them unsuitable for the purpose. Ahuitzotl had the ruler killed, and built the huge dam and aqueduct in the following year. The aqueduct was inaugurated with elaborate ceremonies, the priests dressed in blue gowns of the water goddess Chalchiuhtlicue. The operation of the dam coincided with the beginning of torrential rainstorms that caused a flood covering all of Tenochtitlán, and the dam was destroyed in 1500. Ahuitzotl performed penitential rites for the angry gods.

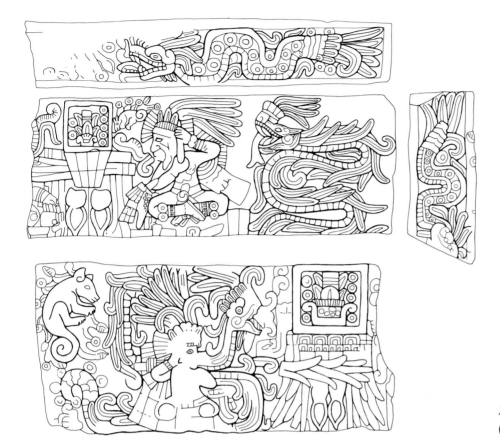

Plate 119. Drawing of Aqueduct Relief (after sketch by Emily Umberger)

Alcocer (1935) has shown that the relief dated 7 Reed must have been commissioned in celebration of the ill-fated aqueduct. It was found not in the Main Temple area but in the south of Mexico City, near the place where the aqueduct was located. On the relief is the ruler Ahuitzotl, seated cross-legged and drawing blood from his ear. His glyph, the water monster that looks like a dog with a snakelike tail, is in front of him. Because he shared his name with a mythical water monster, Ahuitzotl may have believed he had a special relationship with the gods of the waters. Behind him is a feathered serpent that signifies the fertile surface of the earth and the name of the Toltec ruler Quetzalcoatl. The relief on the back is similar to that on the front: Ahuitzotl, represented with a feathered serpent behind him, sits next to a 7 Reed glyph. The glyph referring to the year 1499 may also refer symbolically to Quetzalcoatl (Umberger, 1981, p. 131). Ornamental feathered serpents are carved along the side and edge of the stone.

The Aqueduct Relief is intermediate in style between the monuments erected in the 1480s and those commissioned by Motecuhzoma II. The serpents on the side are similar to the serpent border of the Stone of the Warriors; the seated figure and feathered serpent are similar to the design on stone boxes (see Plates 250, 276). The bordering devices used on the Stone of Tizoc and the Dedication Stone are no longer here, but the composition does not yet have the clear spacing and the modeling in several levels that are characteristic of the Temple Stone (Plate 125).

Umberger suggests that the Tula cliff relief of the water goddess and Quetzalcoatl (see Plates 67, 68) was ordered by Ahuitzotl as a form of propitiation when his aqueduct project failed (1981, pp. 157–64).

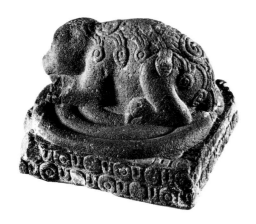

Ahuitzotl Box

Like the Aqueduct Relief, the Ahuitzotl Box was presumably made in 1499, for the date 7 Reed is carved on the interior of the stone lid (Plates 120–23). Seler first demonstrated that the box in the British Museum probably matched the lid in Berlin (1902–21, IV, pp. 513–18). This sculpture includes three-dimensional carving and relief decoration, similar to works in the imperial style under Motecuhzoma II. Ahuitzotl is represented by the water monster in three dimensions on the top, and in relief inside the box. On the only surviving side the rain god Tlaloc is pouring water and maize ears from a vessel which bears the symbol for jade, and a pectoral with a symbol for gold hangs from Tlaloc's necklace. The stream of water surrounding Ahuitzotl and emerging from the vessel is close to the rendering of the water stream be-

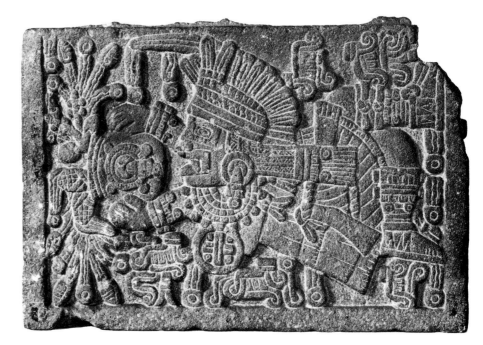

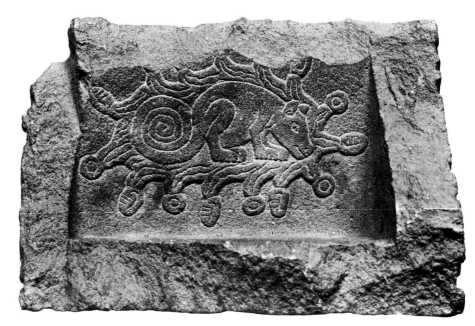

ABOVE

Plate 120. Cover of Ahuitzotl Box. Stone, 33 × 32 cm. Probably 1499. Museum für Völkerkunde, Berlin

Plate 121. Date Glyph "7 Reed" inside Cover of Ahuitzotl Box. Museum für Völkerkunde, Berlin

RIGHT

Plate 122. Side Relief of Tlaloc Pouring Water, Ahuitzotl Box. Stone, 21.5 × 33 cm. Probably 1499. British Museum, London

Plate 123. Ahuitzotl, inside bottom of Ahuitzotl Box. British Museum, London

neath the Head of Coyolxauhqui (see Plate 100), and to designs in the codices.

Stone boxes of this type were probably made to contain sacrificial implements, since the majority were carved with symbols of sacrifice. Because several boxes are associated with the glyphs of rulers, it is possible that these boxes were their personal possessions. As is shown on the Dedication Stone and the Temple Stone, one of the major functions of the ruler in penitential rites, as high priest of the Aztec religion, was the drawing of blood. The implements of royal penance were therefore sacred, and stone boxes were carved to contain them. The earth monster, the recipient of sacrificial blood, was generally carved on the outer bottom.

Year Bundle

The reign of Motecuhzoma II held two major events: the New Fire Ceremony of 1507, and the arrival of the Spaniards in 1519. In 1507 the ruler commemorated the beginning of a new epoch with as much pomp as Ahuitzotl had devoted to the dedication of the Temple of Huitzilopochtli in 1487. The works of art made for the occasion include the Temple Stone (Plates 125–31), the Chapultepec cliff portrait (see Plate 69), greenstone fire serpents (see Plate 264), and the Year Bundle illustrated here (Plate 124). This year bundle is unusual for its fine carving and the iconography it shares with the Temple Stone. In the central panel the 2 Reed glyph is similar to

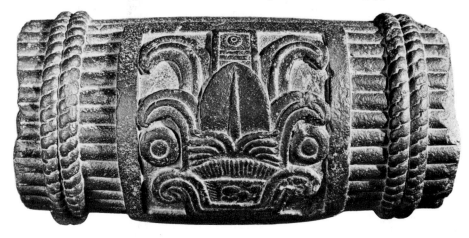

Plate 124. *Year Bundle with Glyph "2 Reed." Stone, length 61 cm., diameter 26 cm. Tenochtitlán(?). 1507. Museo Nacional de Antropología, Mexico City*

that on the right balustrade of the Temple Stone, while on the two ends are seen the glyphs for 1 Flintknife and 1 Death. This means that the two monuments are related to the same event, although the Year Bundle bears no Motecuhzoma glyph.

A year bundle is a stone copy of the actual bundles of fifty-two reeds which were tied together and ceremonially burned every fifty-two years (see Colorplate 35). Carved year bundles have been found deposited inside altars, such as in the Altar of Skulls at Tenochtitlán (see Plate 56). The careful carving of the rope design and the beautifully detailed glyphs distinguish this Year Bundle from other examples (see Plate 258).

Temple Stone

The Temple Stone, which commemorates the New Fire Ceremony of 1507, represents the Mexica of Tenochtitlán as the legitimate power in the Valley of Mexico (Plates

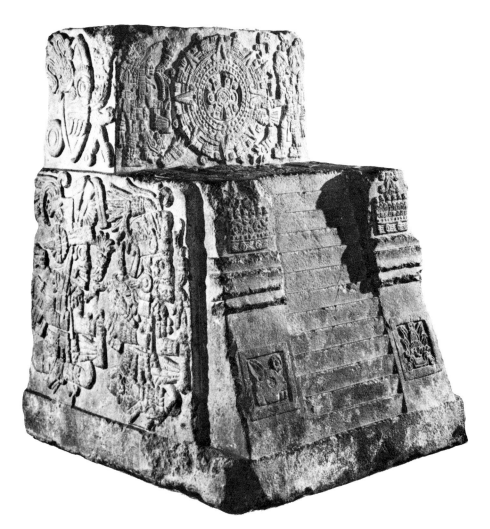

Plate 125. Temple Stone. Stone, 120 × 92 × 99 cm. Tenochtitlán. Museo Nacional de Antropologia, Mexico

Plate 126. Back of Temple Stone

125–31). It is the most complex Mexica monument that we know: on all sides of a temple form, sixteen images and six glyphs are carved (Caso, 1927; Palacios, 1929). The images were drawn from different sources, and they are different from one another in scale and sometimes in style. The seated figures on the sides of the base are larger than the standing figures who flank the solar disk on the backrest; the shield and spear emblems on the seat are large in relation to the earth monster between them (Plate 130). All the figures on the front and sides are single images. On the back is carved a unified scene within a natural setting, the eagle on the cactus being the most naturalistic representation yet found in Aztec relief sculpture (Plate 126).

In its form the monument combines elements of a temple, a royal throne, and a

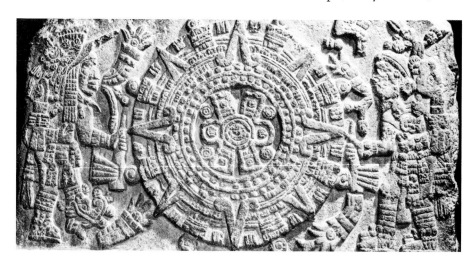

Plate 127. Central Disk and Flanking Figures on backrest of Temple Stone

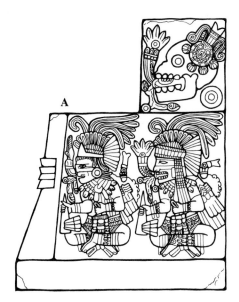
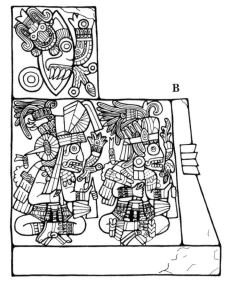

A

B

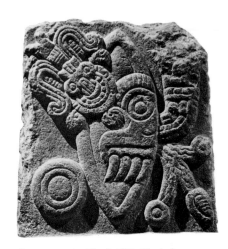

Plate 128 a, b. Drawings of right (a) and left (b) sides of Temple Stone (after Marquina, 1964, figs. 13–14)

year bundle. In Mesoamerican thought, the main temple of a city was the city's symbol; in manuscripts a burning temple symbolizes that city's conquest; the name for city, altepetl, means literally water-mountain, and pyramids were symbolic of mountains. The relief on the back of the Temple Stone—the eagle standing on a cactus that emerges from the reclining body of a goddess, with wavy lines behind that suggest water—is an elaborate version of the name glyph for Tenochtitlán. In the Mexica's migration legend, Huitzilopochtli told the Aztecs to settle where they saw an eagle land upon a cactus growing in a lake. This vision they saw after being expelled from Chapultepec, and on that spot they founded Tenochtitlán; the glyph 2 House on top of the monument is for 1325, the traditional founding date of Tenochtitlán. The whole monument therefore represents the city of Tenochtitlán, rising from Lake Texcoco.

Umberger, who analyzed the sculpture in detail, believes that it was a symbolic throne (1981, pp. 172–92). Its dimensions, some four feet high and three feet wide, are those of a large seat or throne. Many clay figurines represent temples in the form of thrones with deities seated at the top (see Plates 304, 305); no figure is seated on the Temple Stone because it was most likely a royal seat for the living ruler of Tenochtitlán, if indeed anyone sat on it. The Temple Stone has the form of a chair with a backrest, like the icpalli, the royal throne made of woven mats (see Plate 24). While the base is in a temple form with steps and a balustrade, the top has no roof or doorway, but is a simple panel like the back of a chair. Torquemada describes a seat carved out of stone called a momoztli, which stood in the palaces of rulers and represented royal power, no one sitting on it except the king (1969, II, p. 40). The Temple Stone was in fact found in 1831 at the site of Motecuhzoma II's palace (now the National Palace), and may have functioned as a throne, actual or symbolic.

The monument is also related through its glyphs with year bundles, which represented the fifty-two years by fifty-two sticks tied together with rope. On the front of one such year bundle (Plate 124) is the year glyph of the New Fire Ceremony, 2 Reed; on the sides are the glyphs 1 Flintknife and 1 Death. The Temple Stone has the same glyphs, the date 2 Reed carved low on the front of the right balustrade, 1 Flintknife and 1 Death on the outer sides of the backrest (Plate 129). Year bundles were used as the seats for important people at feasts; the form of the Temple Stone therefore embodies a royal throne, the cycle of fifty-two years, and the city of Tenochtitlán as a pyramid.

On the backrest of the Temple Stone is a sun disk with the glyph 4 Movement inside it (Plate 127). The disk represents the new era of Mexica rule and their dedication to the solar cult. It is flanked on the left by the god Huitzilopochtli (or a priest

Plate 129. "1 Flintknife" Glyph from upper left side of Temple Stone

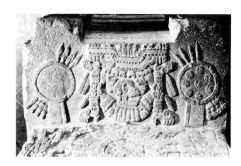

Plate 130. *Earth Monster on seat of Temple Stone*

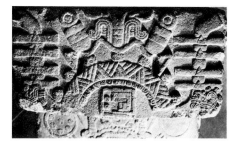

Plate 131. *Grass Ball of Sacrifice on top of Temple Stone*

dressed as the god), and on the right by Motecuhzoma II. Both wear priests' clothing and carry in one hand a pointed bone for drawing blood, and in the other a sacrificial knife. Huitzilopochtli is identified by a hummingbird headdress, Motecuhzoma by his glyph in front of his head, the royal headdress and noseplug. On the top of the backrest is the grass ball of sacrifice in which were set the thorns used in drawing blood, flanked by two torches decorated with paper strips used in the New Fire Ceremony (Plate 131). The monument is therefore crowned by the Mexica ruler and patron god shedding sacrificial blood for the solar emblem of time, light, and life.

By contrast, the lower half is covered with images of death. On the seat, at right angles below the sun disk, crouches the earth monster with its voracious maw, a skull ornament on its belt (Plate 130); it is flanked on the sides by emblems of war, shields with spears and war banners. Townsend (1979) suggests that this is the Mexica conquest of the earth. Vessels for the hearts of captives are carved at the top of the balustrades, the first representation of sacrificial vessels on an imperial monument. Since the vessels are ornamented with eagle feathers and jaguar spots respectively, they refer to the warrior orders of the eagle and the jaguar.

On either side of the monument is a pair of seated figures with skeletal jaws (Plate 128 a, b), richly dressed in triangular loincloths and feather headdresses bedecked with fans and rosettes of folded paper. The figures may represent the old rulers and gods prior to the Mexica reign, or the Mexica deities—the figure on the left has the goggles and moustache of the rain god Tlaloc—or other old rulers, such as the figure on the far left with the royal diadem, either a king or the fire god Xiuhtecuhtli. The paper ornaments, characteristic of nature and fertility deities, are found on mummy bundles. The Mexica associated these gods with the older civilization and the Toltecs, and believed that Tlaloc was their dynastic patron. Umberger has suggested that these four figures in the base of the pyramid represent the vanished gods and civilizations that have passed away but support the new Mexica era. The New Fire Ceremony took place not at Tenochtitlán but on the Hill of the Star close to Culhuacan, the only city near the lake having a dynasty of Toltec descent.

The glyph 1 Rabbit on the front of the Temple Stone, opposite 1 Reed, illustrates some of the difficulties of interpretation that Aztec art presents. This glyph has significance in myth, in the calendar, and in history, but all of these may not be equally relevant in every context. The year 1 Rabbit is the mythic date of the creation of the earth, and as such it could be appropriate on the base of a temple which represents the earth. 1 Rabbit had signified one of the four year bearers, a date on which a new era could begin, but during the reign of Motecuhzoma I the severe drought began on 1 Rabbit, and the New Fire Ceremony was postponed until the year 2 Reed, when the drought had broken; both those dates therefore may refer to a calendric change. By chance, the same succession of events recurred under the rule of Motecuhzoma II —a drought began in 1 Rabbit and ended in 2 Reed—and this coincidence may have given special significance to the celebration of the New Fire Ceremony of 1507. The glyph 1 Rabbit was also carved on several monuments that may have been associated with the dedication of the Main Temple by Ahuitzotl in 1487.

If Motecuhzoma II sat upon this throne, he would have been seated on the earth, the underworld, and the past, and on his back he would symbolically have carried the sun and the present era. The early leaders of the Mexica during their migrations were called *teomama*, or god bearers, and in the historical manuscripts they are shown literally carrying the image of the deity on their backs (see Plate 148). Besides emphasizing his Toltec heritage, Motecuhzoma may have wanted to glorify also his nomadic ancestry. The glyph 1 Flintknife on the side next to Huitzilopochtli is the date on which the Mexica set out on their migrations and also the symbol of Huitzi-

lopochtli. Motecuhzoma is wearing a special headdress of plumes tied to sticks, that was the headdress of their nomadic Chichimec ancestors (Umberger, 1981, p. 176). Unlike Tizoc, who wears Toltec dress on the Stone of Tizoc, Motecuhzoma reasserts his ancestors' humbler origins. The Temple Stone reconciles the opposite concepts: the unbroken continuity of Toltec and Mexica rules, and the special right of the Mexica to supplant the Toltecs by conquest, sacrifice, and divine selection. From the mouth of every figure, living or dead, emerge the red and blue streams of water and fire, prayers invoking Tenochtitlán. The New Fire Ceremony of 1507 commemorated on this stone was dedicated to the past achievements of the Mexica and to the opening of an equally magnificent future.

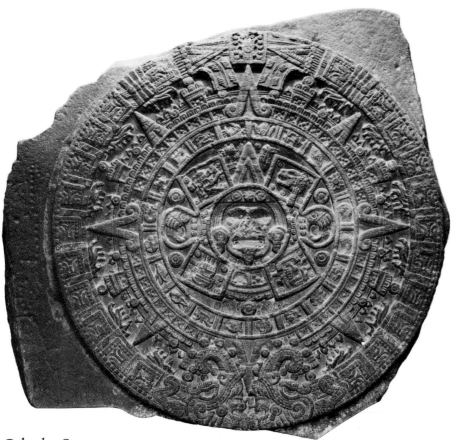

Plate 132. *Calendar Stone. Stone, diameter 3.6 m. Tenochtitlán. Probably 1502–20. Museo Nacional de Antropología, Mexico City*

Calendar Stone

The Calendar Stone is a monument at once simple and complex. Whereas the early Mexica monuments represented figures without glyphs, the Calendar Stone consists of almost nothing else (Plates 132, 133). On the stone are represented certain ideas of time and space that were widely accepted in Mesoamerica many centuries before the Aztecs, yet this work remains a unique Mexica achievement. One must ask why the Mexica erected a colossal monument ten feet in diameter depicting the cosmos, when other cultures who shared these ideas never created anything like it.

The Calendar Stone is a masterpiece of intricate design and iconography (Beyer, 1922). Small-scale motifs in rectangular compartments that are arranged in concentric circles give it the structured look of a mandala: the background is cut deeper to create two bands of shadow that set off the central ring from the outer ring. The disk is divided both by radius and by axis. The central ring consists of the X-shaped glyph 4 Movement, with the face of the deity (whose identity is discussed below)

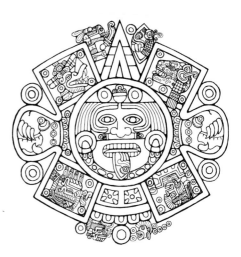

Plate 133. *Drawing of Center of Calendar Stone*

in the center and his claws in two flanking circles. Four glyphs in the four rectangular cartouches represent the dates of destruction of the previous worlds. The next ring contains the twenty symbols of the ritual calendar, arranged counterclockwise starting at the top. Beyond is a narrow ring with four sets of squares, each containing five dots—glyphs for preciousness or turquoise. An ornate solar band with four major and four minor triangular rays projects to the outer ring, where two fire or turquoise serpents encircle the stone, their tails at the top and their heads meeting below. These monsters' open mouths emit two profile heads with skeletal jaws. The border of the cylindrical edge has a night sky with stars and planets. The entire disk rises above a stone panel having an irregular, broken outline; we do not know if this panel was part of the calendar monument, or a portion meant to be cut off later. Crudely incised on this background are circular depressions and connecting lines that are thought to represent the Aztec constellations, not apparently related to the disk.

The Mexica believed they were living in the fifth world; the destructions of the four previous worlds were represented in the four square compartments at the center of the Calendar Stone. On 4 Jaguar, the world was populated by giants who were eaten by jaguars; on 4 Wind, the world was destroyed by wind and hurricanes; on 4 Rain of Fire, the world ended in fiery rain caused by the rain god Tlaloc; and on 4 Water, the world was destroyed by floods sent by the water goddess Chalchiuhtlicue. The Aztecs believed the fifth world would be destroyed on 4 Movement by earthquakes.

The central face of the Calendar Stone has long been identified as Tonatiuh, the sun god of the daytime sky, and the monument is sometimes called a giant sun stone. In fact, the face of the central deity with the clawed hands and a sacrificial knife for a tongue is that of the earth monster, Tlaltecuhtli (Plate 115), as seen on the Metro Earth Monster statue (Navarrete and Heyden, 1974). Since the destroyer of the last world is to be the earth itself, this image is more appropriate than the face of Tonatiuh. Alternatively, it may represent the night sun in the underworld (Klein, 1976b).

The Aztec artist who designed the Calendar Stone conceived a daring combination of two images: the sun disk and the earth monster. These images have major roles in Aztec iconography but they are normally represented separately to signify an opposition of light and dark, life and death. The sun disk usually appears on the inside of sacrificial vessels, the earth monster on the outside bottom (see Colorplates 46–48). On the Calendar Stone the two images interpenetrate, coming together in a single plane that signifies the time and space of this conjunction. The time is 4 Movement, which takes place within the eternal cycle of the ritual calendar days; the space is the surface of the earth.

As the rings signify time, the vertical divisions signify space. The top corresponds to the sky and the upper world; the number 13 in the top glyph refers to the levels of the sky, the date 13 Reed to the sun. The images of fire or turquoise serpents connect the upper and lower worlds, their open mouths at the bottom representing the underworld; the skeletal deities in their jaws are death figures. The center of the monument thus shows the surface of the earth, midway between the sky and the underworld where the sun and earth meet.

Though the central image of the Calendar Stone represents the destruction of the fifth world, it actually celebrates the creation of the world. Each era was named after its day of destruction; paradoxically, its creation could only be indicated by showing its completion in destruction. The date 13 Reed at the top is the date of the creation of the sun, according to the sixteenth-century chronicle "Anales de Cuauhtitlan."

Why did the Mexica erect a monument to commemorate the creation of a new era? Answers are suggested by the glyphs which refer to the rulers and history of the Mexica. The glyph to the right of the ray above the earth monster head represents 1

Flintknife, the traditional day on which the Mexica began their migration from their original homeland (see Plate 148). Umberger suggests that 1 Flintknife was also an important historical date because in that year, 1428, the Mexica defeated the Tepanecs and thereby became masters of the Valley of Mexico (1981, pp. 193–208). The turquoise diadem and noseplug on the other side of the ray is the name glyph of Motecuhzoma II. Thirteen Reed is the traditional date of the birth of the sun, but may also refer to the accession of Itzcoatl to the throne (Townsend, 1979), and under his rule the Mexica became a major power in the valley. He is also credited with the burning of old books and the rewriting, we might call it the creation, of Mexica history, thereby identifying the creation of the new era with the Mexica empire and its history. The skeletal faces in the jaws of the fire serpents below are the gods of the old eras and civilizations superseded by the Mexica, as on the sides of the Temple Stone (Plate 128). The Calendar Stone is a grandiose monument which proclaimed to all of Mesoamerica that the Mexica empire was to be a new cosmic era.

The historic events to which the dates may refer, the conquest of the Tepanecs and the accession of Itzcoatl, took place in the first half of the fifteenth century. The sculpture could not have been carved as early as that: the complexity of its iconography and the presence of the Motecuhzoma glyph indicate a later date. Durán in his chronicles describes sculptures that may have been similar to the Calendar Stone, sacrificial stones carved at the orders of Motecuhzoma I and Axayacatl; Motecuhzoma II's sun stone may have referred to the events commemorated on these earlier sculptures, a reflection of his strong interest in the past history of the Mexica. Durán recounts that Motecuhzoma II ordered a great *temalacatl*, the round sacrificial stone used in gladiatorial combat, which was taken into the city on rollers and escorted by priests and musicians. The stone is said to have fallen through a wooden bridge into the lake, but was retrieved and installed in a temple. After the conquest this misadventure was interpreted as an evil omen (Durán, 1964, pp. 250–54). The story may be a garbled account referring to the Calendar Stone and possibly an explanation of its broken or unfinished form. The constellations incised on the back panel may have been protective signs for the carving and transportation, or made after the accident.

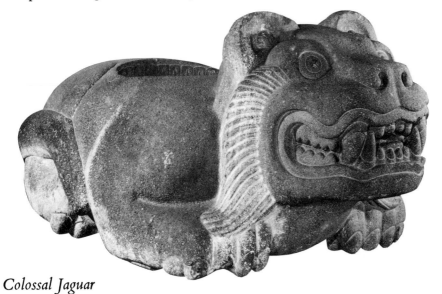

Plate 134. Colossal Jaguar. Stone, 93 × 226 cm. Tenochtitlán. Possibly 1502–20. Museo Nacional de Antropología, Mexico City

Colossal Jaguar

A colossal sculpture of a crouching jaguar (Plate 134) was found in 1901 near the remains of a temple in the patio of the Ministry of Industry on República de Argentina Street, not far from the Main Temple area. One of the simplest Mexica sculptures,

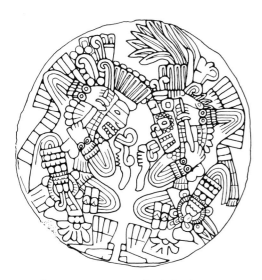

Plate 135. *Drawing of Relief at bottom of Vessel on back of Colossal Jaguar (after Seler, II, 1904, p. 903, fig. 111; see Plate 134)*

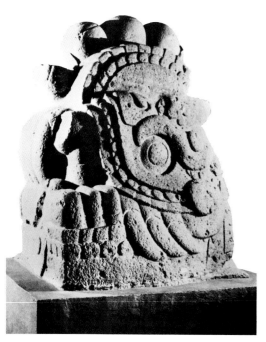

Plate 136. *Colossal Fire Serpent Head. Stone, 1.3 × 1.5 m. Tenochtitlán. Possibly 1502–20. Museo Nacional de Antropología, Mexico City*

it is powerfully modeled with little surface decoration. The body of the jaguar is conceived in cylindrical masses and convex forms, the large claws boldly outlined on the forelegs and hindlegs. A mane or whiskers in parallel lines frames the creature's open snarling mouth; the double curve of lip and gums effectively combines the observation of natural forms with their reduction to simple design. Motecuhzoma II and the other Aztec rulers had zoos in which caged animals could have been observed by artists. Here the massive power of the feline is conveyed, not its swiftness and grace.

This jaguar probably served as a vessel for sacrificial offerings such as hearts, for a cylindrical vessel-like concavity has been carved into the back. At the bottom of the vessel is a relief of two figures with skeletal jaws and striped bodies who pierce their ears with sharp bones (Plate 135); two bones are placed at the human figures' feet. The rim of the vessel is carved with concentric circles representing jades, and with eagle feathers, like those on the exteriors of other sacrificial vessels (see Plate 243; Colorplate 46).

The jaguar had many meanings for the Mexica; its earth symbolism and status-marking significance were probably primary. The night and earth aspect of Tezcatlipoca was the jaguar Tepeyollotl, called the "heart of the mountain" (see Colorplate 36). The jaguar image could thus stand for the earth receiving sacrificial offerings. Tezcatlipoca was however the special patron of royalty, and rulers were associated with jaguars and jaguar skins.

Jaguar imagery in Mexica art is often connected with Motecuhzoma II. On the Temple Stone (Plate 127) he is wearing a jaguar costume. Besides this Colossal Jaguar, the imperial sculptures of a jaguar warrior (Plate 142) and the jaguar and eagle seats at Malinalco (see Plate 83) can be attributed to his reign, suggesting that the cult of the elite jaguar and eagle warriors received special emphasis. The piers of Motecuhzoma's palace were ornamented with eagles and jaguars, according to some sixteenth-century descriptions (Lombardo de Ruíz, 1973, p. 152).

The two figures inside the vessel are represented with the smoking mirror foot of Tezcatlipoca. They are similar to the seated figures on the base of the Temple Stone (Plate 128 a, b) and to the skeletal faces emerging from serpent heads on the Calendar Stone. They probably represent dead rulers of the past civilizations in the guise of deities. It was an innovation during the reign of Motecuhzoma II to refer to the gods of the past as skeletal. The monuments made for the dedications of the temple during the reigns of Axayacatl and Ahuitzotl were images of conquest, mainly female figures of death goddesses. In those erected by Motecuhzoma II, the skeletal figures are male, and their poses imply distance and death: they do not threaten others. Because they draw blood from their ears or are associated with blood-letting implements, these figures represent ancestral images, similar to the early Aztec rulers who are shown performing penitential rites.

The Colossal Jaguar monument is therefore dedicated to the earth, the underworld, and the rulers of the past and their gods. Its stylistic similarity to the Calendar Stone and the Temple Stone makes possible a date in the reign of Motecuhzoma II, but the absence of glyphs prevents a more specific historical attribution.

Fire Serpent Head

The colossal Fire Serpent Head (Plate 136) was found in 1901 near the Colossal Jaguar vessel. The fangs of this serpent and the open maw curving back toward the top of

the head were believed to connect the sky with the earth, and through its body traveled the planets. The image also had a specific Mexica meaning: Xiuhcoatl, the Fire Serpent, was the weapon used by Huitzilopochtli to decapitate Coyolxauhqui, as described in the myth of his birth.

Like the Colossal Jaguar, this is a simple image, dramatic in its great mass, powerful forms, and curving shapes. It resembles the tenoned animal heads used in architectural decoration, but its size, four feet high, makes this use unlikely. The sculpture is attributed to the reign of Motecuhzoma II, because its colossal size and powerful modeling are similar to the Colossal Jaguar. As an iconographic motif the fire serpent also appears on the Calendar Stone, as well as on greenstone sculptures of the fire serpent that bear Motecuhzoma's glyph. Fire serpent imagery may have interested Motecuhzoma because of the New Fire Ceremony of 1507.

Rain God Chac Mool

A comparison of the recently found Chac Mool (Colorplate 28) with the later example illustrated here (Plates 137–40) indicates the course of development in Mexica sculpture. The earlier figure is close to Toltec prototypes and, like them, has no insignia of a deity. The affiliation with Tlaloc is not based on iconography but on its place in front of the Tlaloc temple.

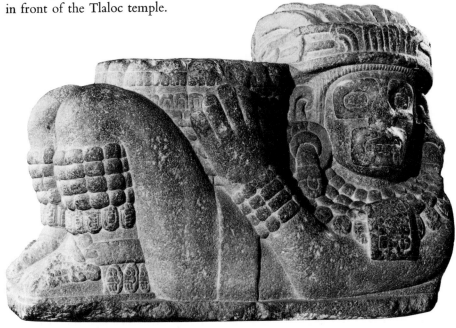

Plate 137. Rain God Chac Mool. Stone, 54 × 78 cm. Mexico City. c. 1502–20. Museo Nacional de Antropología, Mexico City

Several later Mexica *chac mools* are known, of which we illustrate the best preserved, found a few blocks south of the Main Temple area in Mexico City. All represent the deity or impersonator of the rain god Tlaloc and were probably associated with Tlaloc temples, but their iconographic details vary. This reclining figure wears goggles and a mouthmask with fangs that are related to Tlaloc representations without being identical (Plates 188, 189). The relief under the base is Tlaloc in the crouching pose of the earth monster, surrounded by conch shells and water creatures. Water is indicated by a background of wavy lines, as on the Temple Stone (Plate 126).

The vessel the figure holds is a copy of the greenstone sacrificial vessels that were ornamented with hearts (see Colorplate 46). Sacrificial vessels are an important theme

Plate 138. *Top of Rain God Chac Mool*

Plate 139. *Back of Rain God Chac Mool*

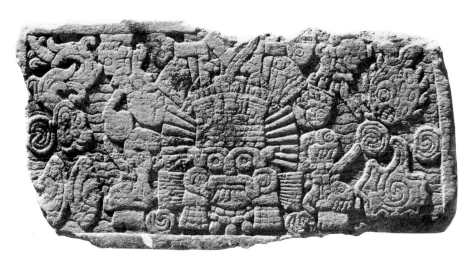

Plate 140. *Relief under base of Rain God Chac Mool*

on the monuments of Motecuhzoma II: two are to be seen on the front of the Temple Stone, and the Colossal Jaguar is itself a vessel. Instead of being hollow, the vessel on this Chac Mool has a flat top bearing a carved relief of an abstract Tlaloc face. The figure wears rich jewelry—anklets, bracelets, and a collar of round beads perhaps made of precious stones or gold. The pendant on the collar represents a jade heirloom with a seated man in cross-legged pose. In the offerings at the Main Temple heirloom jades were found by Batres in 1900 and by Matos Moctezuma in 1979.

In this sculpture the Mexica were illustrating their relationship to the Toltecs: they had supplanted the Toltecs, but continued to venerate them and their gods. The Mexica believed that Tlaloc was the major god of the past, and therefore they put his features on the Chac Mool, a sculptural type they associated with Tula. The reclining figure is probably a Mexica who is impersonating a richly dressed Toltec but holding a Mexica offering bowl. The headdress with its year sign and the rosette on the hair have their prototypes on Toltec sculptures (Pasztory, n.d.). This work renders their special veneration of a Toltec deity by reinterpreting the actual form of a Toltec sculpture in the Mexica manner.

The three-dimensionality of the carving, as in the well-modeled arms and hands, and the complex iconographic theme indicate a late Mexica date for this monument. It has some stylistic similarities with the Man with Jaguar Helmet and with a headless Standard Bearer (Plates 142, 143), all perhaps carved in the same workshop.

Rain God Brazier

A major monument found in Mexico City in 1981, north of the Main Temple, belongs with the Rain God Chac Mool in its style and iconography (Plate 141). The sculpture copies stone braziers from the Classic Teotihuacán period that are usually in the form of an old god carrying a vessel on its head (see Plate 9); to the Aztecs, Tula and Teotihuacán both represented the same ancient civilization. This well-modeled seated figure wears the facial insignia of the rain god Tlaloc and an ornate necklace with an heirloom pendant. Monster masks on his knees associate him with earth-monster imagery. In earlier Aztec monuments the Tlaloc-earth monster was carved in relief on the bottom of sculptures, but in these later carvings the figure takes on a more complex, three-dimensional form. The Teotihuacán precursors of this figure usually carry a vessel for burning incense or receiving offerings. In this Mexica sculpture, as in the Chac Mool discussed above, the vessel is sealed: offerings were no longer made by these ancient cultures, this role having passed on to the Mexica.

Man with Jaguar Helmet

The Man with Jaguar Helmet (Plate 142) is usually thought to represent a Mexica knight of the Jaguar Order, as suggested by the helmet; otherwise the figure does not hold arms. He is squatting in the familiar pose of many male figures in Aztec sculpture, and he wears behind his head the folded paper fan of the nature deities. The rich collar with its pendant that imitates jade jewelry is similar to those worn by the Chac Mool (Plate 137). This may be another Mexica figure impersonating a Toltec deity, as the Chac Mool represents the god Tlaloc, but the nature of the deity is not easy to determine. The jaguar helmet would be appropriate to a god such as Tepeyollotl,

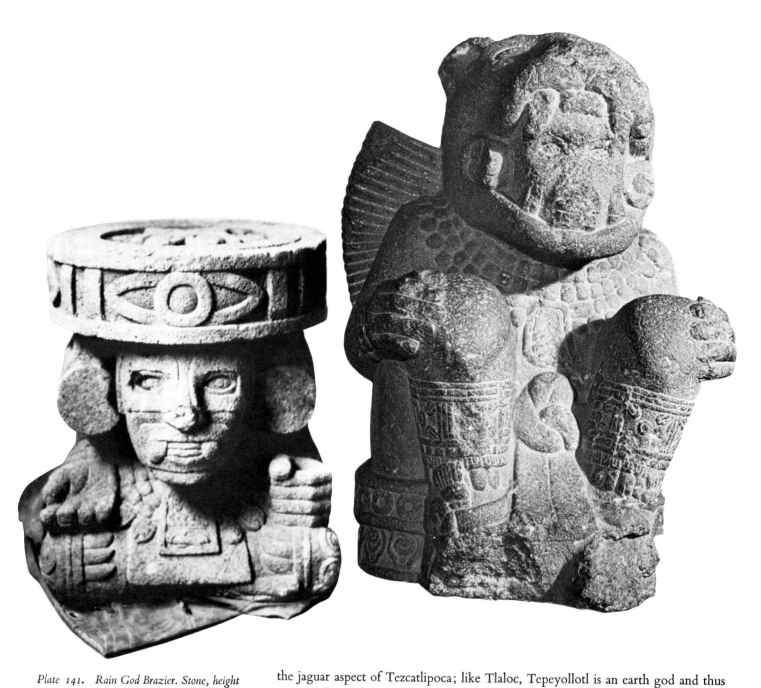

Plate 141. Rain God Brazier. Stone, height
67 cm. North side of Main Temple Area,
Tenochtitlán. 1502–20. In situ, Mexico City

Plate 142. Man with Jaguar Helmet. Stone,
78 × 54 cm. Mexico City. 1502–20. Museo
Nacional de Antropología, Mexico City

the jaguar aspect of Tezcatlipoca; like Tlaloc, Tepeyollotl is an earth god and thus associated with the gods of the past. The jaguar is also associated with caves and the interior of the earth, and Motecuhzoma II was especially fascinated by caves. In Malinalco, jaguar and eagle pelts are carved on a bench in a cavelike interior. At the time of the conquest Motecuhzoma wanted to take refuge in a cave at Chapultepec, there to join the Toltec king Huemac.

The relief at Acatzingo (see Plate 75), near Malinalco, has features remarkably similar to this sculpture. Both figures wear a jaguar helmet and paper fan, and perhaps an heirloom necklace (Umberger, 1981, pp. 164–67).

The emphasis on rich jewels in all three of these sculptures is interesting. The Mexica believed that jewels, especially greenstone, were hoarded in caves and guarded there by rain gods and defunct kings such as Huemac. They also associated jewelry with the Toltecs, and referred to the fact that beads could be found at Tula, by

*Plate 143. Standard Bearer. Stone, 117 ×
78 cm. Tenochtitlán. Probably 1502–20. Museo
Nacional de Antropologia, Mexico City*

digging in the ancient ruins (see page 90). The jewelry on these monuments may
signify heirloom pieces.

Standard Bearer

The seated sculpture of a richly dressed man is assumed to be a standard bearer
because the hole may have been made between the legs to support a banner (Plate
143). In the absence of the head and hands, the identity of the figure is obscure. Rich
clothing, including the wide collar of beads and the anklets and sandals, refers to high
status. Skulls ornament the edge of the stepped platform beneath the figure. The
carving of the knees and legs is the most naturalistic in Aztec sculpture, and the date
of the figure is presumably quite late. Both the naturalism and the rich jewelry carved

in such high relief relate this figure to the style of the Rain God Chac Mool and the Man with Jaguar Helmet.

The illustration of the Main Temple precinct by Sahagún in the Codices Matritenses (see Colorplate 22) shows sculptured standard bearers on either side of the twin pyramid. The figures carry round shields and banners decorated with feathers and paper. These standard bearers must have had importance for the Mexica. It is curious that in the Sahagún picture, standard bearers are the only figures represented next to the Main Temple.

Tula-style Atlantid

While the Mexica reinterpreted Toltec monuments throughout their history, only one instance is known of their copying a sculpture in detail. In a group of Toltec atlantids found together, one atlantid is a Mexica copy (Nicholson, 1971, p. 111). It is recognizable as Mexica from the more naturalistic modeling in the round, the definition of toes and fingers, and the soft modeling of the slightly open mouth (Plates 144–46). The Mexica made one significant change in the Toltec prototype—they added a beard. Since most American Indians have little facial hair, a beard had symbolical importance as a sign of old age and veneration. Because the sculpture has the architectonic rigidity of its prototype, it is not easily placed in the chronology of Mexica sculpture. Perhaps the Toltec sculptures were brought to Tenochtitlán in the same way that the Quetzalcoatl relief was carved at Tula (see Plates 67, 68), a fictitious relationship validated by an exchange of stone monuments.

Plate 144. Tula-style Atlantid. Stone, 130 42 cm. Mexico City. 1502–20. Museo Nacional de Antropología, Mexico City

Plate 145. Back of Tula-style Atlantid

Plate 146. Side of Tula-style Atlantid

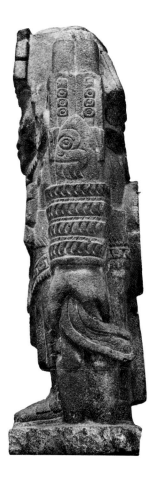

V

CODICES

Introduction

By the time the Aztecs came to power, books and writing were many centuries old in Mesoamerica. Because books were made of deerskin or bark paper, few have survived the destructive forces of time and climate. Only fourteen books are known to date from before the conquest, all from the Postclassic period, and they survived because the conquerors sent them to Europe as curiosities or because they were secretly kept in native hands as heirlooms. Not one of these books is definitely Aztec or Mexica; they are either Mixteca-Puebla or Maya (Glass, 1975), for the conquerors and missionaries saw the Aztec books as works of the devil and burned them. (The Spaniards were not the first to do so in Mesoamerica—the Mexica ruler Itzcoatl is said to have burned the history books of the past and rewritten their history to give the Mexica a more glorious role.) After the conquest, the mere ownership of an Aztec codex was enough to send a native to the fire, condemned by the Inquisition. Don Carlos Chichimecatecatl, a lord of Texcoco, was burned at the stake in 1539 for pagan practices; a book of days or *tonalamatl* was presented as evidence of heathenism at his trial (Robertson, 1959, p. 36).

While the Spaniards destroyed Aztec manuscripts as so many heathen bibles, they also commissioned Christianized natives to illustrate the Aztec chronicles and make painted copies of the old books so that Europeans could understand Aztec history and religion. Some of these copies made of native materials were almost perfect duplicates of preconquest books. But the sixteenth-century native painters, especially those taught in monastic schools, quickly modified their style to follow European models. Realistic drawing, perspective, light and shade, and other elements of Western art were combined with the native heritage (Brown, 1977). Hundreds of these synthetic illustrations have survived in Mexican and European archives. Native painters were also asked, in addition to copying old books, to illustrate subjects for which there was no native tradition but that interested the Spaniards. For example, the Codex Mendoza was commissioned by the viceroy Mendoza for Charles V in 1541–1542; the ship taking it across the Atlantic was captured by French pirates who gave the book to the king of France (Ross, 1978). The book includes a history of the Mexica, a tribute list, and scenes of daily life and customs (see Colorplates 7, 14; Plates 26, 30, 31). For the history and the tribute list, the painters had copied native books. The Aztecs did not draw daily life scenes, however, and the painters had to invent new ways to illustrate this for the Spaniards. A curious aspect of the conquest period in Mexico is that European artists made so few pictures of the natives. Probably the Spaniards used native artists to illustrate their own past because there was already an Aztec tradition of books and writing. The style of the native painters became more and more European as the century progressed (see Colorplates 12, 13). The Spaniards also influenced the content: their interest in the monthly rituals of the solar year led to many colonial manuscripts representing those patrons and events (see page 60);

so far, there is no clear evidence that the rituals of the months were a subject in pre-conquest books (Kubler and Gibson, 1951; Brown, 1977).

The Aztecs had many different kinds of books. The most common was the *tonala-matl* or "book of days," used by priests for prophesying and interpreting the will of the gods. But there were also books of the years, books of the history of ruling families, maps, and tribute lists. Motecuhzoma kept track of Cortés's whereabouts by means of paintings that his spies sent to him. When Cortés asked him about ports on the Gulf Coast, Motecuhzoma gave him a map showing its rivers and coves; Cortés later used a native map to go to Honduras (Cortés, 1971, pp. 94, 339–40). No example survives of each kind of book that once existed. Religious and secular books were painted and interpreted by the aristocratic and priestly sectors of society, and were probably too mysterious and esoteric for commoners to understand.

Pre-Columbian books were generally on long strips which were either accordion-pleated or rolled. The strips were often painted on both sides, and usually read from right to left, and from top to bottom. Unlike the Maya, the Aztecs had no form of hieroglyphic writing. The books were written in pictographs and ideographs, sometimes with phonetic elements that were mnemonic devices for recording what were essentially oral traditions. The ideographs, called glyphs, include personal names, place names, and dates in the calendar. In the historical narratives the same figures reappear many times; direction of events is indicated by successive footprints. In the religious manuscripts the information is not in narrative form but in iconic images, whose meaning is to be found in the costume and insignia of the deities. None of the myths retold in the chronicles is illustrated in narrative form in the codices. The myths belonged to the oral tradition; the gods in the codices were represented in relation to the calendar, for the casting of horoscopes.

The codices have usually been studied as illustrations accompanying the written chronicles, not as works of art in themselves. Though they were made to preserve and communicate information, they were painted by artists with a sense of firm line and dramatic color. Preconquest Aztec style is often equated with Mixtec manuscript style, and all deviations are thought to be the result of colonial influence (Robertson, 1959, p. 12 and *passim*). The Aztecs, however, had their own style, and it differed considerably from the Mixtec, especially in the historical manuscripts. The codices are often interpreted as though their contents were authoritative encyclopaedias of preconquest religion and history. But in fact, all the books are biased in favor of their place of origin, or the family or priests who commissioned them, or the purpose for which they were made. Rather than seeing them as standard references, one must recognize that they often reflect local and specialized subjects.

The codices discussed here were all probably painted after the conquest, but they are still close to indigenous prototypes. They were painted on native paper made from various plants, including the maguey cactus and the wild fig tree (*amatl*). The bark or leaves were soaked in water, the pulp was beaten with stone pounders on a flat surface, and it was dried in the sun (Von Hagen, 1944). The many pigments came from various mineral and vegetable sources and were fixed with vegetable gums, their brightness surviving to the present day.

Codex Borbonicus

The Codex Borbonicus is the largest, most detailed, and most beautifully painted Aztec manuscript that we know. The first record of it is in 1778 when it was listed in

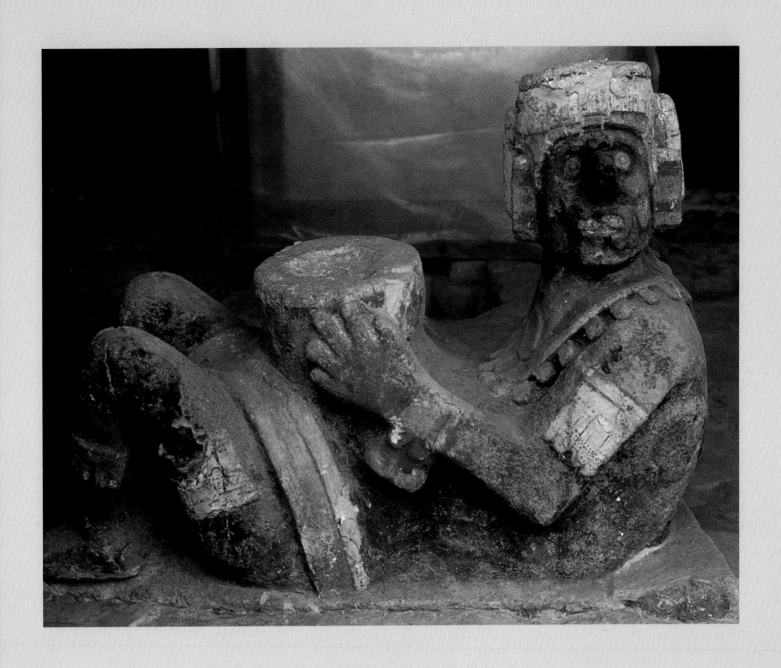

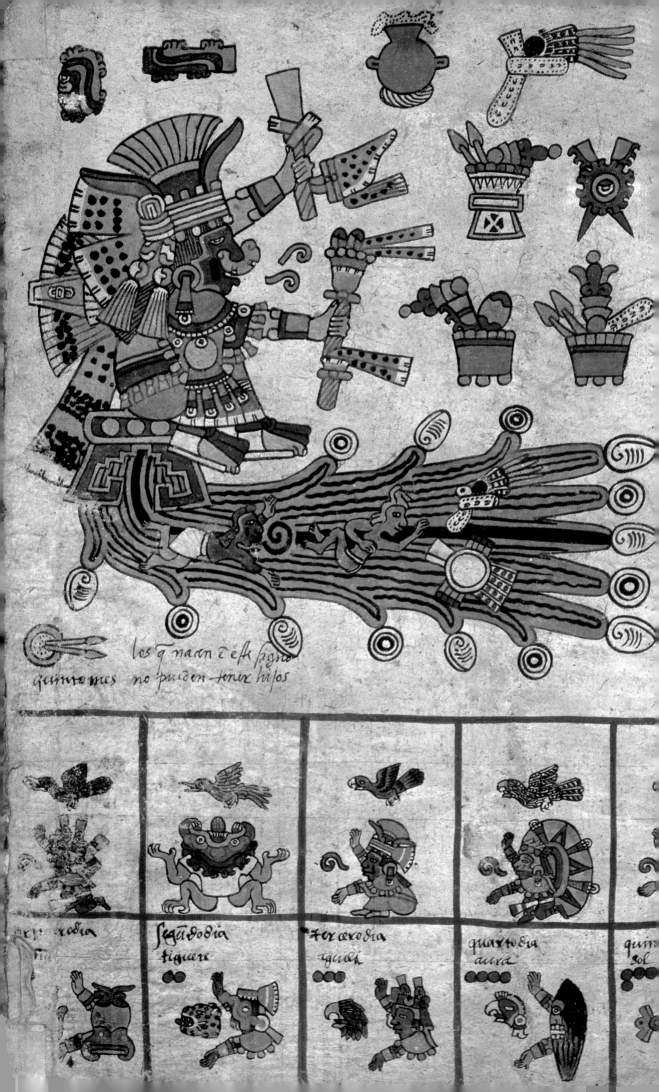

los q̃ nacen ē este signo
quinromes no pueden tener hijos

quarto dia
aura

quin
sol

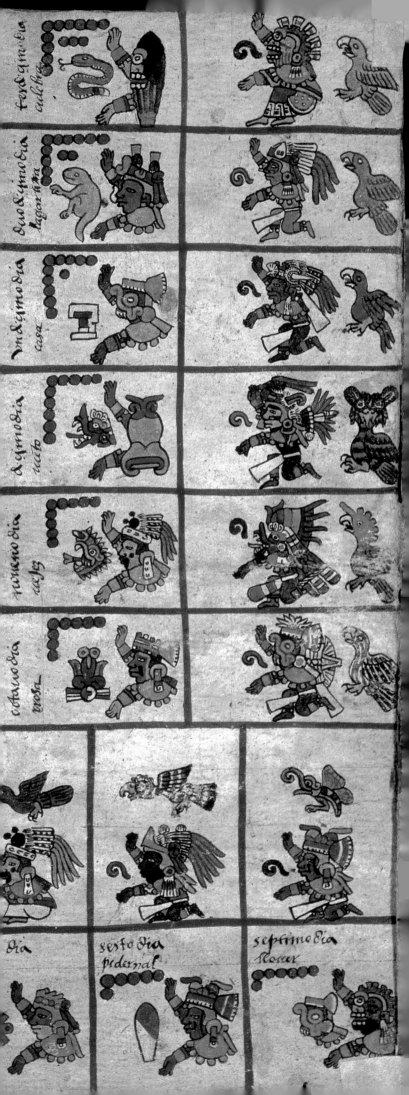

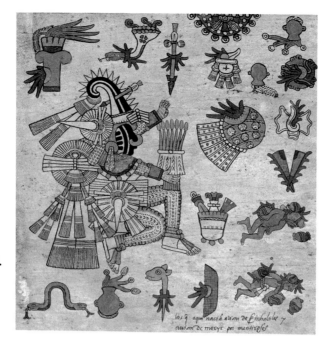

Colorplate 30. Itztlacoliuhqui, "Obsidian Knife," God of the Obsidian Knife. Codex Borbonicus, p. 12 (portion). Screenfold manuscript, panel 39 × 39.5 cm. Mexico City. Preconquest or Early Colonial. Bibliothèque de l'Assemblée Nationale, Paris

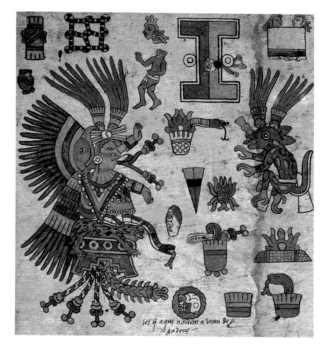

Colorplate 31. Xochiquetzal, "Flower-Quetzalbird," Goddess of Flowers and Love. Codex Borbonicus, p. 19 (portion). Screenfold manuscript, panel 39 × 39.5 cm. Mexico City. Preconquest or Early Colonial. Bibliothèque de l'Assemblée Nationale, Paris

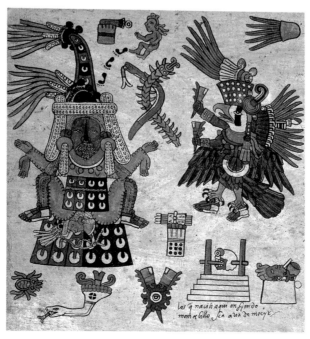

Colorplate 32. Tlazolteotl, "Goddess of Filth," Goddess of Sin and Adultery. Codex Borbonicus, p. 13 (portion). Screenfold manuscript, panel 39 × 39.5 cm. Mexico City. Preconquest or Early Colonial. Bibliothèque de l'Assemblée Nationale, Paris

OPPOSITE

Colorplate 33. Quetzalcoatl, "Feathered Serpent" (left), and Tezcatlipoca, "Smoking Mirror" (right). Codex Borbonicus, p. 22 (portion). Screenfold manuscript, panel 39 × 39.5 cm. Mexico City. Preconquest or Early Colonial. Bibliothèque de l'Assemblée Nationale, Paris (see also Plate 147)

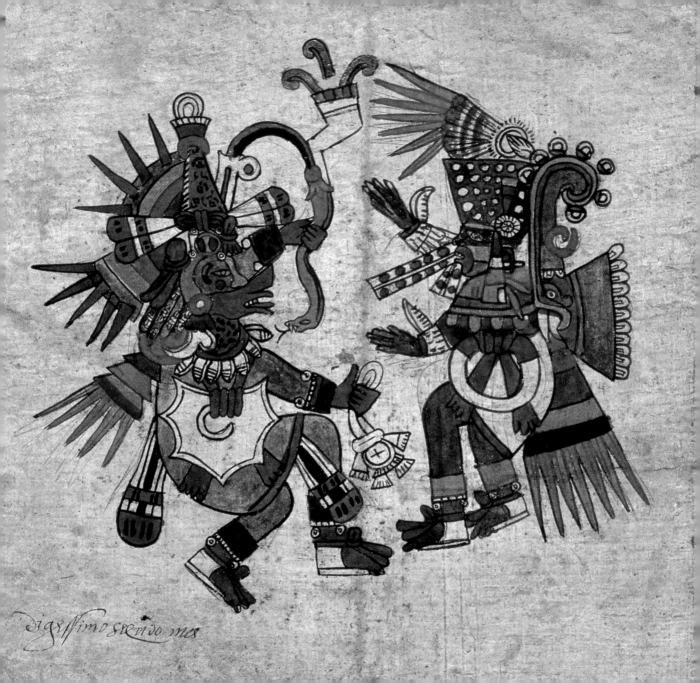

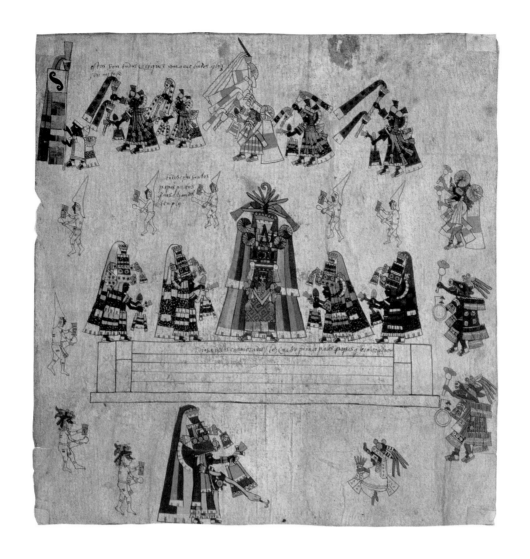

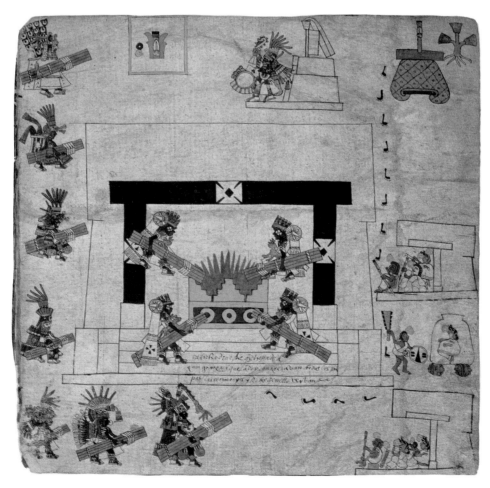

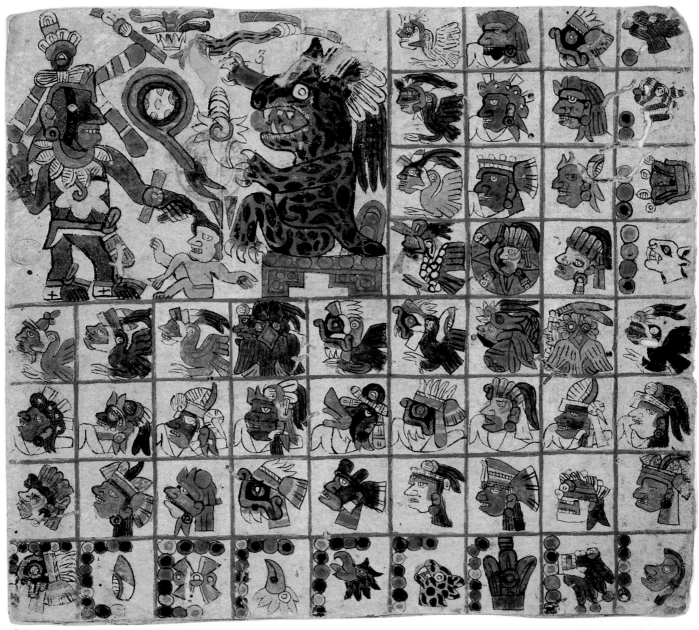

Colorplate 36. Tepeyollotl, "Heart of the Mountain" (Tezcatlipoca in Jaguar Guise). Codex Aubin tonalamatl, p. 3. Screenfold manuscript, panel 24 × 27 cm. Probably Tlaxcala. Early Colonial. Bibliothèque Nationale, Paris

Colorplate 34. The Ochpaniztli Ritual at Harvest Time. Codex Borbonicus, p. 30. Screenfold manuscript, panel 39 × 39.5 cm. Mexico City. Preconquest or Early Colonial. Bibliothèque de l'Assemblée Nationale, Paris

Colorplate 35. New Fire Ceremony. Codex Borbonicus, p. 34. Screenfold manuscript, panel 39 × 39.5 cm. Mexico City. Preconquest or Early Colonial. Bibliothèque de l'Assemblée Nationale, Paris

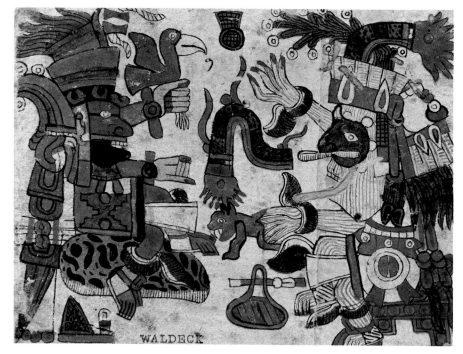

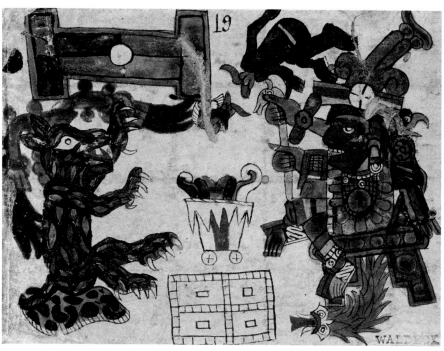

Colorplate 37. Xiuhtecuhtli, "Turquoise Lord," God of Fire (left), and Tlahuizcalpantecuhtli, "Dawn Lord," God of Planet Venus (right). Codex Aubin tonalamatl, p. 9 (portion). Screenfold manuscript, panel 24 × 27 cm. Probably Tlaxcala. Early Colonial. Bibliothèque Nationale, Paris

Colorplate 38. Xochiquetzal, "Flower Quetzalbird," Goddess of Flowers and Love, with Ball Court, Decapitated Victim, and Animal. Codex Aubin tonalamatl, p. 19 (portion). Screenfold manuscript, panel 24 × 27 cm. Probably Tlaxcala. Early Colonial. Bibliothèque Nationale, Paris

OPPOSITE
Colorplate 39. Nomadic Life of the Chichimec at the Time of the Ruler Quinatzin in Texcoco. Mapa Quinatzin, p. 1. Manuscript of 2 pp., each c.38 × 44 cm. Texcoco. Early Colonial, c. 1542–48. Bibliothèque Nationale, Paris

Colorplate 40. The Palace and Administration of Texcoco; Rulers Nezahualcoyotl and Nezahualpilli in the Central Room. Mapa Quinatzin, p. 2. Manuscript of 2 pp., each c.38 × 44 cm. Texcoco. Early Colonial, c. 1542–48. Bibliothèque Nationale, Paris (see Plate 152)

OVERLEAF
Colorplate 41. Tribute from the Province of Xilotepec. Matrícula de Tributos, fol. 6r. Manuscript, 42 × 29 cm. Mexico City. 16th century. Museo Nacional de Antropología, Mexico City

Colorplate 42. Tribute from the Province of Tochpan. Matrícula de Tributos, fol. 15v. Manuscript, 42 × 29 cm. Mexico City. 16th century. Museo Nacional de Antropología, Mexico City

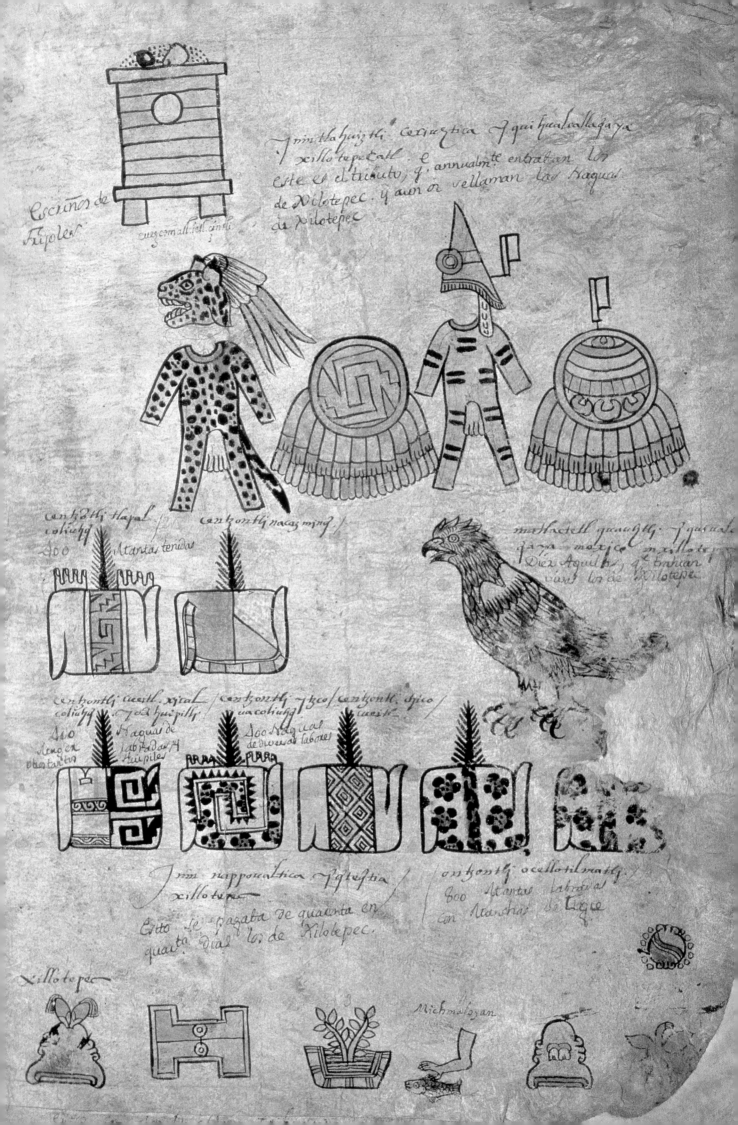

Escaños de
Frijoles

cuezcomatl, petl, cintli

Inin tlahuiztli, certaestia, y qui huilcallagaya
xillotepetal, c, annualmte entraban los
este es el tributo, q, annualmte entraban los
de Xilotepec, y aun os vellaman los tiaguas
de Xilotepec

centzontli tlapal
coliuhq
400 Mtantas tenidas

centzontli nacazming

matlactell quauchtli, y quacual
gaya mexico mxillotep
Diez Aguilas, q, traluan
vivas los de Xilotepec

centzontli acestl, xital
coliuhq 400 huipilly
400 Mxonea
Tenoen labrados, y
quautanhi Huipiles

centzontli yxco
uacoliuhq
400 Naguas
de diversas labores

centzontli chico
cuaxtli

Inin nappoualtica, y, tgtestia
xillotepec
Esto se pagaba de quarenta en
quarta Dias los de Xilotepec

centzontli ocellotilmatli
800 Mtantas labradas
con Mtanchas de tigre

Xillotepec

Michmaloyan

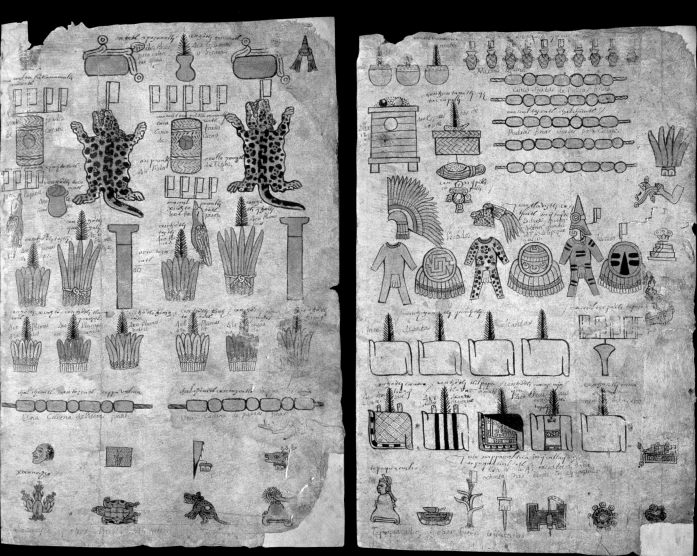

the Escorial in Spain. It was taken from there by the French, probably in 1823, and has remained in Paris ever since. The manuscript is a screenfold of native paper, missing its first two and last two pages. The first part is a *tonalamatl* (*tonalli* = day, sun, fate; *amatl* = paper, book); the second is a fifty-two-year cycle; the third depicts rituals related to the annual festival cycle. There has been much controversy as to the date of the codex, whether it is from before or after the conquest. The use of red guidelines to mark off spaces for Spanish commentaries throughout the first section would seem to indicate that the manuscript was made after the conquest, a copy of a preconquest original (Robertson, 1959, pp. 89–93; Caso, 1967, pp. 103–12).

The Codex Borbonicus is unusual among native preconquest screenfold manuscripts for its large size, the pages being about sixteen inches square, and for its elaborate detail. The manuscript may have been commissioned for presentation to an important patron, possibly a Spaniard; or it may have had a varied history and remained for some time in native hands. Paso y Troncoso's examination in 1898 of the manuscript's physical state suggested possible use, for the first section was quite worn and there was some repainting and correcting. The glosses were written in four separate hands, most of them full of errors and demonstrating that the writers were unfamiliar with the content. Couch (n.d., p. 9) suggests that the Codex Borbonicus may have remained in native hands for a time after the conquest and functioned in their secret rituals. A feather pasted on one page may support this idea.

The *tonalamatl* section consists of the 260-day ritual almanac divided into twenty "weeks" of thirteen days. Each "week" is illustrated by the patron deity of the week in a large panel, accompanied by symbols for the thirteen individual days, the thirteen Lords of the Day, the nine Lords of the Night (see Glossary), and in the sections created by red guidelines, the thirteen birds or insects (Colorplate 29). The patrons of the "weeks" are with some exceptions the same as the deities of the patrons of the twenty day signs.

Tonalamatl books were in the possession of priests and diviners, who made frequent use of them. The book was consulted at birth for naming a child and predicting its future character and fate, and to set the dates for marriage, declaring war, going on a journey, and other major events. The character of the patron of the week determined the nature of the week, but the number and deity of each of the thirteen days were also factors.

Chalchiuhtlicue, the goddess of water, was the patron of the week beginning with 1 Reed. This was a bad sign (Colorplate 29): water signified the shifting nature of life on earth, the flowing away of good fortune; the reed indicated hollowness; the figures and objects in the stream of water below the throne of the goddess represented misfortune. But water was also a symbol of purification, especially of the sins of sexuality: the Aztecs' many forms of divination included looking into reflecting surfaces such as mirrors and containers of water; casting maize kernels, sometimes onto the pages of the *tonalamatl*; and tying and untying knots. The diviner referred to the *tonalamatl* as a mirror and said to his client: "You have come to see your reflection" (Sahagún, 1950–78, bk. 5).

The deities of the ritual almanac had become set before the time the Mexica emerged as rulers in the Valley of Mexico. Therefore Mexica gods such as Huitzilopochtli, Coatlicue, and Coyolxauhqui do not appear in its pages, and its twenty deities include major fertility and astral gods who were venerated in many parts of Postclassic Mesoamerica: Tlaloc, god of water; Mayahuel, goddess of *pulque*; Tonatiuh, god of the sun; Tlahuizcalpantecuhtli, god of Venus; and Xiuhtecuhtli, god of fire. Tlaloc and some other gods had their own temples, and images made in stone, wood,

Colorplate 43. Tribute from the Province of Xoconochco. Matrícula de Tributos, fol. 13r. Manuscript, 42 × 29 cm. Mexico City. 16th century. Museo Nacional de Antropología, Mexico City

Colorplate 44. Tribute from the Province of Tepecoacuilco. Matrícula de Tributos, fol. 19r. Manuscript, 42 × 29 cm. Mexico City. 16th century. Museo Nacional de Antropología, Mexico City

or clay. Itztlacoliuhqui, "obsidian knife" (Colorplate 30), and Chalchiuhto-
tolin, "precious turkey," were purely calendrical deities, however, appearing only
in the pages of these codices and having no separate cults. Yet the solar god, Tonatiuh,
believed to be the central figure in Aztec religion, occurs in the books only once,
and then as a secondary figure. Instead, many of the *tonalamatl* gods were aspects of
Tezcatlipoca, god of the smoking mirror, of darkness, of chance, and of sorcery; he
appears as a major or minor deity in eight out of the twenty scenes. Evidently the
tonalamatl does not give a complete picture of Aztec gods and religion, but em-
phasizes aspects concerned with divination, in which the deity Tezcatlipoca pre-
dominates.

The nature of each god and his area of interest is illustrated by the image of the
deity and the various objects surrounding it. Xochiquetzal, patroness of the nineteenth
week, who occupies a throne of honor, is seated upon the jaguar and serpent skins that
symbolize the earth (Colorplate 31). The quetzalbird helmet and the two tufts of hair
decorated with green feathers signify her name, "flower-quetzalbird." Her richly
embroidered skirt and shoulder cloth refer to her aspects as goddess of beauty and
patroness of embroiderers. Her lunar aspect is indicated by the rabbit she faces, who
is also ornamented with two tufts of quetzal feathers; the Aztecs believed that a
rabbit lived in the moon. Above the goddess's head is a square design representing
the *patolli* game, played much like our game Parcheesi. To the right is a decapitated
man and a ball court, decapitation being associated with female deities and with the
ball game. At top right are a man and a woman covered by a blanket, a pictorial
euphemism for lovemaking: Xochiquetzal was the patroness of sexual love, and,
by extension, of prostitutes. The other emblems scattered around her include a heart,
sacrificial knife, penitential throne, offerings, and a spider, the insect symbolizing the
night, the earth, weavers and spinners, and female deities.

A comparison of this page in the Codex Borbonicus with the same subject in the
Codex Borgia indicates the closeness of the Borbonicus to native prototypes (see
Colorplate 4), the Codex Borgia being a preconquest manuscript from the Puebla,
Tlaxcala, Oaxaca, or Gulf Coast region. A large portion of the Codex Borgia is
concerned with the patrons of the day signs and of the twenty weeks of thirteen days.
As in the Codex Borbonicus, the Codex Borgia Xochiquetzal is seated on a throne
covered with a jaguar skin, and she is ornately dressed in colorful textiles and the
quetzal disguise. There are other parallels in the graceful, open gesture of the hands,
the gameboard design, and the rubber ball referring to the ball game. Besides these
similarities of content, there is close correspondence in style: the figures in both
illustrations are arranged in dramatic designs outlined by solid black contour lines
against the flat background. The lines and forms in the Codex Borgia are more
angular, however, and the internal designs more delicate and smaller in scale. The
forms in the Codex Borbonicus are softer as well as larger, and the outlines are more
curvilinear. But these traits are seen in Aztec art in other mediums, and need
not be a reflection of Spanish influence.

While the Codex Borbonicus artist stayed close to standard prototypes in rep-
resenting Xochiquetzal, his image for the goddess Tlazolteotl is unusual (Colorplate
32). Instead of showing her in profile like other gods, she is in a striking frontal posi-
tion. The name Tlazolteotl means "goddess of filth"; this goddess inspired sin, espe-
cially adultery, but her priests could also absolve a sinner who made full confession.
If unconfessed adulterous couples were found out, they were stoned to death, as seen
at the lower right of the deity Itztlacoliuhqui, the flintknife aspect of Tezcatlipoca
as unmerciful judge (Colorplate 30). Since only one confession could be made in a

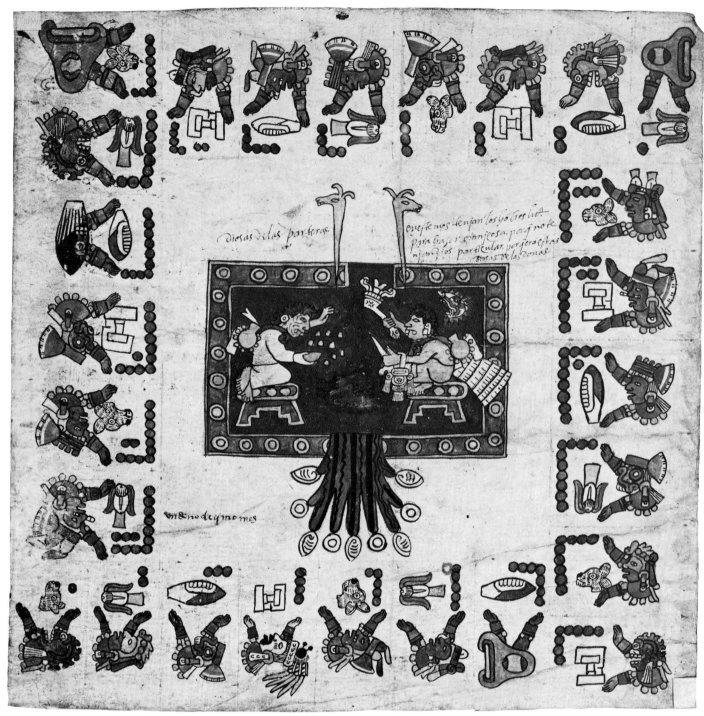

Plate 147. *Oxomoca and Cipactonal, First Created Couple, Patrons of Sustenance and Origins. Codex Borbonicus, p. 21 (portion). Screenfold manuscript, panel 39 × 39.5 cm. Mexico City. Preconquest or Early Colonial. Bibliothèque de l'Assemblée Nationale, Paris (see also Colorplate 33.)*

lifetime, people waited until they were old before doing so. The Aztec practice of confession had similar features to the Catholic sacrament, and the Spaniards were much interested in it; Sahagún's informants described it in detail: ". . . before Tlazolteotl one recited, one told one's sins. And her mediator, the one who became her hearer, was the soothsayer, the wise one, in whose hands lay the books, the paintings; who preserved the writings, who possessed the knowledge, the tradition, the wisdom which hath been uttered. The penitent who would confess first explained to the soothsayer, he said unto him: 'I wish to go to the master, our lord of the near, the nigh, our lord of the night, the wind. I wish to learn of his secrets' " (Sahagún, 1950–78, bk. 1, p. 24).

The priest selected an auspicious day from the *tonalamatl* and on that day the sinner

bought a new mat, and burned incense in the fire. After an exhortation by the priest, he told his sins in "the same order in which he committed them." The priest then required of him the appropriate penance, which might include fasting on certain days, drawing blood from the tongue, the ears, or the penis, going naked with a paper loincloth, singing and dancing, or making images.

In the Codex Borbonicus, Tlazolteotl is wearing the skin of a sacrificial victim and a headdress of cotton. She is giving birth to a small figure who wears a similar headdress and holds intertwined ropes. The cult of Tlazolteotl was said by the Aztecs to have come from the Huastecs, who grew much cotton and had a reputation for loose morals. At the right the secondary figure, wearing a bird costume and Tezcatlipoca's headdress, holds the spines used in drawing blood. He may represent the spirit (or the priest) to whom confession was made. Tezcatlipoca is probably the "lord of the near and the nigh" invoked by Sahagún's sinner. All the other emblems scattered on the page signify sacrifice. The birth-giving figure is unique in Aztec art, which generally avoided so direct a depiction of genitals and body functions. Tlazolteotl is only known from codex paintings; no idols were made of her that we can now recognize, though the textual sources show that she had her cult and priest.

Since the *tonalamatl* illustrations are not telling a narrative, they have no indications of time and space. The deities and associated symbols are distributed on the pages with no ground line or horizon. The gods are often shown in a seated pose but with nothing to sit on. Scattered attributes may refer to the character of the god or to emblems of sacrifice and penance. Their presence makes a composition on the page similar to the verbal repetition of synonyms in Aztec prose, as in the varied references to the soothsayer of Tlazolteotl in the passage quoted above. The mnemonic value of the images resides in the costumes and emblems of the figures, rather than in their actions.

For the sections in the remaining pages of the Codex Borbonicus, no preconquest parallels survive. Pages 21 and 22 contain a fifty-two-year cycle divided into two periods of twenty-six years each (Plate 147). In the borders are represented the year bearers for each year, starting with 1 Rabbit on the lower left, and associated with the nine Lords of the Night. In the center of page 21 an architectural enclosure with Oxomoca and Cipactonal enthroned within it represents the first created couple, the ancestors of the human race, who were similar to the old Lord and Lady of Sustenance and of Origins, Ometeotl and Omecihuatl, toothless old deities who nonetheless dressed simply, like priests. They carry tobacco gourds on their backs. Cipactonal, identified by the alligator-like *cipactli* glyph (the first symbol of the almanac), is burning incense in a ladle and carries an incense bag. Oxomoca is casting maize seeds for divination. Water, the primary gift of the gods, flows from the side of the building in which they sit. The Lord and Lady of Duality are the patrons of the ritual almanac and of divination but they were not directly worshiped or represented by idols. In the codex, they symbolize the principle of male and female duality in the cosmos, and the origin of life.

On the next page is another confrontation, this time between Quetzalcoatl and Tezcatlipoca (Colorplate 33). They are in semi-seated poses against the timeless and spaceless neutrality of the page. The historical traditions of the Aztecs refer to Quetzalcoatl as the saintly ruler of Tula who was tempted into sin and banished from his city by the evil Tezcatlipoca, but in the Codex Borbonicus there is no reference to this legend. These two gods were particularly associated with books and the priesthood. Tezcatlipoca, who could live anywhere and everywhere, symbolized chance and fate, much as the almanac was the book of fate in which the priest read the will

of the gods; Tezcatlipoca's primary emblem is the smoking mirror, and the *tonalamatl* was metaphorically known as the mirror in which life was reflected. The contrary nature of Tezcatlipoca is evident in Sahagún's description: the god is said to bring discord, anguish, and evil, but may also give "wealth, heroism, valor, position of dignity, rulership, nobility, honor" (Sahagún, 1950–78, bk. 1, p. 5). In the religious codices, Tezcatlipoca stands for the principle of chance and the arbitrariness of the gods. The most powerful mortal on earth, the ruler, is under Tezcatlipoca's special patronage; like Tezcatlipoca, the ruler personified arbitrary power on earth.

In the codex, Quetzalcoatl represents the principle of penance and virtue; only by observing this can man ameliorate his fate by his own actions. Most of the deities of the ritual almanac are, therefore, associated with symbols of penance and self-sacrifice. The name Quetzalcoatl was given to the high priests of the temples of Tenochtitlán. These two pages, therefore, indicate the origin of all life through the presence of the creator couple, and the interplay of fate with proper behavior that determines the outcome of life. Because Quetzalcoatl and Tezcatlipoca are related to fate, penance, and the group of priests and diviners, they are among the gods most frequently represented in the religious codices.

The last section of the Codex Borbonicus represents the festivals of the eighteen months of the solar year. We do not know whether the origins of this part of the codex are prehispanic, for there is no prehispanic codex with such a section; the presence of overlapping and perspective in some of the scenes suggests Spanish influence. The narrative quality and the smaller size of the figures in relation to the space are clues that a different artist may have painted this section.

The *tonalamatl* was used in divination, but no function can be ascribed to these last pages. Moreover, we know that the Spaniards were particularly interested in the monthly rituals of the solar year and had illustrations made of them in many sixteenth-century manuscripts. To the Spaniards the rituals of the solar year were perhaps more comprehensible than the esoteric almanac. The ritual almanac was standard throughout Mesoamerica in the Postclassic period, but it represented cosmic time and space. By contrast, the rituals of the months of the solar year were more local in character. Tied to the agricultural cycle, the rituals differed from place to place depending on ecological conditions. Moreover, the patron of the community and the ruling group had a major feast during these rituals.

Each month was under the patronage of a deity, and at the end of the month a festival was prepared in his honor. In the months dedicated to the agricultural fertility gods occurred festivals of commoners; other months belonged to professional groups, such as salt-makers, mat-makers, or merchants; some belonged to the warrior aristocracy or the priests. In every case the festival ended with the god being impersonated by a sacrificial victim who was then killed by priests or warriors. Dances, theatrical performances, and feasts that included special foods were also part of the festivals. The festival calendar was tied in with social and economic events. Tribute was traditionally collected during certain months, and military insignia rewarding bravery were distributed at specified times. When food was scarce before the first maize ripened, foodstuffs were distributed to the populace as part of the rituals.

In the Codex Borbonicus the festivals of the eighteen months are represented by the images of the gods in their temples, by priests or sacrificial victims dressed as gods, by processions and dances, and by the presentation of offerings. It is particularly interesting that the deity Cihuacoatl appears in five different months; that the month Ochpaniztli is spread over three pages, while the other months usually have half a

page; and that the New Fire Ceremony, which occurred only every fifty-two years, is included as part of one of the months. These exceptional features indicate that the codex may have been painted in Culhuacan, for the patron goddess of Culhuacan was Cihuacoatl, the warrior aspect of the mother goddess; the most elaborate festival, Ochpaniztli, occurred at the time of the harvest and was dedicated to maize goddesses such as Chicomecoatl, and to mother goddesses such as Teteoinnan; and the New Fire Ceremony for the Mexica was held on a hill close to Culhuacan, the Hill of the Star. Taking all these together, a Culhuacan origin for the codex is very likely (Nicholson, 1974).

Couch (n.d.) compared the Codex Borbonicus illustrations with the textual descriptions of the festivals, and noted that the Codex Borbonicus differed from many texts, such as the descriptions in Sahagún's Florentine Codex of the rituals in Tenochtitlán. Sahagún describes rituals in which the rulers and nobility participated, but Codex Borbonicus scenes show only priests and commoners. The Codex Borbonicus is primarily concerned with the agricultural rituals of commoners and with the priests, charged with daily timekeeping and organizing the rites of the festivals.

The two elaborate compositions of the ritual of Ochpaniztli and the New Fire Ceremony are among the most beautiful pages of the codex (Colorplates 34, 35). At the bottom of the page is a sacrificial victim dressed as the maize goddess Chicomecoatl. A later moment in the ritual is seen in the center of the composition, after the woman has been sacrificed; a priest is now dressed as the goddess in the victim's flayed skin. Holding double ears of maize in his hands, this impersonator of the goddess stands on top of a temple platform. He wears the tall headdress of Chicomecoatl and rosettes in a rainbow of colors, and colorful paper streamers flow from head to foot. Flanking him are four priests with Tlaloc headdresses in the colors of the four directions: blue, white, yellow, and red. A procession of priests dressed as deities, including two with animal masks, goes around the central platform. Drawn only in black outline, a group of eight men, dressed in conical caps which identify them as Huastecs, form another procession around the goddess. Phallic objects protrude from their waists; the Huastecs were thought by the Aztecs to be particularly lascivious, and this procession expresses the fertility significance of the month which the more puritanical Aztecs would not impersonate themselves. On this page is combined the dramatic and bilaterally symmetrical composition of the center tableau with two separate processions winding around it. On the concluding page, the skin of the goddess is laid on a paper sheet by four priests painted in black. These pages of the Codex Borbonicus offer the most colorful picture of how spectacular the monthly festivals must have been.

Sahagún's description of the same Ochpaniztli festival celebrated in Tenochtitlán includes warlike details—the honored goddess carried weapons, and in the ritual were mock battles. The Codex Borbonicus festival has no military imagery and is concerned exclusively with fertility.

The New Fire Ceremony is part of the month Panquetzaliztli, dedicated to Huitzilopochtli in Tenochtitlán (Colorplate 35). It was first identified by Caso (1967, pp. 43–45, 129–40). At the top of the page Huitzilopochtli stands in front of a pyramid decorated with banners; to the left is the year 2 Reed, in which the New Fire Ceremony occurred (in 1507); in the top right corner there is a green hill symbol with a fire drill stick on top. Next to it is a plant with three leaves, the place glyph of Huixachtlan, "the place in which abounds the huisache [a kind of mimosa] tree," and the name of the hill where the New Fire Ceremony was performed. A row of footprints leads down from the hill to the temple.

Most of the page is taken up by the outline of a temple façade drawn in elevation. The lintel and posts, painted in heavy black bands, enclose the four priests of the fire god Xiuhtecuhtli burning the year bundles. The priests wear ornaments of folded paper characteristic of the mortuary rites of warriors; the orange flames contrast with the turquoise blue of the masonry hearth at the center of the composition. On the left a group of various god-impersonators bring more year bundles. There is no perspective, and the four priests with their bundles are superposed in an X-shaped design over the square form of the temple.

Children, old people, and a pregnant woman, for all of whom this time was full of supernatural danger, are shown at the right in their houses, their faces protected by maguey fiber masks painted blue. The pregnant woman is seated inside a jar-shaped granary elevated on stones, protected from the evil influence of the *tzitzimime* by a warrior with a shield and an obsidian-bladed weapon. Like all the commoners in the codex, these people wear plain white clothes and are barefoot.

Although the subject matter of the last section of the Codex Borbonicus may not be prehispanic in format, it shows that the native artists could adapt their traditional style to illustrate native rituals for the foreign conquerors. The resulting images are impressive for their decorative detail, and for their narrative and dramatic presentation. The *tonalamatl* pages consist of charts of the days and the gods in a timeless context; the rituals of the eighteen months demonstrate the pageantry of their worship in a social context.

The Aubin Tonalamatl

Like the *tonalamatl* of the Codex Borbonicus, the Aubin Tonalamatl is close in its style and content to preconquest manuscripts but was probably painted after 1521. Comments by the collector who acquired it in the eighteenth century suggest that it may have been made in Tlaxcala (Seler, 1900–1901; Aguilera, 1981). It is organized like the Codex Borbonicus in the form of charts, four rows including day signs, patron gods, Lords of the Night, and birds framing a picture of the patron on the upper left of the page. The close parallels with the Codex Borbonicus have suggested to some that it is a poor copy of that manuscript. The manuscript reads in the native manner, top to bottom and right to left. Most of the patrons are seated on thrones and face left. The figures are not as clearly delineated as in the Codex Borbonicus, and fewer colors are used. Awkward shapes and irregular outlines are evident in the illustrations of Tepeyollotl (Tezcatlipoca in jaguar guise; Colorplate 36), and of Xiuhtecuhtli, god of fire, and Tlahuizcalpantecuhtli, god of Venus (Colorplate 37), as patrons of the thirteen-day "weeks" represented on each page. Not enough manuscripts have been preserved for us to know whether the sloppiness is due to the provincial school of Tlaxcala, to a postconquest date, or simply to a poorer artist or less discriminating patron. Since the *tonalamatl* was frequently used for divination, we can assume the existence of many books of varying quality.

How standard became the arrangement of the figures in an Aztec *tonalamatl* is evident in comparing the representations of Xochiquetzal in the two codices (Colorplates 31, 38). In both examples Xochiquetzal is accompanied by a ball court, *patolli* game, decapitated victim, and a spotted animal. There are fewer scattered details in the Aubin, and the emblems crowd each other instead of being carefully arranged to have plenty of surrounding space on the page.

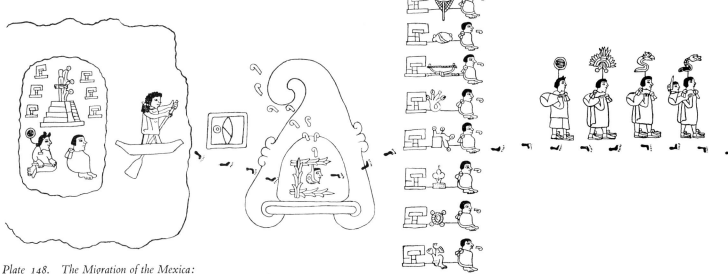

Plate 148. *The Migration of the Mexica:
Island Homeland of the Mexica (Aztlan);
Glyphs "1 Flintknife" and "Curving
Mountain"; the Eight Tribes and Four Leaders
Carrying the Image of Huitzilopochtli; the
Mexica Separating from the Other Tribes
and Continuing Their Migration Alone with
Their God Bearers; Scene of Hunting and
Performing Human Sacrifices on Cacti and
Trees. Codex Boturini. Roll manuscript,
entire dimensions 19.8 × 549 cm. Mexico
City. Early Colonial. Museo Nacional de
Antropología, Mexico City*

Plate 149. *The Mexica Learning to Make
Pulque from the People of Chalco. Codex
Boturini. Roll manuscript, height 19.8 cm.
Mexico City. Early Colonial. Museo
Nacional de Antropología, Mexico City*

Codex Boturini

The Codex Boturini is an example of the type of book the Spaniards used to reconstruct Aztec history (Plates 148–51). It was painted after the conquest, but may be a copy of a preconquest work. It is a very long roll (7 1/2 inches by 15 feet), probably painted in Tenochtitlán, and it tells the story of the migration of the Mexica before the foundation of Tenochtitlán (Radin, 1920). Unlike the religious manuscripts that are richly painted in many colors, the Codex Boturini is painted in black outlines throughout, except for the red lines that connect the dates. Footprints indicate the direction of migration and of reading.

If this example is typical of Mexica historical manuscripts, the Mexica tradition was very different from that of the Mixtec. In Mixtec books such as the Codex Nuttall the human figures are as colorfully dressed and have as many symbolic attributes as the figures in religious manuscripts (see Colorplate 3; Plate 21). But the Mexica figures in the Codex Boturini are not only simply dressed, they are also very small in relation to the empty space of the pages. Poses are limited to walking and sitting positions. When seated, the figure is reduced to essentials: head and feet project from a square mantle that ties on the shoulder and covers the inert body. These simply rendered figures are similar to the human participants in Codex Borbonicus ritual scenes (Colorplates 34, 35).

In the Codex Nuttall, the Mixtec kings had claimed descent from the gods; the Mexica origin myth in the Codex Boturini is more modest, though divinely inspired. In the first scene the homeland of the Mexica, perhaps Aztlan, is shown as an island in a lake, with a temple and six houses (Plate 148). A seated man and a woman with the name Chimalma (indicated by the shield, *chimalli*, above her head) represent the inhabitants. A standing man paddles a canoe to the shore, and there the footprints begin: the date is 1 Flintknife, the traditional date of the Mexica's departure from Aztlan. Footprints lead to a stylized place glyph, "curving mountain," which represents Culhuacan (a mythic Culhuacan, not the real city on Lake Texcoco). The image of Huitzilopochtli, shown as a head emerging from the hummingbird jaw within a reed enclosure in the cave, speaks to the Aztecs. Eight tribes, each identified by a house and a place glyph, are beginning the migration. They are led by four *teomama*, or god bearers; the first in the group carries the image of Huitzilopochtli, and Chimalma comes last. The migrants settle and erect a temple to Huitzilopochtli, and five of them sit in a circle, eating. The tree indicating the location splits in half, considered a

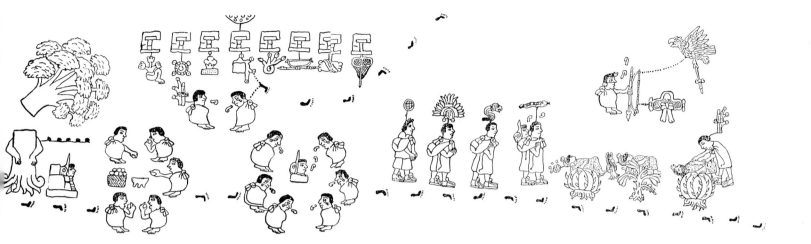

bad omen. (The broken tree is associated in the *tonalamatl* with the goddess Itzpapalotl, and represents the paradisical place of origin lost by humanity.) Six weeping figures surround the image of Huitzilopochtli and ask his advice. Their leader talks to one of the other tribal leaders and the Mexica split off from the other tribes, going their separate way. The four god bearers proceed, stopping to hunt and to perform human sacrifices on trees and cactus plants. After this episode the narration of individual names and dramatic incidents ceases, and most of the rest of the codex consists of twenty-two successive scenes, each showing a place sign, four seated unidentified Mexica, and rows of year signs to indicate the number of years spent at that place. The different directions taken by the footprints relieve the monotony of composition. One of the few episodes shows the Mexica learning from the people of Chalco how to make *pulque* from the maguey cactus (Plate 149), the only suggestion that the Mexica were unfamiliar with the sedentary culture in the Valley of Mexico.

Toward the end of the codex the Mexica settle in Chapultepec on the west bank of Lake Texcoco, indicated by a large hill sign, a spring, and a grasshopper (Plate 150). After twenty years they are driven out to a place called Acocolco, where they are seen weeping and dressed in skins. Their two leaders are taken captive by Coxcox, the ruler of Culhuacan, seated on the mat of rulership with the turquoise diadem on his forehead (Plate 151); otherwise his pose is conventionalized like that of the other

BELOW, LEFT
Plate 150. The Mexica Settlement at Chapultepec. Codex Boturini. Roll manuscript, height 19.8 cm. Mexico City. Early Colonial. Museo Nacional de Antropología, Mexico City

Plate 151. The Mexica as Vassals of Coxcox, Ruler of Culhuacan. Codex Boturini. Roll manuscript, height 19.8 cm. Mexico City. Early Colonial. Museo Nacional de Antropología, Mexico City

figures. The Mexica become the vassals of Coxcox and fight for him in a battle against Xochimilco; they prove their valor by bringing to Coxcox a bag full of the ears of the enemy, but the Culhua are horrified at this Mexica barbarism. In the codex, Coxcox shows his reaction, his head turned away and his hand raised. After a few more place signs, the manuscript breaks off.

Although the European look of the foliage of the broken tree early in the codex (Plate 148) is an indication that it is postconquest in date, other colonial elements are few. The codex presents the Mexica's concept of their own history. Their ancestors are simply dressed followers of their patron deity, not aristocrats with noble lineages; the Mexica themselves are modest, devout, and egalitarian. Unlike the Mixtec manuscripts, here there are no scenes of marriage, birth, or death, and after the initial section, not even names; names reappear at the end of the codex, when the Mexica settle in the Valley of Mexico. One can imagine how the central section, with its listing of the number of years spent in different localities, would have been a useful mnemonic device in reciting oral history. A curious aspect of the Codex Boturini is the absence of many dramatic events of the migration that are well known from other written chronicles; perhaps those stories belonged to the oral tradition and were sometimes brought in to embellish the brevity of other manuscripts. The major monuments emphasize in colossal images the grandeur of the Mexica; the Codex Boturini tells of their pious beginnings.

Mapa Quinatzin

The preconquest city of Texcoco was reputed to have the greatest artists of the Aztec empire, but few works of art can be attributed to Texcoco apart from some sixteenth-century codices. In the historical manuscripts that survive from Texcoco, European influence in figure style is especially evident. The Mapa Quinatzin consists of three sheets of what may have been a continuous roll of native paper. Like the Codex Boturini, page 1 represents the nomadic origins of the Texcocan dynasty, but the Texcocan artists have more interest in representing the geographic localities than in recording the time spent in each. They also care more for genealogy than for the leadership of the gods; gods are not often seen in these manuscripts. These differences between the historical narratives of Tenochtitlán and Texcoco are evidence that there was no single homogeneous tradition in the arts of the Aztec empire.

Map 1 (Colorplate 39) shows the two Chichimec ancestors dressed in animal skins and sitting in a cave; a baby is in a basket hung on the cave wall. The nomadic customs of the Chichimec are illustrated around the cave—hunting deer, toasting snakes for food, and burying the dead in the ground. Trees and maguey and nopal cacti grow outside the cave, providing a desert setting for their activities. The color washes and shading indicate European contact. The ruler Quinatzin, still dressed in skins as a nomad, sits at the lower left on the mat of kingship and receives delegations of Tlailotlaques, Chimalpanecas, and Culhuas, all wearing textile mantles and representing the sedentary and civilized groups in the Valley of Mexico. The Tlailotlaques were a group of artisans who went to study with the Mixtecs, returning with new skills to the Chichimec kingdom of Quinatzin; the maize plant growing from a hillock shows that the Chichimec are learning the arts of agriculture, and the plants in the rectangular enclosure (barely visible at the bottom) stand for the model farms introduced under Quinatzin. His successor, Techotlala, seated in the center on a mat with a back as was customary in the valley, already wears a textile mantle. The

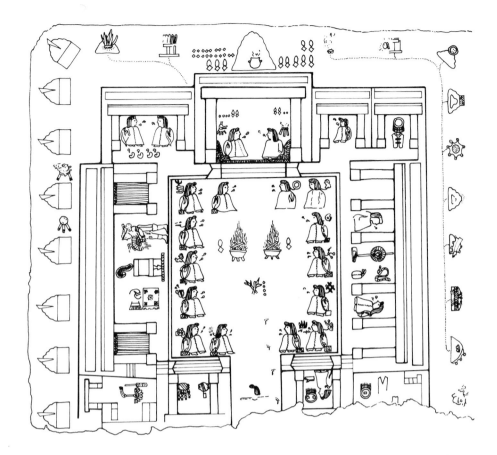

Plate 152. Drawing of the Palace and Administration of Texcoco. Mapa Quinatzin, p. 2 (see Colorplate 40)

Chichimec illustrate their transformation from hunting and gathering nomads into an agricultural society having traditions in the arts as coming not through divine mission, but through secular and political processes.

The male and female figures in the cave who symbolize the dynastic origin of the Texcoco rulers are a frequent element in another Texcoco manuscript, the Mapa Tlotzin, and apparently were characteristic of the Texcoco school of historical painting. The motif is similar to the representation of the Lord and Lady of Duality on page 21 of the Codex Borbonicus (Plate 147). Since there is also a record of marriages and births, these Texcoco paintings are closer to Mixtec traditions than to the Codex Boturini.

The second page of the Mapa Quinatzin (Colorplate 40; Plate 152) illustrates the palace at Texcoco and the political organization under the reign of Nezahualcoyotl (r. 1418–1472) and of his son Nezahualpilli (r. 1472–1515). Nezahualcoyotl is remembered as the greatest king of Texcoco: when Texcoco was conquered by Tezozomoc and Nezahualcoyotl's father was killed, he was a youth of sixteen, and he then spent years in exile in Tenochtitlán. With their help he won back his kingdom. He then reorganized his domain, requiring his vassal lords to live in Texcoco and partake in elaborate court rituals.

The sheet represents the central court and porticos of his palace. Nezahualcoyotl and Nezahualpilli are seated in the central chamber above. The figures with their name glyphs seated in the courtyard are members of the council of state. Burning in the two braziers are the eternal fires that were the care of the vassal towns; the date 4 Reed below and the footprints refer to the arrival and reconquest of Texcoco by Nezahualcoyotl. The palace has special rooms for storing military costumes and shields, and for musical instruments. The dancing figure at the left, next to the drum,

is a son of Nezahualcoyotl, who presided over music and poetry competitions. Vassal towns are symbolized by place glyphs outside three sides of the palace.

This second page demonstrates the Pre-Columbian manner of representing figures in an architectural space. Each wall of the building is shown in elevation, and all four are laid out around the central court that is in the form of a plan. The seated figures wrapped in mantles are in the poses seen in Aztec historical manuscripts.

A third sheet in the Bibliothèque Nationale has been attributed to the Mapa Quinatzin (Barlow, 1950); it illustrates Nezahualcoyotl's new laws (Plates 153, 154). He was said to have codified eighty laws to facilitate the governing of the heterogeneous ethnic groups of his kingdom; the laws were severe, especially against treason. On the manuscript, place glyphs in the top row represent the towns Nezahualcoyotl conquered in reestablishing his kingdom. The pictures in column 1, at the left, show theft and its punishment by hanging. Scantily dressed adulterers in column 3 are placed in stocks, burned in fire, or stoned. A youth who squanders his father's inheritance is hanged at the top of column 2. Below that scene is the treatment accorded to rebellious vassals: emissaries from Tenochtitlán, Texcoco, and Tlacopan (the Triple Alliance), seated above one another on the left, warn the elders, rulers, and eagle and jaguar warriors that if they do not comply, there will be war. Shields in front of the emissaries refer to the manner of declaring war by presenting arms to enemy rulers. Column 4, though badly preserved, shows that punishment by hanging will be the lot of corrupt judges. Since no preconquest legal documents have come down to us, it is difficult to know whether these illustrations follow native prototypes or were sixteenth-century inventions.

Matrícula de Tributos

The aim of war in Mexico was to acquire tribute from conquered territories rather than to incorporate new provinces into the empire. Tax collectors went to conquered towns or lived in them permanently, and the tribute they collected every eighty days was sent to Tenochtitlán to be divided among the members of the Triple Alliance: Tenochtitlán and Texcoco received two fifths each, Tlacopan one fifth. Tribute included edible and utilitarian supplies such as maize, beans, honey, mats, firewood, and stone blades, and elite items such as gold, precious stones, feathers, embroidered mantles, cacao, and seashells—even rare wild animals. Motecuhzoma II even caused lice and fleas to be ordered for tribute (Durán, 1964, pp. 127–31, 208).

These items were brought quarterly to Tenochtitlán during four monthly festivals. They were used to support the needs of the alliance as well as to make lavish gifts to deserving Aztecs or to guests. From a speech attributed to Tlacaelel, Durán quotes the announcement that military insignia are to be won by martial deeds, not bought in the marketplace (Durán, 1964, pp. 141–42). Rare and expensive gifts were given on occasions such as royal funerals, coronations, temple dedications, and other events to which foreign dignitaries were invited. Gift-giving was on a truly lavish scale, and goods changed hands through ritual gifts as much as through trade and markets.

At the dedication of the Temple Huitzilopochtli in Tenochtitlán the tribute bearers paraded in front of the guests to impress them with their rich burdens. "All of these men brought offerings so great in value and quantity that the enemies, guests, and strangers were bewildered, amazed. They saw that the Aztecs were masters of the entire world and they realized that the Aztec people had conquered all the nations and that all were their vassals" (Durán, 1964, p. 195).

The tribute required of conquered provinces was recorded in books (Colorplates

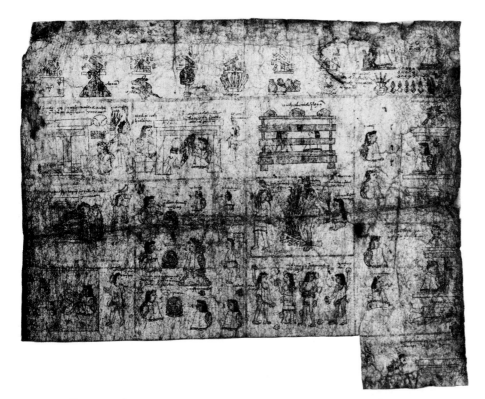

Plate 153. *Nezahualcoyotl's Laws and Punishments for Crimes. Mapa Quinatzin, p. 3. Manuscript of 1 p., 34.5 × 43.5 cm. Texcoco. Early Colonial, c. 1542–48. Bibliothèque Nationale, Paris*

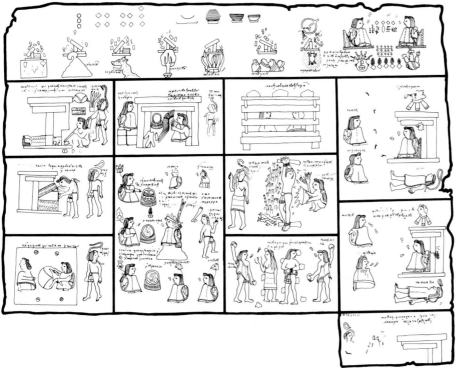

Plate 154. *Drawing of Nezahualcoyotl's Laws and Punishments for Crimes. Mapa Quinatzin, p. 3 (after Barlow, 1950, pls. 1, 2)*

41–44). Bernal Díaz mentions Motecuhzoma's steward showing them such a book, and the house where these records were kept (Díaz del Castillo, 1963, pp. 227–28). The Matrícula de Tributos that we know is made of native paper and drawn in native style, but its bound form is that of a European book, and it must be postconquest in date—perhaps even made for Cortés. The pages are painted on both sides; the codex begins with three pages illustrating the local Aztec governors in charge of collecting tribute in the thirty-three imperial provinces, and each following page deals with one province (Berdan, 1980). On the bottom of each page is the place glyph of the individual city; its tribute in mantles and cloths, military costumes and shields, jewelry, and foodstuffs is arranged above in rows. Specific quantities are indicated

by symbols above the objects of tribute: a dot or no symbol stands for one, a flag for twenty, a feather for four hundred, a bag for eight thousand.

A copy of the Matrícula de Tributos forms one part of the Codex Mendoza. Because pictures in the Codex Mendoza have fuller explanations—written glosses in Nahuatl and Spanish—we know quite precisely the names of towns and the items and quantities collected (Clark, 1938). The Spaniards used such books to set up their own tribute system after the conquest.

Tribute books, even more than the histories and religious books, focus on things rather than on actions. Since economic records are not meant to be metaphoric or interpretative, their language is quite precise; the illustrated pages are the most abstract and standardized of any form of Aztec art, and the most frequently described as "writing systems." The pages are to be read from top to bottom and each line is read from left to right.

The province of Xilotepec was located northwest of Tenochtitlán. On page six of the Matrícula de Tributos the seven tributary cities of this province are painted at the bottom of the page (Colorplate 41), the first city sign, a hill (*tepetl*) with young maize ears (*xilotl*), referring to the name of the province as well, Xilotepec, "hill of the young maize ears." The tributary items take up the rest of the page. The items required of most of the provinces were mantles (*tilmatli*) or cloths (*cuachtli*), represented as rectangular panels either plain or with a design. Women's dresses are illustrated by drawing on top of the rectangular panel a V-necked tunic with a square patch at the neck. Every eighty days Xilotepec was obliged to send to Tenochtitlán the following mantles and dresses: 400 women's dresses and skirts with a stepped fret design; 400 mantles with a design called "twisted obsidian serpent," and with a stepped fret with jaguar markings; 400 mantles either quilted or with a diamond design; 800 mantles with jaguar skin designs; 400 having a red stepped fret design and another 400 with a colorful diagonally divided design. In sum, Xilotepec sent 2,800 mantles every eighty days. The fingers above some mantle designs indicate their size: one finger is believed to represent one *braza*, a length of sixty-six inches. The cloths, presumably assembled from strips, are then eight *brazas* or forty-four feet long (Berdan, 1980, p. 33; Clark, 1938, I, p. 69; III, p. 35).

Why did Tenochtitlán exact such a quantity of mantles in tribute? It must be remembered that cotton cannot be grown in the cool and dry Valley of Mexico region, and had to be imported from warmer climates in the surrounding provinces. A cloth of lesser quality could be woven from the fibers of the agave cactus growing throughout the area, including the highlands, but this cloth was used for the commoners' daily wear. The finest cotton mantles were made in Veracruz and in some of the Huastec-speaking towns.

The cotton mantle was the basic item of men's attire, in addition to a loincloth. Men generally wore a mantle tied at the shoulder, knee-length for commoners and longer for the nobility (see Colorplate 12). Cloths were used to sleep on, as curtains, and as rugs for practical and ritual purposes. In fact, they functioned as a basic medium of exchange and had fixed prices: one large cotton mantle was worth one canoe or one canoeful of fresh water; one mantle decorated with feathers was worth one hundred canoes; thirty mantles could buy a slave, forty mantles a slave who could sing and dance (Clark, 1938, I, pp. 55–56). One *cuachtli* was also worth one hundred grains of cacao, the other major medium of exchange. Durand-Forest (1971, pp. 116–17) shows that one *cuachtli* could buy one man's meals for an Aztec month and twenty *cuachtli* could support him for a year. Because mantles were a form of exchange and their designs indicated status, both the lengths and the designs were

standardized. The Codex Mendoza texts indicate that all the ornate mantles were intended for the nobility; in addition to woven patterns these were often ornamented with embroidery in yarn spun laboriously from rabbit hair and feathers (Fernandez, 1965).

Besides the mantles, Xilotepec had to send regularly to Tenochtitlán ten live eagles, possibly for the zoo or for ritual reasons (the gloss under the eagle in the Codex Mendoza says that only one was required, or as many as they could catch). Above the eagle are two warrior costumes and shields made of featherwork. The costume of jaguar design was for the elite warriors and only one was requested, but twenty of the more common type, with the pointed helmet, had to be sent. Feather costumes were worn by the military in battle, and a large part of the wealth of the Aztec empire was invested in them. In the Codex Mendoza it is stated that the empire received 645 warrior costumes in tribute per year (Clark, 1938, I, p. 56).

The rectangular bin at the top of the page is a container for dry foods such as maize and beans. These bins were large, ten feet high, and plastered inside to be insectproof and to keep the contents dry (Clark, *loc. cit.*).

The six cities of the province of Tochpan were located in Huastec country in the modern state of Veracruz (Colorplate 42). The area was known for its fine textiles, and the 3,440 cloths listed as its required tribute surely included some of the best in the empire. The cloths illustrated at the bottom of the page are ornamented with shells and deity emblems; the middle one is called a cloth of one thousand colors. Tochpan also sent four hundred loincloths and four hundred women's dresses. Besides two elite warrior costumes, Tochpan had to deliver disks and necklaces of turquoise mosaic, and jade necklaces. At the top of the page are illustrated twenty bags of down, for trimming textiles, and eight hundred loads of chili peppers. The Huastec area was as famous for its chili as for its cotton.

Some of the place glyphs on this page are worth noticing. Tochpan, "on the rabbits," has a rabbit and a banner. The next sign shows a hill with dots, signifying chalk, and a footprint above; the name of the place is Tlaltizipan, or "on the large mound of chalk," and the footprint instead of a banner indicates *pan*, "being on top." The last glyph in the row is a mummy bundle with a bean near its head; this place is called Mictlan, from *micqui*, "dead," and *etlan*, "bean" (Clark, 1939, II, pp. 54, 84). However, *tlan* could have been indicated more conventionally by two teeth. These variations show that the Aztecs applied individual interpretations to their written notations. Moreover Mictlan, in Aztec cosmology, is the underworld place of the dead. The presence of actual towns bearing mythic names is not infrequent and can cause problems in interpreting them.

It is evident from a perusal of the tribute manuscripts that the Aztecs asked for two kinds of tribute—standard items such as mantles and warrior costumes, and foodstuffs such as maize and beans—depending on local resources and the ability to acquire them. Feathered warrior costumes were rendered by all areas, even though some provinces had to acquire the necessary exotic feathers by trading among themselves. The other items varied with the regions' special resources. Xilotepec sent live eagles; Tochpan, turquoise mosaic; Tepecoacuilco sent copper axes, jade, incense, greenstone, pottery vessels, and honey.

Tepecoacuilco (Colorplate 43) is a region in central and northern Guerrero. Because this province bordered on the kingdom of Michoacan, the only place in Mesoamerica where copper tools, weapons, and ornaments were manufactured, the Aztecs acquired these objects through tribute from this province, which had to send one hundred copper axes at each period of tribute collection. The axes were another

form of currency. Since this province had twenty towns, the glyphs continue on the right side of the page from bottom to top.

The furthest province paying tribute to the Aztec empire was Xoconochco (Soconusco) located on the Pacific coast near Guatemala (Colorplate 44). This province was divided from the others by a large territory that did not pay tribute to the empire. In natural resources Xoconochco was extremely rich, and many items were greatly desirable as exotica. Being culturally different from the other provinces, Xoconochco was exempted from standard items of tribute, such as cloths and warrior costumes; perhaps the inhabitants did not know how to make them as desired. Instead, items of tribute consisted almost wholly of precious materials: jade beads, feathers, and jaguar pelts. Four thousand handfuls of blue, red, green, and yellow feathers were taken from tropical birds such as the quetzal (green), the cotinga (blue), the parrot (yellow), and a bird from Honduras (green). In addition to feathers, 160 whole cotinga birds were rendered (Clark, 1938, I, p. 81; II, p. 51). Feathers were used to make and adorn warrior costumes, shields, and textiles, the most prized of luxury items.

The tribute of forty jaguar skins was used to cover the seats for royalty and to make such luxury items as sandals for the elite. Amber was rendered in two forms, as lip plugs with golden extensions, illustrated in the T-shaped designs, and as bricks, illustrated at the top of the page. In Mesoamerica amber was called *apoconalli*, "water foam," because it is found washed up by the sea. It is illustrated by an orange block with a water stream above it.

The other major item of tribute from Xoconochco was cacao. Cacao grows in warm climates having well-drained soil, not in the Valley of Mexico. Xoconochco sent regularly two hundred loads of cacao. Cacao was made into a beverage for the elite, consumed at feasts and festivals. It was believed to be the favorite drink of the gods. When the natives brought food to Cortés on his ship off the coast of Veracruz, they included a drink of cacao to see if the "god" would recognize it.

Cacao was also a form of currency, so the beans were individually counted. A sack of eight thousand beans was a *xiquipilli*; three such sacks were one *carga*. At the time of the conquest one *xiquipilli* was worth four or five pesos. Small quantities of cacao functioned as change in lesser transactions when the value of other currency, such as cloths, copper axes, or gold dust, was too high. Cacao continued to function as currency after the conquest; Cortés used it to pay some of his soldiers. Motecuhzoma is said to have had a storehouse of cacao in which he kept forty thousand *cargas*, an enormous amount considering that the annual tribute listed in the books was 980 *cargas*, or over two tons (Durand-Forest, 1971).

Xoconochco also sent four hundred richly decorated cups made of stone and pottery for the drinking of cacao. This tribute was to be paid twice a year, during the festivals of Tlacaxipehualiztli and Ochpaniztli, as indicated at the top of the page by the hat of Xipe on the right and a rather eroded broom, symbol of the harvest festival Ochpaniztli, on the left.

Tribute books such as the Matrícula de Tributos indicate the Aztec concept of wealth. It is worth noting that only a small part of this wealth was in lasting materials, such as precious metals or stones. The vast majority of items were made of textiles or feathers, two materials having low status in the European view and therefore not much collected by them or well preserved. The Aztecs, moreover, thought of wealth in terms of consumption; Mesoamerica is the only major culture in the world where a form of currency was consumed as a drink. While the stone monuments of the Aztecs were permanent displays of wealth and power, other no less important forms of wealth were impermanent or consumable.

VI

STONE SCULPTURE

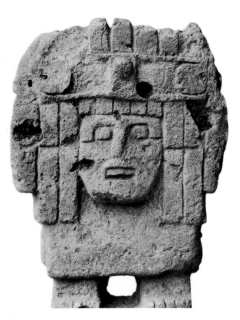

Plate 155. Goddess with Temple Headdress. Stone, height 30.5 cm. Guadalajara. 1200–1521. British Museum, London

Introduction

Besides the many sculptures associated with the Mexica rulers and their temples, hundreds of smaller stone works are known from the period of the Aztec empire: images of gods and goddesses, animals and plants, boxes, sacrificial vessels, and musical instruments. Just as the subjects portrayed cover a wide range, from fleas to gods, the carvings vary from barely hewn rocks to elegantly polished pieces. A Maize Deity (Plate 155) and a Man Carrying a Cacao Pod (Plate 156) illustrate this contrast in quality. Unlike the major dynastic and religious sculptures, this tradition does not have Mixteca-Puebla sources.

Such a variety and quantity of stone sculptures is unusual in Mesoamerican art. Past writers believed that the Aztecs initiated idolatry, or the worship of images, in Mesoamerica and invented these stone sculptures for that purpose. The predecessors of the Aztecs—at Teotihuacán, Tula, and Xochicalco—had few freestanding stone sculptures, and most of these were related to architecture. In style, these older sculptures are flat and angular (see Plates 18, 20). By contrast, the majority of Aztec sculptures are fully in the round with compact body forms, rounded limbs, and sometimes realistic details, as in the Man Carrying a Cacao Pod. Smooth convex forms express the vitality of living bodies, a characteristic not in the tradition of the immediate ancestral sculptures. Similarities between Aztec and Olmec sculpture have been noted by Kubler (1975, p. 59). Although an heirloom Olmec jade mask was found in the 1979 excavations of the Main Temple in Mexico City, we do not know to what extent the Aztecs were aware of the range and variety of Olmec realistic styles.

While Aztec stone sculptures do not resemble stone carvings of the past, they are similar to sculptures in clay and terracotta of Classic Veracruz and Oaxaca (see Plates 12, 13). This is especially evident in those terracotta traditions where the bodies of the figures are reduced to a few basic forms and show little indication of costume. The Monte Albán tradition places the emphasis on the head and headdress which identify the deity. This is also characteristic of Aztec stone sculptures. Many of the Aztec hand gestures, however, are closer in type to Classic Veracruz sculptures. Rather than inventing "idolatry" the Aztecs seem to have translated into stone what previous and neighboring cultures had represented in other media. There are also replicas in stone of wooden drums, rattle staffs, shields, and bundles of reeds. The use of stone as a major medium in sculpture is significantly Aztec, and this preference is related to the late position of the Aztecs in Mesoamerican history. They associated stone with the great civilizations of the past and apparently adopted it even for modest objects because of its connotations of permanence and associations with ancient grandeur (Pasztory, 1976).

A large number of these sculptures have neither a known place of origin nor a date within the Postclassic period. Their wide distribution and the finding of some examples at early Aztec sites such as Tenayuca indicate that this tradition was already

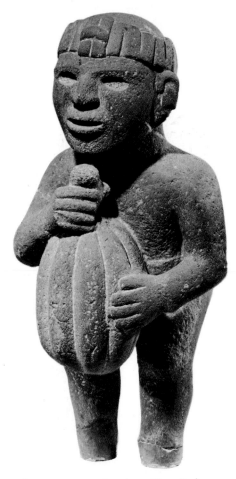

Plate 156. Man Carrying a Cacao Pod. Stone, height 35 cm. 1200–1521. The Brooklyn Museum

established before the rise of the Mexica. A long period of development, perhaps from 1200 to 1400, is suggested by the stylistic and iconographic standardization of the majority of these sculptures, a characteristic that could not have developed within the brief period of Mexica rule. Prior to the creation of the empire through the alliances of 1428, the small city-states of the Valley of Mexico did not have the resources nor perhaps the imperial ambition to create colossal monuments. These simply delineated sculptures were probably the only ones on their temples. Even after the development of the monumental sculpture of Tenochtitlán, these smaller works continued to be made throughout the Aztec empire until the conquest.

The great number of these carvings indicates that they were not the exclusive property of the elite but were widely distributed in Aztec society. Statues were set up outside in sacred locations, or in shrines and temples. Each household, each district, each barrio, each town or village had its own temples with images. Sacred springs, trees, mountains, and crossroads were the locations for many others. Conquest in war was symbolically completed by capturing the statues in the temples. For every statue destroyed in the conquest, the Indians made a new one, hiding them in caves and *barrancas* or in secret walled-up parts of their houses.

These sculptures were necessary objects for the ritual veneration of the gods. They were brightly painted, dressed in real clothing, adorned with jewelry, scented, fed, and paraded in processions during festivals. At the time of the New Fire Ceremony old images were thrown away and new ones were put in their places. Carvings were even made for frivolous purposes: there is a story of one of Nezahualpilli's perverse wives who had a statue made of each of her secret lovers before he was executed to make room for the next (Padden, 1967, 84–85).

Neither the quality of the carving nor the expressiveness of the figures affected their function as the dwelling places of spirits. Most of these sculptures therefore exhibited only the essential features without expressive detail or iconographic complexity, resulting sometimes in dramatic simplifications of form, as in this figure of the Rain God (Plate 157). The variations in style from schematic realism to abstraction, and the variations in finish from roughness to fineness, may indicate differences in time, place of origin, wealth or social standing, and local aesthetic preferences. In the absence of sources dealing with these objects it is difficult to know which factor is significant for a given example.

Small-scale Aztec stone sculptures follow a number of basic conventions. For human figures, three poses are common: standing, sitting, or kneeling. Women are usually shown kneeling, their hands resting on their knees or holding objects. The kneeling position expressed the Aztec ideal of women, who were supposed to be modest and industrious (see Plate 31); quintessentially feminine activities, such as weaving and grinding corn, were performed in a kneeling position. Men are usually shown sitting with their knees drawn up and their arms crossed upon them. This is also the customary pose of male figures in the historical codices except that there the body is usually covered with a mantle, as in the Codex Boturini (see Plate 148). The standing position is used both for men and women, but less frequently for women except for the Goddess with Temple Headdress (Plates 155, 180–82), who is usually standing. The standing position is selected for especially important or large sculptures or for those decorating major temples, and it signifies higher status.

These sculptures give us a very different view of Aztec culture from the aspects expressed in the major monuments of the Mexica. The figures appear calm and pleasant; gruesome or grotesque features are rare. They represent either the gods of fertility—the gods of rain, water, wind, maize, earth, and sun—or animals embodying

Plate 157. God with Goggle Eyes and Fangs. Stone, height 44.5 cm. 1200–1521. Musée de l'Homme, Paris

the forces of nature, or everyman. Probably these images were venerated in the cycle of festivals related to the agricultural year. Sculptures of men seated or standing, but without deity insignia, were used as standard bearers on or near the temples. At festivals, banners and flags were placed in the hole through their hands. These figures are neither deities nor important individuals. They represent the Aztec ideal of man: humble, serious, and dignified.

A few larger sculptures, related in form and iconography to the small sculptures, are remarkable for the fine quality of their carving. Unlike the major monuments of the Mexica, which are new in conception, these works are simply larger and finer versions of small sculptures (Pasztory, 1980). The figures usually stand instead of sit, and they may be beautifully detailed, or naturalistically modeled, or display a complex iconography by the addition of glyphs. For example, the Goddess with Tasseled Headdress (Plates 158, 159) is related in all features to smaller versions of this goddess except that her skirt, ornamented with a diamond pattern, is bound with a serpent belt, and the surfaces are all highly polished. Such outstanding sculptures either were made for major temples or were the patron deities of a particular city. The famous sculpture of a Male God with Buccal Mask found at Calixtlahuaca belongs to this category, an unusually well-made sculpture that is related to the style of the smaller figures (Plate 160). It is uncommon in being lifesize.

The great variety of Aztec sculptures must come partly from local schools of carving, but only a few of these have been defined. The most distinctive is the style of Chalco Province, a region famous for its artists before the Mexica ascendency.

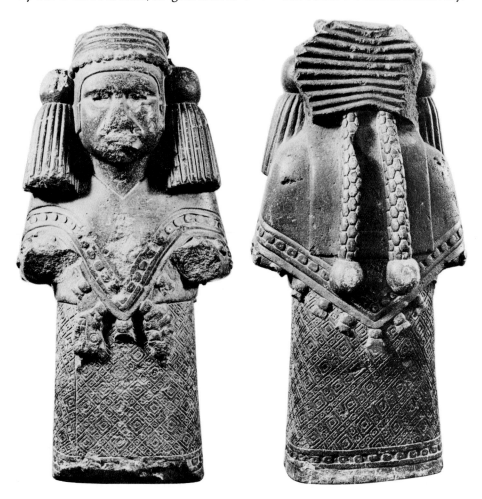

Plate 158. Standing Goddess with Tasseled Headdress. Stone, 77 × 26 cm. 1200–1521. Museo Nacional de Antropología, Mexico City

Plate 159. Back of Standing Goddess with Tasseled Headdress

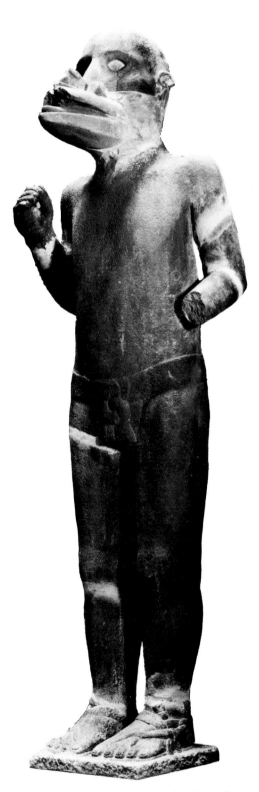

Plate 160. *Standing Male God with Buccal Mask. Stone, height c.1.6 m. Calixtlahuaca. 1200–1521. Museo del Estado de Mexico, Tenango*

The male statue of the god with flower ornaments found in Tlalmanalco is a masterpiece for its reinterpretation of a standard type of seated male deity (Plates 161, 162). The figure sits in a tense position with its legs crossed at the ankles, back arched, and head thrown back. In keeping with Aztec practice the muscles of the body are not individually detailed, but the cylindrical shapes convey a sense of life. The body is covered with a flayed skin ornamented with flowers in relief and a mask on the chest. The identity of the figure is not known, but the flowers suggest that he is Xochipilli (prince of flowers), the god of the sun, feasting, and music. It was undoubtedly associated with a major temple in Tlalmanalco.

The ornamental quality of Chalco style is well shown by the base on which this statue sits (not found with the statue), by a stone replica of a wooden drum (see Plate 256), and by a stone box (Plates 163–65). The double outline surrounding all the forms, the rich floral ornament, and the curvilinear shapes differentiate Chalco style from that of the Mexica. Chalco style is a direct continuation of the style of Classic Veracruz. Double outlines as well as design elements such as shells recall the style of Xochicalco and beautifully carved ball-game objects (see Plates 14, 15). Visual puns and clever details are evident on the stone drum, a meticulous copy of a wooden drum with spotted jaguar skin covering the two ends. The spots are modeled three-dimensionally; the eyes represented within two graceful hands form an arresting facial image. Motifs of Chalco art are flowers, shells, and butterflies rather than symbols of blood sacrifice. The practice of copying wood or clay objects in carved stone may have begun at Chalco with its tradition of fine stone-carving, which was probably influential on the nascent art of Tenochtitlán. Chalco, a traditional enemy of the Mexica, was finally conquered by Motecuhzoma I.

Other local schools can be defined on the basis of a few, particularly well-made sculptures. Two standing figures, male and female, and each over three feet high, come from Coxcatlan in Puebla. Both are intermediate in size between the small works and the great monuments of Tenochtitlán. It is unfortunate that these sculptures are not dated; it would be interesting to know if they predate or postdate the development of monumental sculpture at Tenochtitlán. The Goddess in Serpent Skirt (Plates 166, 167) resembles small death goddess images and also the awesome Coatlicue of Tenochtitlán. The figure is tall and slender, its back hunched; breasts and collarbone are modeled in detail. The male figure (Plates 168, 169) is a simple representation of a well-dressed man with costume details represented as flat panels, similar to Teotihuacán style. The symbol on the back, believed to be a year sign or fire symbol, may identify the figure as a fire god, but other details of the costume are not close to fire god representations in the codices. Both sculptures had glyphs carved on the back of the skull—8 Grass on the goddess and 4 Crocodile on the god. These dates are not common deity names and do not help to identify the figures. The glyphs would have been hidden by the headdress that in each case was apparently once attached at the holes around the hairline; the faces were enlivened by the inlay of shell and turquoise. These two statues may have been carved to be a pair.

The style developed at Castillo de Teayo in Veracruz is defined by a remarkably fine idealization of facial features, as seen in a standard bearer (Plate 170) and a lapidary mask (see Plate 266). These faces with caplike hairlines are characteristically Aztec, but the modeling of cheeks, eyes, and open mouths surpasses all known works in its sensitivity. Other sculptures at Castillo de Teayo are not in this style, however, and they vary greatly in quality (see Plate 182).

Many sixteenth-century accounts refer to Texcoco as the artistic center of the Aztec empire. So many sculptures were indiscriminately attributed to this site in the

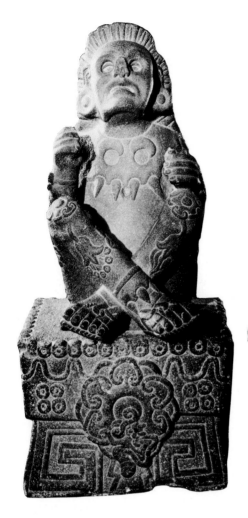

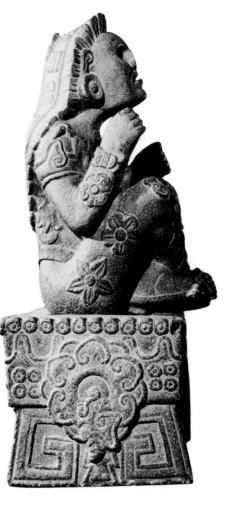

Plate 161. God of Flowers (?) Seated on
Platform. Stone, 115 × 53 cm. Tlalmanalco.
1200–1521. Museo Nacional de Antropología,
Mexico City

Plate 162. Side of God of Flowers (?)

nineteenth century that it is now difficult to ascertain what, if any, was its own style
in stone sculpture. The fragment of a large relief showing a gracefully curving torso
and arm over a solar disk suggests a refined and elegant style (Plate 171). A recently
discovered nude female figure, now dubbed the "Texcoco Venus," is also unusual
for its large size and the naturalistic modeling of legs and torso (Plate 172). Since the
theme of the nude female is not otherwise found in Aztec sculpture and the modeling
is close to European concepts of realism, this figure may be very late, perhaps even
early colonial. If preconquest, it was probably meant to be dressed in the costume of
a deity.

In the fifteenth and sixteenth centuries the major school of sculpture in the Valley

Plate 163. Box with Ornate Tree and Bird,
and Other Emblems. Stone, 56 × 70 cm.
Chalco, Morelos. 1200–1521. Museo Nacional
de Antropología, Mexico City

Plate 164. Side of Box with Trapeze-and-Ray
Emblem

Plate 165. Side of Box with Flower-and-
Shells Emblem

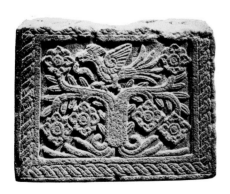

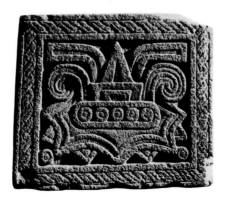

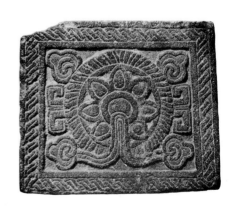

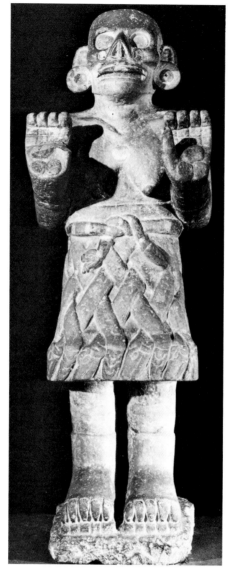

Plate 166. *Death Goddess in Serpent Skirt.
Stone, 115 ✕ 40 cm. Coxcatlan, Puebla.
1200–1521. Museo Nacional de Antropología,
Mexico City*

Plate 167. *Back of Death Goddess in Serpent
Skirt*

OPPOSITE, ABOVE

Plate 168. *Man in Ritual Garb. Stone,
111 ✕ 36 cm. Coxcatlan, Puebla. 1200–
1521. Museo Nacional de Antropología,
Mexico City*

Plate 169. *Back of Man in Ritual Garb,
showing symbol of the fire god Xiuhtecuhtli*

OPPOSITE, BELOW

Plate 170. *Seated Standard Bearer. Sandstone,
height 80.5 cm. Castillo de Teayo, Veracruz.
1200–1521. The Metropolitan Museum of Art,
New York. Harris Brisbane Dick Fund, 1962*

Plate 171. *Relief Fragment of Kneeling Figure
with Sun Disk Ornament. Stone, 2.3 ✕
1.7 m. Texcoco. 15th or 16th century. Museo
Nacional de Antropología, Mexico City*

of Mexico was that of Tenochtitlán. Making use of existing stone-carving traditions
in the valley, including ancient Teotihuacán and Toltec forms, and influenced by the
style of Chalco and possibly the lapidary arts of Classic Veracruz, the Mexica de-
veloped their own style, and one of its aspects is seen in the major monuments of
Tenochtitlán. The Mexica style in smaller sculptures was to retain the simple, tradi-
tional forms, but to execute these with the dramatic sense of design, polish, and
attention to detail seen in the larger works.

The coiled serpent (Plate 173) is a sculptured body consisting of simply rendered
cylindrical segments that suggest life in their convex forms. Clearly defined identi-
fying details such as the rattles, tongue, and teeth are the only ornament; no trivial
design or iconographic symbol hides the beauty of the simple shapes. Like some of the
colossal sculptures, the bottom of these serpent sculptures is also carved, but not always
with the earth monster; an abstract design is created by the serpent's overlapping
scales (Plate 174). These many and arresting serpent images were an Aztec invention;
they have no earlier prototypes, and they indicate that the Aztecs, besides admiring
works of art of the past, also relied on their own perceptions and created new images
to express their sense of the reality and vitality of nature.

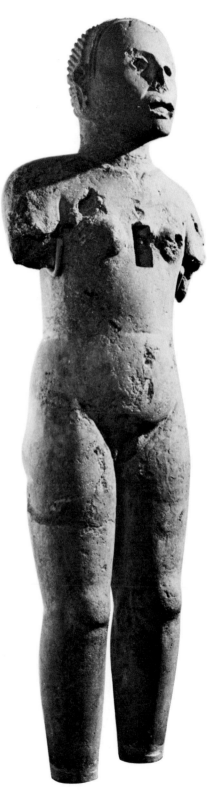

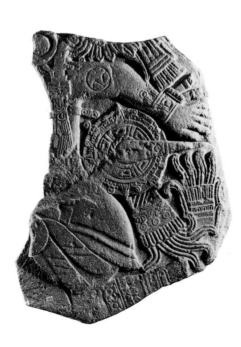

Plate 172. Nude Female Figure. Stone,
146 × 40 cm. Texcoco. 1200–1521. Museo
Nacional de Antropología, Mexico City

Plate 173. Coiled Serpent. Stone, 16 ×
68 cm. Mexico City. 1200–1521. Museo
Nacional de Antropología, Mexico City

Plate 174. Base of Coiled Serpent (similar
to Plate 173). Stone. 1200–1521. Museo
Nacional de Antropología, Mexico City

Mexica deity sculptures are also simply represented with attention paid to the essential costume details. The Goddess with Tasseled Headdress is a rectangular block with rounded corners (see Plates 183, 184); she has a masklike face, and costume details including the tassels, the fringed shawl, and the round beads of the fillet tied about her hair. Mexica style is austere in its simplicity and seriousness, with none of the refined naturalism characterizing Castillo de Teayo or the decorative exuberance of Chalco.

Although a number of sculptures can be described as Mexica in style, not all the sculptures found in Tenochtitlán are carved in that style. Either the city supported workshops with different styles, or sculptures were acquired from other localities. The stylistic diversity was recently confirmed by the unusual discovery during the Metro excavations in Mexico City of a dancing monkey holding its own tail and wearing the buccal mask of the wind god (Plate 175). The twisted torso, bulging belly, and open beak have nothing in common with the compact, bilaterally symmetrical forms typical of the art of Tenochtitlán.

We assume that most of the stone sculptures were placed in shrines, but we do not know how statues and other objects were arranged there. Besides furnishing the shrines, statues were also deposited as part of the offerings made when buildings were erected or renovated, and these offerings indicate how the Aztecs grouped various objects into significant sets. In 1900, a statue of a seated Deity with Crested Headdress (Plate 176) was found in the Escalerillas Street excavations (Batres, 1900). This god was believed to be a deity of song and music because surrounding it were miniature musical instruments—thirteen clay and stone drums, two clay turtle shells, four clay and stone rattles, and several flutes. The Metro excavations of 1966 yielded another offering in the area of the twin temples (Plates 177, 178); a large stone slab covered a group of more than one hundred pieces, the largest a sculpture of the Deity with Headdress of Two Horns. He was surrounded by human skulls, some inlaid with shells and pyrite, and by flint and obsidian blades, many seashells and snail shells, and a large quantity of greenstone beads; the most unusual objects were a group of figurines in Mezcala and Mixtec style made of hard greenstone and other stones from the states of Guerrero and Oaxaca. The Aztecs prized ancient or foreign works of art as highly as exotic raw materials (Castillo Tejero and Solís Olguín, 1975).

Like the offerings buried in the ground, the sculptures set up in the temples may also have been surrounded by a variety of objects. Many of the sculptures that were not deity images, such as animal and plant figures and the stone replicas of other

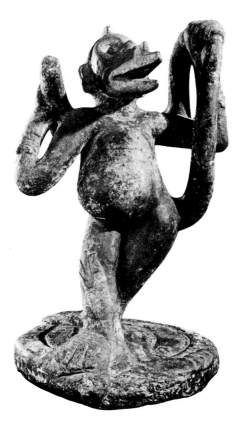

Plate 175. Monkey or Human Figure with
Buccal Mask Holding Serpent. Stone, 60 ×
37 cm. Metro excavations, Mexico City. 1200–
1521. Museo Nacional de Antropología,
Mexico City

objects, were probably ancillary to the major figure sculptures (see Plates 214, 233, 256–58).

The Aztecs visualized their deities as human figures wearing special costumes. Sacredness was believed to reside in the attire and insignia. When a priest or sacrificial victim was dressed as a deity he was magically transformed into the deity. Since the gods and their impersonators were one and the same, the deity images often represent a human being wearing the appropriate apparel. While the deities in the codices are shown in very elaborate costumes, the identity of the deities in stone sculpture is indicated primarily by masks and headdresses.

It is sometimes difficult to tell whether a god, priest, or human being is the subject of a sculpture (Plate 179). In this case the male figure appears to wear the diadem of the rulers and the god Xiuhtecuhtli, the sleeveless jacket of a priest, and the fangs of an animal. The position of the arms is that of standard bearers and attendants, but standard bearers are usually seated (Heyden, 1973).

Many details of the stone deity images correspond to deities known from the codices, and these sculptures have been associated with deity names since the nineteenth century. Sculptures come from many parts of the Aztec empire, however, and the deities may have had different names from those venerated at Tenochtitlán. The sixteenth-century texts indicate that there were many nature gods in Mesoamerica whose roles were parallel, although the chroniclers themselves often preferred to use the Mexica names for the sake of simplicity. Apart from the problem of variant names for local nature gods, some large or unusual sculptures may represent patron deities whose tribal name is no longer known. For these reasons the deity sculptures are grouped by headdress and insignia, and are given purely descriptive names. Their possible identification with a named deity is discussed in the text below. The typology of the deity figures has been developed by Solís Olguín (in press) and Pasztory (1976).

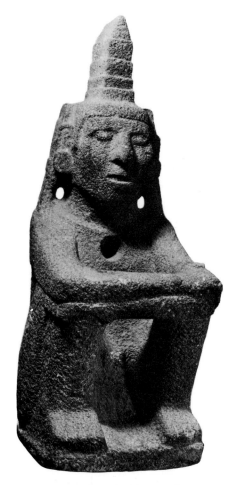

Plate 176. Seated God with Crested Headdress. Andesite, 95 × 36 cm. Mexico City. 1200–1521. Museo Nacional de Antropología, Mexico City

Plate 177. Seated Old God with Headdress of Two Horns. Stone, height c.35.5 cm. Tenochtitlán. 1200–1521. Museo Nacional de Antropología, Mexico City

Plate 178. Back of Seated Old God with Headdress of Two Horns

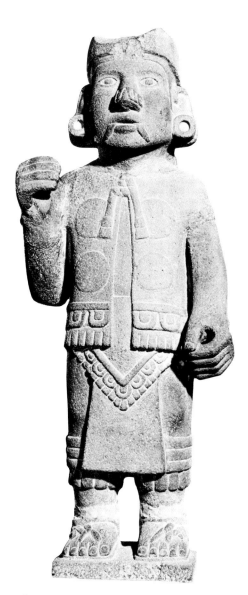

Plate 179. *Man in Ritual Garb. Stone,*
80 × 32 cm. Churubusco. 1200–1521. Museo
Nacional de Antropología, Mexico City

OPPOSITE, ABOVE

Plate 180. *Goddess with Temple Headdress.*
Stone, height 38 cm. 1200–1521. The
Brooklyn Museum

Plate 181. *Goddess with Temple Headdress.*
Stone, height 68 cm. 1200–1521. Museum
für Völkerkunde, Berlin

Female Deities

The good maiden is yet a virgin, mature, clean, unblemished, pious, pure of heart, benign, chaste, candid, well disposed. . . . The good noblewoman [is] patient, gentle, kind, benign, hard-working, resolute, firm of heart, willing as a worker, well disposed. . . . The good mature woman [is] . . . brave, like a man, vigorous, resolute; persevering—not one to falter; a steadfast, resolute worker. She is long-suffering; she accepts reprimands calmly. . . . The bad maiden [is] corrupt, incorrigible, rebellious—a proud woman, shameless, brazen, treacherous, stupid. . . . The bad noblewoman . . . incites riots; she arouses fear, implants fear, spreads fear; she terrorizes [as if] she ate people. . . . The carnal woman is an evil woman who finds pleasure in her body; who sells her body . . . an evil young [or] an evil old woman, besotted, drunk . . . [like] a sacrificial victim . . . a captive. . . . She laughs— goes about laughing; she vomits—vomits constantly. (Sahagún, 1950–78, bk. 10, ch. 13, "which telleth of the noblewomen"; ch. 14, "which telleth of the nature, the condition of the common women"; and ch. 15, "which telleth of the different kinds of evil women"; pp. 45–57)

The Aztecs saw in women two contradictory aspects—they were creators and selfless nurturers of life, and voracious forces of destruction. A decent woman's place was in the home, away from public places except at markets or appropriate festivals. The outside world of streets, canals, and fields was the place of men. Female deities were placed in shrines and temples, but the sculptures of attendants and standard bearers on the exteriors of sacred precincts were mainly of men. Sculptures that cannot be identified as individual deities because they lack specific headdress details and wear minimal or no costumes were probably made for exterior ornament (Plate 172). So important were the ideals of chastity and modesty that statues of nude female figures are extremely rare, and were not meant to be seen as such; they were probably dressed and placed as one of the gods in the temples. (One must remember that "ideals" of chastity may not represent actual behavior—the conquerors were shocked by the loose morality of the Aztec upper class. Yet they were anxious to copy that lifestyle as soon as they came to power. Discrepancies between practice and theory are not limited to the Aztecs.)

Of the great number of stone sculptures, the majority are female deities, especially the Goddess with Temple Headdress (Plates 180–82). This goddess is usually standing, her face framed by a headdress almost as big as she is. Its rectangular panels resemble a temple front, the goddess looking through a doorlike opening. This headdress is the stone version of a flat frame called the *amacalli*, or "house of paper," to which paper streamers, rosettes, and knots were attached. The *amacalli* was worn by an impersonator during the festivals of the goddess, as can be seen in the Codex Borbonicus (see Colorplate 34). The streamers on this headdress are red, yellow, blue, and green, and give us an idea of how the painted statue might have looked.

The Goddess with Temple Headdress is a maize deity, often holding double ears of corn in her hands. The object in the hand of the Berlin Museum goddess (Plate 181) is a rattle staff, associated with the ritual of many fertility deities. In some codices a goddess holding maize is identified as Chicomecoatl (meaning "seven serpent," a "birthday" name for maize), but in the harvest festival illustrated in the Codex Borbonicus she is identified as Teteoinnan, the old mother goddess. The statues may be representations of several maize goddesses. This goddess makes only rare appearances in the codices, and in the ritual books she is merely secondary to the rain god. But stone statues of her are the most numerous of any subject. They range from large, well-made statues to small, crude ones that almost give the impression of being mass-

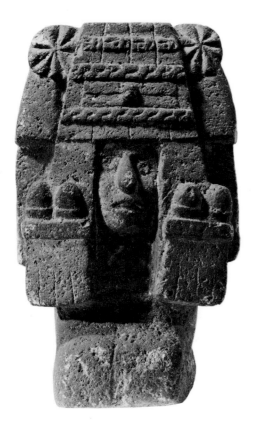

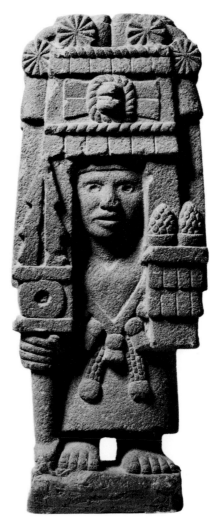

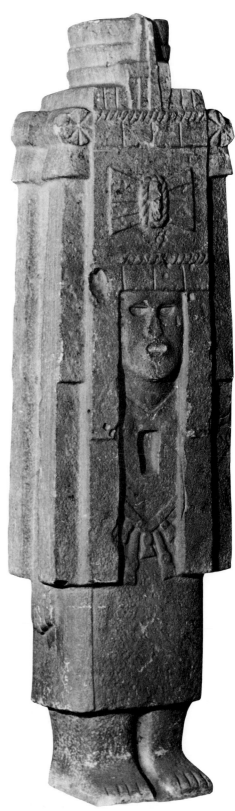

produced (Plate 155). Her cult was not primarily for the rulers of most cities nor for the priests, and seems to have belonged to the non-elite population. The metaphor for fruitfulness is not that of a woman's ripe or pregnant body; the goddess's body is constrained and hidden by the rectangular frame symbolizing the demands of house, field, and harvest sacrifice, and her reward takes the form of the two ears of maize. The virtues suggested are self-effacement and sacrifice.

The flat planes of the standing Goddess with Temple Headdress are atypical of Aztec sculpture, usually more rounded in its forms. The cult of this goddess and the type of statue associated with it may have come from the east, perhaps from the Huastec region, where statues of standing deities in that style were erected before the Aztec period. The most beautifully carved Temple Headdress goddesses are from the site of Castillo de Teayo on the coast of Veracruz (Plate 182).

Second most frequent in stone sculpture is the goddess who wears on her head a fillet bordered with disks, with two large tassels hanging down over her ears (Plates 183, 184). She is customarily dressed in a skirt and a triangular shoulder cloth or shawl, also ornamented with tassels. The Goddess with Tasseled Headdress is usually kneeling in the pose proper for an Aztec woman or, less frequently, standing (see Plates 158, 159). Her hands are in her lap except in the few examples where, like all the gods of fertility, she holds ears of corn (Krickeberg, 1960).

Plate 182. Goddess with Temple Headdress. Stone, height 1.47 m. Castillo de Teayo, Veracruz. 1200–1521. Museo Nacional de Antropología, Mexico City

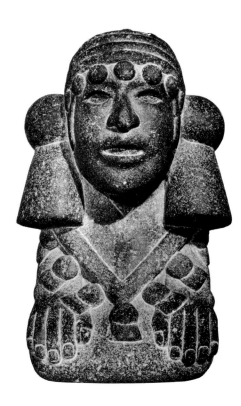

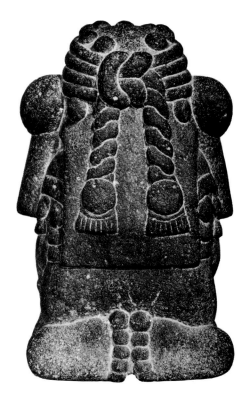

Plate 183. *Goddess with Tasseled Headdress. Basalt, height 30 cm. 1200–1521. Museum für Völkerkunde, Basel*

Plate 184. *Back of Goddess with Tasseled Headdress*

This goddess is often identified as Chalchiuhtlicue (jade skirt); in codices such as the Codex Borbonicus her headdress is the same as that of this goddess (see Colorplate 29). Chalchiuhtlicue is the goddess of water, painted blue in the codices, and in mythology she is described as the wife, mother, or sister of Tlaloc, the rain god, with the surface waters of rivers and lakes as her special province. She is mainly a domestic goddess, concerned not with rain, thunder, or the unpredictable sea—the province of male gods—but with ground water close to home and the fields. Because water was believed to purify, newborn children were dedicated by the midwife to Chalchiuhtlicue, as she could wash off the sins of the parents.

Sculptures of this goddess represent the purity and preciousness of water through the image of a beautiful virgin. Carrera (1979) points out that women in Aztec sculpture are shown at different ages, thereby relating them to the life cycle of maize.

The goddess's oval face, well-proportioned features, and calm gaze present the Aztec ideal of a modest girl. As she is not a goddess of maize or fruition but of water, a necessary precondition for growth, she is not a mature woman but a youthful girl. Beautiful carvings of this goddess in the style of Tenochtitlán indicate her importance for that city, built in the middle of a lake.

A few sculptures showing a less austere version of the maize goddess may originate in the Toluca area west of the Valley of Mexico (Nicholson, 1963, p. 21). Kneeling figures of women are ornately dressed with a flowery band on the head, maize ears in the headdress, a tassel hanging from each earplug, and a necklace over the shoulder garment (Plate 185). The Goddess with Flowered Band may be related to Xochiquetzal (flower-quetzalbird), the goddess of sustenance and sexual love, but the identification is inconclusive: the two plumes that distinguish Xochiquetzal in the codices (see Colorplate 31) are missing on these sculptures. On another statue the maize ears are replaced by the glyph 7 Serpent, meaning Chicomecoatl. This subject may be a local variant of the maize goddess, here stressing the associations of maize and human fertility rather than sacrifice and ritual.

A third image of women in Aztec sculpture is the grotesque or skull-headed goddess (Plates 186, 187). There are fewer of these sculptures than of fertility goddesses, and many of them have come from Tenochtitlán. These deities are usually kneeling and dressed only in a skirt tied with a belt. The femaleness of the naked breasts contrasts with the threatening hands and grimacing or skeletal faces. Instead of a headdress over hair neatly bound in braids, the hair is disorderly, in some cases carved with skulls or the balls of down associated with sacrificial victims. The sexual features of a woman's body here suggest evil and destruction.

These death goddesses may represent the *cihuateteo* or *cihuapipiltin*, the violent spirits of women who died in childbirth (Von Winning, 1961). These women were the equivalents of warriors, for in dying with a child still in the womb they were taking a "captive" into the afterworld. These women's corpses were guarded because thieves and sorcerers tried to steal their thigh bones, a powerful item of black magic. The *cihuateteo* were evil spirits resembling witches, who were believed to haunt crossroads at night and steal children; people who came under their spell became possessed and paralyzed, and fell into fits, foaming at the mouth.

The Aztecs' two ideas about death were contradictory but interrelated: death was chaos, evil, and darkness overcoming the forces of order, good, and light; yet it was also necessary, for without it life could not continue. Death had to be venerated as both a major force of nature, the power of dissolution, and paradoxically a precondition of life. The woman who symbolized death was at once witch, skeleton, and harlot. These death goddesses were connected with the cults of war and sacrifice.

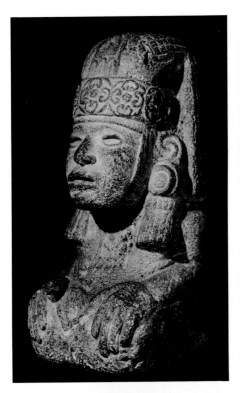

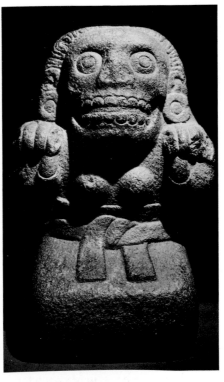

Plate 185. *Goddess with Flowered Band.*
Stone, 37 × 19 cm. 1200–1521. Museo
Nacional de Antropología, Mexico City

Plate 186. *Kneeling Death Goddess. Stone,*
c.80 × 52 cm. 1200–1521. Museo Nacional
de Antropología, Mexico City

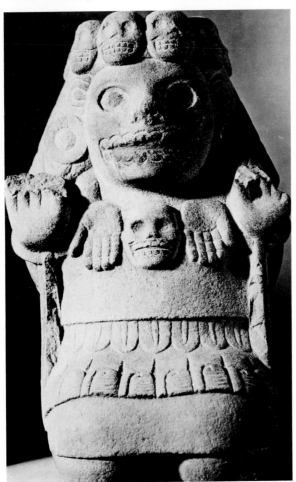

Plate 187. *Kneeling Death Goddess. Basalt,*
112 × 53 cm. Calixtlahuaca. 1200–1521.
Museo Nacional de Antropología, Mexico City

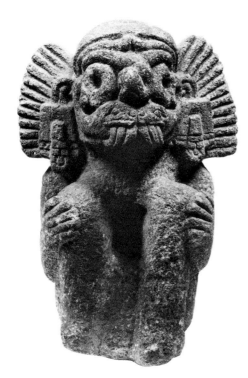

Plate 188. *Seated God with Goggle Eyes and Fangs. Stone, height 40 cm. 1200–1521. Museum für Völkerkunde, Berlin*

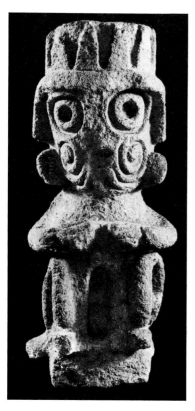

Plate 189. *Seated God with Goggle Eyes and Fangs. 45 × 19 cm. Puebla. 1200–1521. Museum für Völkerkunde, Vienna*

The death goddess statue in Plate 187 has a crown of skulls atop her head, and, like the great Coatlicue (see Plate 110), wears pectoral ornaments of a skull and trophy hands.

Male Deities

Like the female deities, the male gods were among the principal spirits venerated in the agricultural rituals of the annual festival cycle. Six categories of major deities can be distinguished by the different headdresses and facial features representing human forces and activities; except for the God with Flayed Skin, none is associated with warfare. Conversely, some of the important gods in the codices, such as Tezcatlipoca, are rarely seen as stone sculptures.

The god most frequently represented in Aztec art is perhaps the best-known deity in Mesoamerica, the rain god Tlaloc. Goggles around the eyes, a mustache-like upper lip, and fangs cover the face of a human. It has been suggested (Caso, 1958, pp. 52–53) that this grotesque face was derived from the image of serpents coiled over the face, as on a sculpture in Berlin (Plate 188). But the goggles and mustache were already, as early as Teotihuacán art, found on a figure associated with water (see Plate 11), so this abstraction must be an ancient one.

The closest prototypes to the Aztec figures of Tlaloc are Mixtec representations, the deity seated with his legs drawn up (Easby and Scott, 1970, fig. 267). There are few stone deity images in Mixtec art, the most frequent being small rain god carvings of greenish stone.

The monstrous features suggest animal forms such as the jaguar and serpent, but the similarities are not specific. Animalistic features may have been used in the depiction of the God with Goggle Eyes and Fangs to suggest the violence of tropical rainstorms. Tlaloc and his many helpers, the Tlaloque, were believed to make rain by pouring water from a vessel and to produce thunder by striking the vessel with axes. They were often painted black, the color of thunder clouds that gather near the tops of tall mountains. The rain gods were believed to dwell on mountaintops and a large volcano in Central Mexico is still called Mount Tlaloc. Sixteenth-century accounts tell us that rain god images were set up on Mount Tlaloc and that Aztec rulers made pilgrimages and brought offerings to these shrines. Crudely carved stone images of the rain gods have been found on several mountaintops; several statues appeared in recent excavations near the springs of Chapultepec where the aqueduct to Tenochtitlán originated. Two represented Tlaloc, one was of the Goddess with Tasseled Headdress, or Chalchiuhtlicue (Rubén Cabrera, 1975).

Tlaloc was also associated with the earth, and the name Tlaloc is derived from the Nahuatl word for "earth" (Sullivan, 1974). Tlaloc was sometimes represented on the base of monuments rather than the earth monster. For the Aztec elite, Tlaloc stood for the fertility gods of the civilizations prior to the Mexica empire; for the commoners, Tlaloc was one of the important nature gods that assured survival (Broda, 1971; Durand-Forest, 1979). Prior to the rainy season the rain gods were propitiated in ritual sacrifices of children whose tears were supposed to call down the rains by imitative magic.

The great idol of Tlaloc on the Main Temple of Tenochtitlán has not survived, but it seems clear that in imperial Mexica art Tlaloc functioned usually as a secondary figure. Large numbers of rain god images belong in the category of simple or crude sculptures. The numerous sculptures of the Deity with Goggle Eyes and Fangs represent a human figure wearing the grotesque features like a mask. The figure may

be naturalistically seated with one leg raised and the other on the ground, but more often its pose is reduced to a rectilinear abstraction (Plates 157, 189). The headdress usually consists of a paper crown on the head and a paper fan at the base of the neck.

Second to the rain god in importance was the god of wind, known by the Nahuatl name Ehecatl. This deity took the form of a human wearing a mouth mask of enigmatic shape—it could represent a duckbill, a crocodile, or a monkey snout (Plates 160, 190–91). On some figures the mask is clearly worn over the face, while on others it is an integral part of the body. When this deity wears a headdress it is usually a conical cap.

Codex representations have led to identifying the God with Buccal Mask with Ehecatl. In the ritual almanac the head of the god Ehecatl symbolizes the day sign for wind. The wind gods were important for agriculture because they helped to bring storms and rains. The puffed cheeks of the buccal mask may have been believed to produce the whistling sound of fierce winds. In the codices, the god Ehecatl was related to Quetzalcoatl, the god of penitence, and contrasted to Tezcatlipoca (see Colorplate 36). Since the breath of life has a similarity to wind, this god was also the god of life and of the soul of man. The temples traditionally associated with Ehecatl are circular; the beautiful statue of this god from Calixtlahuaca was found in a circular temple (Plate 160). Most statues of the God with Buccal Mask, however, may represent not the complex personage of Quetzalcoatl but the nature god.

Since the gods of wind and rain represent potentially violent forces, the features identifying these gods are monstrous or derived from the animal world. Male gods whose features are more anthropomorphic represent more passive aspects of nature. One type of figure is difficult to identify because of its simplicity—a standing youth with a folded paper fan at the back of the head, sometimes wearing a fillet with jade circles on the forehead (Plate 192). Perhaps he is Centeotl, the tender maize, who appears as a youth in the art of many Mesoamerican cultures.

Also difficult to identify are a number of old men having two protuberances on their heads (Plates 193, 194). The figures are seated, their crossed arms resting on flexed knees. Age is suggested by toothless gums, or by two remaining teeth projecting over the lower lip. A fillet around the head has circular beads, and at the back is a paper fan. On the streamers hanging down the back are ovoid knobs.

The difficulties in identifying these deities illustrate not only those faced by the scholar, but also those inherent in the Aztec system of symbols. This deity may be identified either as Tonacatecuhtli or Ometeotl (Lord of Sustenance, or Lord of Duality), as Xiuhtecuhtli (Lord of Fire), as Nappatecuhtli (Lord of the Four Directions), or as Tepeyollotl (Jaguar of the Interior of the Earth). One such sculpture, painted blue (Plate 193), was found in 1970 during the Metro excavations, in a round building with offerings placed at the four axes of the structure. Heyden (1970) identified the figure as Nappatecuhtli, Lord of the Four Directions and one of the Tlalocs. This deity was venerated with the Tlalocs during the festival when all the mountains were celebrated. Because most of these figures have projecting, animal-like fangs, Nicholson identified them as Tepeyollotl, the jaguar god of the interior of the earth (Heyden, 1970, p. 37). The two hornlike projections on top of the head have been interpreted by Castillo Tejero and Solís Olguín as the fire sticks worn in the headdress of Xiuhtecuhtli (1975, p. 44). The horns on the sculpture in Basel appear to represent ears of maize (Plate 194), which are also seen in the headdresses of Tonacatecuhtli and Ometeotl in the codices (Pasztory, 1976).

There is little doubt that this deity is an important nature god. Indications of old age, the beard and few teeth, are appropriate to Tonacatecuhtli and Xiuhtecuhtli,

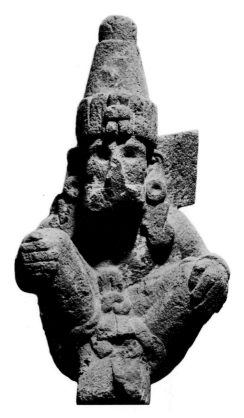

Plate 190. Seated God with Buccal Mask and Conical Hat. Stone, 61 × 34 cm. 1200–1521. Museum für Völkerkunde, Vienna

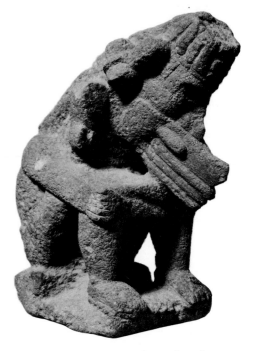

Plate 191. Seated God with Buccal Mask. Stone, height 33 cm. 1200–1521. Philadelphia Museum of Art (The Louise and Walter Arensberg Collection)

both considered "old" gods; these two are also the first and the last patrons of the thirteen-day divisions of the divinatory calendar. Tonacatecuhtli begins the series in the sky, and Xiuhtecuhtli ends it in the earth. Both refer to the center of the universe where oppositions, such as sky and earth, are transcended. They are thus two faces of the same concept.

The formal ambiguity of the simple horns, which may be ears of maize or fire sticks or both, is perhaps intentional. Ometeotl in the Codex Borgia wears the head of a lizard in his headdress because he is the patron of the year and the first name in the twenty-day cycle is *cipactli* or alligator-lizard. In Codex Vaticanus A, Tonacatecuhtli is shown in his aspect of Ometeotl in the thirteenth heaven (see Colorplate 8). He has a lizard-like ornament in his headdress and he sits on a throne of maize. Such a *cipactli* lizard creature appears on the front of the headdress of many of the horned deity figures carved in stone.

That the deity has earth aspects as well is indicated by the turtle carapace, an earth symbol that the Basel figure wears on its back. Moreover, an unusual number of these figures have been found buried as offerings at the foot of temples. Batres excavated many of them in Escalerillas Street in 1900; one was found in the 1960s in the area of the Main Temple of Huitzilopochtli; several were associated with the offerings near the Coyolxauhqui Relief (Angulo, 1966; Garcia Cook and Arana A., 1978). Xiuhtecuhtli was frequently evoked in rhetorical speeches as a god of the interior of the earth, especially by the nobility when a new ruler was crowned. The god was called the progenitor of Tezcatlipoca and of the ruler who had been chosen as his representative on earth, "the mother of the gods, the father of the gods, Huehueteotl [Old God], who is set in the center of the hearth, in the turquoise enclosure, Xiuhtecuhtli, who batheth the people, washeth the people, and who deter-

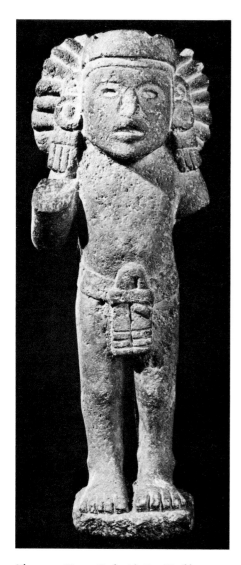

Plate 192. *Young God with Fan Headdress. Stone, 70 × 27 cm. 1200–1521. Museo Nacional de Antropología, Mexico City*

Plate 193. *Seated Old God with Headdress of Two Horns. Stone, 40 × 18 cm. 1200–1521. Mexico City. Museo Nacional de Antropología, Mexico City*

Plate 194. *Seated Old God with Headdress of Two Horns. Basalt, height 34 cm. 1200–1521. Museum für Völkerkunde, Basel (Collection Lukas Vischer)*

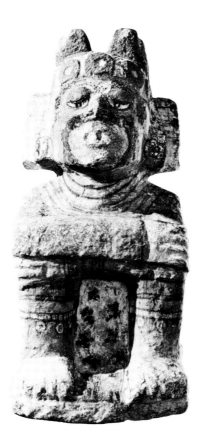

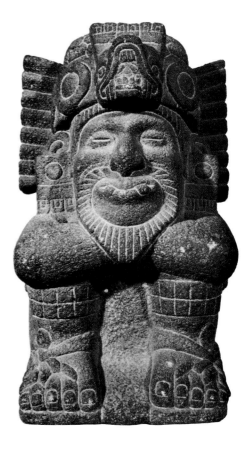

mineth, who concedeth the destruction, the exaltation of the vassals, of the common folk," as said by the ruler in a humble prayer at his installation ceremonies (Sahagún, 1950–78, bk. 6, pp. 41–42). Like Chalchiuhtlicue, the water goddess who purified by water, the old fire god Xiuhtecuhtli purified through fire.

Although the worship of Xiuhtecuhtli was important for the aristocratic elite and the ruler, the major monuments of Tenochtitlán do not usually include this god except in the buried offerings. Moreover, judging by the many crude versions of this deity, he must also have been part of a popular cult in which the fertility aspect of Tonacatecuhtli perhaps predominated. The traits identifying the crude versions of the deity are his mouth with its missing teeth and the two horns in the headdress. One unusual version shows his face as half human and half skull (Plate 195), a graphic representation of the dual and ambivalent nature of this Aztec god.

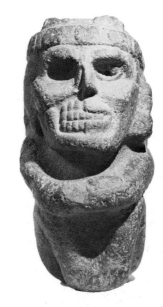

Plate 195. *Seated Old God with Headdress of Two Horns. Stone, 27 × 14 cm. 1200–1521. The Brooklyn Museum*

As a sculptural concept, the old deity of the earth goes back to Teotihuacán and even earlier. Figures of hunched old men carrying vessels, probably for burning incense, have been found associated with hearths. In 1981 Matos excavated an Aztec copy of one of these Teotihuacán old man braziers, but the figure wears the mask of Tlaloc, similar to the Rain God Chac Mool (Matos Moctezuma, Paris, 1981, fig. 95). An unusual aspect of the Aztecs' veneration of this deity is the large number of its images that were buried as offerings. Sculptures of deities are rarely found in the offerings of previous cultures; more customary are jade pieces, obsidian points, and pottery vessels. The Aztecs were the first to bury many sculptures; perhaps this practice is a reflection of how they found old sculptures, buried at abandoned sites.

Next in popularity to the nature gods in Aztec stone sculpture is the image of the god of music and feasting, one of whose names is Macuilxochitl, meaning 5 Flower (Plates 161, 162). Identifying him are the tall crest on the top of his head and two or three tassels hanging from rosettes on the sides and back; one statue wears a bird helmet as well (Plates 196). A statue of this deity was found in the Escalerillas Street excavations as part of an offering of musical instruments (Plate 176). The Seated God with Crested Headdress is not, however, one of the major patrons of the thirteen-day divisions of the divinatory calendar. Since the deity is also found among Aztec clay figurines, his cult appears to have been largely a popular rather than a priestly or aristocratic one. A unique version is a sculpture in the British Museum in which the deity's face is a skull and the glyphs 2 Death, 4 House, and 5 Eagle are carved on the back (Plates 197, 198), one of their few skull-headed male deities. This demonstrates dramatically that even the most hedonistic and benevolent Aztec deities may have a close relationship to death.

Macuilxochitl represented pleasure in music, dance, feasting, and sexuality. He was responsible for illness caused by excess, such as venereal disease, and he had the power to cure it. Although none of the festivals of the annual cycle was dedicated to him, his importance in everyday life was considerable. Durán describes the central role of music and dance in Aztec life (1971, pp. 287–300). Special houses called *cuicacalli* (house of song) were erected near the main temples, and there the young men and women assembled every evening, chaperoned by elders. Dances were performed for pleasure and in practice for the festivals; they were also occasions for courtship and ribaldry. Durán wrote disapprovingly of erotic dances called the "tickling dance" and the "dance of the itch," and he mentions many other dances including satirical ones making fun of drunkards. Dances were also held in the warriors' school, the *telpochcalli* where the young men could enjoy themselves with their prostitute mistresses. The many statues of the God with Crested Headdress indicate the importance of amusement and pleasure in Aztec life—a fact as upsetting to the

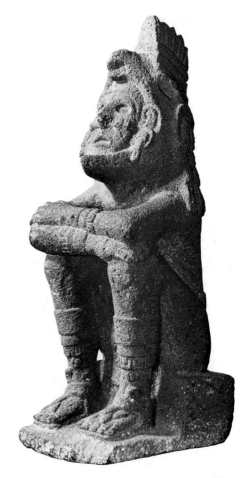

Plate 196. *Seated God with Crested Headdress and Bird Helmet. Stone, height 74.8 cm. 1200–1520. Völkerkundliches Museum, Mannheim*

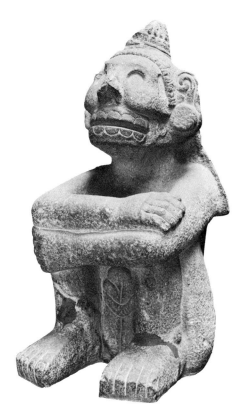

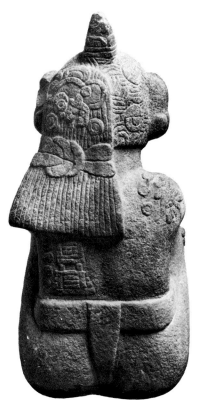

Plate 197. *Seated God with Skeletal Face and Crested Headdress. Stone, height 61 cm. 1200–1521. British Museum, London*

Plate 198. *Back of Seated God with Skeletal Face and Crested Headdress*

Spanish chroniclers as the human sacrifices were. But they described sacrifices in gruesome detail, while sparing the sensibilities of the European reader by not describing "immoral behavior" at all. The cult of the deity Macuilxochitl appears to have emphasized the positive aspects of sexuality, which were regarded as male, while the negative aspects of excessive sexuality were seen mainly as female.

Male gods in our last category of stone sculpture wear the flayed skin of a sacrificial victim and are identified as Xipe Totec (Plates 199, 200; Colorplate, half-title page). Xipe Totec was a deity worshiped since the Classic period. Aztec stone sculptures are copies of the clay figures known in earlier times, and clay statues of Xipe continued to exist (see Plate 298).

Xipe Totec was one of the patrons of the thirteen-day periods in the divinatory calendar, and the patron of the festival Tlacaxipehualiztli, celebrated both by the commoners and the elite (Broda, 1970). Foreign dignitaries were invited to witness the sacrifices at Tenochtitlán. Prisoners were tied to a round stone and given ineffectual weapons with which to fight fully armed warriors in gladiatorial combat. The victims were subsequently flayed, and their skins were worn by penitents who wandered through the streets collecting alms. After forty days the skins, smelling abominably, were taken to the god's temple and buried in an underground chamber.

This ritual had both military and fertility aspects. The flaying ritual and the begging appear to refer to agricultural rites and the beginning of the rainy season, as indicated in the hymn to Xipe Totec Youallauan:

> O Youallauan, why dost thou mask thyself?
> Put on thy disguise.
> Don thy golden cape.
>
> My god, thy precious water hath come down from Coapan.
> It hath made the cypress a quetzal.
> The fire serpent hath been made a quetzal serpent.
> Want hath gone from me.
>
> (SAHAGÚN, 1950–78, BK. 2, p. 213)

The reference to the golden cape has a dual connotation: it refers to the color of the flayed human skin, and since Xipe Totec was the patron of goldworkers, it may also be an allusion to him. The images of the cypress turning into a quetzal and the fire serpent turning into a quetzal serpent both symbolize the rebirth of nature in the rainy season, when all becomes as green as the feathers of the quetzalbird.

The gladiatorial sacrifice with the participation of the elite warriors and invited lords appears to link Xipe with military activities. Tribute collected from conquered areas arrived in Tenochtitlán at this time, and was paraded around to impress the people and the foreigners. The Mexica may have introduced this aspect of the Xipe rituals.

Xipe sculptures of a man wearing a flayed skin are among the most awesome visual images created by Mesoamerican artists, expressing the deeply held belief that only through death can life exist. The contrast between the tight layer of skin and the animate form within is represented simply, with none of the gruesome dramatization that characterizes the images of the death goddesses. Detail is restricted to the ropes tying the skin together at the chest, back, and head. The figure in Basel (see Colorplate, half-title page) still has its painted surface; the outer skin was yellow and the figure underneath was red. The Xipe figure in the Museum of the American Indian,

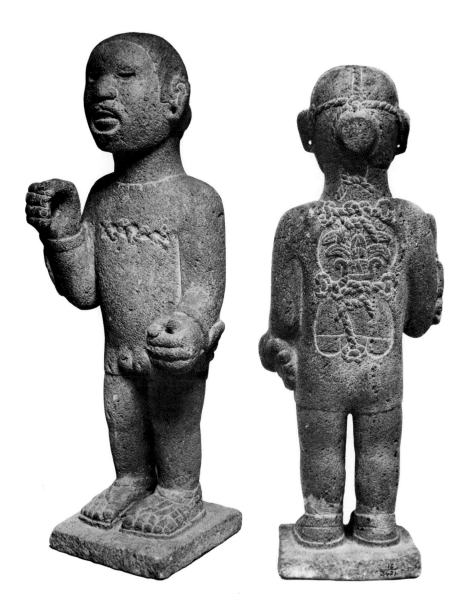

Plate 199. *Standing God in Flayed Skin. Stone with traces of red paint, height 77.5 cm. Tepepan. 1507. Museum of the American Indian, Heye Foundation, New York*

Plate 200. *Back of Standing God in Flayed Skin*

New York, has the date 2 Reed carved on the back (Plate 199). This date may have historical or mythical significance, but its frequent occurrence on Tenochtitlán monuments makes its meaning on this sculpture unclear.

Human Figures

The one of noble lineage wishes no praise; [he is] a concealer, a hider, a coverer of himself. . . . The good one of noble lineage [is] one who magnifies, praises, exalts, commends [the things of others]. . . . The good one of noble lineage [is] a mourner for the dead, a doer of penances, a gracious speaker. . . . The good valiant warrior . . . hurls himself to his death. . . . He is unchallenged; no man meets his gaze. . . . The good farmer [is] strong, hardy, energetic, wiry, powerful.

The bad one of noble lineage [is] one who brags of his noble lineage . . . who lifts his head in pride, who disparages the things of others. . . . The bad one of noble lineage . . . goes about content, always satisfied, continually amusing himself. . . . The bad valiant warrior [is] . . . dainty, delicate of body, self-indulgent, afraid, fearful, cowardly. . . .

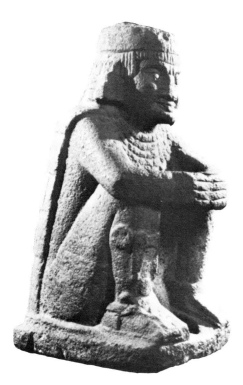

Plate 201. *Seated Standard Bearer (El Indio Triste). Stone, 107 × 65 cm. Mexico City. 1200–1521. Museo Nacional de Antropología, Mexico City*

The bad farmer [is] . . . lazy, negligent, mad, wicked, noisy, coarse . . . a glutton—one who gorges himself. (Sahagún, 1950–78: bk. 10, ch. 5: "here are mentioned the honored nobles"; ch. 6: "which telleth of the men, the valiant men"; and ch. 12: "which telleth of . . . some of the ways of gaining a livelihood of those such as . . . workers of the soil": pp. 19–24, 41–43)

Human figures having no deity insignia are frequent in Aztec sculpture. Some represent standard bearers, placed on or near the temples and holding flags or banners during festivals (Plates 170, 201), some may have been costumed as deities in actual clothes (Plate 206), and some are engaged in ritual activities (Plates 156, 202–5). Since these figures are not individuals but everyman, they reflect the Aztec physical and ethical ideals.

The standard bearers exhibit the calm, dignified, and humble behavior appropriate to servants of the gods in the temples. All of them are male, because they belong to the world outside the home, the confines of women. Although they usually wear only a loincloth, occasionally sandals and necklaces indicate that they are not men of the lower class: in Tenochtitlán only the nobles could wear sandals, and even they had to remove them in the temples and in the presence of the ruler. Westerners have considered "sad" the serious expressions on the faces of these figures, and a seated standard bearer in the National Museum of Anthropology (Plate 201) was named "El Indio Triste" in the nineteenth century.

Human figures carrying burdens on their backs may represent humility and self-abasement. Among the social classes in the Aztec empire, porters who carried loads ranked low; perhaps a sculptured porter was a metaphor for humility and responsibility. In the Codex Boturini the leaders of the Mexica migration, called *teomama*, meaning "god bearers," are carrying bundles and the image of their deity (see Plate 148). The gods themselves were described as carrying time and the cosmos on their backs.

A number of Aztec stone figures carry maize on their backs (Plates 202, 203). Maize carriers include male figures wearing the conical cap associated with the God with Buccal Mask. It is appropriate that these gods of wind and rain should be bringing maize. An unusual sculpture in the Cleveland Museum shows a deity who may be Macuilxochitl; he is holding either a flower or a peyote cactus near his face, as well as carrying on his back a basket of maize (Plate 204).

The deities who carry maize are metaphorically related to figures who carry a stone sculpture of the maize goddess—who stands after all for the maize itself (Plate 205). These simply dressed carriers sometimes wear the conical hat of the God with Buccal Mask, and they may represent priests or possibly merchants who bear cult objects on their backs by means of a tumpline over the forehead. The weight of the burden is physically expressed by the bearer's hunched-over posture, casting his face in shadow and elevating his ritual object into prominence. These bearers of ritual burdens express a status different from that of a stone figure of a man who carries before him a large cacao pod (Plate 156). Since cacao beans were a form of currency as well as the source of an elite beverage, this unique figure may represent a proud merchant displaying this item of wealth.

Nude stone figures were probably dressed in costumes as deities or attendants (Plate 206). They stand rigidly erect, the weight distributed evenly on both feet. Head, hands, and feet are large in proportion to the short and slender bodies. The musculature may be quite realistic, but there is no idealization of the nude human body as in the Greco-Roman classical tradition. Sahagún describes the Aztec physical ideal

Plate 202. *Man Carrying Maize. Stone, 42 × 18 cm. 1200–1521. Museum für Völkerkunde, Vienna*

in his account of the youth chosen to represent Tezcatlipoca for a year, and then be sacrificed:

> For he who was chosen was of fair countenance, of good understanding and quick, of clean body—slender like a reed; long and thin like a stout cane; well-built; not of overfed body, not corpulent, and neither very small nor exceedingly tall. . . . [He was] like something smoothed, like a tomato, or like a pebble, as if hewn of wood. [He did] not [have] curly hair, [but] straight, long hair; [he had] no scabs, pustules, or boils on the forehead, nor [was he] large-headed. . . . For he was much honored when he appeared as the impersonator; because he was the likeness of Titlacauan; he was acknowledged as our lord, treated like a lord; one begged favors, with sighs; before him the common people bowed in reverence and kissed the earth. (SAHAGÚN, 1950–78, BK. 2, PP. 64, 66)

The Aztec facial ideal may be seen in a number of heads and masks (Plates 207–10; see Frontispiece). The typical face is broad; the low forehead is defined by the

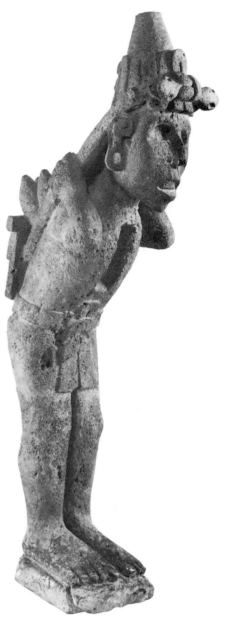

Plate 203. *Man Carrying Maize on His Back. Dark gray basalt with traces of polychrome paint, height 75 cm. Central Highlands. 1200–1521. The Saint Louis Art Museum (Gift of Morton D. May)*

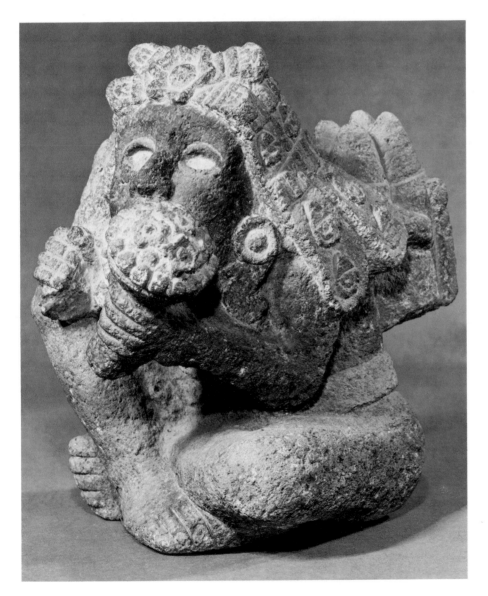

Plate 204. *Man Holding Peyote or Flower and Carrying Maize on His Back. Stone, 28 × 24 cm. 1200–1521. The Cleveland Museum of Art (The Norweb Collection)*

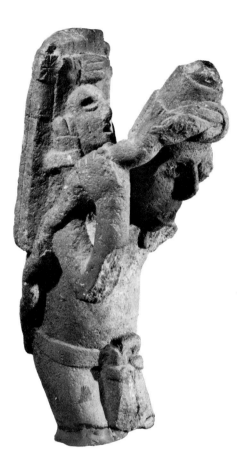

Plate 205. Man Carrying Statue of Goddess on His Back. Stone, height c.43 cm. 1200–1521. Stendahl Collection, Hollywood, California

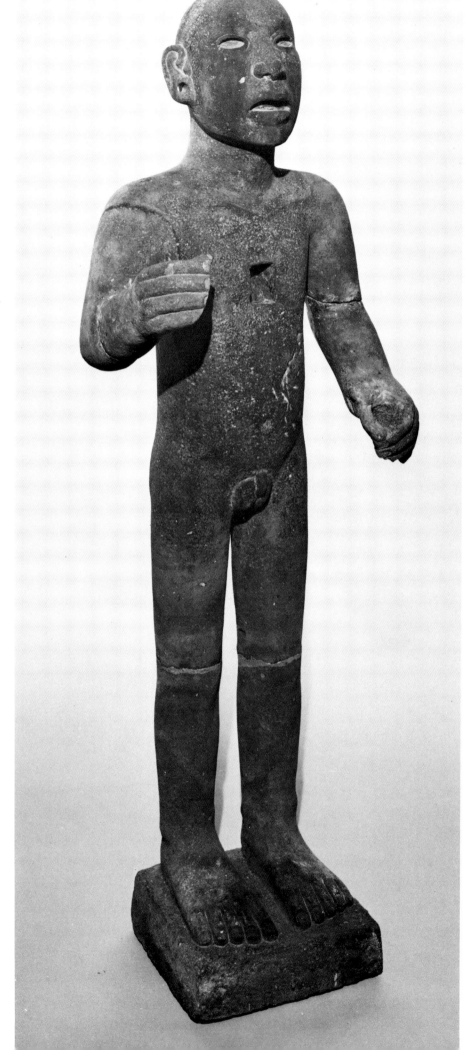

Plate 206. Standing Nude Male. Stone, height 1.1 m. Puebla. 1200–1521. Peabody Museum of Natural History, Yale University, New Haven

230

smooth hairline fitting like a cap. The eyes, often inlaid with shell, stare forward with no cover by upper eyelids. The lips are parted, with sometimes a row of teeth in inlay. The open mouth and staring eyes convey life and vitality.

Aztec figure sculpture does not always fit into a category—the majority of human figures are youthful or ageless, but there are sculptures of hunchbacks and old men with wrinkled faces (Plates 211, 212). These too could have been dressed as deities or attendants for the shrines. More problematical is the famous head representing a dead man (Plate 208). Its function is unknown. The closed eyes and flaccid modeling of the face indicates the Aztec ability to represent death in its human rather than metaphysical dimension. Recent finds of Aztec sculpture include a number of highly unusual and aberrant pieces. One of these is a couple, each half human and half simian (Plate 213), who are embracing each other while seated on a bench. Their lively comradeship is unique in Aztec sculpture, noted so far for its gravity.

Plate 207. Head of Man Wearing Eagle Helmet. Stone, 32 × 30 cm. Texcoco. 1200–1521. Museo Nacional de Antropología, Mexico City

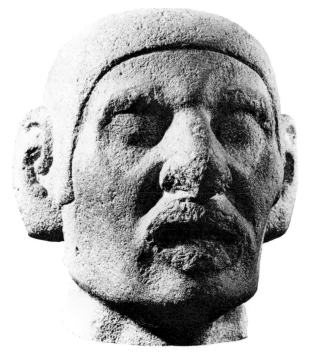

Plate 208. Head of a Dead Man. Basalt, 28 × 31 cm. Veracruz. 1200–1521. Museo Nacional de Antropología, Mexico City

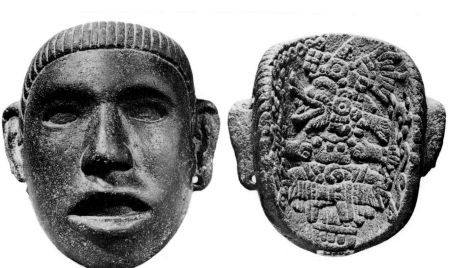

Plate 209. Mask. Stone, height 14.2 cm. 1200–1521. Museum für Völkerkunde, Berlin

Plate 210. Back of Mask, with relief of God with Buccal Mask and the Number 9

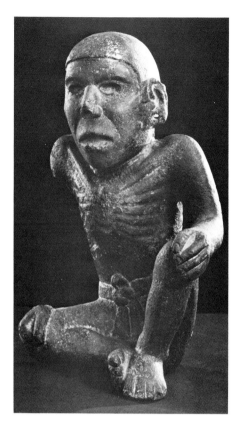

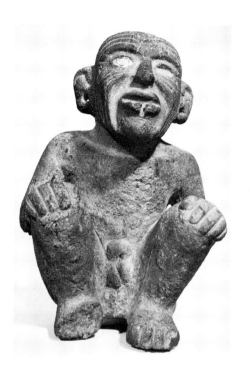

Plate 211. Seated Hunchback. Stone, 33 ×
17 cm. 1200–1521. Museo Nacional de
Antropología, Mexico City

Plate 212. Seated Old Man. Stone, height
30 cm. 1200–1521. Museum für Völkerkunde,
Basel (Collection Lukas Vischer)

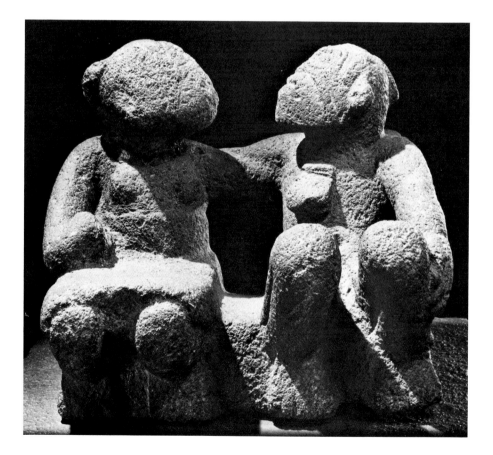

Plate 213. Seated Couple. Stone, 38 × 45 cm.
Mexico City. 1200–1521. Museo Nacional
de Antropología, Mexico City

Animals and Plants

In the Aztec concept of an animate universe, many animals and plants had supernatural symbolic associations. Although the Aztec gods were usually visualized in human form, most gods also had animal aspects. Both men and gods were believed to be capable of transforming themselves into flora or fauna. Sorcerers could change themselves into powerful animals for rituals of curing or to cause evil deeds. Tepeyollotl, patron of the third "week" of the divinatory calendar, was the jaguar aspect of Tezcatlipoca (see Colorplate 36). The names of some deities indicated their animal aspects: Xochiquetzal means "flower-quetzalbird" and she is shown in the Codex Borbonicus with flowers and a quetzalbird head helmet (see Colorplate 31). Details of animal physiognomy, such as beaks or fangs, were added to the anthropomorphic representations of Tlaloc and Ehecatl to express their powers as nature gods. Ten of the twenty day signs represent animals.

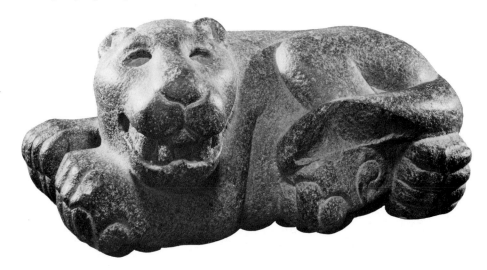

Plate 214. Reclining Jaguar. Stone, length 25.5 cm. 1200–1521. The Brooklyn Museum

The Aztecs, like many ancient cultures, did not worship animals but turned to animal imagery to explain the varied forms of supernatural power. They used animals as metaphors to illustrate special abilities, and not every animal that had symbolic significance for them was represented in stone sculpture. Many birds important in the calendar—the eagle, owl, quetzal, hawk, turkey, vulture, and hummingbird—are rarely or not yet found at all in stone sculpture. Most frequent are the jaguar, serpent, coyote, and dog; unexpected subjects for stone sculpture are insects, such as the flea and the grasshopper.

The largest mammal of Central America, the jaguar, was surrounded by a host of associations. It symbolized power and courage. The highest ranking warriors of the Mexica were called jaguar and eagle warriors. Since the jaguar was the king of the jungle, Tezcatlipoca, the deity with a jaguar aspect, was the patron of the human ruler, and the ruler alone could sit on a jaguar skin mat. Being a night hunter, the jaguar represented in Aztec mythology the sun enveloped at night in the darkness of the underworld. Because the jaguar represented danger and darkness, its power was ambivalent, for good or evil. Sorcerers also claimed it as their patron. None of these associations is represented directly in the simple naturalistic sculptures of jaguars in Aztec art, but they were known to everybody (Plate 214).

In Aztec thought the serpent had many different meanings, most of them positive. Its undulating movements and speed made the serpent an image of moving water and

Plate 215. *Feathered Serpent. Stone, height 28.5 cm., depth 46 cm. 1200–1521. Museum für Völkerkunde, Basel*

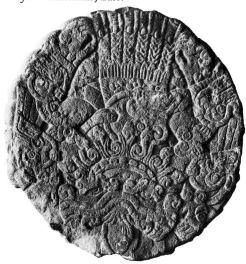

Plate 216. *Relief of Earth Monster, under base of Feathered Serpent*

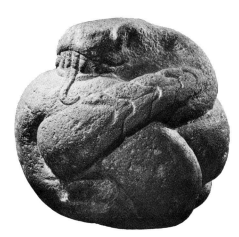

Plate 217. *Serpent Coiled in a Ball. Stone, paint, height 35.5 cm. 1200–1521. The Metropolitan Museum of Art, New York. The Michael C. Rockefeller Memorial Collection, Bequest of Nelson A. Rockefeller, 1979*

of lightning; as such, it was widely used to symbolize water and fertility. (The serpent could also symbolize another liquid, blood, as on the statue of Coatlicue.) Because they shed their skins, serpents symbolized renewal and transformation. A line in the hymn to Xipe Totec says: "the fire serpent hath been made a quetzal serpent" (page 226). The fire serpent, Xiuhcoatl, signified the dry season, and this mythical beast was believed to carry the hot, daytime sun across the sky; the quetzal serpent, Quetzalcoatl, is a metaphoric reference to the earth covered by a green mantle of vegetation in the rainy season. Xiuhcoatl and Quetzalcoatl were gods rather than mythical creatures, two visual metaphors that illustrated the alternating seasons in time and the transformations of the earth's surface. Like the ancient rain god Tlaloc, the feathered serpent was a fertility spirit associated with the ancient Toltecs. Fire serpents are rarely found in small-scale stone sculpture which tends toward representing positive images of feathered or natural serpents (Plates 215–18).

The most elaborate animal sculptures are feathered serpents with an earth monster carved under the base (Plates 215, 216). They signify the green surface of the earth overlying the voracious underworld. The unexpected combination of the scales and rattles of a serpent with ears of corn (Plate 218) also links the serpent with the idea of agricultural abundance.

Another animal frequently represented in Aztec stone sculpture is the dog (Plates 219, 220); unlike serpents and jaguars, both important in cosmic imagery and found on the major monuments of Tenochtitlán, the dog referred to domestic life and ordinary death, and occurs only among the smaller sculptures; in Mesoamerica dogs were kept as pets and used also for food. It was Aztec belief that the dog led the soul of the dead through the underworld, and a dog was sacrificed at every burial to act as a guide in the afterlife. When the vertebrae are exposed in a dog sculpture, it is performing its function as a leader in the underworld.

A water creature called *ahuitzotl*, having the body of a dog and the tail of a serpent, was believed to exist in the Valley of Mexico. The representation of this animal in sculpture may be related to the fact that a Mexica king had been named Ahuitzotl (Plate 221). Umberger (1981) has suggested that certain sculptured animals could embody the names of persons or of some of the day signs.

Animals that occur less frequently in Aztec sculpture in the round include the coyote, monkey, eagle, turtle, frog, fish, bee, and flea. The coyote and eagle, like the jaguar, were powerful predators, and all were the patrons of elite warrior orders (Plates 222, 223). The flight of the eagle was used as a metaphor to describe the sun's descent in the west. The monkey symbolized sexuality and gluttonous appetites and was therefore related to the god of pleasure, Macuilxochitl (Plates 161, 224, 225). The turtle, frog, and fish symbolized water and fertility (Plates 226–29), a turtle's head emerging from its shell suggesting plants emerging from the soil. Because turtle carapaces were used for musical instruments, the turtle was also related to Macuilxochitl.

A major category in small-scale Aztec sculpture is insects (Plate 230), which are divided into two classes. Moths and butterflies, because they emerge from cocoons, were symbols of the transformation after death of the soul of a brave warrior or sacrificial victim. Spiders, scorpions, and other noxious insects were associated with the *tzitzimime* monsters who would devour man at the destruction of the world. Some insects had significance as place names in the history of the Mexica. A grasshopper sculpture may have been a reference to Chapultepec, or "Grasshopper Hill," the first Mexica settlement in the lake area (Plate 231).

The Aztecs also carved sculptures of plants, such as cacti and flowers. The cactus

may represent the city of Tenochtitlán, which was the "place of the cactus" (Plate 232). A remarkable disk has carved on one side a squash blossom and on the other a bee with the head of the God with Buccal Mask (Plate 233). This may represent the wind god in the guise of a bee who pollinates the flower which would otherwise not bear fruit. To the Aztecs flowers signified refinement and sexual pleasure.

Animal and plant images are frequent in Mesoamerican terracottas, paintings, and reliefs, but they are rare in three-dimensional sculpture except in Aztec art. Because Aztec animals are usually represented without symbolic attributes, their religious or supernatural significance is not explicit. Perhaps such sculptures were set up near images of the appropriate god—frogs and fish near Tlaloc and Chalchiuhtlicue, monkeys with Xochipilli and Macuilxochitl. Sculptures of frogs were found on the balustrades of the Tlaloc side of the Main Temple of Tenochtitlán.

Plate 218. *Serpent Rattle with Scales and Ears of Maize. Stone, 1 × 1.35 m. Mexico City. 1200–1521. Museo Nacional de Antropología, Mexico City*

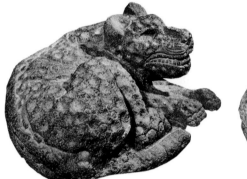
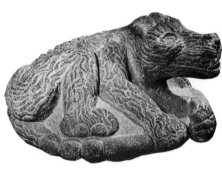

Plate 219. *Spotted Dog Showing Vertebrae. Stone, 25.5 × 45.5 cm. 1200–1521. Museo Nacional de Antropología, Mexico City*

Plate 220. *Dog Showing Vertebrae. Stone, 25.5 × 51 cm. 1200–1521. Museo Nacional de Antropología, Mexico City*

Like the sculptures of human figures, the animals and plants were carved in a naturalistic but simplified style; but unlike human forms, that have a few standard poses, the animals are represented in a variety of ways—standing, crouching, reclining, or curled up. Often the fur, scales, or feather markings are strongly emphasized. Nevertheless, the natural forms are reduced to basic geometric shapes, those of the serpents being the most remarkable. The Aztecs sought to convey the special character of different species and to express the kind of vitality each species possessed. This is particularly evident in the monkey figures, shown in various unexpected positions.

Aztec sculptors could observe animals whose habitats were far from Tenochtitlán for Motecuhzoma II had his own zoo, described by Cortés in one of his letters to Charles V:

[Motecuhzoma] had another very beautiful house, with a large patio, laid with pretty tiles in the manner of a chessboard. There were rooms nine feet high and as large as six paces square. . . . In each of these rooms there was kept a bird of prey of every sort that is found in Spain, from the kestrel to the eagle, and many others which have never been seen there. . . . In this house there were several large low rooms filled with big cages, made from heavy timbers and very well joined. In all, or in most of them, were large numbers of lions, tigers, wolves, foxes and cats of various kinds which were given as many chickens to eat as they needed. Another three hundred men looked after these birds and animals.

(CORTÉS, 1971, PP. 110–11)

Nezahualcoyotl was known for his gardens in Tetzcotzingo where he tried to grow every type of plant known in the empire. In setting up zoos and botanical gardens, the Aztec rulers were not motivated solely by curiosity or scientific interest. Since they saw the capital cities as the mythic centers of the universe, they tried to

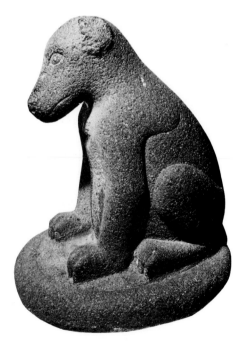

Plate 221. *Ahuitzotl, Mythical Water Creature with Dog's Body and Serpent's Tail. Stone, 47 × 50 cm. Tenochtitlán. 1200–1521. Museo Nacional de Antropología, Mexico City*

Stone Sculpture **235**

Plate 222. Coyote. Stone, 38 × 17 cm. Mexico City. 1200–1521. Museo Nacional de Antropología, Mexico City

Plate 223. Eagle. Volcanic stone, height 20 cm., length 28 cm. 1200–1521. British Museum, London

create a physical reflection of that status by making of their zoos and gardens microcosms of the known world with all its flora and fauna.

Ritual Objects

Besides sculptures of deities, human attendants, animals, and plants, Aztec shrines were furnished with stone platforms, sacrificial stones, containers, and stone replicas of wooden and clay objects. Platforms may have been bases for sculpture or other objects. Sacrificial victims reclined on cylindrical stones in position for the heart to be cut out. Specially decorated vessels held blood and hearts; other receptacles may have contained water or *pulque*. Boxes held ritual objects such as offerings or the thorns used in penance. Replicas were made of drums, shields, and incense burners as special offerings.

Since many of these objects were used in rituals or in offerings they were as important as the deity images. The surfaces were carved in relief with images whose themes were related to some of the major monuments of Aztec sculpture, themes such as the sun disk, emblems of the four destructions of the cosmic ages, earth monsters, the grass ball of self-mortification, and skulls. But these carvings are simpler in conception than those on the major monuments, often having no historical dates or complex thematic reinterpretations. In fact, the iconographies of the major monuments were probably based partly on some of these ritual objects. Monuments such as the platform carved with the solar disk and movement glyph in the center and the emblems of the four destructions in the corners (Plate 234), or the cube-shaped stone with the four eras represented on the sides (Plates 235–37), may have been the visual prototypes for carvings such as the Calendar Stone (see Plate 132). The major monuments differ from these smaller sculptures in their multiple levels of meaning and in breaking compositional rules to create special effects.

Platforms are distinguished from reliefs by having sides that also bear carvings. In addition to solar disks and the emblems of the four cosmic eras, many other subjects are represented. More unusual is a platform carved with wavy lines suggesting water in which float skulls, bones, and human hands (Plates 238–40). A large butterfly, its wings ornamented with obsidian knives, holds bleeding hearts in its human hands. This image may refer to the cult of sacrifice and the *tzitzimime*, female monsters of destruction.

Although most temples must have had sacrificial stones, only one can be definitely identified as such on the basis of codex representations (Plate 241). The cylindrical stone narrowing toward the top has a simple carving of a row of symbols for jade, meaning preciousness, a metaphoric reference to the human offering.

Stone receptacles of many forms may have been used as containers for sacrificial hearts and blood (Plate 242), and decorated with various combinations of the sun disk, earth monster, the grass penitential ball emblem, or skulls. An unusual tall receptacle in the British Museum has two constrictions (Plate 243), the circle of human hearts at the top making it resemble greenstone sacrificial vessels (see Colorplate 46), but in shape it is closer to *pulque* vessels. On one side there is a solar disk, on the other a partially defaced U-shaped design which may represent the moon. The glyph 1 Rain is associated with the sun, 2 Rabbit with the moon emblem.

In addition to stone vessels for blood sacrifice, vessels were made for the cult of the God with Goggle Eyes and Fangs (Plate 244), globular in shape and showing the facial features and paper headdress of the rain god Tlaloc. There is no reference to blood

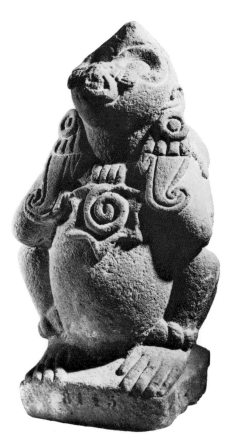

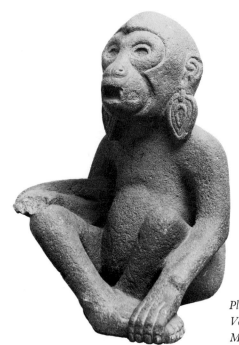

Plate 225. *Seated Monkey with Earplugs. Volcanic stone, 35.5 × 27 cm. 1200–1521. Museum of Art, Rhode Island School of Design, Providence (Mary B. Jackson Fund)*

Plate 224. *Seated Monkey Wearing a Shell Pendant. Stone, 44.5 × 24 cm. 1200–1521. Musée de l'Homme, Paris*

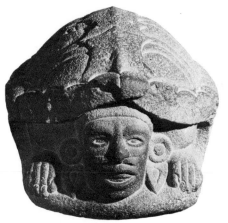

Plate 226. *Turtle with Human Face. Stone, height 38 cm., length 54 cm. 1200–1521. Museo Nacional de Antropología, Mexico City*

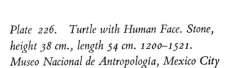

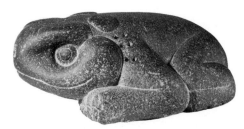

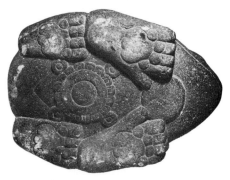

Plate 227. *Frog. Stone, height 19 cm., length 51 cm. 1200–1521. Museo Nacional de Antropología, Mexico City*

Plate 228. *Glyph for Jade under base of Frog*

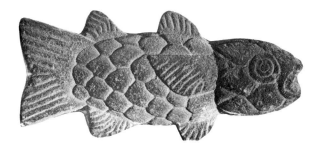

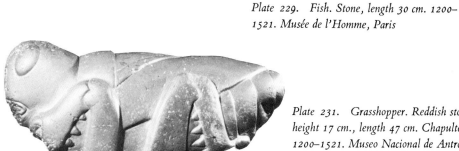

Plate 229. Fish. Stone, length 30 cm. 1200–1521. Musée de l'Homme, Paris

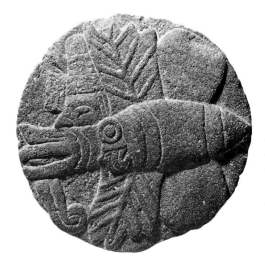

Plate 231. Grasshopper. Reddish stone, height 17 cm., length 47 cm. Chapultepec. 1200–1521. Museo Nacional de Antropología, Mexico City

Plate 230. Flea. Stone, height 26 cm., length 37 cm. 1200–1521. Museo Nacional de Antropología, Mexico City

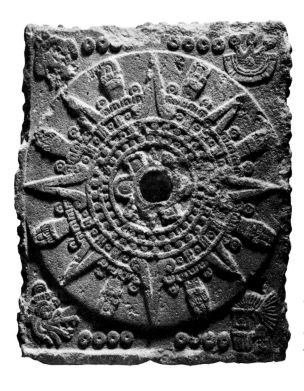

Plate 233. Disk in form of a Flower with Bee Representing God with Buccal Mask. Stone, diameter 18.5 cm. Probably Oaxaca. 1200–1521. American Museum of Natural History, New York

Plate 232. Cactus Plant with Roots. Volcanic stone, 99 × 27 cm. 1200–1521. Museo Nacional de Antropología, Mexico City

Plate 234. Platform with Sun Disk in center, Glyphs of Four Cosmic Eras in corners. Stone, 53.3 × 45.7 × 25.4 cm. 1200–1521. Peabody Museum of Natural History, Yale University, New Haven

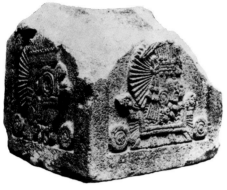

Plate 235. Box or Platform with Glyphs
of Four Cosmic Eras: left side, "4 Fiery-rain"
Glyph (Head of Rain God Tlaloc); right
side, "4 Water" Glyph (Head of Water
Goddess Chalchiuhtlicue). Stone, 60 × 63 cm.
Tenochtitlán. 1200–1521. Museo Nacional de
Antropología, Mexico City

Plate 236. Side of Box or Platform with
"4 Jaguar" Glyph

Plate 237. Side of Box or Platform with
"4 Wind" Glyph (Head of Ehecatl)

BELOW
Plate 238. Platform with Butterflies and
Symbols of Sacrifice and Warfare. Stone,
78 × 99 cm. Mexico City. 1200–1521. Museo
Nacional de Antropología, Mexico City

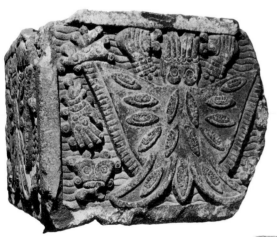

Plate 240. Side of Platform with Hand
Holding Shield and Darts, detail

Plate 239. Side of Platform with
Water Imagery

Plate 241. Sacrificial Stone, with Jade Glyphs.
Stone, 38 × 20 cm. 1200–1521. Museo
Nacional de Antropología, Mexico City

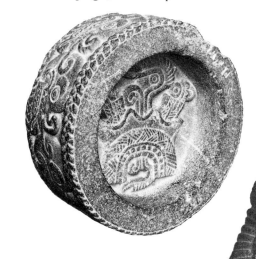

Plate 242. Vessel with Skulls on outside,
Grass Ball of Sacrifice inside. Stone, 17 ×
40 cm. Mexico City. 1200–1521. Museo
Nacional de Antropología, Mexico City

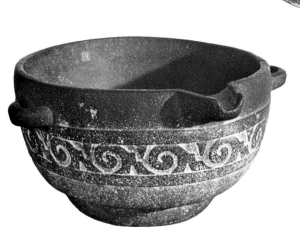

Plate 243. Tall Vessel with Hearts on top,
Solar Disk on side. Stone, height c. 68 cm.
1200–1521. British Museum, London

Plate 244. Globular Vessel with God with
Goggle Eyes and Fangs. Stone, height 24 cm.
1200–1521. Museum für Völkerkunde, Basel
(Collection Lukas Vischer)

Plate 245. Large Bowl with Stepped-fret
and Spiral Design. Stone, 48 × 100 cm.
Mexico City. 16th century. Museo Nacional de
Antropología, Mexico City

OPPOSITE
Colorplate 45. Rabbit with Head of a
Warrior in Eagle Helmet Emerging from Belly.
Jadeite, 18.1 × 9.15 cm. Cempoala, Veracruz.
1350–1521. Dumbarton Oaks Pre-Columbian
Collection, Washington, D.C.

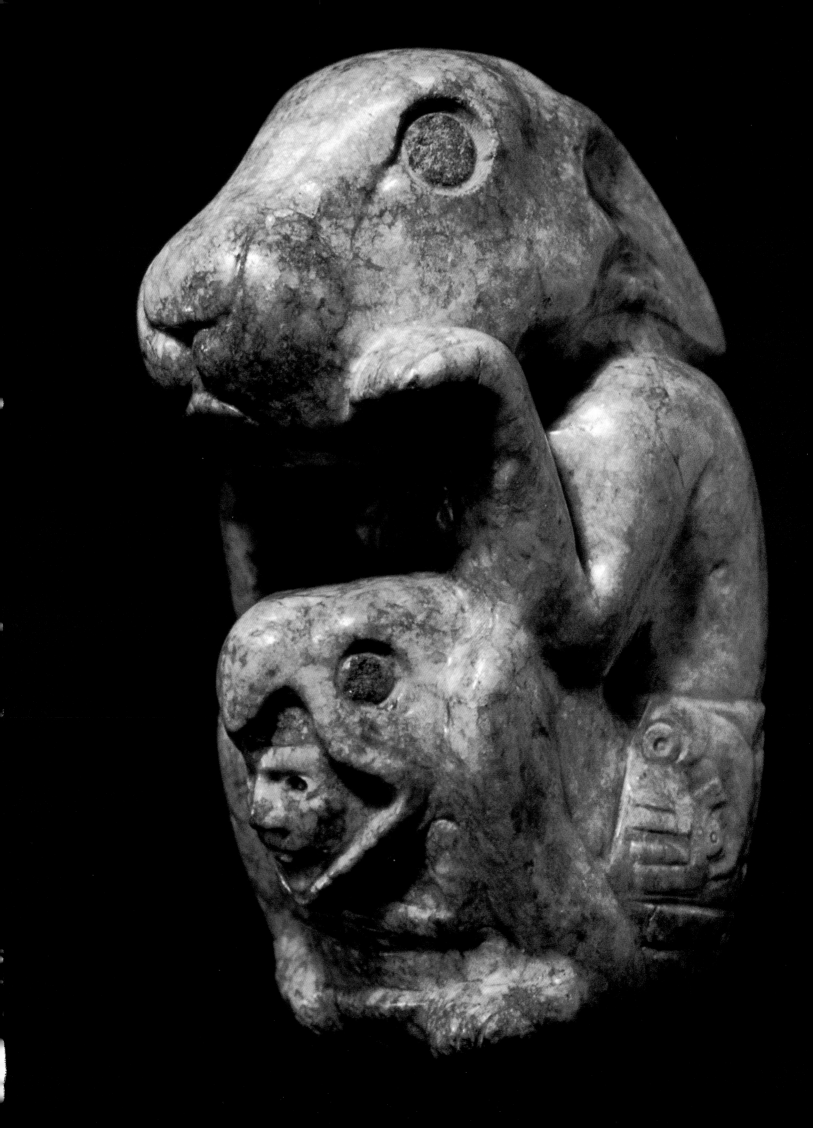

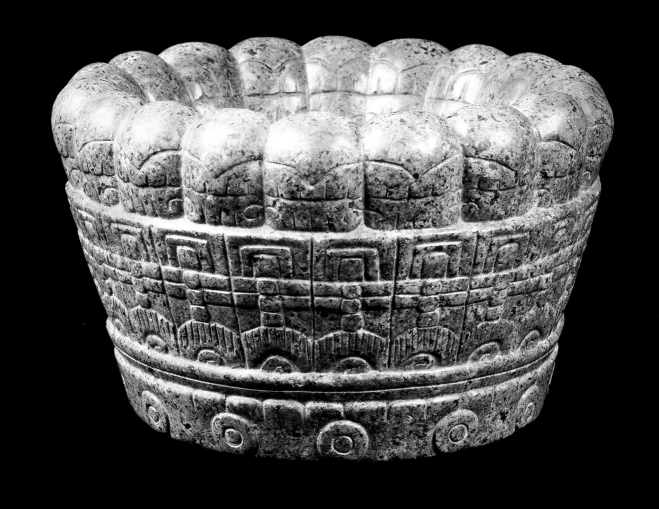

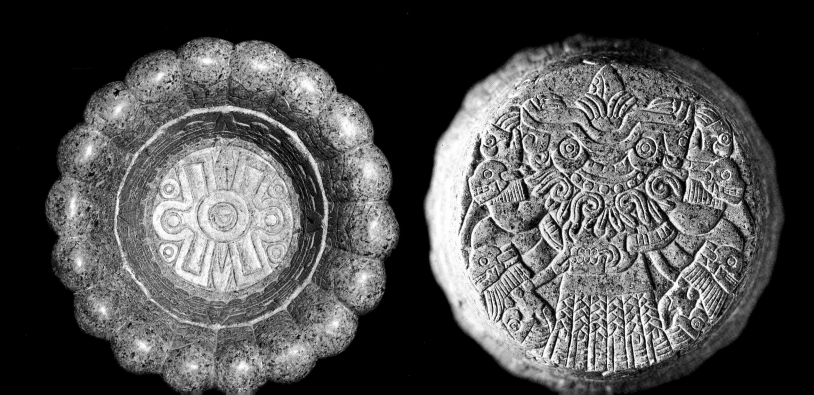

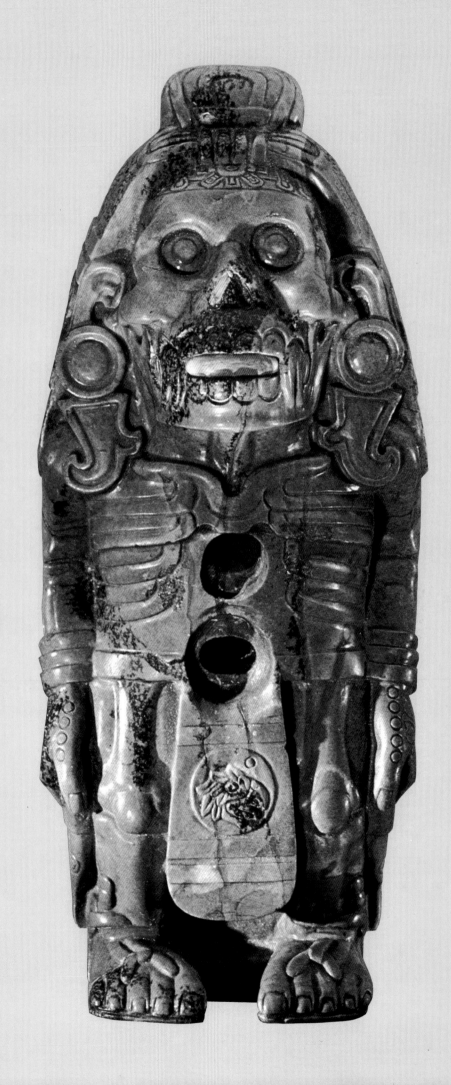

Colorplate 46. Sacrificial Vessel, side decorations of Glyphs of Jade, Feathers, and Hearts. Greenstone, height 14.5 cm., diameter 23.8 cm. 1350–1521. Museum für Völkerkunde, Berlin

Colorplate 47. Sacrificial Vessel, interior decoration of Sun Disk, Glyph "4 Movement" in center

Colorplate 48. Earth Monster under base of Sacrificial Vessel

Colorplate 49. Skeletal Figure. Greenstone with inlaid shell, 22.8 × 12 cm. Probably 1502–20. Württembergisches Landesmuseum, Stuttgart (see Plates 278, 279)

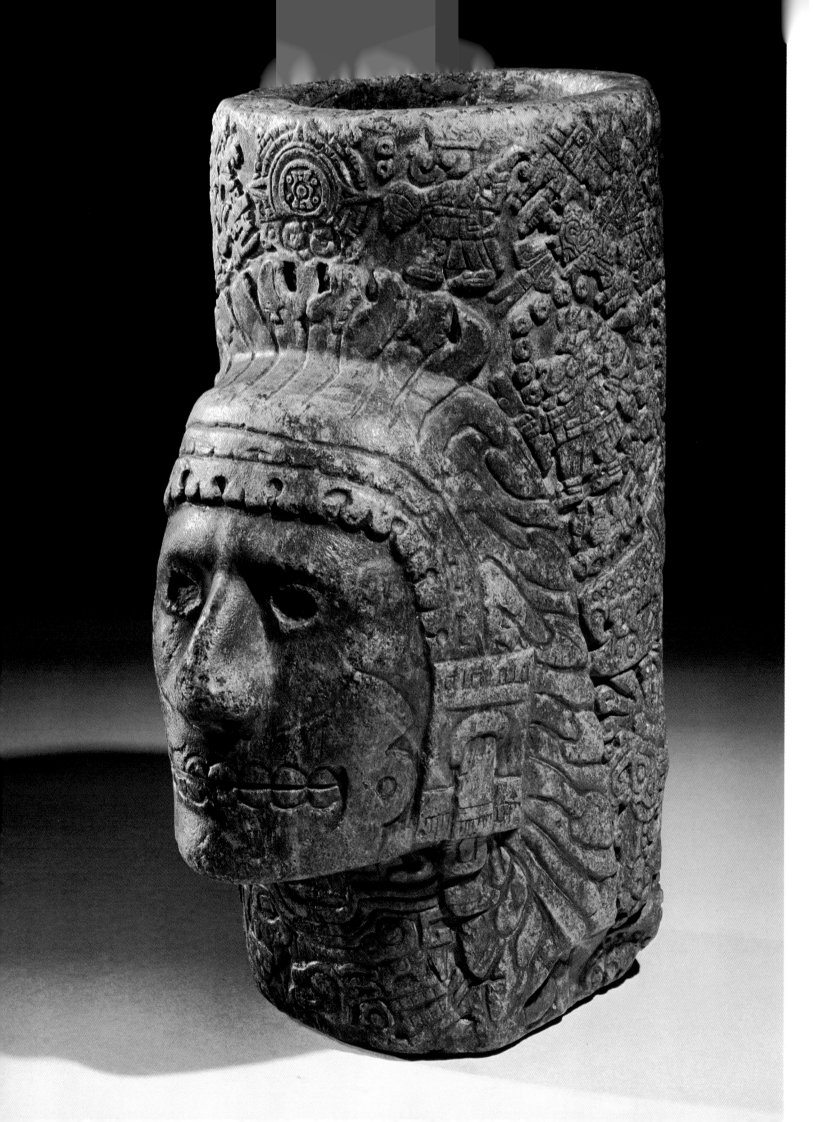

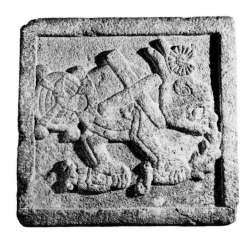

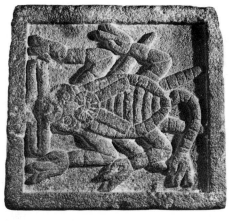

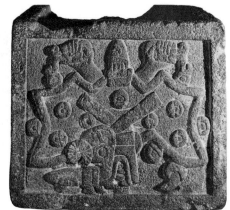

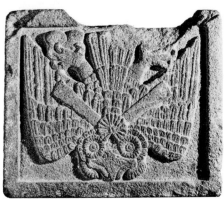

Plate 246. *Box or Platform with Creatures of Destruction: Side with Spider. Stone, 40 × 60 cm. Mexico City. 1200–1521. Museo Nacional de Antropología, Mexico City*

Plate 247. *Side of Box with Scorpion*

Plate 248. *Side of Box with Bat*

Plate 249. *Side of Box with Owl*

Plate 250. *Box Painted with Four Crouching Figures of God with Goggle Eyes and Fangs. Stone with paint, 20 × 25 cm. Tizapan. 1200–1521. Museo Nacional de Antropología, Mexico City (see Plate 270 for figurine contained in box when found)*

Plate 251. *Inside of Cover of Box Painted with Four Crouching Tlaloc Figures*

OPPOSITE

Colorplate 50. *Side of* Pulque Beaker, with Head having Skeletal Mouth. Phyllite, 36 × 17 cm. Probably 1502–20. Museum für Völkrkunde, Vienna (see Plates 280–83)

OPPOSITE
Plate 252. Box with Figure Drawing Blood and Fire Serpent. Stone, 21.5 × 31.5 × 31.5 cm. 1200–1521. Museo Nacional de Antropología, Mexico City

Plate 253. Side of Box with Grass Ball of Sacrifice

LEFT
Plate 254. Box with Royal Headdress of Motecuhzoma II and Other Glyphs. Stone, 21 × 32 cm. 1502–20. Museo Nacional de Antropología, Mexico City

imagery in the iconography. These vessels may be stone copies of ceramic forms and therefore belong in the category of stone replicas, together with drums and shields. Several of these globular vessels were found in offerings in the Main Temple area in 1978. Rain gods carrying vessels with the faces of rain gods are found in the murals of Tepantitla at Teotihuacán (see Plate 11). Ceramic Tlaloc effigy vessels are also known in Teotihuacán and in later art. These Aztec stone Tlaloc vessels are another example of the translation of clay works into stone images, on the basis of archaic prototypes.

Among the stone vessels one specimen (Plate 245) has unusually simple decoration, the ample curve of the bowl ornamented with a beautiful row of stepped frets. The uncommon form of this vessel and its restrained design may mark it as an early colonial work.

Stone boxes or *tepetlacalli* (literally, stone houses) also have no precedents in pre-Aztec art and may be stone copies of wooden prototypes. They may have had quite varied functions: containers for the ashes of the aristocratic dead, hearts from ritual sacrifices, thorns used in drawing blood, or assorted offerings. The iconography of the boxes is correspondingly varied except for the bottom, on which the earth monster is always carved.

The Chalco box (see Plates 163–65) is remarkable for the flowering tree with a bird in its branches and the glyphlike emblems on the sides in the ornate style characteristic of that southern town, Chalco. An unusually shallow box or perhaps a platform is carved in the Mexica style with emblems of destruction—a spider with a web near its back, and a scorpion, bat, and descending owl (Plates 246–49); each animal also wears on its head a paper rosette and streamers. They represent the *tzitzimime* monsters. On the base is an earth monster in the guise of the God with Goggle Eyes and Fangs. Another unusual box with a painted design of four crouching rain god figures was found in Tizapan (Plates 250, 251). It had been an offering, for it contained the jade figure of a goddess holding maize ears (see Plate 270).

A group of boxes carved with imagery associated with penitential rites may have contained such ritual objects (Plates 252, 253). Usual designs on the sides are the figure drawing blood from its ear and the grass ball emblem. Penitential figures are seated in front of a smoking ladle-shaped incense burner. Such ladle censers made of clay were used in actual rituals (see Colorplate 69).

Many of these boxes are carved with glyphs, some of these appearing to relate to the names of rulers. One box has been associated with the ruler Ahuitzotl (see Plates 120–23). Several boxes are ornamented with glyphs that include that of the royal headdress, the name of Motecuhzoma II (Plates 254, 255 a, b). Umberger (1981, p. 106) suggests that such boxes may have been given to visitors as presents, so many having

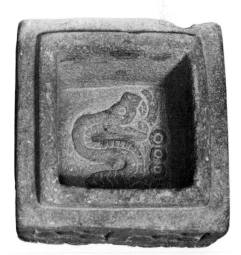

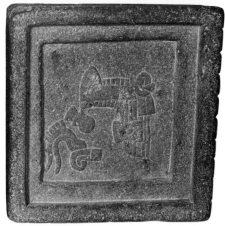

Plate 255 a, b. Interior of Box with Glyph "4 Serpent" (above); interior of Lid with Headdress Glyph of Motecuhzoma II (below)

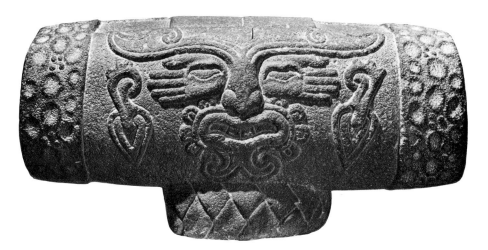

Plate 256. *Drum with Facial Features of a Deity. Stone, 35 × 72 cm. Chalco. 1200–1521. Museo Nacional de Antropología, Mexico City*

Plate 257. *Shield (reverse) with Holding Straps. Stone, diameter 28 cm. Mexico City. 1200–1521. Museo Nacional de Antropología, Mexico City*

been found outside of Tenochtitlán. However, many objects were hidden away far from their original locations during the conquest and the Spaniards' subsequent search for "heathen idols," thus making it difficult to know their provenance.

While most Aztec stone sculptures can be considered replicas of earlier clay or wood forms, some are stone replicas in a more literal sense—drums, shields, incense burners, and year bundles. The making of stone replicas in Mesoamerica did not begin with the Aztecs. The objects associated with the Classic Veracruz ball game—yokes, *hachas*, and *palmas*—were probably stone replicas of gear worn by ball players in the game (see Plates 14, 15). Several of the most unusual Aztec stone replicas come from the city of Chalco, whose art derives in part from that of Classic Veracruz.

Two Chalco drums, one horizontal (Plate 256) and one vertical, represent wooden originals (Castañeda and Mendoza, 1933, fig. 52). The upright drum is similar to the signal drum carried on the back of Nezahualcoyotl in the Codex Ixtlilxochitl illustration (see Colorplate 13), and to a wooden drum found in Malinalco (see Plate 288). The facial features of a deity, possibly Macuilxochitl, god of dance and music, are spread out on the side of the horizontal drum. The eyes that stare from the palms of the hands add a supernatural quality. It is more usual, when this deity is represented in Mixtec art, to place the hand design covering the mouth. Nonfunctional stone drums served as offerings; in the Escalerillas Street excavation, in Mexico City, the statue of the Deity with Crested Headdress was found surrounded by stone and clay drums.

The Aztecs also carved stone replicas of clay incense burners, wooden shields (Plate 257), and the bundles of fifty-two sticks representing as many years (Plate 258). These year bundles either bore no designs or had glyphs referring to particular time cycles.

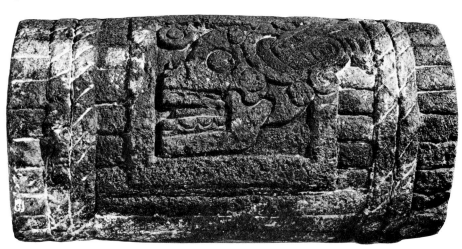

Plate 258. *Year Bundle with Glyph "1 Death." Stone, 33 × 66 cm. Mexico City. 1200–1521. Museo Nacional de Antropología, Mexico City*

Reliefs

The major production of Aztec stone sculpture is figures in the round; the small number of relief carvings that we know may have been used to decorate temples or other buildings. These reliefs represent deities in a less standardized manner than the three-dimensional sculptures do. Some relief sculptures are simply conceived and crudely executed; others, such as the Goddess with Fangs and Square Eye, are as detailed and sensitively carved as the later monuments of Tenochtitlán (Plate 259). The panel with the human face emerging from a monster maw is a superb reinterpretation of a Toltec theme (Plate 260).

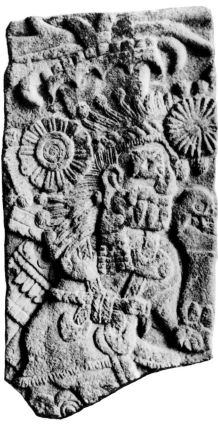

Plate 259. *Relief of Goddess with Fangs and Square Eye. Stone, 120 × 64 cm. Mexico City. 1200–1521. Museo Nacional de Antropología, Mexico City*

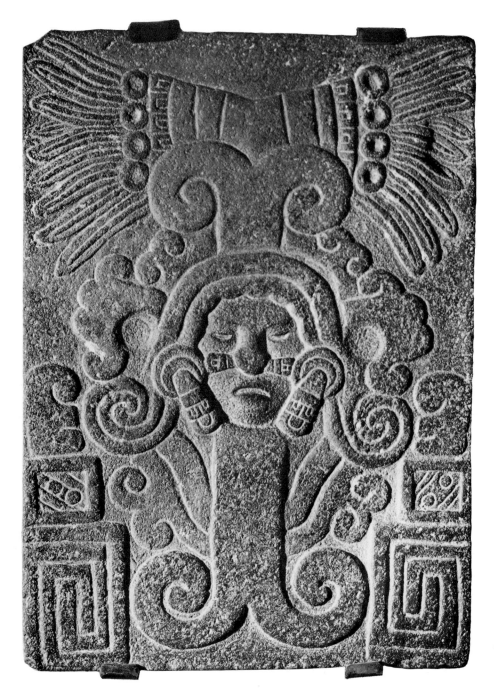

Plate 260. *Relief with Human Face Emerging from Monster Maw. Stone, 61 × 44.5 cm. 1200–1521. Museo Nacional de Antropología, Mexico City*

VII

LAPIDARY ARTS

Plate 261. Pair of Earspools. Obsidian,
3.5 × 2.8 cm., less than 1 mm. thick. Mixtec-
Aztec, 1350–1521. The Metropolitan Museum
of Art, New York. The Michael C.
Rockefeller Memorial Collection, Bequest of
Nelson A. Rockefeller, 1979

OPPOSITE
Plate 262. Effigy Vessel, Monkey with Tail
over Its Head. Onyx, pyrite, and shell, height
19 cm. Mixteca-Puebla region. Mixtec-Aztec,
1350–1521. The Metropolitan Museum of
Art, New York. The Michael C. Rockefeller
Memorial Collection, Bequest of Nelson A.
Rockefeller, 1979

The Aztecs had an aesthetic and practical interest in stones of all kinds. Although they had some copper tools, their culture was essentially neolithic and they mainly used stones as cutting implements. Flint was used for making knives, as in the sacrificial knives (see Colorplates 55, 56); obsidian was used for cutting and scraping tools. As a stone-using people, the Aztecs were interested in hard stones having different colors and shiny surfaces, such as greenstone, porphyry, obsidian, rock crystal, and onyx, and out of these they made a variety of sculptures, containers, and jewelry. These pieces became favorite collectors items for Westerners in the nineteenth century for their precious material, generally small size, and beautiful carving; the market for such pieces led to the making of forgeries, which still continues. Aztec lapidary art has never been studied in detail, so we have little knowledge of the styles by which to judge unusual pieces as authentic or fake. One entire category of objects, obsidian masks, is considered fake since the Aztecs generally did not make large carvings out of obsidian (Ekholm, 1964, p. 25). Westerners favor such masks because they consider obsidian to be a prehispanic material, and masks are popular with collectors of primitive art. A small obsidian jar bearing a very simple skull has been found in the Main Temple offerings (*Bellas Artes*, 1980, p. 32).

Obsidian was carved for jewelry such as labrets and earspools (Plate 261). In many instances, Mixtec and Aztec works are hard to distinguish. The technical virtuosity of the Aztec-Mixtec lapidary artists is evident in these earspools which are worked to less than one millimeter in thickness, the obsidian becoming translucent, brownish in color. Onyx marble was another material used for sumptuary arts in lapidary carving. Numerous onyx vessels are known, some plain and some as effigy figures; a frequent subject is a monkey holding its tail above its head (Plate 262). These vessels retain their globular form, the limbs emerging from it quite abruptly. The iconography is so simple that we have little idea of the meaning or function of these vessels. Several examples are believed to come from Veracruz and the Gulf Coast; possibly the Aztecs imported them.

Green stones, including jadeite, diorite, and serpentine, were the most important of the precious stones in Mesoamerica. Greenstone, the material most valued by the Olmecs, was also prized by each succeeding Mesoamerican culture. Pieces were often handed down as heirlooms and recarved in a later period. As in China, a jade bead was placed in the mouth of the dead to be used as payment during the trip of the soul in the afterworld. Greenstone objects were often buried in the floor of temples as offerings. The green color of the stone was symbolically equated with the green of water and vegetation and was seen as a metaphor for life and fertility. The Aztec *chalchihuitl* or jade symbol signified preciousness. It is no accident that three of the Aztecs' most precious materials were blue or green—quetzal feathers, turquoise, and greenstone. They were valued for their rarity as well as for their auspicious color significance. A beautiful young girl was compared in preciousness to a quetzal feather, to turquoise, and to greenstone in the rhetorical speeches of the elders collected by Sahagún (1950–69, bk. 6). By contrast, gold, which was secondary in im-

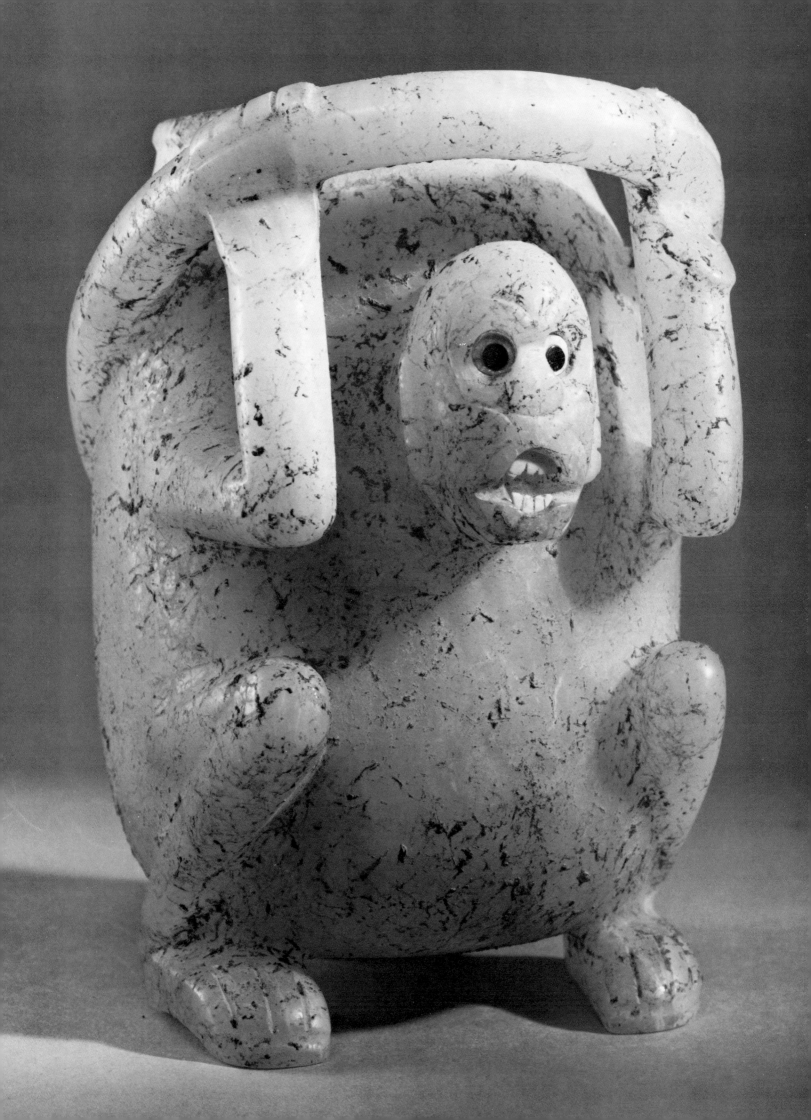

Plate 263. Mask of Goddess Coyolxauhqui.
Jadeite, 11 × 14.5 × 3.5 cm. 1350–1521.
Peabody Museum, Harvard University,
Cambridge, Mass.

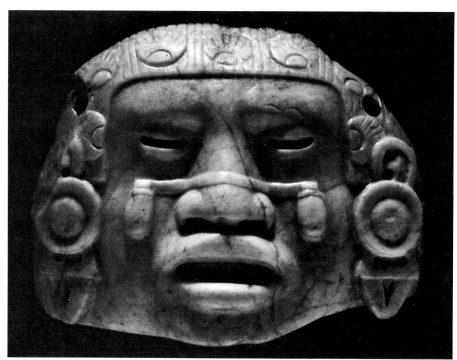

Plate 264. Coiled Fire Serpent. Quartz
diorite, 43.5 × 45.5 cm. 1507. Dumbarton
Oaks Pre-Columbian Collection,
Washington, D.C.

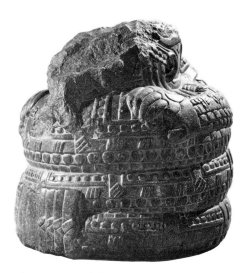

Plate 265. Relief under Coiled Fire
Serpent, with Date Glyph "2 Reed" and Name
Glyph of Motecuhzoma II

portance, was called *teocuitlatl,* "excrement of the gods," and was not usually a metaphor for beauty.

Greenstone came from Guerrero and was given as tribute by the southern provinces. Hundreds of greenstone figures from Guerrero were found in the offerings during the recent excavations of the Main Temple of Tenochtitlán. In the Valley of Mexico region the best-known lapidary artists were the people of Chalco and Xochimilco. Sahagún describes their work in detail: their tools were of copper and flint, with bamboo and sand for polishing. The patron gods of the lapidary artists were Chantico, fire goddess and patroness of the city of Xochimilco, and Nahualpilli, Macuilcalli, and Centeotl. Their idols were richly dressed and sacrifices were performed in their honor so that they would endow skill and artistry to craftsmen (Saville, 1922, pp. 33–34).

Jade necklaces were the most frequent form of greenstone; the material was also used to make deity statues, masks, sacrificial vessels, and boxes. Very large pieces of greenstone, made into some of the major temple sculptures of Tenochtitlán, included the Head of Coyolxauhqui and the Dedication Stone (see Plates 94, 99). Because the material was so precious, these were objects of conspicuous wealth and consumption that would awe the visitors to Tenochtitlán. A jade mask pectoral in Harvard's Peabody Museum (Plate 263) represents Coyolxauhqui, perhaps made at the time of the dedication of the Main Temple and the Coyolxauhqui Relief (see Plate 102).

It appears that almost any sculpture could, for a special purpose, be copied in greenstone. Two almost identical sculptures, now in Mexico City and Dumbarton Oaks, respectively, represent coiled fire serpents (Plates 264, 265). The headdress glyph for Motecuhzoma II's name is carved on the bottom, above the glyph 2 Reed, the date of the New Fire Ceremony of 1507 for which so many important sculptures were made. In style and iconography these greenstone serpents are related to the major monuments of Tenochtitlán.

Except for jewelry, all greenstone sculptures appear to be ritual objects rather than objects of status or rank. Some unusual, unique objects made of this precious material are as complex as larger monuments; others are simply smaller versions in greenstone of sculptures usually carved of other stones. Masks and sacrificial vessels appear to be the only sculptures that were characteristically made of greenstone.

Greenstone sculptures do not have a stylistic coherence. The hardness of the stone accounts for some being carved with less detail than many stone carvings, yet others are as intricate and detailed as the illustrations in a codex.

There is no prototype in any other medium for the sculpture of a rabbit with a helmeted man's head emerging from its belly (Colorplate 45). The sculpture has the slightly irregular surface modeling often found on greenstone carving, which makes it appear lively rather than rigid. Images of rabbits are rare in any medium except in the codex illustrations. The Mesoamericans believed that the moon, often personified as a female deity, was inhabited by a rabbit. Rabbits were also associated with the gods of *pulque* and drunkenness. This rabbit sits with its arms raised, similar to figures of death goddesses in stone sculpture (see Plates 186, 187), and wears a belt

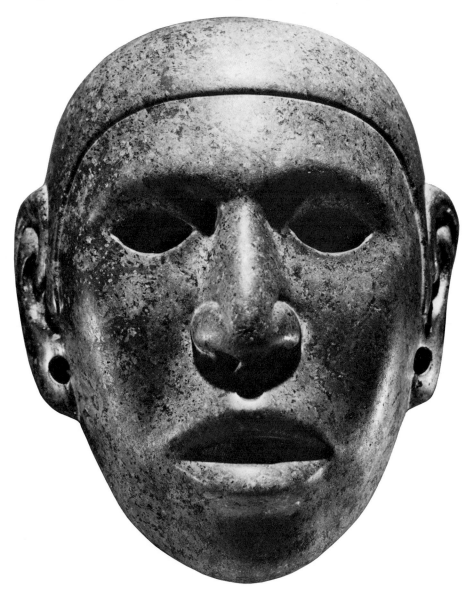

Plate 266. Mask. Greenstone, height 18.5 cm. Castillo de Teayo, Veracruz. 1350–1521. American Museum of Natural History, New York

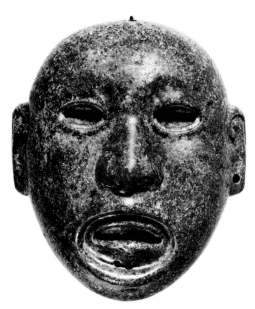

with skulls and crossed bones like the Greenstone Relief of a Goddess (see Plate 105). The man wearing the bird-helmet is probably a warrior. The meaning of the sculpture is not entirely clear: the figure may refer to birth and death, to a woman dying in childbirth, or to a victim captured in battle. The rabbit form implies that the figure may be a deity associated with the moon. The image is said to come from Cempoala in Veracruz.

The Aztecs made masks out of many materials, but greenstone was one of the most important. Such stone masks appear to represent deities; apparently they were not meant to be worn by humans, because the eyes are usually not perforated. The open mouth of most masks suggests life and breath. One of the most beautiful is a naturalistic face from Castillo de Teayo (Plate 266) which would appear even more dramatic had its eyes retained their inlay. Its simplicity prevents the identification of this mask with a deity. One mask is known of the flayed god Xipe (Plate 267) and another one may represent Tezcatlipoca (Plates 268, 269); the latter has Tezcatlipoca's emblem, the smoking mirror, carved near each of its temples and the date 2 Reed carved on the back. These masks represent the Aztec facial ideal: a long head, wide mouth, straight nose, and eyebrows set close to the eyes. In all cases the ears are carefully detailed with a spiral form and the lobes have holes for the insertion of ornaments.

Various extant stone vessels could have been used as containers for sacrificial hearts and blood, but the most elaborate in conception are those made of greenstone, of which three survive. Two of these are surprisingly small flat-bottomed dishes with flaring sides; the larger is in Berlin (Colorplates 46–48). The thick, rounded walls give these objects a monumental look. These were standard sacrificial vessel forms, represented as such on other works of art: they are seen on the Temple Stone (see Plate 125) and in the Codex Borbonicus (see Colorplates 29–31). The vessels are called *quauhxicalli*, eagle vessels, and eagle feathers carved on the sides refer to the sun in eagle guise. In abbreviated form, the imagery is the quintessence of Mexica ideology: inside, the vessel is carved with a solar disk, its 4 Movement glyph at the bottom and rays encircling the sides; on the vessel's bottom is an earth monster with an open maw, the limbs studded with skulls. These images represent sacrifice in its cosmic sense and the regulated cycle of darkness and light. Sacrificial vessels in this form were made

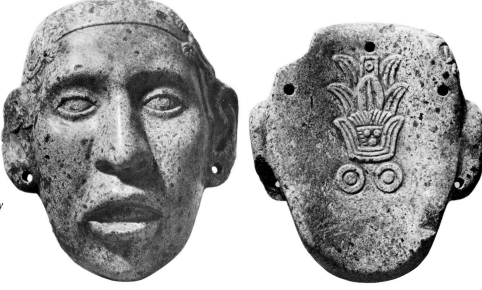

Plate 268. Mask with Smoking Mirror Emblem. Greenstone, 18.5 × 16.3 cm. Possibly 1507. Dumbarton Oaks Pre-Columbian Collection, Washington, D.C.

Plate 269. Back of Mask with "2 Reed" Glyph

only of greenstone, to emphasize the preciousness of the human offering to the gods.

Many greenstone carvings have prototypes in stone sculpture, including the Goddess with Tasseled Headdress (Plate 270), the fly (Plate 271), and the squash (Plate 272). In the offerings before the stairway of the Temple of Tlaloc at Tenochtitlán were a greenstone God with Goggle Eyes and Fangs and an alabaster God with Headdress of Two Horns. Both are close in form, size, and iconography to stone sculptures of these gods, and remarkable for their fine surface polish (*Bellas Artes*, 1980, pp. 58–59).

The themes of most of these sculptures are related to water and fertility or suggest the color green in nature, thus appropriate to greenstone. The Goddess with Tasseled Headdress who is holding maize was found as an offering in the box painted with Tlaloc designs (see Plates 250, 251), an association of objects symbolizing the precious grain growing in the earth with the help of the rain gods. The fly and squash are excellent examples of the lapidary artist's ability to convey the vitality of living forms through simple shapes, possibly adapted to the stone's original shape. The carvings of squash are masterpieces in the abstraction of nature: bulging forms between parallel lines suggest the vegetable's shape, and the star design at the end is the flower.

Three greenstone carvings—a box now in Hamburg, a statuette in Stuttgart, and a beaker in Vienna—are so unusually complex in their detail that they must have been made late in the history of Mexica art. The rectangular Hamburg Box has, with its lid, five figures and seven glyphs, carved inside and on all its outer surfaces (Plates 273–77). Its iconography is similar in conception to that of other boxes (see Plates 250–55), with seated figures on the sides and an earth monster on the base. Specially significant for this box, however, is its association with Motecuhzoma II; the iconography recalls that of the Temple Stone (see Plate 125), and both works bear representations of that ruler. But the Temple Stone was a public monument representing the Mexica, and the Hamburg Box was an object privately owned, made perhaps to contain the ruler's sacrificial implements.

This is the most precious and beautiful box linked with Motecuhzoma II (Umberger, 1981, 99–105). While Motecuhzoma was paired with Huitzilopochtli on the Temple Stone, on the Hamburg Box he is paired with the Toltec ruler Quetzalcoatl: Motecuhzoma, with his glyph, is drawing blood from his ear; Quetzalcoatl, identified by the 1 Reed glyph, is a bearded elder dressed in a jaguar skin, holding a spearthrower and a priest's bag. Quetzalcoatl is not drawing blood, for he is dead; the ruler now doing this penance is Motecuhzoma. On the lid is another image referring to Quetzalcoatl, a feathered serpent who is falling and two dates associated with Quetzalcoatl, 1 Reed and 7 Reed.

An emblem inside the lid represents the starry sky at night, a ring with eyes surrounding a skull. Carved on the sides of the box are the glyphs 1 Rabbit and 4 Rabbit, referring to the date of the creation of the earth. On the inner bottom is the date 1 Lizard, the first day of the ritual calendar and the date on which Mexica rulers were crowned. With these glyphs the box becomes a microcosm of the sacred time and space of the world; and on the outer bottom, as the underworld, is one of the most beautifully designed earth monsters in Aztec art. The entire box represents the universe, juxtaposing the past ruler-priest, who was associated with the ritual of penance, with the current Mexica ruler.

The Hamburg Box is the clearest expression of Motecuhzoma's fascination with the Quetzalcoatl myth. There is much controversy on this topic: some suggest that his interest in Quetzalcoatl dates only from the conquest, when native legends were scrutinized for some explanation of the arrival of Cortés (Lafaye, 1976); another pos-

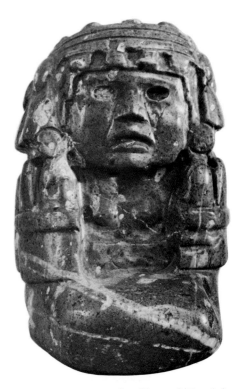

Plate 270. *Figurine of Goddess with Tasseled Headdress, found in Box shown in Plate 250. Greenstone, 8 × 4 cm. Tizapan. 1350–1521. Museo Nacional de Antropología, Mexico City*

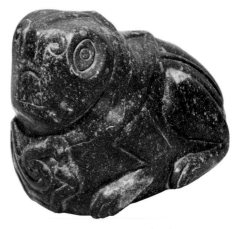

Plate 271. *Fly. Greenstone, height 13.5 cm., length 18 cm. 1350–1521. Museum für Völkerkunde, Vienna*

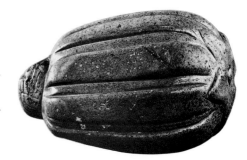

Plate 272. *Squash. Greenstone, 16 × 36 cm. 1350–1521. Museo Nacional de Antropología, Mexico City*

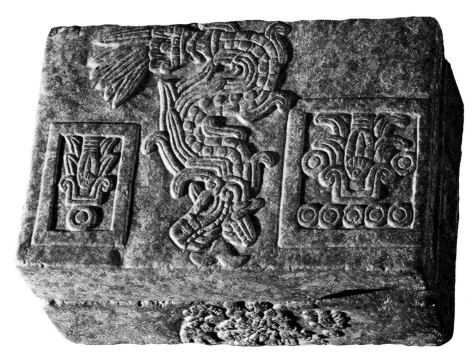

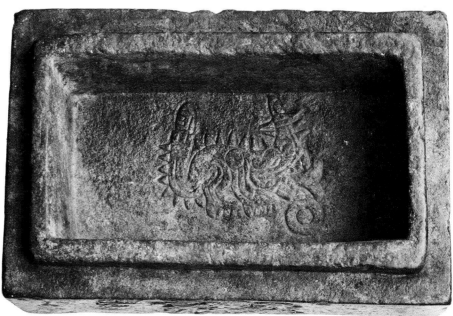

Plate 273. *Carved Stone Box. Greenstone, 15.4 × 33.4 × 21 cm. Probably 1502–20. Hamburgisches Museum für Völkerkunde und Vorgeschichte, Hamburg*

Plate 274. *Inner bottom of Box with Glyph "1 Lizard"*

sibility is that Motecuhzoma's priestly training and interests had already led him deeply into the cult of Quetzalcoatl. The Hamburg Box offers no help in this dilemma, for it could have been carved when Motecuhzoma renewed his penitential activity with the first disturbing news of strangers off the coast—or at any time before. One argument for a 1519 date is the presence of the glyph 1 Reed, the bearded Quetzalcoatl, and the feathered serpent, which do not appear on other monuments associated with Motecuhzoma's name glyph: the sudden coincidence of these important images on so precious a box might indicate his specific concern with Quetzalcoatl sparked by the arrival of Cortés, and his use of the implements in this special container for propitiatory sacrifices.

In addition to iconographic parallels with the Temple Stone, there are stylistic similarities as well. In both works, figures and emblems carved at various scales are

arranged on flat backgrounds with plenty of space around them. This expressive use of space is a Mexica characteristic, quite unlike Mixtec design, in which motifs cover all areas evenly. But the earth monster on the base, unlike the motifs above in their surrounding spaces, is fitted in to fill the bottom rectangle completely. In adapting the design to the shape it is comparable to the Metro Earth Monster that is carved as a rectangular block (Plate 115). These stylistic usages have iconographic meaning in the Hamburg Box—the openness of space around the emblems of the lid suggests the openness of the sky, while the earth monster, stretched to cover the entire base, suggests the closed and all-encompassing darkness of the earth.

The two other unique greenstone vessels are likewise remarkable for their iconographic designs and the fine quality of carving. One, representing a skeletal figure, is in Stuttgart (Colorplate 49; Plates 278, 279); the other, a beaker with a three-dimensional head on the vessel's side, is in Vienna (Colorplate 50; Plates 280–83). These sculptures are similar in bearing a large number of glyphs and symbols, in their imagery of death and destruction, and in the realism of their style. The hands and feet of the Stuttgart figure and the face on the Vienna beaker are among the most

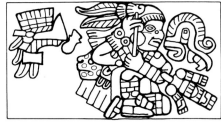

Plate 275. *Drawings of two side reliefs on Box: above,* Motecuhzoma; *below,* Quetzalcoatl *(after Seler, II, 1904, figs. 18–19)*

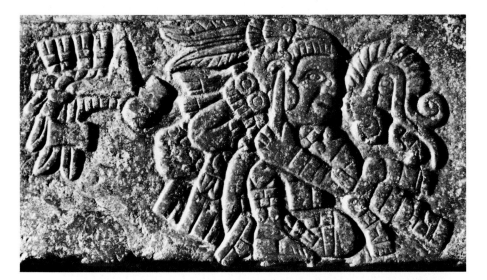

Plate 276. *Side of Box, detail of Motecuhzoma*

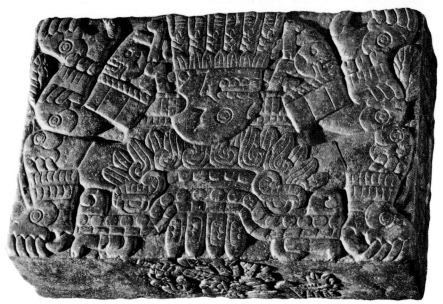

Plate 277. *Relief of Earth Monster under Box*

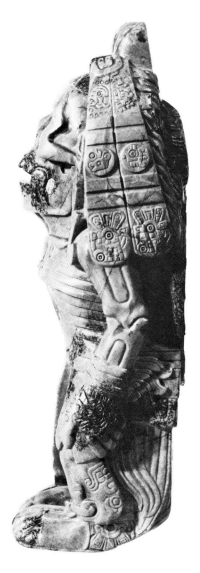

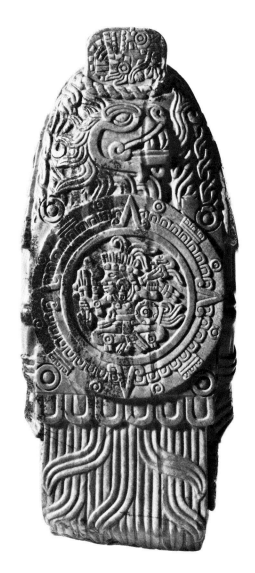

Plate 278. Side of Skeletal Figure (see Colorplate 49)

Plate 279. Back of Skeletal Figure, with Eagle and Sun Disk

naturalistic carvings in Aztec art. These traits indicate the probability of a very late date for the carvings.

The Stuttgart figure belongs in the category of standing deity sculptures, but there is no exact parallel to it. Male skeletal gods are few in Aztec art (see Plates 197, 198), and this figure does not resemble any of them: it stands with its arms hanging at its sides like the atlantean figures at Tula (see Plate 18) and their Aztec copies (see Plates 144–46). His hair is tied in a topknot and two wide ribbons hang down at either side, ornamented with glyphs and symbols. Carved in relief on the back is an eagle in profile, with a sun disk at the center; in the disk sits a youthful warrior holding weapons, presumably the sun deity; on the base of the sculpture is the earth monster. The figure bears twelve glyphs on its hair ribbons, loincloth, hands, and back, but none of them identifies it conclusively: the dates 1 Deer, 1 Rain, 1 Monkey, and 1 House on the ribbons, and 1 Eagle on the loincloth, are all days on which the *cihuateteo*, female monsters, descended at the crossroads (Umberger, 1981, p. 91). Seler identified the figure as Xolotl (1902–23, III, pp. 392–409), the deformed twin of Quetzalcoatl, but this is not a deformed figure. Seler's other interpretation was with Tlahuizcalpantecuhtli, the planet Venus in its manifestation as the evening star, and symbols of the night sky and the planet Venus can be seen on the hair ribbons and the forehead. The earplugs with comma-shaped pendants are Quetzalcoatl's usual insignia in the codices.

The sculpture may represent not a deity but a concept, expressed in part by the

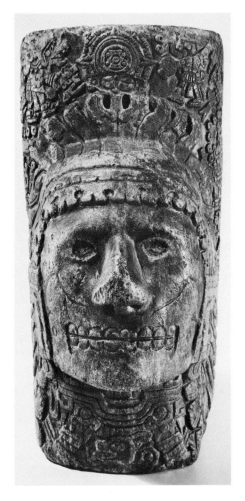

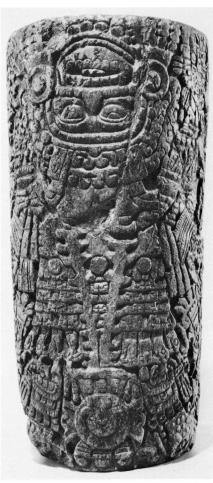

Plate 280. Front of Pulque Beaker
(see Colorplate 50)

Plate 281. Back of Pulque Beaker,
with Earth Monster

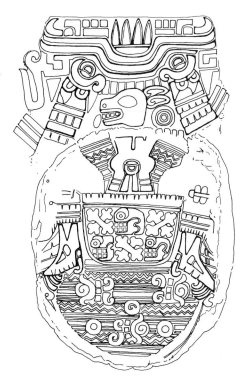

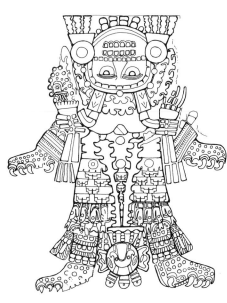

Plate 282. Drawing of Earth Monster under
base of Pulque Beaker (after Seler, II, 1904,
fig. 53)

Plate 283. Drawing of back of Pulque Beaker
(after Seler, II, 1904, fig. 49)

glyphs we cannot interpret. It is remarkable that of the twelve glyphs not one refers to an important date associated with Mexica power, such as 1 Flintknife. Moreover, while Quetzalcoatl is seen as a benevolent legendary ancestral figure on most Aztec monuments, here he is associated with symbols of destruction. The sun disk is on an eagle, which represents the setting sun; it is unclear whether the number 4 refers to the eagle or to the sun disk. But the skeletal figure signifies the underworld and the night sky; the glyphs of the descent of the *cihuateteo* represent impending disaster; the entire composition can be read as the death of the sun at night.

Destructive imagery also prevails on the *Pulque* Beaker (Colorplate 50; Plates 280–83). The head with its skeletal jaw and the hair ending in leaf-shaped forms is a three-dimensional version of the day sign *malinalli*, or grass. This day sign had unfortunate connotations because it signified good fortune ending in disaster (Sahagún, 1950–78, bk. 4, p. 55). The deity wears the square earplugs and on its back the crescent ornament of the *pulque* gods, patrons of warriors dying on the sacrificial stone. Above the face of the vessel is a 4 Movement sign, and below is the earth monster's maw and a sign for 1 Rabbit (Seler, 1902–23, III, pp. 913–75).

The back of the beaker is covered with an unusual representation of a female figure similar to an earth monster, the head hanging back but the hands and feet ending in jaguar paws. A more typical earth monster is carved on the base, its head beneath the three-dimensional face. On the sides of the beaker three small figures with numbers, possibly deities, and war symbols fill the space between the earth goddess and the face.

These two sculptures, each unique, are so well carved and so complex that they must have been made for specific purposes. As innovative concepts they belong among the great stone sculptures of Tenochtitlán, but they differ in having no reference to the conquering mission and divine history of the Mexica. The Temple Stone and the Calendar Stone refer to the exalted cosmic role of the Mexica, celebrated with such pomp by Motecuhzoma II in 1507, but these greenstone images represent double disaster, and in the *Pulque* Beaker this content is emphasized by the presence of two different earth monsters. One disastrous event for which sculptures might have been carved was the flood caused by Ahuitzotl's aqueduct. Umberger suggests that the *Pulque* Beaker was carved for that occasion (1981, pp. 120–21).

Another possibility is that they were made for Motecuhzoma II between 1519 and 1520, in his time of anxiety about the coming of the strangers from the east. Or the works could have been made later, after Motecuhzoma's death. It is interesting to note that Motecuhzoma's successor was called Cuauhtemoc, "falling eagle." He led the resistance against the Spaniards but was captured by Cortés. The destructive aspects of Quetzalcoatl would be appropriate here to the Aztecs' identification of Cortés with Quetzalcoatl.

We know that the Mexica did not suspend ritual activities during the conquest but renewed their efforts to please the gods. León-Portilla has suggested that one poem in Nahuatl was written by a Texcocan lord while he was a captive of Cortés (1978, p. 116). Works of art might well have been commissioned and made in that time of crisis (Pasztory, in press).

Perhaps these objects, the one a figurine and possibly an idol, the other a ritual vessel, were made for propitiatory rituals to avert the approaching disaster. A dark, pessimistic outlook is suggested in part by the sun disk and 4 Movement glyph on the *Pulque* Beaker. The sun disk above the projecting face is partially covered by a sign that Seler interprets as night. Another Movement sign is beneath the base, in the body of the earth monster. The unusual placing of these solar emblems is graphic of the threatening victory of the powers of destruction over the Mexica sun and state.

Colorplate 51. Drum in form of Crouching
Feline. Wood, length 48 cm. Aztec, 1350–
1521. American Museum of Natural History,
New York

OVERLEAF: LEFT, CENTER, AND RIGHT
Colorplate 52. Gilded Spearthrowers.
Wood, gold leaf, shell, and cord, 57 × 3.8 cm.
Mixtec-Aztec, 1350–1521. Museo Nazionale
Preistorico ed Etnografico Luigi Pigorini, Rome

Colorplate 53. Gilded Spearthrower, detail.
Wood, gold leaf, and cord, length 42 cm.
Mixtec-Aztec, 1350–1521. British Museum,
London (see Plate 293)

Colorplate 54. Seated Animal with Receptacle
on Back. Wood covered with turquoise and some
pink shell, malachite, and iron pyrite, height
18 cm. Mixtec-Aztec, 1350–1521. British
Museum, London

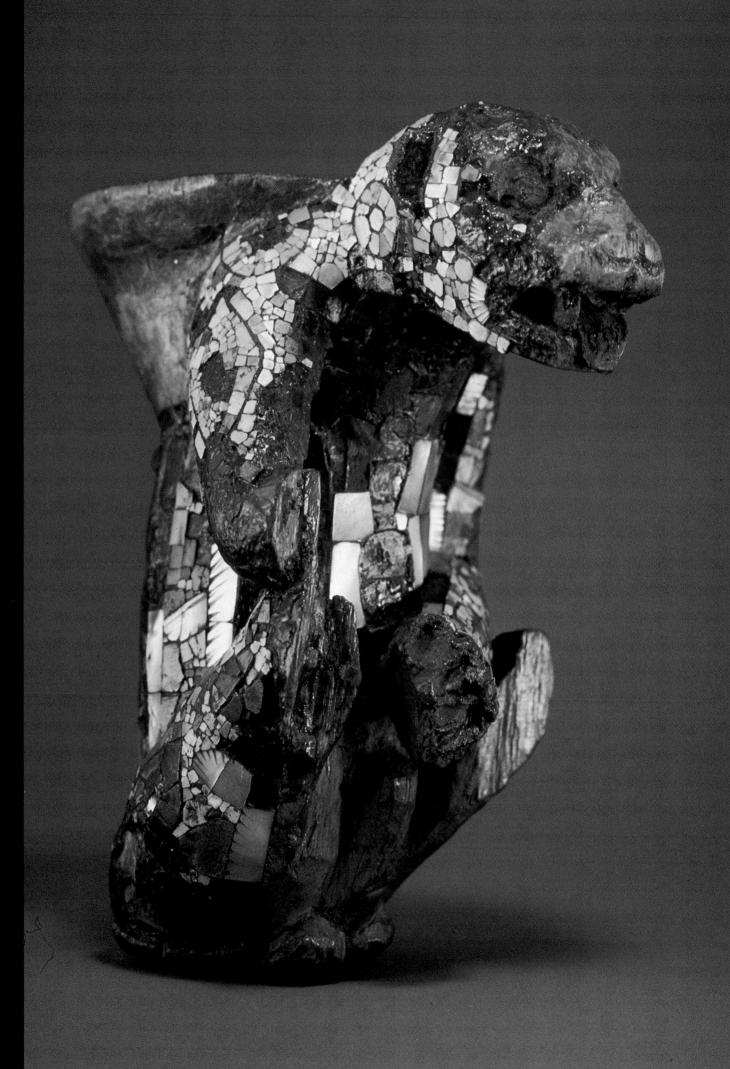

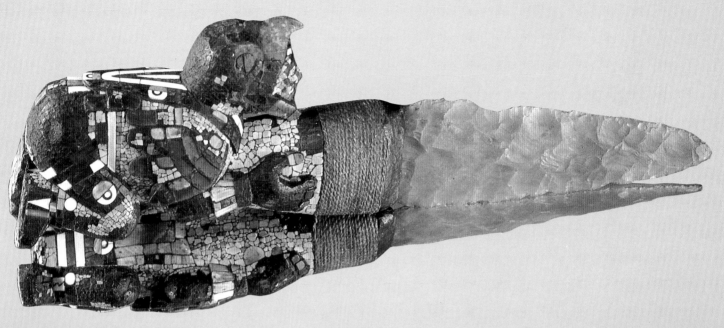

Colorplate 55. Sacrificial Knife. Flint with turquoise mosaic handle, length 30.5 cm. Mixtec-Aztec, 1350–1521. British Museum, London (photographed on mirror)

OPPOSITE

Colorplate 57. Helmet. Wood covered with mosaic of turquoise, malachite, mother-of-pearl, and pink shell, width 20.5 cm. Mixtec-Aztec, 1350–1521. British Museum, London

Colorplate 58. Mosaic Serpent Pectoral. Hollowed wood faced with turquoise mosaic, length 43 cm. Mixtec-Aztec, 1350–1521. British Museum, London

Colorplate 56. Mosaic Handle of Sacrificial Knife. Wood with turquoise, malachite, shell, and-mother-of-pearl, 9 × 13 cm. Mixtec-Aztec, 1350–1521. Museo Nazionale Preistorico ed Etnografico Luigi Pigorini, Rome

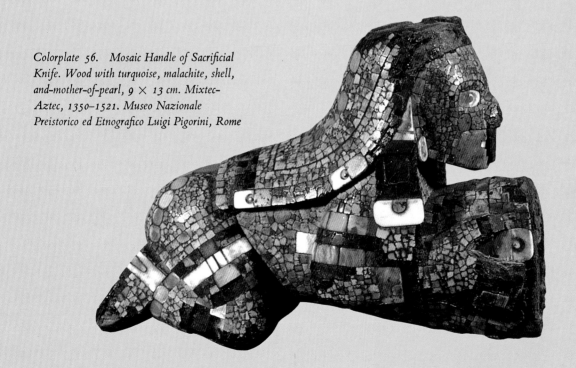

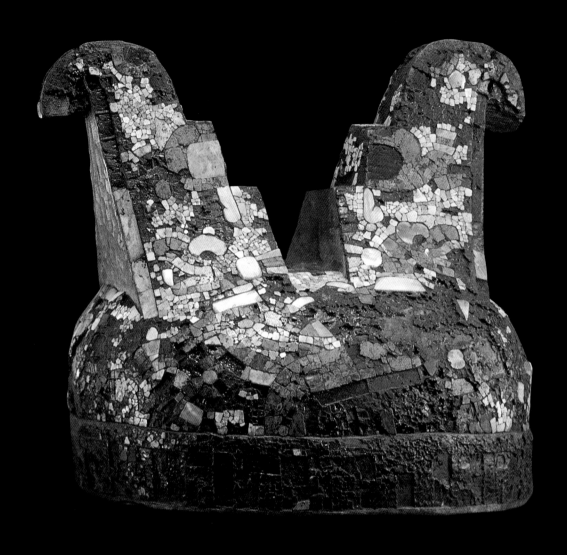

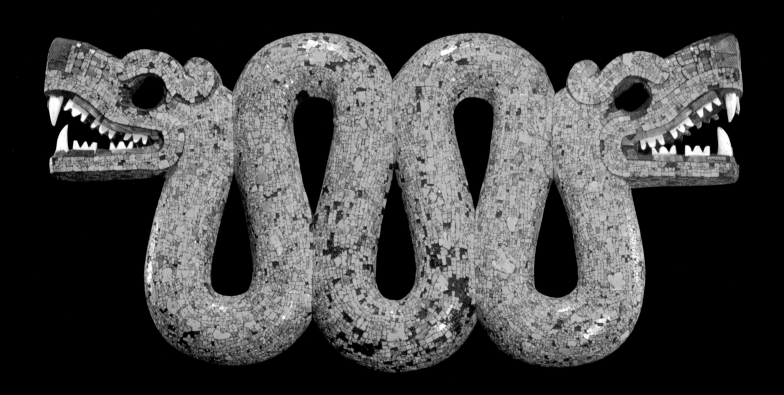

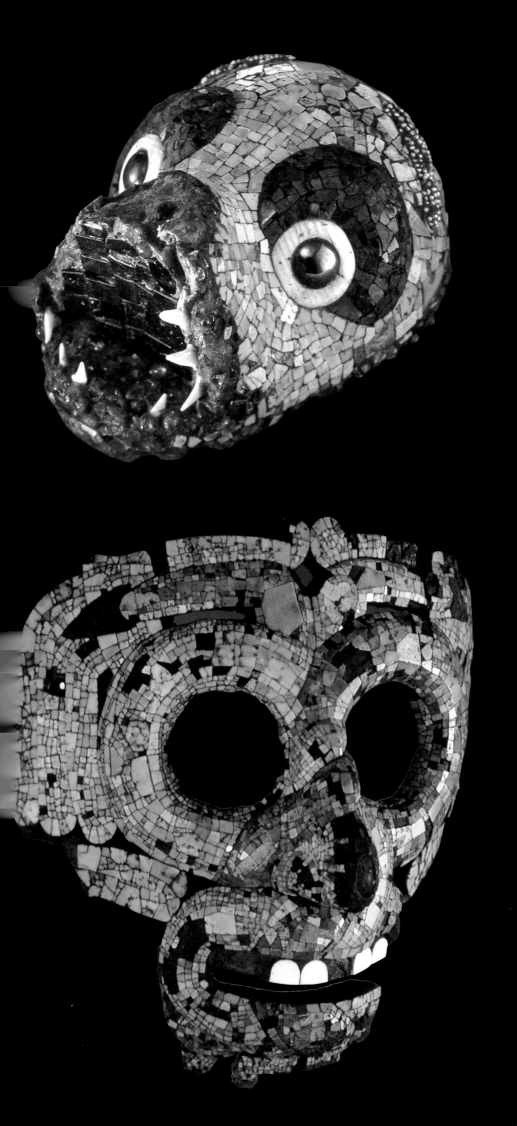

Colorplate 59. Mosaic Pendant of Animal Head. Wood with turquoise mosaic and precious stones, length 10 cm. Mixtec-Aztec, 16th century. British Museum, London

Colorplate 60. Mosaic Mask. Cedar wood faced with intertwining serpents in turquoise mosaic with shell teeth, height 18 cm. Mixtec-Aztec, 1350–1521. British Museum, London

OPPOSITE
Colorplate 61. Mosaic Mask with Inlaid Teeth and Eyes. Cedar wood faced with turquoise mosaic, eyes and teeth inlaid with white shell, 17 × 15 cm. Mixtec-Aztec, 1350–1521. British Museum, London

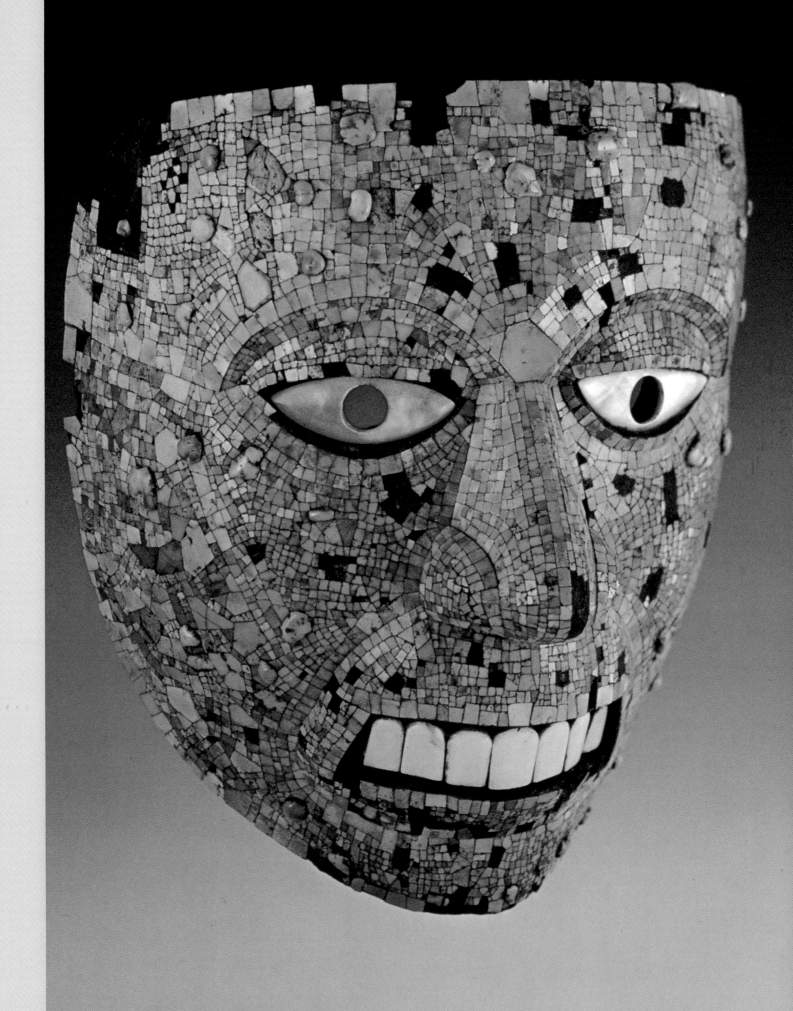

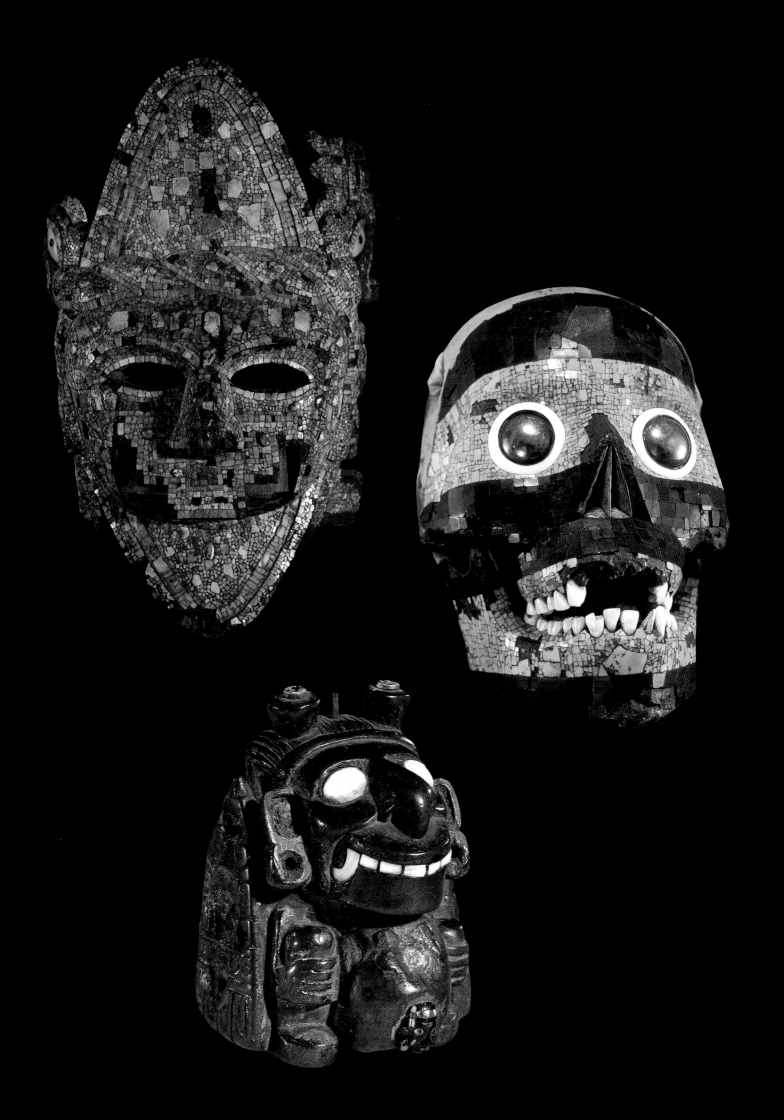

VIII
WOOD SCULPTURE
AND TURQUOISE MOSAIC

Wood Sculpture

Woodcarving was one of the major artistic techniques of the Aztecs. Buildings, furniture, canoes, idols, tools, weapons, bowls, and even codex covers were made of wood. The material was used for everyday purposes by the whole population and, encrusted with turquoise mosaic, feathers, and gold foil, served in the sumptuary and ritual art of the aristocracy. Sixteenth-century texts describe ornately carved ceiling beams, canoes with carved prows, and gilded screens. Bernal Díaz describes how Motecuhzoma II had his meals:

> If it was cold, they built a large fire of live coals made by burning the bark of a tree which gave off no smoke. . . . In order that he should get no more heat than he wanted, they placed a sort of screen in front of it adorned with the figures of idols worked in gold. He would sit on a soft low stool, which was richly worked. His table, which was also low and decorated in the same way, was covered with white tablecloths and rather long napkins of the same material. . . . When he began his meal they placed in front of him a sort of wooden screen, richly decorated with gold, so that no one should see him eat.
>
> (DÍAZ DEL CASTILLO, 1963, P. 226)

Codex illustrations give an idea of the form of thrones (see Colorplates 29, 31, 36, 38), but screens, tables, and wardrobes were never illustrated.

Wood was not merely a cheap substitute for stone. Many of the idols in the major temples are described as made of wood and dressed in rich clothes and jewelry. But the symbolic significance that wood had for the Aztecs is not clear. Many Aztec texts refer to the superiority of stone images to wooden ones because they were more durable; Aztec rulers deplored the loss of monuments that their ancestors had carved out of wood. But its lightness, flexibility, and resonance made wood a natural choice for objects such as drums, spearthrowers, shields, and masks. Perishability, too, was sometimes a ritual requirement: certain idols made of a dough of amaranth seeds were used for a particular ceremony and eaten afterward. Wood, as a material, was intermediate in permanence between stone and dough.

Because wooden objects were made for a variety of social strata and functions, their style and compositions range from schematic to elaborate. Carvings intended to be covered with turquoise mosaic often have a relatively simple shape, although a few are in openwork (see Colorplate 60). The technique of turquoise mosaic is attributed to the Mixtec craftsmen who came to work in the Aztec cities; Aztec works are hard to distinguish from Mixtec. Some prehispanic drums were still being used in native rituals in the nineteenth century. Wooden objects in the native style, such as drums, continued to be made throughout the colonial period and were kept as prized possessions in native villages.

About one hundred pieces now survive, out of the thousands of decorated objects that once existed. What the Spaniards did not burn was destroyed by neglect

ABOVE, LEFT

Colorplate 62. Mosaic Mask with Nosebar. Wood faced with turquoise, jadeite, shell, and mother-of-pearl, height 24 cm. Mixtec-Aztec, 1350–1521. Museo Nazionale Preistorico ed Etnografico Luigi Pigorini, Rome

Colorplate 63. Human Skull with Mosaic Inlay. Bone with hinged jaw, mosaic inlay of turquoise and lignite, eyes of iron pyrite, 20.5 × 14.5 cm. Mixtec-Aztec, 1350–1521. British Museum, London

Colorplate 64. Figurine of Deity (Xolotl?) with Two Horns, and Small Head Projecting from Abdomen. Wood inlaid with shell, turquoise mosaic, carved jet, and silver nails, height 9 cm. Mixtec-Aztec, possibly Colonial(?). Museum für Völkerkunde, Vienna

and natural decay. Some objects sent back to Europe by Cortés and others were kept as curiosities in royal collections, but no one had serious interest in preserving these objects and most of the pieces listed in old inventories of royal collections have now vanished. As late as the 1820s, the mosaic masks were thought to be "Turkish" and turquoise chips were removed to repair European mosaics (Carmichael, 1970). It is assumed that most of the wooden pieces in European museums today were part of Cortés's original shipments. Other pieces have come to light in Mexico from caves and shelters where they were hidden and fortuitously preserved.

The chronicles indicate clearly that a large majority of deity sculptures was made of wood. At present, fewer than ten Aztec wooden sculptures are known. The seated male figure now in Vienna is said to have been found in a cave at Puebla (Plate 284). It can be identified as the Deity with Crested Headdress since it resembles stone sculptures of that deity so closely in iconography (see Plates 196–98). Evidently some stone and wood idols were similar even though they were probably made by different guilds. We do not know whether the material was selected for ritual reasons or because of cost.

An unusual pair of male and female statues was discovered below ground near Texcoco (Plates 285, 286), preserved in the salt deposit of the ancient lake (Nicholson and Berger, 1968). The figures are noteworthy for their formal simplicity, not unlike African woodcarvings. Since wooden sculptures so often have schematic form, it is assumed that they were once dressed and painted. Traces of blue paint and designs suggest an identification of the female statue as the water goddess, who usually wears a tasseled headdress (see Plates 158–59, 183–84). The round depression in the goddess's torso may have contained a mirror or inlaid shield similar to those in Plates 291 and 294; the Coxcatlan figure of the Serpent Woman goddess in the National Museum, Mexico City, has a small pyrite mirror inlaid in her chest. The surviving details of the male statue do not permit his identity to be determined conclusively. Deity pairs are unusual in stone sculpture but not unknown: the deity with the year sign on its back (see Plates 166–69) was found with the Serpent Woman at Coxcatlan.

A special kind of wood, red with black veins, was used for making wooden drums (Saville, 1925, p. 8). The horizontal drum, *teponaztli*, was a hollowed log with a hole in the bottom and an H-shaped opening at the top; it was played with drumsticks with rubber tips. The *huehuetl* was the common vertical drum with an animal skin stretched over the top. These drums were used for entertainment, ritual, and war. In the Codex Ixtlilxochitl the ruler Nezahualcoyotl, dressed in battle regalia, carries a vertical drum on his back (see Colorplate 13). To the sound of drums during battle, old men recited the heroic deeds of the past. Drums resembling the *teponaztli* are still used in villages in Mexico, although the preconquest and colonial drums are presumably now in museums. About twenty of these drums survive, and the carving on them is quite varied. Some have a simple glyph, mask, flower, or animal design in the center. Decorative possibilities can be emphatic, as in the rendering of the feathers surrounding the face of an owl on a drum in the British Museum (Plate 287). Other drums were carved in the form of human or animal effigies (Colorplate 51; Plate 288); the example in Mexico City's Museum of Anthropology was found in Tlaxcala in the nineteenth century (Castañeda, 1933a, 1933b).

One of the most elaborate vertical drums was still being played in a village near Malinalco in the nineteenth century (Plates 289, 290). It is in the style of the major sculpture of Tenochtitlán, and was probably used in the temples of Malinalco. The carving is in low relief in several layers, delicately detailed. A band of intertwined war symbols and shields separates the design into upper and lower parts. The iconography

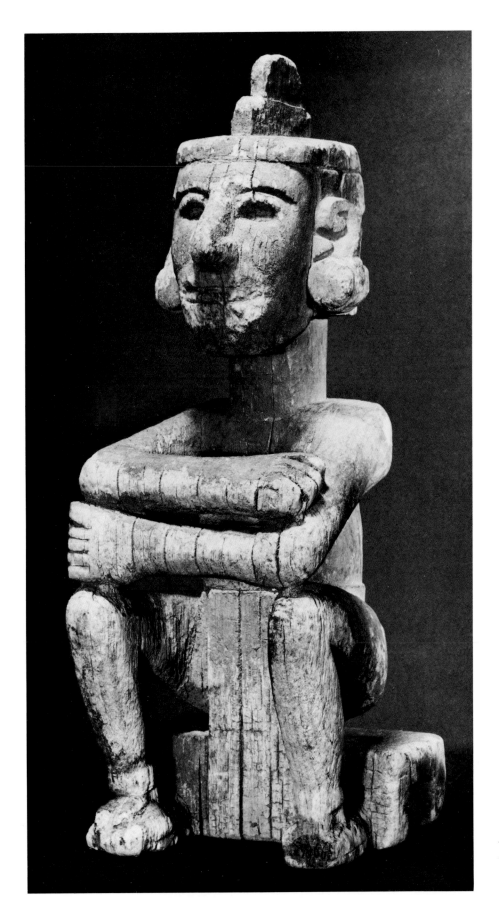

Plate 284. Seated Deity with Crested Headdress. Wood, 44 × 18 cm. Puebla. Aztec, 1350–1521. Museum für Völkerkunde, Vienna

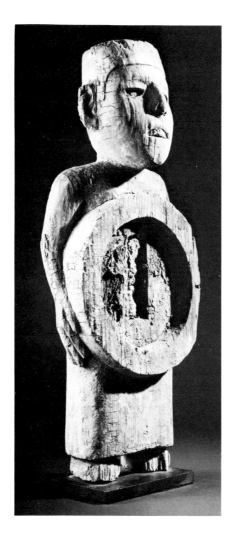
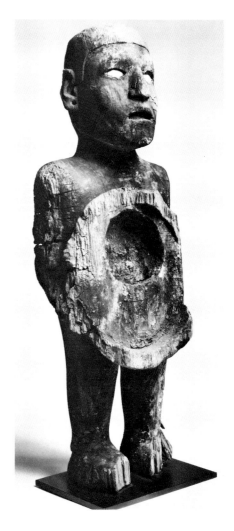

Plate 285. *Standing Female Figure. Wood with traces of adhesive for inlay in shield, 52.5 × 22.5 × 11.8 cm. Aztec, 14th century. Saint Louis Art Museum (Gift of Morton D. May)*

Plate 286. *Standing Male Figure. Wood with shell eyes, height 54.5 cm. Aztec, 14th century. Walter Randel Collection, New York*

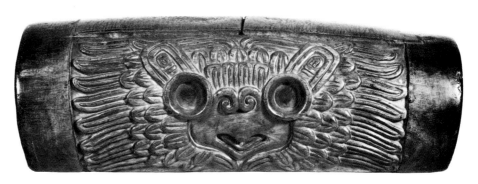

Plate 287. *Drum with Owl Face. Wood, length 49 cm., diameter 17 cm. Aztec, 1350– 1521. British Museum, London*

Plate 288. *Drum in form of Human Effigy. Wood, length 60 cm. Tlaxcala. Aztec, 1350– 1521. Museo Nacional de Antropología Mexico City*

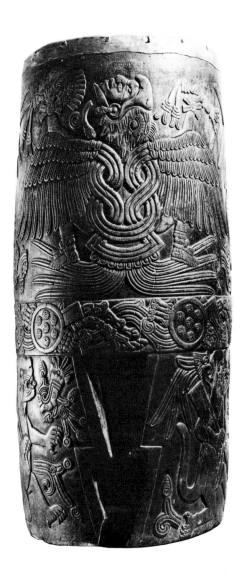

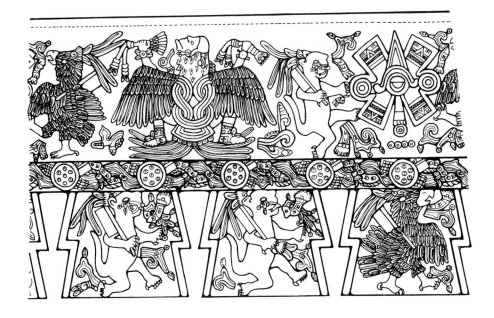

Plate 289. *Vertical Drum: above, Warriors Flanking Sun Deity in Eagle Dress; below, Jaguar and Eagle Warriors. Wood, height 96 cm. Malinalco. Aztec, 1350–1521. Museo del Estado de Mexico, Tenango*

Plate 290. *Rollout Drawing of Vertical Drum (after Marquina, 1964, fig. 15)*

Plate 291. *Obsidian Mirror in Gilded Wood Frame. Obsidian and wood with gilt, diameter 26 cm. Aztec, 1350–1521. American Museum of Natural History, New York*

of the glyph 4 Movement and the anthropomorphic eagle–jaguar figures is related to that of the rock-cut temple of Malinalco and to Mexica warrior imagery. These anthropomorphic eagles and jaguars carry the paper banners of sacrificial victims, and they represent warriors destined to die as captives. Tears fall from their eyes and war symbols emerge from their mouths. Similar eagles and jaguars in the Codex Aubin and the Codex Borbonicus are associated with the *pulque* gods, meaning that those born under the sign of the *pulque* gods will be strong warriors and will die a sacrificial death. The Malinalco drum represents the warrior cult ideology of the Mexica and it is related in conception to the major stone sculptures of Tenochtitlán.

The most elaborate ceremonial objects of wood, in addition to being carved, were also painted, gilded, and encrusted with turquoise and shell mosaic and feathers. A few objects decorated only with gilding are known—an obsidian mirror in a wood frame (Plate 291), a mask (Plate 292), and several spearthrowers (Colorplates 52, 53;

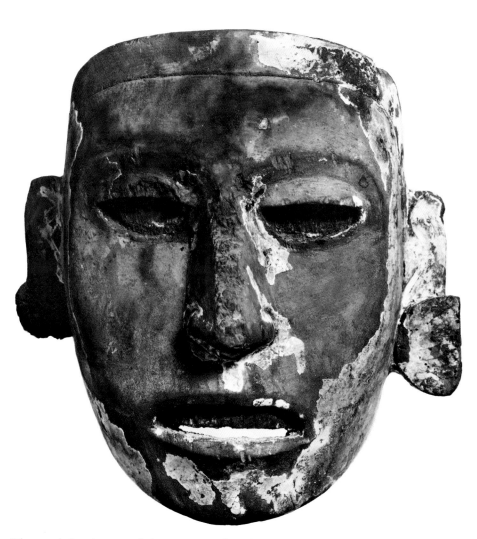

Plate 292. *Gilded Wooden Mask. Wood, 20.5 × 20 cm. 1350–1521. Art Museum, Princeton University, Princeton (Gift of Mrs. Gerard B. Lambert)*

Plate 293), but in general the Aztecs preferred the richness and complexity of several precious materials used together. Unfortunately, many of these objects were later dismantled: the gold was removed and melted, the little jade masks and the mosaic tesserae reused in European objets d'art, and the feathers thrown away as useless.

Turquoise Mosaic

Turquoise mosaic, a characteristically Mesoamerican technique, goes back to Preclassic times. It was especially developed among the Mixtecs; the turquoise mosaic pieces collected from the Aztecs may all have been either tribute from the Oaxaca region or made by Mixtec craftsmen living in the Valley of Mexico. Sahagún does not include turquoise mosaic in his long description of crafts, and possibly it was not practiced in Tenochtitlán-Tlatelolco. The Matrícula de Tributos indicates that finished masks and turquoise chips were collected as tribute from southern towns. To the nomadic Mexica, the painstaking craft of turquoise mosaic stood for the civilized achievements of the Mixtecs and other descendants of the Toltecs whom the Mexica had conquered and joined. Huitzilopochtli, who was the sun in the blue sky and their patron god, had on his idol a turquoise mosaic headdress, shield, and serpent staff.

Turquoise mosaic is a general term used to describe mosaics of many colorful and shiny materials as well—red, pink, and white shell, jadeite, malachite, beryl, lignite, iron pyrite, and seed pearls (Saville, 1922). Turquoise usually predominates, the other materials being used to form eyes and teeth or to pick out salient elements of the design in contrasting colors. The mosaic chips vary in size but are usually quite tiny. They are arranged so as to outline the features or to alternate larger with smaller pieces. It is estimated that the shield in the Museum of the American Indian (Plate 294) consists of 14,000 pieces of turquoise (Saville, 1922, p. 72). On some examples evenly spaced cabochon pieces intersperse the flat, irregular mosaic (Colorplate 60). The backing is usually of wood, but mosaic was also based on stone, gold, shell, bone, and pottery. A vegetable pitch glued the pieces firmly in place; when new, the fit of the mosaic was so precise that a fingernail could not be inserted between two pieces. The polished objects shone in the sun like large, faceted jewels.

To the Aztecs, turquoise was among the most precious stones which they imported from the far south and north. Its color symbolized the blue of water and the gods Tlaloc and Chalchiuhtlicue; it also stood for the blue of the daytime sky, and was related to sun gods such as Tonatiuh and Huitzilopochtli. Turquoise, like jade, symbolized the preciousness of life, and turquoise mosaic was used to make ritual objects—staffs, masks, pectorals, and headdresses—for statues of the gods. Some large idols were entirely encrusted with precious materials. It was used for containers (Colorplate 54) and for sacrificial knives (Colorplates 55, 56). Mosaic also covered the ceremonial shields, weapons, helmets, and standards that the aristocracy and elite warriors carried (Colorplate 57), and their pectoral ornaments, from the large, seventeen-inch folded double-headed serpent (Colorplate 58) to the small, four-inch animal head (Colorplate 59).

The animal head may be a monkey or even a fish, and is remarkable for its rare, precious materials. The face is turquoise, the eyes are iron pyrite rimmed with shell, and the green areas above are malachite; the teeth are those of a fish, possibly shark, and they ring a large mouth cavity lined with garnet pieces and bits of gold foil; the eyebrows are of seed pearls. There is gum on the flat back of the pendant that may once have held a mirror (Carmichael, 1970, pp. 28–29, 35–36). Because some of these materials are unique to this piece, its date may be early colonial, like the unusual Xolotl in Vienna (Colorplate 64), but too few mosaic pieces are known for us to determine those definitely made before the conquest.

The costumes of the gods that Motecuhzoma gave to Cortés were luxurious works of ritual art. This is how Sahagún described them:

Plate 293. *Drawing of Spearthrower in Colorplate 53 (after Saville, 1925, pl. XIII)*

To the . . . [messengers] Montezuma spoke, and said, "Look, it has been said that our Lord Quetzalcoatl has arrived; go and receive him and listen to what he may say to you with great attention; see to it that you do not forget anything of what he may say; see here these jewels which you are to present to him in my behalf, and which are all priestly ornaments that belong to him." First a mask wrought in mosaic of turquoise; this mask had wrought in the same stones a doubled and twisted snake, the fold of which was the beak of the nose; then the tail was parted from the head, and the head with part of the body came over one eye so that it formed an eyebrow, and the tail with part of the body went over the other eye, to form the other eyebrow. This mask was inserted on a high and big crown full of rich feathers, long and very beautiful, so that on placing the crown on the head, the mask was placed over the face: it had for a [central] jewel a medallion of gold, round and wide; it was tied with nine strings of precious stones, which, placed around the neck, covered the shoulders and the whole breast. . . ."

<div align="right">

(SAHAGÚN, 1956, IV, PP. 27–28; TRANS. IN SAVILLE, 1922, PP. 13–14)

</div>

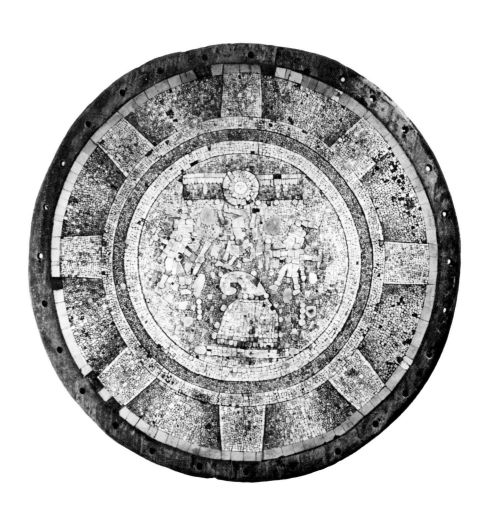

Plate 294. Circular Shield with Mosaic Inlay. Wood inlaid with turquoise mosaic, diameter 32 cm. Puebla. Mixtec, 1350–1521. Museum of the American Indian, Heye Foundation, New York

It is difficult to identify the surviving mosaic-covered sculpture with the objects described in the sixteenth-century texts and the inventory lists. Some of the objects were known to be in collections as early as the sixteenth century, others came to light in the nineteenth century. In the British Museum there is a mask resembling that described in Sahagún's text (Colorplate 60). The iconography of serpents intertwined above the circular eye-holes is similar to some representations of the rain god Tlaloc

(see Plate 188), but Sahagún specifies Quetzalcoatl. Ambiguity of this sort between texts and images makes iconographic identification difficult in Aztec art.

The identity of the other masks has proved impossible to determine. Two of the best-preserved masks, in the British Museum and in Rome (Colorplates 61, 62), illustrate the exquisite refinement of Aztec sumptuary art. Another unusual mask in the British Museum is made of turquoise and black lignite mosaic over the front half of a human skull (Colorplate 63). Iron pyrite in the eyes, red shell in the nose, and white teeth give it an almost surrealistic appearance. Since the nineteenth century this skull has symbolized for most Westerners the civilized yet barbaric art of the Aztecs.

These masks may have had multiple functions, some possibly placed on idols or worn by god-impersonators. Masks were placed on the bundles containing deceased rulers who were dressed in the regalia of the gods for the funeral in which they were finally cremated. One account tells us that when the ruler was ill, masks were placed on the idols of the gods in the temples (Saville, 1922, p. 19).

The relatively simple iconography of Aztec sumptuary art is from preference, and because the faceted mosaic ornamentation does not allow for much detail. Mixtec iconography is usually more complex, similar to historical manuscript painting. Carved on wooden drums, spearthrowers, and mosaic shields, it consists of narrative scenes with small human figures, as on the gilded spearthrower in Rome (Colorplate 52) and the shield in the Museum of the American Indian (Plates 294, 295). The design on the shield represents a horizontal sky band with a sun disk in the center; below that is a curved hill motif, the glyph for the legendary homeland called Culhuacan in historical manuscripts such as the Codex Boturini (see Plate 148). Two warrior figures flank the hill glyph, and a third figure is falling from the sun toward the hill. This shield may illustrate a myth of dynastic origins, but probably not a Mexica myth because the shield was found in a cave in the Puebla area. A similar shield in Vienna has a scene with twenty-four figures. The gilded spearthrowers and mosaic shields were ceremonial regalia, not functional weapons. The conquerors noted that soldiers went into battle with more practical, less ornate weapons.

Plate 295. *Drawing of center of Shield*

While the Aztecs had a taste for the colossal in stone sculptures and cliff reliefs, they were also interested in the precious and miniature. A miniature wooden sculpture in Vienna, a Deity with Two Horns, is under four inches high (Colorplate 64). Like all Aztec wood sculpture, the figure is dramatic in its simplicity and distorted proportions, but in iconography it is altogether unusual: the mouth with fangs, the big belly, the little mask emerging from the abdomen, and the inlaid genitals and anus on the base have no ready parallel in other Aztec art. Nowotny (1960, p. 68) argues that the figure may have been a pectoral ornament representing the god Xolotl, the dog-headed aspect of Quetzalcoatl. The silver nails placed in the horns may indicate that this is another object created at the time of the conquest.

Cortés reported that Motecuhzoma had representations made of gold, precious stones, and feathers of every object in his kingdom (Cortés, 1971, pp. 100, 107–8). Similarly, Nezahualcoyotl had representations of all the creatures he could not keep alive in his zoos and botanical gardens (Carmichael, 1970, p. 28). As a custodian of the universe, ruling by divine mandate, the Aztec *tlatoani* lived as in a microcosm, surrounded by all the inhabitants of the cosmos. This belief had legendary precedent in the Toltec past: the Aztecs thought that the Toltecs had separate rooms in their palaces for all the precious materials they knew.

IX

FEATHERWORK

In the European imagination feathers have always been associated with the American Indian, from the plains of the United States to the Amazon region of South America. As a perishable material having no intrinsic value, feathers have symbolized barbaric and exotic splendor. For the Aztecs, featherwork was as precious as gold, silver, jade, and turquoise. The feathers had to be imported from southern Mexico and Guatemala, and featherwork, like turquoise mosaic, was an intricate and time-consuming art, one of the ancient crafts of the settled populations in the Valley of Mexico and hence symbolic of civilization. The costliest garments and costumes of the aristocracy and the military were made of featherwork—even the coyote and jaguar costumes illustrated in the Matrícula de Tributos (see Colorplates 41–44) and the Codex Mendoza (see Colorplate 14) were made of feathers, not of animal pelts. Costumes of animal pelts were worn by common soldiers (Durán, 1971, p. 200). The Aztecs associated animal pelts with their own nomadic origins; feather mosaic, by contrast, was the dress of civilized men (Broda, 1970, p. 142).

While the Spanish conquerors did not consider featherworks to be treasure worth preserving, they did send shiploads of it to Spain as curiosities. The various churches, monasteries, and individuals who received these gifts made no effort to protect them from the natural process of decay, and out of the hundreds of costumes, mantles, standards, and shields sent to Europe fewer than ten pieces survive today (Saville, 1920, pp. 58–100). The craft of feather mosaic was encouraged during the colonial period and several bishop's mitres and Christian "paintings" were made in Renaissance style, tours-de-force of the featherworker's art. Feather mosaic remained an exotic, colonial craft, however, and by the nineteenth century it had degenerated into manufacturing souvenirs for tourists (Anders, 1971).

Colorful tropical birds such as the scarlet macaw, various species of parrot, the troupial, red spoonbill, blue cotinga, and quetzal provided most of the feathers used in mosaic. The most common colors were red and yellow, the most precious were blue and green. Green quetzal feathers were among the rarest and most sought after, and the Nahuatl word *quetzal* could also mean "precious." The two long green tailfeathers of male quetzal birds were collected for great headdresses and standards (the quetzal, whose habitat is the highlands of Guatemala, is now almost extinct). Next to the quetzal, most prized were feathers of the hummingbird; generally greenish in color, hummingbird feathers become iridescent when lighted from certain angles. In making shields and insignia, the feathers were glued to maguey leaves, which acted as thin paper over bamboo frameworks. For clothing, the feathers were sewn on to make designs by overlapping the colors (Anders, 1971). To enrich an especially elaborate object the feathers were ornamented with gold.

Tlatelolco, Texcoco, and Huaxtepec were among the major centers of featherworking in the Valley of Mexico. The featherworkers, called the *amanteca*, also had several guilds in Tenochtitlán: one group lived in the royal palace and made personal objects for the ruler and for his gifts; another guild made ceremonial costumes and insignia. Guilds in the city made objects to sell in the marketplace, but these works were of the less precious feathers. A great quantity of featherwork was exacted as tribute from captured populations. As the Matrícula de Tributos indicates, out of more than thirty provinces only eight did not send feathers or featherworks, and of these four were located in far corners of the empire (Broda, 1970, p. 129).

The status of the Aztec aristocracy and warriors could be seen in the costumes they were entitled to wear. A warrior was rewarded by a specific costume for the number of captives he took, as illustrated in the Codex Mendoza (see Colorplate 14). A military costume consisted of either a feathered fitted garment resembling a jumpsuit or a tunic and kilt, plus a headdress or a standard worn on the back, and a shield. In addition to these items, the individual could claim certain necklaces, lip plugs, and mantles woven in specific designs. Sahagún lists about twenty named outfits that could be worn by the ruler and upper nobility and another twenty worn by the lesser nobility (Seler, 1902–23, II, pp. 509–619). Some outfits and standards were associated with gods or with foreign ethnic groups, other costumes were purely ornamental. One unusual standard represented a child eating a tortilla! The costumes often came in five colors associated with the four cardinal directions and the fifth, the center. Warrior costumes for the rulers of Tenochtitlán and Texcoco represented Xipe Totec, the flayed god, and the back standard worn with this was a blue or gilded drum, as illustrated in the portrait of Nezahualcoyotl (see Colorplate 13).

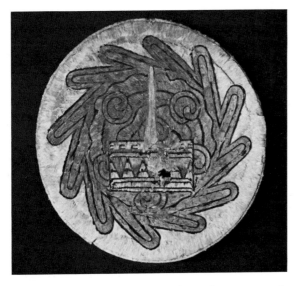

Plate 296. *Circular Shield with Blue Face of God with Goggle Eyes and Fangs. Feathers and gold, diameter 24 cm. Mexico City. 1350–1521. Museo Nacional de Antropología, Mexico City*

These costumes and standards were heavy and cumbersome, and restricted bodily movement. They indicate how far Aztec methods of warfare were directed toward pomp and display rather than military efficiency. In many rituals the deities, priests, and sacrifices were dressed in inexpensive paper ornaments, whereas the aristocratic battle display was the most sumptuous imaginable. Alas, rulers and leaders, being especially conspicuous, made easy targets for the Spaniards.

Of the eight surviving pieces of featherwork, five are shields. The shield representing the blue face of the rain god was probably used in ritual (Plate 296), since it is unlike most of the military shields. The face of the rain god appears to emerge from a pool of water and circular ripples represent the eyes. The two shields in Stuttgart are examples of common military insignia of high status (Colorplates 65, 66). The designs of these shields as represented in the Matrícula de Tributos usually consisted of simple geometric or figurative forms (see Colorplates 41–44): the green-and-yellow shield with the stepped fret is one of the most common, called *quetzalxicalcoliuhqui chimalli*. It could be used with a number of different costumes.

The magnificent shield now in Vienna's Museum für Völkerkunde (Colorplate 67) was found in the eighteenth century, together with a fan and quetzal headdress, in a storage chest at Ambras Castle in the Tyrol. It is unusual for its figurative design—

an animal with the sign for warfare in front of its mouth (Anders, 1978). The animal is made of blue cotinga feathers over a red-feather background; eyes, teeth, and claws are made from thin gold sheets, and gold outlines the feather pattern and fire–water band, a war symbol. The animal has generally been identified as a coyote, but the suggestion has been made that here again is the water monster *ahuitzotl* (Nuttall, 1892; Anders, 1978), and the design resembles the Ahuitzotl Relief found at Tepoztlan (see Plate 79). The monster probably appears on this unusually beautiful shield because that was also the name of the ruler Ahuitzotl, and perhaps it was his personal possession. This shield may have been part of the treasure of Motecuhzoma's predecessors and stored in the Palace of Axayacatl, where it was found by Cortés and his men. No Mexica ruler could use the finery of his predecessors but had to acquire his own. All gold and feather treasures were kept sealed in the old palace.

The other surviving featherwork pieces are a fan, a mantle, and a headdress. The fan, also found at Ambras Castle, is a delicate bamboo construction with a central design of a butterfly and on the other side a flower (Colorplate, page 4); the iconography is similar to that of the stone sculpture having a bee on one side and a squash blossom on the other (see Plate 233). A V-shaped design in a rainbow of colors rings the central motif and the fan is bordered with blue cotinga feathers. The mantle, formerly in Brussels and now in the National Museum of History at Chapultepec Castle, in Mexico City, is very poorly preserved. The ornament is of red feathers on a net backing, with a border of red, black, and blue feathers (Calberg, 1939).

The great quetzal headdress (Colorplate 68) was found at Ambras Castle with the *ahuitzotl* shield and the fan. It is the most dramatic object in feathers that we have. The headdress is almost forty-six inches high, made primarily of green quetzal and blue cotinga feathers with gold disks. Originally the piece also had 500 quetzal tail-feathers, taken from at least 250 birds; several quetzal feathers were removed and worn by the Archduke of Bavaria and his horse, as seen in a sixteenth-century miniature (Anders, 1971, p. 23). By 1566, when the headdress was listed in an inventory of the castle, its Pre-Columbian origin had been lost and it was called a "moorish hat."

Although this headdress is now popularly called "Montezuma's crown," its use and ownership cannot be so precisely determined. The crown of the Aztec ruler as illustrated in the Codex Mendoza was a turquoise diadem, not a feather headdress (see Plate 26). Rather than crowns, such feather objects were standards attached to a bamboo framework and worn as military insignia on the warrior's back (see Colorplate 14). Since the nineteenth century this ornament has been described as a standard, but recent research has shown that it was in fact a headdress (Anders, 1971, pp. 55–57; Nowotny, 1960). Other evidence indicates that such headdresses existed and were part of royal or ritual regalia; on the Stone of Tizoc the ruler shown in battle dress wears a hummingbird helmet with a great quetzal-feather crown (see Plate 91). Durán illustrates the priest-king Quetzalcoatl wearing a feather headdress very similar to the Vienna "crown" (see Plate 3).

We do not know under what circumstances this headdress was collected by the Spaniards. It cannot be clearly identified with the items described in the costumes of the gods given to Cortés, nor with the items in the existing inventories. Therefore the origin and function of this unusual headdress remain a mystery. Because the shape of the headdress is close to the European idea of a native chief's crown, it has become symbolically associated with the last king of the Aztecs. Mexico City's National Museum of Anthropology has a reproduction of this headdress on exhibit and many Mexicans would like to see their relic returned to its place of origin.

X

TERRACOTTA SCULPTURE

In the Preclassic and Classic periods terracotta was one of the principal materials for sculpture in Mesoamerica, but the Aztecs, so preoccupied with stone for making their images, worked less often in clay. Except for a few larger hollow figures, most terracottas are small, solid, mold-made figurines. Mass-produced, these figurines have not interested Pre-Columbian collectors, but they are nonetheless important aids in identifying the cults and deities worshiped by the lower classes in cities and rural areas. The main subjects are deities of nature and fertility, especially a mother holding a child. This theme contrasts dramatically with themes in the art of the elite, where the focus is on death and sacrifice.

Examples of larger terracotta sculptures are a clay plaque with the head of a deity (Plate 297), and the figure of the Flayed God (Plate 298). The clay plaque has preserved remarkably its color and surface forms. The face with closed eyes and open mouth suggests Xipe figures, but the ornate headdress and the butterfly-shaped object in the mouth are closer to the iconography of Xochipilli, the solar-fertility deity. Such clay plaques may have been set, like stone reliefs, into the walls of temples or shrines.

Terracotta figurines of the Flayed God go back to the early Postclassic period, and several almost lifesize figures are known from the late Postclassic. Large clay figures are characteristically made in the Veracruz region, and our Plate 298 is said to come from Puebla, south of the Valley of Mexico. Such figures were probably the clay prototypes of Aztec stone sculptures, but the large terracottas are less symmetrical and regular in form than the stone figures. In this sculpture a slight bend in the back and the uneven surface gives a sense of life and movement. The Xipe identification comes from the head with its closed eyes and large open mouth, presumably a human skin worn like a mask over the face. That the man had been sacrificed is evident from the rectangular cavity in the chest. Unlike the smooth skin represented in stone sculptures (see Colorplate, half-title page; Plate 199), the skin on this figure is textured with overlapping scalloped forms. These make the surface resemble more closely the feathered costumes worn by warriors, some of which also show a design suggesting heart sacrifice; it is not clear whether the hollow terracotta figures wearing a Xipe skin refer to the flaying ritual or to warrior representations. We know that the Aztec rulers often dressed as the Flayed God when going to war, but it has never been suggested that they wore actual human skins. Xipe costumes may well have been made of feathers when worn as a status dress and of human skin for religious rituals. An unusual aspect of this figure is the erect phallus visible under the costume. The Aztecs associated overt sexuality with the people of the south and east.

Thousands of small clay figurines have been made in the Valley of Mexico since Preclassic times—indeed, figurines are the earliest art form in Mesoamerica, found at the site of Puerto Marquez together with pottery dating to about 2400 B.C. (Brush, 1968, p. 53). Beautiful handmade figurines were found in Preclassic burials at Tlatilco (see Plate 7) and in household debris at most sites. These figurines represent simply clad or naked men and women, and animals. Later figurines were mold-made and became a folk art activity in contrast to major works such as stone sculpture and

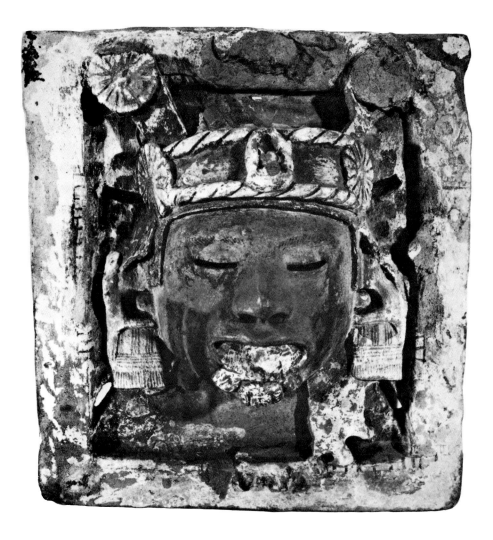

Plate 297. Plaque, Head of Deity with Butterfly-shaped Object in Mouth. Terracotta with paint, 31 × 28 cm. Culhuacan, 1200–1521. Museo Nacional de Antropología, Mexico City

OPPOSITE

Plate 298. Standing Figure Wearing Flayed Skin. Terracotta, hollow, with paint, height 1.4 m. Puebla. 1200–1521. The Metropolitan Museum of Art, New York. The Michael C. Rockefeller Memorial Collection, Gift of Nelson A. Rockefeller, 1969

OVERLEAF

Plate 299. Figurine Mold. Terracotta, 10 × 6 cm. Texcoco, 1200–1521. Museo Nacional de Antropología, Mexico City

Plate 300. Figurine of Goddess and Two Children. Terracotta, height 19 cm. 1200–1521. Musée de l'Homme, Paris

mural painting. Some figurines continue to represent simply dressed men and women; other Teotihuacán, Toltec, and Aztec figurines are of elaborate deity images.

In all periods, figurines of women predominate. A theme belonging primarily to figurine art is a woman holding a child in her arms; for this reason, figurines are generally thought to symbolize fertility. However, figurines appear to have had multiple uses, and fertility was only one of their meanings. Though frequent in burials and in household debris, they are rarely found in offerings. There were none in the recent Main Temple excavations in Tenochtitlán; the offerings were mainly of precious and rare materials. By the Aztec period, figurines had definitely become a peasant art.

The Aztec peasant lived in poverty and had few material possessions. His household consisted of a thatched adobe hut furnished with sleeping mats, a hearth, and a shrine for the household deities which were probably clay figurines. The home had much ritual importance: Sahagún, describing the festivals of the months of the solar year, states that most either began or ended in the homes. The homes were cleansed, scented, and the altars decorated for ritual celebrations. Household shrines are still in use today in modified form as the altars of Mexican peasants: instead of Pre-Columbian deities, there are inexpensive pictures of saints, souvenirs from pilgrimages, candles, and flower decorations, and miniature altars may be set up in the front of buses and trucks by their owners.

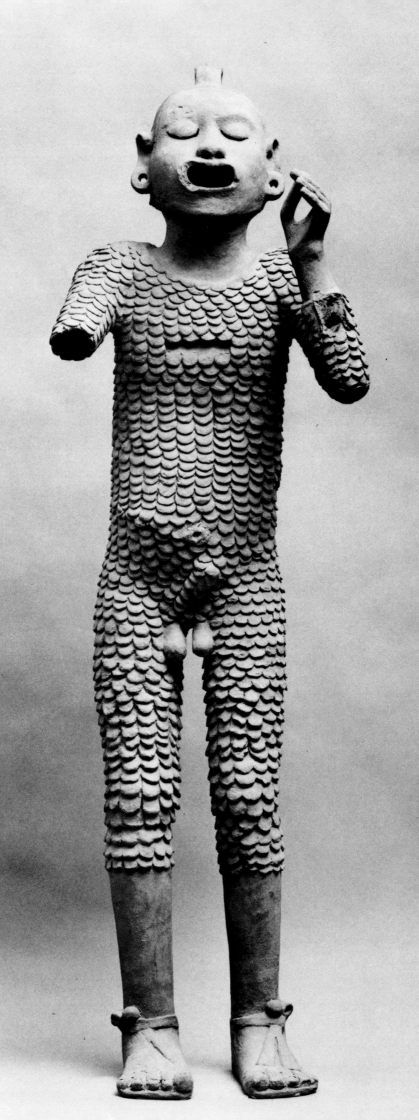

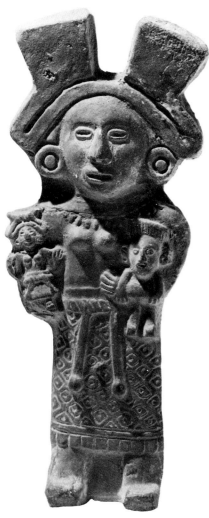

The vast amount of sixteenth-century literature about the Aztecs contains not one clear reference to clay figurines. This is consistent with the outlook of the Spanish chroniclers; they were interested primarily in the culture of the elite, and gave detailed descriptions of exotic crafts such as gold- and featherworking. Figurines continued to be made in the colonial period, including mold-made figurines of Spanish soldiers and friars. Like domestic Aztec pottery, figurine manufacture continued its role in the life of the commoner.

The use of figurines on household altars was only one of their functions. Mexican folk healers today use figurines of saints and animals, and some prehispanic figurines may also have had a curing function. Many figurines are actually rattles—hollow molds with clay pellets inside—and were used as musical instruments in rituals, to call down the fertility deities. At the time of the New Fire Ceremony every fifty-two years all household images were thrown out and replaced by new ones, a practice that may partially explain the large number of figurines found. Because Aztec figurines from throughout the Valley of Mexico are all similar (Plate 299), they must have been mass-produced in a few localities and distributed through markets (Parsons, 1972, p. 117).

Only a handful of studies have been made of Aztec figurines, and the most significant ones deal with problems of classification (Seler, 1902–23, II, pp. 305–13, Preuss, 1901; Barlow and Lehman, 1956; Cook de Leonard, 1950; Kaplan, n.d.; Parsons, 1972; Millian, n.d.). Parsons divided the figurines by clay and type into hollow and solid examples. The hollow figurines are made of a reddish clay and have an unpainted, shiny surface; most are rattles, and most represent women. The solid figurines are often of a buff-colored clay, and represent men, women, and animals, usually painted; traces of color on a white, chalky surface remain on many. All the figurines stand or sit on solid feet or bases.

The most common Aztec figurine is the hollow rattle representing a standing woman (Plate 300) dressed in a skirt, and bare-breasted. Her hair is arranged in two neat braids or coils that are tied at the top of the head and end in two projections; and she carries one or two smaller figures in her arms. This woman has been variously identified as Coatlicue, Cihuacoatl, Tonantzin, or Xochiquetzal—all Aztec mother goddesses. Millian (n.d.) has shown, however, that the figures do not wear the costume or headdress of any deity, and that they may represent idealized Aztec women. Aztec women generally wore their hair tied up in two projections, as illustrated in the Codex Mendoza (see Plate 31). Until the Spaniards insisted in the sixteenth century that women cover their breasts, only upper-class women wore shirts.

In these figurines the Aztec woman holds one or two children in her arms. The "child" on her right arm is a rigid little figure that is identical except for its size with the woman herself, a miniature statue or figurine quite enigmatic in its meaning. The only parallel is the figure of Tlazolteotl in the Codex Borbonicus, who gives birth to a miniature version of herself (see Colorplate 32). The miniature figure may refer to the theme of continuity through birth and human fertility. The other figure the woman sometimes carries is a small being that looks more like a real baby, its large head and small limbs hanging loosely over her arms. This figurine may represent a midwife or a patroness of childbirth and fertility. The mother and child image is a positive metaphor for continuity, the opposite of the negative elite metaphor for the cycle of life with its focus on death. Recent surveys have shown that this type of rattle figurine was more frequently found in rural areas than in towns (Parsons, n.d.).

The solid figurines represent humans and deities. A female figurine with two feather tufts in her headdress probably represents Xochiquetzal, her headdress as in

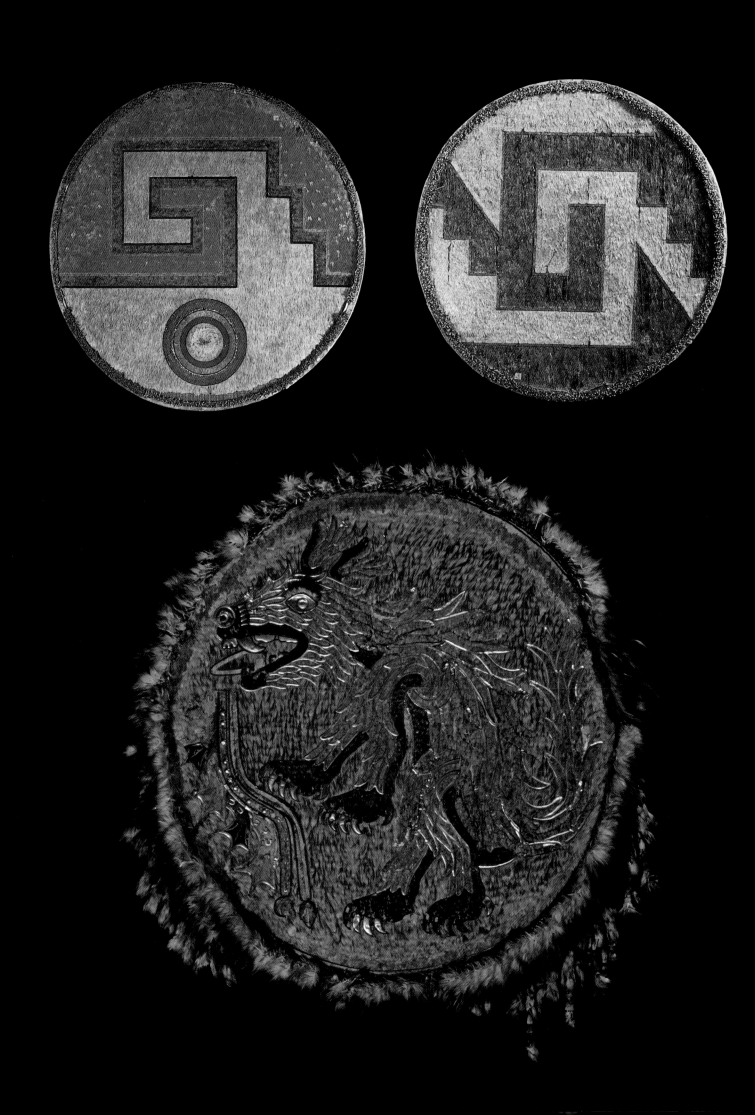

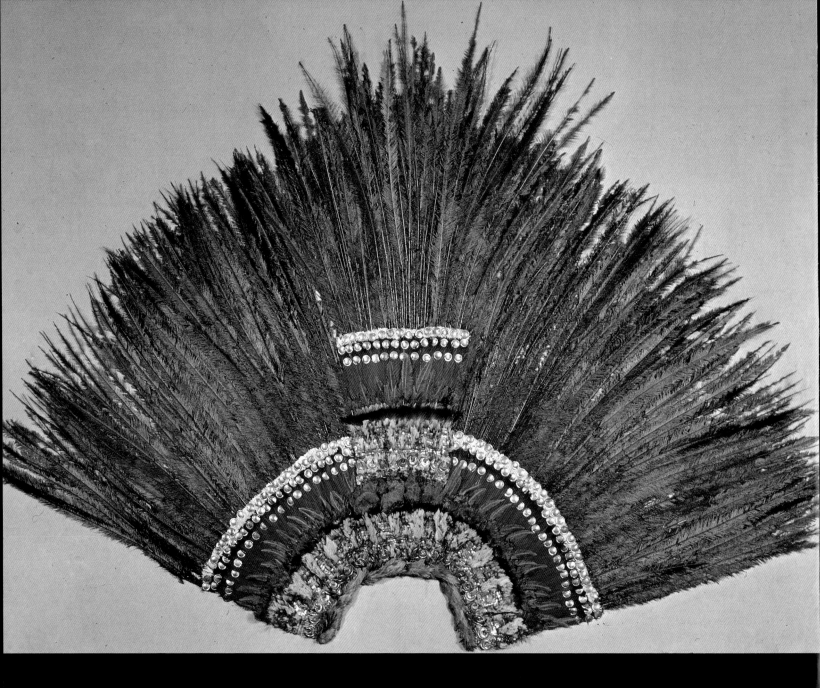

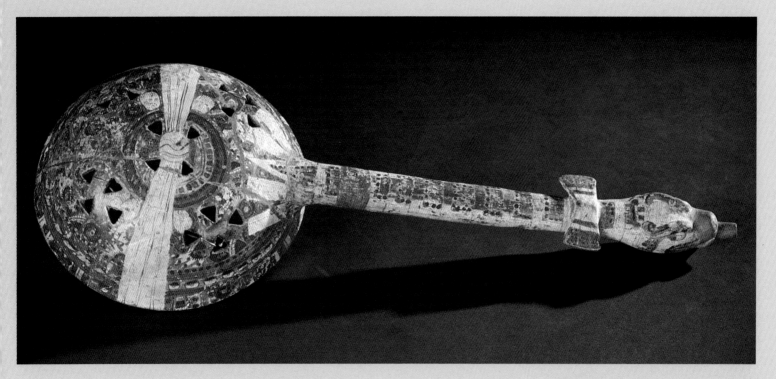

Colorplate 69. Mixtec-style Incense Ladle.
Ceramic. 1350–1521. Museo Nacional de
Antropología, Mexico City

BELOW
Colorplate 70. Red-ware Pitcher with
Geometric Design. Ceramic. Aztec III–IV,
1350–Early Colonial. Museo Nacional de
Antropología, Mexico City

PRECEDING OVERLEAF, LEFT
Colorplate 65. Circular Shield with
Geometric Design. Feathers, diameter 73.5 cm.
1350–1521. Württembergisches
Landesmuseum, Stuttgart

RIGHT
Colorplate 66. Circular Shield with Stepped-
fret Design. Feathers, diameter 70 cm. 1350–
1521. Württembergisches Landesmuseum,
Stuttgart

BELOW
Colorplate 67. Circular Shield with Coyote
or Ahuitzotl. Feathers and gold inlay, diameter
70 cm. 1350–1521. Museum für Völkerkunde,
Vienna

OPPOSITE
Colorplate 68. Great Quetzal Feather
Headdress. Green quetzal feathers, blue cotinga
feathers, and gold disks, 1.66 × 1.75 m.
1350–1521. Museum für Völkerkunde, Vienna

the codices (Plate 301; see Colorplate 31). Another figurine with a form projecting from a beaded helmet shows a female deity wearing a necklace of maize ears (Plate 302), perhaps referring to both agricultural and human fertility. Interestingly, these figurines do not generally resemble stone sculptures or other works, but have their own vocabulary of form, suggesting a subculture in the Aztec peasantry with an imagery that differed from art in the rest of Aztec society.

The male figurines are less numerous than the female, but they show more variety. Male deities also represent fertility and nature gods, but parallel stone sculptures more closely. They include the rain god Tlaloc with goggles around his eyes, the Deity with Buccal Mask, identified as a wind god (Plate 303), and the God with Crested Headdress, Macuilxochitl. One group of figurines represents drummers, referring to ritual music and dance. Martial themes are less common, but there are figurines of warriors in animal disguise and of deities such as Xipe holding weapons (Plate 304). Millian has shown that all the male deities represented among the figurines were patrons of various diseases, possibly used by folk doctors in rituals for health and well-being; she concludes that in general the figurines functioned in personal and family contexts, since public rituals were undertaken at the temples rather than in households.

The most unusual Aztec terracottas represent temples, sometimes with a deity at

Colorplate 71. Tripod Bowl with Graphite Band. Ceramic. Aztec III, 1350–1521. Museo Nacional de Antropología, Mexico City

Colorplate 72. Orange-ware Bowl with Painted Black Decoration, Chili Grater. Ceramic. Aztec III, 1350–1521. Museo Nacional de Antropología, Mexico City

Plate 301. Figurine of Kneeling Goddess with Headdress in Two Feathered Tufts. Terracotta, height c.12 cm. 1200–1521. Museo Nacional de Antropología, Mexico City

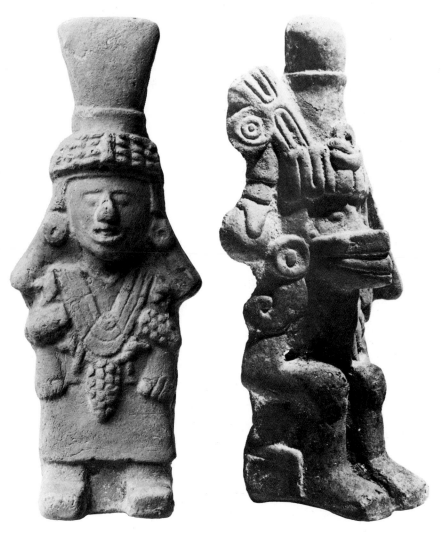

Plate 302. Figurine of Goddess Wearing Corn Necklace. Terracotta, height c.15 cm. 1200–1521. British Museum, London

Plate 303. Figurine of Seated God with Buccal Mask. Terracotta, height c.15 cm. 1200–1521. Museo Nacional de Antropología, Mexico City

Terracotta Sculpture **289**

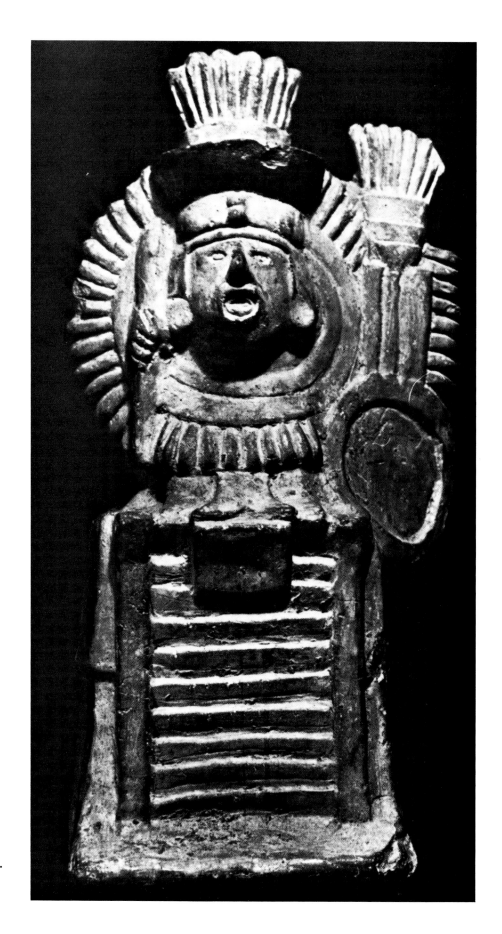

Plate 304. *Temple Model with Armed Deity on Top. Terracotta, 23 × 10 cm. Mexico City. 1200–1521. Museo Nacional de Antropología, Mexico City*

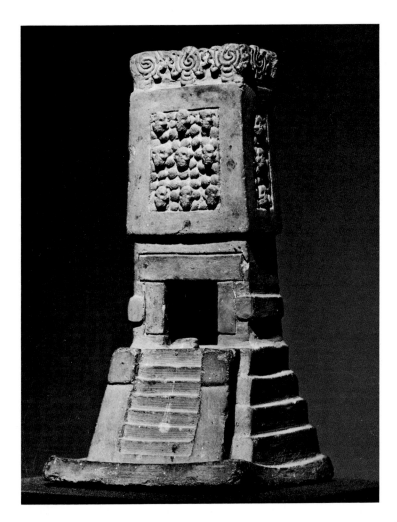

*Plate 305. Temple Model. Terracotta,
32 × 17 cm. Mexico City. 1200–1521. Museo
Nacional de Antropología, Mexico City*

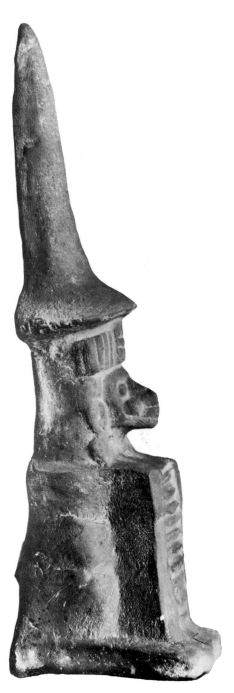

the top (Plates 304–6). These have no prototype in pre-Aztec figurines, although fig-
urines seated on thrones were found at Teotihuacán. One Aztec terracotta shows
a rectangular temple having a steep roof ornamented with tenoned skulls and shell-
shaped finials, recalling descriptions of the twin pyramids of Tenochtitlán; in front of
the doorway is a sacrificial stone. Others show round temples with conical roofs.
These temple models are so varied in their form and ornamental details that they may
be models of actual temples in Aztec cities. Just as modern pilgrims buy souvenirs
at their pilgrimage churches, the Aztecs may have offered miniature replicas of their
different temples. They reflect the Aztec tendency to copy objects in different me-
diums, even on the folk level. In their concept, these clay temples are related to the
elaborately carved Temple Stone (see Plates 125–31).

Deities shown on the temples are usually male and they often hold weapons.
Perhaps the temples with deities represented the major tribal temples at different
centers. Kaplan has suggested that the temples with figurines are late Aztec, and that
the temple figurines may have served to integrate the peasant cults with the urban
cults of the elite.

For the ordinary populace the temple models may have represented the elite warrior
cults of the aristocracy; the people had some participation in these cults through the
Aztec ideology of creating social mobility by way of warfare. The female figurines,
in contrast, have few parallels in monumental stone art; they represent agricultural
occupations and the commoners' concern with fertility, health, and well-being.

*Plate 306. Model of Round Temple with Face
Topped by Conical Roof. Terracotta, height
c.11 cm. 1200–1521. Musée de l'Homme,
Paris*

XI

CERAMICS

The Aztecs made a variety of functional and ceremonial objects out of clay: incense burners, dishes, stamps, and spindle whorls. Many of these bear decoration but usually without the elaborate iconographic meaning that characterized the stonecarvings and manuscript painting. Aztec pottery vessels are sometimes in simple abstract forms with little figurative ornament.

Large vase-shaped incense burners were probably common once, although few were known until the recent Main Temple excavations. They were sometimes over three feet in height with a figure in high relief on one side or an ornament of projections and flanges. Some color is still preserved on the incense burner bearing a maize deity, found at Tlatelolco (Plate 307); much of the figure is in high relief, the head ornamented with clay versions of the folded paper fans associated with fertility deities. The necklace of flowers and maize ears provides the agricultural connection; this necklace resembles one modeled on a figurine of a female deity (see Plate 302), but we cannot tell the sex of the deity on the incense burner. Several similar large incense burners ornamented with figures were found in the Main Temple offerings. All seem to represent deities of fertility ornamented with paper fans. A Tlaloc effigy in stucco similar to the incense burner was set in the north wall of the Main Temple (Matos Moctezuma, 1981, foto 8). Such incense burners must have been a common sight on Aztec temples.

The incense burners abstract in form are more dramatic (Plate 308). One of the most startling works of Aztec art is the clay urn resting on three tilted cylindrical legs, also found in Tlatelolco. The sharp conical projections and leaf-shaped flanges suggest bronze-casting rather than pottery, and indeed bronze replicas of this work embellish the plaza in front of the National Museum of Anthropology in Mexico City. The Aztecs also copied abstract ceramic incense burners in stone; some were recently found in the Main Temple offerings. Generally, incense burners stood at the top of the balustrades of pyramid stairways, as seen on the temple pyramid of Santa Cecilia Acatitlan (see Coloplate 25).

The Aztecs considered their own household wares to be less fine than Mixteca-Puebla pottery. They imported the polychrome pottery of the Cholula-Mixtec area as luxury ware. Mixtec pottery is polychromed and extremely ornate, decorated with registers of abstract designs such as stepped frets, and with complex narrative scenes similar to those in religious manuscripts such as the Codex Borgia. Many Mixtec ladle-shaped incense burners were found in the Escalerillas Street excavations in 1902 (Colorplate 69). The incense ladle illustrated here is from the excavation made there by Batres; it is fashioned in openwork, the handle ending in a serpent's head, and a white painted band imitates a cloth ribbon tied around the bowl. Such incense ladles carved in monumental relief appear on the Dedication Stone of Tenochtitlán (see Plate 94), and the priests are shown using them in the codices (see Plate 30; Colorplate 22), apparently for the most important state rituals. In the pottery offering found in 1936 at El Volador in Mexico City, thousands of vessels were stacked on a platform 230 feet square, with the imported Mixtec pottery in the center, the most protected

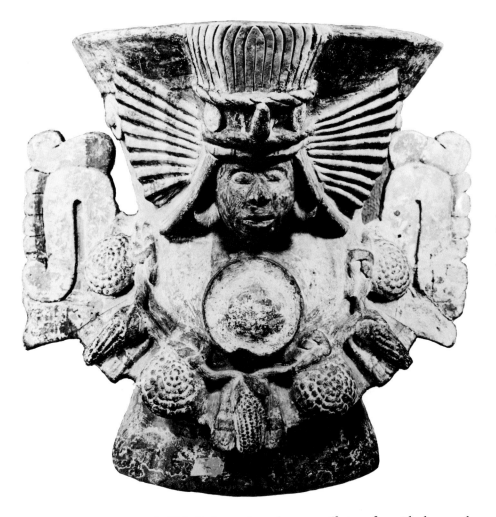

Plate 307. *Incense Burner with Relief Figure of Maize Deity. Ceramic, 54.5 × 64 cm. Tlatelolco. 1350–1521. Museo Nacional de Antropología, Mexico City*

position (Noguera, 1968). This find may have been an offering, for with the vessels was a sculpture of a Deity with Headdress of Two Horns.

Since early in the twentieth century scholars have studied Aztec pottery in detail: they have attempted to develop a chronology based on stratigraphic excavations, to connect pottery designs with ethnic groups in the Valley of Mexico, and to chart the development of decorative designs (Vaillant, 1938, 1965; Franco, 1945; Griffin and Espejo, 1950; Parsons, 1966; Noguera, 1975). Aztec pottery has simpler ornament than Mixtec pottery, usually of a single color, black, or more infrequently black, white, and yellow over an orange or red background. Four major types of Aztec pottery are known: black designs on orange ground; black designs on red ground; black and white and sometimes yellow designs on a red ground; designs with graphite paint. Of these, the black-on-orange ware has been studied the most; less information is available on the others. This tradition probably comes from the ornament of Toltec pottery, its wavy lines, frets, and spirals painted in a hurried and cursive style. Basic Aztec shapes are bowls, plates, cups, and pitchers, the bowls and plates often supported on three legs. Some of these vessels have unusual features: on the inside many bowls are roughened by crosshatched incisions for grating chili peppers (Colorplate 72); certain tripod dishes have depressions at different levels that separate two different sauces (Plate 312).

The ceramics of the Valley of Mexico have been divided into nine different wares on the basis of clay, type, vessel shape, surface, and decoration (Parsons, 1966). Orange

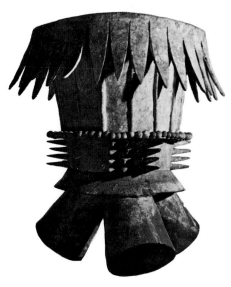

Plate 308. *Tripod Incense Burner. Ceramic, 112 × 97 cm. Tlatelolco. 1350–1521. Museo Nacional de Antropología, Mexico City*

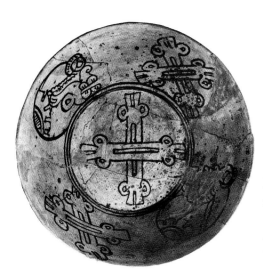

Plate 309. Bowl with Painted Skulls and Crossed Bones. Ceramic, 5 × 15 cm. El Volador, Mexico City. Aztec III–IV, 1350–1521. Museo Nacional de Antropología, Mexico City

and red wares are the most common. Red ware, generally associated with Texcoco, is usually highly burnished and painted with a red slip; its painted designs are in black, black and white, or black, white, and yellow, and they consist of simple lines and frets that often appear hastily applied. These vessels vary in quality; the pitcher with a simple stepped fret and spiral design has a remarkably elegant shape and high polish (Colorplate 70).

Red ware is sometimes completely covered with a white slip, then painted with black designs of skulls and crossed bones (Plate 309). In its controlled quality the line and design suggest Mixteca-Puebla vessels. Many red-ware goblets were made for drinking *pulque* at feasts.

An unusual feature of Aztec vessel decoration was the use of graphite paint having a metallic luster (Colorplate 71). Graphite is often applied in a thick band, separate from the rest of the design. Vessels made of buff-colored clay were covered in part with a red slip, in other parts with graphite. The contrasts among areas of natural clay, polished red, and metallic gray are striking in texture and aesthetically effective. The vessel illustrated has angular tripod feet, one of them stepped and cut out in open-work. Such vessel supports occur late in the Aztec pottery sequence. They are remarkably similar to the tripod supports of Teotihuacán vessels and may have been an archaistic element in Aztec pottery.

The most common ceramics in orange ware were vessels with black designs, though the color is actually grayish or brownish, rather than black, and does not stand out sharply from the background orange color (Colorplate 72). This pottery, along with undecorated wares, was in common household use in the Valley of Mexico. Its distinctive designs have permitted this type of pottery to be studied in greater detail than any other type. Various scholars have defined four styles, which may have both temporal and spatial significance (Griffin and Espejo, 1950).

Pottery in the style of Aztec I is sometimes called Culhuacan black-on-orange (Plate 310, upper left), and it is found at many sites in the Valley of Mexico, usually beneath the shards of other Aztec styles. The pottery is thick and poorly fired; it is decorated with a central medallion, which may be a flower or stylized serpent head, and border designs of frets, spirals, circles, and parallel lines; they are executed with a thick brush in uneven lines. The cursive style appears to have been done with fast strokes, the pattern of many slanting lines suggesting a rapidly moving hand (Brenner, 1931).

Aztec II style, usually associated with the site of Tenayuca, is found primarily in the northern part of the Valley of Mexico. Aztec II pottery is thinner and better fired than Aztec I; the designs appear similar to Aztec I, but the elements are multiple and smaller; they have a remarkably lively rhythm. Covering the vessel interiors are many rows of slanting lines and spirals, and fewer symbolic or representational elements (Plate 310, upper right). The date of this style is prior to the historical date of the Mexica settlement at Tenochtitlán.

The rise of the Mexica empire is associated with Aztec III and Aztec IV pottery. Widely distributed, these styles coincide with the fullest extent of the empire: pottery found at Tenochtitlán and Tlatelolco is primarily of these types. We do not know where this pottery was made, but its distribution point was Tenochtitlán. Aztec III and Aztec IV pottery is thin and well fired. The decorative vocabulary comes from Aztec I and II but the line is more controlled, the quality less free and casual, and contrasts are emphatic among light, dark, and designed areas. A vessel transitional between Aztec II and III (Plate 310, lower left) and an Aztec III vessel (Plate 310, lower right) both retain the lines, circles, and spirals, but the forms have become fuller and more static. The plates often have a bilateral, symmetrical design with asymmet-

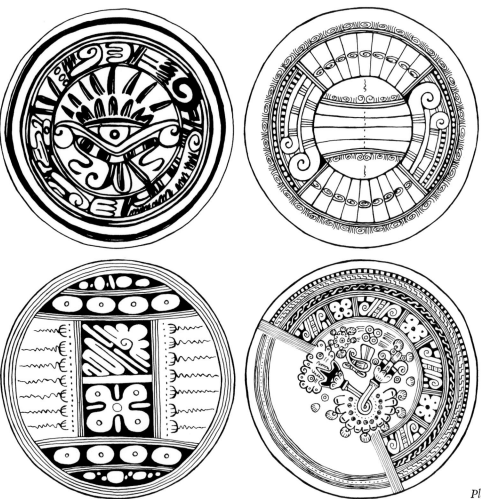

Plate 310. Chronology of Black-on-Orange Pottery Designs: upper left, *Aztec I;* upper right, *Aztec II;* lower left, *Aztec II–III;* lower right, *Aztec III*

rical elements. In Plate 310, lower left, two inner squares contain different symbols: a flower, and an S-shaped motif. It is remarkable that the design motifs of Aztec II and III pottery are quite different from the symbols seen in other forms of Aztec art. Some designs in Aztec III come from codex-style decorations: the central medallion in Plate 310, lower right, has two intertwined flowers ornamented with balls of down. With its complex, asymmetrical composition, the design of this vessel is one of the most elaborate in Aztec pottery.

Aztec III pottery, although the most abundant, has been little studied. King (1981) has shown that these vessels vary from relatively crude pieces to extremely fine examples, from simple designs to complex patterns. Social, functional, or other explanations that we do not yet know may lie behind these distinctions. Some vessels are ornamented simply with lines and dots, but many elegant examples are to be found among these. In Plate 311, a tripod bowl with a design of parallel lines and dashes around the side, a question-mark-shaped spiral emerges at four intervals, rising dramatically to the rim of the bowl. The artist had complete mastery of this vocabulary of fluid, linear design. Less fastidious is the design of the divided bowl (Plate 312), painted on the sides with the usual lines and dots. One half of the interior is undecorated, the other half has angular frets and a boldly stylized conch shell at the center, with dark areas emphasizing these heavy motifs. These two vessels probably come from different workshops or artists.

Plate 311. Orange-ware Tripod Bowl with Painted Lines, Dots, and Spirals. Ceramic, diameter 20.5 cm. Aztec III, 1350–1521. British Museum, London

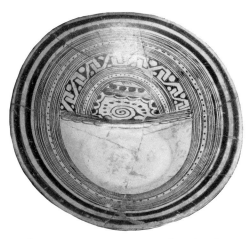

Plate 312. *Orange-ware Tripod Bowl with Two Depressions, Painted Gray-black Designs. Ceramic, diameter 24.6 cm. Aztec III, 1350–1521. Museum für Völkerkunde, Berlin*

Plate 313 a, b. *Interior and exterior of Orange-ware Tripod Vessel with Painted Eagle in center. Ceramic, diameter 20 cm. El Volador, Mexico City. Aztec III, 1350–1521. Cambridge University Museum of Archaeology and Anthropology, Cambridge, England*

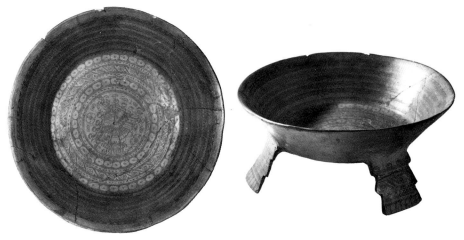

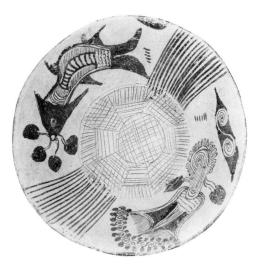

Plate 314. *Orange-ware Tripod Bowl with Painted Black Decorations Including a Fish and Flower, and incised center. Ceramic, diameter 22.9 cm. San Miguel. Aztec IV, 16th century. Museum of the American Indian, Heye Foundation, New York*

One of the most beautiful Aztec III vessels, now in the Cambridge University Museum (Plate 313 a, b), was found among the offerings at El Volador. The concentric arrangement of lines, dots, circles, and stepped frets is a typical, pleasing pattern of alternating large and small forms, not unlike Plates 311 and 312 but with finer, more even lines. The central eagle medallion, however, ornamented with tufts of down and surrounded by flowers and figure-eight motifs, is altogether unusual. In its drawing style the eagle is reminiscent of codex painting; it rarely occurs in black-on-orange pottery. The design being unique, we do not know its intended meaning; normally the eagle was a major symbol for the sun and for the Aztec state. On the three elaborate feet are also designs of balls of down, stepped frets, lines, and dots. This vessel may well have been made for an important ritual or high state function.

In the brief period of Aztec IV pottery, developing in the late years of the Aztec empire and lasting into the colonial period, the designs become more cursive and

the forms more naturalistic. Figurative motifs are frequent, such as flowers, birds, fish, crustaceans, deer, monkeys, and skulls and crossed bones (Plate 314); often these images are no longer confined to the decorative bands of lines and designs that structure the earlier pottery, but float more freely on empty backgrounds.

The developing naturalism in painted pottery parallels the increasing naturalism in sculpture and manuscript painting late in the Postclassic period. But the manuscript forms remain relatively static, while the cursive quality of ceramic paintings continues in the outline painting of animals, the textures of their fur or feathers suggested by solid areas and short parallel lines.

Until recently it was thought that these four pottery styles developed successively from one another, with Aztec IV lasting into the colonial period. It is now believed that Aztec I and II pottery were contemporary in the Valley of Mexico between 1150 and 1350, with Aztec I made in the southern part of the valley, Aztec II in the north. Aztec III pottery is associated with the Mexica empire of Tenochtitlán and dates from 1350–1519, and was still being made in the colonial period in some regions; Aztec IV is found only in urban areas, and may be entirely colonial in date (Sanders, Parsons, and Santley, 1979, pp. 466–67).

Most Aztec pottery studies have been based on individual motifs found on broken

sherds. King (1981) analyzed nearly 600 entire vessels and found that the overall compositions on the black-on-orange vessels fell into seventeen types, while the red ware had only four design types. She suggests that while some of these types may reflect chronological changes, others may be the characteristic products of regional workshops. She has also found that despite an overall regularity in design, the vessels have wide variety, and even individual workshop styles may be recognized. All her groups included vessels well made as well as those poorly made, side by side.

The vocabulary of Aztec II and III pottery rarely uses naturalistic or figurative designs. Some motifs appear to represent flowers, but they may also refer to religious symbolism—and to what extent we do not know (Vega Sosa, 1975). Designs are often similar to those on clay stamps (Plates 315, 316), and like the figurines, clay stamps were found in great quantity in the Valley of Mexico. Field (1967) has shown that the stamps were probably used to print designs on paper for ritual offerings. Many represent the animals, such as lizards and monkeys, that frequently occur in Aztec

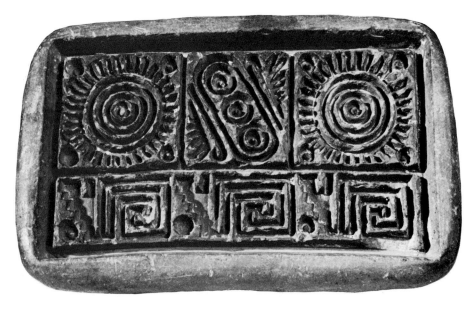

Plate 315. Mold for Pottery Stamp (sello). Ceramic, 2 × 17 cm. 1200–1521. Museo Nacional de Antropología, Mexico City

IV pottery. Clay stamps were probably part of the same folk art that made use of the figurines emphasizing fertility and festivity. The motif of intertwined flowers on Plate 310, lower right, is popular on stamps (Plate 316, right). It is significant that most of the designs on Aztec black-on-orange ware, among the most widespread pottery types, are quite different from designs in the elite arts, another suggestion that major differences in the culture of the elite set it apart from that of the commoner. They had different visual languages.

The introduction of naturalistic designs in the early colonial period is the most

Plate 316. Drawing of Designs on Two Rectangular Stamps (sellos): left, monkey, and head of fire serpent with rattle staff; right, intertwined flowers with shells and butterflies. Ceramic, each height about 4 cm. Mexico City. 1200–1521. Left, Museo Nacional de Antropología, Mexico City; right, provenance unknown (after Enciso, 1953: left, p. 120, fig. III; right, p. 151, fig. III)

surprising aspect of Aztec ceramic development. Although the other arts died out soon after the conquest, Aztec-type pottery continued to be made until the seventeenth century (Charlton, 1968). Some vessels incorporated Spanish themes, such as the Hapsburg double-headed eagle with crown (Franco, 1949, fig. 24, p. 202), but the majority were ornamented with native flowers and animals. Perhaps ceramic painting could continue to flourish after the conquest because the Spaniards did not consider these motifs idolatrous. The Aztecs could represent eagles and monkeys as natural forms without revealing any ritual meanings. Because Aztec IV pottery is largely urban, elite groups that went into hiding may have had these designs made for their native cults, under the guise of "naturalism."

The trauma of the conquest and the ensuing colonial period were the source of many artistic innovations for the Aztecs, primarily in the hybrid Spanish-Indian arts, such as manuscript painting, and in those nativistic arts that persisted, mainly ceramics. Ceramics rose in that time to become a major form of Aztec art as well as a vehicle for communicating ideas among the surviving elite.

Certain unique or unusual ceramic forms that are colonial in date support the idea that ceramics took on new importance in this period. One example is a famous plate from Tlatelolco (Plates 317–19). This vessel has an uncommon shape, a plate molded into six undulating parts and resting on three "legs" that are actually flat disks. There is no prototype for such a form in earlier Aztec ceramics, and few were

Plate 317. Tripod Plate. Ceramic, diameter c. 15 cm. Tlatelolco. Early Colonial, after 1519. Museo Nacional de Antropología, Mexico City

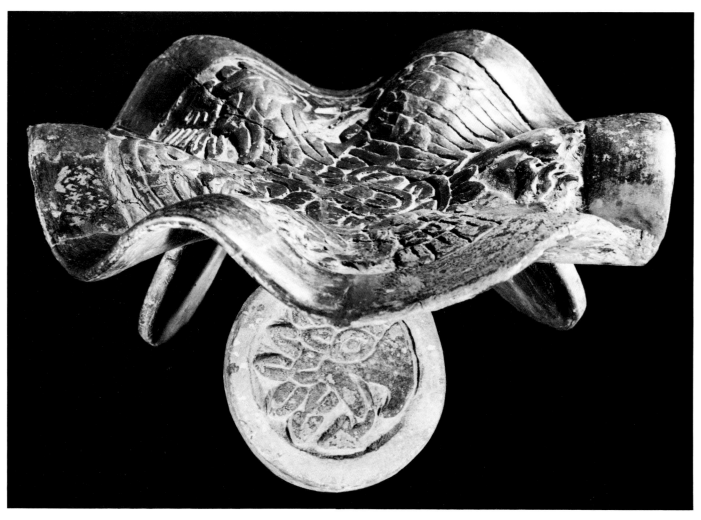

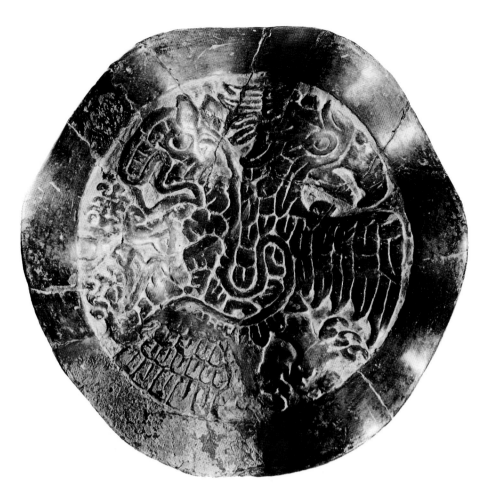

Plate 318. Top of Tripod Plate

made in the colonial period. The vessel is clearly ceremonial rather than functional; the design is openly nativistic. Carved in relief on the surface are an eagle and a jaguar intertwined; eagle heads are carved on the supports. Neither the carving in relief nor the theme of jaguar and eagle, referring to the warrior orders, normally occurred on Aztec II or III pottery, but the eagle and jaguar designs were well known in the elite arts. The affirmation of the warrior cult together with the baroque shape of the vessel suggest other unusual works, such as the *Pulque* Beaker (see Colorplate 50) and the Skeletal Figure (see Colorplate 49). These unconventional pieces seem to refer to the stressful time during or soon after the Spanish conquest. Since the Spaniards were alert to heathen idols on large monuments but were less concerned with pottery designs, the Aztecs apparently transferred their elite imagery to pottery for a brief period in the sixteenth century. The intertwined eagle and jaguar on the Tlatelolco Plate are a forceful expression of the need for unity among the Aztec warriors (Pasztory, in press).

This plate may embody nativistic reactions as the Aztecs saw their way of life being destroyed, and its manufacture may coincide with the short reign of Cuauhtemoc ("Falling Eagle"), who put up a valiant though unsuccessful resistance to the Spaniards after the death of Motecuhzoma. Cuauhtemoc made his last stand at Tlatelolco during the siege of Cortés. To the Aztecs, war meant fighting not only in battle but through magic and ritual. It is not unlikely that cult objects could have been commissioned whose iconography referred to these appalling events. The Tlatelolco Plate probably indicates that under the trauma of the conquest Aztec artists were led to create new types in an attempt to hold on to essential values. They were so successful that some of these works seem to us the most articulate invocations of the Aztec spirit and way of life.

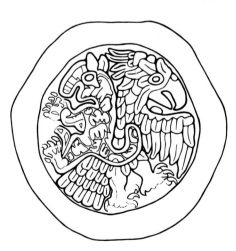

Plate 319. Drawing of Top of Tripod Plate

GLOSSARY

Guide to Pronunciation

Nahuatl was transcribed by Spaniards, and normally stresses the penultimate syllable. Vowels follow Spanish pronunciation:

a	as in b*ar*	Amatl
e	as in r*e*d	Mexica
i	as in k*ee*p	Tizoc
o	as in p*o*se	Toltec
u	as in *u*se	Tula, Motecuhzoma
y	as in *y*et	Yucatan

Consonants correspond to English equivalents, except for the following:

h	is slightly aspirated as in *h*umor	Huitzilopochtli
que, qui	is like k	quetzal
qua, quo	is like kw	Atamalqualitzli
x	is like sh	Xipe
z	is like s	Zapotec

Acamapichtli: First in the line of Aztec emperors (r. 1372–1391). Sent to the Mexica from Culhuacan, he was the offspring of a Mexica union with a royal Culhua (*q.v.*). This connection allowed his successors to claim a direct line of descent from Toltec rulers.

acatl: Nahuatl word meaning "reed." Reed was one of the twenty day signs of the ritual calendar and one of the four names for Aztec years, the other three being House (*calli*), Flintknife (*tecpatl*), and Rabbit (*tochtli*).

Acolhua: Traditionally, the first of the nomadic Chichimec groups to arrive in the Valley of Mexico, led by their king, Xolotl. The Acolhua established cities to the north and east of Lake Texcoco, including Tenayuca and their capital Texcoco, one of the three cities which formed the Triple Alliance of the Aztec empire. Their patron deity was Mixcoatl, and they were famous for their achievements in literature and the arts.

Ahuitzotl (1): Eighth Aztec emperor (r. 1486–1502), he was the son of Motecuhzoma I and the father of Cuauhtemoc, the last emperor. His reign was marked by expansion of the empire into Guerrero, and by major public works, including completion of the renovation of the Main Temple begun by his predecessor, Tizoc, and the building of the ill-fated aqueduct from Coyoacan to Tenochtitlán which caused the flood of 1486.

ahuitzotl (2): Mythological water monster with the body of a dog and the tail of a serpent.

altepetl: Nahuatl word meaning "city," a combination of the words for water (*atl*) and mountain (*tepetl*).

amacalli: Large paper headdress (literally "paper house"), complex and brightly colored, worn in religious rituals by impersonators of the maize goddesses.

amanteca: The featherworkers, organized in guilds, who decorated costumes, mantles, shields, and other items with the feather mosaics used by the upper classes.

amatl: Nahuatl word for paper made from the inner bark of a native fig tree. Paper had many

religious and secular uses, including clothing for the lower classes, banners, costumes for some ritual performers, painted manuscripts, and as the base for feather mosaics.

Atamalqualiztli: Festival held every eight years, the observance of which included eating certain foods (the name means "the eating of water tamales"), and the carrying out of rites for Tlaloc, the rain god.

atl tlachinolli: Literally this phrase means "water, fire," but metaphorically it refers to warfare. It is symbolized by a band composed of two intertwined elements, one indicating a stream of water, the other containing flame designs.

Atzcapotzalco: Capital city of the Tepanecs, located on the western shore of Lake Texcoco. Founded in the mid-13th century by migrants from the fallen Toltec kingdom, it grew to be the most powerful city-state in the valley until conquered by the alliance formed in 1428. Most of its lands and rights to tribute were taken over by Tenochtitlán, and distributed among the developing Mexica noble classes.

Axayacatl: Sixth Aztec emperor (r. 1468–1481), a grandson of Motecuhzoma I, and younger brother of the subsequent emperors Tizoc and Ahuitzotl. He led Tenochtitlán to victory in the Mexica civil war of 1473, after which Tlatelolco's temple was destroyed and its great market taken over. His military campaigns against the Tarascans in the west were not successful.

Aztlan: Legendary homeland in the northwest of Mexico from which the Aztec tribes migrated into the Valley of Mexico. Like Tenochtitlán, Aztlan was said to be an island in a lake.

Cacama: Ruler of Texcoco (r. 1516–1520); his appointment by his uncle, Motecuhzoma II, divided the Acolhua kingdom into hostile factions. He was held captive by the Spaniards and ultimately killed.

Calixtlahuaca: A Matlatzinca center in the Toluca Valley known for its ruins, which include a round, tiered structure thought to have been dedicated to the wind god Ehecatl (*q.v.*).

calmecac: Schools attached to the temples in which young men, primarily the sons of nobles, were trained to become priests.

calpulli: Type of social unit found in Tenochtitlán and other Aztec cities consisting of a group of free commoners who held land, paid taxes, and performed other social and political functions in common, under the direction of a ward headman. *Calpulli* groups consisted of farmers, each extended family working land assigned to them by the headman; or of members of specialized craft groups. Each ward had its own temple and *telpochcalli*, young mens' school.

Castillo de Teayo: Site in the Huastec region, in the northern part of the modern State of Veracruz, that includes a Toltec-style pyramid; it is the location of important Huastec- and Aztec-style stone sculptures.

Centeotl: "Maize ear lord," patron deity of corn, usually conceived of as a young male lord, the son of Chicomecoatl, goddess of sustenance. Centeotl is also considered to be one of the gods, together with Xochipilli and Macuilxochitl, associated with feasting and growth.

Centzon Totochtin: "Four hundred rabbits," the multiple gods of drunkenness. "Four hundred" metaphorically means many or innumerable; the rabbit was associated with *pulque* (and with the moon), and therefore with intoxication.

chac mool: A type of sculpture found at early Postclassic sites such as Tula and Chichén Itzá. It represents a reclining male figure holding a dish or disk on his stomach. The name, meaning "red jaguar" in Maya, was given to these figures in the 19th century.

Chalchiuhtlicue: "Jade skirt," the female deity whose province was surface water, streams, and lakes; female counterpart of Tlaloc, who oversaw rain. She was described as both the sister and the wife of Tlaloc. Like Tlaloc, she played an important role in the divinatory calendar, as well as having a role in the festivals and appearing in the forms of idol and impersonator.

Chalchiuhtotolin: "Precious turkey," a deity appearing only in the *tonalamatl*, the divinatory calendar, as ruler of one of its twenty divisions; depicted as a turkey wearing a Tezcatlipoca costume.

chalchihuitl: Nahuatl word for jade and other prized green stones. Metaphorically it also meant "precious," by analogy with the value and rarity of the stones. The green color and the value and translucence of the stones caused the word to be used as a symbol for water.

Chalco: City located at the western edge of Lake Chalco, one of the freshwater lakes in the Valley of Mexico where productive *chinampa* cultivation was practiced. Chalco was famous for its artisans who worked in stone. Chalco's location made it an important center for control of trade with lands to the south, and it was conquered by the Triple Alliance in 1465 after a long war.

Chantico: Goddess of fire and the hearth, patron deity of the city of Xochimilco; one of the patron deities of lapidaries and goldworkers.

Chapultepec: "Grasshopper hill," now the site of a major park in Mexico City. In Chapultepec was located the pleasure garden of the Aztec emperors. Beginning with Motecuhzoma I, each emperor toward the end of his reign had his image carved in the rocks there. The Mexica settled at Chapultepec at the end of their migration into the Valley of Mexico, but were driven from it into the lake where they founded Tenochtitlán. Later an aqueduct from the springs at Chapultepec supplied the city with fresh water.

Chichén Itzá: Site of a Postclassic Maya center in the northern Yucatan Peninsula. Architecture there, after the 10th century, shows great similarity to works in the Toltec city of Tula in Central Mexico.

Chichimec: "Dog people," name used to describe nomadic groups who dressed in skins and lived by hunting and gathering in the arid region of northern Mexico. Chichimec groups migrated into Central Mexico after the fall of the Toltec empire, frequently by way of Tula. Their relative status depended as much on which group arrived first in the Valley of Mexico and on the ties they could claim with the royal house of Tula as on their political power. The most important of these groups were the Acolhua, the Tepaneca, and the Mexica.

Chicomecoatl: "Seven serpent," a goddess of sustenance, especially of edible plants and corn. Her garb included red facepaint and a large paper headdress with rosettes of pleated paper, and she often carries double maize ears. Seven Serpent is her "birthday" in the divinatory calendar.

Chicomoztoc: "Seven caves," a legendary place of origin from which the ancestral Chichimec tribes of a number of Aztec groups are said to have begun their migration to the Valley of Mexico.

Chimalma: The name derives from *chimalli*, meaning shield. A woman who was one of the four *teomama* (god bearers), priests who carried the cult objects of the gods and led the Aztec tribes on their migrations.

chinampa: Agricultural land created by draining shallow areas of lakes with canals, while adding vegetal matter to the surfaces and mud from the lake bottom. The development of these fertile lands, together with the expansion of older agricultural practices like irrigation and terracing, made the Valley of Mexico very productive during the Aztec period. *Chinampas* were particularly extensive in the freshwater southern lakes, Xochimilco and Chalco.

Cholula: Great religious and pilgrimage center, southwest of the Valley of Mexico near the modern city of Puebla. Cholula, famous for its many temples, flourished contemporaneously with Tula and continued to be a religious center throughout the Postclassic period. The primary temple, dedicated to the city's patron, Quetzalcoatl, was the largest pyramidal structure in Pre-Columbian America.

Cihuacoatl (1): "Woman serpent," one of a complex of earth-mother goddesses; she was thought of as a well-dressed woman with a skeletal jaw, and a figure of evil omen who had brought the misery of hard labor to men, and demanded war and sacrificial victims. patroness of the *cihuateteo,* wailing spirits of women who had died in childbirth. Cihuacoatl was the patron deity of Culhuacan, and revered in other towns of the fertile *chinampa* area.

cihuacoatl (2): Office held by the second-in-command to the Mexica emperor, the most important in his council of four advisors. The *tlatoani,* or emperor, oversaw military and foreign relations; the *cihuacoatl* possibly had charge of domestic affairs. This division of rulership may have symbolized male and female forces active in creation, and the fusion of traditions of the nomadic Chichimec and settled Toltec peoples.

cihuapipiltin: "Noble women," the spirits of women who died in childbirth; equivalent to *cihuateteo* (*q.v.*).

cihuateteo: "Divine women," the spirits of women who died in childbirth, this death considered as honorable as that of a warrior in battle. They inhabited a western paradise, Cihuatlampa, and accompanied the sun from the zenith down to the western horizon, just as warriors accompanied the sun's rising. They were frightful beings with flowing hair and skeletal jaws, who at certain times might be encountered at night.

Cipactli: "Alligator," the first of the twenty day names of the ritual calendar. The first date of the ritual calendar was 1 *Cipactli*, associated with the coronation of Aztec emperors, the day of the creator deity Tonacatecuhtli. The *cipactli* was the earth monster on whose back the world rested.

Cipactonal: Mythological first man, with his female counterpart Oxomoco, the investor of divination and the ritual calendar (his name is derived from the calendar's first day).

Classic period: Mesoamerican history is generally divided into three periods: Preclassic, Classic, and Postclassic. The Classic period extends from 200–900 A.D., coinciding with the use of initial series or long count dates on Maya monuments. Long count dates are fixed points in time in a system having a definite initial point, thus differentiating it from the cyclical dating characteristics of Postclassic calendrical systems (including the Aztec calendar). In Mesoamerica only southern cultures, and especially the Maya, used long count dating systems. Such a system is similar to our own, which begins with a fixed point, Christ's birth, in 1 A.D. The Classic period includes the high periods of the Teotihuacán and Maya civilizations.

Classic Veracruz: Term for a number of related archaeological traditions found in the present State of Veracruz, dating to the Classic period. The style of stonecarving most often associated with these traditions has intricate patterns of interlacing or interlocking scrolls with interspersed zoomorphic elements; this style may have been one influence on Postclassic stone carving in central Mexico.

Coatepec: "Serpent hill," legendary stopping place of the Mexica near Tula, where Huitzilopochtli was born and the first New Fire Ceremony celebrated. A site near Chalco, on the shore of Lake Chalco, also had this name.

Coatlicue: "Serpent skirt," the earth-mother goddess particularly associated with the Mexica. She was the mother of their patron deity Huitzilopochtli, and also of Coyolxauhqui and of the 400 Stars. In the myth of his birth, Huitzilopochtli is conceived when Coatlicue places a ball of down (a symbol of sacrifice) in her bosom. This apparently dishonorable pregnancy causes Huitzilopochtli's 400 siblings to kill Coatlicue, but he, born fully armed at her death, dispatches them. Coatlicue was closely associated with agricultural fertility, and symbols of death are also prominent in the iconography associated with her.

Copal: A resin derived from any of several types of conifers, usually formed into balls and burned as incense or used as an offering in burials and other contexts.

Copil: Son of Malinalxochitl, female leader of a group abandoned by the migrating Mexica, who sought vengeance while the Mexica occupied Chapultepec. Copil was captured and sacrificed, and his heart thrown among the reeds out in the lake. From it sprang the nopal cactus that later marked the site of Tenochtitlán.

Coyoacan: Tepanec city, taken by the Triple Alliance in the Tepanec war; the site of the last stand of the final Tepanec ruler. After the war, the Mexica ordered a causeway built to Tenochtitlán. Under Ahuitzotl, an aqueduct was built from springs near Coyoacan, which led to the great flood of 1486.

Coyolxauhqui: Moon goddess who conspired with her brothers, the 400 Stars, to kill their mother Coatlicue after she conceived Huitzilopochtli. At the moment of his mother's death Huitzilopochtli was born fully grown and armed. He routed his siblings and decapitated and dismembered Coyolxauhqui. This myth is usually interpreted as having cosmological significance, Huitzilopochtli being identified as the sun which banishes the moon and stars. Coyolxauhqui served the Mexica as a symbol of the destruction of their enemies.

Cuauhtemoc: Last Aztec ruler (r. 1520–1524), son of Ahuitzotl and cousin of Motecuhzoma II. He led the final Aztec resistance to Cortés and was defeated at Tlatelolco. After his capture, Cortés held him prisoner and finally executed him on the march to Honduras. His name means "falling eagle," symbol of the setting sun.

cuauhxicalli: "Eagle vessel," a bowl of stone or wood used in Aztec temples to hold the hearts or blood of sacrificial victims.

Cuernavaca: Modern name of Cuauhnahuac, capital of the present State of Morelos, near the Aztec ceremonial center of Teopanzolco and the pleasure gardens built by Motecuhzoma I at Uaxtepec. The palace from which Cortés oversaw his personal landholdings after the conquest still stands on the main square.

cuicacalli: "House of songs," special type of building located near a temple where young men and women from the schools assembled to learn songs and dances for social purposes and for public performances at festivals.

Cuitlahuac: Penultimate Aztec ruler (r. 1520), he became emperor while his brother Motecuhzoma II was held prisoner. He pursued the Spaniards out of Tenochtitlán and prepared for defense against them, but died of smallpox after a few months.

Culhua: Group surviving the Toltec empire's fall who migrated from a probably mythical place called Teoculhuacan to the Valley of Mexico, founding the prestigious city of Culhuacan.

Culhuacan: City on the south shore of Lake Texcoco, in the productive *chinampa* area. One of the first cities founded in the Valley of Mexico by migrants from the north, its ruling house was generally recognized as the legitimate heirs of the revered kings of Tula. Rulers of other cities sought marital alliances with Culhuacan royalty. Acamapichtli, first in the line of Mexica emperors, was the offspring of such a union, which allowed his successors to claim royal Toltec ancestry. The Mexica were vassals of the Culhua after their arrival in the Valley of Mexico.

Earth monster: The earth was conceived of as a crocodilian or toadlike monster, surrounded by a primeval sea. The entrance to the underworld was visualized as the open jaws of the monster. Frequently it was depicted in a crouching posture, sometimes with teeth in the form of sacrificial knives and with skulls or mouths at its anatomical joints. Heavenly bodies were believed to pass through the earth monster in their daily cycles, and sacrificial victims were devoured by it. An earth monster is often depicted on the bottom surfaces of sculptures or boxes.

Ehecatl: God of wind, usually depicted as wearing a mouth mask, or having a beak or long snout. Wind gods were agricultural deities and also gods of life, because wind was associated with storms and with the breath of life. Circular temples were traditionally associated with Ehecatl, and the deity was considered one of the manifestations of Quetzalcoatl. Ehecatl was the name of certain days in the divinatory calendar whose auguries were unfavorable.

Eight Deer: Mixtec ruler of Tilantongo, Oaxaca, in the 11th century; the history of the reign of 8 Deer is told in several Mixtec pictorial manuscripts, notably the Codex Nuttall.

Four Hundred Stars: In the myth of the birth of Huitzilopochtli, the 400 Stars are the sons of Coatlicue. They conspired with their sister, Coyolxauhqui, to kill their mother after she became mysteriously pregnant, and were vanquished by the newly born Huitzilopochtli. "Four hundred" is a metaphor for "many"; like certain other Aztec deities, the stars were conceived of as a group having an uncountable number of similar members.

hacha: Object used in the Mesoamerican ball game. *Hacha*, Spanish for "axe," was applied to these objects because of their tapering, wedgelike shape. The objects were apparently worn at the side of the body, set into yokes which went around the waist. Surviving examples are of stone, probably copies of actual equipment made of perishable materials.

Hill of the Star: Located near the city of Culhuacan this was the site where the New Fire Ceremony was carried out to mark the end of the 52-year cycle of the calendar.

Huastec: Inhabitants of the region of the present State of Veracruz, linguistically related to but culturally distant from the Maya. The Huastecs, who paid tribute to the Aztec empire, were famous for their colorful cotton cloth, but were considered by the Aztecs to be lascivious barbarians inhabiting a land of tropical abundance. Despite this attitude, the Huastecs influenced Central Mexican religion, possibly being the source for the cult of Ehecatl and that of Tlazolteotl, and other aspects of the worship of goddesses of fertility.

huehuetl: Vertical wooden drum, a cylindrical body that rests on three legs and has an animal-skin membrane stretched across the top.

Huejotzingo: City nestled at a lower altitude below the volcanoes east of the Valley of Mexico; sometimes allied with Tlaxcala, traditional enemy of the Mexica.

Huemac: Last king of Tula who fled south from the fallen city to Chapultepec. There he bequeathed a portion of the Toltec heritage to the Aztecs, and disappeared with his treasures into a paradisical kingdom in a sacred cave.

Huitzilihuitl: Second of the line of Aztec emperors (r. 1391–1451), son of Acamapichtli and father of Motecuhzoma I. He extended the power of the Mexica ruling house, both by conquests and by his marriage to a daughter of Tezozomoc, ruler of the Tepanecs.

Huitzilopochtli: Patron deity of the Mexica, a complex figure to whom were ascribed multiple roles in myth and history. In the Mexica migration myth, he led the group into the Valley of Mexico and to the site of Tenochtitlán, marked by the appearance of the eagle on a cactus. He played the foremost role in Aztec state religion, sharing the Main Temple with the ancient god Tlaloc; his cult was spread as the empire expanded. He provided the divine pattern for the ideal Mexica warrior, and in his role as solar deity and god of war, was the being who demanded war and human sacrifice for his nourishment. The myth of his miraculous birth from Coatlicue and then his dispatching of his treacherous siblings—Coyolxauhqui, the moon goddess, and the 400 Stars—reflects the daily passage of the sun. He was partially fused with Tezcatlipoca in myth and calendrical observances.

Itzcoatl: Fourth Aztec emperor (r. 1426–1440). He led the Mexica to victory over their Tepanec overlords in the war that produced the Triple Alliance and the beginning of the Aztec empire. He ordered the burning of books and the rewriting of Mexica history, and began the reconstruction of Tenochtitlán on a grander scale.

Itzpapalotl: "Obsidian butterfly," female consort of Mixcoatl, the Chichimec hunting god. She was patroness of one of the days of the divinatory almanac, and could appear as one of the *tzitzimime* (q.v.).

Itztlacoliuhqui: "Obsidian knife," a god dressed in white and wearing a tall serrated cap; son of the grandmother goddess Toci, he personified frost. He was patron of the day Flintknife in the divinatory calendar.

Ixtapalapa: Town near Culhuacan, at the end of the important causeway that ran south from Tenochtitlán; the causeway was also called by this name.

Lords of the Day: In the *tonalamatl*, or divinatory almanac, a repeating series of thirteen Lords of the Day, i.e., thirteen different deities, accompanies the day signs and their numbers. These deities may be associated with the concept of the heavens as having thirteen levels.

Lords of the Night: In the *tonalamatl*, or divinatory almanac, a repeating series of nine Lords of the Night, i.e., nine different deities, accompanies the day signs and their numbers. (Several deities appear both as Lords of the Day and of the Night.) They may be associated with the concept of the underworld as having nine levels.

Macuilxochitl: "Five flower," a deity associated with pleasure in music and dance, in sexuality, and in feasting and games such as *patolli*. His characteristics include a youthful appearance, and the wearing of a crested headdress and rosettes with hanging tassels.

maguey: Agave or century plant. This spiny desert plant was a source of thorns used as needles or for autosacrifice, and of a type of paper. Its juice was fermented to make *pulque*. The goddess Mayahuel was the patroness of maguey.

Main Temple: Major building of the central ceremonial precinct of Tenochtitlán; in Spanish, Templo Mayor. It was a twin temple, one side dedicated to the Mexica patron deity Huitzilopochtli, the other to the rain god Tlaloc. The terms Templo Mayor or Main Temple are sometimes used to refer to the entire walled precinct.

Malinalco: Ceremonial site on a mountain in the Toluca Valley area, southwest of the Valley of Mexico, with a temple carved from a solid rock cliff featuring carvings of eagles, a jaguar, and a serpent-mouth doorway.

Malinalxochitl: "Maguey flower," sorceress sister of Huitzilopochtli, abandoned by the Mexica during their migration. She and her followers founded Malinalco. Later her son, Copil, sought revenge on the Mexica while they resided in Chapultepec, but was killed by Huitzilopochtli's priests.

Malinche: Slave woman acquired by Cortés on the Gulf Coast, La Malinche served as his interpreter and mistress during the conquest. She was baptized Doña Marina; Malinche is a corruption of Malintzin, a Nahuatl form of Marina.

Matlatzinca: Speakers of Otomí; a group having cultural similarities to the Aztecs and residing in the Toluca Valley.

Mayahuel: Patron goddess of the maguey plant, and also a goddess of *pulque*, fermented from its juices.

Mexica: Aztec tribe who, led by their warlike patron deity or culture hero, Huitzilopochtli, migrated from the north into the Valley of Mexico, and after serving as mercenaries for other city-states in the valley, founded the city of Tenochtitlán. Although they were one of the last groups of Nahua-speakers to arrive in the valley and were considered bloodthirsty barbarians by their neighbors, they became the dominant group in the Aztec empire.

Mezcala: Region on the Balsas River in the present State of Guerrero; name also applied to a long-lived style of abstract, small-scale stone sculpture often carved in greenstone.

Mictlan: The underworld, destination of the souls of most commoners. Ruled by Mictlantecuhtli and his wife, Mictecacíhuatl, it was a cold, dark place beneath the northern lands. Souls, guided by a dog, could reach it only after a long journey through difficult trials.

Mixcoatl: "Cloud serpent," special patron deity of the nomadic and warlike Chichimec tribes, who lived by hunting. The god was thus a patron of hunters, and may have been associated with the Milky Way.

Mixtec: Group in the Puebla and Oaxaca regions whose cultural achievements in art and writing influenced the Aztecs. Mixtec culture began to develop in the late Classic period, forming a series of city-states but never establishing large urban or ceremonial centers. They were famous for small-scale, extremely fine works of art, including polychrome pottery, gold objects, and painted manuscripts. Much of the Mixtec region was conquered during the reign of Motecuhzoma I, and thereafter finely made luxuries flowed as tribute to the Aztec nobility.

Mixteca: The geographic region inhabited by the Mixtecs. It included areas from the coast of Oaxaca to the State of Puebla.

Mixteca-Puebla: Artistic and cultural tradition that exercised a dominant influence in Postclassic central Mexico. Mixteca-Puebla is so named because it appears to have crystallized in the Mixteca and Puebla regions; it synthesized preceding Mesoamerican styles, including those of Teotihuacán, Classic Veracruz, and Xochicalco. It found its most typical expression in polychrome two-dimensional forms, richly painted ceramics, and codices. Aztec art and writing were profoundly shaped by it, and diverge from the characteristic Mixteca-Puebla style by incorporating more Toltec influences, and a greater literalness or naturalism.

Monte Albán: Magnificent mountaintop ceremonial center in the present State of Oaxaca. The site was first occupied in the Classic period by the Zapotecs, and in the Postclassic period the Mixtecs used it as a necropolis.

Motecuhzoma I Ilhuicamina: "Angry lord who shoots into the sky," fifth Aztec emperor (r. 1440–1468), the son of Huitzilhuitl. Motecuhzoma I formally established the Triple Alliance, codified laws, and awarded insignia of rank. He began the great expansion of Mexica power, making conquests from the edge of the Tarascan kingdom to the Gulf Coast. His reign was marred by severe famine and floods, but on advice from Nezahualcoyotl (*q.v.*) he built a great dike that allowed control of the saline waters of Lake Texcoco.

Motecuhzoma II Xocoyotzin: "Angry lord, the younger," ninth Aztec emperor (r. 1502–1520), the son of Axayacatl and grandson of Motecuhzoma I. A ruler with a deep interest in religion, he presided over a lavish New Fire Ceremony in 1507, rebuilt temples, and erected sculptures. He reorganized the empire's hierarchy, purging commoners in the process. He died in Tenochtitlán while Cortés's prisoner.

Nahuatl: A member of the Uto-Aztecan language family spoken by the indigenous inhabitants of Central Mexico. As recorded after the conquest by Spanish and native writers, it was a language rich in metaphors with an extensive oral tradition of poetry and rhetoric. Its use spread with the expanding Aztec empire. In the early colonial period the language was

written down, and it became a medium for religious conversion and legal proceedings.

Nappatecuhtli: "Lord of the four directions," patron deity of those who wove mats out of reeds; he was considered to be one of the Tlaloque, the multiple rain spirits of Tlaloc.

New Fire Ceremony: Major rite carried out every 52 years, when the great cycle ended that was formed by multiplying the 365 days of the solar cycle with the 260 days of the divinatory cycle. Events of the rite included the dousing of all fires in the Valley of Mexico, a procession of priests dressed as gods from Tenochtitlán to the Hill of the Star near Culhuacan, the new fire kindled there on the breast of a sacrificial victim, and its distribution to temples and homes. It was believed that the world might be destroyed at the end of each cycle; this ceremony celebrated the world's continued existence.

Nezahualcoyotl: "Fasting coyote," ruler of Texcoco (r. 1418–1472), famed as a statesman, philosopher, poet, and hydraulic engineer. Because his father, King Ixtlilxochitl I, was killed and Texcoco was conquered by Tezozomoc, Nezahualcoyotl did not take the throne until after the Tepanecs were defeated by a new alliance. He demonstrated his military and political abilities by forming the alliance and conducting the war. Under him, Texcoco gained its reputation as artistic center of the empire. He designed his gardens at Tetzcotzingo, and he advised the Mexica on the construction of Chapultepec and of the great dike east of Tenochtitlán, that controlled floods and separated saline from fresh water.

Nezahualpilli: "Fasting noble," ruler of Texcoco (r. 1472–1515), son of Nezahualcoyotl. Like his father, he was a master builder, and advised Ahuitzotl after the Aztec emperor's aqueduct had flooded Tenochtitlán. He was famed as a religious practitioner, and counseled Motecuhzoma II on the fateful meaning of the first portents of his loss of empire.

Ochpaniztli: "Sweeping of the way," the harvest festival, one of the eighteen festival months of the solar year. The festival was dedicated to the earth-mother goddess Toci, or Teteoinnan; rites included the sweeping of homes and streets, mock battles, and the sacrifice of an impersonator of the goddess.

Olmec: The most complex and influential culture of Preclassic Mesoamerica, flourished c. 1200–500 B.C. Olmec civilization's heartland was on the Gulf Coast, in southern Veracruz and western Tabasco. Ceremonial centers in that area include pyramids, plazas, and monumental sculptures of which the best known are naturalistic colossal heads. The Olmec style of art spread across much of Mesoamerica, and outside the heartland it is most often found in ceramics and fine lapidary works. Frequently called the "mother culture" of Mesoamerica.

Omecihuatl: The Lady of Duality, the female counterpart of Ometeotl (q.v.). She is identified with earth and fertility goddesses, with the old sorceress Oxomoco, and with the goddess Tonacacihuatl.

Ometeotl: The Lord of Duality. He and his female counterpart, Omecihuatl, represent the union of male and female principles that was responsible for the creation of the universe; they are the progenitors of all the gods and of man. Ometeotl is identified with the solar deities, with the old sorcerer of the divinatory calendar, Cipactonal, and with Tonacatecuhtli, Lord of Sustenance. This creator couple were patrons of the *tonalamatl* and of divination, and were believed to reside in the thirteenth and highest layer of the heavens.

Otomí: Group inhabiting the Valley of Mexico before the immigration of Chichimec groups. These indigenous agriculturalists were subject peoples within the Tepanec kingdom and later the Mexica state.

Panquetzaliztli: "Raising of banners," one of the eighteen festival months of the solar year. In Tenochtitlán, the birth of Huitzilopochtli was celebrated in this month.

patolli: Game of chance in which marked beans were used as dice to determine the moves of stones on a board. The game had astrological significance, and was played by all levels of society.

Postclassic: Designation for the period in Mesoamerican history from 900–1521. The beginning of the period is set by the final use of long count dates on Maya monuments (see Classic period); it ends with the Spanish conquest of the Aztec empire. Cultures that also flourished in this period include the Toltec, Mixtec, Haustec, and Tarascan.

Preclassic: Designation for the period in Mesoamerican history from 1500 B.C.–200 A.D. The

rise of the Olmec civilization sets the beginning of the period, and the first use of long count dates on Maya monuments marks its end and the beginning of the Classic period (*q.v.*).

pulque: Moderately alcoholic beverage made by fermenting the juice of the agave plant. *Pulque* gods were numerous; their characteristic ornament was a crescent-shaped nosebar. The use of *pulque* was restricted, usually limited to the elderly. Punishment for drunkenness in others was harsh.

quetzal: Bird of the mountain forests of Guatemala and the southern Mexican highlands; its brilliant green tailfeathers were especially prized. An important item of tribute and trade, they were used in costumes and ornaments for the elite.

Quetzalcoatl: "Quetzalbird serpent" or "precious twin," a complex mythological and historical figure. The deity Quetzalcoatl was the most important patron of learning and the priesthood (his name formed part of many priestly titles), and of the arts. He was identified with other deities, including his deformed twin, Xolotl, the wind god, Ehecatl, and Tlahuizcalpantecuhtli, the planet Venus. The quasihistorical Quetzalcoatl was also a king of Tula, a priest-ruler perhaps opposed to human sacrifice. The sorceror deity Tezcatlipoca drove him from the throne and the city, after which he immolated himself, or, according to other accounts, sailed away on a raft of serpents, promising to return in a year named 1 Reed (his birthdate). 1519 was such a year; the Aztecs were thus predisposed to believe that Cortés might indeed be Quetzalcoatl.

skull rack: Wooden framework on which the heads of sacrificed victims were placed.

Tarascans: Kingdom to the northwest of the Valley of Mexico, centered in the present State of Michoacan. A warlike state ruled by a supreme lord, it was never conquered by the Mexica despite repeated attempts; copper weapons may have given them a military advantage. The Tarascans were known for their feather mosaics and painted pottery, and especially for their copper work.

telpochcalli: "Young mens' house," school in which young men were trained as warriors. These schools were attended by male children of ordinary citizens, in contrast to the priestly schools (*calmecac*) attended by the sons of the nobility. The training included manual labor, as well as the arts of war, but discipline was not as harsh as in priestly training.

temalacatl: Circular stone used in gladiatorial sacrifice. The victim, a captured warrior, was tied to a rope passed through a hole in the center of the stone and armed with a ceremonial weapon, without obsidian blades; he was sacrificed by an armed and costumed warrior.

Tenayuca: Town founded by the Chichimec leader Xolotl, and known for its pyramid, which had undergone six major amplifications since the mid-13th century. This structure is notable for its surrounding serpent wall, for the apparent coincidence of its reconstructions with the completion of the 52-year cycles of the calendar, and for being the first known pyramid composed of two platforms surmounted by two temples, thereby serving as the model for the Main Temple of Tenochtitlán.

Tenochtitlán: Capital city of the Mexica Aztecs, and foremost city of the Aztec empire. Traditionally founded in 1325, the city was built upon land reclaimed from Lake Texcoco. By 1521 its population was 200,000–300,000. Joined to the mainland by three major causeways, it was crisscrossed by an efficient grid of streets and canals, and divided into four quarters consisting of well-organized neighborhoods with local temples and markets. The temple precinct, including the Main Temple of Tlaloc and Huitzilopochtli, was in the center of the city, surrounded by the palaces of the emperor and nobles. The city was leveled and burned, and the canals filled in, during the conquest.

teocuitlatl: "Excrement of the gods," the Nahuatl name for gold. Gold was usually panned and found in granules or nuggets.

teomama: "God bearers," priest-rulers who led the Mexica on their migration. They literally carried on their backs the sacred fetishes of the gods wrapped in bundles, and also spoke for the gods.

Teopanzolco: Aztec ceremonial center with twin pyramid in modern Cuernavaca.

Teotihuacán: Urban center in the northeast of the Valley of Mexico, it flourished between 100 and 700 A.D. and influenced all of Mesoamerica during the Classic period. The site covers

over twenty square miles; the central ceremonial area contains two major pyramids, and numerous platforms and compounds along a north-south avenue, surrounded by residential compounds. Sculpture is relatively uncommon and mostly restrained and geometric, but many buildings were painted with complex polychrome murals on a plaster surface. The Aztecs retained no factual traditions of the history of Teotihuacán; for them, the abandoned city was the place where the gods had gathered to create the present world and its inhabitants. They considered it to be "Toltec."

Tepanec: Chichimec group which entered the Valley of Mexico prior to the Mexica, and settled in the city of Atzcapotzalco. When the Mexica founded Tenochtitlán, they became vassals of the Tepanecs. Under King Tezozomoc, the Tepanecs rose to the foremost power in the valley, and remained so until defeated by the alliance formed in 1428.

Tepeilhuitl: "Mountain festival," one of the eighteen festival months of the solar year; it honored the mountains surrounding the Valley of Mexico. Images of mountains were made of dough that was then broken up and eaten for curative purposes.

Tepeyacac: Site at end of northern causeway out of Tenochtitlán, where a temple was built to the Aztec mother goddess Tonantzin; now the site of the shrine of the Virgin of Guadalupe.

Tepeyollotl: "Heart of the mountain," the jaguar god of the interior of the earth, an aspect of the sorceror god Tezcatlipoca, emphasizing the associations of that deity with darkness and magical power. One of the Lords of the Night, and patron of the third "week" of 13 days in the divinatory calendar.

teponaztli: Horizontal wooden drum with an H-shaped opening at the top. Each side was of a different thickness, producing a different tone when struck with a rubber-tipped drumstick.

Tepoztlan: Town on a hillside near Cuernavaca that had an Aztec temple with bench reliefs; it was dedicated to the pulque gods and built about 1500.

Teteoinnan: "Mother of the gods," a goddess of the earth and fertility, honored in the harvest festival Ochpaniztli (q.v.).

Tetzcotzingo: Pleasure garden built by King Nezahualcoyotl on a hill near Texcoco; it included sculpture, baths, and an aqueduct system.

Texcoco: Capital city of the Acolhua Aztecs, member of the Triple Alliance, and foremost literary and artistic center of the Aztec empire. The first Acolhua ruler of Texcoco was Quinatzin, who began the process of civilizing the Chichimecs. His efforts were continued by Nezahualcoyotl, famed poet, philosopher, and engineer, who had also a leading military role in the war against the Tepanecs.

Texcoco, Lake: Large lake in the Valley of Mexico. It consisted of five interconnected lakes: three had saline water, Lakes Zumpango, Xaltocan, and Texcoco; two had fresh water, Lakes Xochimilco and Chalco, which included the chinampa region. The process of turning the lake into dry land—which began with the building of Tenochtitlán, the creation of chinampas in the south, the filling in of the canals by the conquerors' destruction, and periodic draining projects in the 17th and 18th centuries—was nearly completed in this century with the draining of most of the rest of the lake. Only a small part of Lake Xochimilco survives today.

Tezcatlipoca: "Smoking mirror," a powerful deity having many aspects. As a god of sorcery, fate, and divination, he wears the mirrors used in divination in his headdress and in place of his left foot, lost in a struggle with the earth monster during the creation of the world. As a god of chance, he could bring discord and disaster to men, or bestow wealth and honor. His aspects include Tepeyollotl and Huitzilopochtli. Tezcatlipoca was a major deity of the divinatory almanac and a patron of the Aztec ruler.

Tezozomoc (1): Ruthless and brilliant king of the Tepanecs (r. c.1366–1426). Under his rule Atzcapotzalco became the most powerful city in the Valley of Mexico. The Mexica, after they founded Tenochtitlán, became his vassals and served as mercenaries. Tezozomoc was unable to consolidate his empire, and after his death it fell to the alliance formed by cities which had been subject to his rule.

Tezozomoc, Hernando Alvarado (b. c.1525–30) (2): Descendant of the Mexica royal house, Tezozomoc recorded the historical traditions of his family in the Crónica Mexicana (after 1598) and in the Nahuatl work Crónica Mexicayotl (1609).

Tizoc: Seventh Aztec emperor (r. 1481–1486), brother of Axayacatl and Ahuitzotl. Apparently a weak ruler; an unsuccessful warrior who was unable to take captives to celebrate his own coronation. Possibly poisoned by Ahuitzotl, who succeeded him. He initiated a major renovation of the Temple of Huitzilopochtli, completed by Ahuitzotl.

Tlacaelel: Long-lived and politically brilliant counsellor or *cihuacoatl* to five Aztec emperors: Itzcoatl, Motecuhzoma I, Axayacatl, Tizoc, and Ahuitzotl. A nephew of the third Aztec emperor, Chimalpopoca, Tlacaelel had an important role in the victory over the Tepanecs, and was the major architect of the Aztec state that subsequently emerged. He is credited with spurring the development of the elite warrior classes, and with planning the temple precinct at Tenochtitlán and the mass sacrifices held there to instill awe in subject peoples.

Tlacaxipehualiztli: "Feast of the flaying of men," one of the eighteen monthly festivals of the solar year. Rites that included gladiatorial sacrifice and flaying of victims were often interpreted as marking the renewal in spring of the earth's vegetation.

Tlacopan: The junior member of the Triple Alliance (*q.v.*), this city stood at the end of one of the three great causeways of Tenochtitlán, on the site of today's city of Tacuba.

Tlahuizcalpantecuhtli: "Dawn lord," deity of the planet Venus in its aspect as the morning or evening star, also an aspect of Quetzalcoatl; an important deity of the divinatory almanac.

Tlailotlaque: "Those who have returned," a group of artisans who went to the Mixteca to learn the skills of writing and painting manuscripts, and returned to settle in Texcoco.

Tlalmanalco: City located near, and allied to, the *chinampa* city of Chalco.

Tlaloc: God of rain, his name was probably derived from the word for earth, "tlalli." He was the most important fertility deity; half of the Main Temple of Tenochtitlán was dedicated to him, and many festivals honored him. He was associated with mountains, clouds, serpents, hail, lightning, and floods. The Aztecs considered him to be an ancient god, associated with the Toltecs. His characteristic appearance included rings or "goggles" around the eyes, and a fanged mouth.

Tlalocan: "Place of Tlaloc," paradise associated with Tlaloc; certain souls, especially of those who had drowned, went there after death.

Tlaltecuhtli: "Lord of the earth," the earth monster, a crocodilian or toadlike monster, devourer of sacrificial victims.

Tlatelolco: Founded in 1357 by a group which had split from the Mexica. Tenochtitlán and Tlatelolco underwent nearly parallel developments, though Tlatelolco's great market brought it more commercial activity. After 1473, when Tlatelolco was defeated in the civil war, Tenochtitlán took over the market.

tlatoani: "He who speaks," the ruler of the Aztec state, the emperor who governed with a council of four (including the *cihuacoatl*). The office was hereditary, but each new ruler had to be approved by the council.

Tlaxcala: City of Nahuatl-speaking persons southeast of the Valley of Mexico. Bitter enemies of the Mexica, the Aztec empire kept them unconquered and used them as adversaries in "flowery wars," ceremonial wars to gain captives. The Tlaxcalans were important allies of Cortés during the conquest.

Tlazolteotl: "Goddess of filth," a goddess of fertility and lust, who inspired men to carnal sins; her priests could hear confessions and absolve sinners. Often called "eater of filth."

Toci: "Our grandmother," a goddess of the earth and fertility, honored in the harvest festival Ochpaniztli (*q.v.*).

Toltec: Inhabitants of Tula, a city north of the Valley of Mexico that flourished in the 9th to 11th centuries. For the Aztecs, the Toltecs symbolized the civilization of the past, practices the Aztecs adopted after migrating into the Valley of Mexico. To establish their right to rule, Aztec dynastic families claimed descent from Toltec royalty, particularly through the ruling house of Culhuacan. The Aztecs did not distinguish between the Tula and Teotihuacán civilizations, and called both "Toltec." "Toltec" was a praise-name for a fine artist or craftsman.

Tonacatecuhtli: "Lord of Sustenance," a creator divinity identified with Ometeotl (*q.v.*). Husband of Tonacacihuitl.

tonalamatl: "Book of days," the divinatory almanac giving the gods and auguries of the 260

days (20 periods of 13 days each). Utilized by the priests and diviners to name children and predict their fates, and to advise on auspicious times for various undertakings.

Tonantzin: "Little mother," the earth-mother goddess; her temple at Tepeyacac is now the location of the shrine of the Virgin of Guadalupe.

Tonatiuh: The sun god, ruler of the daytime sky, who required human sacrifice to keep moving in his course and prevent darkness from engulfing the world. The warrior deity Huitzilopochtli was identified with the sun, and the spirits of warriors accompanied Tonatiuh in his daily passage across the sky.

Triple Alliance: After a successful revolt of the vassal cities against the Tepanec kingdom in 1428, three important cities banded together to form an alliance. As formalized under Motecuhzoma I, Tenochtitlán retained military power over Texcoco and Tlacopan, and grew to be the dominant power in the Aztec empire, but all three retained theoretical sovereignty.

Tula: Site north of the Valley of Mexico, in the present State of Hidalgo; Tula, the city of the Toltecs, was the home of the mythical deity-kings Quetzalcoatl and Tezcatlipoca, and it flourished in the 10th to 12th centuries. The Aztecs laid claim to their own legitimacy through descent from its royal house via Culhuacan. Migration myths include descriptions of a stop at Tula. The Aztecs imitated Toltec sculptures either directly, as in the *chac mool,* or by referring indirectly to Toltec arts in their major monuments.

tzitzimime: Female demons with skeletal features who, it was believed, would appear at the end of the world to devour men.

Xaltocan, Lake: One of the two saline bodies of water that formed the northern section of Lake Texcoco.

Xipe Totec: "Our lord, the flayed one," deity associated with spring and fertility, and with success in warfare. Flaying of sacrificial victims was an ancient and widespread practice in Mesoamerica, associated with the renewal of the earth's vegetation in the spring. Tlacaxipehualiztli, his festival month, symbolized this and was also an important martial occasion. His insignia, including a pointed cap and rattle staff, was the war costume of the Mexica emperor. He was patron of lapidaries and metalworkers.

Xiuhcoatl: "Fire serpent," mythical beast that signified the dry season and was believed to carry the sun across the daytime sky. The fire serpent was also a weapon and symbol of office carried by deities, particularly Huitzilopochtli and Xiuhtecuhtli (*qq.v.*).

Xiuhtecuhtli: "Turquoise lord," the old god of fire, an ancient and widespread Mesoamerican deity often depicted as an aged toothless and bearded man. The eldest of the gods, a creator deity merged with Ometeotl (*q.v.*), he was a special patron of rulers.

Xochicalco: Site southwest of Cuernavaca, whose major monuments belong to the late Classic period. These include a Maya-style ball court; a platform temple whose architecture shows Teotihuacán influence, while the reliefs of a feathered serpent and other figures show Classic Veracruz and Maya influence; and three stelae which are probably the earliest true stelae in central Mexico. Xochicalco appears to have been a point where aspects of Classic cultures converged, and perhaps these came to Tula by this avenue. The Aztecs may have believed that Tamoanchan was the ruined city of Xochicalco.

Xochimilco: City on Lake Xochimilco, one of the two southern freshwater sections of Lake Texcoco. Xochimilco was the major city of the *chinampa* area, the most productive agricultural region of the Valley of Mexico. Its patroness was the fire goddess Chantico.

Xochipilli: "Prince of flowers," youthful solar god, a patron of feasting, music, and poetry, and sexual pleasure. He was associated with flowers, butterflies, and monkeys.

Xochiquetzal: "Flower-quetzalbird," female counterpart of Xochipilli; goddess of sexual love and patroness of prostitutes; also a goddess of drunkenness, and thus related to the Centzon Totochtin (*q.v.*), rabbit deities of inebriation. Her characteristic garb included a quetzalbird helmet with two feathered tufts. Symbolizing feasting and pleasure, she was the embodiment of female beauty.

Xolotl (1): Warlike leader of one of the earliest Chichimec groups to enter the Valley of Mexico; founder of the city of Tenayuca.

Xolotl (2): Deity usually depicted with the head of a dog, the monstrous twin brother of the

god Quetzalcoatl.

year bearers: The days which began the solar years. Each day of the 260-day divinatory calendar had a name, one within a repeating cycle of 20 names, and this divinatory cycle ran concurrently with a 365-day solar year cycle. The day name of the first day of the solar year was the year bearer. Only four day names could be given to a year: Rabbit, Reed, Flintknife, or House.

yoke: Stone copy of a type of equipment used in the Mesoamerican ball game. The U-shaped objects were worn around the waist, apparently as a protective belt.

Yollotlicue: "Heart skirt," the name invented by scholars for the statue resembling that of Coatlicue but wearing a skirt made of hearts rather than plaited serpents.

BIBLIOGRAPHY

ABBREVIATIONS: INAH, Instituto Nacional de Antropología e Historia
UNAM, Universidad Nacional Autonoma de Mexico

ALCOCER, IGNACIO

1927 *Apuntes sobre la antigua Mexico–Tenochtitlán.* Instituto Panamericano de Geografia e Historia, Tacubaya, Mexico.

AGUILERA, CARMEN

1978 *Coyolxauhqui: Ensayo Iconografico.* INAH, Mexico City.

1981 *El Tonalamatl de Aubin.* Tlaxcala, Mexico.

ANAWALT, PATRICIA RIEFF

1981 *Indian Clothing Before Cortés: Mesoamerican Costumes from the Codices.* University of Oklahoma Press, Norman.

ANDERS, FERDINAND

1971 "Las Artes Menores; Minor Arts," *Artes de Mexico,* no. 137, pp. 4–66. Mexico City.

1978 "Der altmexikanische Federmosaikschild in Wien," *Archiv für Völkerkunde,* XXXII, pp. 67–88. Vienna.

ANGULO, JORGE R.

1966 "Una ofrenda en el Templo Mayor de Tenochtitlán," INAH, *Boletín,* 26, pp. 1–6. Mexico City.

AVENI, ANTHONY F.

1975 "Possible Astronomical Orientations in Ancient Mesoamerica," in *Archaeoastronomy in Pre-Columbian America* (Anthony F. Aveni, ed.), pp. 163–90. University of Texas Press, Austin.

BARLOW, ROBERT H.

1945 "La Crónica X: versiones coloniales de la historia de los Mexica Tenocha," *Revista Mexicana de Estudios Antropológicos,* 7, pp. 65–87, and 2 plates. Mexico City.

1949 "The Extent of the Empire of the Culhua Mexica," *Ibero-Americana,* 28. University of California Press, Berkeley.

1950 "Una nueva lámina del Mapa Quinatzin," *Journal de la Société des Américanistes,* n.s. 39, pp. 111–24. Paris.

BARLOW, ROBERT H., AND HENRI LEHMANN

1956 "Statuettes—Grelots Aztèques de la Vallé de Mexico," *Tribus,* 4–5, pp. 157–76. Museum für Länder und Völkerkunde, Stuttgart.

BATRES, LEOPOLDO

1902 *Exploraciones arqueológicas en la Calle de Escalerillas.* Mexico City.

Bellas Artes

1980 *El arte del Templo Mayor.* INAH, Museo del Palacio de Bellas Artes, Mexico City.

BERDAN, FRANCES FREI

1980 Commentary to the *Matrícula de Tributos "Codice de Moctezuma"* (Museo Nacional de Antropología e Historia, Codice 35–52). Akademische Druck- und Verlagsanstalt, Graz, Austria.

BERNAL, IGNACIO

1968 *3000 Years of Art and Life in Mexico, as seen in the National Museum of Anthropology, Mexico City* (Ignacio Bernal, with Roman Pina-Chan and Fernando Barbachano; Carolyn B. Czitrom, trans.). New York.

1975 *Mexico Before Cortés: Art, History, Legend* (Willis Barnstone, trans.). Rev. edition. New York.

BEYER, HERMANN

1921 "La lapida commemorativa de la inauguracion del Templo Mayor de Mexico," *Revista de Revistas.* Mexico City.

1922 "El llamada 'Calendario Azteca': Descripción e interpretación del cuauhxicalli de la 'Casa de las Aguilas,'" *El Mexico Antiguo*, X, pp. 154–256. Mexico City (repr. 1965).

1925 "El origen, desarrollo y significado de la greca escalonada," *El Mexico Antiguo*, II, pp. 61–122. Mexico City.

1955 "La 'procesión de los señores,' decoración del primer teocalli de piedra en Mexico-Tenochtitlán," *El Mexico Antiguo*, VIII, pp. 1–65. Mexico City.

BIERHORST, JOHN (ED.)

1974 *Four Masterworks of American Indian Literature.* New York.

BOBRY, ANITA

n.d. "The Colossal Stone Head of the Aztec Goddess Coyolxauhqui: An Image of Conquest," Master's essay, Department of Art History and Archaeology, Columbia University, New York, 1976.

BOONE, ELIZABETH HILL

n.d. "A Re-evaluation of the Coatlicue," lecture presented at the University of Texas, Austin, 1973.

1977 *The Prototype of the Magliabechiano Manuscripts: The Reconstruction of a Sixteenth-Century Pictorial Codex from Central Mexico.* Ph. D. dissertation, Department of Art History, University of Texas, Austin.

BRODA, JOHANNA

1969 "The Mexican Calendar as Compared to Other Mesoamerican Systems," *Acta Ethnologica et Linguistica*, 15. Vienna.

1970a "Tlacaxipeualiztli: A Reconstruction of an Aztec Calendar Festival from Sixteenth-Century Sources," *Revista Española de Antropología Americana*, 5, pp. 197–274. Madrid.

1970b "El tributo en trajes guerreros y la estructura del sistema tributario Mexica," in *Economía Política e Ideología en el México Prehispánico* (Pedro Carrasco and Johanna Broda, eds.), pp. 115–74. INAH, Mexico City.

1971 "Las fiestas Aztecas de los dioses de la lluvia: Una reconstrucción segun las fuentes del siglo XVI," *Revista Española de Antropología Americana*, 6, pp. 245–327. Madrid.

BROWN, BETTY ANN

1977 *European Influences in the Early Colonial Descriptions and Illustrations of the Mexica Monthly Calendar.* Ph. D. dissertation, Department of Art History, University of New Mexico, Albuquerque.

BRUNDAGE, BURR CARTWRIGHT

1972 *A Rain of Darts: The Mexica Aztecs.* University of Texas Press, Austin.

BRUSH, ELLEN S.

1968 *The Archaeological Significance of Ceramic Figurines from Guerrero, Mexico.* Ph.D.

dissertation, Department of Anthropology, Columbia University, New York.

CAHUANTZI, PROSPERO

1939 *Lienzo de Tlaxcala: Manuscrito pictorico de mediados del siglo XVI Mexico*. Libreria Anticuaria de G. M. Echaniz (text by Mazincatzin, 1927), 15. Mexico City.

CALBERG, MARGUERITE

1939 "Le manteau de plumes dit 'de Montezuma,'" Société des Américanistes de Belgique, *Bulletin*, XXX, pp. 103–33. Brussels.

CALNEK, EDWARD E.

1971 "Settlement Patterns and Chinampa Agriculture at Tenochtitlán," *American Antiquity*, 37, pp. 104–15. Menasha, Wisconsin.

1976 "The Internal Structure of Tenochtitlán," in *The Valley of Mexico* (Eric R. Wolf, ed.), pp. 287–302. University of New Mexico Press, Albuquerque.

CARMICHAEL, ELIZABETH

1970 *Turquoise Mosaics from Mexico*. The British Museum, London.

CARRASCO, PEDRO

1971 "Social Organization of Ancient Mexico," in *Handbook of Middle American Indians* (Robert Wauchope, gen. ed.; Gordon S. Ekholm and Ignacio Bernal, vol. eds.), vol. 10, *The Archaeology of Northern Mesoamerica*, part 2, pp. 349–75. University of Texas Press, Austin.

1976 *Estratificación social en la Mesoamerica prehispanica*. INAH, Centro de Investigaciones Superiores, Mexico City.

CARRASCO, PEDRO, AND JOHANNA BRODA (EDS.)

1978 *Economía Política e Ideología en el México Prehispánico*. INAH, Centro de Investigaciones Superiores, Mexico City.

CARRERA, MAGALI M.

1979 *The Representation of Women in Aztec-Mexica Sculpture*. Ph.D. dissertation, Department of Art History and Archaeology, Columbia University, New York.

CASO, ALFONSO

1927 "El teocalli de la guerra sagrada." Museo Nacional de Arqueología, Historia y Etnografía, *Monografías*, Mexico City.

1956 "Los barrios antiguos de Tenochtitlán y Tlatelolco," Academia Mexicana de la Historia, *Memorias*, 15 (1); pp. 7–63. Mexico City.

1958 *The Aztecs: People of the Sun* (Lowell Dunham, trans.). University of Oklahoma Press, Norman.

1967 "Los Calendarios Prehispanicos." UNAM, Instituto de Investagaciones Historicas, Cultura Nahuatl, *Monografías*, 6, Mexico City.

CASTAÑEDA, DANIEL, AND VINCENTE T. MENDOZA

1933a "Los huehuetls en las civilizaciones precortesianas," Museo Nacional de Arqueología, Historia y Etnografía, *Anales*, 8 (ser. 4a), pp. 287–310. Mexico City.

1933b "Los teponaztlis en las civilizaciones precortesianas," Museo Nacional de Arqueología, Historia y Etnografía, *Anales*, 8 (ser. 4b), pp. 5–80. Mexico City.

CASTILLO TEJERO, NOEMI, AND FELIPE SOLÍS OLGUÍN

1975 "Ofrendas mexicanas en el Museo Nacional de Antropología," *Corpus Antiquitatum Americanensium*, 8. INAH, Mexico City.

CHARLTON, T. H.

1968 "Post-Conquest Aztec Ceramics: Implications for Archaeological Interpretation," *The Florida Anthropologist*, 21, pp. 96–101. Gainesville.

CLARK, JAMES COOPER

1938 *Codex Mendoza. The Mexican manuscript known as the Collection of Mendoza and preserved in the Bodleian Library, Oxford* (James Cooper Clark, ed. and trans.). 3 vols. London.

COE, MICHAEL D.

1966 *The Maya*. New York.

1977 *Mexico*. 2nd edition. New York.

COHODAS, MARVIN

1974 "The Iconography of the Panels of the Sun, Cross and Foliated Cross at Palenque: Part II," in *Primera Mesa Redonda de Palenque* (Merle Green Robertson, ed.), part 1, pp. 95–108. The Robert Louis Stevenson School, Pebble Beach, California.

COLUMBUS, CHRISTOPHER

1968 *The Journals of Christopher Columbus* (Cecil Jane, trans.). London.

CONWAY, WILLIAM MARTIN

1889 *Literary Remains of Albrecht Dürer* (W. M. Conway, ed. and trans.). Cambridge University Press, Cambridge, England.

COOK DE LEONARD, CARMEN

1950 "Figurillas de Barro de Santiago Tlatelolco," Academia Mexicana de la Historia, *Memorias*, 9 (1), pp. 93–100 (Tlatelolco a Través de los Tiempos). Mexico City.

CORTÉS, HERNÁN

1971 *Hernán Cortés: Letters from Mexico* (Anthony R. Pagden, ed. and trans.). New York.

COUCH, N. C. CHRISTOPHER

n.d. "The Festival Cycle of the Aztec Codex Borbonicus," Master's essay, Department of Art History and Archaeology, Columbia University, New York, 1980.

DAVIES, NIGEL

1973 *The Aztecs: A History*. New York.

DÍAZ DEL CASTILLO, BERNAL

1963 *The Conquest of New Spain* (John M. Cohen, trans.). New York.

DIBBLE, CHARLES E.

1971 "Writing in Central Mexico," in *Handbook of Middle American Indians* (Robert Wauchope, gen. ed.; Gordon S. Ekholm and Ignacio Bernal, vol. eds.), vol. 10, *The Archaeology of Northern Mesoamerica*, part 1, pp. 322–32. University of Texas Press, Austin.

DURÁN, DIEGO

1964 *The Aztecs: The History of the Indies of New Spain* (Doris Heyden and Fernando Horcasitas, trans.). New York.

1971 *Book of the Gods and Rites and the Ancient Calendar* (Fernando Horcasitas and Doris Heyden, trans.). University of Oklahoma Press, Norman.

DURAND-FOREST, JACQUELINE

1971 "Cambios economicos y moneda entre los Aztecas," *Estudios de Cultura Nahuatl*, 9, pp. 105–24. Mexico City.

1979 "Tlaloc: Dieu au Double Visage," 42nd International Congress of Americanists, *Proceedings*, 6 (1976), pp. 119–26. Paris.

EASBY, ELIZABETH K., AND JOHN F. SCOTT

1970 *Before Cortés: Sculpture of Middle America*. Metropolitan Museum of Art, New York.

EDMONSON, MUNRO S. (ED.)

1974 *Sixteenth-Century Mexico: The Work of Sahagún*. School of American Research, University of New Mexico Press, Albuquerque.

EKHOLM, GORDON F.

1964 "The Problem of Fakes in Pre-Columbian Art," *Curator*, VII (1), pp. 19–32. American Museum of Natural History, New York.

FERNÁNDEZ, JOSEFINA BARRERA

1965 "El arte textil entre los Nahuas," *Estudios de Cultura Nahuatl*, 5, pp. 143–52. Mexico City.

FERNÁNDEZ, JUSTINO

1954 *Coatlicue, estética del arte indígena antigua*. Centro de Estudios Filosóficos, Mexico City.

FIELD, FREDERICK V.

1967 "Thoughts on the Meaning and Use of Pre-Hispanic Mexican Sellos," *Studies in Pre-Columbian Art and Archaeology*, No. 3. Dumbarton Oaks, Washington, D.C.

1974 *Pre-Hispanic Mexican Stamp Designs*. New York.

FRANCO C., JOSÉ LUIS

1945 "Comentarios sobre tipología y filogenía de la decoración negra sobre color natural del barro en la ceramica Azteca II," *Revista Mexicana de Estudios Antropológicos*, 7, pp. 163–86. Mexico City.

1949 "Algunos problemas relativos a la ceramica Azteca," *El Mexico Antiguo*, VII, pp. 162–208. Mexico City.

FUENTES, PATRICIA DE

1963 *The Conquistadors, First-Person Accounts of the Conquest of Mexico* (P. de Fuentes, ed. and intro.). New York.

GALARZA, JOAQUIN

1980 *Estudios de escritura indigena tradicional Azteca-Nahuatl.* Archivo General de la Nación, INAH, Centro de Investigaciones Superiores, Mexico City.

GARCÍA COOK, ANGEL, AND RAUL M. ARANA A.

1978 *Rescate arqueológico del monolito Coyolxauhqui, informe preliminar.* INAH, Mexico City.

GIBSON, CHARLES

1964 *The Aztecs Under Spanish Rule: A History of the Indians of the Valley of Mexico.* Stanford University Press, Stanford, California.

GIMENEZ, GILBERTO

1978 *Cultura Popular y Religion en Anahuac.* Centro de Estudios Ecumenicos, Mexico City.

GIRARD, RAFAEL

1966 *Los Mayas, su civilización, su historia, sus vinculaciones continentales.* Mexico City.

GLASS, JOHN B., WITH DONALD ROBERTSON

1975 "A Census of Native Middle American Pictorial Manuscripts," in *Handbook of Middle American Indians* (Robert Wauchope, gen. ed.; Howard F. Cline, vol. ed.), vol. 14, pp. 3–80. University of Texas Press, Austin.

GONZALEZ APARICIO, LUIS

1973 *Plano reconstructivo de la region de Tenochtittán al comienzo de la Conquista.* INAH, Mexico City.

GONZALEZ RUL, FRANCISCO

1964 "Trabajos en Tlatelolco," INAH, *Boletín*, 1 (15), pp. 17–19. Mexico City.

GONZALEZ RUL, FRANCISCO, AND FEDERICO MOOSER

1961 "La Calzada de Ixtapalapa," INAH, *Anales*, 15, pp. 113–19. Mexico City.

GRIFFIN, JAMES B., AND ANTONIETA ESPEJO

1950 "La alfarería correspondiente al último período de ocupación nahua del Valle de Mexico: 2," Academia Mexicana de la Historia, *Memorias*, 11, pp. 5–66 (Tlatelolco a Través de los Tiempos). Mexico City.

GUSSINYER, J.

1970 "Un adoratorio dedicado a Tlaloc," INAH, *Boletín*, 39, pp. 7–12. Mexico City.

HARDOY, JORGE E.

1973 *Pre-Columbian Cities* (Judith Thorne, trans.). New York.

HEYDEN, DORIS

1970 "Deidad del Agua encontrada en el Metro," INAH, *Boletín*, 40, pp. 35–40. Mexico City.

1973 "Xiuhtecuhtli, investidor de soberanos," INAH, *Boletín*, 11 (3), pp. 3–10. Mexico City.

1979 "Flores, creencias, el control social," 42nd International Congress of Americanists, *Proceedings*, 6 (1976), pp. 85–97. Paris.

HORCASITAS, FERNANDO

1979 *The Aztecs, Then and Now.* Mexico City.

HOYO, EUGENIO DEL

1957 "Ensayo Historiográfico sobre D. Fernando de Alva Ixtlilxochitl," Academia Mexicana de la Historia, *Memorias*, 16 (4), pp. 339–60. Mexico City.

HUNT, EVA

1977 *The Transformation of the Hummingbird, Cultural Roots of a Zinacantecan Mythical Poem.* Cornell University Press, Ithaca.

HVIDTFELDT, A.
1958 *Teotl and Ixiptlatli: Some Central Conceptions in Ancient Mexican Religion*. Copenhagen.

KAPLAN, FLORA
n.d. "The Post-Classic Figurines of Central Mexico," Master's essay, Department of Anthropology, Columbia University, New York, 1958.

KIRCHHOFF, PAUL
1949–50 "The Mexican Calendar and the Founding of Tenochtitlán-Tlatelolco," The New York Academy of Sciences, *Transactions*, ser. 2, 12(4), pp. 126–32. New York.

KLEIN, CECELIA F.
n.d. "Rethinking Cihuacoatl: Aztec Political Imagery of the Conquered Woman," lecture presented at the 43rd International Congress of Americanists, Vancouver, British Columbia, 1979.
1976a *The Face of the Earth: Frontality in Two-Dimensional Mesoamerican Art*. Ph.D. dissertation, Department of Art History and Archaeology, Columbia University, New York (published by Garland Publications, New York).
1976b "The Identity of the Central Deity on the Aztec Calendar Stone," *Art Bulletin*, LVIII, pp. 1–12. New York.

KRICKEBERG, WALTER
1949 *Felsplastik und Felsbilder bei den Kulturvolkern Altamerikas*, vol. 1. Berlin.
1960 "Xochipilli und Chalchiuhtlicue," *Baessler Archiv*, n.s. VIII, pp. 1–30. Berlin.
1969 *Felsplastik und Felsbilder bei den Kulturvolkern Altamerikas*, vol. 2. Berlin.

KUBLER, GEORGE
1943 "The Cycle of Life and Death in Metropolitan Aztec Sculpture," *Gazette des Beaux-Arts*, 23, pp. 257–68. Paris.
1973 "Science and Humanism Among Americanists," in *The Iconography of Middle American Sculpture*, pp. 163–67. The Metropolitan Museum of Art, New York.
1975 *The Art and Architecture of Ancient America: The Mexican, Maya, and Andean Peoples*. Pelican History of Art, 2nd edition. Baltimore.

KUBLER, GEORGE, AND CHARLES GIBSON
1951 "The Tovar Calendar," Connecticut Academy of Science, *Memoirs*, XII. New Haven.

LAFAYE, JACQUES
1976 *Quetzalcoatl and Guadalupe: The Formation of Mexican National Consciousness, 1531–1851* (foreword by Octavio Paz; B. Keen, trans.). University of Chicago Press.

LEÓN-PORTILLA, MIGUEL
1962 *Broken Spears: The Aztec Account of the Conquest of Mexico*. Boston.
1969 *Pre-Columbian Literatures of Mexico* (Grace Lobanov and Miguel León-Portilla, trans.). University of Oklahoma Press, Norman.
1971 *Aztec Thought and Culture: A Study of the Ancient Nahuatl Mind* (Jack Emory Davis, trans.). University of Oklahoma Press, Norman.
1978 *Trece Poetas del Mundo Azteca*. UNAM, Instituto de Investigaciones Historicas, Mexico City.

LEON Y GAMA, ANTONIO
1972 *Descripción Histórica y Cronológica de las Dos Piedras que con ocasión del nuevo empedrado que se está formando en la Plaza Principal de México se Hallaron en ella en el año 1790*. Imprenta de D. Felipe Zuñiga y Ontiveros, Mexico City.

LITVAK KING, JAIME
1971 *Cihuatlán y Tepecoacuilco, provincias tributarias de Mexico en el siglo XVI*. UNAM, Instituto de Investigaciones Historicas, Mexico City.

LOMBARDO DE RUIZ, SONIA
1973 *Desarollo urbano de Mexico-Tenochtitlán segun las fuentes históricas*. INAH, Mexico City.

LÓPEZ AUSTIN, ALFREDO
n.d. "Iconografia Mexica, El monolito verde del Templo Mayor," lecture presented at the second Congreso Interno del Instituto de Investigaciones Antropológicas, UNAM, Mexico City, 1978.
1973 *Hombre-Dios, religión y política en el mundo náhuatl*. UNAM, Mexico City.

Lopez de Gómara, Francisco
 1964 *Cortés: The Life of the Conqueror by His Secretary* (Lesley Byrd Simpson, ed. and trans.). University of California Press, Berkeley.

Madsen, William
 1960 *The Virgin's Children: Life in an Aztec Village Today*. Austin, Texas.
 1969 "The Nahua," in *Handbook of Middle American Indians* (Robert Wauchope, gen. ed.; Evon Z. Vogt, vol. ed.), vol. 8, *Ethnology*, part 2, pp. 602–37. University of Texas Press, Austin.

Marquina, Ignacio
 1960 *El Templo Mayor de Mexico*. INAH, Mexico City.
 1964 *Arquitectura Prehispanica*. Mexico City.

Martínez, José Luis
 1972 *Nezahualcoyotl: vida y obra*. Fondo de Cultura Economico, Mexico City.

Matos Moctezuma, Eduardo
 1978 "El Proyecto Templo Mayor," INAH, *Boletín*, III (24), pp. 3–17. Mexico City.
 1979 *Trabajos Arqueologicos en el Centro de la Ciudad de Mexico (Antología)*. INAH, Secretaría de Educación Pública, Mexico City.
 1981 *Una visita al Templo Mayor de Tenochtitlán*. INAH, Mexico City.

Millian, Alva C.
 n.d. "The Iconography of Aztec Ceramic Figurines," Master's essay, Department of Art History and Archaeology, Columbia University, New York, 1981.

Motolinía, Fray Toribio de Benavente
 1950 *Motolinía's History of the Indians of New Spain* (Elizabeth Andros Foster, trans.), in *Documents and Narratives Concerning the Discovery and Conquest of Latin America*, n.s. 4. Cortés Society, Berkeley, California.

Navarrete, Carlos, and Doris Heyden
 1974 "La Cara central de la piedra del sol: una hipotesis," *Estudios de la Cultura Nahuatl*, XI, pp. 355–76. Mexico City.

Nicholson, Henry B.
 n.d. "Aztec Style Calendric Inscriptions of Possible Historical Significance: A Survey," lecture presented at the Mesa Redonda on Calendric Problems of Ancient Central Mexico, Chapultepec, Mexico, 1955.
 1957 *Topiltzin Quetzalcoatl of Tollan: A Problem in Mesoamerican Ethnohistory*. Ph.D. dissertation, Department of Anthropology, Harvard University, Cambridge, Massachusetts.
 1961 "The Chapultepec Cliff Sculpture of Motecuhzoma Xocoyotzin," *El Mexico Antiguo*, 9, pp. 379–444. Mexico City.
 1963 "An Aztec Stone Image of a Fertility Goddess," *Baessler Archiv*, n.s. 11, pp. 9–29. Berlin.
 1966 "The Mixteca-Puebla Concept in Mesoamerican Archaeology: A Re-examination," in *Ancient Mesoamerica, Selected Readings* (John A. Graham, ed.), pp. 258–63. Palo Alto, California.
 1967 "A Fragment of an Aztec Relief Carving of the Earth Monster," *Journal de la Société des Amèricanistes*, 16, pp. 81–94. Paris.
 1971a "Major Sculpture in Pre-Hispanic Central Mexico," in *Handbook of Middle American Indians* (Robert Wauchope, gen. ed., Gordon S. Ekholm and Ignacio Bernal, vol. eds.), vol. 10, *The Archaeology of Northern Mesoamerica*, part 1, pp. 92–134. University of Texas Press, Austin.
 1971b "Religion in Pre-Hispanic Central Mexico," in *Handbook of Middle American Indians* (Robert Wauchope, gen. ed.; Gordon S. Ekholm and Ignacio Bernal, vol. eds.), vol. 10, *The Archaeology of Northern Mesoamerica*, part 1, pp. 395–446. University of Texas Press, Austin.
 1973 "Phoneticism in the Late Pre-Hispanic Central Mexican Writing System," in *Meso-american Writing Systems* (Elizabeth P. Benson, ed.), pp. 1–46. Dumbarton Oaks, Washington, D.C.

1974 "Some Remarks on the Provenience of the Codex Borbonicus," *Adeva-Mitteilungen*, 40, pp. 14–18. Akademische Druck- und Verlagsanstalt, Graz, Austria.

in press "The New Tenochtitlán Templo Mayor Coyolxauhqui-Chantico Monument," *Kutscher Festschrift*.

NICHOLSON, HENRY B., AND RAINER BERGER

1968 "Two Aztec Wood Idols: Iconographic and Chronologic Analysis," *Studies in Pre-Columbian Art and Archaeology*, No. 5. Dumbarton Oaks, Washington, D.C.

NOGUERA, EDUARDO

1968 "Ceremonias del Fuego Nuevo," *Cuadernos Americanos*, año XXVIII, vol. CLVIII (3), pp. 146–51. Mexico City.

1975 *La cerámica arqueológica de Mesoamerica*. UNAM, Mexico City.

NOGUEZ RAMIREZ, FRANCISCO XAVIER

n.d. "Huetlatoani y su Relacion con el Complejo del Dios del Fuego Xiuhtecuhtli," Thesis, UNAM, Mexico City, 1971.

NOWOTNY, KARL ANTON

1960 *Mexikanische Kostarbeiten aus Kunstkammern der Renaissance im Museum für Völkerkunde Wien und in der Nationalbibliothek Wien*. Museum für Völkerkunde, Vienna.

NUTTALL, ZELIA

1892 "On Ancient Mexican Shields," *International Archives of Ethnography*, V, pp. 34–53. Leiden, The Netherlands.

OROZCO Y BERRA, MANUEL

1877 "El Cuauhxicalli de Tizoc," Museo Nacional de Mexico, *Anales*, I, pp. 3–39. Mexico City.

PADDEN, R. C.

1967 *The Hummingbird and the Hawk, Conquest and Sovereignty in the Valley of Mexico, 1503–1541*. Ohio State University Press, Columbus.

PALACIOS, ENRIQUE JUAN

1929 "La piedra del escudo nacional de Mexico," Secretaría de Educación Pública, *Publicaciones*, XXII (9). Mexico City.

PARIS

1981–82 *Mexique d'hier et d'aujourd'hui: Découverte du Templo Mayor de Mexico; Artistes contemporains*. Exhibition catalogue, Ministère des Relations Extérieures, Paris.

PARSONS, JEFFREY R.

1966 *The Aztec Ceramic Sequence in the Teotihuacán Valley, Mexico*. Ph.D. dissertation, Department of Anthropology, University of Michigan, Ann Arbor.

1971 "Prehistoric Settlement Patterns in the Texcoco Region, Mexico," Museum of Anthropology, *Memoirs*, no. 3. University of Michigan, Ann Arbor.

PARSONS, MARY H.

1972 "Aztec Figurines from the Teotihuacán Valley," *Miscellaneous Studies in Mexican Prehistory*, 45, pp. 81–170. Museum of Anthropology, University of Michigan, Ann Arbor.

n.d. "Aztec Figurines: A Look at Their Function and Distribution," lecture presented at the University Seminar on Primitive and Pre-Columbian Art, Columbia University, New York, 1981.

PASO Y TRONCOSO, FRANCISCO DEL

1898 *Descripción, historia y exposición del códice pictório de los antiguos Nahuas que se conserva en la Biblioteca de la Cámara de Diputados de París*. Florence, Italy.

PASZTORY, ESTHER

n.d. "The Aztec Tlaloc: God of Water and Antiquity," lecture presented at the 43rd International Congress of Americanists, Vancouver, British Columbia, 1979.

1974 "The Iconography of the Teotihuacán Tlaloc," *Studies in Pre-Columbian Art and Archaeology*, No. 15. Dumbarton Oaks, Washington, D.C.

1976 *Aztec Stone Sculpture*, ed. Center for Inter-American Relations, New York.

1980 "Masterpieces in Pre-Columbian Art," 42nd International Congress of Americanists, *Proceedings*, 7 (1976), pp. 377–90. Paris.

in press "El arte azteca y la conquista española," *Estudios de Cultura Nahuatl,* Mexico City.

PHELAN, J. L.

1956 "The Millennial Kingdom of the Franciscans in the New World: A Study of the Writing of Geronimo de Mendieta (1525–1604)," *University of California Publications in History,* No. 52. University of California Press, Berkeley.

POLLOCK, H. E. D.

1936 "Round Structures of Aboriginal Middle America," *Carnegie Institution of Washington Publication No. 471.* Washington, D.C.

PRESCOTT, WILLIAM H.

1931 *The Conquest of Mexico* (1844). New York.

PREUSS, KONRAD T.

1901 "Mexikanische Thonfiguren," *Globus,* 79 (6), pp. 85–91. Braunschweig, Germany.

RADIN, PAUL

1920 "The Sources and Authenticity of the History of the Ancient Mexicans," *University of California Publications in American Archaeology and Ethnology,* 17, pp. 1–150. Berkeley.

REYES CORTÉS, MANUEL

1978 "Estratigrafía del área Templo Mayor–Catedral Metropolitana," INAH, *Boletín,* III (24), pp. 52–71. Mexico City.

ROBERTSON, DONALD

1959 *Mexican Manuscript Painting of the Early Colonial Period: The Metropolitan Schools.* Yale University Press, New Haven.

ROBERTSON, JANICE LYNN

n.d. "Glyphs in the Codex Mendoza: The Language of the Glyphs," Master's essay, Department of Art History and Archaeology, Columbia University, New York, 1983.

ROSS, KURT

1978 *Codex Mendoza, Aztec Manuscript.* Inbourg.

RUBÉN CABRERA, MARIA, ANTONIETA CERVANTES, AND FELIPE SOLÍS OLGUÍN

1975 "Excavaciones en Chapultepec, Mexico, D. F.," INAH, *Boletín,* 15, pp. 35–46. Mexico City.

SAHAGÚN, BERNARDINO DE

1950–78 *Florentine Codex, General History of the Things of New Spain* (Arthur J. O. Anderson and Charles E. Dibble, trans.), no. 14, parts 2–13. The School of American Research and the University of Utah, Santa Fe, New Mexico.

1956 *Historia General de las Cosas de Nueva España* (Angel Maria Garibay K., ed.), 4 vols. Mexico City.

1974 *'Primeros Memoriales' de Fray Bernardino de Sahagún* (Wigberto Jimenez Moreno, trans.). INAH, Consejo de Historia, Colección Científica, 16, Mexico City.

1978 *The War of Conquest, How it Was Waged Here in Mexico. The Aztecs' Own Story as Given to Fr. Bernadino de Sahagún* (Arthur J. O. Anderson and Charles E. Dibble, trans.). University of Utah Press, Salt Lake City.

SANDERS, WILLIAM T., JEFFREY PARSONS, AND ROBERT SANTLEY

1979 *The Basin of Mexico: Ecological Processes in the Evolution of a Civilization.* New York.

SAVILLE, MARSHALL H.

1920 "The Goldsmith's Art in Ancient Mexico," Museum of the American Indian, Heye Foundation, *Indian Notes and Monographs,* No. 7. New York.

1922 "Turquoise Mosaic Art in Ancient Mexico," Museum of the American Indian, Heye Foundation, *Contributions,* No. 6. New York.

1925 *The Woodcarver's Art in Ancient Mexico.* Museum of the American Indian, Heye Foundation, New York.

SELER, EDUARD

1900–01 *The Tonalamatl of the Aubin Collection: An Old Mexican Picture Manuscript in the Paris National Library* (Manuscrits mexicains, no. 18–19). Berlin and London.

1902–23 *Gesammelte Abhandlungen zur amerikanischen Sprach- und Altertumskunde*, 5 vols. Berlin. (Reprinted, Graz, Austria, 1960.)

SOLÍS OLGUÍN, FELIPE

1982 "The Formal Pattern of Anthropomorphic Sculpture and the Ideology of the Aztec State," in *The Art and Iconography of Late Post-Classic Central Mexico* (E. P. Benson and E. H. Boone, eds.), pp. 73–110. Dumbarton Oaks, Washington, D.C.

SOUSTELLE, JACQUES

1970 *Daily Life of the Aztecs on the Eve of the Spanish Conquest* (Jack O'Brien, trans.). Stanford University Press, Stanford, California.

1979 *L'Univers des Aztèques*. Paris.

SULLIVAN, THELMA D.

1963 "Nahuatl Proverbs, Conundrums and Metaphors, Collected by Sahagún," *Estudios de Cultura Nahuatl*, 4, pp. 93–177. Mexico City.

1965 "A Prayer to Tlaloc," *Estudios de Cultura Nahuatl*, 5, pp. 39–55. Mexico City.

1974 "Tlaloc: A New Etymological Interpretation of the God's Name and What It Reveals of His Essence and Nature," 40th International Congress of Americanists, *Proceedings*, 2 (1972), pp. 213–19. Rome.

TAYLOR, DICEY

n.d. "Ceremonial Architecture of the Aztec Period," Master's essay, Department of Art History, Tulane University, New Orleans.

Tenayuca

1935 Estudio arqueológico de la piramide de este lugar hecho por el Departamento de Monumentos de la Secretaría de Educación Pública, Mexico City.

TEZOZOMOC, HERNANDO ALVARADO

1878 *Crónica Mexicana escrita por Hernando Alvarado Tezozomoc hacia el año de MDXCVIII* (Manuel Orozco y Berra, ed.). Mexico City. (Reprinted, 1975.)

THOMPSON, J. ERIC S.

1939 "The Moon Goddess in Middle America, With Notes on Related Deities," *Carnegie Institution of Washington, Publication No. 509*, Contribution 29. Washington, D.C.

TLATELOLCO A TRAVÉS DE LOS TIEMPOS

1944 I, in Academia Mexicana de la Historia, *Memorias*, Mexico City.

1956 II, in Academia Mexicana de la Historia, *Memorias*, Mexico City.

TORQUEMADA, JUAN DE

1969 *Monarquia Indiana* (1723). 4th edition. Mexico City.

TOUSSAINT, MANUEL, FEDERICO GOMEZ DE OROZCO, AND JUSTINO FERNÁNDEZ

1938 *Planos de la ciudad de Mexico, siglos XVI y XVII*. Universidad de Mexico, Instituto de Investigaciones Esteticas, Mexico City.

TOWNSEND, RICHARD F.

n.d. "Sacred Places and the Landscape in Highland Mexico," lecture presented at the University Seminar on Primitive and Pre-Columbian Art, Columbia University, New York, 1978.

1979 "State and Cosmos in the Art of Tenochtitlán," *Studies in Pre-Columbian Art and Archaeology*, No. 20. Dumbarton Oaks, Washington, D.C.

UMBERGER, EMILY G.

1981 *Aztec Sculptures, Hieroglyphs and History*. Ph.D. dissertation, Department of Art History and Archaeology, Columbia University, New York.

VAILLANT, GEORGE C.

1938 "A Correlation of Archaeological and Historical Sequences in the Valley of Mexico," *American Anthropologist*, n.s. 40, pp. 535–73. Menasha, Wisconsin.

1962 *Aztecs of Mexico: Origin, Rise, and Fall of the Aztec Nation*. 2nd edition (rev. Suzannah B. Vaillant). Baltimore.

VEGA SOSA, COSTANZA

1978 "Datos para una cronologia relativa en el area del recinto sagrado de Mexico-Tenochtitlán," INAH, *Boletín*, III (24), pp. 72–79. Mexico City.

1980 *El Recinto Sagrado de Mexico-Tenochlitlán, Excavaciones 1968–69 y 1975–76* (Costanza Vega Sosa, ed.). INAH, Secretaría Educación Pública, Mexico City.

VON HAGEN, VICTOR W.

1944 *The Aztec and Maya Papermakers.* New York.

VON WINNING, HASSO

1961 "A Stone Sculpture of an Aztec Deity," *The Masterkey*, 35, pp. 4–12. Los Angeles.

1968 *Pre-Columbian Art of Mexico and Central America.* New York.

WAUCHOPE, ROBERT (GEN. ED.)

1965 *The Handbook of Middle American Indians*, vols. 2 and 3, *The Archaeology of Southern Mesoamerica* (Gordon Willey, vol. ed.), parts 1 and 2. University of Texas Press, Austin.

1971 *The Handbook of Middle American Indians*, vols. 10 and 11, *The Archaeology of Northern Mesoamerica* (Gordon S. Ekholm and Ignacio Bernal, vol. eds.), parts 1 and 2. University of Texas Press, Austin.

WEAVER, MURIEL PORTER

1981 *The Aztecs, Maya, and Their Predecessors: Archaeology of Mesoamerica.* 2nd edition. New York.

WESTHEIM, PAUL

1965 *The Art of Ancient Mexico* (Ursula Bernard, trans.). Garden City, New York.

WICKE, CHARLES

1976 "Once More Around the Tizoc Stone: A Reconsideration," 41st International Congress of Americanists, *Proceedings*, 2 (1974), pp. 209–22. Mexico City.

WICKE, CHARLES, AND FERNANDO HORCASITAS

1957 "Archaeological Investigations on Monte Tlaloc, Mexico," *Mesoamerican Notes*, 5, pp. 83–95. Mexico City.

WILKERSON, JEFFREY K.

1974 "The Ethnographic Works of Andres de Olmos, Precursor and Contemporary of Sahagún," in *Sixteenth-Century Mexico: The Work of Sahagún* (Munro S. Edmonson, ed.), pp. 27–77. University of New Mexico Press, Albuquerque.

WOLF, ERIC R.

1959 *Sons of the Shaking Earth.* University of Chicago Press, Chicago.

ZANTWIJK, RUDOLF A. M. VAN

1963 "Principios organizadores de los mexicas: una introduccion al estudio del sistema interno del regimen azteca," *Estudios de la Cultura Nahuatl*, 4, pp. 187–222. Mexico City.

INDEX

Deity of Venus, *see* Tlahuizcalpantecuhtli
Deity, War, *see* Huitzilopochtli
Deity, Water, *see* Chalchiutlicue; Tlaloc
Deity, Wind, *see* Ehecatl
designs, 79–80; *Plates 33, 34*
 on textile mantles, 78; *Colorplates 17, 41,*
 42, 44
Díaz del Castillo, Bernal, 18
divination, 66, 193
divinatory almanac, *see* calendar: ritual
dog, 73, 234; *Plates 219, 220*
Dominicans, 19
dough images, 78–79; *Colorplate 18*
drums, 248, 270, 274; *Plates 256, 287–90;*
 Colorplate 51
Durán, Diego, 19, 20

E
eagle, 112, 234, 296; *Plates 223, 279, 313*
 vessels, 254; *Colorplates 46–49*
 See also warriors: eagle and jaguar
Eagle Helmet, Man Wearing, *Plate 207*
eagle on a cactus, 50, 116; *Plate 126;*
 Colorplate 7
earspools, 250; *Plate 261*
earth band, 82
 See also earth monster
earth monster, 58, 81–82, 157, 158, 170,
 236, 254, 255, 258; *Plates 37, 89, 109,*
 113, 117, 130, 132, 133, 140, 216, 250,
 251, 277, 282; Colorplate 48
 as earth band, *Plates 90, 94, 95*
 Greenstone, 151–52; *Plates 97, 98*
 as mask, 155, 175; *Plates 102, 141*
 "Metro," 160–61; *Plate 115*
Eecatontin, 62
Ehecatl, 223; *Plate 237*
 See also Deity with Buccal Mask; Temple
 of Ehecatl
Eight Deer, Codex Nuttall, 46; *Plate 21*
elite, 65–66, 67
 art of, 71, 74–75, 76, 77–78, 90–91, 93,
 124–39, 225, 298–99
 costume of, 69, 78, 206–7, 208, 278–80
 deities and concerns of, 62–64
emblems, 81–84, 236; *Plates 36–44*
excavations
 near Chapultepec, 222
 in Mexico City (Tenochtitlán–Tlatelolco),
 34–35, 104–6, 110–12, 114–15, 140–41;
 Plates 52, 58, 115
 at Tenayuca, 34
 See also offerings

F
fan 280, 292; *Plate 307; Colorplate, page 4*
 See also headdress: of fertility deities
feathered serpent, 82–83, 161–62, 234, 255;
 Plates 41, 54, 86–89, 116, 117, 215–16,
 273
feathers, 76, 90, 93, 109, 146, 207, 278, 280,
 Chapter IX, *passim*
festivals, 61–62, 179–80, 197–98, 210, 211,
 225
 Atamalqualiztli, 62; *Colorplate 10*
 Ochpaniztli, 198, 208; *Colorplate 34*
 Panquetzaliztli, 116, 198; *Colorplate 35*
 Tepeilhuitl, 124
 Tlacaxipehualiztli, 208, 226
 tribute-related, 204
 of Xipe, 112
 Xocotlhuetzi, 78
figurines, 281–91
fire serpent, 83, 116, 138, 172–73, 234;
 Plates 42, 132, 133, 136, 252, 264, 265,
 316
fish, *Plate 229*
Flayed God, *see* Xipe Totec
flea, 234; *Plate 230*
Florentine Codex (Sahagún), 19, 109, 110,
 198; *Plate 11*
flower, 80, 84, 235; *Plates 35 f, 233;*
 Colorplate 31
flower-and-shells emblem, *Plate 165*
flowery war, 52
Franciscans, 16–17, 19
frog, *Plate 227*

G
gladiatorial stone, *see* sacrifice: stones
glyphs, 42, 46, 84–86; *Plates 16, 23, 27–29,*
 45, 46, 93; Colorplates 41–44
 specific glyphs: 1 Flintknife, 168–69, 171;
 2 House, 167; 4 Movement, 60;
 1 Rabbit, 168; 2 Reed, 85
 in Aztec codices, 59–60, 180
 in Aztec stone sculpture, 211, 212
 Maya, 39
 in Mexica monuments, 142, Chapter IV,
 passim
 Mixtec, 46
 name glyphs of Aztec rulers, *Plate 23*
 Xochicalco, 42; *Plate 16*
god-impersonators, *see* Deity: impersonators
Goggle Eyes and Fangs, *see* Deity with
 Goggle Eyes and Fangs
gods and goddesses, *see* Deity, *specific entries*

Peñón de los Baños, 116

period, *see* Classic period; Postclassic
 period; Preclassic period

petroglyphs, *see* reliefs: cliff

Piccadilly, Egyptian Hall exhibition, 140;
 Plate 85

pictographs, *see* glyphs

Piltzintecuhtli, 81

place names, *see* glyphs

plan
 of Aztec cities, 101–2, 109
 of Tenochtitlán, 117, 108–9, 111; *Plate 51*
 by Calnek, 109; *Plate 49*
 in Codices Matritenses, 110; *Colorplate 22*
 by Marquina, 110–11, 112, 115; *Plate 50*
 Nuremberg map, 104, 108, 109–10, 112;
 Plate 48
 of Tlatelolco, 109

Planet, *see* Venus, Planet

plants, 131, 234–36; *Plates 232, 233, 272*

plate, from Tlatelolco, 298–99; *Plates 317–
 19*

platform, *Plates 58, 234, 238–40*
 See also boxes: stone; temple: models of;
 sacrifice: objects related to

Plaza de las Tres Culturas, 105

pochteca, see merchants

poetry, 63, 64, 92, 118–19

Pomar, Juan Bautista, 33

Postclassic period, 43–49; *Plate 5*

pottery, 293–98; *Plates 310–14; Colorplates
 70–72*

*Praeclara Ferdinandi Cortesii de Nova Maris
 Oceani Narratio, Plate 48*

precinct, *see* temple: precinct

Preclassic period, 37–38; *Plate 5*

priests, 62–63, 66, 68, 91, 193, 194–96, 197,
 198; *Plate 30; Colorplates 34, 35*

Primeros Memoriales (Sahagún), 19

Puerto Marquez, 281

pulque, 134; *Plate 149*
 vessels, 236, 260, 294; *Plates 243, 280–83;
 Colorplate 50*

pyramid, *see* temple

Pyramid B, Tula, 44; *Plate 17*

Q

quauhxicalli, 254

"Queen's Bath," Tetzcotzingo, 129, 131;
 Colorplates 26, 27

Quetzalcoatl, 63, 125, 127, 163, 196–97, 223,
 234, 255–56, 258, 260; *Plates 3, 67, 68,
 275; Colorplate 33*

emblem for, 82–83; *Plate 41*

legend of, 20, 42, 44
 significance of, to Mexica, 55–56
 role of, during conquest, 13, 15, 20–23

missionaries' view of, 33

Quinatzin, 202; *Plate 152; Colorplate 39*
 See also Mapa Quinitzin

R

rabbit, 253–54; *Plate 46; Colorplates 31, 45*

Rain God, *see* Tlaloc

Rain God Brazier, 175; *Plate 141*

Rain God Chac Mool, 173–75; *Plates 137–40*

rattle staff, 218; *Plate 181*

reliefs, 249; *Plates 259, 260*
 on boulder, Cuernavaca, 125; *Plate 66*
 cliff
 at Acatzingo, 133; *Plate 75*
 at Cerro de la Malinche, Tula, 125–27,
 163; *Plates 67, 68*
 at Chapultepec, 127–29, 142; *Plate 69*
 at Malinalco, wall, 135; *Plate 79*
 at Tepetzingo, 116–17; *Plate 59*
 at Tepeyacac, 132
 at Tepoztlan, 135; *Plate 79*
 at Tetzcotzingo, 129–32; *Plates 71, 72*
 See also Bench Relief; Dedication Stone;
 Coyolxauhqui Relief; Greenstone
 Goddess

religion, 20, 56–65, 78, 124–25
 modern syncretism, 17–18, 34
 See also festivals; *tonalamatl*

resin images, 79; *Plate 32*

ritual, 74, 78, 119–20, 260, 279
 objects associated with, 77, 236, 247–48,
 253, 254–57, 260, 275; *Plates 120–23,
 163–65, 234–55, 273–77, 280–83;
 Colorplates 46–48*
 See also ball game; calendar: ritual;
 festivals: New Fire Ceremony; sacrifice:
 objects related to

Ritual Garb, Man in, *Plates 168, 169, 179*

rulers, *see* Mexica: history of

S

sacrifice, 53–54, 194, 196, 197–98, 222, 226;
 Colorplates 31, 32, 34, 35
 significance of, 58, 75, 78
 objects related to, 140
 knives, 168, 170; *Colorplates 55, 56*
 platforms, 110, 111, 112–13, 115, 236;
 Plates 238–40

PHOTOGRAPHIC CREDITS

The author and publisher wish to thank the libraries, museums, and private collectors for permitting the reproduction of works in their collections. Photographs have been supplied by owners or custodians of the works of art and by the following photographers; all are listed alphabetically by city or photographer's surname (italic type indicates colorplate):

Arostegui, Carlos, 141; Salvador Guilliem Arroyo, Museo Templo Mayor, INAH, 102; Basel, Museum für Völkerkunde, *Half-title page*, 183, 184, 194, 212, 215, 216, 244; Berlin, Museum für Völkerkunde, *46–48*, 120, 121, 181, 188, 209, 210, 312; Boltin, Lee, 6, *15, 32, 51, 57–61*, 110, 132, 139; Brooklyn, The Brooklyn Museum, 156, 180, 195, 214; Cambridge, Engl., Cambridge University Museum of Archaeology and Anthropology, 313 a, b; Cambridge, Mass., Peabody Museum of Archaeology and Anthropology, Harvard University, 263 (H. Burger); Cleveland, Cleveland Museum of Art, 204; Cline, Howard, 3, *19*, 84; Florence, Biblioteca Medicea Laurenziana, *11;* Florence, Biblioteca Nazionale Centrale, *17;* Hamburg, Hamburgisches Museum für Völkerkunde und Vorgeschichte, 273, 274, 276, 277; Hollywood, Cal., Stendahl Collection, 205; Jalapa, Veracruz, Museo Etnográfico ed Arqueológico, 6; London, The British Library, 48; London, The British Museum, *3*, 21, *53–55, 57–63*, 85, 122, 123, 155, 197, 198, 223, 243, 287, 302, 311; Madrid, Biblioteca Nacional, 3, *19*, 84; Madrid, Real Casa, Patrimonio Nacional, Palacio Real, *10, 18, 22*, 28, 29; Mannheim, Völkerkundliches Museum, 196; Mazenod, Jean, 99, 137; Mexico City, Museo Nacional de Antropología, *Frontispiece, 1*, 7, 10, 13, 18 (Stupakoff), 32, *41–44*, 53, 56, 65, *70–73*, 73, 74, 79, 86, 87, 89, 90, 94, 96, 97, 100, 112–16, 118, 124–32, 134, 138, 140, 142–46, 148–51, 158, 159, 161–69, 171–79, 182, 185–87, 192, 193, 201, 207, 208, 211, 213, 218–22, 226–28, 230–32, 235–42, 245–49, 250 (Saenz), 251–60, 270, 272, 288, 296, 297, 299 (Saenz), 301, 303 (Medina de los Reyes), 304–5, 307–9, 315, 317, 318; Nagao, Debra, 16, *26, 27*; New Haven, Peabody Museum of Natural History, Yale University, 206, 234; New York, The American Museum of Natural History, 14, *15, 51*, 233, 266, 291; New York, The Metropolitan Museum of Art, 170, 217 (C. Uht), 261, 298; New York, The Museum of the American Indian, Heye Foundation, 15 (C. Guadagna), 199, 200, 294, 314; Oxford, Bodleian Library, *7, 14, 21*, 26, 30, 31; Pachuca, Mexico, Archivo Histórico Fotográfico, INAH, S.E.P., 17, 18, 52, 61, 63, 64, 66, 76, 77, 82, 83, 111, *161*; Paris, Bibliothèque de l'Assemblée Nationale, *29–35*, 147; Paris, Bibliothèque Nationale, *6, 12, 13*, 22, 24, *36–40*, 55, 153; Paris, Musée de l'Homme, 157, 224, 229 (J. Oster), 300 (J. Oster), 306; Pasztory, Esther, 2, 20, *20*, 24, 25, 55, 62, 69, *70, 71*, 71, 91, 92, 104 a, b, 136, 139, 259; Philadelphia, Philadelphia Museum of Art, 191; Princeton, Art Museum, Princeton University, 292; Providence, Museum of Art, Rhode Island School of Design, 225; Randel, Walter, 286; Rome, Biblioteca Vaticana Apostolica, *4, 5, 8, 9*; Rome, Museo Nazionale Preistorico ed Etnografico Luigi Pigorini, *52, 56, 62*; Saint Louis, Saint Louis Art Museum, 203, 285; Stuttgart, Württembergisches Landesmuseum, *49, 65, 66*, 278, 279; Tenango, Museo del Estado de Mexico, 160, 289; Teotihuacán, Museo Arqueológico, 9; Umberger, Emily, *28*, 67, 92, 96, 107, 117, 127, 128, 240, 247, 252, 253; Vienna, Museum für Völkerkunde, 12 (Mandl), *16* (Mandl), *50* (Mandl), *67, 68*, and *page 4* (all Mandl), 189 (Mandl), 190 (Mandl), 202, 267, 271, 280, 281, 284; Washington, D.C., Dumbarton Oaks Pre-Columbian Collection, *47*, 264, 265, 268, 269.